Exploring Color Photography

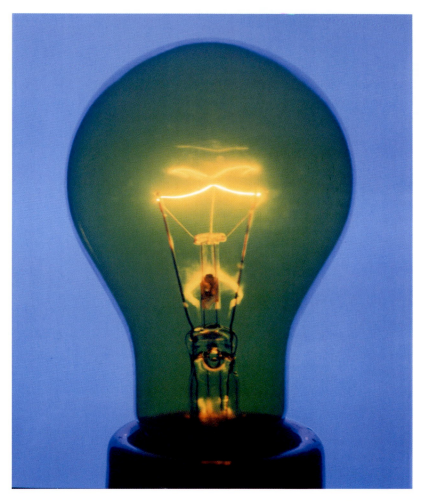

© Amanda Means. *Light Bulb 00016C,* 2001. 24 × 20 inches. Diffusion transfer print.

Exploring Color Photography

FROM FILM TO PIXELS FIFTH EDITION

Robert Hirsch

with contributing writer Greg Erf

ELSEVIER

AMSTERDAM • BOSTON • HEIDELBERG • LONDON • NEW YORK • OXFORD
PARIS • SAN DIEGO • SAN FRANCISCO • SINGAPORE • SYDNEY • TOKYO

Focal Press is an imprint of Elsevier

Acquisitions Editor: Cara St. Hilaire
Developmental Editor: Stacey Walker
Publishing Services Manager: Debbie Clark
Project Manager: Lisa Jones
Marketing Manager: Kate Iannotti
Cover and Interior Design: Joanne Blank
Illustrator: Greg Erf

Focal Press is an imprint of Elsevier
The Boulevard, Langford Lane, Kidlington, Oxford, OX5 1GB, UK
30 Corporate Drive, Suite 400, Burlington, MA 01803, USA

Fifth edition 2011

British Library Cataloguing in Publication Data
A catalogue record for this book is available from the British Library

Library of Congress Control Number: 2010934883

ISBN: 978-0-240-81335-6

For information on all Focal Press publications
visit our website at www.focalpress.com

Printed and bound in China

11 12 13 11 10 9 8 7 6 5 4 3 2

Contents

CHAPTER 1

Color Photography Concepts .. 1

CHAPTER 2

A Concise History of Color Photography 15

Contents

Contents

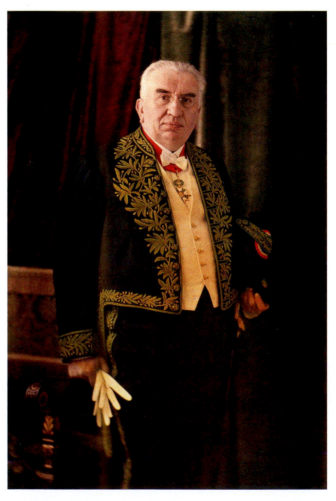

The brothers Auguste and Louis Lumière were pioneers in filmmaking and color photography. They patented a color photography process, the Autochrome Lumière (1903), which was marketed in 1907 (see Chapter 2). Louis said, "Of all the things I have invented, Cinema cost me the least and making Autochromes practical gave me the greatest pleasure."

© Unknown Photographer. *Louis Lumière in his Science Academician Regalia,* 1935. 7¼ × 9½ inches. Autochrome. Mark Jacobs Collection.

Dedication

To my mother, Muriel Hirsch, for teaching me to read, and my wife, Adele Henderson, for her inspiration and ongoing support.

And to the memory of my father, Edwin Hirsch, for introducing me to photography; and Ernest Shackleton (1874–1922), explorer of Antarctica, and the crew of the Endurance expedition, who provided me with insight into the nature of true exploration:

> *"The qualities necessary to be an explorer are, in order of importance: optimism, patience, physical endurance, idealism, and courage. Optimism nullifies disappointment. Impatience means disaster. Physical endurance will not compensate for the first two moral or temperamental qualities."*

Unknown Artist. *Don't Forget Your Camera,* circa 1950s. 4 × 9 inches. Offset on paper.

© Brian Ulrich. *Six Flags Mall*, from the series *Dark Stores*, 2009. Variable dimension. Chromogenic color print.

"Everything that lives strives for color."
—Johann Wolfgang von Goethe,
Theory of Colors (1810)

Much has changed since *Exploring Color Photography* was first published in 1989. Digital imaging was then in its infancy and accounted for only a few pages of text and a handful of images. As the reader will see, that is no longer the case. Yet as I conclude the fifth edition, a great deal remains the same. Color photography continues to evolve as a flexible and permutable amalgamation of aesthetics, culture, psychology, and science. The book keeps striving to provide a stimulating introduction to the approaches, images, techniques, and history of color photography. As photo-based technology evolves, the text relies on a conceptual methodology that stresses understanding ideas from which aesthetic and technical explorations can be conducted. The resources presented are based on my experiences as an imagemaker, teacher, curator, and writer who actively maintains an ongoing dialogue with the medium and its makers. Like its predecessors, the purpose of this extensively revised and updated text remains to provide comprehensive foreknowledge to assist one to think through and comprehend photo-based color work. The approach is pragmatic, explaining how theory relates directly to the practice of the making of color photo-based images. By concentrating on the fundamental and stable aspects of photographic practice rather than those in flux, the text presents necessary means for the elaboration of ideas by photographic means. It assumes a basic working knowledge and understanding of photography, digital image processing, and photographic history. In a time of electronic imaging dominance, this book's position is that digital imaging is yet another valuable tool for use by imaginative photographers, which can be integrated into their creation process whenever deemed necessary.

In this edition the chapter ordering has been revised to encompass the latest photographic trends, with digital imaging given priority over analog methods. The opening chapters provide the foundational information needed to make intelligent and accessible work. The core chapters cover numerous working approaches and detailed technical data. The latter chapters offer problem solving and presentation solutions. The book closes with appendices on darkroom safety plus the Zone System. Each chapter is broken down into discrete units to assist readers in easily finding major topics of interest. This arrangement also encourages readers to skip around and generate their own ordering structure based on their particular needs. As in previous editions, terms are defined in context as they are introduced. This system of amplification facilitates a clearer definition and a broader understanding that is possible only through personal interaction with the materials being discussed and eliminates the need for a glossary.

The underlying premise of the book stresses visual thinking and encourages imagemakers to select materials and processes that will express their internal ideas. To be an explorer is to investigate the unknown for the purpose of discovering what is out there. Once the mysterious becomes knowable, it is possible to gain an understanding that can lead to creation. From creation an uncovering of meaning is made possible. This book presents a structured starting place for ideas and techniques of known exploration. The text offers guided paths to get you involved with the spirit of discovery, to promote thinking and questioning, and to provide the means to begin to express your visual voice. Since this book is not intended to be the final authority, additional sources of information are provided throughout the text to encourage you to make your own explorations. Ultimately, this book's rationale is to arouse your curiosity and provide the means and direction for you to make your own informed artistic decisions.

The illustration program of this fifth edition has been completely revamped to showcase diverse and innovative images being made by 250 contemporary artists, professionals, teachers, and students. It is valuable for people entering color practice to be exposed to the many varied aspects the medium has to offer in terms of content and practice. The images presented reflect current photographic tendencies to experiment and push the definitions and limits of what defines color photographic practice. It encourages a vital curiosity that fosters a personal expansion of the boundaries of color photography. This edition makes use of images that are not intended to act solely in an illustrative mode, but that demonstrate the extraordinary rich interconnectedness and interaction of the sensory areas of the brain that go into the making, viewing, and comprehension of visual images.

The captions provide a concise forum whereby the photographers speak directly to the reader about their work. They are based on the extensive materials I have collected from artists' statements, personal correspondence, e-mails, and conversations, in which the photographers explain key aesthetic and technical choices made in the creation of their work. Due to space limitations, I have condensed, edited, and clarified statements to show how the work relates to the text and to give insight into the photographer's working methods. These captions are not intended as final closures of meaning, but as initial toeholds into the thinking behind the image. They are designed to spur your thinking and encourage you to provide your own explanation and evaluation of the medium, as well as to question the limits of language within the visual arts.

Acknowledgments

Just as critic Northrop Frye noted that "poetry can only be made out of other poems; novels out of other novels," so it is with all art, including photography. This book is about the spirit of transmitting knowledge and as such I would like to thank the teachers who have made a difference to me: Mr. Gordon Rice, my high school art teacher, for giving me the hope to pursue a life involving photography; Dr. Stan McKenzie, for encouraging me to think and write; Judy Harold-Steinhauser, for supporting experimentation and group interaction; Art Terry, for not being a

hypocrite; and the numerous imagemakers and writers who have shaped my thinking.

This book would not have been possible without the generosity of numerous individuals, especially the artists who have allowed me to reproduce their work. For this fifth edition I want to thank the many contributors, expert consultants, and readers of this and preceding editions for sharing their knowledge.

Special thanks are in order for the following people who have made significant contributions to this fifth edition:

Professor Greg Erf, Eastern New Mexico University, Portales, NM, with whom I co-created the digital chapters. After jointly devising a working outline, Greg wrote the drafts while I acted as editor and rewriter. Greg also created all the new illustrations and updated previous ones. He also reviewed the entire working manuscript. Additionally, Greg and I have worked together creating and teaching the history of photography online (www.enmu.edu/photohistory), writing columns for *Photovision* magazine, and various other activities (see: www.negativepositive.com);

Anna Kuehl, who ably assisted with the art program, caption writing, correspondence, database management, and manuscript organization;

Greg Drake, for expertly reading, editing, suggesting, and fact-checking the entire manuscript;

Mark Jacobs for his expertise on early color processes, providing numerous examples from his collection, and reading drafts of the color history chapter and photo timeline;

Eric Joseph, Senior Vice President of Merchandising and Product Development for Freestyle Photographic Supplies, Los Angeles, CA, for technical support;

Trina Semorile, for her counsel on health and safety issues;

To those who read sections of the working manuscript and gave invaluable input:

Professor Michael Bosworth, Villa Maria College, Buffalo, NY

Professor Katherine Campbell, Appalachian State University, Boone, NC

Professor Jill Enfield, Parsons The New School for Design, New York, NY

Professor Robin Germany, Texas Tech University, Lubbock, TX

Professor Liz Lee, SUNY Fredonia, Fredonia, NY

Professor Ford Lowcock, Santa Monica College, Santa Monica, CA

Dean Roland Miller, College of Lake County, Grayslake, IL.

To those who have shared their classroom assignments:

Professor Joyce Culver, School of Visual Arts, New York, NY

Professor Francois Deschamps, SUNY New Paltz, New Paltz, NY

Professor Liz Lee, SUNY Fredonia, Fredonia, NY

Professor Gary Minnix, University of Illinois, Chicago, IL

Professor Christian Widmer, Arizona State University, Tempe, AZ.

To my final manuscript readers:

Professor Adam DeKraker, Ferris State University, Grand Rapids, MI

Professor Steven Johnson, Eastern Mennonite University, Harrisonburg, VR

Thanks to all the people at Focal Press who have offered their cooperation, time, and knowledge in producing this book especially Cara St Hilaire and Stacey Walker, my project editors; Joanne Blank, project designer; Lisa Jones, my production editor; Elaine Leek, my copy-editor; and Dave Tyler, my indexer; for their thoughtful efforts in making improvements to this fifth edition; plus all my Focal Press reviewers.

A word of caution: In many color photography processes you will be working with materials that can be hazardous to your health, if they are not handled properly. To prevent problems from occurring, read all directions, precautions, and safety measures (especially those outlined in the safety appendices) thoroughly before you begin working in any process. Preventative common sense will go a long way to ensure a safe, healthy involvement with color photography. Enjoy your explorations.

Robert Hirsch
Buffalo, New York
www.lightresearch.net

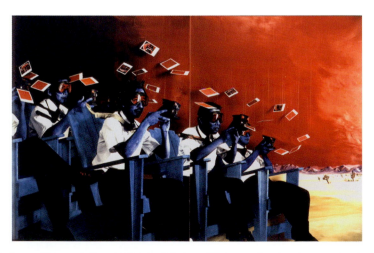

© Patrick Nagatani and Andrée Tracey. *Alamogordo Blues*. 1986. 24 × 60 inches. Diffusion transfer prints. Courtesy of Andrew Smith Gallery, Sante Fe, NM.

Contributors to Exploring Color Photography

Koya Abe, Kim Abeles, Bill Adams, Linda Adele, David R. Allison, Jeremiah Ariaz, Bill Armstrong, Shimon Attie, Jo Babcock, Pat Bacon, Evan Baden, Darryl Baird, Nathan Baker, Joan Barker, Tina Barney, Thomas Barrow, Wayne Martin Belger, Paul Berger, Phil Bergerson, Robert Bergman, Laura Blacklow, Diana Bloomfield, Michael Bosworth, Christa Kreeger Bowden, Thomas Brummett, Christopher Bucklow, Dan Burkholder, Edward Burtynsky, Diane Bush, Roger Camp, Kathleen Campbell, John Paul Caponigro, Ellen Carey, Vincent Carney, Christine Carr, Carl Chiarenza, William Christenberry, Doug Clark, Fred Payne Clatworthy, Cora Cohen, Douglas Collins, Kelli Connell, Jules-Gervais Courtellemont, Barbara Crane, Gregory Crewdson, Joyce Culver, Binh Danh, Jen Davis, Steve Davis, Pamela de Marris, Dennis DeHart, Brian DeLevie, Alyson Denny, Deena des Rioux, François Deschamps, Seze Devres, Philip-Lorca diCorcia, Rick Dingus, Todd Dobbs, Kerri Dornicik, Greg Drake, Robin Dru, Doug DuBois, Beth Yarnelle Edwards, William Eggleston, Olafur Eliasson, Mitch Epstein, Greg Erf, Janyce Erlich-Moss, Terry Evans, Susan E. Evans,

Katie E. Lehman, William Lesch, David Levinthal, Mark Lewis, Adriane Little, Jonathan Long, Ford Lowcock, Lumière Brothers, Joshua Lutz, Martha Madigan, Florian Maier-Aichen, Curtis Mann, MANUAL (Ed Hill/Suzanne Bloom), Stephen Marc, Ken Marchionno, Antonio Mari, Fredrik Marsh, James Clerk Maxwell, Dan McCormack, Thomas McGovern, Gerald C. Mead Jr., Amanda Means, Pedro Meyer, Joel Meyerowitz, Marcel Meys, Roland Miller, Sybil Miller, Gary Minnix, Marilyn Minter, Richard Misrach, Akihiko Miyoshi, Rebekah Modrak, Delilah Montoya, Yasumasa Morimura, Steven P. Mosch, Brian Moss,

Nickolas Muray, Jeff Murphy, Patrick Ryoichi Nagatani, NASA, Ardine Nelson, Bea Nettles, Janet Neuhauser, Lori Nix, Simon Norfolk, Michael Northrup, Jayme Odgers, Ted Orland, Deborah Orloff, Bill Owens, Trevor Paglen, Luis González Palma, Carol Panaro-Smith, Robert and Shana ParkeHarrison, Olivia Parker, Tom Patton, Lauren Peralta, John Pfahl, Andrew Phelps, Cara Phillips, Alexis Pike, Colleen Plumb, Kathleen Pompe, Eliot Porter, Greta Pratt, Douglas Prince, Justin Quinnell, Eric Renner, Holly Roberts, Mariah Robertson, Lisa Robinson, Joyce Roetter, Anne C. Savedge, Lynn Saville, William Saville-Kent, Joseph Scheer, Betsy Schneider, Larry Schwarm, Del Scoville, Fred Scruton, J. Seeley, Richard Selesnick, Andres Serrano, Paul Shambroom, Christine Shank, E. Sanger Shepherd, Cindy Sherman, Stephen Shore, Matt Siber, Laurie Simmons, Rebecca Sittler, Kerry Skarbakka, Sandy Skoglund, Mark Slankard, Clarissa Sligh, Ursula Sokolowska, Jerry Spagnoli, Nancy Spencer, Jan Staller, Jim Stone, Evon Streetman, Thomas Struth, Tosh Tanaka, Brian Taylor, Maggie Taylor, Deborah Tharp, H.C. Tibbitts, Jessica Todd, Andrée Tracey, David Trautrimas, Marcia Treiger, Arthur Tress, Linda Troeller, Laurie Tümer, Brian Ulrich, John Vachon, Kathryn Vajda, Jeff Van Kleeck, Robert Voit, Todd c/o Melanie Walker, Jeff Wall, Jeffu Warmouth, William Wegman, Annette Weintraub, Jo Whaley, Susan Wides, Christian Widmer, Lloyd Wolf, Byron Wolfe, Claudia Wornum, Anne Zahalka, Jody Zellen, Liu Zheng, Unidentified Photographers.

Mick Farrell, Robert Fichter, Carol Flax, Kelly Flynn, Robert Flynt, Harris Fogel, Jennifer Formica, Nicole Fournier, James Friedman, Barry Frydlender, Adam Fuss, Jonathan Gitelson, Robert Glenn, Peter Goin, Gary Goldberg, Judith Golden, Nan Goldin, Sondra Goodwin, Daniel Gordon, Laura Paresky Gould, David Graham, Jill Greenberg, Lauren Greenfield, Andreas Gursky, Toni Hafkenscheid, Stefan Hagen, Tim Hailand, James Hajicek, Heide Hatry, Cliff Haynes, Robert Heinecken, Adele Henderson, Lori Hepner, Liz Hickok, Levi L. Hill, Stephen Hilyard, Robert Hirsch, Douglas Holleley, Amy Holmes, Kitty Hubbard, Allison Hunter, Ambler Hutchinson, Mark Jacobs, Bill Jacobson, Ellen Jantzen, Keith Johnson, Kiel Johnson, Tom Jones, Chris Jordan, Ron Jude, Susan Kae, Nicholas Kahn, Jennifer Karady, Thomas Kellner, Kay Kenny, Atta Kim, Mark Klett, Kevin Charles Kline, Karl Koenig, Richard Koenig, Martin Kruck, Barbara Kruger, Anna Kuehl, Heidi Kumao, Joseph Labate, Sally Grizzell Larson, Dinh Q. Lê, Liz Lee, Myoung Ho Lee,

Ellen Carey's work examines "color as subject and object, material with meaning, and process in photographic art." Here she utilizes color theory with its additive (red, green, and blue) and subtractive (cyan, magenta, and yellow) primary colors.

© Ellen Carey. *Color Theory*, 1995. 24 × 60 inches. Diffusion transfer prints. Courtesy of the artist and Jayne H. Baum Gallery, New York, NY.

Color Photography Concepts

Newton's Light Experiment

From the time of Aristotle, common wisdom held that the purest form of light was white. In 1666 Englishman Isaac Newton debunked this belief by demonstrating that light is the source of color. In an elegantly simple experiment he passed a beam of sunlight through a glass prism, making the rainbow of colors that form the visible spectrum (red, orange, yellow, green, blue, indigo, violet, and the gradations in between). Newton then passed the rainbow back through a second prism, which converted all the hues back into white light (Figure 1.1). From this experiment he determined that color is in the light, not in the glass prism, as had been previously thought, and that what we see as white light is actually a mixture of all wavelengths of the spectrum visible to the human eye.

A prism, such as the one Newton used, separates the colors of light through the process of refraction. When light is refracted, each wavelength of light is bent to a different degree. This separates light into the individual color bands that make up the spectrum. It is the wavelength of the light that determines its visible color. Newton's presentation also serves as a reminder against reductionism, for what appeared to be simple on the surface—a beam of white light—was, when examined more deeply, beautifully complex.

Separating Light

The colors of light are also separated by the surfaces of objects. We perceive the color of an object by responding to the particular wavelengths of light reflected back to our eyes from the surface of the object. For example, a red car looks red because it absorbs most of the light waves reaching it but reflects back those of the red part of the spectrum (Figure 1.2). An eggshell appears white because it reflects all the wavelengths of light that reach it (Figure 1.3).

When light is filtered, it changes the apparent color of any object that it illuminates. If the white eggshell is lit only by a red-filtered light source, it appears to be red. This occurs because red is the only wavelength that strikes the eggshell, and in turn, red is the only color reflected back from the eggshell (Figure 1.4). Objects that transmit light, such as color transparencies (a.k.a slides), also absorb some of the colors of light. Transparencies contain dyes that absorb specific wavelengths of light while allowing others to pass through. We perceive only those colors that are transmitted, that is, that are allowed to pass through the transparency.

Figure 1.1 Isaac Newton's experiment proved that colors exist in white light and that white light is made up of the entire visible spectrum of colors.

Figure 1.2 A red object appears to be red because it reflects red wavelengths of light while absorbing most of the other wavelengths of light.

Figure 1.3 A white object looks white because it reflects all wavelengths of light that strike it.

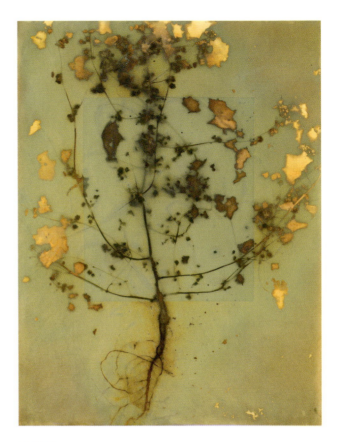

Figure 1.5 Influenced by the nineteenth-century imagemaker Henry Fox Talbot's experiments with light and photographic materials, Carol Panaro-Smith and James Hajicek make photogenic drawings by placing botanical specimens in contact with light-sensitive paper. The artists cover the specimens with sheets of glass during the long exposures, which may last several hours. Afterwards, they wash and fix the prints in a saturated salt bath in order to preserve the colors of the print as well as encourage slight color shifts over the course of time. They explain, "The transitory nature of the print is reflective of our feelings about everything worth thinking about— art, life, death, and the art world's obsession with permanency."

© Carol Panaro-Smith and James Hajicek. *EV-05-22*, from the series *Earth Vegetation*, 2005. 24 × 18 inches. Photogenic drawing.

Figure 1.4 If a white object is illuminated by only a single-filtered source of light (e.g., red), it will appear to be only that single color. When only one color strikes an object, that color is the only color that can be reflected back.

Dual Nature of Light: Heisenberg's Uncertainty Principle

In 1803 Thomas Young, an English physician and early researcher in physics, demonstrated that light travels in waves of specific frequency and length. This had important consequences for it

showed that light seemed to have characteristics of both particles and waves. This apparent contradiction was not resolved until the development of quantum theory in the early decades of the twentieth century. It proposes a dual nature for both waves and particles, with one aspect predominating in some situations and the other predominating in other situations. This is explained in Werner Heisenberg's paper "The Uncertainty Principle" (1927) that places an absolute theoretical limit on the accuracy of certain measurements.[1] The result is that the assumption by earlier scientists that the physical state of a system could be exactly measured and used to predict future states had to be abandoned. These lessons were reflected in new multifaceted ways of visualizing the world as seen by artists such as Pablo Picasso, Marcel Duchamp, and David Hockney.

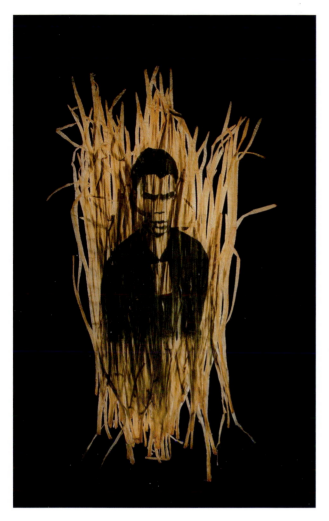

Figure 1.6 After observing his lawn changing color when a water hose was left on it for long periods of time in the sun, Binh Danh began experimenting with the process he calls chlorophyll printing. With this process, he creates images through the interaction of light, chlorophyll, carbon dioxide, and water. First, he produces a digital negative. After several weeks in the sun, a positive image is contact printed to a leaf or grass through photosynthesis. The process itself lends heavily to the meaning he wishes to convey in his work. Danh asserts, "This process deals with the idea of elemental transmigration: the decomposition and composition of matter into other forms. The images of war are part of the leaves, and live inside and outside of them. The leaves express the continuum of war."

© Binh Danh. *Found Portrait #24*, from the series *Ancestral Altars*, 2005. 20½ × 13¼ inches. Chlorophyll print on grass with resin. Courtesy of Haines Gallery, San Francisco, CA.

Young's Theory/RGB

In 1807 Young advanced a theory of color vision, which states that the human eye is sensitive to only three wavelengths of light: red, green, and blue (RGB). The brain blends these three primary colors to form all the other colors. Young's ideas later formed the basis of the additive theory of light: white light is made up of red, green, and blue light, which is also the basis of color reproduction in the digital world. Theoretically all the remaining colors visible to the human eye can be formed by mixing two or more of these colors (see The Additive Theory in Chapter 2). When all three of these primary colors are combined in equal amounts the result is white light. Young's theory has yet to be disproved, even though it does not seem to fully explain all the various phenomena concerning color vision (see The Additive Theory section in Chapter 2). It continues to provide the most useful model to date to explain all the principal photographic processes in which analog and digital color images have been produced.

How We See Color

It is rare for us to see pure color, that is, light composed solely of one wavelength. Almost all the hues we see are a mixture of many wavelengths. Color vision combines both the sensory response of the eye and the interpretive response of the brain to the different wavelengths of the spectrum. Light enters the eye and travels through the cornea, passing through the iris, which acts as a variable aperture controlling the amount of light entering the eye. The image that has been formed is now focused by the lens onto a thin membrane at the back of the eye called the retina. The retina contains light-sensitive cells known as rods and cones, named after how they appear when viewed with a microscope. The cones function in daylight conditions and give us color vision. The rods function under low illumination and provide vision only in shades of gray. The rods and cones create an image-receiving screen in the back of the eye. The physical information received by the rods and cones is sorted in the retina and translated into signals that are sent through the optic nerves to the nerve cells in the back of the brain. The optic nerves meet at the chiasma. Visual images from the right side of the brain go to the left and images from the left side of the brain go to the right (see Figure 1.8).

Humans can see a spectrum of about one thousand colors that ranges from red light, which travels in long wavelengths, through the midrange of orange, yellow, and greens, to the blues and violets, which have shorter wavelengths. The distance from wave crest to wave crest determines the length of the light waves. The difference between the longest and the shortest wavelengths is only about 0.00012 of an inch.

How the Brain Sees Color

In the brain this visual information is analyzed and interpreted. Scientists have not yet discovered the chemical and neurological reactions that actually let us perceive light or color. It is currently believed that the effects of light and color on an individual are dependent on our subjective emotional, physical, and psychological states and our past experiences, memories, and preferences. It appears the brain is an active and dynamic system where all data are constantly revised and recorrelated. There is nothing mechanical or camera-like, as every perception is a conception and every memory a reconception. There are no fixed memories, no "authentic" views of the past unaffected by the present.

Seeing color is a dynamic process, and remembering it is always a reconstruction as opposed to a reproduction. It has been

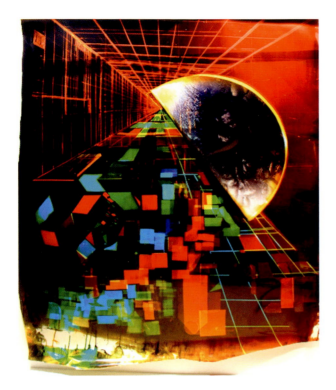

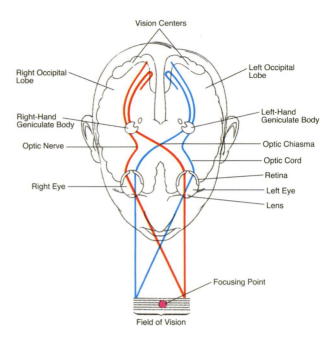

Figure 1.8 This top cutaway view of the human skull reveals how color images are believed to be formed in the brain.

Figure 1.7 In her *I Am Passions* series, Mariah Robertson tests the limits of color and the roles of photography. She constructed a synthetic 4 × 5-inch negative from pieces of colored gels and tape, placed it on light-sensitive paper, and used two color-filtered camera flashes as exposure sources. To make the center of the image, she masked a semicircular section of the negative, which she then exposed under the enlarger to an image of cooled lava. Robertson tells us, "I like to put things together that don't belong for quick examples of representations and abstractions. There is so much image potential inherent to the photographic process … The answer is always in the disasters, the flaws."

© Mariah Robertson. *18*, from the series *I Am Passions*, 2009. 56 × 48 inches. Chromogenic color print.

proven that when a group views a single specific color, the individual responses to it vary considerably (see Color Is a Personal Experience, page 13). Although color can be defined objectively with scientific instruments, we lack this ability and see color subjectively rather than quantifiably. The act of experiencing color and light involves a participatory consciousness in which we feel identified with what we perceive.

This brings up the toughest problem in neuroscience: consciousness. We know what red is, but one will never know the character of another's experience of red. This denotes that our understanding and interpretation of color is based on neurological phenomena, their relationship to physiological mechanisms, and their integration with philosophy of mind.

Color Blindness

We the sighted, who are able to build our own images so effortlessly, believe we are experiencing "reality" itself. Color-blind people remind us that reality is a colossal act of analysis and synthesis that involves the subjective act of seeing.

Irregular color vision most commonly manifests itself as the inability to distinguish red from green, followed by the inability to tell blue from yellow; rarely is there the inability to perceive any color. Color blindness affects approximately 8 percent of males and 0.5 percent of females. A mother transmits the genes that affect color vision. The reason for this anomaly is not certain because there appear to be many causes. It is possible to learn how to make accurate color prints with mild to moderate color blindness, but it is not generally advisable for people with severe anomalous color vision to take on situations where precise evaluation is of critical importance. Some imaging software programs offer a simulation of various types of color blindness, which can be useful in understanding and overcoming its effects.

Young's Theory Applied to Color Photography

Current techniques for creating digital color photographs make use of Thomas Young's theory that almost any color we can see may be reproduced optically by combining only three basic colors of light: red, green, and blue (RGB). For example, a typical color film consists of up to 20 layers that precisely combine about 200 separate ingredients supported by an acetate base (Figure 1.9). Each of the three basic emulsion layers is primarily sensitive to only one of the three additive primary colors. The top layer is sensitive to blue light, the middle to green light, and the bottom to red light. Blue light is recorded only on the layer of film that is sensitive to blue, green light on the green-sensitive layer, and red light on the red-sensitive layer. All other colors are recorded on a combination of two or more of the layers. Some

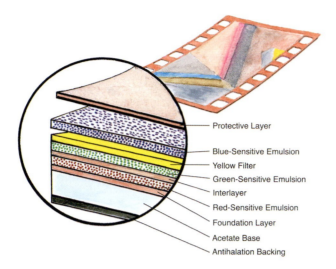

Figure 1.9 This enlarged cutaway view shows the general construction of three-layered color film.

films have a fourth emulsion layer that improves the film's ability to record the green portion of the spectrum, which can be valuable under fluorescent, artificial, and mixed light situations.

How Film Produces Color

During development each layer makes a different black-and-white image that corresponds to the amount of colored light that was recorded in each individual layer during the exposure (Figure 1.10). The developer oxidizes and combines with the color chemical couplers in the emulsion to create the dyes. The red-sensitive layer forms the cyan dye, the green-sensitive layer the magenta dye, and the blue-sensitive layer the yellow dye. During the remaining stages of the process, the silver is removed from each of the three layers. This leaves an image created solely from the dyes in each of the three layers (Figure 1.11). This is a significant difference between color and black-and-white films where the image is physically formed by clumps of silver in the

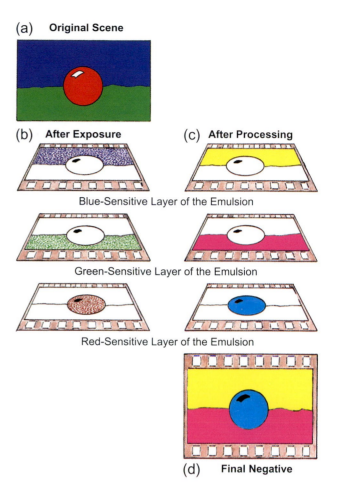

Figure 1.10 This is a representation of how color negative film produces an image from a scene: (a) the original scene; (b) how each layer of the film records the colors; (c) how each layer responds to processing; (d) the final makeup of the color negative that is used to produce a color print.

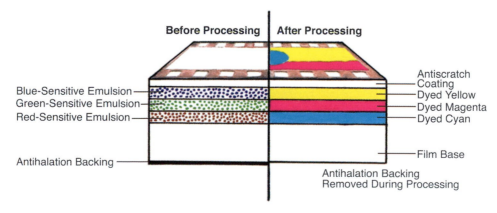

Figure 1.11 A cross-section of a typical contemporary color film before and after processing.

emulsion. The film is then fixed, washed, and dried to produce a complete color image (see Chapter 10 for details).

How Digital Cameras Record Color

One-shot digital image capture, as in commonly used digital cameras, also is based on RGB. Most sensors use a color filter array, a pattern of RGB squares, also known as a color filter mosaic (CFM). Each pixel is covered by either a red, green, or blue filter. One common array is the Bayer pattern, invented at Kodak, in which 25 percent of the pixels are red, 25 percent blue, and 50 percent green. This formula favors the more sensitive green range of human vision by sacrificing the data in the red and blue ranges. To fill in the gaps of missing information, a computer-imaging program in either the camera or host computer takes an average of the neighboring pixels utilizing algorithms based on visual perception to fabricate an acceptable representation known as interpolation. Interpolation works because the eye is more sensitive to variations in luminance (brightness) than variations in color. Using a scanner to capture an image from film or a print provides more accurate and complete data because it makes multiple exposures, one for each RGB color, which limits it to recording still subjects. There are also medium- and large-format cameras with scan backs that make use of the multi-shot method.

Color Reality

Color has not always been synonymous with truth and reality. In the past, Plato and Aristotle both attacked the use of color in painting because they considered color to be an ornament that obstructed the truth. Even the word "color" contains a snub against it. The Latin *colorem* is related to *celare*, to

hide or conceal; in Middle English to color is to embellish or adorn, to disguise, to render specious or plausible, to misrepresent. Today most people prefer color pictures to black-and-white pictures. They claim that color photographs are more "real" than black-and-white photographs. This implies that people tend to conflate color photography and reality to an even a greater extent than they do with black-and-white photographs. Many people have had the experience of someone pointing to an 8 × 10-inch color glossy and saying, "There's Mary. She sure looks good, doesn't she?" We know that it is not Mary, but such a typical response acts as a vivid reminder of how we expect photography to duplicate our reality for us. This expectation reveals an entire series of problems dealing with the construction of photographic color materials and our own powers of description and memory. The photographer and the audience continually face these issues when working with color.

Lack of Color Film Standards

Digitally, there are numerous products available to calibrate one's camera, monitor, and printer to achieve the desired visual outcome. However, in all analog color processes, the final outcome hinges on how successfully the synthetic dyes replicate a "natural" color balance. Each film manufacturer makes emulsions that emphasize different color balances. Certain colors are overemphasized in some and in others their degree of saturation is exaggerated. While these colors may look appealing, they are not accurate and produce a loss in delicate and subdued colors. The overriding issue is the lack of an industrial standard. Some films tend to create a cool, neutral, or even detached look. They emphasize blue and green. Other films give a warm look, favoring red and yellow. These colors seem more intense and vivid. The warmth tends to draw people in and create more involvement.

This lack of a standard color balance affects all color negative and transparency films. The dyes simulate the look of reality, but they do not reproduce true colors. What you get is an interpretation of the scene. For this reason it is imperative that each photographer should work personally with many of the available materials to find one that agrees with his or her personal color sense. By learning the characteristics of films, the photographer will also know what film will create the look he or she wants in a given situation.

Talking About Color

Have you ever noticed how few words there are in the English language to describe colors? Some languages have up to 20 words to distinguish slight differences within one color. Without words to describe, we have a very limited ability to see and distinguish subtle variations in color. Most people simply say a car is red. This covers a great deal of territory. A car dealer may call the same car "candy apple red." Neither term is an accurate description and doesn't give another person much sense of what we are attempting to describe. These vague generalizations cause problems translating into words what we see in pictures.

Figure 1.12 Kiel Johnson's single-lens reflex camera explores the intersection of analog and digital camera technology. Drawing on his lifelong interest in manual machinery, Johnson utilizes widely accessible materials such as chipboard and X-Acto knives to construct his handmade models of digital cameras. He states, "I'm thinking about dying technologies, communication highways, information networks, power of the press, memories of youth, searching, investigating, lessons learned, stories told."

© Kiel Johnson. *SLR #8*, 2010. 7 × 8 × 8 feet. Chipboard and hot glue. Courtesy of Mark Moore Gallery, Santa Monica, CA, and Davidson Contemporary, New York, NY.

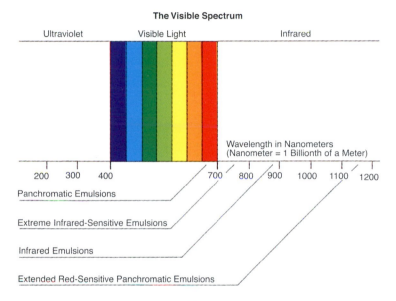

The Electromagnetic Spectrum

Frequency (Oscillations per Second)

10^{22} 10^{20} 10^{18} 10^{16} 10^{14} 10^{12} 10^{10} 10^{8} 10^{6} 10^{4} 10^{2} 1

Power
Transmission

Ultraviolet Infrared

X-Rays Radio & TV Broadcast Band

Gamma Rays Microwaves

Visible Light

1 X unit 1Å 1μm 1cm 1km
 1nm

10^{-14} 10^{-12} 10^{-10} 10^{-8} 10^{-6} 10^{-4} 10^{-2} 1 10^{2} 10^{4} 10^{6} 10^{8}

Wavelength in Meters

The Visible Spectrum

Ultraviolet Visible Light Infrared

Wavelength in Nanometers
(Nanometer = 1 Billionth of a Meter)

200 300 400 700 800 900 1000 1100 1200

Panchromatic Emulsions

Extreme Infrared-Sensitive Emulsions

Infrared Emulsions

Extended Red-Sensitive Panchromatic Emulsions

Figure 1.13 The complete spectrum is made up of all forms of electromagnetic energy. Only an extremely limited range of the entire spectrum, called the visual spectrum, or white light, can be detected by the human eye. When white light is broken up into its various wavelengths, the eye sees these wavelengths as separate colors.

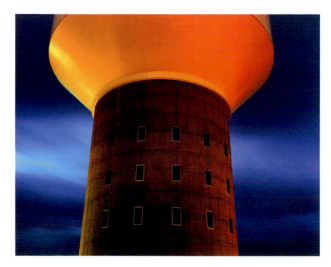

Figure 1.14 In her *Threshold* project, Christine Carr investigates color reality by testing its transformative qualities. She seeks out ambiguous spaces dominated by shape and pattern instead of scale or horizon, and she deliberately abstracts these images by using a wide-angle lens, a long exposure, and a mix of natural and artificial light. Carr aims to "heighten the transfiguration" of space and color, and for the "point in which the images have become otherworldly, rather than referencing the known environment."

© Christine Carr. *221.05.85*, from the series *Threshold*, 2005. 18 × 23 inches. Chromogenic color print.

Color Description—Hue, Saturation, and Luminance (HSL)

Each color can be defined by three essential qualities. The first is hue, which is the name of the color, such as blue or yellow. It gives the specific wavelength that is dominant in the color source. The second quality is saturation, or chroma, which indicates the apparent vividness or purity of a hue. The spectrum shows perfectly saturated hues (Figure 1.13). The narrower the band of wavelengths, the purer the color. Strong, vivid hues are referred to as saturated colors. Almost all colors we see are desaturated by a wider band of other wavelengths. When different wavelengths are present, the hue is said to be weaker, or desaturated.

The third quality of color is luminance, or brightness. Luminance deals with the appearance of lightness or darkness in a color. These terms are relative to the viewing conditions and therefore describe color as it is seen in specific situations.

Hue, saturation, and luminance (HSL) can be applied to color description in any situation. Take as an example the specific hue of red, which has the longest wavelength of visible light. Mix it with a great deal of white light and it produces pink, which is a desaturated red. Now paint this color on a building that is half in sunlight and half in shadow (Figure 1.15). Each side of the building has the same hue and saturation, but a different luminance. If a beam of sunlight strikes an object and makes a "hot spot," then that area is called desaturated, as the color has been diluted with a large amount of white light. White is a hue with no saturation but a high luminance. Black contains no saturation and only a very small amount of luminance.

Understanding these three basic HSL concepts helps a photographer translate what the eye sees into how it will be recorded by photographic-based materials. It also provides a common vocabulary of terms that we can utilize in accurately discussing our work with others. HSL controls can be used in image-processing programs to adjust individual color ranges.

Color Relativity

Our perception of color is relative. Hue does not exist for the human eye without a reference. A room that is lit by only a red light will, after a time, appear to us as normal. Household tungsten lights are much warmer than daylight, yet we think color balance also appears normal under these conditions. When a scene is photographed under tungsten light with a digital camera set for daylight white balance, or when using daylight color-balanced film, it will be recorded with an orange-red cast.

Stare at a white wall through a red filter. In time, your eyes will stop seeing the color. Now place an object of a different color into this scene. The red reappears along with the new color.

This point is important to remember when making accurate, color-balanced prints. If you stare at the print too long, the color imbalances will appear correct. For this reason, it is recommended that when using color-management software or a standard reference, such as the Lee Color Print Viewing Filter

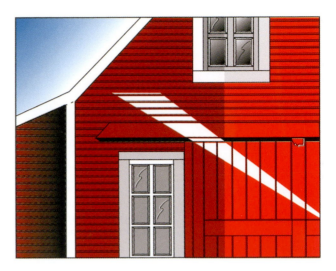

Figure 1.15 This is an example of color description for red. Notice how this hue's saturation and luminance have been altered, producing a wide variety of color effects.

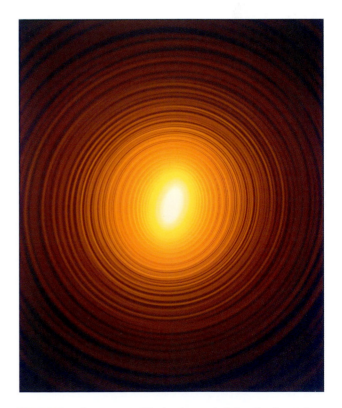

Figure 1.16 Adam Fuss says, "The lens is a manipulation of an image. To me the photogram is a non-manipulation of the object and the interaction of the object with light and the direct recording of that. To me that's pure photographic imagery. It's a different language of light. The one with the camera has seemingly a lot more detailed information, but I find that there is information of a different kind that is no less rich."

© Adam Fuss. *Untitled*, 2001. 61¾ × 50¼ inches. Dye-destruction print. Courtesy of Cheim & Read, New York, NY.

Kit for determining color balance (see Chapter 12), that the surrounding environment be a neutral white or light gray.

The color luminance and saturation of an object within a scene appear to change depending on the colors surrounding it. A simple experiment can be performed to see how luminance is relative. Cut two ovals from a piece of colored paper. Put one of the ovals in the center of a bigger piece of black paper and the other on a piece of white paper (Figure 1.17). The oval on the black paper will seem to have a greater luminance than the oval on the white paper, demonstrating how color luminance and saturation are subjective and dependent on the surrounding colors.

This phenomenon, also called simultaneous contrast, will cause the hue and brightness of a color to change. For example, a gray oval will appear yellowish on a purple background, reddish on a green background, and orange on a blue background.

Color Contrast

Color contrast happens when complementary colors, opposite colors on the color wheel, appear next to each other in the picture (Figure 1.19). Blue next to yellow is an example. The appearance of great contrast is given, even if the color intensity is identical.

The human eye helps to create this impression. Since every color is a different wavelength of light—blue is the shortest and red the longest—when two primary colors appear next to one another, the eye cannot consistently process the color responses. Thus, the colors appear to vibrate, creating contrast. Contrast is the major element that influences balance and movement in a composition. In color photography, unlike in black-and-white photography, contrast does not depend solely on light reflectance and thus becomes an important means for pictorial variation.

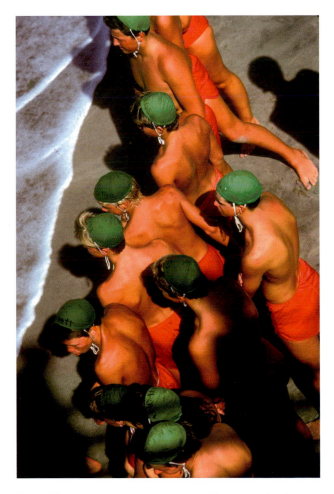

Figure 1.19 Color contrast is created when complementary colors (opposite colors on the color wheel for either light or paint) appear next to each other. This presents the appearance of greater contrast, even if the color intensity is the same. The closer the colors are to each other on the color wheel, the less color contrast will be produced.

© Roger Camp. *The Race*, 1985. Variable dimensions. Dye-destruction print.

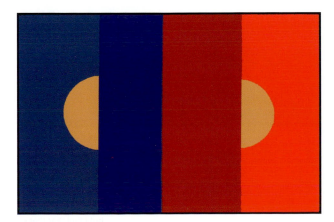

Figure 1.17 The ovals in this illustration are the same color. The oval on the right appears to have a greater luminance than the oval on the left because both color luminance and saturation are subjective and dependent on the surrounding colors.

Figure 1.18 The two halves of the circle are the same color, yet the human eye does not see them as the same color. This phenomenon is an example of color relativity.

Color Harmony

Color harmony is a product of both reflected light and the relationship of the colors to each other on the color wheel. A low-contrast picture has an even amount of illumination and colors that are next to one another on the color wheel (Figure 1.20). These harmonious colors can reflect greatly varying amounts of light yet still not provide as much visual contrast as complementary colors with closer reflectance values.

In color photography contrast is the result of the amount of light reflected, the colors present, and the relationship of the colors on the color wheel. Regardless of the illumination level, complementary colors create higher contrast and more vibrancy than the same scene containing colors next to each other on the color wheel. Such harmonious colors produce a more placid scene with lower contrast (see Chapter 7, Color Harmony).

Color Observations

Color Memory

Josef Albers, the artist and teacher who wrote *Interaction of Color* (1963/2009), discovered that people have a poor memory for color. Albers asked an audience to visualize a familiar color, such as the red on the Coca-Cola logo. Then he showed different shades of red and asked the audience to pick which one was "Coca-Cola red." There was always disagreement. To Albers this indicated that we have a short-term color memory. Albers's

book is an excellent reference to help one gain a deeper understanding of how color interacts with our perceptions.

Color Deceives

To begin to see and use color effectively, it is first necessary to recognize the fact that color continually deceives us. It is possible for one color to appear as two different colors. In Figure 1.22 the two halves of the oval are the same color, yet the human eye does not see them as the same.

This tells us that one color can and does evoke many different readings depending on the circumstances. This indicates that it is necessary to experience color through the process of trial and error. Patience, practice, and an open mind are needed to see

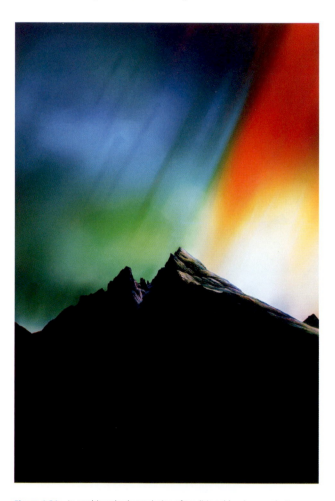

Figure 1.21 In pushing the boundaries of traditional landscape photography, Florian Maier-Aichen experiments with the role of color. Drawing on his experiences in Germany and in California, he references both the nineteenth-century German artist Caspar David Friedrich's similarly titled painting and grandiose nineteenth-century views of the American West. Injecting a spectrum of color into his rendition of an iconic image, Maier-Aichen asks the viewer to reconsider the limits of his surroundings and the manner in which environment informs thought.

© Florian Maier-Aichen. *Der Watzmann*, 2009. 71¾ × 47⅝ inches. Chromogenic color print. Courtesy of 303 Gallery, New York, NY.

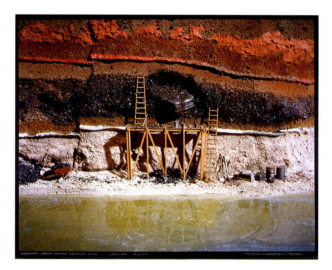

Figure 1.20 Using specific color choices in this image of a fictional archaeological dig, Patrick Nagatani achieves subdued color harmony. His work suggests an alternative past to the historic excavations undertaken by Japanese archaeologist Ryoichi in the 1980s and comments on today's ever-thriving automobile culture. By using colors that are next to one another on the color wheel, Nagatani simulates the visual effect of the American Southwest's desert environment.

© Patrick Ryoichi Nagatani. *Mercedes, Grand Canyon, Arizona, U.S.A.*, 1994/1999. 17¾ × 22⅞ inches. Dye-destruction print. Courtesy of Andrew Smith Gallery, Santa Fe, NM.

the instability and relativity of color. Observation will reveal the discrepancy between the physical fact of color perception and its psychological effect. In any scene there is a constant interplay between the colors themselves and between the viewer and his or her perceptions of the colors.

Color Changes

Colors are in a continuous state of change, depending on their relationship to their neighboring colors, and lighting and compositional conditions. The following sections provide a series of visual examples that reveal the flux of color.

Subtraction of Color

In Figure 1.22, the two ovals in the centers of the rectangles appear to be the same color. To get the best comparison, do not look from the center of one to the center of the other but at a point midway between the two. The small, elongated semicircles at the top and bottom of the figure show the actual colors of the ovals in the rectangles. The oval on the white ground is an ocher yellow, while the one on the green ground is a dark ocher. This demonstrates that any ground subtracts its own color from the hues that it possesses.

Experiments with light colors on light grounds indicate that the light ground subtracts its lightness in the same manner that hue absorbs its own color. The same is true for dark colors on a dark ground. This indicates that any diversion among colors in hue or in the light/dark relationship can either be visually reduced or obliterated on grounds of equal qualities.

The conclusion is that color differences are caused by two factors, hue and light, and in many instances by both at the same time.

Afterimage

Stare steadily at the marked center of the green oval in Figure 1.23 for a minimum of 30 seconds, and then rapidly shift your focus to the center of the white oval. Red or light red will appear instead of white. This example reveals how color can appear differently from what it physically is.

Eye Fatigue: Bleaching

Why does this happen? Nobody knows for certain, but one hypothesis is that the nerve endings of the human retina, the cones and the rods, are set up to receive any of the three primary colors, which in turn make up all colors. This theory implies that by staring at green, the blue- and red-sensitive parts of the eye become chemically fatigued, causing the complement, red, to be visible. When the eye quickly shifts to white (a combination of red, green, and blue) only the red part of the spectrum is seen.

Another theory says that the photo pigments of the retina are bleached by bright light. This bleaching process, which is not understood, stimulates the nerves, and it takes time for the photochemical in the eye to return to normal. When a region

Figure 1.22 The subtraction of color shows how two different colors can be made to look the same.

Figure 1.23 Look steadily at the oval on the left for 30 seconds, and then look immediately at the oval on the right. Do you see the afterimage? In an afterimage a color may appear to be different than it is in reality.

of photo pigment is bleached, this part of the retina is less sensitive than its surrounding regions and produces visual afterimages.

Reversed Afterimage

Stare at the blue figures with a black inverted triangle in the center in Figure 1.25 for at least 30 seconds, and then quickly shift your focus to the square on the right. Instead of seeing the afterimage of the blue figures in their complement, the leftover spaces will predominate, being seen in blue. This double illusion is called reversed afterimage, or contrast reversal.

Positive Afterimage

When the eye has been "adapted" to a bright light (a light bulb viewed with the eye held steady or an electronic flash) a dark shape, of the same form as the adapting light, appears to hover in space near the light source. This floating shape appears dark when seen against a light-colored background. It may appear very bright during the first few seconds, especially if viewed in

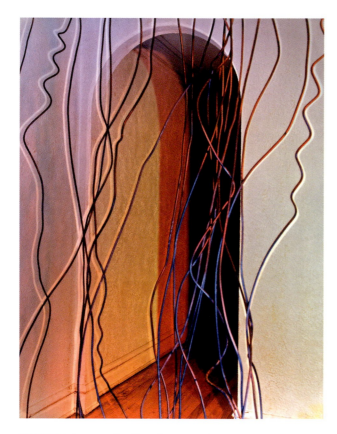

Figure 1.24 To create the effect of seeing an afterimage, Gary Minnix first made a straight color print to be used as a paper negative in the making of the final image. Then, a new sheet of color paper was exposed to the original negative for a predetermined time in the enlarger. This newly exposed print was left in the easel and the first straight print was laid over the top of it. The enlarger was twice turned on for a brief time, with the straight print lined up with, and then slightly offset from, the projected image. The film negative was then removed and replaced by a clear orange negative mask for a brief exposure made through the paper negative (the straight print) onto the paper in the easel. This created a light exposure of the image in reversed tone and negative color.

© Gary Minnix. *Untitled*, 1985. 24 × 20 inches. Chromogenic color print.

Figure 1.25 Stare steadily at the black inverted triangle on the left, and then quickly shift your focus to the inverted triangle at the right. In the reversed afterimage the white areas of the original will appear as blue and the blue areas as pale orange.

Figure 1.26 Using digital technology, Akihiko Miyoshi makes grid images out of photographs of urban landscapes and natural scenes. The colors rendered in each grid are averaged and reduced into a single color. Elemental properties of color are distilled to create landscapes from the colors that are present in the original image. "A liberation of color from form occurs without obliterating the recognizable value of the original image."

© Akihiko Miyoshi. *Harlem, New York, NY*, 2003. 20 x 24 inches. Inkjet print.

darkness. This is known as positive afterimage and is caused by the continuing firing of the retina and optical nerve after stimulation.

The phenomena of afterimage, reversed afterimage, and positive afterimage show us that the human eye, even one that has been trained in color observation, can be deceived by color. The conclusion is that colors cannot be seen independently of their illusionary changes by the human eye/brain configuration (Figure 1.25).

Cooking with Color

Learning to work with color has many similarities to learning how to cook. A good recipe is no guarantee of success; the secret is often in preparation. The cook must constantly sample, taste,

and make adjustments. The colors in a scene can be thought of as the ingredients that make up the picture; their arrangement and mixture will determine the final result. Two cooks can start off with the same ingredients yet produce a completed dish that tastes quite different. Simply by making small changes in quantity, one of the ingredients will lose its identity while another becomes more dominant. Cooking teaches that a successful meal involves more than reading a recipe. The same holds true for a photographer. Changes in color placement within a composition cause shifts in dominance, which can alter the entire

Figure 1.27 For Sondra Goodwin, combining red and white brings to mind the story of when Snow White, the fairy tale princess, "pricks her finger and three drops of blood fall into the snow: red and white, blood and snow, hot and cold." The artist incorporates these colors into her mask portraits, which were prompted by her father's death and thoughts of the face as a façade. To make these images, she applies layers of paint to a model's face and uses an 8 × 10-inch field camera to capture the way the paint mask delineates the distinctiveness of each feature and highlights unique responses.

© Sondra Goodwin. *John Red Mask*, 2005. 60 × 48 inches. Inkjet print.

Problem Solving

Study the works of the visual influential makers of color photography to gain an artistic understanding of what they knew about color relationships and how they applied them (see Figure 1.19). The purpose is not to copy, compete, or revive the past. Rather, the aim is to understand history and create new work built on the successful past outcomes that reflects present-day concerns, directions, and ideas.

feeling or mood of the picture. Also remember that properly presented food/photographs show that the cook/photographer has thought about every stage of the dining/visual experience, and set the psychological stage for the diner's/viewer's response.

Color Is a Personal Experience

Learning about color is a step-by-step process of observation, memory, and training that teaches us that seeing is a creative process involving the entire mind. What is ultimately learned is that color continues to be private, relative, elusive, and hard to define. Our perception of color is hardly ever as it actually appears in the physical world. There are no orthodox rules because of mutual influences colors have on one another. We may know the actual wavelength of a certain color, but we hardly ever perceive what the color physically is. Although a group of people may be simultaneously looking at the same color, there is no way to know how each individual actually perceives the color.

In photography this problem is compounded by the fact that the registration and sensitivity of the retina in the human eye is not the same as that of analog or digital photographic materials. In the world of human vision, colors are busily interacting with each other and altering our perceptions of them. This interaction and interdependence keeps colors in an active state of flux and in spite of attempts to organize color, color remains unruly.

NOTE

1. Heisenberg stated that it is not possible to simultaneously determine both the position and velocity of an electron or any other particle with a great degree of accuracy or certainty.

RESOURCES

Albers, Josef. *Interaction of Color*, rev. ed. New Haven, CT and London: Yale University Press, 2009.

Arnheim, Rudolf. *Art and Visual Perception: A Psychology of the Creative Eye*, rev. ed. Berkeley, CA: University of California Press, 1993.

Camilleri, Kristian. *Heisenberg and the Interpretation of Quantum Mechanics: The Physicist as Philosopher*. Cambridge University Press, 2009.

Gregory, Richard L. *Eye and Brain: The Psychology of Seeing*, 5th ed. Princeton, NJ: Princeton University Press, 1997.

Rock, Irvin. *Perception*. New York: Scientific American Books, 1984.

Goethe, Johann Wolfgang von. *Theory of Colours*. Cambridge, MA: MIT Press, 1970.

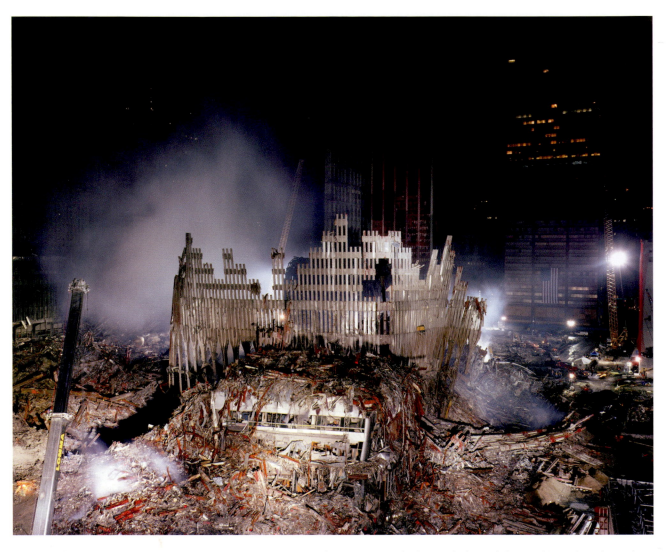

The ability of a photograph to record and act as a surrogate witness to a specific moment in time has been at the heart of photographic practice. When Joel Meyerowitz was standing in a crowd viewing the remains from the collapse of the Twin Towers, a police officer reminded him that it was a crime scene and no photographs were allowed. "To me," said Meyerowitz, "no photographs meant no history. I decided that my job was to make a photographic record of the aftermath."

© Joel Meyerowitz. *Twin Towers (right panel) 9-25-2001*, from the series *Images from Ground Zero*, 2003. 48 × 60 inches. Chromogenic color print. Courtesy of Edwynn Houk Gallery, New York, NY.

 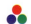

A Concise History of Color Photography

The First Color Photographs: Applied Color Processes

To understand what is happening in color photography today it is beneficial to know what has been previously accomplished. The quest for color photography can be traced to Louis-Jacques-Mandé Daguerre's 1839 public announcement of his daguerreotype process, which produced a finely detailed, one-of-a-kind, direct-positive photographic image through the action of light on a silver-coated copper plate. Daguerreotypes astonished and delighted, but nevertheless people complained that the images lacked color. As we see the world in color, others immediately began to seek ways to overcome this deficiency and the first colored photographs made their appearance that same year. The color was applied by hand, directly on the daguerreotype's surface (Figure 2.1). Since then scores of improvements and new processes have been patented for commercial use.

In the United States, four major methods were employed in the coloring of daguerreotypes: (1) applying paint directly to a gilded (gold toning enhanced appearance and stability) daguerreotype; (2) applying a transparent protective varnish over the plate, then hand coloring with paints; (3) applying transparent colors to specific areas of the image and fixing them by passing an electrical current through the plate with the aid of a galvanic battery; and (4) heating the back of the plate with a spirit lamp, instead of a battery, to fix colors that were selectively applied to the front of the plate.

Figure 2.1 The first color photographs were black-and-white images that had the color applied by hand. This erotic image, part of a brisk underground trade in "artist's studies," is an outstanding example of what could be accomplished. Most were more crudely done, lacking the attention to detail that the colorist lavished upon this daguerreotype.

© Unidentified photographer (French). *Female Nude*, ca. 1858. Daguerreotype with applied color. Courtesy of George Eastman House, Rochester, NY.

By 1843 John Plumbe, Jr., of Boston was advertising that his chain of six galleries in the Northeast could make colored daguerreotypes. Despite such rapid initial progress, it would take nearly a hundred years of research and development to perfect the rendition of color through purely photographic means.

Direct Color Process: First Experiments

In 1840 Sir John Herschel, renowned British astronomer and originator of many seminal ideas in photography, reported being able to record red, green, and blue on silver chloride-coated paper. These three colors corresponded to the rays of light cast on the paper by a prismed solar spectrum. Herschel's work suggested that color photographs could be made directly from the action of light on a chemically sensitive surface. However, as Herschel was unable to fix the colors on the coated paper, they could be looked at only very briefly under lamplight before they darkened into blackness. Other experimenters, including Edmond Becquerel working in the late 1840s and early 1850s and Nièpce de Saint-Victor in the 1850s and 1860s, attempted to record colors directly on daguerreotypes. This was done through Heliochromy, a process that referenced the sun and color and did not make use of any filters or dyes. Although the colors did not fade by themselves, Nièpce de Saint-Victor never found a method to permanently fix them. When exposed to direct light, without a protective coating they quickly turned gray.

The Hillotype Controversy

In early 1851 Levi L. Hill, a Baptist minister from Westkill, New York, announced a direct color process, known as the Hillotype, by which he was able to produce permanent color images (Figure 2.2). Hill's announcement created quite a stir and temporarily brought the daguerreotype portrait business to a halt, since the public decided to wait for the arrival of the new color process. Everyone clamored to know how Hill had achieved this miracle. Although the public waited excitedly, nothing was forthcoming from Hill, and he was roundly denounced as a charlatan. Five years later, Hill finally published, by advance subscription, *A Treatise on Heliochromy* (1856). Rather than a step-by-step method, it was a rambling tale of his life and experiments that did not contain any workable instructions for his secret process of making color photographic images. He did say the method was based on the use of a new, unnamed developing agent in place of mercury. At the time, the process was dismissed as a hoax that Hill had carried out by cleverly hand coloring his daguerreotypes. Just before his death in 1865, Hill still claimed to have made color photographic images, but said it had occurred by accident. He stated that he had spent the last 15 years of his life attempting to repeat this accidental combination without success. The latest scientific evidence reports that Hill did invent a partial direct color process capable of producing several natural colors, but hand colored his plates to makeup for their deficiencies.[1]

Figure 2.2 Levi L. Hill stirred up a sensation in the 1850s by announcing he had discovered a way to make color photographs directly from nature. The photographic community waited in vain for Hill to publish repeatable results of the process and his claim was dismissed as a hoax. Now, it appears his method combined a camera-made image that was enhanced with hand-applied color.

© Rev. Levi L. Hill. *Landscape with Farmhouse*, 1851. Hillotype. Courtesy of the Photographic History Collection, National Museum of American History, Washington, DC.

The Additive Theory: First Photographic Image in Color

The first legitimate color photographic image was made in 1861 for James Clerk Maxwell, a Scottish scientist. Maxwell used the additive theory developed by Thomas Young and refined by the German scientist Hermann von Helmholtz. The additive theory was based on the principle that all colors of light can be mixed optically by combining in different proportions the three primary colors of the spectrum: red, green, and blue (RGB). Just two primary colors can be mixed in varying proportions to produce many colors of light. For example, a mixture of the right proportion of red and green light produces yellow. When all three of the primary colors of light are combined in equal amounts the result is white light (Figure 2.3). When white light is passed through a primary-colored filter (RGB), that filter transmits only that particular color of light and absorbs the other colors. A red filter transmits red light, while absorbing all the other colors, which are combinations of green and blue light.

Maxwell's Projection Process

Making use of this theory, Maxwell commissioned photographer Thomas Sutton to produce a color image. Sutton made four—not three as commonly believed—individual black-and-white negatives of a tartan plaid ribbon through separate blue-violet, green, red, and yellow-colored fluids (filters).[2] Black-and-white positives were made from each negative. These positives, except for the yellow, were projected in register (all images perfectly aligned) onto a white screen from separate apparatuses, called

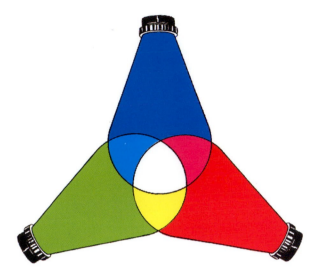

Figure 2.3 In the additive process separate colored beams of red, green, and blue light are mixed to form any color in the visible spectrum. When the three additive primaries are mixed in equal proportions, they appear as white light to the human eye.

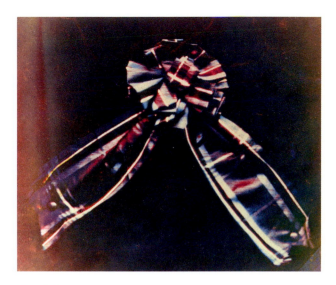

Figure 2.4 James Clerk Maxwell commissioned Thomas Sutten to make the first true color photographic image in 1861. His success proved the additive color theory and provided the first path for the creation of a true color photographic process.

© James Clerk Maxwell. *Tartan Ribbon*, 1861. Reproduced by permission of the Trustees of the Science Museum, South Kensington, London.

lantern projectors or magic lanterns, with each slide conveyed through the same colored filter used to make the original negative. For example, the positive photographed through the green filter was projected through the same green filter. When all three positives were simultaneously superimposed on a screen, the result was a projected color image (not a photograph) of the multicolored ribbon (Figure 2.4). Although no practical results came until German photochemist Hermann Wilhelm Vogel was able to make emulsions more color-sensitive through the use of dyes, Maxwell's demonstration proved the additive color theory and offered a practical projection process for producing photographic color images.

Later scientific investigation revealed that the early photographic emulsions Sutton used for Maxwell's experiment were not capable of recording the full visible spectrum. Neither orthochromatic (sensitive to all colors except red and deep orange) nor panchromatic (sensitive to red, green, blue, and ultraviolet) emulsions had been invented. The test should have failed since the emulsion used was not sensitive to red and only slightly sensitive to green. Scientists took a century to figure out why Maxwell's experiment worked with an emulsion that was not sensitive to all the primary colors. It is now thought that Maxwell's method succeeded because of two other deficiencies in the materials that canceled out the effect of the nonsensitive emulsion: (1) the red dye of the ribbon reflected ultraviolet light that was recorded on the red negative, and (2) his green filter was faulty and let some blue light strike the plate. Both of these defects corrected for the lack of sensitivity of the emulsion to red and green light. It is also thought that Sutton made the fourth yellow exposure to help compensate for the green filter, allowing more blue light to reach the plate. Regardless, when done with contemporary panchromatic emulsions Maxwell's research proves to be theoretically sound and provides the basis for how digital sensors electronically capture color images.

Direct Interference Method of Gabriel Lippmann

Isaac Newton observed that colors could be produced by interference when a very thin film of air or liquid separates two glass plates. If a slightly convex surface of glass is placed on a flat surface, a thin film around the point of contact will produce colored circles known as Newton's rings. Also, the colors in certain beetles, birds, and butterflies, as well as tints of mother-of-pearl and soap bubbles, are the result of the interference phenomena and not due to actual pigments. Another common example can be seen when gasoline or oil sits on a wet road.

In 1891 the French physicist Gabriel Lippmann introduced a direct color process based on wavelength interference principles that did not use colorants, dyes, or pigments, which gives the process excellent archival properties. Lippmann made color photographs by using a panchromatic emulsion and a mercury mirror that reflected waves of light, in a manner similar to how color is produced on oil slicks. In the camera, the emulsion plate was placed in contact with a mirror of liquid mercury, facing away from the lens. Light traveled through the plate and was reflected by the mercury, producing a latent image of the interference pattern on the plate. The plate was developed and the faint color image could be viewed by illuminating the plate with diffuse light from the same side that the viewer is positioned. The light is reflected off the surface (emulsion-side) of the plate. In order to separate the directly reflected light from the light reflected from the recorded fringes in the emulsion, a glass wedge or prism was cemented on top of the emulsion. Although the colors could be surprisingly true, the process was impractical for general commercial use because it required scientific precision, extremely

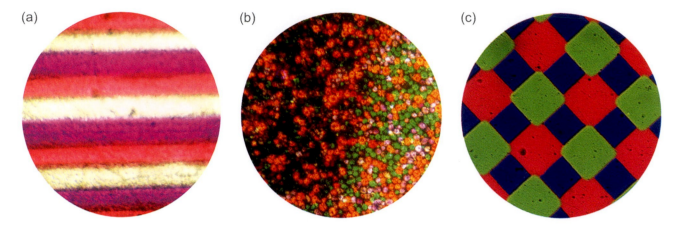

(a) (b) (c)

Figure 2.5 These photomicrographs of the (a) Joly Color, magnified 20×, (b) Autochrome, magnified 50×, and (c) Finlay Colour, magnified 50×, allow a direct visual comparison of how each of these additive screen processes constructed a color image.

Courtesy of George Eastman House, Rochester, NY.

long exposure times, and complex viewing methods. This process, for which Lippmann won the Nobel Prize, is considered to be a cornerstone for the future development of holography.

Additive Screen Processes

In 1869 Louis Ducos du Hauron, a French scientist, published *Les Couleurs en photographie—solution du problème*, which anticipated many of the theoretical frameworks for making analog color photographs. Among his proposed solutions was one in which the additive theory could be applied in a manner that did not require the complicated separation process that Maxwell devised. Du Hauron speculated that a screen ruled with fine lines in the three primary colors would act as a filter to produce a color photograph with a single exposure instead of the theoretical three needed in Maxwell's experiment (Figure 2.4). At the time, he photographed each scene through green, orange, and violet filters (at the time considered the primary colors of light), then printed his three exposures on thin sheets of bichromated gelatin containing carbon pigments of red, blue, and yellow— the complementary colors. When the three positives (transparencies) were superimposed, a full-color photograph resulted. Simultaneously, Charles Cros independently demonstrated how color images could be made using three-color separation negatives/positives, confirming the path that could be followed for a practical color process to evolve.

To simplify the process, in the first decade of the twentieth century, companies such as Sanger Shepherd in England began to manufacture "Repeating Back" attachments, which allowed the photographer to make separate exposures of a static subject—each time through a different colored filter— that were later combined to form a single color image. This was followed by "One-Shot" cameras that used black-and-white plates to simultaneously make three exposures of the same subject through three separate color filters (Figure 2.5). This method was also employed for the Lumiere Brothers Trichromie (a.k.a. Trichrome) process. Improvements followed,

and these triple-exposure cameras were used for advertising and portrait work until the advent of multi-layered films like Kodachrome, Agfacolor, and Kodacolor.

Joly Color

In 1894 John Joly, a Dublin physicist, patented the first line-screen process for additive color photographs, based on Ducos du Hauron's concept. In this process, a glass screen with transparent ruled lines of red, green, and blue, about two hundred lines per inch, was placed against the emulsion of an orthochromatic (not sensitive to red light) plate. The exposure was made and the screen removed. The plate was processed and contact printed on another plate to make a positive black-and-white transparency which was placed in exact register with the same screen used to make the exposure. The final result was a limited-color photographic transparency that was viewed by transmitted light. Introduced in 1896 as the Joly Color process (Figure 2.6), this method enjoyed only a brief success. It was expensive and the available emulsions still were not sensitive to the full range of the spectrum, thus the final image was not able to achieve the look of "natural" color. However, Joly's work indicated that the additive screen process had the potential to become a commercially viable way of making color photographs.

Autochrome

In Lyons, France, Auguste and Louis Lumière, the inventors of the first practical motion picture projector, patented a major breakthrough in the making of color photographs in 1904. The Autochrome Lumière was the first commercially viable and extensively used color photographic process. Introduced to the market in 1907, it remained in production until 1935. Autochrome was a reversal process, which produced one unique image—a positive transparency on a glass support that was viewed by projection or through a transmitted light source.

An Autochrome plate was produced as follows: (1) a glass support was covered with an initial layer of varnish that

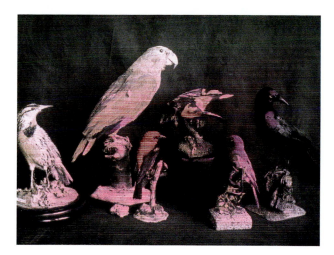

Figure 2.6 Joly Color, the first commercial line-screen process for additive color photographs, was introduced to the public in 1896. Although it had only limited success, it indicated the additive method could become a commercially viable way for making color photographs.

© Unidentified (Irish?) photographer. *Stuffed Birds*, ca. 1895. 4 × 5 inches. Joly Color. Courtesy of George Eastman House, Rochester, NY.

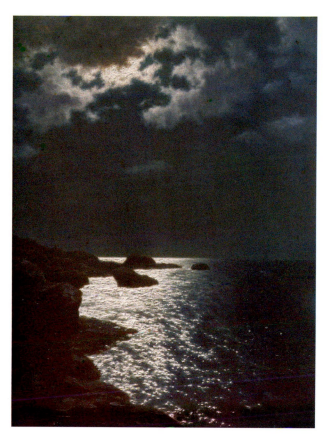

Figure 2.7 Marcel Meys was known as the photochromist because of his artistic and technical abilities that enabled him to use 'special effects' to create artistic and moody compositions. Meys's work can be considered a forerunner of modern multimedia presentations with its image projections that were done to accompany poems and even singing and dancing.

Marcel Meys. *Rocky Coastline at Night*, ca. 1908. 4¾ × 3½ inches. Autochrome. Courtesy of Mark Jacobs Collection.

remained tacky; (2) the color screen layer, composed of potato starch grains dyed orange-red, green, and violet-blue, was dusted onto the sticky varnish; (3) a fine carbon black powder was used to fill remaining gaps between the grains, and the layers were then pressed flat in a rolling press; (4) a second varnish was applied to protect the starch grains from moisture; (5) a photosensitive layer of silver gelatin emulsion was then applied; panchromatic emulsion, which greatly extended the accuracy of recording the full range of the visible spectrum, became the emulsion of choice once it became commercially available in 1906; (6) after exposure and processing, the manufacturer recommended a final coat of varnish to further protect the plate before a cover glass was applied to preserve the entire color image.

To maintain a proper color balance, a deep yellow filter was placed in front of the camera lens. The exposure was made with the plate's filter layer pointed toward the lens, so that the dyed potato starch acted as tiny filters. After development, the plate was re-exposed to light, and finally redeveloped to form a positive transparency made up of tiny dots of the primary colors. The Autochrome was a pioneering method of utilizing the principles articulated by Ducos du Hauron and Charles Cros in which the eye mixed the colors, in a fashion much like George Seurat's pointillist painting *Sunday Afternoon on the Island of La Grande Jatte* (1884–1886), to make a color-positive image. Alfred Stieglitz sang its praises in *Camera Work*, Number 20, October 1907: "Color photography is an accomplished fact. The seemingly everlasting question whether color would ever be within the reach of the photographer has been definitely answered … The possibilities of the process seem to be unlimited … In short, soon the world will be color-mad, and Lumière will be responsible."

Used from 1907 to 1935, Autochrome did have its limitations. Since the light had to travel through the potato starch grains and the yellow filter on the front of the lens, exposure times were much longer than with the black-and-white films of the day. In the additive processes, it was not uncommon for 75 percent or more of the light to be absorbed by this combination of filters before reaching the emulsion. Suggested starting exposure time was between 1/5 of a second and 1 second at f/4 in direct sunlight at midday in the summer and six times longer on a cloudy day, although over time there were many suggestions on how to increase its sensitivity. The randomly applied potato grains tended to bunch up, creating blobs of color. Also, Autochromes that were not lantern projected could be difficult to see and were sometimes placed in specially designed viewers called diascopes (Figure 2.8). When they were regularly marketed in New York (ca. 1910), a box of four 3¼ × 4-inch plates cost $1.20 and a box of 7 × 14-inch plates sold for $7.50, making them pricey for an average working person.

The advantages of this process, however, were numerous. Autochromes could be used in any regular plate camera with the addition of a special yellow-orange filter; the image was made in one exposure, not in three; although pricey, the cost was not

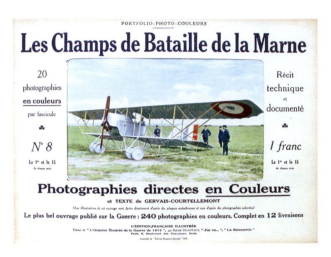

Figure 2.8 Autochromes were difficult to see and were often looked at in specially designed viewers called diascopes. The thirteenth edition of the instruction booklet *Color Photography with Autochrom [sic] Plates* stated, "Diascopes are reflectors so arranged that the light first passes through the picture, which is then reflected into a mirror. When closed they fold like a book and protect the picture; when open they are neat and decorative as a table ornament. They are made for either upright or landscape (horizontal) pictures." The image in the diascope is a 5 × 4-inch Autochrome by an unidentified photographer.

Diascope No. 1, ca. 1908. 7 × 6 × 1½ inches (flat). Folding door style covered in black leather with a mirror. Unidentified photographer. *Girl with Flowers*, ca. 1912. 5 × 4 inches. Autochrome. Courtesy of Mark Jacobs Collection.

Figure 2.9 World War I (1914–1918) was the first major conflict to be photographed in color. It saw 65 million people under arms, and produced about 10 million dead and another 20 million wounded without a single decisive battle. This image was made as part of a series of 240 Autochromes that appeared in one of the earliest books on war published in color, chronicling the Battle of the Marne, one of the bloodiest battles of the war.

Jules-Gervais Courtellemont. *Les Champs de Bataille de la Marne*, from *L'Histoire illustrée de la guerre de 1914*, 1915. 9½ × 13 inches. Color halftone from an Autochrome. Courtesy of Mark Jacobs Collection.

overly prohibitive; it gave serious amateurs much easier access to color (Figure 2.8); and while the colors were not accurate by today's standards, they did produce a warm, soft, and inviting pastel image that people considered to be quite pleasing.

World War I was the first major conflict to be covered by color photography. Autochromes became the basis for publications such as *L'Histoire illustrée de la guerre de 1914* (Figure 2.9). By the end of World War I, magazines such as *National Geographic* were using Autochromes to make color reproductions for the first time in their publications. Between 1914 and 1938, *National Geographic* published a reported 2355 Autochromes, more than any other journal, thus taking a leadership role in bringing the "realism" of color photography into mass circulation (Figure 2.10). Autochrome was the first color process to get beyond the novelty stage and to become successful in the market place. It cracked a major aesthetic barrier because it was taken seriously for its picture-making potentialities. This enabled photographers to begin to explore the visual possibilities of making meaningful color photographs for ambitious projects such as Albert Kahn's *Archives of the Planet*. Between 1909 and 1931, the French banker financed photographic teams who visited over 50 countries and amassed some 72,000 Autochrome plates that documented the diversity of the human condition in color, not just as ethnography or reportage but also for the purpose of inspiring education and universal peace.[3]

Finlay Colour Process and Paget Dry Plate

Other additive screen processes followed on the heels of Autochrome. In 1906 Clare L. Finlay of England patented a process that was introduced in 1908 as Thames Screen Plates (a.k.a.

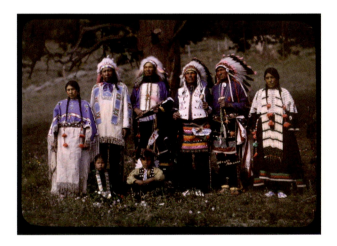

Figure 2.10 Fred Payne Clatworthy, the favorite independent autochromist of *National Geographic*'s illustrations editor Franklin Fisher, specialized in scenic Autochromes of the American West. Clatworthy owned and operated a photo studio in Rocky Mountain National Park. The original *National Geographic* (Vol. LIII, June 1928) caption for this image reads, "No other tribe resisted the oncoming tide of the white man's civilization with more determination than the brave and aggressive Sioux. A well-equipped people, both physically and mentally, they were for many years monarchs of the country that is now Minnesota, the Dakotas, and Montana. The ancestors of some of the chiefs pictured here planned and executed the campaign in which Custer's immortal band perished."

Fred Payne Clatworthy. *Sioux Indian Group*, 1927. 5 × 7 inches. Autochrome. Courtesy of Mark Jacobs Collection.

Figure 2.11 The Thames Colour Plate, which combined the Thames Colour Screen with emulsion into one unit, was an additive screen process used from 1909 until about 1918. The process was later improved and re-released as Finlay Colour.

Unidentified British photographer. *[Youth Group by Ocean]*, ca. 1913. 4 × 5 inches. Thames plate. Courtesy of Mark Jacobs Collection.

Figure 2.12 The modestly successful Paget color screen process used a regular mosaic color screen-plate. For a brief time (ca. 1912–1914), it was one of the few additive color processes used to make paper reflection-type prints.

H.C. Tibbitts. *Festival Hall from the West, Panama-Pacific International Exposition, San Francisco, CA*, 1915. 3¼ × 3¼ inches. Paget plate. Courtesy of Mark Jacobs Collection.

Thames Colour Screen). Made up of closely crowded red and green circles surrounded with blue, rather than the random mosaic pattern used in Autochrome, this separate screen could be used with any type of panchromatic film or plate to make a color photograph. The Thames Colour Plate, which combined an integral screen with the emulsion to form a single plate, was released in 1909. Both were abandoned by the time of World War I, but different versions were marketed under the name of Finlay Colour in 1929 and 1931 (Figure 2.11). The precise checkerboard screen Finlay Colour processes became the major rivals to Dufaycolor until the introduction of subtractive-process materials in the mid-1930s.

In 1912 G.S. Whitfield also obtained a patent for screen-plates that were marketed by the Paget Dry Plate Company (Figure 2.12). Renamed Duplex in 1926, the process was discontinued a few years later.

Dufaycolor

From about 1909 to 1914, the French firm of Louis Dufay made the Dioptichrome Plate to compete with the Autochrome. Although withdrawn from production, the process later was improved and renamed Dufaycolor when it was introduced as a ciné film in 1932. Soon produced as both cut-sheet and roll film, thus making it simple to use, Dufaycolor gave wider public access to color photography. The process became popular, especially in the UK, because it was faster (more light sensitive) than Autochrome and did not require any additional optical device to form a viewable image. Also, some people preferred the structure of its screen, which was a mosaic of alternating blue-dye and green-dye squares that were crossed at right angles by a pattern of parallel red-dye lines. This design offered greater color accuracy and a faster emulsion; by the mid-1930s exposures of f/8 at 1/25 of a second on a sunny day were possible (Figure 2.13), but the projected image was subdued and flawed by the conspicuous mosaic pattern. Dufaycolor was marketed until the late 1940s. By this time, the quest for an easier-to-use process that would provide more realistic and natural colors brought about technical discoveries that would eventually make the additive screen processes commercially obsolete. However, various film-based versions of Autochrome, including Filmcolor (1931), Lumicolor (1933), and Atticolor (1952), were made into the mid-1950s.

Polachrome

Between 1983 and 2002 Polaroid (see Diffusion-Transfer Process later in this chapter) marketed Polachrome, an instant 35mm color slide film that could be used in any 35mm camera, which was based on additive-color, line-screen, positive-transparency film similar to Joly Color. The film was inserted with an individual chemical pod into a small tabletop Polaroid AutoProcessor for processing. Although it was convenient, it never achieved widespread use due to issues of color accuracy and because the line-screen became highly visible when the image was projected or enlarged.

Additive Equipment

Additive Enlargers

Today the additive method is occasionally employed in color printmaking. It is in limited use because additive enlarger systems are more complex and expensive. To make a full color print with

Figure 2.13 Dufaycolor, introduced in the 1930s, became the most popular of the additive screen processes because it was faster, had an improved screen that provided more realistic color, and, since it was film rather than plates, was easier to use.

Unidentified British photographer. *USSR Pavilion, Paris*, 1938. 3½ × 2⅜ inches. Dufaycolor. Courtesy of Mark Jacobs Collection.

the additive process, the enlarger is used to make three separate exposures, one through each of the three primary-colored filters. The blue filter is used first and controls the amount of blue in the print, next the green filter is used for the green content, and last is the red filter. Some people prefer this additive technique, also known as tricolor printing, because it is relatively easy to make adjustments in the filter pack, with each filter controlling its own color.

Digital Enlargers

A major change in additive color printing is the use of digital enlargers in professional photography labs that continue to make chemical prints on silver halide paper (light-sensitive compounds in paper and film). Instead of the older bulb-based printers, this combination of chemical-based color printing and digital imaging relies on rapid bursts of laser light in three colors—red, green, and blue—to expose the photographic paper. The laser light is bounced off a rotating six-sided mirror that reflects the light dots onto the paper. As the mirror turns, it draws a line across the paper in light, making extremely sharp images. These digital enlargers have the additional advantage of high-speed scanners and the ability to work from a digital file, which allows each image to be analyzed by software that adjusts color, contrast, and exposure as needed. It also has facial recognition software for smoothing facial features so that not every skin pore is sharply apparent. Other systems, such as Durst Lambda and LightJet, use LED light printers instead of lasers.

Television

The additive system is the ideal vehicle for color television since the set creates and then emits the light-forming picture. The cathode ray tube (CRT) in color television has three electron guns, each corresponding to one of the additive primaries. These guns stimulate red, green, or blue phosphors on the screen to create different combinations of the three primaries. This creates all the colors that form the images we see on the television set. Liquid crystal display (LCD) and plasma (a type of gas) flat-screen televisions use the same RGB concept to have pixels (picture element) form the color image. A typical 8-bit LCD or plasma television utilizes a 256 red × 256 green × 256 blue sub-pixel depth to deliver 16,777,216 color combinations.

The Subtractive Method

Louis Ducos du Hauron not only proposed a method for making color photographs with the additive process in *Les Couleurs en photographie*, he also suggested a method for making color photographs using the subtractive process.

The subtractive process operates by removing certain colors from white light while allowing others to pass. The modern subtractive primaries (cyan, magenta, and yellow) are the complementary colors of the three additive primaries (red, green, and blue). When white light is passed through one of the subtractive-colored filters it transmits two of the primaries and absorbs (subtracts) the other. Individually, each subtractive filter transmits two-thirds of the spectrum while blocking one-third of it. For example, a magenta filter passes red and blue but blocks green. When two filters are superimposed, they subtract two primaries and transmit one. Magenta and yellow filters block green and blue, allowing red to pass. When all three subtractive primaries overlap in equal amounts, they block all the wavelengths and produce black. When mixed in varying proportions, they are capable of making almost any color (Figure 2.14). The advantages of the subtractive method over the additive process are twofold: It makes possible a full-color reproduction on paper and dispenses with the prior need for expensive and cumbersome viewing equipment.

Primary Pigment Colors

When working with pigments—as in painting—instead of light, the colors are also formed subtractively. The different colors of pigments absorb certain wavelengths of light and reflect others back for us to see. However, there is a major distinction between the primary colors of pigment and those of light, as painters

Figure 2.14 The subtractive process allows almost any color to be formed by removing certain colors from white light while permitting other colors to pass. The subtractive primary colors in photography are cyan, magenta, and yellow. They are the complementary colors of the additive primaries: red, green, and blue. Black is formed when equal amounts of all three of the subtractive primaries overlap.

generally use red, blue, and yellow for their primary colors. These colors cannot be mixed from any other colors and in theory are used to make all other colors, with the assistance of black-and-white. For example, red and yellow make orange, red and blue make purple, and blue and yellow make green. Green, an additive primary, is not a primary color in paint because it must be made from two colors: blue and yellow. In practice, it is necessary to use secondary and intermediate colors when mixing other colors, such as green and violet, because artist's pigment is not "pure color." The wavelengths of its minor components are different from the dominant wavelength and therefore affect the color produced.

The Subtractive Assembly Process: Heliography

In Ducos du Hauron's patented subtractive method, known as Heliochromy, three negatives were made behind separate filters of violet, green, and orange-red (the current modern subtractive filters had not yet been established). From these negatives, positives were made and assembled in register to create the final print, known as a Heliochrome. These positives contained carbon pigments of blue, red, and yellow, which Ducos du Hauron believed to be the complementary colors of the filters that were used to form the colors in the original exposure. Color prints or transparencies could be made with the assembly process, depending on whether the carbon transparencies were attached onto an opaque or transparent support. One of the first commercial subtractive assembly processes was the bichromated gelatin glue process, which was known as Trichromie and was patented by the Lumière Brothers in 1895. The assembly process is the principle used in the carbro process (see below).

Though the subtractive process proved to be practical, it saddled photographers with long exposure times. Ducos du Hauron reported typical daylight exposures of 1 to 2 seconds with the blue-violet filter, 2 to 3 minutes with the green, and 25 to 30 minutes behind the red filter. If the light changed during the exposure process, the color balance would be incorrect in the final result. This problem was solved in 1893, when Frederic E. Ives perfected Ducos du Hauron's single-plate color camera.

The Krōmskōp Triple Camera and Krōmskōp Viewer

Ives's apparatus, the Krōmskōp Triple Camera, made three separate black-and-white negatives simultaneously on a single plate through red, green, and blue-violet separation filters. Positives were made by contact printing on glass, then cut apart and hinged together with cloth strips for use on Ives's Krōmskōp viewer. This viewing system employed colored filters in the same sequence as the camera, and used a system of mirrors to optically superimpose the three separations and create a color Kromogram image (Figure 2.15). Although conceptually similar to Maxwell's additive projection process, Ives's color images could be seen after being assembled in this viewer (the Kromogram itself consisted only of image components). While Ives's methods did work, they were complex, time-consuming, and expensive.

Numerous other one-shot cameras followed, such as the Sanger Shepherd in the first decade of the twentieth century, which used black-and-white plates to simultaneously make three exposures through three separate color filters that were later combined to form a color image (Figure 2.16). Improvements followed, and these one-shot cameras were used for advertising and portrait work until the advent of multi-layered films like Kodachrome, Agfacolor, and Kodacolor.

Carbro Process

In 1855 Alphonse Louis Poitevin patented a carbon process to make prints from photographic negatives and positives by using an emulsion containing particles of carbon or colored, non-silver pigment to form the image. The original purpose of this process was not to make colored images but to provide a permanent solution to the fading and discoloration problems that plagued the early positive silver print processes. The carbro process, considered the most versatile of the carbon processes, evolved from Thomas Manly's Ozotype (1899) and Ozobrome processes (1905). The name carbro was given to an improved version of the process in 1919 by the Autotype Company to signify that carbon tissue was used in conjunction with a bromide print (car/bro).

Separation negatives were exposed through red, green, and blue filters and used to make a matched set of bromide prints. In the carbro process, the image is formed by chemical action when the pigmented carbon tissue is placed face-to-face with a fully processed black-and-white print on bromide paper. When the print and the tissue are held in contact, the gelatin of the tissue becomes insoluble in water in proportion to the density of the silver on the bromide print. After soaking, this sandwich

Figure 2.15 The Kromogram was the name given to the transparencies used in the Ives Krōmskōp for projecting "photographs in natural colors." William Saville-Kent. *Butterfly and Flowers*, 1898. Ives Kromogram. Digitally reconstructed image by Victor Minakhin from original stereo glass positives. Courtesy of Mark Jacobs Collection.

Figure 2.16 E. Sanger Shepherd got involved in color photography as an assistant to Frederic E. Ives. By the early part of the twentieth century, Sanger Shepherd was advertising his own spinoff process and camera. He continued to work on simplifying ways of making color photographs until his death in 1937.

E. Sanger Shepherd. *Feather*, ca. 1902. 3¼ × 3¼ inches. Sanger Shepherd process. Courtesy of Mark Jacobs Collection.

is separated. The tissue is transferred onto a paper support, where it is washed until only a pigment image remains. This is repeated for each of the three-pigmented tissues, and the final print is an assemblage of cyan, magenta, and yellow (CMY) carbon tissues in register, producing a full-color print. Autotype's

tricolor carbro process produced splendid color prints from the CMY pigmented tissues. Using a bromide print created numerous advantages, including the following: (1) enlargements could be made from small-format negatives (Figure 2.17); (2) ordinary exposure light sources could be used instead of high-intensity ultraviolet; (3) contrast was determined by the bromide print; and (4) regular photographic printing controls such as burning and dodging could be used. The perfecting of the carbro process demonstrated it was possible to make full-color images from black-and-white materials and was an important step on the path towards a practical chromogenic method for making color images (see the following section, Subtractive Film and Chromogenic Development). Other variations of this three-color subtractive assembly printing method, such as the affordable Vivex process (1931–1939), followed.

Color Halftones

The first color images to receive widespread viewing were not made by direct photographic means. They were created indirectly by applying the subtractive principles of color photography on William Kurtz's photoengraver's letterpress in New York in 1892. Using an early halftone process, a scene of fruit on a table was photographed, screened, and run through the press three times (a separate pass for each of the three subtractive-colored inks: cyan, magenta, and yellow). The halftone process is a printing method that enables a photographic image to be reproduced in ink by making a halftone screen of the original picture. The screen divides the picture into tiny dots that deposit ink in proportion to the density of the original image tones in the areas they represent. Kurtz's color reproductions were bound into the January 1, 1893, issue of *Photographische Mittheilungen*, published in Germany. Even though it still was not possible to obtain color prints from color film in an ordinary camera, this printing procedure pointed to a way in which color images could be photographically produced.

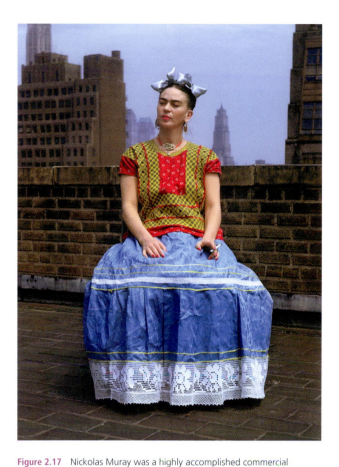

Figure 2.17 Nickolas Muray was a highly accomplished commercial photographer and carbro printer. In addition to his advertising work, Muray did color celebrity portraits that included Joan Crawford, Elizabeth Taylor, and Marilyn Monroe. This formally informal rooftop portrait uses color to capture the style, mystique, and allure surrounding Frida Kahlo. The original photograph was a Kodachrome transparency in the Kodak Bantam 828 format (40 × 28mm) that was scanned and produced as a color carbon print.

© Nickolas Muray. *Frida Kahlo in New York*, 1946. 11 × 8 inches. Carbro print. Courtesy of the Nickolas Muray Photo Archives and Art & Soul Studio, Seattle, WA.

Dye-Imbibition Process/Dye Transfer Process

In the imbibition process, a dye image is transferred from a gelatin relief image to a receiving layer made either of paper or film. Charles Cros described this method of "hydrotypie" transfer printing in 1880 and suggested it could be used to transfer three individual dye images in register. The Hydrotype (1881) and the Pinatype (1905) were examples of the early use of this process. One of the notable, though not widely used, relief matrix processes was developed by Dr Arthur Traube and introduced in 1929 as the Uvatype, which was an improved version of his earlier Diachrome (1906) and dye mordant Uvachrome (1916) processes. The Eastman Wash-off Relief process (1935) was a refinement of the imbibition process that was replaced by the improved Dye Transfer process (1946–1993). The widest commercial application of the imbibition process was the Technicolor process, originally introduced as a two-color system in 1916, for producing motion-picture release prints.

Subtractive Film and Chromogenic Development

Between 1911 and 1914 Rudolf Fischer of Germany, working closely with Karl Schinzel of Austria, invented a color film that had the color-forming ingredients, known as color couplers, incorporated directly into it. This discovery, that color couplers could produce images by chromogenic development (see next paragraph), laid the foundation for most color film processes in use today. In this type of film, known as an integral tri-pack, three layers of emulsion are stacked one on top of another, with each layer sensitive to red, green, or blue.

Through the process known as chromogenic development, the color couplers in each layer of the emulsion form a dye image in complementary colors of the original subject. During chromogenic development, the dye image is made at the same time as the silver halide image is developed in the emulsion. The silver image is then bleached away, leaving only the dye, which is fixed to form the final image. The problem with the original RGB color tri-pack was that unwanted migration of the dyes between the three layers could not be prevented, causing color inaccuracies in the completed image.

Some black-and-white films, such as Ilford's XP2 Super 400 or Kodak's BW400CN, also make use of the chromogenic system to deliver various densities of black dye. Any lab that develops conventional color negative film (C-41 process) can process these products. For best results, these negatives can be printed on RA-4 paper or scanned and digitally printed.

In 1930, Kodak Research Laboratories hired Leopold Godowsky, Jr., and Leopold Mannes, musicians who had been experimenting with making color films in makeshift labs since they were teenagers. By 1935 they were able to overcome the numerous technical difficulties and produce the first truly successful integral tri-pack subtractive color reversal film. This film was called Kodachrome and first marketed as a 16mm movie film.[4] It was said, only half jokingly, that it took God and Man (Godowsky and Mannes) to solve the problem of the color couplers' unwanted migration between the emulsion layers. Their ingenious solution to this problem was to use the color couplers in separate developers during the processing of the film, rather than build them into the film emulsion itself.

In Kodachrome film, only one exposure was needed to record a latent image of all three primary colors. The top emulsion layer was sensitive only to blue. Under this was a temporary yellow-dye filter that absorbed blue light, preventing it from affecting the emulsion below. This temporary yellow filter, which dissolved during processing, allowed the green and red light to pass through and be recorded in the proper emulsions below.

The Kodachrome Process

Kodachrome was first developed into a negative and then, through reversal processing, into a positive. During the second development, the colors of the original subject were transformed into the complementary dyes of cyan, magenta, and yellow, which formed the final color image. Then the positive silver images were bleached away and the emulsion was fixed and

washed. This left a positive color image that was made up of only subtractive colored dyes, with no silver.

In 1936 Kodachrome was made for the 35mm still-photography market. Eastman Kodak was concerned that nobody would want a tiny slide that had to be held up to the light to be seen. In a shrewd move, by 1938 the company was returning each processed slide in a 2 × 2-inch cardboard "Readymount" so that it could be projected onto a screen. At this time Kodak also introduced the Kodaslide projector, reinvigorating the Victorian-era magic lantern slide exhibition, which had been in decline. By the late 1930s the union of the 35mm camera with Kodachrome launched the modern color boom and signaled the end of the additive screen processes such as Autochrome.

Kodachrome was the first film to achieve the dream of an accurate, inexpensive, practical, and reliable method for making color images (Figure 2.18). The major drawbacks of Kodachrome were its slow speed (the original ISO of 8 was eventually increased to 200), its complex processing that meant the film had to be sent to a special lab, and the difficulty and expense of making prints from transparencies. Kodachrome's legendary characteristics, which were commemorated in the naming of Utah's Kodachrome Basin State Park as well as the 1973 popular song by Paul Simon, allowed it to reign as the benchmark in color accuracy, rendition, contrast, and grain until it finally succumbed to improved and much faster chromogenic films and digital image capture. After a 74-year run as a photography icon, Kodachrome was "retired" in 2009.

Chromogenic Transparency Film

In 1936 Agfa released Agfacolor Neu film, which overcame the problem of migrating the color couplers by making their molecules very big. In this manner, they would mix easily with the liquid emulsion during the manufacturing of the film. Once the gelatin that bound them together had set, the color coupler molecules were trapped in the tiny spaces of the gelatin and unable to move. This was the first three-layer, subtractive color reversal film that had the color couplers built into the emulsion layers themselves and employed a single developer to make the positive image. This simplified process allowed the photographer to process the film. Kodak countered Agfacolor with its own version of the process, Ektachrome, in 1946.

Chromogenic Negative Film

Agfa brought out a color negative film in 1939 from which positive color prints could be made directly on a special companion paper. Kodak followed suit in 1942 with Kodacolor, which is considered to be the first subtractive color negative film that completely solved the problem of the color couplers migrating from layer to layer in the emulsion. Color negative films, such as Kodacolor, overcame the limitation of each image being one-of-a-kind since any number of positive prints could be made from a color negative film.

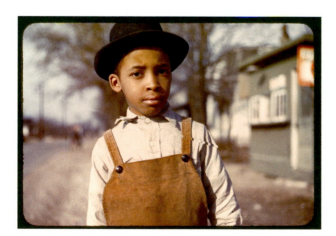

Figure 2.18 The introduction of Kodachrome in 1936 marked the modern era in color photography and accurate, reliable, affordable, and easy-to-use color films. Kodachrome gave photographers the ability to respond in color to subject matter from new points of view and to represent previously unseen subjects and situations. In the late 1930s and early 1940s, photographers for the Farm Security Administration, including John Vachon, made some of their photographs in color, using the then revolutionary Kodachrome film in a variety of formats from 35mm to 4 × 5 inches. The complete FSA collection of 170,000 images is available at the Library of Congress.

© John Vachon. *Negro Boy Near Cincinnati, Ohio*, ca. 1942. 1 × 2 inches. Kodachrome. Courtesy of Library of Congress, Prints and Photographs Division, Washington, DC.

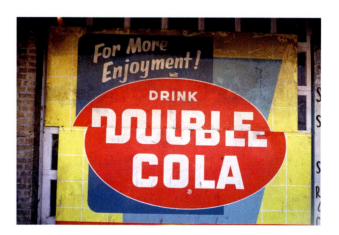

Figure 2.19 William Christenberry grew up in Tuscaloosa, Alabama, and has referenced his home environment in his work since he began making color photographs in the 1960s. He states, "This is and always will be where my heart is. It is what I care about. Everything that I want to say and try to say through my work comes out of that, the feelings about that place, its positive aspects and its negative aspects. For a long time it was the poorest [county in the state], but it is also a county with great lore and legend ... One thing that is quite interesting is the response that people in Alabama have had to my work ... They think that I am being critical of Alabama and the South. On the contrary it is a love affair with the place. I just happen to choose the passing of time and its effect on things for aesthetic interest."

© William Christenberry. *Double Cola Sign, Memphis, Tennessee*, 1966. 11 × 14 inches. Chromogenic color print.

C-41: Chromogenic Negative Development

The processing method created for Kodacolor is, with many improvements, the basis for all color negative film processes utilized today (see Chapter 10). In this process, currently called C-41, a single developer produces a negative silver image and a corresponding dye image in all three layers of the emulsion at the same time. Bleach is used to remove all the silver, leaving only the dye. The film is fixed, washed, and dried, which completes the process.

When making prints from a chromogenic negative with the subtractive method, the light is filtered in the enlarger before it reaches the negative. Correct color balance can thus be achieved in a single exposure. One of the three dye layers in the negative is usually left unfiltered. Printing is simplified because it is not necessary to use more than two filters at one time to make a print. The subtractive method also enables pictures to be made directly from transparency film in a reversal printing process, such as Ilfochrome Classic P3.

Additional Color Processes

Silver Dye-Bleach/Dye-Destruction Process

The silver dye-bleach (or dye-destruction) process is a method of making color prints from positives or negatives. Bleach is used to remove the unnecessary dyes from the emulsion, rather than using chromogenic development to produce dyes in the emulsion. In 1933 Hungarian chemist Bela Gaspar commercially introduced this method as Gasparcolor for use in color motion-picture work. Today's Ilfochrome Classic materials, introduced as Cibachrome in 1963, make use of this process to make prints directly from transparencies (see Chapter 12).

Internal Dye Diffusion-Transfer Process

Modern "instant" photography, or, more accurately, self-processing film, began in 1948 with the marketing of Edwin Land's first black-and-white Polaroid process. Polacolor, which Polaroid introduced in 1963 and was the first full-color, peel-apart print film, developed itself and produced a color print in 60 seconds. In 1976 Kodak launched its own line of instant products but 10 years later was forced to withdraw them when Polaroid won patent infringement suits against Kodak's design. In 2008 Polaroid ceased its film production. However, in 2010 the owners of the Polaroid brand announced a newly designed version of the Polaroid OneStep camera that uses Polaroid Color 600 Instant Film, which is still being manufactured by the Impossible Project. Fuji continues to manufacture its own line of instant (Instax) films as well as an instant film camera.

Self-processing materials, such as Polaroid, use the internal dye diffusion-transfer process, often called the diffusion-transfer process. It operates by causing the dye-formers to transfer out of the negative emulsions layer(s) to a single receiving layer (also in the material), where the visual positive image forms. The three phases of the process—negative development, transfer, and positive development—happen simultaneously, so that the positive images begin to form almost immediately (see Chapter 10).

The Polaroid Process: Diffusion-Transfer

The Polaroid SX-70 camera and film (1972–1981), and the later Spectra camera and film (1986– present) called Time Zero, make use of the diffusion-transfer method. After the shutter is pressed, the motor drive, which is powered by a battery in each film pack, automatically ejects the film through a set of rollers that break a pod of reagent located at the bottom of each piece of film. Development is then automatic and requires no timing. Development can take place in daylight because the light-sensitive negative is protected by opaque dyes in the reagent. Both the positive and negative images are contained within each sheet of film (see Chapter 10, Instant Photography). The diffusion-transfer process was also the basis for Polaroid's Polachrome, an additive color screen film.

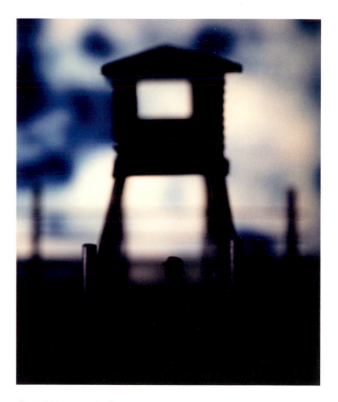

Figure 2.20 In much of David Levinthal's work, including the series *Mein Kampf*, the artist uses a large-format Polaroid camera with Polacolor ER Land Film, which allows him to alter the sense of scale in his images and make toy figures appear lifelike. He tells us, "Working, as I have for over 30 years, with toy figures and models, you often will discover new ideas as the work progresses. The instant viewing that Polaroid provides is a critical part of this process ... Being able to work so quickly also enhances the sense of discovery."

© David Levinthal. *Untitled*, from the series *Mein Kampf*, 1994. 24 × 20 inches. Polaroid Polacolor print. Courtesy of Stellan Holm Gallery, New York, NY.

Color Gains Acceptance in the Art World

Since the 1930s, color photography was equated with advertising, while black-and-white photography was associated with both art and authenticity. This attitude is expressed in *Camera Lucida* (1980) where Roland Barthes wrote "color is a coating applied later on to the original truth of the black-and-white photograph. For me, color is an artifice, a cosmetic (like the kind used to paint corpses)."⁵ But vast improvements in color film technology, especially in terms of rendition, film speed, and archival qualities, led more photographers to work with color in new and challenging situations. In turn, this produced an attitudinal shift about how and what color photography could communicate, as seen in Eliot Porter's *In Wildness Is the Preservation of the World* (1962). This seminal project was published by the Sierra Club and in the preface its Executive Director, environmentalist David Brower, wrote:

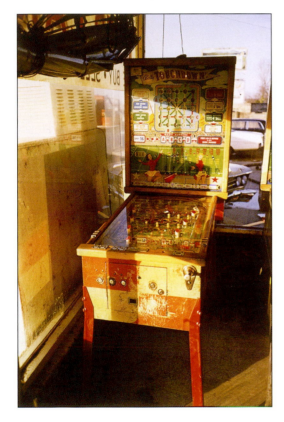

None but a very literal person would fail to see that color is his music, that there is melody line, counterpoint, harmony, dynamics, voicing, and phrasing all there for those who will listen. There is absolute pitch, too—absolute color pitch. As we looked at the dye-transfer prints in Porter's exhibit … we were quietly amazed by what this man knows about color.⁶

In the 1960s William Christenberry began making drugstore color photographs as visual references for his practice, but these images of ordinary Southern rural scenes began to be recognized for their ability to stand alone as individual works. By the late 1960s a few museums and galleries began acknowledging color photography as a legitimate art practice. A key breakthrough occurred when John Szarkowski, the curator of photography at the Museum of Modern Art, presented a show by another Southern photographer entitled *William Eggleston's Guide* in 1976 (Figure 2.21). In the exhibition catalog Szarkowski proclaimed the images to be "perfect: irreducible surrogates" of understated, vernacular views dealing with the social landscape of the New South. Others, like critic Hilton Kramer, who called them "perfectly boring," saw them as overblown, trivial snapshots of the mundane that confronted viewers with an insipid emptiness. Nevertheless, the prohibition against color as too crass and commercial to be art had been cracked, granting photographers such as Joel Meyerowitz and Stephen Shore (Figure 2.22) the freedom to begin to use color for its descriptive qualities. In his book *Cape Light* Meyerowitz said: "When I committed myself to color exclusively, it was a response to a greater need for description … color plays itself out along a richer band of feeling—more

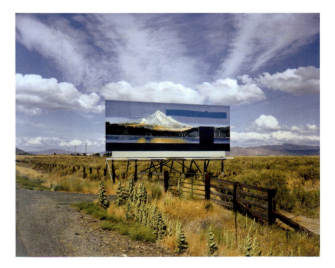

Figure 2.21 The 1976 debut of *William Eggleston's Guide* at the Museum of Modern Art marks the color photograph's entrée into the world of fine art. Critics of Eggleston claim he is a slumming aristocrat whose photographs are not worthy of a frame of film. His admirers counter by saying he possesses the gift of being able to make photographs out of nothing. At his best, the seemingly casual and dispassionate manner of his images masks his adroitness as a caustic yet affectionate memoirist of the banality and strangeness of everyday America in which objects take on a personality and become portraits.

© William Eggleston. *Untitled*, from the *Troubled Waters Portfolio*, 1980. 20 × 16 inches. Dye-transfer print. Courtesy of Cheim and Read, New York, NY.

Figure 2.22 Stephen Shore's 8 × 10-inch recording of vernacular spaces radiates a sense of nostalgia for ordinary scenes that are fading out of existence. These sharply focused, familiar, and figureless scenes of the human-altered landscape were indicative of the New Topographics style of the mid-1970s and follow Shore's axiom, "Attention to focus concentrates our attention." Shore's passive yet circumspect approach to atmosphere, color, and light contemplate the secular world with the utmost clarity and detail. His work was exhibited by the Museum of Modern Art in 1976 and thus was instrumental in the acceptance of color photography as an art form.

© Stephen Shore. *U.S. 97, South of Klamath Falls, Oregon, July 21, 1973*, 2002. 20 × 24 inches. Chromogenic color print. Courtesy of 303 Gallery, New York, NY.

wavelengths, more radiance, more sensation … Color suggests more things to look at [and] it tells us more. There's more content [and] the form for the content is more complex."[7] Today, with digital cameras and desktop printers, color is so ubiquitous that it is difficult to imagine a time when it was not the norm.

Amateur Systems Propel the Use of Color

The 1963 introduction of the Kodak Instamatic with its drop-in film cartridge generated a tidal wave of amateurs making color snapshots. To service this new consumer demand, companies like Fotomat provided drive-thru kiosks located in shopping center parking lots that offered 24-hour photo processing. At its peak around 1980, Fotomat operated over 4000 kiosks throughout the United States. This democratization of color also led more professionals to work in the medium as people came to expect color photographs. The photography industry attempted and failed to duplicate this success with the creation of other formats such as the 110 in 1975, the Disc in 1982, and the Advanced Photo System (APS) in 1996. Designed for amateurs, APS film is about 40 percent smaller than 35mm, which allowed camera manufacturers to make less bulky cameras and lenses. APS never took hold because the film area was too small for high-quality images and ultimately amateurs elected to go digital. By early 2004 Kodak ceased APS camera production, though Kodak and a few other companies continue to produce APS films.

Digital Imaging

In 2002 CNET.com calculated that of an estimated 100 billion photographs made that year, 25 percent were digital, and almost all were in color. The Photo Marketing Association's (PMA) *US Photo Industry 2009 Review and Forecast* gives 20.5 billion as the estimated number of "Prints Made by US Consumers" in 2008. Of those, 14.8 billion are digital and 5.7 billion are traditional prints, flipping the analog to digital image capture percentage in just six years.[8]

Computer images, like their sister analog images, are shaped by technology. Knowing the challenges early computer image-makers faced can deepen appreciation of their work and provide the framework to contemplate an evolving medium. Although the first electronic digital computers were built between 1937 and 1942, text and images had been digitized and electronically transmitted via fax for more than 30 years by then. Scottish physicist Alexander Bain created a proto-facsimile machine in 1843, but it was not until 1902 that Arthur Korn demonstrated a practical photoelectric scanning facsimile. The system used light-sensitive elements to convert different tones of an image into a varying electric current. Using the same basic principles employed by scanners today, these early fax machines digitized an image by assigning the area a number, such as "0" for white or OFF and "1" for black or ON. The fax then transmitted, via telephone lines, the signal to another facsimile receiver that made marks on paper corresponding to the area on the original image. Commercial use of Korn's system began in Germany in 1908 by means of two synchronized, rotating drums, one for sending and the other for receiving, which were connected via the telephone. An image was mounted on the sending drum, scanned by a point light source that converted the image to electrical impulses, which were then transmitted to the receiving unit. By 1910, Paris, London and Berlin were all linked by facsimile transmission over the telephone network. Facsimile then made slow but steady progress through the 1920s and 1930s, and in 1935 the Associated Press introduced a wire photo service.

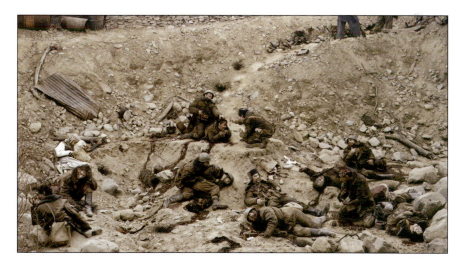

Figure 2.23 Jeff Wall's canvas-size fabricated photograph, situated on the divide between chemical and digital practice, meditates on war. Inspired by Goya, his giant lightbox tableau imagines 13 dead Russian soldiers who appear totally uninterested in the living. This approach is significant, for it acknowledges the role of the artist in representing physical and psychic pain. It dismantles the limited and lingering notion that a photograph is an objective mirror, instead of an expressive medium capable of portraying multiple realities. In her book *Regarding the Pain of Others* (2003), Susan Sontag used this image to conclude that we, who have not directly experienced "their" specific dread and terror, cannot understand or imagine their suffering.

© Jeff Wall. *Dead Troops Talk* (a vision after an ambush of a Red Army patrol, near Moqor, Afghanistan, winter 1986), 1992. 90⅛ × 164⅛ inches. Transparency in lightbox.

The Birth of Computing

The first electronic computers, such as Britain's Colossus of 1943, were used to decipher codes and calculate weapons trajectories. In 1946 the Electronic Numerical Integrator and Computer (ENIAC), the first large-scale, general-purpose electronic digital computer, was built in the United States. ENIAC weighed 30 tons, had 500 miles of wire, and used 18,000 vacuum tubes, which burned out at the rate of one every 7 minutes.

The computers of the early 1950s were room-sized machines marketed to the government, military, and big business. Even though access to the machines was limited, early scientist-artists found ways to make pictures. In 1950 Ben F. Laposky made the first artistic electronic image, *Oscillon Number Four—Electron Abstraction*, which was an analog wave pattern photographed from an oscilloscope. In the mid-1950s Russell A. Kirsch and his colleagues at the National Bureau of Standards made a proto-drum scanner that could trace variations in intensity over the surfaces of photographs. These recordings of light and shadow were converted into binary digits but, unlike the facsimile machines of the time, this information was processable electronic digital information. Such activities reveal the unintended consequences that accompany new ideas, as it is doubtful that these scientist-artists, who were developing new technologies mainly for military applications, imagined that their work might one day revolutionize photography.

By 1957 IBM was marketing the disk drive, a stack of 50 disks that could store 5 million characters. By the end of the decade transistors made computers cheaper, smaller, faster, and more readily available. An important innovation for imagemakers was the 1959 introduction of the first commercial ink output printing device, the plotter. Plotters used a pen that moved across a sheet of paper to draw lines. The pen was controlled by two motors that moved the pen on x-and y-axes in a manner like an Etch-a-Sketch. Plotters could not draw curves so images were composed of lines and broken curves, and were generally black-and-white. Angular geometric shapes were the dominant visual language and compositions were frequently made up of rotated and scaled copies of themselves. As the pioneering photographers before them, scientist-artists looked to painting for inspiration and many of these early computer artworks resembled cubist and constructivist art.

The 1960s: Art in the Research Lab

In the 1960s anyone wishing to create computer-generated images needed either to be a programmer or to work closely with one. Working blind, unable to see their work until it was output, scientist-imagemakers mathematically mapped out an image before beginning to work on the computer. Mathematical instructions were inputted into another computer using 4 × 7-inch punch cards that contained information to drive a plotter. It could take boxes of cards to represent a single image and if the image did not come out as planned, the whole process had to be repeated.

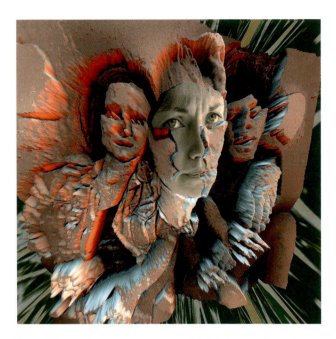

Figure 2.24 Todd Walker was a pioneer of digital photography. Having experimented since the 1960s with alternative photographic processes, he began utilizing computers as a tool for image-processing in the early 1980s. His daughter, Professor Melanie Walker, tells us, "Even before his foray into digital photography, Walker had been dissatisfied with the formal options offered by conventional photographic media ... Walker's work not only demonstrates his prescience, but reveals the visually and formally stunning possibilities that existed before digital imaging became [commonplace]."

© Todd Walker. *TRINPEN*, ca. 1995. Digital file. Courtesy of the Walker Image Trust.

During the 1960s, NASA developed digital technology for recording and transmitting images from outer space. By 1964 NASA scientists were able to use digital image-processing techniques to remove imperfections from the images of the lunar surface sent back by spacecraft, giving the public its first introduction to digital imaging. Later NASA projects, such as the Hubble Space Telescope and Cassini Saturn mission, are the legacy of these early efforts.

In the arena of popular culture, in 1968 *Life* commissioned John Mott-Smith, a physicist with the Air Force Cambridge Research Laboratories, to create computer images, which the editors described as being "intricate and jewel-like, reminiscent of stained-glass windows which medieval craftsmen made for their cathedrals."[9] By today's standards, Mott-Smith's process was primitive. He programmed his computer to move points of light in patterns on the face of an oscilloscope. Watching the screen, he edited the patterns to create different effects and then photographed the screen image using colored filters as well as multiple and time exposures. Mott-Smith observed, "Although I set the program, it's hard to predict what I will see. As I watch the screen a sort of symbiosis develops between me and the computer."[10]

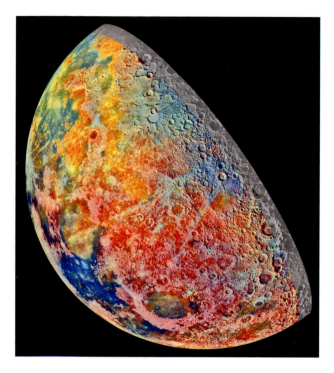

Figure 2.25 NASA uses color imaging as a tool in much of its photographic work, allowing scientists and others to understand data through the application of synthetic, symbolic color. This image was made from a combination of 53 photographs taken by the spacecraft Galileo. The artificial colors in this composite image represent geographical variations in the Moon's landscape.

© *Moon: False Color Mosaic*, 1992. Variable dimensions. Inkjet print. Courtesy of NASA/JPL.

The 1970s and 1980s: Computers Get Personal

In 1970 a Xerox research team at the Palo Alto Research Center (PARC) divided the computer screen into a mosaic of phosphor dots that were turned on or off by a beam of electrons that swept the screen methodically row by row. They called the rows "raster" after a row of type. Raster graphics were revolutionary because they allowed users to create realistic-looking computer images by filling in selected areas of a screen. Xerox researchers took advantage of raster graphics to develop an interface that used image icons to create a virtual desktop, the forerunner of the Macintosh and Windows operating systems. The interface worked best with a device called a mouse, which had been invented a decade earlier.

In the 1970s personal computers became available as kits, leading to the formation of information-sharing clubs. In 1975 Steve Wozniak brought a circuit board he built to a gathering of the Homebrew Computer Club. Friend and fellow member Steve Jobs was so impressed that he proposed a partnership that eventually became the Apple Computer Company. Their Apple II computer was a breakthrough in terms of its cost, superior color graphics capabilities, and art applications. Apple's combination of art and business applications paved the way for

the desktop computer transformation of the 1980s that brought sophisticated machines to the home, office, school, and artist's studio. By the end of the 1980s, new equipment and software designed for artists resulted in the appearance of books, magazines, and exhibitions of computer art, and digital imaging.

In 1975 Kodak researchers, led by electrical engineer Steven J. Sasson, spent most of the year creating an unwieldy "handheld electronic still camera" and playback system using stock components, including one of the first commercially available charge-coupled device (CCD) imagers, and specially designed circuitry. Late that year, the black-and-white image they made for display on a conventional television was the first taken with what is now known as a digital camera. The prototype camera and playback system were patented in 1978 but otherwise remained undisclosed until 2001.

In 1981 Sony introduced a prototype of its Mavica (magnetic video camera), an electronic still video camera. Unlike the Kodak, Mavica recorded images in analog (a continuously variable scale) rather than digital signals, by capturing stills from video output on magnetic disks and playing them back on a monitor. Over the next few years, several other manufacturers developed their own prototypes, though it remains unclear whether Sony or Canon was first to produce its camera commercially. In any case, the still video camera's high cost, low image quality, and expensive output limited its practical application.

The world had to wait for the first true digital still cameras until 1991, when Kodak brought out its Digital Camera System (DCS), the first professional model, which included a separate digital storage unit, and Dycam began selling its Model 1, the first consumer model. These cameras sold for about $20,000 and $1,000, respectively. Since then, manufacturers have introduced greatly improved, lower-cost digital cameras and backs for film cameras. The research firm Gartner Dataquest projects that consumer digital still cameras now have a U.S. household penetration of 80 percent, thus continuing the rapid decline of silver-based photography in everyday applications.

Digital Imaging Enters the Mainstream

In the 1980s and early 1990s the rapid growth of personal computers and consumer imaging software made computer-generated and -manipulated imaging an option for others besides the scientist-artist. Again, computer artists looked to older forms of artwork for inspiration. The computer coupled with a scanner and/or digital camera was the perfect tool for montage, a favorite technique of Dadaist and Surrealist artists. Coupled with these advances was the development of affordable desktop inkjet printers for the making of photographic-quality color prints at home or in the studio.

The Internet, which began in 1969 for the exclusive use of research labs and universities, was now hosting the World Wide Web. Before public access to the Internet, during the day people used one computer at their place of work, and in the evening used another to balance their checkbook, look at photographs, and to play games at home. Today we have access to a single Internet-connected device, whether a computer, personal digital assistant, or cell phone, which can also act as our news source,

Figure 2.26 Neda Salehi Agha Soltan was a 26-year-old Iranian philosophy student in Tehran who was senselessly murdered by a sniper during street confrontations between Iranian security forces and opposition Green protesters. The amateur-quality cellphone video that captured her bloody demise was posted online and quickly went viral, making her death a worldwide symbol of what can happen to those who dare to speak out against Iran's strict theocracy. Just as the photographs from Abu Ghraib Prison shamed America, "This is an image that will be burnt into the Iranian psyche," one Iranian analyst said. "It will haunt the regime forever."

Neda Salehi murdered by Basiji Sniper in Tehran on 20th June 2009. Video still. www.youtube.com/watch?v=Ej59Ul5yyw8

reference and personal libraries, jukebox, television, movie theater, art gallery, playground, and artist's studio.

Since the Abu Ghraib Prison digital snapshots made during the Iraq War became public in 2003, the cell phone camera has irreversibly altered photojournalism, allowing private messages to become public news that can circumvent the restrictions of both the military and the mainline media. Such images also have shown that the veracity of digital images can be authenticated within the guidelines of reliable journalistic practice.

As more artists utilized computers, a debate began as to whether digital imaging was another photographic tool that, combined with analog methods, would define the future of photography or if digital imaging was a separate entity that would supplant previous notions of what constitutes photography. As the discussion continues digital imagemakers have come to realize that they cannot escape the way computer-generated images are indelibly affected by the multiple characteristics of the computer. Artists have been responding to this challenge by developing aesthetics and ethics that are uniquely digital and have built on the abilities of the computer to combine media, including still and moving images plus sound. Evolving technology and conventions, including new visual values inspired by the vernacular of online dialogue on YouTube, Google, and Facebook, is not only providing new tools for artistic creation, but also fresh subjects for social commentary and innovative ways of reflection. We are experiencing a paradigm shift brought about by groundbreaking technology that opens the possibility for new ways of storytelling, novel forms of creation, and fresh ways of contemplating a subject, all while cultivating new audiences. Major photographic companies, such as Agfa, Ilford, Kodak, and Polaroid, have faced bankruptcies, reorganization, and a curtailing of chemical-based products. Stay tuned as we witness an expansion in directions and uses of color images.

NOTES

1. "Was the inventor of the first color photograph a genius, or a fraud? New research reveals the answer to a much-debated 156 year-old mystery," Getty Press Release October 29, 2007, www.getty.edu/news/press/center/hillotypes_release_102307.html.

2. E.J. Wall, *The History of Three-Color Photography* (New York: American Photographic Publishers, 1925, and London and New York: Focal Press reprint, 1970), pp. 2–4 based on reports in Photo. Notes, 1861: 169 and *British Journal Photography*, 1861, 8: 272.

3. See David Okuefuna, *The Dawn of the Color Photograph: Albert Kahn's Archives of the Planet* (Princeton, NJ and Oxford: Princeton University Press, 2008), p. 7.

4. In 1915 Kodak patented a 2-color Kodachrome process. It consisted of two glass transparencies: one green and the other red, which when superimposed produced a limited spectrum color image. It was never marketed.

5. Roland Barthes, *Camera Lucida: Reflections on Photography*, translated by Richard Howard (New York: Hill & Wang, 1981), p. 81.

6. David Brower in Eliot Porter, *In Wildness Is the Preservation of the World* (San Francisco, CA: Sierra Club, 1962), p. 9.

7. Joel Meyerowitz, *Cape Light: Color Photographs by Joel Meyerowitz* (Boston, MA: New York Graphic Society, 1978), unp.

8. www.pmai.org/. A footnote to this report states that digital prints include prints from received images and camera phone prints. There is no attempt to further define the distinction between these categories or specify what percentage are inkjet, dye sublimation, or chromogenic. Based on this information, digital seems to refer to image capture rather than the printing process.

9. "The Luminous Art of the Computer" *Life*, 1968, 65 (19): 53.

10. Ibid.

RESOURCES

Coe, Brian. *Colour Photography: The First Hundred Years 1840–1940*. London: Ash and Grant, 1978.

Coote, Jack H. *The Illustrated History of Colour Photography.* Surbiton, UK: Fountain Press, 1993.

Déribéré, Maurice, ed. *Encyclopaedia of Colour Photography.* Watford, UK: Fountain Press, 1962.

Eder, Josef Maria. *History of Photography,* 4th ed. Edward Epstean, trans. New York: Dover Publications, 1978.

Friedman, Joseph S. *History of Color Photography*, 2nd ed. New York: Focal Press, 1968.

Gernsheim, Helmet, and Gernsheim, Alison. *The History of Photography, 1685–1914*, 2nd ed. New York: McGraw-Hill, 1969.

Gustavson, Todd. *Camera: A History of Photography from Daguerreotype to Digital.* New York: Sterling Publishing, 2009.

Hirsch, Robert. *Seizing the Light: A Social History of Photography*, 2nd ed. New York: McGraw-Hill, 2009.

Mees, C.E. Kenneth. *From Dry Plates to Ektachrome Film: A Story of Photographic Research.* New York: Ziff–Davis, 1961.

Moore, Kevin. *Starburst: Color Photography in America 1970–1980.* Stuttgart, Germany: Hatje Cantz Verlag and Cincinnati Art Museum, 2010.

Newhall, Beaumont. *The History of Photography from 1839 to the Present,* 5th ed. New York: Museum of Modern Art, 1982.

Okuefuna, David. *The Dawn of the Color Photograph: Albert Kahn's Archives of the Planet.* Princeton, NJ: Princeton University Press, 2008.

Ostroff, Eugene, ed. *Pioneers of Photography: Their Achievements in Science and Technology.* Springfield, VA: The Society for Imaging Science and Technology, 1987.

Peres, Michael, ed. *The Focal Encyclopedia of Photography,* 4th ed. Boston, MA: Focal Press, 2007.

Rijper, Els, ed. *Kodachrome: The American Invention of Our World, 1939–1959.* New York: Delano Greenidge Editions, 2002.

Roberts, Pam. *A Century of Colour Photography: From the Autochrome to the Digital Age.* London: André Deutsch, 2007.

Roumette, Sylvain, and Frizot, Michel. *Early Color Photography.* New York and Paris: Pantheon Books/Centre National de la Photographie, 1986 [A translation of the 1985 *Autochromes* exhibition.]

Sipley, Louis Walton. *A Half Century of Color.* New York: Macmillan, 1951.

Wall, E.J. *The History of Three-Color Photography.* New York: Focal Press, 1970.

Welling, William. *Photography in America: The Formative Years 1839–1900.* Albuquerque, NM: University of New Mexico Press, 1987.

Wood, John. *The Art of the Autochrome: The Birth of Color Photography.* Iowa City: University of Iowa Press, 1993.

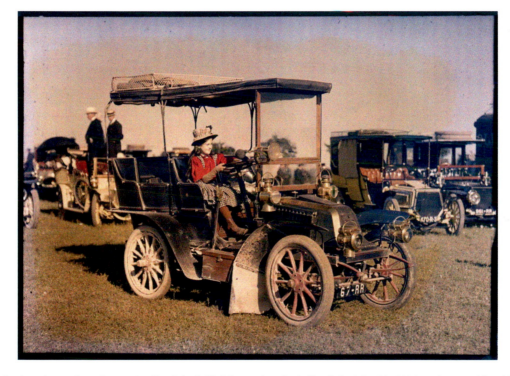

This preproduction Autochrome shows Suzanne Lumière sitting behind the steering wheel of her father's (Louis) 1902 Renault automobile, which was powered by a 2-cylinder, 8-horsepower motor. Autochrome paved the way for the practical recording of such family color snapshots, which previously were beyond the reach of all but the most advanced photographers.
© Lumière Brothers. *During the Race,* 1906. 3½ × 4¾ inches. Autochrome. Mark Jacobs Collection.

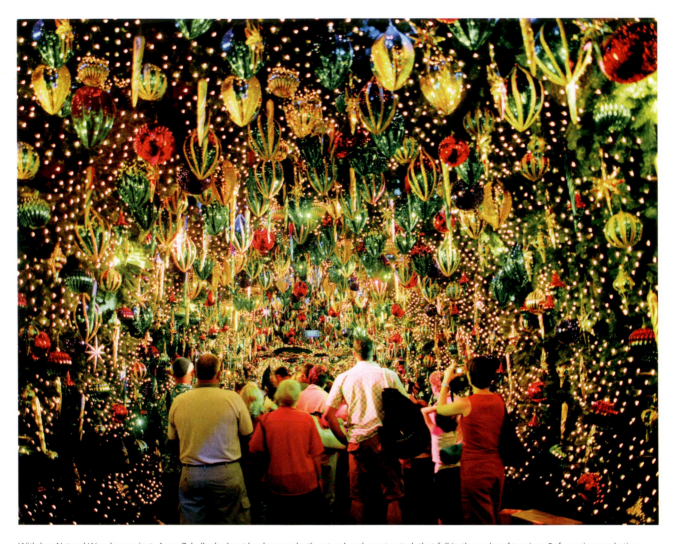

With her *Natural Wonders* project, Anne Zahalka looks at landscapes, both natural and constructed, that fall in the realm of tourism. Referencing marketing material for these sites, she explores how they often fall short of the idealized space that they advertise. Not quite utopia, Zahalka states that "these are fabrications of magical worlds where reality is substituted for an illusion that seems more wonderful than nature itself."

© Anne Zahalka. *Santa's Kingdom Christmas Tunnel, Fox Studios, Sydney*, 2004. 45¼ × 57⅛ inches. Chromogenic color print. Courtesy of the artist; Roslyn Oxley9 Gallery, Sydney, Australia; and Arc One Gallery, Melbourne, Australia.

 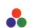

Exposing the Light

An Exposure Starting Place

Proper exposure technique—acceptable shadow and highlight detail—is the prerequisite to the process of transforming ideas into photographs. However, having the light match the subject is also essential to make a good photograph, and this is where the art of photography comes to the fore. Although digital imaging software offers numerous corrections tools, it is preferable to make original digital and analog exposures as accurately as possible to avoid compromising image quality.

Digital images are usually captured either as JPEG or RAW files, although some cameras can do both. The essential difference is that JPEG files apply predetermined standards to generate a finished photographic file while RAW does not. RAW is simply a collection of 0's and 1's that the user processes after capture to make an image, thus allowing the most control over how the file is configured in terms of color, contrast, saturation, sharpness, and so on (see Chapter 9).

Regardless of capture mode, digital cameras with their image and histogram displays simplify making good exposures. Nevertheless, the exposure latitude of digital cameras is similar to color transparency materials, making accurate metering essential and still a solid cornerstone of imagemaking.

Determining the correct exposure with color film is essentially the same as it is for black-and-white film. Transparency film requires the greatest accuracy because the developed film itself is the final product; its exposure latitude is not wide, so small changes can produce dramatic results. In general, underexposure of transparency film by up to 1/2 f-stop produces a richer, more saturated color effect. With negative film, overexposure of up to a full f-stop produces similar results. Good detail in key shadow areas is needed to print well. Negative film has a much wider exposure range, plus the printing stage allows for further corrections after initial exposure of the film.

Figure 3.1 Phil Bergerson carefully planned this photograph by positioning himself to maximize the legibility of the scene's details, stopping down enough to capture both the foreground and the background, and exposing to capture the largest range of highlight and shadow details. His photographs deliver "messages from the quirky, unsophisticated ramblings of demented souls to the struggling lyrics of the sophisticated artist, from high and low art, from franchises and from the disenfranchised … I pursue that material which carries some deeper meaning beyond what first strikes the viewer, material that has a rich undercurrent of meaning. The best of my images shout and whisper about promise, change, desire, hope, and loss."

© Phil Bergerson. *Untitled, Temple, Texas*, from the series *Shards of America*, 1998. 29 × 29 inches. Chromogenic color print. Courtesy of Stephen Bulger Gallery, Toronto, ON, Canada.

The guidelines in this chapter will produce satisfactory exposures under a wide variety of conditions without an extensive amount of knowledge, testing, or frustration, regardless of whether you are using a digital or film camera. As you gain experience and confidence, you can employ the more advanced exposure procedures discussed at the end of this chapter and in Addendum 3, The Zone System for Color Photography.

How a Camera Light Meter Works

Built-in camera exposure meters are what most of us initially employ to make our exposure calculations. All digital single-lens reflex cameras (DSLRs) and most analog single-lens reflex cameras (SLRs) have a sophisticated through (or thru)-the-lens (TTL) reflective metering system that makes getting a good automatic exposure a sure thing in most situations. That said, one needs to bear in mind that a camera's light meter is designed to see an approximate middle 18 percent gray reflectance (see Using a Gray Card section later in this chapter), which means the meter's reading only tells a photographer how to set the camera for an average exposure that assumes an 18 percent reflectance. Think of it this way: A reflective light meter sees the world as if looking through frosted glass. By blurring all the details and eliminating the specifics, the meter is able to accurately measure a scene's overall average brightness. This averaging method allows a photographer shooting a subject illuminated by daylight to get a proper exposure at least 90 percent of the time. However, for scenes that do not average out to 18 percent middle gray to appear normal in your image, it is necessary to use a different exposure than the meter indicates. With a digital camera, using a histogram makes this task easier to achieve (see How a Histogram Works below).

In its basic Average mode, your camera's meter reads the light reflecting back from all parts of the scene shown in the viewfinder to generate an average, middle exposure from all reflecting surfaces within the entire scene. The meter's coverage area (the amount of the scene it reads) changes whenever you alter the camera-to-subject distance, use a zoom lens, or change metering modes. If you move close to your subject, zoom in on a detail within the scene, or change to a spot meter reading (see Matrix Metering later in this chapter), the suggested exposure (aperture and shutter speed settings) will probably be different than if you use an Average meter setting or meter the scene overall from a distance.

The bottom line is that an in-camera light meter reading only tells a photographer what setting to use for an average exposure that assumes an overall 18 percent reflectance. A meter cannot judge the quality of the light or the feeling and mood that the light produces upon the subject. This means that your ideal exposure is not necessarily the same as the meter indicates, and therefore the more you know about a camera's metering system, the greater the likelihood you can use it to achieve an exposure that will deliver the visual results you desire. To accomplish this you must first become skilled with the basic technical metering guidelines summarized in Box 3.1.

Box 3.1 Reflectance Metering Guidelines

1. Make sure the sensitivity selector (ISO) is at the desired setting.
2. Perform a battery check before going out to take pictures.
3. When taking a reflected light reading, point the meter at the most visually important neutral-toned item in the scene.
4. Get close to the main subject, so that it fills the metering area. Avoid extremes of dark or light when selecting areas on which to base your general exposure.
5. When it is not possible to meter directly from the subject, place an 18 percent gray card in the same type of light, meter off it, and adjust accordingly. You may need to use your exposure lock that "locks in" the camera exposure and white balance settings, which remain in effect until the lock is released in the Menu options.
6. In situations of extreme contrast and/or a wide tonal range, consider averaging the key highlight and shadow areas or taking a reading from an 18 percent gray card under the same quality of light.

Reflective and Incident Light

There are two fundamental ways of measuring the amount of light in a scene. Reflective light, which is metered as it bounces off the subject, is the kind all in-camera meters are designed to read. Metering is done by pointing the lens directly at the primary subject (see Figure 3.2). A reading from low midtones and high shadows delivers good general results in most situations.

Incident light is measured as it falls on the subject. The meter is not pointed at the subject but toward the camera or main light source (see Figure 3.3). Incident meters are not influenced by the multiple reflectance values of a subject and therefore do not require as much expertise to achieve satisfactory results. Most in-camera meters cannot read incident light without a special attachment that fits over the front of the lens. This adapter permits incident reading with most TTL (through-the-lens) metering systems.

How a Histogram Works

DSLRs can display a histogram of each exposure and can be an important exposure guide. Basically, a histogram is a graph that visually displays the distribution of reflected light in a scene, showing where the reflectance (brightness) levels are located. The right side of the histogram represents the brightest (96 percent reflectance) areas of the scene while the left side represents the darkest (3 percent reflectance). The histogram can be found in the menu settings of your digital camera and is viewed on the camera's LCD display. Histogram viewing options may include superimposing the histogram over the picture, or it may

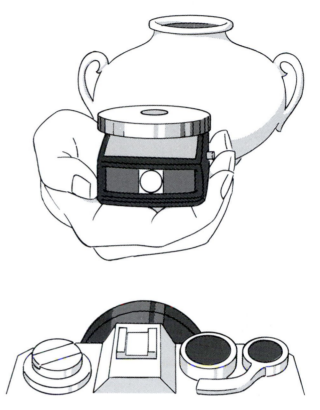

Figure 3.2 A reflective light reading is made by pointing the light meter directly at the subject. This reading measures the light that is bounced off, or reflected from, the subject. Most in-camera meters can measure only reflected light.

Figure 3.3 An incident light reading measures the light that falls on the subject. To make such a reading, the photographer stands in front of the subject and points the meter at the camera or main light source, never toward the subject. Most meters require a special light-diffusing dome attachment to read incident light.

be shown by itself. Other options include a single black-and-white graph of reflectance, single graphs of the colors red, green, and blue (RGB), or everything shown simultaneously, as seen in Figure 3.5.

There is no such thing as a bad histogram. Contrary to what many camera manuals state, your histogram does not have to be in the middle of the graph. The distribution of the reflectances can be clustered to the right, representing a high-key photograph such as a snow scene, or gathered to the left, representing a low-key photograph such as a monochromatic scene. A histogram grouped in the middle only means there is a great deal of reflectance (brightness) around the mean or 18 percent gray. A scene with an equal distribution of reflectances from 3 to 96 percent will show a more full-bodied histogram. Overexposure and underexposure will also affect the histogram and ultimately the brightness or darkness of that digital image file. The histogram is especially useful in determining if any highlights have been clipped and thus washed out. A little bit of clipping is usually fine, but clipping broad areas, such as a person's forehead, is rarely desirable and it can also produce unwanted colors shifts

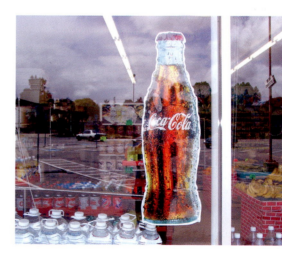

Figure 3.4 Deliberately capturing the reflections in the window of this Mexican market enabled Bill Owens to add an additional layer of visual information to his image. Owens, whose work highlights the banality and oddity of suburban life, examines the pursuit of the American dream in domestic and commercial settings.

© Bill Owens. *Coca Cola*, 1998. Variable dimensions. Inkjet print.

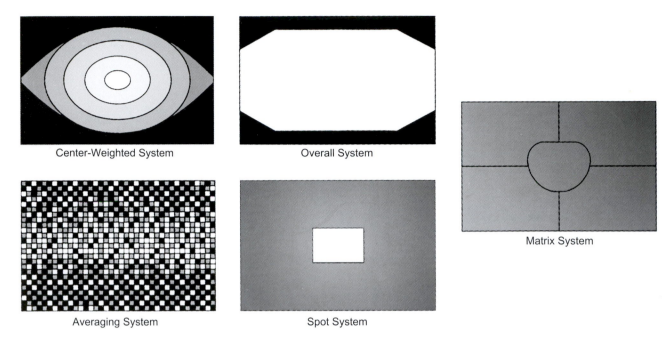

Center-Weighted System Overall System Matrix System

Averaging System Spot System

Figure 3.5 How five basic in-camera metering system patterns are set up to determine exposure.

as well. Generally, overexposure is a fatal flaw for digital images because it cannot be corrected as the sensor becomes saturated. Histograms make this simple to check. If you have washed-out areas of 100 percent white (digital value 255) you will see a tall vertical line at the far right of the histogram indicating there is no digital data beyond 255, thus making modification unfeasible. Cameras that display a histogram with the image or superimposed over the image make the histogram much more meaningful and easy to interpret. Once you become proficient at "reading" a histogram, especially with JPEG capture, you will be able to evaluate the quality of the exposure based on middle gray and see how its placement affects your outcome. For more information see Bruce Fraser's paper on "Raw Capture, Linear Gamma and Exposure" at www.adobe.com/digitalimag/pdfs/linear_gamma.pdf.

Using a Gray Card

An 18 percent middle gray is chiefly determined by the theoretical laws of reflectance, which is the median, or middle ground, of all readings of light reflected from a scene. In other words, it represents the compromise reading between all the blacks and whites within a scene. A reflective meter, like the type built into your camera, can be easily fooled if there is an unusual distribution in the tones of the subject being metered. In such situations, it is desirable to ignore the subject completely and take your meter reading from an 18 percent gray card. Designed to reflect all visible wavelengths of light equally, the gray card returns about 18 percent of the light striking it. The card's neutral color provides a surface of unvarying tone that is influenced only by

changes in illumination. This means that while metering from a gray card measures reflective light, the unchanging measurement makes it more like an incident reading.

To obtain accurate results, be certain the gray card is clean and not bent. Place it in a position parallel to the principal subject and in similar light. Point your reflective meter to cover as much of the gray card as possible, and avoid casting any shadows in the area being metered. It is a popular misconception that the gray card represents the average reflectance of an ideal subject; actually, the average reflectance of a full tonal range subject in average daylight is about 9 percent.

Additionally, commercial digital calibration targets, for pre- and post-exposure adjustments, can be purchased to do accurate metering, custom white balancing, and exposure monitoring through the camera's histogram function.

In difficult lighting situations a good method of achieving an accurate exposure is by metering from a middle-toned area of a scene, rather than overly light or dark areas. Ideally, this is accomplished by metering from a gray card that is placed directly in front of the key subject in the same type of light. If this is not possible, look for a key area within the scene that comes close to representing an 18 percent gray and meter off that value. Use the monitor to review and make appropriate adjustments.

In all instances, a gray card reading is a guidepost that requires customization by the photographer to achieve the desired result (see Addendum 3, Advanced Exposure Techniques/The Zone System for Color Photography). Also, read the instructions for exposure determination, depending on application, that accompany the gray card.

Camera Metering Methods and Programs

Matrix Metering/In-Camera Metering Methods

Most DSLRs have computer-assisted matrix metering. With this feature, the meter is programmed to recognize common lighting situations and adjust the exposure accordingly. Typically, the camera's meter divides the scene into a series of weighted sectors and compares the scene being metered with the light patterns from numerous photographs in its memory. The meter may automatically shift between sensitivity patterns, depending on whether the camera is held horizontally or vertically. Such features make matrix metering effective in the majority of general situations. It can also be effectual where the frame is dominated by either bright or dark colors. Matrix metering also allows one to choose between different meter programs to automatically deliver accurate results, depending on the light. Options typically include center-weighted, spot, highlight- or shadow-biased, and segment averaging. Metering modes are often displayed in the control panel and are simple to change.

The center-weighted method meters the entire frame but assigns the greatest sensitivity to light in the center quarter of the frame. It is an excellent choice for portraits and when using filters with a filter factor greater than 1X (1/2 f-stop). (See Chapter 4 for filter factor details.)

The spot or partial meter method measures light from a small zone in the center of the viewfinder. As it may be reading only 1 percent of the frame, care must be taken to select crucial areas of detail in the picture to obtain the desired results. When it is not practical for the photographer to get up close to measure the light on a subject, as with a distant landscape or a sporting event, the spot meter has the advantage of being able to measure the light from any number of key areas of the scene from a distance. It is most helpful in ensuring proper exposure when the background is much brighter or darker than the principal subject.

Utilizing a Camera's Monitor

Almost every digital camera has a viewing monitor, commonly a liquid crystal display (LCD). Monitors come in a variety of sizes,

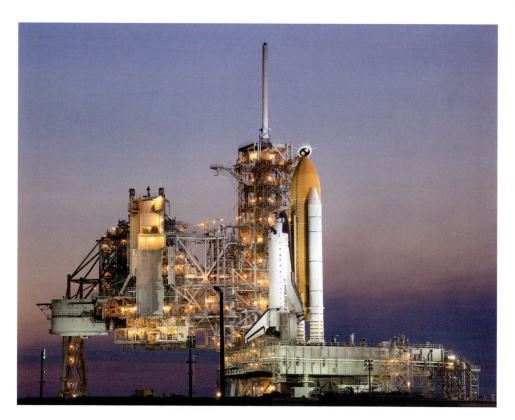

Figure 3.6 To balance the natural light from the sunset with the artificial light shining on the spacecraft, Roland Miller used a spot meter to measure the area of the sky that he wanted to use as a midtone and compared that with readings taken from the neutral midtones in the launch tower. When he later color-corrected the image in Photoshop, Miller determined the neutrality of the midtones by using the Color sample tool and establishing an appropriate compromise of the colors from the varying light sources. As an imagemaker, he believes in striving for a balance between technique and aesthetics. He elaborates, "It is important to attain technical competence in order to gain control of the media, but not to meet some false expectation of the craft. On the other hand, a wonderful concept, poorly executed, fails to be wonderful. One of my goals is to find an appropriate equilibrium."

© Roland Miller. *STS125 Atlantis Sunset*, 2009. 20 × 24 inches. Inkjet print.

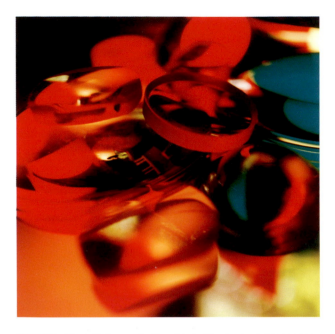

Figure 3.7 Marcia Treiger used a Hasselblad with extension tubes to make this abstract image that explores design, color, and translucency. Exposing for the various glass prisms and the resulting mirrored surfaces was a challenge that she took on enthusiastically. Viewing her images as experiments with light and reflection, Treiger explains, "These photographs are about the web, the illusion of reality, and the core of unseen worlds."

© Marcia Treiger. *Translucent Objects #15*, 2006. 20 × 20 inches. Inkjet print. Courtesy of AxD Gallery, Philadelphia, PA, and Museum of Fine Arts, Houston, TX.

dynamic ranges (the maximum contrast ratio of dark and light areas that can be accurately displayed without distortion), and resolutions, and have played a major role in popularizing digital cameras because they also conveniently permit you to instantly view and share images with those around you. Viewing monitors have other characteristics that are innately different from conventional optical viewfinders. Unlike most optical viewfinders, which crop off 5 to 10 percent of a scene, thus not showing exactly what the camera will record, a digital camera monitor can display 100 percent of the image that the camera will capture, permitting accurate, full-frame composition. Additionally, a camera monitor can effectively show focus and exposure, and it offers a convenient way to compare changes in exposure and/or color settings as you bracket exposures. The monitor allows the camera to be held away from your eye, making it viable to simultaneously compose while following live action. The maneuverability of adjustable camera monitors is also expedient for overhead and low-angle frame composition. Some DSLR cameras have Live View, a second sensor in the path of the light that captures the image and continually transmits it to the camera's LCD. This allows one to follow subjects in motion and without experiencing image black out when the mirror moves out of the way of the sensor when the exposure button is depressed. The monitor also displays the camera's various menus, simplifying the navigation process of selecting modes and options.

On the downside, camera monitors drain battery power, can be difficult to see in bright light and when glare and/or reflections are present (optional shades are available), and do not deliver as high a level of fine detail as an optical viewfinder (some cameras have both—see the following section). All these factors may undercut the effectiveness of what you can actually see on a monitor, making precise exposure calculations difficult to determine. Also, the dynamic range of a camera monitor will not accurately show the levels of highlight or shadow detail contained in the actual image file.

Electronic Viewfinder (EVF)

While some digital cameras offer both a monitor and an optical viewfinder, others have a monitor and an electronic viewfinder (EVF). An EVF is essentially a miniature second monitor inside the back of the camera that replaces the traditional optical viewfinder. The photographer looks at the monitor through a small window and sees the scene from the same viewpoint as the lens. Thus, parallax error, where the viewfinder image does not match the image seen through the lens, which can occur when doing close-up work, can be avoided.

The desire to make cameras smaller and less expensive has resulted in the increased use of EVFs. Using an EVF on a camera is equivalent to looking at the world through a video monitor. Compared with an optical viewfinder, an EVF view is less sharp, colors are less accurate, and the resolution is generally too low for precise manual focusing. The main advantage of an EVF is that it is internal and shaded, thus providing the ability to see picture files under very bright conditions when it is not possible to see them clearly on the camera's monitor.

EVF Superzoom cameras boast powerful but fixed (non-interchangeable) zoom lenses that use only the EVF, making them less bulky and heavy than a DSLR. Electronic viewfinders are also available in EVIL (electronic viewfinder interchangeable lens) cameras. Whether or not the lens is fixed, the EVF shows the image directly from the image sensor on a tiny eyepiece LCD, thus preventing parallax error. The electronic viewfinder also makes for very quiet, vibration-free shooting. The only shutter noise is an electronic sound effect, which can be adjusted or turned off. While the EVFs are highly accurate in terms of showing you almost 100 percent of what the camera sees, the image you view is video that can be jumpy. Therefore, an EVF does not provide the clarity of a DSLR viewfinder and can make tracking a moving subject difficult.

How a Meter Gets Fooled

Scenes with an overbalance of either light or dark areas usually will not meter properly. For example, scenes containing large areas of light, such as fog, sand, snow, or white walls, deliver a meter reading that causes underexposure because the meter is fooled by the overall brightness of the scene. To correct the meter error, an exposure of between one and two additional f-stops is needed. Review the image on your monitor and make the necessary adjustments including exposure compensation.

Scenes with a great deal of dark shadow produce overexposures. This happens because the meter is designed to reproduce an 18 percent gray under all conditions. If the predominant

tones are appreciably darker or lighter than 18 percent gray, the exposure may not be accurate and must be corrected by the photographer. A reduction of one to two f-stops is often needed for dark subjects. Again, review the image on your monitor and make the required adjustments. An incident reading performs well in such situations because it is unaffected by any tonal differences within the subject. Bracketing of exposure (see the following section) is a good solution in both these situations.

Exposure Bracketing

Exposure bracketing begins by first making what you believed is the correct exposure. Then, you make a second exposure 1/2 f-stop under that "correct" exposure. And finally, you make a third exposure 1/2 f-stop over the original exposure. In tricky lighting situations, it is a good idea to bracket two 1/2 f-stops in each direction (overexposure and underexposure) for a total of five exposures of the scene. Many DSLRs have auto-bracketing that will make a series of three exposures: normal, under, and over (usually ± 0.5 or ± 1 f-stop) in rapid succession. This can be useful for making High Dynamic Range images too. Do not hesitate to shoot additional frames and review your results on the monitor. Bracketing can help a photographer gain an understanding of the relationship between light and exposure. Analyze and learn from the results, so you can utilize your experience the next time a similar situation is encountered.

Exposure Compensation

Many cameras offer an exposure compensation mode that can be set to automatically provide the desired amount of correction. For instance, if you photographed a dark figure against a dominant light background, the exposure suggested by an averaged meter reading will produce an unexposed image. By setting an exposure compensation of +1.5, for example, the result will be more natural. Remember to reset the exposure compensation mode back to zero after photographing each corrected scene, so as not to improperly expose your next subject.

Manual Override

Cameras that have fully automatic exposure systems without a manual override reduce one's photographic options. The machine decides how the picture should look, how much depth of field it should have, and whether to stop the action or to blur it. If you have only an automatic camera, try experimenting with it by adjusting the shutter speeds, altering the ISO setting, or using the backlight control to change your lens aperture. Learn to control the machine, so as not to be a prisoner to its programmed decisions.

Handheld Meters

Once the in-camera meter is mastered, those wishing to learn more about measuring light may want to acquire a handheld meter. When purchasing a handheld meter make certain it can read both reflected and incident light (see figures Figure 3.2 and 3.3). Incident light readings are accomplished by fitting a light-diffusing attachment over the meter's cell. The meter can then

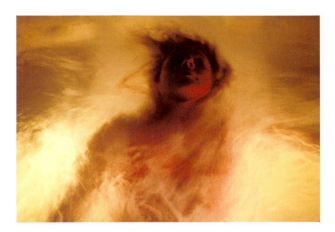

Figure 3.8 Linda Troeller looks at exposure and metering in her book *Healing Waters*. Through these images of women at healing spas, the artist explores how the visual effects of blur, atmosphere, and natural light can reveal the psychological states of her subjects. She says, "My images encourage the viewer to explore the unknown in nature, its mysteries. They orchestrate a paradigm for absorbing nature and healing into our consciousness."

© Linda Troeller. *Healing Waters*, 1995. 16 × 20 inches. Chromogenic color print.

be pointed at the light source rather than at the subject. Since it measures the light falling on the subject, and not the light reflected by the subject, the incident reading is useful in contrasty light or when a scene has a large variation in tonal values. Many handheld meters can also take spot meter readings of a very small, selected portion of a scene or deliver a reading when using an off-camera electronic flash or strobe system, either via a cord connected to the unit's PC terminal or wirelessly.

Brightness Range

The brightness range of a subject (the difference in the number of f-stops between the key highlight and key shadow area of a scene) is one way to determine exposure. Some digital cameras can record a brightness or dynamic range of up to 64:1. However, in many cases the brightness range forces you either to expose for the highlights and let the shadows go black, or vice versa. In 1965, Gordon Moore, a founder of the Intel Corporation, observed that the number of transistors on a chip doubles every 18 months. Since then, Moore's Law has pretty much held true, which means that future digital sensors soon will have a greater dynamic range. But what does one do to retain wanted detail now?

Exposing to the Right

Bearing in mind what Vladimir Nabokov, the Russian-American author of *Lolita* (1955), observed, "In art as in science there is no delight without the detail", the general rule for average scenes is to expose for the highlights. This entails finding that spot where the scene retains detail in the brightness areas without "blowing out"

and losing detail. In digital terms, this is also referred to as "Exposing to the Right," as you want to ensure that the highlights fall as close to the right side of the histogram as possible to retain useable detail (data). With a film camera, take an initial meter reading from the area in which you want to retain key highlight features.

High Dynamic Range/HDR

When the brightness range exceeds the limitations of your equipment, you can consider high dynamic range (HDR) solutions. Suppose, for example, you want to photograph inside a room but also want to maintain detail in the view beyond the windows. Usually you have to choose either the interior or the exterior view and allow the detail in the other to be lost. To overcome this problem, you can make an HDR image using multiple photographs, each captured with a different exposure of the same scene. In this case, you would place the camera on a tripod and make a correctly exposed view of the interior and then a second exposure for the exterior. Later you would use HDR software to sort through the resulting images, which range from nearly black, underexposed views to washed-out overexposures, to calculate the full dynamic range of the scene. Using that data, the software then constructs a single, high dynamic range image. Some of the latest digital cameras have an HDR mode, allowing photographers to easily create images that were previously very difficult to accomplish. Many imaging programs have an automated HDR process. A similar effect can be achieved with film by bracketing (lens aperture must remain constant for all exposures), scanning the film, and then applying software to combine exposures. Regardless of capture method, take care not to over-process the image as this will result in an unintentionally surreal rendition. Usually, the idea is to represent the entire dynamic range of a scene with an extreme contrast range that retains realistic color and contrast (see Chapter 9, Figure 9.10 for HDR info).

Basic Light Reading Methods

The brightness range method can be divided into four broad categories: (1) average bright daylight with no extreme highlights or shadows; (2) brilliant, contrasty, direct sunlight; (3) diffused, even, or flat light; and (4) dim light.

Average Daylight

In a scene of average bright daylight, the contrast is more distinct, the colors look more saturated, and the highlights are brighter and the shadows darker, with good detail in both areas. Meter reading from different parts of the scene may reveal a range of about seven f-stops. Care must be given to where meter readings are taken. If the subject is in direct sunlight and the meter is in the shadow, overexposure of the subject will result.

Brilliant Sunlight

Brilliant, direct sunlight generates maximum contrast and produces the deepest color saturation. The exposure range can be 12 f-stops or greater, which stretches or surpasses the ability of film

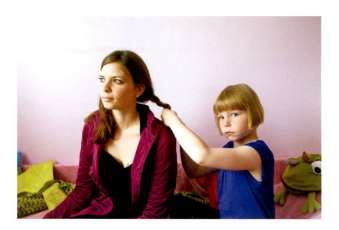

Figure 3.9 Beth Yarnelle Edwards made this image in Skagaströnd, Iceland, in June, when the country experiences 24 hour light. She took the photograph in the early evening using only daylight streaming in from a nearby window. She says that in Iceland "the winters can be very dark, so homes are designed to make the most of any light coming from outdoors. Unlike my previous work, which is usually lit artificially, I did my entire project in Iceland with available light. I wanted to celebrate the exquisite light, which filled me with joy and energy!"

© Beth Yarnelle Edwards. *Maria and Laufey*, from the *Iceland Series*, 2009. Variable dimensions. Chromogenic color print. Courtesy of Robert Klein Gallery, Boston, MA, and Galerie f5,6, Munich, Germany.

or the sensor to record the scene but can be corrected with imaging software. These conditions result in deep, black shadows and bright highlights. Color separation is at its greatest; white appears at its purest. Determining on which areas to base the meter reading is critical for obtaining the desired results. These effects can be compounded when photographing reflections off glass, polished metal, or water. Selective exposure techniques such as incident light or spot reading may be needed (see Unusual Lighting Conditions section later in this chapter).

A hood or shade may be needed to prevent lens flare (the scattering and internal reflection and refraction of bright light) that commonly occurs when an optical system is pointed toward intense light sources.

Diffused Light

Overcast days offer an even, diffused quality of light. Both highlights and shadows are minimal. Colors appear muted, quiet, and subdued. Wherever the scene is metered, the reading usually remains within a range of three f-stops. A scene's apparent brightness range and contrast can be increased by the following: slight overexposure, post-exposure software, increased development time of film, or with fill flash (see Electronic Flash and Basic Fill Flash section later in this chapter).

Dim Light

Dim natural light taxes the ability of the sensor or film to record the necessary color and detail of the scene. Colors can be flat and monochromatic, and contrast can be lacking, with details often difficult to determine. When artificial light sources are included

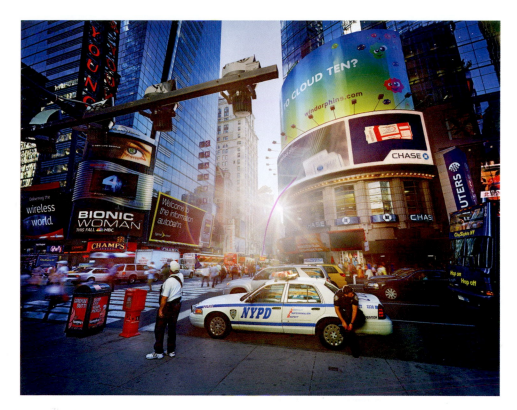

Figure 3.10 Jerry Spagnoli was able to capture the brilliant sunlight in this scene by using 8 × 10-inch color negative film, scanning the negative, and correcting the image for excessive contrast and lens flare. This image, from his *Local Stories* project, looks at the idea that "history is what occurs everywhere, all the time, all at once … The persistence of the idea of history as 'the story of great men' (or women for that matter), a singular narrative which excludes 'extraneous' stories, robs individuals of the awareness of their own roles in the day-to-day creation of the world. These images are a metaphor for the democratization of the history of the world: they are general in viewpoint, diffuse in subject, and the only constant is the thing surely there from before the beginning and certain to be there after the end—the sun in the center of the sky."

© Jerry Spagnoli. *Times Square, NYC*, from the series *Local Stories*, 2008. 44 × 55 inches. Inkjet print.

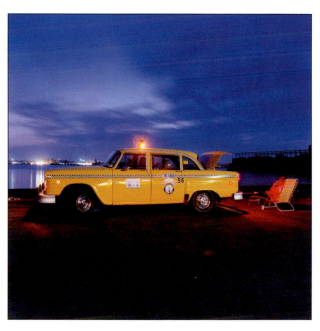

Figure 3.11 Dim light can strain a film's ability to record the necessary color and detail, resulting in monochromatic colors and an extreme contrast range. When Jan Staller first started photographing the West Side of Manhattan after sunset, he "began to notice the theatrical quality of streetlight illumination upon the cityscape. In my photographs, this effect was most dramatic when the street was brightly lit by the commonly found sodium vapor streetlights of New York City." Though these lights appeared too yellow on film, Staller color-corrected the print by adding blue and cyan to increase the intensity of the sky, making the image look the way he remembered seeing it.

© Jan Staller. *Taxi, New York City*, 1985. 15 × 15 inches. Chromogenic color print.

within the scene, contrast can be pushed to the other extreme. Either way, post-exposure corrections are often necessary. Low levels of light translate into long exposures; a tripod, a higher ISO setting that increases digital noise or film graininess (see section on Long Exposures and Digital Aberrations on page 49), or additional lighting may be needed to make the desired picture. Despite these issues, dim lighting conditions can be visually compelling due to the atmosphere of mystery generated by unusual colors and lack of detail that spark the imagination.

Contrast Control/Tone Compensation

DSLRs have an image adjustment control for altering the image-contrast and brightness at the time of exposure. Altering the tone curve can control image-contrast, the relationship between the distribution of light and dark tones. This is sometimes referred to as tone compensation. DSLRs offer a host of contrast management options. The Automatic or default option optimizes the contrast of each exposure by selecting a tone curve to match the situation. Normal uses the same curve setting for all images. Low contrast prevents highlights from being washed out in direct sunlight. Medium–Low contrast produces slightly less contrast than Normal. Medium–High produces slightly more contrast than Normal. High contrast can preserve detail in low-contrast situations such as in a foggy landscape. Some cameras allow the creation of a custom tone curve to deliver a unique look. RAW

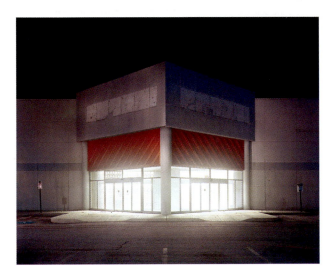

Figure 3.12 Composing this image in extremely dim light and dealing with the high-contrast between shadows and highlights presented a challenge for Brian Ulrich. He was able to capture the image by using a handheld flashlight for the shadows and photographing with an 8 × 10 large format camera, which allowed for an extremely high fidelity image. Ulrich's *Copia* project, which examines American consumer culture, was influenced by the terrorism and collective grief of 2001 and the almost immediate governmental urge for citizens to bolster the failing economy. He states that this project "explores not only the everyday activities of shopping, but also the economic, cultural, social, and political implications of commercialism and the roles we play in self-destruction, over-consumption, and as targets of marketing and advertising."

© Brian Ulrich. *Pep Boys 3*, from the series *Copia*, 2009. Variable dimensions. Chromogenic color print.

users will adjust their contrast later, using post-processing software, rather than in the camera. The contrast of film can be managed slightly by altering the choice of film stock and the time of the first developer. Finer control is possible by scanning the film and then using image software to make adjustments.

Light Metering Techniques

Metering the Subject

Metering the subject is another way to determine proper exposure. When in doubt about where to take an exposure reading, decide what the principal subject is in the picture and take a reflected reading from it. For instance, when making a portrait, go up to the person or zoom in and take the meter reading directly from the face. When photographing a landscape in diffused, even light, an overall meter reading can be made from the camera position. If the light is hard (not diffused) or directional, the camera meter can be pointed up, down, or sideways to emphasize the sky, the ground, the highlights, or the shadows. In this situation bracketing is recommended.

Exposing for Tonal Variations

Exposing for tonal variations is another method that can be used in calculating the exposure. A scene having large areas of either dark or light tones can give incorrect information if the exposure is based on a single reading. When photographing a general outdoor scene, taking two manual light meter readings—one each from key highlight and shadow areas—and then averaging them together can deliver a correct exposure. For example, suppose you are photographing a landscape late in the day, when the sky is brighter than the ground, and detail needs to be retained in both areas. First, meter a critical highlight area, in this case the sky, in which detail is required. Let's say the reading is f/16 at 1/250 of a second. If the exposure was made at this setting, the sky would be rich and deep, but detail in the ground would be lost and might appear as a vast black area. Second, take another meter reading from a key shadow area of the ground. Say it is f/5.6 at 1/250 of a second. This would provide an excellent rendition of the ground, but the sky would be overexposed, completely desaturated of color and with no discernible detail. To obtain an average reading, meter the highlight (sky) and the shadow (ground) and halve the f-stop difference between the two readings. In this case, an average reading would be about f/8-1/2 at 1/250 of a second. It is permissible to set the aperture in between the f-stops, though DSLRs display the actual f-stop number, such as f/8, f/9, f/10, and so on. The final result is a compromise of the two situations, with acceptable detail and color saturation in each area. Bracket your exposures to ensure the result you desire. Often one will favor capturing highlight detail instead of shadow detail, as overexposed "blown out" highlights are gone forever.

If the subject being photographed is either a great deal darker or lighter than the background, such as a dark-skinned person against a white background or a fair-skinned person against a black background, averaging will not provide good

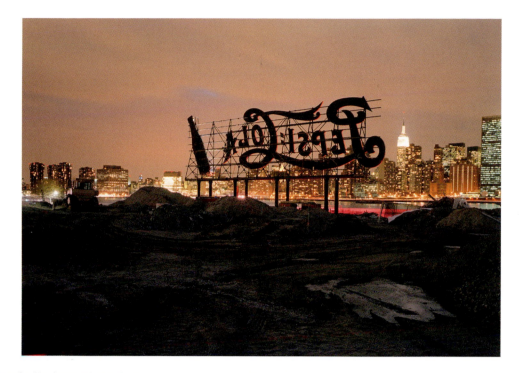

Figure 3.13 To make this photograph at twilight, Lynn Saville used a Fuji GSW 690III 6 × 9 rangefinder camera, which has a 65mm lens. She used Fujicolor Pro 400, a daylight film. Saville says, "I used f/16 and a slow shutter speed of 5 seconds to allow the details in the foreground to register clearly on the film. I used a tripod and a cable release to make sure I didn't move the camera."

© Lynn Saville. *Pepsi Sign*, from the series *Night/Shift*, 2008. 20 × 24 inches. Chromogenic color print. Yancey Richardson Gallery, New York, NY.

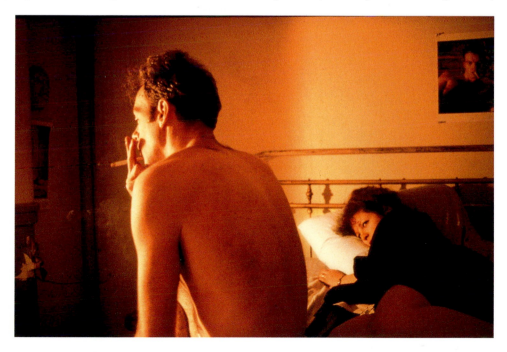

Figure 3.14 Nan Goldin is known for using a seemingly casual snapshot aesthetic to photograph the private lives of her close circle of friends. In this image of herself and her lover in an intimate setting, subtle detail is important for a full appreciation of a sensitive moment. When a scene contains large amounts of dark and/or light areas, taking an average reading for tonal variation is a good way to get a wide range of detail and retain the atmospheric flavor of the moment.

© Nan Goldin. *Nan and Brian in Bed, NYC*, 1983. 30 × 40 inches. Dye-destruction print. Courtesy of Matthew Marks Gallery, New York, NY.

results. If there is more than a five-f-stop range between the highlight and shadow areas, there can be an unacceptable loss of detail in both areas. In a case like this, let the background go and use post-exposure correction methods, or use additional lighting techniques such as flash fill to compensate for the difference.

White Balance

In analog color photography one needs to match the film type, such as daylight or tungsten, with color temperature of the scene to achieve a natural color balance (see Chapter 4). Digital cameras can automatically or manually adjust the color balance of each frame electronically, according to the color temperature of the light coming through the lens. One image can be white balanced for daylight, while the next one can be white balanced for incandescent (indoor) light. Better cameras have a larger variety of settings for different lighting sources. These can include any of the following: daylight, cloudy, shade, incandescent, and fluorescent (see Table 3.1). High-end digital cameras also offer white balance bracketing for mixed lighting sources. RAW users can set the white balance after the fact in a RAW converter. Learning how to adjust and control the white balance can mean the difference between capturing a spectacular sunset or having the camera automatically "correct" it down to gray sky.

Color Modes

Digital cameras have image-processing algorithms designed to achieve accurate color, but there are variables within these programs and within the scene that may produce distinct color variations. Professional cameras offer a range of application modes. For instance, one mode might be optimized to set the hue and chroma values for skin tones in portraits. A second mode could be Adobe RGB gamut-based, which gives a wider range of color for output on color printers. A third mode could be optimized for outdoor landscape or nature work. Lastly, there can be a black-and-white mode. RAW users are not affected by these color modes.

Image Enhancement Modes

Digital cameras have programming modes that automatically optimize contrast, hue (color), outlines, and saturation based on the scene being recorded. Standard exposure modes include *Normal*, suggested for most situations; *Vivid*, which enhances the contrast, saturation, and sharpness to produce more vibrant reds, greens, and blues; *Sharp*, which sharpens outlines by making edges look more distinct; *Soft*, which softens outlines to ensure smooth, natural-looking flesh tones; *Direct Print*, which adjusts images for printing "as is" directly from the picture file; *Portrait*, which lowers contrast and softens background details while providing natural-looking skin color and texture; *Landscape*, which enhances saturation and sharpness to produce more vibrant blues and greens; and *Custom*, which allows you to customize color, contrast, saturation, and sharpness. Additionally, some cameras provide a monochrome image profile for making black-and-white images, which often can be tweaked to adjust sharpness, contrast, filter effects, and toning (see Table 3.2). Again, RAW users are not affected.

TABLE 3.1 COMMON CUSTOM DIGITAL WHITE BALANCE CONTROLS

Control	Description
Auto	White balance is automatically measured and adjusted
Preset	White balance is manually measured and adjusted in the same lighting as the subject (a gray card is recommended as a target). This is useful under mixed light conditions
Daylight	Preset for daylight. Subsets let you make the image either more red (warm) or blue (cool)
Incandescent	Preset for incandescent (tungsten) light
Fluorescent	Preset for fluorescent light. May have subsets for FL1 (white), FL2 (neutral), or FL3 (daylight) fluorescent lights. Check the camera owner's manual for the correct setting designations
Cloudy	Preset for cloudy or overcast skies
Shade	Preset for shade
Flash	Preset for flash photography
Bracket	Makes different white balance exposures (selected value, reddish, and bluish)
Fine Tune	Kelvin color temperature
Sun	Preset for daylight
Custom	White balance is set by the user

TABLE 3.2 MAJOR IMAGE ENHANCEMENT MODES

Enhancement mode	Use
Normal or Off	Suggested for most situations
Vivid	Enhances the contrast, saturation, and sharpness to produce more vibrant reds, greens, and blues
Sharp	Sharpens outlines by making edges look more distinct
Soft	Softens outlines to ensure smooth, natural-looking flesh tones
Direct Print	Optimizes images for printing "as is" directly from the picture file
Portrait	Lowers contrast and softens background details while providing natural-looking skin color and texture
Landscape	Enhances saturation and sharpness to produce more vibrant blues and greens
Custom	Customizes color, contrast, saturation, and sharpness
Monochrome	For black-and-white images

Electronic Flash and Basic Fill Flash

Electronic flash operates by producing a veritable bolt of lightning between two electrodes inside a quartz-crystal tube that is typically filled with xenon gas. A quick discharge of high-voltage current from the system's capacitor excites the gas, and a brief, intense burst of light is emitted in the color temperature range of 5600 to 6000 K (see Color Temperature and the Kelvin Scale section in Chapter 4). Many cameras have built-in flash units that are convenient but have limited capabilities. The range of the built-in flash is determined by the ISO setting and lens aperture and will cover only certain focal lengths, such as 20–300mm (see your camera manual for details). Flash can be extremely useful, as non-professional digital cameras often tend to perform badly in low light without the benefit of electronic flash, producing significant digital noise (see page 49) at longer exposures. Film suffers from reciprocity failure, which produces color shifts and graininess (see section on Reciprocity Law).

Other cameras have dedicated external flash units designed to function with a particular camera. These provide automatic exposure control and expanded versatility. Professional portable and studio flash units are synchronized with a camera by means of a sync cord or a "slave" unit. The shutter must be completely open at the time the flash fires. Many DSLRs will not sync at speeds faster than 1/500 of a second and most SLRs with focal plane shutters will not sync at speeds faster than 1/250 of a second (check your camera manual). If the shutter speed is too high, only part of the frame will be exposed. Professional external flashes may have a high-speed mode that enables flash sync at any shutter speed. Systems can have multiple flash heads and variable power control that can be set to use only a portion of the available light. This allows you to control the intensity of the light, which is very useful for stopping action, bringing a subject forward in a composition, and for creating atmospheric and fill flash effects. Filters can be placed over the flash head(s) to alter the color of the light for purposes of correction or to create a mood.

DSLRs and many SLRs offer a basic automatic fill flash option. In this selection the camera calculates how much extra flash to deliver based on the distance to main subject and available light. Fill flash is used to brighten deep shadow areas, typically outside on sunny days, but the technique can be helpful any time the background is significantly brighter than the subject. To use fill flash, the aperture and shutter speed are adjusted, either automatically or manually, to correctly expose the background, and the flash is fired to lighten the foreground. Remember that there are two potential light sources that determine flash exposure. One is the ambient light and the other is the light emitted by the flash—and you must always consider both. Experiment with exposure settings because there are times you need to go beyond the default settings to get the desired look between ambient light and flash. Also, don't forget to use the proper sync shutter speed (see your camera manual). Also use the test button on the back of your flash and if a green or equivalent light is glowing, then you are ready to properly expose the scene. Be sure to review each exposure on the camera monitor and make adjustments as needed. Bracketing is advisable with an SLR.

A basic fill flash technique involves first taking an available-light meter reading of the scene, setting your camera's shutter to the desired flash synchronization speed, and then determining the f-stop. Next, divide the exposure f-stop number into the guide number (GN) of your flash unit, which can be found in your camera manual. The result is the distance (in number of feet) you need to be from your subject. Shoot at the available-light meter reading with the flash at this distance. For example, suppose the meter reads f/16 at a synchronization speed of 1/125. Your flash unit has a GN of 80. Divide 16 (f/16) into 80 (GN). The result is 5: The number of feet you need to be from the subject with an exposure of f/16 at 1/125.

A second fill flash method is to set the camera to make a proper ambient light exposure, using a correct synchronization speed. Note the correct f-stop that is required. Position or adjust the flash unit to produce light that is the equivalent of one or two f-stops less exposure, depending on the desired effect. If the flash produces an amount of light equal to the original exposure, the shadow areas will be as bright as the directly lighted areas. This equal balance of light will cause the loss of the modeling effect that normally defines the three-dimensional features of a subject, producing a flat, featureless-looking image.

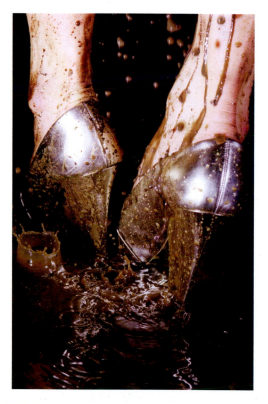

Figure 3.15 For this project Marilyn Minter used stop-action flash to reinvent luxuriant images that she had previously made for fashion magazines. Here she substituted mud for water, replacing the unattainable fashion ideal with its messy, flawed, and highly human form. Minter states, "I want to make a fresh vision of something that commands our attention and is so visually lush that you'll give it multiple readings, adding your own history and traditions to the layered content."

© Marilyn Minter. *Splish Splash*, 2005. 60 × 40 inches. Chromogenic color print. Courtesy of the artist and Salon 94, New York, NY.

A third technique is to determine the correct ambient light exposure at the proper flash synchronization speed and then vary the output of the flash by using a different power setting (half- or quarter-power) so the amount of flashlight is correct for the subject-to-flash distance. If the flash does not have a power setting, putting a diffuser or neutral density filter in front of the flash head can reduce the output. You can also improvise by putting a clean, white translucent cloth in front of the flash head; each layer of cloth reduces the output by about one f-stop. Most external dedicated flash units can also make automatic fill flash exposures. Fill flash can also be employed selectively to provide additional illumination, or with filters to alter the color of specific areas in the scene and add a 3D modeling effect.

A fourth method is to diffuse the flash by bouncing it off of a neutral-colored surface, such as a white piece of Fome-Cor (a.k.a. foam core). Avoid any colored material, unless you wish to inject color contamination into the scene. Also, if your flash has a detachable head, use a bare bulb attachment, which will produce a soft light within about a 15-foot range.

Red Eye

When photographing any living human or animal with a flash unit attached to the camera, red eye can result. If your subject looks directly at the camera, and the light is next to the lens axis, light passes directly into the pupils of your subject's eyes and is strongly reflected back to the camera. This is recorded as a pink or red spot in the center of the eye because the light illuminates the blood vessels in the retina of the eye. If this effect is not desired, try one of the following: Use the camera's red-eye reduction mode; have the subject look to one side of the camera; bounce the flash light; or move the flash unit a distance of 6 inches or more from the lens axis. The unit can be moved by elevating the flash on a commercially available extender post or by getting a long flash synchronization cord and holding the unit away from the camera with one hand. The red-eye reduction mode fires a small light about 1 second before the flash,

causing the pupils in the subject's eyes to contract and thereby reducing the red effect sometimes caused by the flash. You will find that the camera needs to be held still when the lamp goes on, and the 1-second delay makes this mode unsuitable with moving subjects or when a quick shutter response is needed. Digital imaging software, often built into DSLR cameras, can be employed for red-eye correction. Most quality cameras have numerous in-camera editing features including color balance and filter effects.

Unusual Lighting Conditions

Many unusual lighting conditions can result in exposure problems, including uneven light, light hitting the subject from an odd angle, backlight, glare and reflections, areas with large highlights, and shadows such as those inside doorways and windows, as well as light emitting from computer, cell phone, or television screens. The wide range of tones in such scenes can tax the sensor's or film's ability to record them. A photographer must decide what is important to record and how to get it done.

Subject in Bright Light

Should your main point of interest be in a brightly lit area, take a reflected reading from the key highlight area or use an incident reading. Dealing with a contrasty subject in this fashion provides dramatic, rich, and saturated color along with good detail in the bright areas, though the shadows will lack detail, and provide little visual information. Anything that is backlit becomes a silhouette with no detail under these circumstances.

Inexpensive digital cameras often overexpose highlights, resulting in a lack of detail. In contrasty situations, determine which areas you want to retain detail and texture, and expose for them by zooming in, locking the exposure by depressing the shutter button halfway, reframing, and then making the photograph. When in doubt, bracket your exposures.

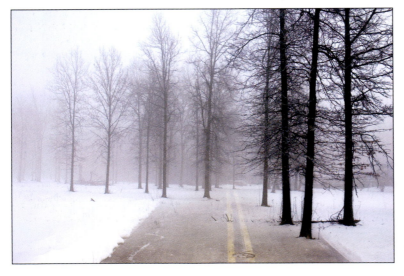

Figure 3.16 Deborah Orloff deals with the unusual lighting conditions that snow presents by layering multiple photographs to create a composite image. She shoots each image at eye level, using a wide-angle lens with a small aperture to get maximum depth of field. In Photoshop, she changes the opacity and selectively reveals parts of the layers, resulting in an image that invites the viewer into the space. She tells us that *Holzwege* "refers to paths in the forest that lead nowhere. These paths meander through the woods and end abruptly; you never know where one will take you … presenting opportunities for exploration, transformation, and previously unimagined destinies."

© Deborah Orloff. *Holzwege #1*, 2006–2009. 22½ × 34 inches. Chromogenic color print.

Subject in Shadow

When the subject is in shadow, the photographer must decide which is the most important area of the picture, which details need to be seen, and which colors are most intriguing. If the subject is in shadow, take a reflected meter reading from the most important shadow region. This provides the correct exposure information for that key area. Other areas, mainly the highlights, may experience a loss of color saturation and detail due to over-exposure, which can be corrected to some degree with imaging software. At other times, there may be a key highlight striking the subject in shadow. The exposure can be made based on the highlight reading, letting the remainder of the subject fall into obscurity. Additional light, by means of flash and/or reflective fill-cards, such as a piece of white foam core, can be used to put more illumination on the subject. Bracketing will provide you with more choices to consider.

Alternate Solutions: Using a Handheld Meter

If it is not acceptable to lose the details in the shadows, there are other alternatives. These include averaging the reflective reading, bracketing, using additional lighting techniques such as flash fill, or combining both a reflective and an incident reading. This last method is accomplished by using a handheld meter to take an in-cident reading, pointing the meter toward the camera, instead of reading the light striking the subject. This reading is not affected by extreme highlights. Then take a reflected reading with the meter aimed at the key subject area. Now expose for the aver-age of the two readings. When in doubt, the best insurance is to bracket and use imaging software to make additional corrections.

Subject in Dim Light: Long Exposures, Increased ISO, and Digital Aberrations

In dim light situations that require long exposures—such as be-fore sunrise, after sunset, at night, and in poorly lit interiors—it is often necessary to increase the ISO sensitivity setting to produce a decent exposure. However, increasing the ISO has side effects. With film, raising the ISO rating increases deterioration of im-age quality in terms of graininess and color saturation. In digital photography, the higher the ISO setting, the more the electric charge to the sensor is amplified, which results in a greater like-lihood that pictures will contain "noise" in the form of ran-domly spaced, off-color pixels. Digital noise can be described as "flecks" of visual static, known as artifacts, which mar color con-tinuity in the image. Although they do not produce global color shifts, artifacts can cause color tinges around their edges. Digital noise most often occurs in areas lit near the ends of the spec-trum, where some pixels malfunction and result in either "hot" or "dead" pixels. Hot pixels appear as bright white on a dark background, whereas dead pixels lack all color in a well-lit scene. Using an ISO setting of greater than 400 or working in dim light may degrade image quality with noise. Although a factor with all digital cameras, noise is reduced with higher megapixel cameras and many have a long exposure noise reduction feature. Many digital camera manufacturers suggest turning off "image sharp-ening" features in these conditions, as they will exacerbate the

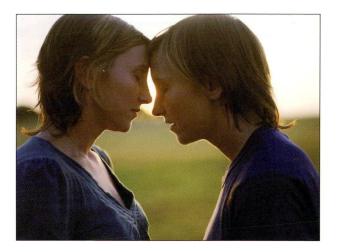

Figure 3.17 Kelli Connell utilizes backlight to set the mood of this image, which explores gender and self-identification. To make the photograph, she shoots a roll of her model dressed as each character. After developing the film, the artist analyzes the negatives to determine which two images she can composite to create the most intriguing relationship between the two characters. She then "scans the selected negatives and manipulates them in Photoshop to create a seamless image that appears to be a reality, when in fact it is a document that reflects an internal questioning." Connell elaborates, "The importance of these images lies in the representation of interior dilemmas portrayed as an external object—a photograph. Through these images the audience is presented with 'constructed realities.' I am interested in not only what the subject matter says about myself, but also what the viewers' response to these images says about their own identities and social constructs."

© Kelli Connell. *Head to Head*, 2008. 30 × 40 inches. Chromogenic color print.

noise problem. Fortunately, imaging software programs usually have a filter that can help reduce noise by discarding pixels that are too different from adjacent pixels.

Banding, the appearance of unpredicted bands in areas with no detail, also is more likely to occur at a higher ISO. Blown-out highlights that have spread into adjacent image areas (referred to as fringing) and lack detail are caused by overexposure and are known as blooming. Software can compensate for fringing. Bracketing and exposure compensation is recommended to keep blooming in check. Most DSLRs can be custom programmed to automatically carry out these tasks.

In dim light, image stabilization and motion detection fea-tures can compensate for camera shake and subject movement and deliver sharper images.

Mixed Light

There are times when a scene obtains various color temperatures by including both artificial and natural light. Such mixed lighting combinations can be intriguing and therefore courted, but other times you may wish to alter the color relationships. Digitally this can be accomplished by experimenting with different Color Balance settings or using RAW capture in post-production. For example, if a scene looks too neutral switch the color balance

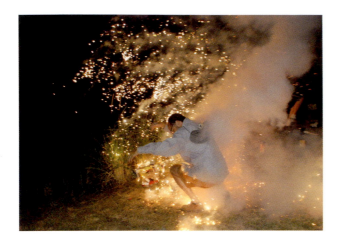

Figure 3.18 To photograph nighttime fireworks Janet Neuhauser used a strobe flash on her handheld DSLR along with a high ISO setting. This combination allowed her to capture moments of Independence Day activities while portraying "that gritty, intense feeling of being surrounded by fireworks for about three to four hours straight."

© Janet Neuhauser. *10:28:59*, from the series *Fireworks*, 2008. 8 × 12 inches. Inkjet print.

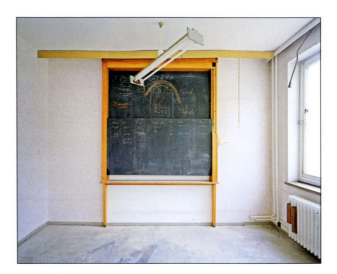

Figure 3.19 Fredrik Marsh used a medium-format camera to capture the light in this scene, which includes a mix of dim interior light and bright exterior daylight. After exposing his 120 film, he scanned the negative and performed subtle digital corrections to ensure that the image appeared as close as possible to his memory of the scene. Marsh explains that this image looks at "the detritus of human culture discovered in the decaying interior spaces of vacant factories, abandoned apartments, and hotel rooms. *The Dresden Project* demonstrates the juxtapositions and ironies still abundant in the post-socialist world, showing the old and the new as well as the grandeur and the decay of these once-majestic buildings."

© Fredrik Marsh. *Former Office, Tower Block (Plattenbau), Dresden*, from *Transitions: The Dresden Project*, 2005. 31 × 38 inches. Inkjet print.

from Normal to Partly Cloudy, which will warm up the image by lowering the color temperature. Many cameras provide a Custom Color setting and/or a setting that allows you to select from a list of color temperature values. Other solutions include: electronic flash as a fill light, flash with a colored filter, flash with a diffuser, or light shaping tools such as reflectors.

Reciprocity Law

The reciprocity law is the theoretical relationship between the length of exposure and the intensity of light. It states that an increase in one is balanced by a decrease in the other. For example, doubling the light intensity should be balanced by exactly halving the exposure time. In practical terms, this means that if you meter a scene and calculate the exposure to be f/8 at 1/250 of a second, you could obtain the same exposure by doubling your f-stop opening and cutting your exposure time in half (Table 3.3 shows some of the theoretical exposures equivalent to an exposure of f/8 at 1/250 second). Thus, shooting at f/5.6 at 1/500 of a second should produce the same results as shooting at your initial calculation. You could also cut your f-stop in half and double your exposure time, so that shooting at f/11 at 1/125 of a second is the same as shooting at f/8 at 1/250.

This can be useful when you need to stop action, as you can swap a decrease in aperture for an increase in shutter speed. Suppose you calculate the exposure to be f/8 at 1/125 second, but you know that you need 1/500 second (an increase of two full f-stops) to freeze the motion (see Chapter 8). Using the reciprocity law, you can then determine that you would need to open your lens aperture an additional two full f-stops to compensate, thus giving you an exposure of f/4 at 1/500 second (see Table 3.3).

Reciprocity Law Failure and Film

Unfortunately, the reciprocity law does not hold true in every situation. When using film to make either very long or very brief exposures, reciprocity failure can take place. Depending on the type of film used, exposures at about 1/5 second or longer begin to show the effects of reciprocity failure and for exposures of about 1 second or longer, the normal ratio of aperture and shutter speed may cause underexposure. Exposures faster than 1/10,000 second also begin to exhibit reciprocity failure, but since only specialized cameras are capable of such high shutter speeds, few photographers will have to worry. Some electronic flash units, when set on fractional power, can achieve exposures that are brief enough to cause reciprocity failure. Some films can now tolerate exposures of up to 30 seconds without exposure compensation. Check the manufacturer's suggested guidelines for details.

Reciprocity Failure and Its Effect on Color Materials

With black-and-white film one can increase the exposure time to compensate for the slow reaction time and avoid underexposure of the film. The problem with color materials is that the individual emulsion layers do not respond to the reciprocity effect in the same manner. This can produce a shift in the color balance of the film or paper. If you wish to correct for

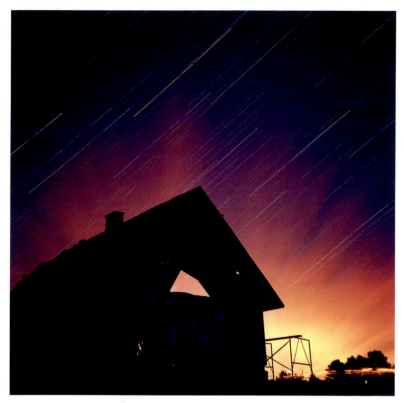

Figure 3.20 Photographing at night in a rural setting presents a unique set of challenges. Kay Kenny scouts locations and plans her shots during daylight; she begins photographing around ten o'clock at night, when the stars appear. She balances exposure time and light intensity by exposing 400 ISO film at f/3.5 to f/5.6 for about an hour with focus set to infinity. Despite her calculations, Kenny tells us, "The result is always magical and unexpected. So many factors play a role: How long to light the object with a flashlight, car headlights, porch lights, or window lights? What weather conditions would affect the film and camera—dew point, atmospheric moisture, wind, or even rain? It is not unusual to leave my camera in the field, shutter open, only to return and find the lens covered with moisture, creating a misty, dreamy effect, if I am lucky."

© Kay Kenny. *Blue Drape*, 2008. 16 × 16 inches. Inkjet print.

TABLE 3.3 THEORETICAL EXPOSURE EQUIVALENTS (BASED ON A STARTING EXPOSURE OF F/8 AT 1/250 OF A SECOND)

f-stop	Time in seconds
f/16	1/60
f/11	1/125
f/8*	1/250*
f/5.6	1/500
f/4	1/1000

*Starting exposure.

reciprocity failure, follow the exposure and filtering instructions provided with the film or paper. These are merely starting points, and you must experiment to discover what works best in a particular situation.

The problem with filtering is that by adding filters you make the exposure even longer, which in turn can cause the reciprocity effect to be even more pronounced. Additionally, when using an SLR camera the filters add optical density, which can make viewing and focusing more difficult in a dimly lit situation.

Fortunately, the quality of light encountered during times of reciprocity failure tends to be strange. This means there is no standard by which we can judge whether or not you have succeeded in producing an acceptable color balance. Accurate color does not always mean realistic color. At times of extreme lighting, you may want to gamble that the combination of light and reciprocity shift will work in your favor to create an unusual color balance that gives your picture an impact impossible to achieve in any other fashion. Apply what you have learned from this experience to future situations.

Problem Solving

Reciprocity

Do not let reciprocity law failure stop you from making pictures. Intentionally photograph a scene that introduces reciprocity failure. Experiment with a variety of exposure times, bracketing, lighting modes, and/or with the recommended and non-recommended light balances and correction filters. Being a photographer entails making photographs, so expose numerous frames and refer to metadata or keep detailed exposure notes. Review your images on your playback monitor and/or make contact sheets. Do not expect every frame to be a work of art. Ansel Adams is reported to have said he was content to produce 12 good photographs in a year. Critically analyze your results and decide what combination you find to be the most visually intriguing. Check your notes so you can apply what you have learned the next time you encounter a similar situation.

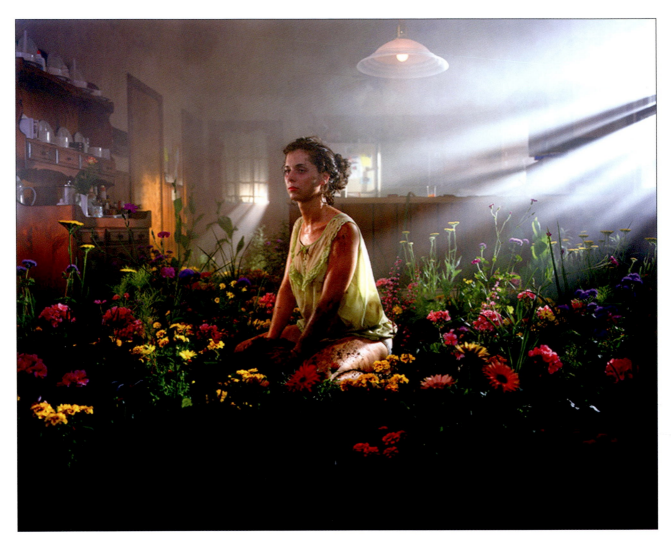

The making of Gregory Crewdson's photographs is an elaborately planned event that involves coordinating a specialized team of assistants and technicians. It reflects the artist's belief that you "do whatever you have to do to make your work." Crewdson, whose father was a psychoanalyst, comments, "I photograph it out of longing and desire. My photographs are also about repression and internal angst."

© Gregory Crewdson. *Untitled*, 1998. 50 × 60 inches. Chromogenic color print. Courtesy of Luhring Augustine, New York, NY.

Filtering the Light

Our Sun: A Continuous Spectrum Source

Our sun radiates "white" light, which is a continuous spectrum of all the visible wavelengths that are produced by the elements burning on the sun's surface. As these wavelengths are separated out by absorption and reflection, we see them as color. The shortest visible wavelengths appear as violet, the longest as red, and all other colors fall somewhere in between these boundaries. In total, the human eye detects only a tiny portion of the electromagnetic spectrum, the slice known as the visual spectrum. Just beyond the blue-violet end of the visual spectrum lie the ultraviolet (UV) wavelengths that are too short to be seen by the human eye. In the other direction, just past the visible red portion of the electromagnetic spectrum, are the infrared (IR) wavelengths that are too long for humans to see.

Color Temperature and the Kelvin Scale

The amount and proportion of visible colors in a light source, which includes the wavelengths of red, orange, yellow, green, blue, and violet, can be measured as color temperature. Color temperature is expressed on the Kelvin scale. An absolute scale based on the laws of thermodynamics, the Kelvin scale starts at absolute zero, which is −273.15 (usually rounded to −273) degrees Celsius, and is the temperature at which all molecular motion theoretically stops. The Kelvin temperature (which isn't expressed with a degree symbol) of a particular color is determined by adding 273 to the number of degrees Celsius to which a black metal radiator must be heated before turning that color. A black body is used as the standard gauge since it ideally does not reflect any light falling on it and emits radiation only when heat is applied to it. Just as the ISO scale expresses the sensitivity of an image sensor or film, the Kelvin scale describes the color temperature of light (Figure 4.1; Table 4.1).

Color Temperature Meters

A color temperature meter can measure the photographic color temperature of a light source. The most reliable and expensive meters compare the relative amounts of red, green, and blue energy in the light. They work well with sunlight and incandescent light sources, but are not as accurate for measuring fluorescent light. This is because some artificial light sources, such as fluorescent light, do not radiate color continuously and evenly throughout the spectrum, and cannot be given an exact color temperature. Consequently, such discontinuous sources are assigned color temperatures on the basis of the color sensor's or film's visual response to the light. Sometimes the designated value includes measurement with a color temperature meter, though not always.

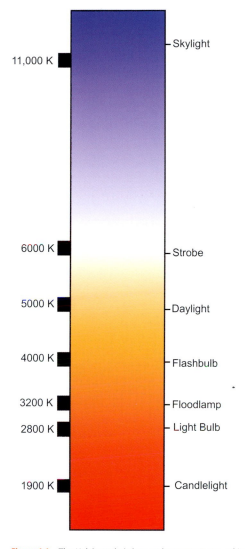

Figure 4.1 The Kelvin scale is how color temperature of light is measured. The bluer the light, the higher the Kelvin temperature. This chart gives common illumination sources and their approximate Kelvin temperature.

To operate a digital color meter, set the film type (daylight or tungsten), position the meter near the principal subject and point it at the camera and/or main light source, and read the temperature and filtration recommendations in the meter's display window. Its suggested filtration should work with negative film, though transparency film may require test exposures for accurate results, due to fluctuations or differences between the same film emulsion (type) or processing (see Testing for a Critical Neutral Color Match section later in this chapter).

TABLE 4.1 COMMON LIGHT SOURCES AND THEIR APPROXIMATE COLOR TEMPERATURES

Sources	Color temperature (K)
Daylight sources*	
Skylight during summer	9500 to 30,000
Summer shade, average	7100
Summer sun and blue skylight	6500
Overcast sky	6000
Direct sunlight, midsummer	5800
Noon sun with clear sky (summer)	5000 to 7000
Noon sun with clear sky (winter)	5500 to 6000
Photographic daylight (Average)	5500
Noon sunlight (depends on time of year)	4900 to 5800
Average noon sunlight (Northern hemisphere)	5400
Sunlight at 30 degree latitude	4500
Sunlight in the early morning and late afternoon	4300
Sunlight one hour after sunrise	3500
Sunrise and sunset	2000 to 3000
Artificial sources†	
Electronic flash	5500 to 6500
Warm white fluorescent tubes	4000
500W 3400 K photolamp (photofloods)	3400
500W 3200 K tungsten lamp (photolamps)	3200
200W household lamp	2980
100W household lamp	2900
75W household lamp	2820
40W household lamp	2650
Gaslight	2000 to 2200
Candlelight (British Standard)	1930

*All daylight color temperatures vary according to the time of day, season of the year, and latitude and altitude of the location. Sunlight refers only to the direct light of the sun, while daylight is a combination of direct and indirect outdoor light. The values given are approximate because many factors affect color temperature outdoors: The sun angle, and the conditions of the sky—clouds, haze, dust particles—raise or lower the color temperature.

†The age and the amount of use of the bulb, lamp, or tube affect the color temperature indoors: Lamp age (and blackening), voltage, and type of reflectors and diffusers all affect tungsten bulbs, and each can influence the actual color temperature of the light.

Color Temperature of Digital Devices

When working in color photography it is important that the color temperature of an on-screen image matches that of a color print as closely as possible. For this reason, know your monitor's color temperature and use color-matching software to adjust the color temperature appropriately. Here are some frequent monitor color temperatures, along with their CIE Standard Illuminants for Colorimetry in parentheses: 5000 K (D50), 5500 K (D55), 6500 K (D65), 7500 K (D75), 9300 K. The "D" numbers do not indicate color temperature, but are scientific designations that represent daylight simulators. For example, D65 is intended to represent average daylight, or white light, at a temperature of about 6500 K. In the photo field, these values are used to classify the illumination of monitors, light tables, and viewing booths. Most digital cameras, web graphics, and DVDs are designed to approximate a 6500 K color temperature. The sRGB standard normally used for Internet images and other digital devices also specifies a 6500 K display. When viewing a color transparency on a light table, it is critical that the light be balanced properly to permit accurate viewing.

The Color of Light

Although we think of daylight as being "white," its color varies according to the time of day, the time of year, and atmospheric conditions. Nor is artificial light usually white. Our brain remembers how things are supposed to look and often will recast a scene for us, fooling our eyes into believing that light is white, even when it is not. However, photographing a non–white scene can be another matter. While digital cameras often will make the desired color adjustments through electronic means, unfiltered color film, on the other hand, will record only the actual light, forgoing the reconciliation of color differences that our brain frequently supplies.

Digital White Balance

Digital cameras have built-in white balance control, which compensates for variations in the color of common types of light so that white and gray objects appear to have a neutral color balance. The color of a light source is described in terms of its color temperature, measured in degrees Kelvin (K). If the color temperature of the light does not match the white balance setting, the final image will have a color cast to it. Think of the white balance control as a built-in group of electronic filters that allows you to alter the color temperature of each frame. Typically, the white balance can be set automatically, based on a variety of fixed values, or can be measured and manually set.

Learning how to adjust and control the white balance is the best initial method for achieving the desired color balance of the final image. DSLRs can automatically or manually adjust the color balance of each frame electronically according to the color temperature of the light coming through the lens. Begin with Auto White Balance for general light sources of 3500 to 8000 K. If the desired results are not achieved, then try one of the following settings: Incandescent, for use with 3000 K incandescent

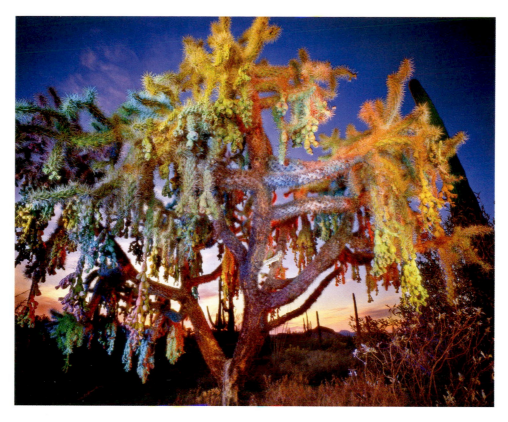

Figure 4.2 William Lesch investigates the color of light by experimenting with multiple long exposures and light painting. To create this image he made two exposures totaling four hours, one during daylight and one incorporating nighttime light painting, blending the two on a single sheet of film to create a new reality. Lesch states that he was able to perfect his technique by spending countless days working on single shots. He continues, "practice like a maniac to get to that point where you can turn off your mind and listen to and look at the music of the world around you. Get to that point, and you will know what needs to be done to put it on paper."

© William Lesch. *Cholla and Sunset, Organ Pipe National Monument*, 1991. Variable dimensions. Dye-destruction print. Courtesy of Etherton Gallery, Tucson, AZ.

lighting; Fluorescent, for use under 4200 K fluorescent lighting; Direct sunlight, for use with subjects lit by 5200 K direct sunlight; Flash, for use with 5400 K built-in flash units; Cloudy, for use in daylight under 6000 K overcast conditions; Shade, for use with subjects in 8000 K shady conditions; and Preset, for use with a gray card or white object as a reference to create a custom white balance. Using Preset allows the white balance to be fine-tuned to compensate for variations in the color of the light source, or to deliberately introduce a slight warm or cool cast into an image. Raising the White Balance setting can slightly compensate for light sources with a red or yellow cast, making an image look more bluish. Lowering the White Balance setting can slightly compensate for bluish light sources, making an image appear a bit more red or yellow. Many DSLRs offer White Balance Bracketing, in which the white balance is automatically varied across a series of exposures. When using the RAW file format you can adjust the color balance to suit your needs during post-processing.

Camera Color Modes

Digital cameras have image-processing algorithms designed to achieve accurate color, but there are variables within these programs and within the scene that may produce distinct color variations. DSLRs offer a range of application modes. For instance, one mode might be optimized to set the hue and chroma values for skin tones in portraits that will be used "as is" (no or minimal post-exposure processing). A second mode could be Adobe RGB color space that can give a wider gamut of colors, which is the preferred choice when images will be extensively processed. A third mode could be optimized for making "as is" outdoor landscape or nature images.

Color Saturation Control

Digital cameras usually have a saturation control for adjusting the intensity of color in the image for printing and/or manipulation in the computer. The color saturation or vividness of an image can be set to Normal, recommended for most general situations; Moderate, useful when post-exposure image-processing is planned; or Enhanced, for increased saturation, which can be useful in "as is" situations when no additional post-modifications are planned.

Hue Adjustment/RGB Color Mixing

The RGB color model used in digital photography reproduces colors using differing amounts of red, green, and blue light.

By mixing two colors of light, a variety of different colors can be produced. For instance, red light combined with a small amount of green light produces orange. Mixing equal amounts of red and green will produce yellow. Combining various amounts of red and blue light can generate a range of colors from reddish-purple through purple to navy. Combinations of all three colors produce a range from white through gray. Arranging this progression of hues in a circle results in what is known as a color wheel. Using this method, the hue or color of a captured image can be adjusted slightly in varying increments. For example, raising the hue adjustment of red would increase the amount of yellow, resulting in a more orange image. Lowering the hue level would increase the amount of blue, giving a more purple image.

How Film Sees Color

Every color film is designed to accurately record the quality of light for a certain manufactured "normal" color temperature. Therefore, if you use a film whose designation does not match the color temperature of the scene, the picture will have an unnatural color cast to it. Silver-based photographic materials have an inherent sensitivity to the blue wavelengths of the visual spectrum and to all the shorter wavelengths. Their sensitivity can be extended to green, yellow, and red visible wavelengths as well as into part of the infrared portion of the spectrum.

Daylight Type Film

The most common color film is designed to give an accurate representation of a scene in daylight when color temperatures are between 5200 K and 5800 K. At midday, the Kelvin temperature of outdoor light is about 5500 K. When the color temperature drops below 5200 K, daylight film begins to record the scene with a warmer than normal color balance. Full daylight has predominately blue color content. If you make pictures at times substantially removed from midday, such as early in the morning or near sunset, the light has less blue in it and the results will have a warmer color cast. The more color temperature drops below 5200 K, the more pronounced the cast will be. In artificial tungsten light, daylight film produces a warm orange-reddish-yellow cast.

Bear in mind that in winter light everything appears slightly cooler or bluish. Light reflected off colored walls or passing through translucent objects creates a color cast that influences the entire scene. This is known as color contamination (see the section on monochrome in Chapter 7 for more information).

Tungsten and Type L Films

Tungsten Type B transparency film and Type L negative film, both color balanced at 3200 K, are to be used with 250–500 W photolamps or spots. Using tungsten film in daylight produces a blue cast. If you use it with a light source of a lower (redder) color temperature, such as a household bulb, the result is yellower. If these shifts in color are not desired, they must be filtered out. The most favorable results generally are obtained when filtering at the time of exposure, rather than attempting to correct the color shifts later.

What Does a Filter Do?

A photographic filter is a transparent device that can alter the quality and quantity of light. It can be placed in front of the camera or enlarging lens, or in the path of the light falling on the subject. Filters that go in front of the lens must be of optical quality or they can degrade the image quality. Those used in front of a light source or with a color enlarger do not have to be of optical quality, though they must be able to withstand high heat without becoming distorted or faded.

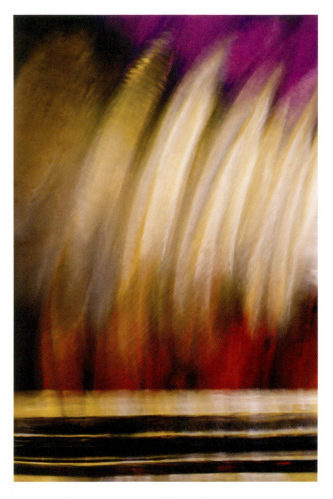

Figure 4.3 Alyson Denny's *Horizontal Line Series* functions as an exploration of "the emotional power of light." To make these images, she arranged a variety of glass and colored water and shot the photographs using a skylight filter and a macro lens with her 35mm camera. Denny tells us that the key to this series "has been my interest in combining the anchor that the horizontal line provides with an anything-goes approach to what happens in the rest of the picture. This gives me a way to get at the broadest possible range of moods and feelings. It also serves one of the key concerns of my work in general, which is to seek creative balances between order, rules, and systems on the one hand and freedom, variation, and improvisation on the other."

© Alyson Denny. *Horizontal Line Series #24*, 2000. 40 × 30 inches. Chromogenic color print. Courtesy of Alan Klotz Gallery, New York, NY.

How Filters Work

Most filters are colored and work subtractively, absorbing the wavelengths of light of their complementary (opposite) color while transmitting wavelengths of their own color. The color of a filter is the color of the light it transmits. For example, a red filter absorbs green and blue light while emitting red light. Although a filter transmits its own color, it also passes all or parts of the colors next to it in the spectrum while absorbing part or most of all other colors. For instance, a red filter does not transmit yellow light but does allow some light from yellow objects to pass. This occurs because yellow light is made up of green and red. Thus the red filter passes the red portion of the yellow while blocking the green.

Filter Factor

Filters are normally uniform in color but may differ in density (color strength). The amount of light absorbed depends on the density of the filter. Since filters block some of the light, they generally require an increase in exposure to make up for the light lost due to absorption. This compensation is known as the filter factor and is indicated as a number, followed by an X sign, which tells how much the exposure must be multiplied. A filter factor of 2X means that one additional f-stop of exposure is needed;

2.5X shows 1-1/3 additional f-stops are necessary; 3X means an extra 1-2/3 f-stops are needed; and 4X indicates two additional f-stops of exposure. To simplify matters, many manufacturers indicate how many f-stops to increase the exposure. Table 4.2 shows the effect of filter factors on exposure.

Most TTL camera metering systems give an accurate reading with a filter in place; if not, adjust the ISO to compensate. When you do, make sure that the meter doesn't further compensate once the filter is put back in place. For example, if you are using an ISO of 100 and a filter with a 2X factor, you change the ISO to 50. Then meter with the new ISO, set the aperture and speed, and make the exposure with the new ISO, which will provide one additional f-stop to compensate for the filter factor. Some TTL meters can be fooled and give faulty readings with certain filters, including deep red, orange, and linear polarizers. Bracket and review your exposures when using a filter for the first time. Table 4.2 shows the amount of additional exposure needed for many common filters when working with a handheld or non–TTL camera meter. Autofocus systems may not operate properly with heavy filtration, diffusion, or certain special effects filters. If the system balks, switch to manual focus.

Dichroic Filters

Dichroic filters, such as those found in many color enlargers, act by interference. A thin coating on the surface of the filter causes certain wavelengths to be reflected, and thus canceled out, while permitting other wavelengths to pass through it.

How Filters Are Identified

Filters are described and identified in a variety of systems. The most widely used is the Kodak Wratten number system in which filters are simply identified by number and letter, such as 85B (see Figure 4.4). Other designation systems are used as well, so check with the manufacturer to avoid confusion.

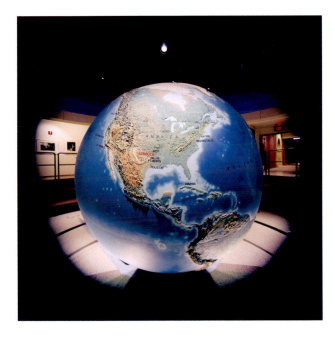

Figure 4.4 Rick Dingus used a homemade camera, based on an old 2-1/4 inch Graflex back, to produce this photograph. To construct the camera, he modified a Cokin filter system to fit over a lens from a preexisting camera, and to make the image, he set the focus to infinity. Dingus states, "while maps most often strive for physically accurate depictions of space, I think of my photographs as urban legends or rural myths that might tell new stories each time they are seen. As I work, I reflect on how the details in photographs, and the photographs themselves, act more like symbols than as records of existing situations."

© Rick Dingus. *Lubbock-Marked Globe, International Cultural Center, Lubbock, TX*, 2004–2006. 24 × 24 inches. Inkjet print.

TABLE 4.2	FILTER FACTOR ADJUSTMENTS
Filter factor	**Exposure adjustment**
1.2X	+1/3 stop
1.5X	+2/3 stop
2X	+1 stop
2.5X	+1–1/3 stops
3X	+1–2/3 stops
4X	+2 stops
5X	+2–1/3 stops
6X	+2–2/3 stops
8X	+3 stops

Note: Cameras with TTL meters should make the correct filter factor adjustment automatically. When using a handheld meter, you'll have to make the adjustment manually. The lens aperture may be set in between the standard f-stops to achieve accurate exposure adjustment.

In color photography, filters are employed to make changes in the color balance of the light that creates the image. If the color temperature of a light source, as measured in degrees Kelvin (K), does not match that of the film, the final image will have a color cast to it. A color temperature meter can be used to provide a precise reading of the Kelvin temperature of the light source when extremely accurate color correction is needed.

Matching Film to the Light

It is best to match the color of the light with the film and any correction filters at the time of exposure. Negative film allows for some correction when the print is made, but transparency film leaves little room for error, although current films are slightly more forgiving than in the past. Manufacturers supply transparency film for daylight (5500 K), Type A (balanced for photo floodlights at 3400 K), and Type B (balanced for studio lights at 3200 K) lighting. Type A and Type B film exposed in sunlight produce a strong blue cast, while daylight film exposed in artificial light has a distinct red-orange-yellow cast.

There are about 100 different correction filters available to deal with the range of color temperature encountered. Of course, ignoring the rules and doing the opposite can produce startling visual results.

Filter Categories for Color Films

The following are general categories of filters that are commonly employed with color films (Figure 4.5).

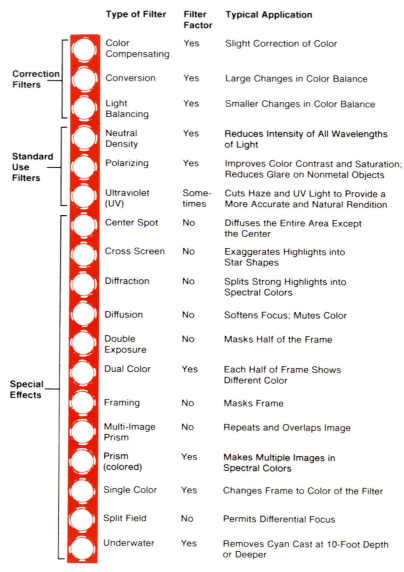

	Type of Filter	Filter Factor	Typical Application
Correction Filters	Color Compensating	Yes	Slight Correction of Color
	Conversion	Yes	Large Changes in Color Balance
	Light Balancing	Yes	Smaller Changes in Color Balance
Standard Use Filters	Neutral Density	Yes	Reduces Intensity of All Wavelengths of Light
	Polarizing	Yes	Improves Color Contrast and Saturation; Reduces Glare on Nonmetal Objects
	Ultraviolet (UV)	Sometimes	Cuts Haze and UV Light to Provide a More Accurate and Natural Rendition
Special Effects	Center Spot	No	Diffuses the Entire Area Except the Center
	Cross Screen	No	Exaggerates Highlights into Star Shapes
	Diffraction	No	Splits Strong Highlights into Spectral Colors
	Diffusion	No	Softens Focus; Mutes Color
	Double Exposure	No	Masks Half of the Frame
	Dual Color	Yes	Each Half of Frame Shows Different Color
	Framing	No	Masks Frame
	Multi-Image Prism	No	Repeats and Overlaps Image
	Prism (colored)	Yes	Makes Multiple Images in Spectral Colors
	Single Color	Yes	Changes Frame to Color of the Filter
	Split Field	No	Permits Differential Focus
	Underwater	Yes	Removes Cyan Cast at 10-Foot Depth or Deeper

Figure 4.5 Common filters and their typical applications in color photography.

Color Compensating Filters

Color compensating (CC) filters mostly are used in front of a camera lens at the time of exposure to make slight and precise corrections in one or two colors of the light. They counteract small color shifts and correct minor color casts. These filters also can be used to correct for a particular color cast that certain films produce, and in the darkroom to gain proper balance when color printing.

CC filters usually are used to control the primary colors. A filter of one primary color affects the other two primaries. For example, a red CC filter reduces green and blue light. A filter of one of the secondary colors affects its primary complement. Thus a cyan filter reduces red light, a magenta filter reduces green, and a yellow filter reduces blue. The amount of light reduced depends on the filter's density. CC filters come in various densities of red, green, blue, cyan, magenta, and yellow. Their density is indicated by designations like CC10R—the 10 represents a density of 0.10 and is commonly referred to as 10 units, or points, of red.

Conversion Filters

Conversion filters are used to make large changes in color balance. Generally they correct a mismatch of film type and illumination, but they can be employed to create a deliberate color shift. They consist of 80 series (dark blue) and 85 series (amber/dark yellow) filters (see Table 4.3). The common 80 series filters are used with daylight film to color-correct it when used under tungsten light. For example, if you were photographing a person under a tungsten light source with daylight film, an 80A or 80B filter would render a more accurate color match. The 85 series filters correct tungsten film when it is used in daylight. See Table 4.3 to determine the correct combination of film and filter for common lighting situations. As with most other filters, these reduce the amount of light entering the camera lens and require an increase in exposure. They also can make focusing more difficult, reduce the depth of field, and extend shutter speeds to unacceptably long times. See Table 4.4 for exposure corrections when working with common conversion filters.

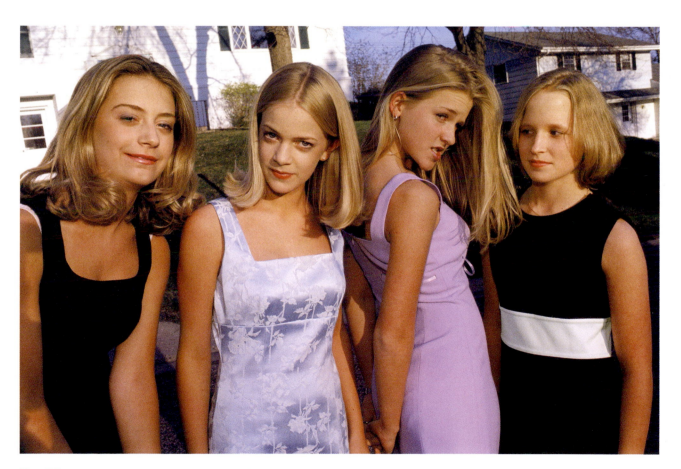

Figure 4.6 Lauren Greenfield utilized an 81A filter to reduce the appearance of blue light in this outdoor scene. This image of four teenage girls posing for the camera just before a seventh grade social event is from her series *Girl Culture*, which explores the ways young American women use their bodies to express their individual identities.

© Lauren Greenfield. *Alli, Annie, Hannah, and Berit, all 13, before First Big Party of the Seventh Grade, Edina, MN*, 1998. Variable dimensions. Dye-destruction print.

TABLE 4.3 CONVERSION FILTERS FOR COLOR FILMS

		LIGHTING CONDITIONS		
Color film type	Designed for	Daylight (5500 K)	Photo-lamp (3400 K)	Tungsten (3200 K)
Daylight type (5500 K)	Daylight and flash	No filter	80B	80A
Type A (3400 K)	Photo-lamps (3400 K)	85	No filter	82A
Tungsten Type B	Tung-sten	85B	81B	No filter

TABLE 4.4 EXPOSURE COMPENSATION WITH CONVERSION FILTERS

Filter	Changes Color Temperature		Exposure Increase	
	From	To	Film	In f-stops*
80A	3200 K	5500 K	Daylight	2
80B	3400 K	5500 K	Daylight	1–2/3
80C	3800 K	5500 K	Daylight	1
80D	4200 K	5500 K	Daylight	1/3
85	5500 K	3400 K	Tungsten (Type A)	2/3
85B	5500 K	3200 K	Tungsten	2/3
85C	4650 K	3400 K	Tungsten (Type A)	1/3

*These are suggested starting points. For critical work, especially with color slide film, a visual test should be conducted.

Light Balancing Filters

Light balancing filters make smaller changes in the color balance than conversion filters. They are used to match an artificial light source more closely with a tungsten film (Table 4.5). The 81 series filters, known as warming filters, have a yellowish or amber color to counteract excessive blue light and lower the color temperature. Use an 81A or 81B filter to reduce excessive blue in aerial, marine, and snow scenes. It also is effective on overcast and rainy days, in open shade, and directly after sunset. An 81C can be used in daylight conditions having an inordinate amount of blue. Filters in the 82 series possess a bluish color, to counteract excessive yellow, and raise the color temperature of the light. An 82A filter is used to reduce the warm cast in early morning and late afternoon light.

TABLE 4.5 LIGHT BALANCING FILTERS

Subject conditions	Filtration for day-light films (5500 K)	Filtration for tungsten films (3200 K)
Sunrise, sunset	80B or 80C (blue)	82 (blue)
Two hours after sunrise or before sunset	80D (blue)	81 + 81EF (yellow)
Average noon sunlight	None	85B (orange)
Overcast	81A or 81B (amber)	85B + 81B
Open shade	81B or 81C (amber)	85B + 81A

Note: Sky conditions vary dramatically depending on the time of day, the weather, and location. While these filters may not always fully correct the color, they should provide much better results than if no filter was used at all.

Correcting Color Balance with Electronic Flash

Electronic flash has a color temperature equivalent to bright daylight, usually about 5600 K to 6000 K. Each unit is different; some tend to be cooler and bluer than others. Electronic flash also produces ultraviolet wavelengths that can appear as blue on color film. If your flash is putting out light that is too cool for your taste, a yellow CC or CP filter of slight color value can be cut and taped in front of the unit. Usually a filter with a value of 05 or 10 will make the correction. DSLRs usually will allow you to adjust your white balance setting to make a Custom setting to correct for such situations. Flash also can be employed if you are shooting daylight film in tungsten light. The flash can help to off-set the tungsten light and maintain a more natural color balance.

In addition to correcting color balance, filters can be combined with flash to provide creative lighting changes within a scene (Figure 4.7). Thoughtful use of flash also can produce strongly contrasting effects of light and shade known as chiaroscuro, the interplay of light and shadow, which can set the psychological atmosphere of a scene.

Problem Solving

Make photographs under lighting conditions that do not match the type of light for which the camera's white balance or film is set. Then, under the same mismatch of conditions, take corrective actions using white balance, flash, and/or filters to make corrections. Compare your results. Discuss the emotional effect that is created when the white balance and light do not match. Might there be a situation when you would intentionally create a mismatch? Why? Observe any frequently occurring problem situations that a filter would help to solve. Base future purchases on your own shooting experiences, acquiring equipment that allows you to make the pictures you desire.

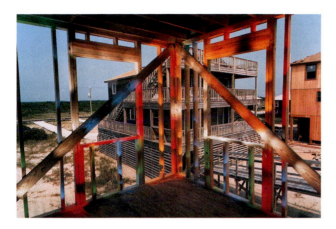

Figure 4.7 Colored filters or gels can be placed in front of a flash or other light source to create color changes within a scene. In this photograph, Michael Northrup combined about 75 colored flashes with daylight. The effect helps to lead the eye around and make visual connections within the composition.

© Michael Northrup. *Strobacolor Series: House Frame*, 1984. 16 × 20 inches. Chromogenic color print.

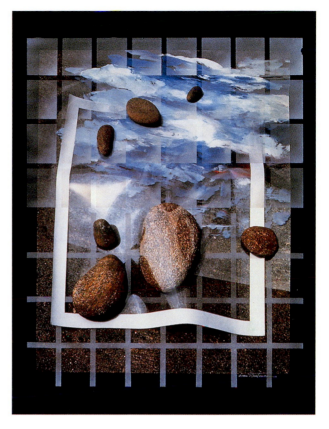

Figure 4.8 It is the imagemaker's job to pay attention and control reflections. Bringing a virtual studio to the wilderness, Evon Streetman superimposed a silver grid to make use of the reflection that shifts from silver to gray depending on the viewer's position. The clouds were painted on the underside of two large sheets of Mylar. In placing the rocks both under and over the Mylar, Streetman produced gestural marks with the reflections on the surface. Streetman says she designed visual cues that invite the more curious observer to discover the deception and to be reminded of the traditional value of the artist as craftsperson.

© Evon Streetman. *Landscape and Systems*, 1984. 24 × 30 inches. Dye-destruction print with mixed media.

Neutral Density Filters

Neutral density (ND) filters are applied to reduce the intensity of the light by absorbing the same amount of all the wavelengths. ND filters will not affect the color balance or tonal range of the scene. They have an overall gray appearance and come in different densities (ND2, ND4, and ND8) that will cut the light by one, two, or four f-stops. An ND2 transmits 50 percent of the light, ND4 25 percent, and ND8 12.5 percent. Kodak's Wratten ND filters, available in dye gelatin squares, come in 13 different densities, ranging from 0.1 (needing 1/3 f-stop more exposure) to 4.0 (needing 13-1/3 more f-stops of exposure). The Kodak density (logarithmic) values are not the same as the ND filters labeled with simple filter factors. ND filter effects can be mimicked digitally by lowering the camera's ISO setting.

An ND filter can be used anytime the light is too bright to use a large lens opening and/or a slow shutter speed. Using ND filters for outdoor portraiture can be very effective, because it permits you to use a large aperture to reduce the depth of field, thus putting the background out of focus and giving more emphasis to the subject. ND filters also can be employed in order to get the slower shutter speeds necessary to produce certain effects like intentional blur action shots. For example, a slow shutter speed would let the movement of cascading water be captured as a soft blur. In another instance, when moving the zoom control of the lens during the exposure you will want to use a tripod and a shutter speed of 1/15 of a second or slower.

ND filters also can be useful in making pan shots or when you have to use a very high-speed film in extremely bright light. Center-weighted ND filters are used with certain panoramic cameras to even out the overall exposure by correcting the light fall-off that reduces the exposure at the corners of the image by up to one f-stop.

Reflections: Polarized and Unpolarized Light

Normally, while a light wave moves in one direction, the light energy itself vibrates in all directions perpendicular to the direction of travel of the light wave. Such light is said to be unpolarized. Polarizers, such as the naturally occurring mineral called Iceland spar, transmit only the part of each light wave vibrating in a particular direction; the rest of the light wave is refracted away from its original direction. The portion of the light that is transmitted is called polarized light.

What a Polarizing Filter Can Do

A polarizing filter is made up of submicroscopic crystals that are lined up like a series of parallel slats. The crystal slats let

light waves traveling parallel to them pass through unobstructed, while blocking those light waves vibrating at all other angles. Manufactured polarizing materials, such as Polaroid, which was first produced in 1932 by Dr. Edwin Land and gave name to a corporation, have replaced the naturally-occurring Iceland spar crystals.

In photography, rotating polarizing filters are used to polarize light before it passes through the camera lens. Usually gray-brown in color, they are used to eliminate reflections from smooth, nonmetallic, polished surfaces such as glass, tile, tabletops, and water, which often improves the color saturation. The increase in saturation results from a decrease in surface glare. Since most semi-smooth objects, such as flowers, leaves, rocks, and water, have a surface sheen, they reflect light, thus masking some of the color beneath the sheen. By reducing these reflections, polarizers intensify the colors. They also can make a clear blue sky appear deeper and richer and have more contrast, without altering the overall color balance of the scene.

For cutting through haze, a polarizing filter can be more effective than a haze filter because it reduces more of the scattered blue light and decreases reflections from dust and/or water particles (Figure 4.9). The net effect is to make the scene appear to be more distinct and sharp, while also increasing the sense of visual depth and adding to the vividness of the colors. When copying original art and reproductions from books, or when photographing glossy-surfaced objects, maximum glare control can be obtained by using polarizers in front of the light sources as well as in front of the camera lens. Evaluate each situation before using a polarizer, as there are circumstances where the purposeful inclusion of reflections strengthens the photographer's underlying concept.

Using a Polarizer

When using a polarizing filter, focus first; turn the filter mount until the glare decreases and the colors look richer; then make the exposure. The filter factor, which varies from about 2X to 3X depending on the type of polarizer used, will not be affected by how much the filter is rotated. The amount of the effect is determined by how much polarized light is present in the scene and the viewing angle of the scene. At an angle of about 35 degrees from the surface, the maximum reduction in reflections can be achieved when the polarizer is rotated to the correct position.

A polarizer may also be combined with other filters for special effects. Some polarizers come with color, combining a gray and a single-colored polarizing filter. Any color, from gray to the full color of the other filter, can be achieved by rotating the filter frame ring. There also are multicolored polarizers that combine a single gray polarizing filter and two colored polarizing filters. Rotating the filter frame ring alters the colors.

Linear and Circular Polarizers

There are two types of polarizers used in photography: the traditional linear and the newer circular models. If your camera has a semi-silvered mirror (this includes all current autofocus DSLR and SLR cameras), the linear filter will produce underexposed and out-of-focus pictures. Circular filters work on all DSLR and SLR cameras without producing these undesirable side effects, but are considerably more expensive. A linear model can be used effectively with a semi-silvered mirror camera by: (1) determining the exposure without the filter on the camera; (2) manually setting the exposure to compensate for the filter factor

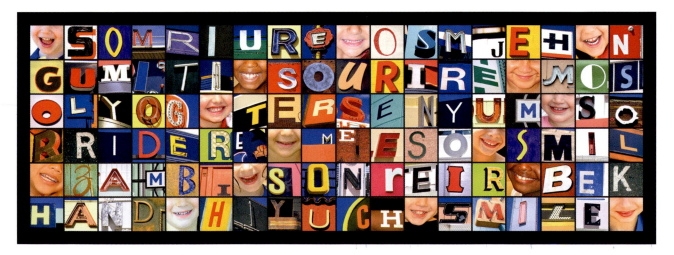

Figure 4.9 Laura Paresky Gould constructed this installation for the Zimmer Children's Museum in Los Angeles by assembling numerous photographs of signs and letters taken around the world. The images were printed as Duratrans and installed in a light box, with a polarizing filter covering certain sections. A second polarizing filter, placed slightly away from the work, functions as an interactive device, inviting viewers to manually highlight parts of the image. The resulting image spells out "OUR SMILE" and incorporates several images of smiling children.

© Laura Paresky Gould. *SMILE*, 2009. 30½ × 92 inches. Duratrans. Courtesy of Zimmer Children's Museum, Los Angeles, CA.

(to give more exposure) before attaching the filter to the front of the camera's lens; or (3) manually focusing the camera. Do not rely on the autofocus.

Ultraviolet Light Filters

Ultraviolet, haze, and skylight filters are commonly used with film cameras because they absorb ultraviolet (UV) radiation and have no filter factor. With the absorption of UV radiation, the effects of scattered light that adversely affects a film's color dyes (often giving a blue cast) are reduced, thus producing a more accurate and natural rendition. Typically, a UV filter is effective with landscapes, especially scenes of mountains, the seashore, or snow, in which UV radiation is intense. UV filters also can help to ensure optimum quality when shooting copy work, close-ups of plants (Figure 4.10), and objects with bright colors such as porcelain ware. However, UV filters are not effective in reducing the excess amount of blue light in scenes containing shade (81 series should be used). Although UV radiation does not adversely affect digital image sensors, many photographers leave a UV filter on all their lenses to protect the lens surface from dirt, moisture, and scratches.

Special Effects Filters

Special effects filters produce unusual visual effects at the time of exposure (see Box 4.1). These same effects can be replicated,

post-exposure, with imaging software, especially with after-market plugins (see Digital Filters and Plugins section below). Such plugins simulate popular camera filters, specialized lenses, optical lab processes, film grain, exacting color correction, as well as natural and infrared light, and photographic effects—all in a controlled digital environment. Be sure to exercise care and thought before using any special effects filters, however, for they have been chronically overused by imagemakers who lack genuine picture-making ideas. Most images made with such effects are clichéd and entirely predictable.

Homemade Colored and Diffusion Filters

You can express your ingenuity by making your own filters for artistic purposes that are unobtainable with manufactured materials and software. Homemade filters may not match the quality of commercially manufactured filters or software, but they can produce unique results that otherwise would not be possible. A universal filter holder, attached in front of the lens, permits experimentation with a variety of materials and can also hold gelatin squares of commercial filters.

All you need to make a filter is some type of transparent material. Colored cellophane and theatrical gels provide simple and affordable starting places. Marking clear acetate with color felt-tipped pens is an excellent way for producing pastel-like colors. Photographing a light-colored subject against a bright background can heighten the pastel effect. There are endless possibilities, including making split-field filters with numerous color combinations.

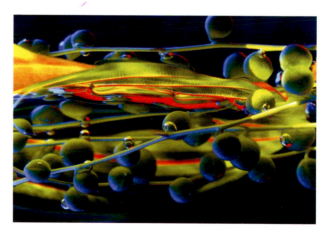

Figure 4.10 Martin Kruck affixes a custom-made, sandblasted UV filter to his digital camera and alters the camera's settings to increase saturation and decrease sharpness. These effects allow the artist to create images that blur specific elements and instead focus on color, light, and atmosphere. Kruck elaborates, "While the subject of some of the images may be discernible, either immediately or through investigative looking, it is not my intention to further define the scenes or their significance, be it cultural, historical, or emotional, through titles. From a global perspective, titling the series 'India' as opposed to, say, Spain or Thailand (which would yield different imagery) is, I believe, signifier enough without relying on specialized knowledge from the viewer to construct meaning."

© Martin Kruck. *Untitled (#2)*, from *The India Pictures*, 2010. 30 × 20 inches. Inkjet print.

Figure 4.11 Roger Camp tells us, "My work in color grew out of my beginnings as a poet who was writing imagist poem, but wanted to deal with color in a more tangible form than that expressed in words … I was influenced by Steichen's *Heavy Roses* into using dead and dying flowers as subject matter … to escape the bounds of the traditional still-life I made the transition from a vase to a bowl to an aquarium in which to float flowers in order to free them from the frozen specimen-looking appearance so many still-lifes possess. Water has many properties of its own, one of which is that it picks up colors that are in proximity to it. I discovered stained glass would act as a filter, transferring its color to the surface of the water as well as to the flowers themselves."

© Roger Camp. *Water Music #24*, 1995. 16 × 20 inches. Dye-destruction print.

Box 4.1 **Special Effects Filters**

▪ Center spot: Diffuses the entire area except the center.

▪ Changeable color: Used in combination with a polarizing filter. Rotating the filter changes the color, from one primary, through the midtones, to a different primary color. Available in yellow to red, yellow to green, green to red, blue to yellow, and red to blue.

▪ Close-up: Fitted with a normal lens to permit you to focus closer than the minimum distance the lens was designed to accommodate.

▪ Color spot: A defined center portion of filter is clear with the surrounding area colored.

▪ Color vignette: A clear center portion of filter shades off into colored edges.

▪ Cross screen: Exaggerates highlights into star shapes.

▪ Diffraction: Takes strong highlights and splits them into spectral color beams.

▪ Diffusion: Softens and mutes the image and color. Available in a variety of strengths that provide different degrees of the effect.

▪ Double exposure: Masks half the frame at a time.

▪ Dual color: Each half of the frame receives a different color cast.

▪ Fog: Delivers a soft glow in highlight areas while lowering contrast and sharpness. Available in several strengths. Effect varies depending on aperture of the lens; stopping down reduces the effect.

▪ Framing: Masks the frame to form a black or colored shape.

▪ Graduated: Half the filter is colored and the other half is clear. The colored portion fades to colorless toward the center line of the filter.

▪ Prism/multi-image: Repeats and overlaps the image within the frame.

▪ Prism/colored: Makes multiple images with spectrum-colored casts.

▪ Split field: Allows differential focus within the frame.

▪ Tricolor: Filter has three sections—red, green, and blue—in a single filter element.

▪ Underwater: Removes the cyan cast that appears at a depth of 10 feet or more.

▪ Variable/Multitask: Combines neutral density, polarizing, and warming filters that are controlled by two rotating rings.

Note: Filter kits that utilize a universal holder and gelatin squares provide an economical way to work with a variety of filters.

See Filter Manufacturers at the end of this chapter for website addresses.

Box 4.2 **Homemade Filters**

▪ Cellophane: Crumple up a piece of cellophane, and then smooth it out and attach the cellophane to the front of your lens with a rubber band.

▪ Matte spray: On an unwanted clear filter or a plain piece of Plexiglas or glass, apply a fine mist of spray matte material.

▪ Nail polish: Brush some clear nail polish on a piece of clear glass or an unwanted UV filter. Allow it to dry and it's ready to use. Painting different patterns and/or using a stipple effect will deliver a variety of possibilities. Nail polish remover can be used for cleanup.

▪ Petroleum jelly: Carefully apply the petroleum jelly to a clear piece of glass or a UV filter with your finger, lint-free towel, or a brush. Remove any that overflows onto the sides or the back of the support so it won't get on your lens. The direction of application and the thickness of the jelly will determine the amount of diffusion. Cleanup is done with soap and warm water.

▪ Stockings: Stretch a piece of fine-meshed nylon stocking over the front of the lens and attach it with a rubber band. Use a beige or gray color unless you want the color of the stocking to influence the color balance of the final image. White stockings scatter a greater amount of light and thus considerably reduce the overall contrast of the scene.

▪ Transparent tape: Apply a crisscross pattern of transparent tape on a UV filter. The amount of diffusion is influenced by the width and thickness of the tape.

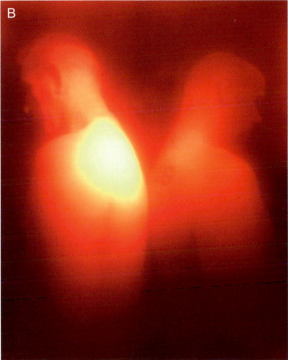

Figure 4.12 Wayne Martin Belger constructs handmade cameras for specific purposes, considering these objects to be composed of "relics designed to be the sacred bridge of a communion offering between myself and the subject." "Untouchable" (B) is a handmade 4 × 5-inch pinhole camera that uses HIV-positive blood as a red filter and is designed to photograph HIV sufferers. Belger explains that "with pinhole photography, the same air that touches my subject can pass through the pinhole and touch the photo emulsion on the film. There's no barrier between the two … With pinhole what you get is an unmanipulated true representation of a segment of light and time, a pure reflection of what is at that moment."

© Wayne Martin Belger. *Bloodworks 6*, 2008. 36 × 30 inches. Inkjet print.
© Wayne Martin Belger. *Untouchable*, 2006. 24 × 60 × 24 inches.
Aluminum, copper, titanium, acrylic, HIV-positive blood.

Photographing through transparent objects, such as stained glass or water, is another way to transfer color and pattern to a subject.

Homemade diffusion filters can be made from any transparent material, with each creating its own unique way of scattering the light and producing a different visual effect. Test some of the methods in Box 4.2 to see what suits your needs.

Digital Filters and Plugins

Imaging software programs have an abundance of digital filters that may be applied after image capture to mimic traditional photographic filters and/or to correct, distort, enhance, or manipulate all or any part of an image. The best way to see what each filter can do is to open an image with your imaging software, and work down through the Filter menu. Some filters provide a pop-up dialog box that will allow you to see the default action, while others require the use of sliders to see the various effects. Most have a preview window that shows the filter's effect on the image. The most commonly used filters for general photographic image-processing are sharpening and noise reduction. For instance, Gaussian Blur is widely applied to reduce pixilation, image noise, and detail by softening a selected area or an entire image. It operates by smoothing the transitional areas between pixels through averaging the pixels next to the hard edges of defined lines and shaded areas in an image. Lens Blur can manage the widespread problem of too much depth of field by adding a controllable amount of blur to an image so that some areas in the scene remain sharply in focus while others appear to be out of focus.

A third-party filter, known as a plugin, is a program designed to be integrated into another software application, such as Aperture, Lightroom, or Photoshop, and provide additional functionality that is not available in the original application. A plugin can take many different forms: filters, image-processing, file formats, text, automation, and more, with the most common being special effects. The special effect can be as simple as shifting a pixel to the right or as complex as altering the direction of light and shadow in an image. Optical filter manufacturers, such as Tiffin, offer filters for compositing and editing, including options for creating your own filters and effects such as multiple layering, masking, and color-management. Other companies supply selective focus, including tilt/shift, and vignetting options. Smartphones, such as iPhone, offer numerous downloadable applications consisting of filters, textures, and image adjustment tools. Thousands of digital filters and plugins are available and can be viewed online. Many websites offer free, downloadable demonstration trials. Once installed, these filters and plugins usually appear at the bottom of the Filter menu.

Applying a filter or plugin to a mediocre picture and converting it into something that looks like a Georges-Pierre Seurat pointillist painting will not make it a better picture. These tools should be applied thoughtfully, to avoid making overbearing, hackneyed pictures. The use of filters and plugins has the potential to descend into seductive side trips that waste time and steer you away from your vision. Bear in mind such sayings as "You can't make a silk purse out of a sow's ear" and the more

contemporary "Garbage in, garbage out," and be sure you begin with an appropriate and visually articulate image before experimenting. Think of filters and plugins as tools capable of reinforcing well-seen images, and not as lifesavers for trite pictures.

For further information, see Roger Pring's *Photoshop Filter Effects Encyclopedia: The Hands-On Desktop Reference for Digital Photographers* (Sebastopol, CA: O'Reilly Media, 2005).

Fluorescent and Other Gas-Filled Lights

A fluorescent light source consists of a gas discharge tube in which the discharge radiation causes a phosphor coating on the inside of the tube to fluoresce. Although such light may appear to look similar to light from that of other artificial sources, it is not. Fluorescent light possesses both a discontinuous and unbalanced spectrum. The type of gas and phosphor used affects the color of the light, which has peak outputs in the green and blue regions of the spectrum, valleys or deficiencies in red, and gaps of other wavelengths. Light intensity varies as the gas moves in the tube. This makes fluorescent light a discontinuous source, lacking the full range of wavelengths that are present in the visible spectrum. For this reason, it is generally unsuitable for naturalistic color photography. However, there are "full-spectrum" fluorescent lamps with a high CRI (Color Rendition Index) that have color temperatures of about 5000 K to 6000 K.

If you photograph with improper white balance or use a daylight film under fluorescent light, the resulting image will have a green cast. This generally is not attractive, especially if you are making portraits. Unless green-skinned people are what you have in mind, corrective action is required.

When working digitally, start by using the fluorescent White Balance setting. If you are not satisfied with the results, try experimenting with different white balance settings and features. Should problems continue, consider the following corrective actions:

1. Use a shutter speed of 1/60 of a second or slower to minimize the flickering effect of the fluorescent lamp.
2. Replace the standard fluorescent lights with tungsten lights or with "full-spectrum" fluorescent lamps.
3. Place corrective plastic filters over the tubes to bring the color temperature closer to daylight.
4. Use fill flash to help to offset the green cast.
5. Correct using post-capture imaging software.

When using film, several unnumbered filters are available to make general adjustments for the excessive blue-green cast of fluorescent lights. With daylight film, two basic fluorescent filters will deliver good starting results: Use an FL–D filter under daylight-type fluorescent lamps and an FL–W filter with warm white or white-type fluorescent lamps. With Type B tungsten film, use an FL–B filter. For more accurate results, it is necessary to experiment with a variety of filters (see Table 4.6).

The following are possible corrective actions that can be taken:

1. Match film to tubes. The light of certain tubes photographs more naturally with specific films. For instance, results under daylight and color-matching tubes look more natural if you use a daylight-type film and filter. Warm white tubes reproduce better with tungsten films and filters.
2. Use Fujicolor that has an additional fourth emulsion. The extra layer responds to blue and green light (which forms a magenta dye image) and generates developer inhibitors that act on the red-sensitive emulsion layers to enhance the reproduction of blue-green colors. With proper printing filtration, people photographed under cool-white fluorescents can have natural-looking skin tones.
3. Shoot a fast daylight negative film rated at ISO 400 or more. This provides two opportunities to make corrections. Once at the time of exposure and again when making the print. Also, the higher speed films have a greater tolerance for this type of light.
4. Make use of a shutter speed of 1/60 of a second or slower to minimize the flickering effect of the fluorescent lamp.
5. Employ an electronic flash as a fill light. This will help to offset some of the green cast and make the scene appear as our brain tells us it should be.
6. Use a fluorescent filter. They are available for both daylight and tungsten films, and can be used with either slide or print film. These generally make a big improvement (Figure 4.13). If critical results are needed, run tests using CC filters to determine the exact filtration. You usually will need magenta or a combination of magenta and blue filters. With daylight film, start with about CC30 magenta and increase filtration as needed.
7. Place plastic corrective filters over the tubes to bring the color temperature closer to daylight.
8. Replace the standard fluorescent lights with tungsten lights or with "full-spectrum" fluorescent lamps.
9. In the darkroom, experiment with the filter pack when making a print from a daylight negative film. Sometimes it is possible to get more naturalistic color with the use of only one filter, usually yellow. To color-correct in printing, it may be necessary to set the magenta filter to zero in order to compensate for the excessive green cast. Results depend on the type of fluorescent tube, film, and enlarger.

TABLE 4.6 FILTERING FOR DISCONTINUOUS LIGHT SOURCES

Lamp type	FILM TYPE		
	Daylight	Tungsten	Type A
Fluorescent bulbs			
Daylight	50R	85B + 30R + 10M	85 + 40R
White	40M	50R + 10M	30R + 10M
Warm white	20B + 20M	40R + 10M	20R + 10M
Warm white deluxe	30C + 30B	10R	No filter needed
Cool white	30M + 10R	60R	50R
Cool white deluxe	10B + 10C	20R + 20Y	20Y + 10R
Unknown	30M	50R	40R
High-intensity discharge lamps			
Lucalox	80B + 20C	30M + 20B	50B + 05M
Multivapor	20R + 20M	60R + 20Y	50R + 10Y
Deluxe white mercury	30R + 30M	70R + 10Y	50R + 10Y
Clear mercury	70R	90R + 40Y	90R + 40Y

Note: These recommendations are general and should be used only as starting points. For critical applications, testing is necessary, as filter effect will vary from one type of film to another.

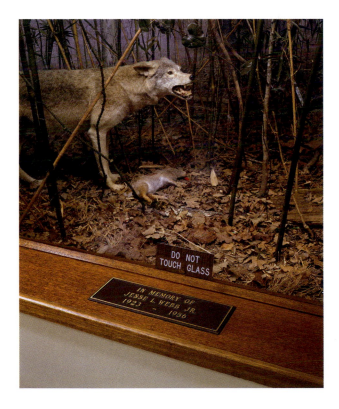

Figure 4.13 Concerns with exposing the myth of the document led Ron Jude to deal with the absurd placement of animals and objects in natural history museums. He aims to create "an awareness of the straight photograph's value not as a reliable formal document, but as a visual catalyst of thought." Public places, such as the museum that provides the setting for this picture, are often lit by fluorescent lights that can be difficult to color-correct. Jude used an FLD filter at the time of exposure. He states, "The flat lighting, along with a slight underdevelopment of the daylight transparency film, produced an acceptable level of contrast in the dye-destruction print. I find it best to somewhat compromise the quality of the transparency in order to avoid the usually harsh contrast of dye-destruction print."

© Ron Jude. *LSU Natural History Museum*, 1990. 6¼ × 8 inches. Dye-destruction print. Courtesy of Gallery Luisotti, Santa Monica, CA.

High-Intensity Discharge Lamps/Mercury and Sodium Vapor Sources

High-intensity discharge lamps, such as those mercury vapor lights that are rated at about 4100 K to 4500 K and sodium vapor at proximity 2100 K to 2500 K, fit into the category of gas-filled lights. These bright lamps are generally used to light industrial and public spaces. They are extremely deficient in many of the wavelengths that make up white light, especially red, making them difficult to impossible to correct (see Table 4.6). Try experimenting with different white balance settings and features, but the situation may require extreme amounts of additional filtration in front of the lens.

Testing for a Critical Neutral Color Match

Achieving a neutral color match with any discontinuous light source requires testing with heavy filtration. Shoot a test roll of transparency film, bracketing in 1/3 f-stops, with and without selected correction filters of the subject, under the expected lighting conditions (this method can be used in any situation requiring critical color balance). Use a color temperature meter or see Table 4.5 for suggested starting filters. Keep a record of each frame's exposure and filtration. Process and examine unmounted film on a correctly balanced 5000 K light box. Placing filters over the processed film lets you determine what effect those filters will have if you reshoot with film from the same emulsion batch (the number is printed on the side of the film box).

When using a digital camera, be sure it is set to the desired white balance.

Using the Color Reference Guide

Place the color reference guide next to the transparency on the light box. Look at the grayscale first, which will make it easier to see which color is in excess. For example, if the grayscale has a slight blue cast, add a slight yellow filter (05Y) over the transparency. Scan rapidly back and forth between the color reference guide and the image to see if it looks correct. If it does, then a 05C filter should be used to achieve a neutral color balance with the same film emulsion batch and processing chemicals. This same procedure can be used with negative film, bracketing in 1/2 f-stops and producing test prints to be compared with the color reference guide.

Problem Solving

Photograph a subject under fluorescent light with no color-correction. Next, under the same fluorescent conditions, try one or more of the suggested corrective actions. Compare the two. Which do you favor? Why? Photograph a subject under natural and "unnatural" lighting conditions. Evaluate how the unusual colors affect your emotional and intellectual response. Which elicits a stronger response? Why?

Why a Color May Not Reproduce Correctly

Camera image sensors and the dye layers of color film are designed to replicate what their designers believe is an agreeable rendering for most subjects in a variety of situations. Since the sensors and films are not sensitive to colors in precisely the same way as the human eye, there can be times when it is impossible to recreate a specific color. Sensor and film designers concentrate on trying to successfully reproduce flesh tones, neutrals (whites, grays, and blacks), and common "memory" colors such as sky blue and grass green under a variety of imagemaking situations. As a result, other colors, such as yellow and orange, often do not reproduce as well. Also, the ability to properly match the input to the output source—transparency, print, or screen—plays a major role in determining how accurately colors reproduce (see Chapter 11, Digital Output).

Regarding film, there can be times when it is impossible to recreate a specific color, even when the film has been properly manufactured, stored, exposed, and processed. For example, color film is sensitive to ultraviolet radiation. A fabric that reflects ultraviolet energy appears bluer in a color photograph than it does to the human eye. This is why a neutral garment, such as a black tuxedo made of synthetic material, may appear blue in a color print. Using an UV filter can reduce this effect.

Other fabrics absorb ultraviolet radiation and re-emit it in the blue portion of the visible spectrum. Since the human eye is not particularly sensitive to the shortest (blue) wavelengths of the spectrum, this effect, known as ultraviolet fluorescence, often is not noticed until viewing a color print. White fabrics that have had brighteners added during manufacture or laundering to give a whiter appearance, such as those used in wedding dresses, are the most likely to appear with a blue cast in a color photograph. Unfortunately, a filter over the lens will not correct the problem entirely. Instead, an ultraviolet absorber, such as a Kodak Wratten Filter No. 2B, is needed over the light source of an electronic flash for accurate correction.

Another troublespot is anomalous reflectance, which results from high reflectance at the far-red and infrared end of the spectrum, where the human eye has almost no sensitivity. This is commonly observed in color photographs of certain flowers, such as blue morning glories and gentians, which reproduce unnaturally because color films are more sensitive to the far-red portion of the spectrum than is the human eye.

Also, some organic dyes used to color fabrics, especially synthetic materials, often have high reflectance in the far-red portion of the spectrum. The effect is most frequent in medium- to dark-green fabrics, which may reproduce as neutrals or warm colors. There is no effective correction.

Color Crossover

A color crossover occurs when the highlight and shadow areas of a scene are of different color balances. This condition is almost impossible to correct without digital or physical retouching. Crossovers occur under the following situations: using an incorrect white balance; mismatch of the film and light source; longer or shorter exposure times than the film was designed for; improper film storage; and/or outdated film. While often unwanted, color crossovers can produce unexpected visual excitement by creating an unreal color palette.

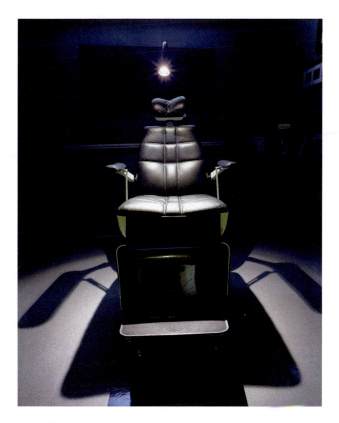

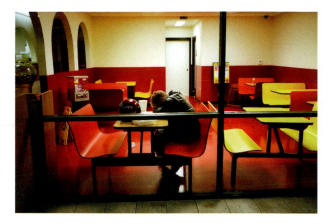

Figure 4.15 Christian Widmer made this photograph with a 35mm camera and Fuji Superia 400 film. He advocates taking photographic chances and being in a constant state of looking at one's surroundings. Following his own advice, along with having "a roving eye, a quick-draw of the camera, and a steady hand" allowed him to capture this fleeting moment in the flow of daily events.

Figure 4.14 Photographing under unusually bright artificial light like those in high-end plastic surgeons' offices often causes colors not to reproduce correctly. Instead of using filters, Cara Phillips scans her 4 × 5-inch negatives and performs slight color corrections to compensate for any color shifts caused by the lights. In this series, the artist comments on the continually expanding cosmetic surgery industry, capturing the emotional impact of these sites on "those who sought their salvation in these chairs, beds, machines, and tools."

© Cara Phillips. *Brown Consultation Chair, Beverly Hills*, 2007. 30 × 37½ inches. Chromogenic color print.

Box 4.3 **Filter Manufacturers**

- B+W Filters—www.schneideroptics.com
- Calumet Photographic—www.calumetphoto.com
- Cokin—www.cokin.fr
- Heliopan—www.hpmarketingcorp.com
- Hoya—www.hoyafilter.com
- Kenko—www.thkphoto.com
- Singh-Ray—www.singh-ray.com
- Tiffen—www.tiffen.com

Taking Chances

Do not be afraid to make pictures even if your white balance or film does not match the color temperature of the light. Sometimes you can get an evocative color mood piece when this mismatch occurs. Often the combination of different light sources enlivens and creates surprise in your picture (Figure 4.15). When in doubt, make it and see what it looks like. At worst, you will learn what does not work for you. At best, you may have interacted with the unexpected and come away from the situation with something artist Jean Cocteau would have referred to as astonishing. Being a photographer means making pictures. So go ahead, take lots of them! Today's exposures will serve you twice, as a springboard for both current work and future ideas. "Art is about taking chances. Danger and chaos—those are the real muses an artist must court," said Robert Rauschenberg. Be a visual explorer and see what you can discover.

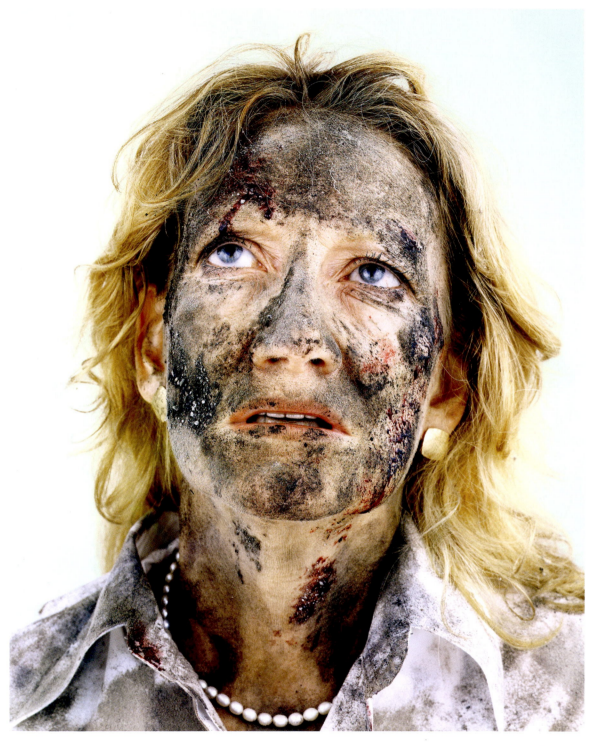

In his *Survivor* series, Liu Zheng presents viewers with portraits of traumatized people, creating images that echo reactions to the 9/11 World Trade Center attack. Covered in residue and blood, the tightly composed faces gaze fixedly not at the viewer, but rather at some imagined horrific event just beyond the borders of the frame. Having previously worked in a largely Chinese context, here Liu viscerally addresses real and fictional occurrences and states of mind regarding personal safety in an age of global terrorism.

© Liu Zheng. *Survivor No.6*, 2004. Variable dimensions. Chromogenic color print. Courtesy of the artist and Pékin Fine Arts, Beijing, China.

Seeing the Light

How We See

Seeing is an act of perception that helps us to experience, learn, ascertain, and understand our world. An individual skill that is conditioned by our physical anatomy, culture, and education, seeing develops with exercise.

Our Western industrialized society is dependent on literacy to function. To be fully literate means that, just as it is necessary to learn to decipher messages that have been put into a written code or language, we must be able to interpret the coded information of pictorial language.

Visual Literacy

When dealing with pictures, we use an evolving set of skills that differs from those used for reading and writing. Visual literacy is based on the quality and quantity of our stored information. Yet sometimes we are reluctant to learn to read new images. We often tend to accept the old familiar ways and reject anything that is different or unusual. By overcoming this dread of the new, we can begin to observe and think for ourselves, and learning can become a joyful, invigorating, mind-expanding experience. This open mindset adds to our storehouse of information that can

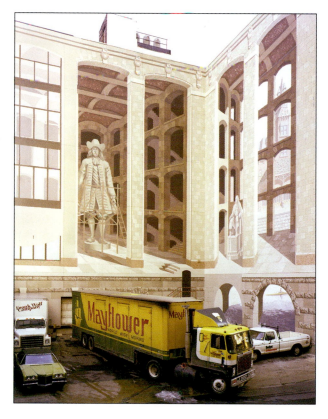

Figure 5.1 Judith Golden manually constructed this montage to question how the viewer sees a photograph. Borrowing from her own body of work, the artist assembled 2-inch square segments of digital and film photographs, finally joining them with paint, gold and silver leaf, and wax into a single composite image. Golden cites "memory, time, and the essence of inner and outer travels" as motivations for this work.

© Judith Golden. *Memory Mosaic #2*, 2002–2006. 20 × 16 inches. Inkjet and chromogenic color prints with mixed media.

Figure 5.2 Looking at a photograph is not like looking out a window. Learning to read and interpret pictures requires using a system of thought processes to reach a decision. It is not a mysterious, innate gift, but rather a method involving visual language that can be taught and mastered to stimulate thought and action.

© David Graham. *Mayflower, Philadelphia, PA*, 1984. 24 × 20 inches. Chromogenic color print.

be called upon when dealing with new situations, thereby increasing our range of responses.

Regardless of the means of communication, understanding occurs only when the receiver knows the code. In the past, pictures commonly showed people something of established cultural importance. Traditionally, picture-making has been used as a means of identifying and classifying (typology) subject matter, a role that many photographers are content in playing. However, problems can arise when something unexpected appears and we have no data or mechanism to deal with it. What is not familiar tends to make us uneasy. Often this discomfort manifests itself in the form of rejection, not only of the work but of the new ideas it represents as well. We need to be conscious that looking at a picture is not the same as looking out a window. Rather, "reading" a picture requires informed analysis that leads to thoughtful decision making, a process that can be successfully taught and learned.

Societal Values

Once formal education begins, Western society greatly reduces the value it places on learning the visual language. Without these skills, individuals may not be aware of a picture maker's function within society as someone who can perceive, interpret, and communicate a more complex understanding of reality. Yet these same people embrace the commercial products that these imaginative explorations can bring forth. We do not make fun of the scientist in the laboratory, even if we do not understand what the scientist is doing, because society recognizes the value of the scientific activities. A major difference between art and science is that art offers an intuitive approach to explain reality while science provides an exact, objective, rational set of repeatable measurements. Art believes there are many correct answers; science seeks a single explanation. The splendor of contemporary art, and thus contribution of the artist-citizen to a democratic society, is that the act of discovery can lead to a diversity of thought. This in turn can generate new forms of communication such as the graphic novel, which relies on the interplay between pictures and words.

Visual Illiteracy

Western cultural values reflect an Aristotelian, scientific mode of thought; achievements have to be measured in words and numbers. Our educational system stresses the teaching of the 26 symbols of our alphabet and the numerals 0 through 9.

This criterion meets the basic requirements of industrial nations, but fails to offer a pathway for information analysis. Education should be a process, and not just a product. Unfortunately, the educational system tends to ignore visual literacy, leaving many without the necessary skills to understand the messages that bombard us in our media-saturated environment. When we are not able to accurately question, analyze, and decipher visual data we become removed from a decision making process.

Insightful picture makers are active participants in this determination method. Imagemaking offers opportunities to interact and comment on societal issues. The photographic process

can make life deeper, more diverse, and meaningful, stimulating others to thought and action. This is worth something, even if it cannot always be measured in monetary terms.

Seeing is a personal endeavor, and its results depend on each viewer's ability to decode the messages that are received in a symbolic form. A broad, flexible response helps audiences to understand that our culture determines the hierarchy of subject matter. Keeping an unrestricted mindset enables us to explore a multitude of levels and possibilities of new materials and to view the familiar anew.

The Photographer as a Reconnoiterer

Pursuing the role of the picture maker as the "reconnoiterer," journeying out in front of the main body, making observations of unknown territory and reporting back the findings to the group, requires a mastery of the basic ingredients of imagemaking. Understanding essential design elements (see Chapter 6) and how light affects a subject is crucial in learning how to look at and make pictures.

Becoming visually literate is one step we can take in accepting responsibility for affirming our own aesthetic and ethical ideals. Such small individual actions can have widespread effects. Once people are visually educated, they become more aware of their surroundings and are able to see and better evaluate the world for themselves. Then, they can participate more fully in making decisions that affect the manner in which the business of society is conducted.

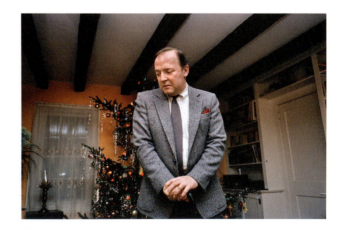

Figure 5.3 Doug DuBois has photographed his family for over 25 years, capturing them in various states of growth, togetherness, and separation. He concentrates on individual and group portraits of his immediate family members, preferring to convey their emotional states over the course of much time and many changes. He tells us, "While I don't appear in any of the photographs, my presence is held in the gaze of my family whenever they stare out at the camera. The repertoire of gestures, settings, and poses reveals my hand as the photographer, and our emotional engagement speaks of a life together and my particular history with each."

© Doug DuBois. *My Father, Christmas Eve, Far Hills, NJ*, from the book *All the Days and Nights*, 1985. Variable dimensions. Chromogenic color print. Courtesy of Higher Pictures, New York, NY.

Visual or Haptic—Which Are You?

Have you ever wondered how and why photographers make pictures in a specific style or why viewers react more strongly to certain pictures? This section presents some ideas on this subject to spur your thinking so that you may draw your own conclusions and apply them to your picture-making activities.

The Work of Victor Lowenfeld

In 1939, while working with people who were partially blind, Victor Lowenfeld did the initial work of discovering some of the ways that we acquaint ourselves with our environment. He found that when they worked with modeling clay some of these people used their limited eyesight to examine objects, while others relied on their sense of touch. These observations led Lowenfeld to conduct a study of people with normal vision. He learned that fully sighted people have the same tendencies: Some favor their sense of sight, others their sense of touch.

Lowenfeld determined that the first group took an intellectual, literal, realistic, quantitative approach to things. He called this group "visual." The second group functioned in an intuitive, qualitative, expressionistic-subjective mode. He labeled these people "haptic." Lowenfeld then set out to determine the major characteristics of each of these two creative types. In actuality, individuals are rarely one or the other; rather they are a combination of both with a tendency to favor one approach more than the other.

Visual-Realist Photographers

Lowenfeld found that "visuals" tend to produce whole representational images. They are concerned with "correct" colors, measurements, and proportion. The visual-realist likes to become acquainted with the environment primarily through the eyes, leaving the other senses to play a secondary role.

Generally, visual photographers prefer to preserve the illusion of the world: A concrete, unobtrusive, objective mirror of the "actual" world. They tend to be observers/spectators who use the camera in its time-honored fashion as a recording device that acts as a witness to an event, favoring facts over abstract form. The subject is always supreme. The documentary mode is their most obvious style. Visual-realists usually preserve spatial continuity and favor a normal focal length lens, photographing from eye level and avoiding extreme angles. Their style is open, subtle, or informal, leaning towards the unobtrusive, and building on the familiar.

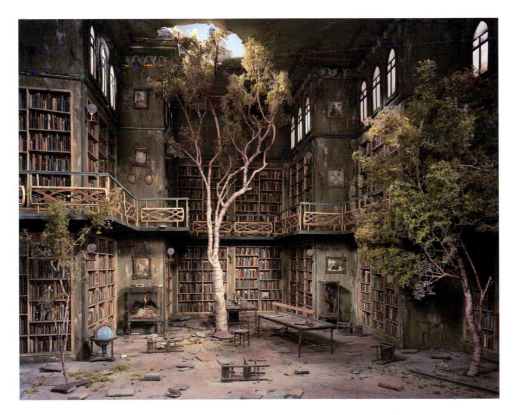

Figure 5.4 Lori Nix challenges the tradition of photography as evidence by constructing images from her imagination. She uses simple materials to hand build her elaborate sets, which she transforms into a surreal space through the photographic process. She explains that in this work, "scale, perspective, and the document of the photograph create a tension between the material reality of the scene and the impossibility of the depicted narrative. In this space, between evidence and plot, the imagination of the viewer is unlocked, engaged, and provoked."

© Lori Nix. *Library*, October 8, 2007. 48 × 60 inches. Chromogenic color print. Courtesy of ClampArt Gallery, New York, NY.

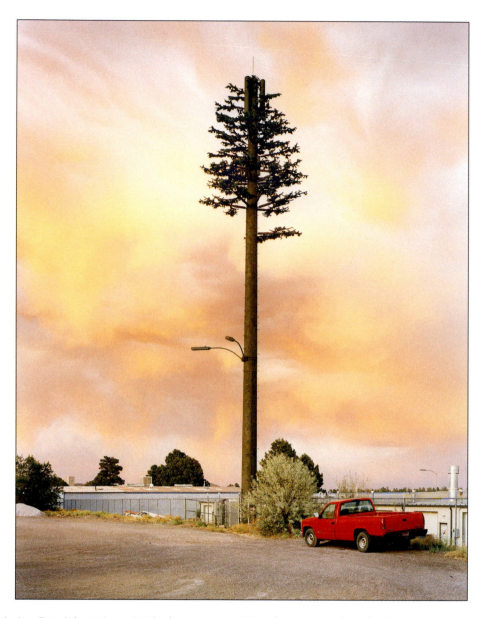

Figure 5.5 In his series *New Trees*, Robert Voit examines the documentary possibilities of photography with an 8 × 10-inch camera to catalog the numerous cellular telephone poles that have been disguised as artificial trees throughout the United States. These hybrids of nature and technology "appear in the landscape as idealized forms of vegetation … Classified thus as unique objects, formally these fake trees take on an absurd dynamism which creates a need for natural artificiality. The tree, a traditional carrier of meaning, mutates into a gross foil for longing."

© Robert Voit. *Industrial Drive, Flagstaff, AZ*, from the series *New Trees*, 2006. Variable dimensions. Chromogenic color print. Courtesy of Amador Gallery, New York, NY, and Walter Storms Gallery, Munich, Germany.

Visual-Realist Working Methods

The code of the visual-realist is one of linear reality, resulting in pictures that reflect concrete themes and often tell a story or present detailed visual descriptions. The visual-realist uses the "straight" technique and enjoys presenting a wealth of detail, often in the form of large prints. Straight photography is the most widely accepted and collected form of practice.

In this practice, the picture is usually created at the moment the shutter is released. Post-exposure work is not flaunted.

There are no apparent displays of technical prowess; rather, such expertise is concealed within the work. Visual-realists may not carry out their own post-capture work, such as processing or printing, believing their energy should be put into witnessing the world. They use photography to match reality, enabling us to see people, places, and things that we are not able to experience for ourselves. Often their work delivers factual information and points out things that are indicative of our society or in need of change.

Figure 5.6 Thomas McGovern relied solely on sunlight in documenting this scene of a retro California tire shop. Getting into the site proved to be a challenge, but bringing into play the "photographer's special license," the artist gained access by navigating the yard's roaming pit bulls and speaking with the shop's owners. McGovern's visual project looks at the hand-painted signs and murals present throughout Southern California, documenting sites "where immigrants and established locals alike set up shop and try to provide for themselves and their communities … Advertising is an age-old tradition and as these pictures attest, if all you have is a brush and some paint, you make the most of it."

© Thomas McGovern. *Old School Tire Shop, Highland Avenue, San Bernardino*, from the series *Vital Signs*, 2008. 19 × 19 inches. Chromogenic color print.

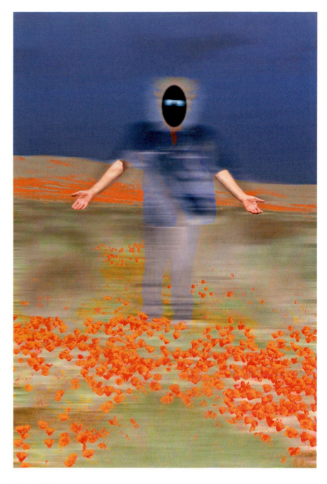

Figure 5.7 Ellen Jantzen digitally manipulated this image to examine the layers and masks of reality and surreality emanating from her subject. She elaborates, "I set about using a mask in conjunction with 'real' substances, objects, and environments. I first determined what objects and environments provided the greatest opportunity for creating a hidden view of the world, then I set about to strengthen these elements by capturing my staged setups as digital photographs … My choices along the way determine a level of absence that I then hope the viewer will experience based on their particular emotional makeup."

© Ellen Jantzen. *Emanation*, from the series *Masking Reality*, 2008. 36 × 24 inches. Inkjet print.

Haptic-Expressionist Photographers

Haptic, which means "laying hold of," comes from the Greek word *haptos*. "Haptics" are concerned with their bodily sensations and subjective experiences, and therefore are more kinesthetic (hands-on) learners than the visuals. The haptic becomes part of the picture, using the color and form of objects to express emotional and subjective values rather than relying on external description.

Haptic-expressionist photographers do not accept the world as a "given" and therefore often alter, exaggerate, and reinvent a subject for emotional effect. They actively participate in the photographic process and become integrated into the picture. The haptics, explorers of the inner self, try to liberate their internal vision rather than reproduce an image of the outer world. They are concerned with a subjective, highly personalized type of vision. Their unorthodox approach, which often incorporates private symbols dealing with psychological and spiritual issues, can require more active viewer interpretation.

Haptic-Expressionist Working Methods

The "haptics" break with tradition and ritual, often giving prominence to the unfamiliar. Their emphasis is on form that stresses the essential, rather than physical, nature of the subject. Haptic-expressionists use the camera to actively comment on the subject at hand. Haptics decide color, contrast, and tonal range based on how they feel about the subject as opposed to replicating outer reality. They manipulate the image, if this will heighten the response. They move and rearrange the given reality to suit their needs, often creating their own mini-universe in the process. Haptics saturate their images with visual clues and information, fragmenting real space, and directing viewers around a tightly controlled composition.

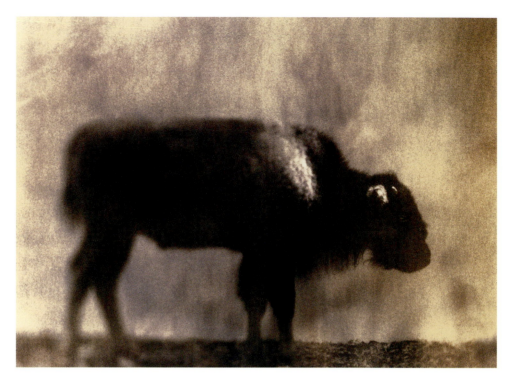

Figure 5.8 In his series *Animalis*, Thomas Brummett examines the role of the handmade in photography. His images begin as black-and-white prints, which he then manipulates by hand in the darkroom to bring out particular aspects of the film and print grain. He tells us, "Over the years it's become a kind of private alchemy, but in this case I am not turning straw into gold but silver into a type of new mark. My intent is to show that by manipulating the film grain via bleaches and multiple development baths, brushes, and toners, I can achieve a type of mark that is unique in the history of art. My goal is to link the world of drawing and the world of photography in these images. I want them to be part document, part cave drawing, and part dream."

© Thomas Brummett. *Bison Baby*, from the series *Animalis*, 2009. 38 × 50 inches. Inkjet print. Courtesy of Galerie Karsten Greve, Paris, and Schmidt-Dean Gallery, Philadelphia, PA.

Haptics frequently practice postvisualization, considering image manipulation as an opportunity to carry on visual research. Experimenting with different cameras, materials, and techniques, their digital studio or darkroom are places for contemplation, discovery, and observation.

Photography's Visual Transformation

Photography continues to bring about groundbreaking changes in the arts. Initially, it freed painters and writers from having to describe objects and events, allowing artists to move from outer matching to inner matching. By turning art toward the inner processes of creativity in expression, photography helped lead to the development of abstract art. Now, digital imaging has liberated the photograph from its direct connection to reality, giving photographers the same options as other artists to alter space/time realities.

The rapid changes in photo-based imagemaking make it difficult to stay current with the latest aesthetic trends and techniques. In this sea of flux it can be comforting to cling to what we know, but this attitude can block the path of creativity.

Experimentation in any field is necessary to keep it alive, growing, and expanding. Photographers should conduct experiments in the pursuit of new representational knowledge.

As both a photographer and viewer of photographs, it is important to know that there is no fixed way of perceiving a subject. No interpretation can be absolute, as there are many ways that a subject can be experienced. Strive to photograph your experience of what is mentally and emotionally important, what is actively in your mind, and what you care about during the process of picture-making. When looking at other photographs, especially those previously unknown to you or that you do not understand, attempt to envision the mental process that the photographer used to arrive at the final image. Regardless of approach, the visual photographers are most often concerned with the "what" and the haptics with the "how."

The Process of Rediscovery

Photography offers a rapid sequence of rediscovery. A new picture can alter the way we look at a past picture. You should feel free to use whatever methods are necessary to make your picture work, whether it is chemical or digital, previsualized or

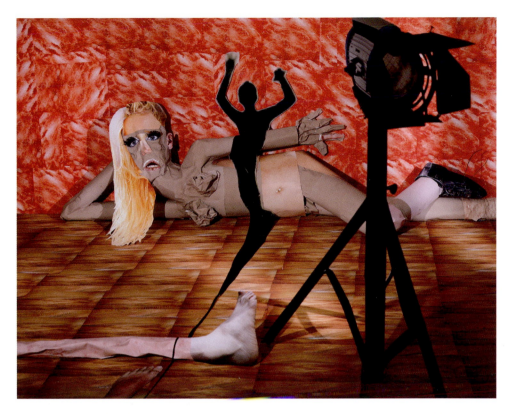

Figure 5.9 To construct this photograph, Daniel Gordon built a three-dimensional collage from images that he found online, "slicing images and joining fragments to create bizarre, whimsical, and sometimes disturbing figures and environments that stimulate both attraction and repulsion." After photographing his constructions, the artist dismantles them and refashions the pieces into new structures. The hybrid "Frankenstein" figures are a deliberate challenge to conventional feminine beauty and traditional subjects of portraiture. With these pictures, Gordon deliberately "misuses" the representational quality of photographic materials.

© Daniel Gordon. *Shadow Portrait*, from the series *Portrait Studio*, 2008. 40 × 50 inches. Chromogenic color print.

postvisualized, a preprocess idea or an in-process discovery. In your work you do not think with your eyes, so give yourself the freedom to question the acceptance of any method of working. Make the digital lab or chemical darkroom a place and a time for exploration, not a situation in which you display your rote-memory abilities. Do not be too inhibited to walk near the edge. Do not let others set your limits. Something unexpected is not something wrong. Enjoy the process of making photographs. Don't turn it into a competition with yourself or others. Randall Jarrell, poet, novelist, and critic, remarked: "A good poet is someone who manages, in a lifetime of standing out in thunderstorms, to be struck by lightning five or six times, a dozen or two dozen times and he is great."

There are major discoveries waiting to be made in photography. Keep your definition of photography broad and wide. If you are able to let your true values and concerns come through, you will be on the course that allows your best capabilities to come forward and be seen. Do not be awed by trendy art fashions, for they are not indicators of awareness, knowledge, or truth. They are simply a way of being "with it." Talking about photography is still nothing more than talk. Words are not pictures. As a picture maker, your goal should be making pictures.

Problem Solving

Determine whether you possess the more general qualities of either the visual or the haptic way of imagemaking. Choose a subject and photograph it in that manner. Next, flip that switch inside your brain and think in the opposite mode. Make a picture of the same subject that reveals these different concerns. Compare the results. What have you learned?

The Color Key and the Composition Key

Color and composition keys offer a guide for understanding how we visually think. They are not hard-and-fast rules for making pictures and should show that there is more than one way to see things. When you learn how others view the world, it is then possible to see more for yourself.

The Color Key

How is the decision reached about which colors to include in a picture? Your color key works as an automatic pilot. It will take over in situations when you do not have time to think.

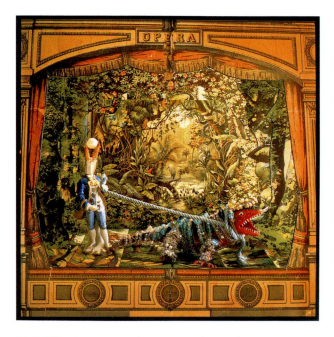

Figure 5.10 The composition key is an internal sense of design the photographer instinctively uses to structure an image. It reveals the photographer's sense of visual order and style. This sense is not fixed, but instead represents an ongoing visual developmental process. Arthur Tress uses his sense of design "to create an image that stimulates viewers' imagination by transforming ordinary objects into a surreal fantasy world."

© Arthur Tress. *Act II: The Voyage … Where They Came Upon Fantastic Creatures and Strange Botanical Species*, from the *Teapot Opera Series*, 1980. 10 × 10 inches. Dye-destruction print. Courtesy of ClampArt Gallery, New York, NY.

Everyone has a built-in key. It cannot be made, but has to be discovered. We each have colors we tend to favor. Notice the colors with which you chose to surround yourself. Observe the colors of your clothes or room because they are a good indication of your prevailing color key.

In the visual arts, your color key often mirrors your inner state of mind. The key is not a constant and may change as your inner state does. At one point it is possible to see dark, moody hues; later, bright, happy, and warm colors are prominent. When the picture is composed, the framing establishes the relationship of the colors to one another, which affects how they are perceived. The colors selected are those that the photographer currently identifies with in a fundamental way. Look at 10 images each by several photographers shooting in color and see if you can identify a pattern of dominant color choices in each photographer's work.

The Composition Key

The composition key is the internal sense of construction and order that is applied when putting the picture parts together. It is a framework that cannot be forced. Our true sense of design and style is a developmental process. It is a rendition of how one configures the world in terms of picture construction. Your internal sense of organization is the key. It is incorporated into the work

and is given back in the final image. Some common compositional keys used for organizing life are the triangle, circle, figure eight, and spiral, along with the H, S, V, and W forms. Russian artist Wassily Kandinsky wrote about being fascinated by the circle in *From Point and Line to Plane* (1926)[1] because it "is a most modest form, but asserts itself unconditionally." It is "simultaneously stable and unstable," "loud and soft," "a single tension that carries countless tensions within," and "is the synthesis of the greatest oppositions."

Recognizing the Keys

Recognizing these keys is a way to make oneself more aware and a better imagemaker. A good photographer can learn to make pictures in less than ideal conditions. The ability to see that there is more than one side to any situation helps make this happen. For example, you could say it is raining and not go out to make a picture, or you could see that it is raining and make this an opportunity to make the diffused, shadowless picture that has been in the back of your mind.

Problem Solving

Identify your personal color and composition keys. Do not expect to find them in every piece. They can be hidden. Everyday habits like clothing choice and doodles may provide clues to these innate keys. If you are having trouble seeing these phenomena, get together with another photographer and see if you can identify each other's keys. What does this tell you about how you configure the world? How can knowing this structure be applied to making better pictures?

Find a body of work by a photographer that you find personally meaningful. Notice the color and compositional devices that this photographer uses in the work. Now, make a photograph in the manner of this photographer. Do not copy or replicate the photographer's work, but take the essential ingredients and employ them to make your own photograph. Next, compare the photograph that you have made with the work of the photographer. Last, compare both photographs with your other work. What similarities and differences in color and composition do you notice? What can you see that you did not notice before making these comparisons? Now return to the same subject and make an image your way. Compare the results with what you previously have done. Has your thinking been altered in any way? Explain.

Figure–Ground Relationships

What Is Figure–Ground?

Figure–ground is the relationship between the subject and the background. It also refers to the positive/negative space relationship within your picture. "Figure," in this case, is the meaningful content of your composition. "Ground" describes the background of the picture.

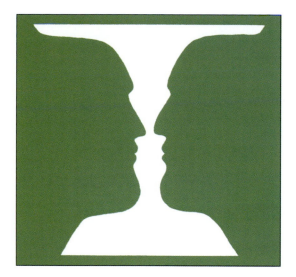

Figure 5.11 An example of the figure–ground relationship phenomenon. What strikes you first? How might this type of ambiguity affect how the viewer might read and respond to an image? What roles do contrast and color play in how you see this image?

Figure 5.12 Janyce Erlich-Moss made this photograph in a Pennsylvania park and then manipulated the image once back in the studio. There, she processed the Polaroid film, prematurely pulling it apart, and then rolling it onto watercolor paper. When the print was dry, she selectively painted with watercolor over the image. Erlich-Moss explains, "In my landscape photography, I try to capture the fleeting emotional experiences of a place: the time, the season, and especially the light … Each image has been selected not only for its visual impact, but also for the spiritual mood that is evoked. I have attempted to convey the sense of tranquility and serenity of my subjective experiences when surrounded by the natural configurations of rocks, streams, flowers, and forests."

© Janyce Erlich-Moss. *Fall Mist*, from the series *Ephemeral Perceptions*, 1993. 4 × 5 inches. Polaroid transfer with hand coloring.

Figure 5.13 Linda Adele Goodine photographed this tableau in New Zealand with the intention of "representing a still-life in one frame, layering foreground, middle ground, and background, to create a relevant historical, social, and cultural document." She further explains, "In the New Zealand images, the objects of observation, the sweeping landscape specific to place, and the middle ground (culture) is the space of action and activity. This is a shifting ground where man manipulates and attempts to control, colonize, and reap. It is that liminal space that suggests narrative and invites my viewers to question and consider the dialectic of wanting development, yet at the same time yearning to preserve the garden. There remains a palpable connection to the myth of the expulsion from Eden, as well as parallels to America's history and its relationship to colonization, exploration, and the concept of the wilderness."

© Linda Adele Goodine. *A Lamb Named Mary*, from the *Gibson Lemon Series*, 2005. 40 × 60 inches. Chromogenic color print.

Figure 5.11 is a classic example of the figure–ground phenomenon. What do you see first? Can you discern a different figure–ground relationship? What do you think most people see first? Why? What does this tell you about the role of contrast?

Why Is Figure–Ground Important?

When the figure and the ground are similar, perception is difficult. The viewer might have difficulty determining what is important to see in the picture. This often occurs when the photographer attempts to show too much. The viewer's eyes wander throughout the scene without coming to a point of attention. The composition lacks a climax, so the viewer loses interest and leaves the image. If the viewer cannot discover what you were trying to reveal, there is a strong chance that your figure–ground relationship is weak.

Figure–Ground Strategies

When you observe a scene, determine exactly what interests you. Visualize how your content (figure) and background (ground) are going to appear in your final photograph. Put together a composition that will let the viewer see the visual relationships that attracted you to the scene. Try varying the lens's focal length and the angles that you approach the subject from to alter the areas of focus. Be selective about what is included in the picture. Find ways to both isolate and connect the key visual elements of the composition. Conduct a test

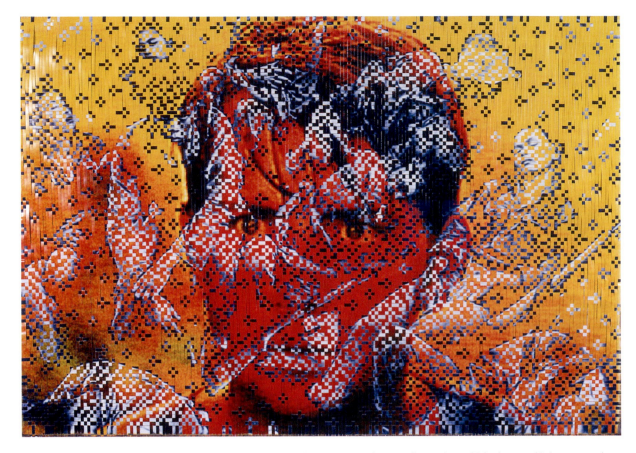

Figure 5.14 Dinh Q. Lê experiments with the figure–ground relationship in his compositions by manually weaving multiple photographic images together. Often incorporating found images, the artist creates work that spans American and Vietnamese culture. Discussing his process of locating source material, Lê says, "Sifting through these old photographs, I was hoping that one day I would find some of ours. Along the way I realized these photographs are in a way my family's photographs. These people also were probably forced to abandon memories of their lives because either they did not survive the war or they had escaped from Vietnam."

© Dinh Q. Lê. *Untitled (Persistence of Memory #11)*, 2000–2001. 46½ × 66⅛ x 3 inches. Chromogenic color prints with linen tape. Courtesy of Shoshana Wayne Gallery, Santa Monica, CA, and Gene Ogami.

with a higher shutter speed and larger lens aperture to lessen the depth of field. Experiment with focus and see what happens when spatial visual clues are reduced. Do not attempt to show "everything." Often, showing less can tell the audience more about the subject because they do not have to sort through visual underbrush. Try limiting the number of colors in a photograph. A color photograph does not have to contain every color in the universe. Keep it simple and to your point. Writer/photographer Wright Morris, commenting about "the problem" with color photography, said: "By including almost everything within our spectrum, the color photograph forces upon it the ultimate banality of 'appearances.' That is why we tire of them so quickly. The first effect is dazzling; the total effect is wearying. … Where everything seems to be of interest, the burden of the photographer is greater, not less. The color photograph not merely says, but often shouts, that everything is of interest. And it is not."[2] Use your abilities to meet the challenge and fulfill the promise that color provides the visual artist. These tools can help you to make images that are more focused in content and design.

Problem Solving

Make two photographs of the same scene/subject. One should show a clearly definable figure–ground relationship of the scene. The other should portray a weak figure–ground relationship. Then compare and contrast the two. Identity the methods used to improve your figure–ground relationship. How can they be applied to further picture-making situations? Now apply what you have learned by making one photograph that shows a simple but intriguing figure–ground relationship and another that creates a successful complex figure–ground relationship.

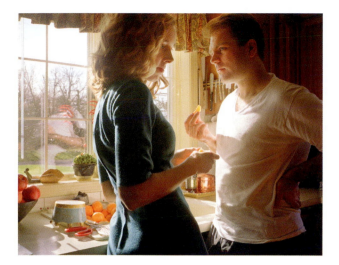

Figure 5.15 Natural light features prominently in Jessica Todd Harper's portrait work, which she makes with a Mamiya 7 on a tripod. She tells us, "I think the most difficult thing about photographing people in their real lives in their homes—and insisting on natural light—is that you have to be patient. The sun is not always out, nor is it always shining into a usable space. On top of that, my subjects are not always in the mood or even available. So in short, what I need a lot of is patience. I pay attention, wait, and then move very quickly when fortune grants me an opportunity."

© Jessica Todd Harper. *Self-Portrait with Christopher (Clementines)*, 2007. 32 × 40 inches. Chromogenic color print.

Natural Light

Light is a paradox, being both permanent and impermanent. Light is ambiguous, for it possesses the qualities of both particles and waves. Light's multi-dimensionalism shows us that as soon as we think we know the characteristics of any subject, the light will change and reveal a previously hidden attribute. Light's physical presence demonstrates that everything is in flux and nothing is as it appears. Light's changeability reveals the complex, multi-layered matrix of life, signifying the many ways a situation may be viewed and understood.

Good Light and the Camera

The definition of "good light" rests solely on the intent of a photographer. Have you ever encountered a scene that you knew should make a good photograph, yet the results were disappointing? There is a strong likelihood that it was photographed at a time of day when the light did not reveal the fundamental aspects of the subject that were important and attracted you to the scene in the first place. Try photographing the scene again at a different time of day or under artificial lighting conditions that may include flash or illumination from a digital device such as an iPhone or computer monitor.

Creative photographers have mastered combining the aesthetics of light with the technology of their equipment to produce the desired outcome. All cameras are merely recording devices that do not give life to a scene or an experience

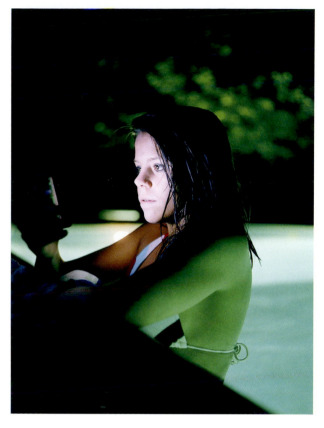

Figure 5.16 Evan Baden controls the illuminated atmosphere in his photographs by utilizing intriguing artificial light sources, such as swimming pool lights and an iPhone. He captured this image with a 4 × 5-inch camera and a 3-second exposure. Interactions between people and technology predominate throughout Baden's work. He states, "In Westernized cultures today, there is a generation that is growing up without the knowledge of what it is to be disconnected … And now, with the Internet, instant messaging, and e-mail in our pocket, right there with our phones, we can always feel as if we are part of a greater whole. These devices grace us with the ability to instantly connect to others, and at the same time, they isolate us from those with whom we are connected … They ordain us with a wealth of knowledge and communication that would have been unbelievable a generation ago. More and more, we are bathed in a silent, soft, and heavenly blue glow. It is as if we carry divinity in our pockets and purses."

© Evan Baden. *Alicia with iPhone*, from the series *The Illuminati*, 2007. 30 × 40 inches. Chromogenic color print mounted to Plexiglas.

without your guidance. A camera can isolate a scene within a frozen slice of time, reducing what is in front of it to two dimensions and setting it into a frame. However, it cannot record the sequence of events that led up to the moment that the shutter clicked or your private emotional response to what was happening. You must learn to incorporate these elements into your pictures if you expect to make photographs instead of snapshots. The camera does not discriminate in what it sees and records, but you can—and must—make distinctions, in order to create successful images.

The Time of Day/Types of Light

The old Kodak adage instructed people to "Take pictures after ten in the morning and before two in the afternoon." This rule had nothing to do with aesthetics. Its purpose was to encourage amateur photographers to take pictures when the light was generally the brightest, because early roll film was not very sensitive to light. By breaking such canons you can avoid trite responses and form your own intriguing solutions.

Light is the key ingredient shared by every photograph. Before anything else, every photograph is about light. The light in which you work will determine the look of every photograph you make. If the light does not reveal the perceived nature of the subject, the picture will not communicate your ideas to the viewer. Light not only illuminates, it provides a sense of physicality (volume). Begin to recognize what light artist James Turrell calls the "thingness" of light, the ever-changing characteristics and qualities that light possesses throughout the day, and learn

to incorporate them into your composition for a complete visual statement.

The Cycle of Light and Its Basic Characteristics

Before Sunrise

In the earliest hours of the day, our world is essentially black-and-white. Light exhibits a cool, almost shadowless quality, and colors are muted. Up to the moment of sunrise, colors remain flat and opalescent. The intensity of the colors grows as the sun rises. Artificial lights can appear as accents and/or create contrast with their unnatural color casts.

Morning

As soon as the sun comes up, the light changes dramatically. Since the sun is low and must penetrate a great amount of the atmosphere, the light that gets through is diffused and much warmer in color than it will be later in the day. This is the brief

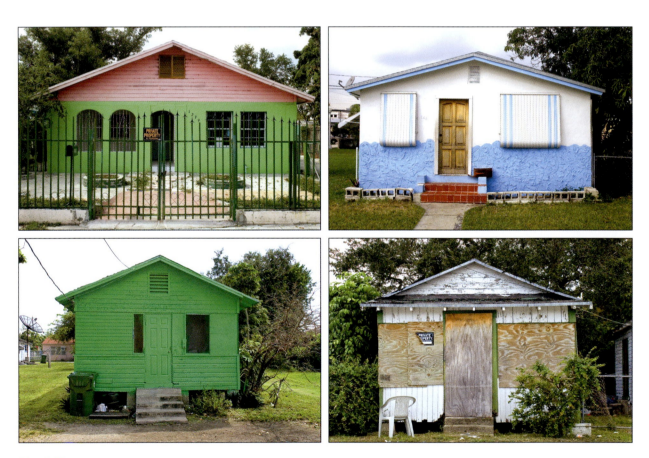

Figure 5.17 In her *Housing Project—Miami* series, Kelly Flynn documents the various types of homes that appear throughout Miami neighborhoods. The time of day that she works is integral to the project; the bright, well-balanced light in these four images is indicative of late morning and early afternoon. Flynn found it important to document these homes "because they are on the verge of extinction due to ever-increasing land value around the Miami area. People are being forced out of their neighborhoods as the surrounding downtown area is being expanded by mansions and high-rise condos for the rich. The houses that I choose to photograph have far more personality, meaning, color, and excitement than what is being built on top of them. The only way the houses and culture could live on forever was to be photographed before they were destroyed."

© Kelly Flynn. *House 27, House 54, House 63*, and *House 68*, from *The Housing Project—Miami*, 2006–2007. 20 × 30 inches each. Inkjet prints. Courtesy of Southeast Museum of Photography, Daytona Beach, FL.

 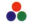

time that is commonly referred to as the Golden or Magic Hour, which also repeats at the end of the day. Shadows may appear blue, due to the lack of high brilliant sunlight, the deep blue from the overhead sky, and simultaneous contrast. For a while, as the sun still rises, the color of light becomes warmer (red-orange), but by midmorning the light begins to lose its warm color and starts to appear clear and white.

Midday

The higher the sun climbs in the sky, the greater the contrast between colors. At noon the light is white and may be considered to be harsh, stark, or crisp. Colors stand out strongly, each in its own hue. Shadows are black and deep. Contrast is at its peak. Subjects can appear to look like three-dimensional cutouts.

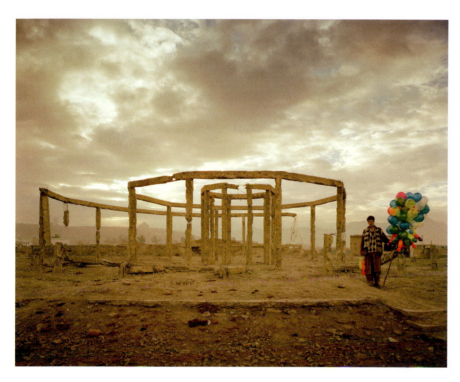

Figure 5.18 Simon Norfolk uses Mikhail Bakhtin's term "chromotope" to describe this landscape as "a place that allows movement through space and time simultaneously, and a place that displays the layers of time." The fluorescent balloons provide uneasy visual contrast when juxtaposed with both the crumbling remains of a modern concrete teahouse destroyed by years of war and the warm tones of an early morning desert sunrise.

© Simon Norfolk. *Former Teahouse in a Park Next to the Afghan Exhibition of Economic and Social Achievements*, 2001. 40 × 50 inches. Chromogenic color print. Courtesy of Gallery Luisotti, Santa Monica, CA.

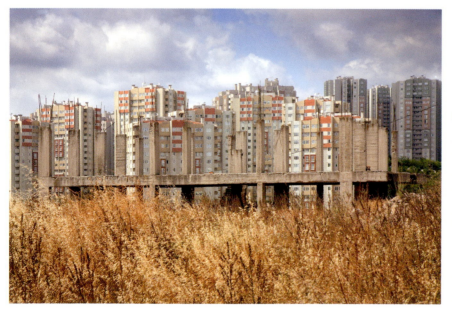

Figure 5.19 The construction and destruction of Turkish suburbs serve as Mark Slankard's subject, and here he photographs the scene in full midday light. On this day, a hazy sky subtly filtered the midday sun, resulting in particularly striking light. The rapidly changing landscape that Slankard captures juxtaposes the rural setting with the dense urban structures. He elaborates, "This is the everyday Turkey of a rising middle class, heavily influenced by Western Europe and the United States. This is also the Turkey of displaced migrants, shantytowns, and gentrification. This is the site where they intersect."

© Mark Slankard. *Structure, Ümraniye, Istanbul*, from the series *Toplu: Landscapes of New Turkish Suburbia*, 2008. 30 × 44 inches. Inkjet print.

Afternoon

As the sun drops to the horizon, the light begins to warm up again. It is a gradual process and should be observed carefully. On clear evenings objects can take on an unearthly glow. Look for an increase in red. The shadows lengthen and become bluer. Surfaces are strongly textured. An increasing amount of detail is revealed by the low angle of the light from the sinking sun.

Twilight/Evening

After sunset there is still a great amount of light in the sky. Notice the tremendous range of light intensity between the eastern and western skies. Often the sunset colors are reflected from the clouds. Just as at dawn, the light is very soft, and contrast and shadow are at a minimum (Golden Hour). After sunset and throughout twilight, notice the warm colors in the landscape. This phenomenon, known as purple light, arises from light from the blue end of the spectrum falling vertically from the overhead sky. Observe the glowing pink and violet colors as they gradually disappear and the earth becomes a pattern of blacks and grays.

At twilight it is possible to observe the earth's shadow (the dark gray-blue band across the eastern horizon just after sunset). It is only visible until it rises to about 6 degrees high; after that, its upper boundary quickly fades. The earth's shadow is immediately visible after sunset because our eastward view is directly along the boundary between the illuminated and nonilluminated portions of the atmosphere. As time passes, we view this boundary with an ever-steepening angle and it shortly disappears. When observing the earth's shadow, notice the red-to-orange-to-yellow development of color just about at its upper edge produced as the sun's rays pass overhead and reflect directly back down to earth. This phenomenon, called counter-twilight, disappears at about the same time as the earth's shadow.

Night

The world after the sun has set is seen by artificial light and reflected light from the moon. Photographing under these conditions usually requires a tripod, a brace, or a very steady hand. The light is generally harsh; contrast is extreme, and the color unnatural. Combinations of artificial light and long exposure can create a surreal atmosphere. However, you may want to adjust your white balance and/or use filters to make the most of these conditions. Many DSLRs have a setting to compensate for the extra color noise that often appears in low light situations. With film, an increase in exposure can lead to reciprocity failure and possible color shift. Add exposure time and use filters, if correction is desired.

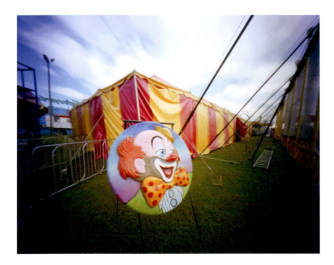

Figure 5.20 A pinhole camera, a 4-minute exposure, and late afternoon light allowed Diana Bloomfield to get her perfect image. She made the photograph at the North Carolina State Fair during a particularly crowded afternoon, but because the exposure was so long, any passersby who happened to walk through her frame simply disappeared from the image. She elaborates, "I like the long exposures and love the look of a super-wide pinhole camera—how that can change the perspective to appear more dreamlike … The relatively long exposures can result in wonderful color shifts, and with a saturated color film, like Fuji, the colors can often bleed into one another. It all just seems a little more fluid, as though everything is still in transition and, like the clouds, is still moving."

© Diana Bloomfield. *Midway Clown*, from the series *The Midway*, 2000. 20 × 24 inches. Inkjet print.

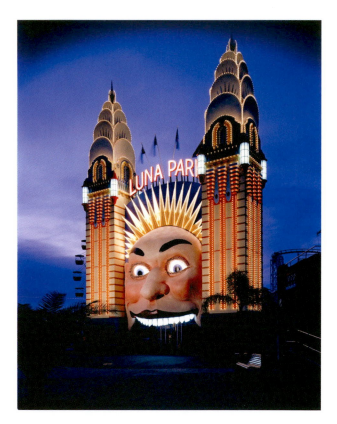

Figure 5.21 Douglas Holleley states, "What I like about this image is that it is a good example of photographing at that time of the day (in this case the evening), when the light of the natural world is about the same as the light of the artificial light sources in the image. It is as if God and man are mutually participating in the illumination of the subject."

© Douglas Holleley. *Luna En-Trance, Luna Park, Sydney, Australia*, 1995. 24 × 20 inches. Chromogenic color print.

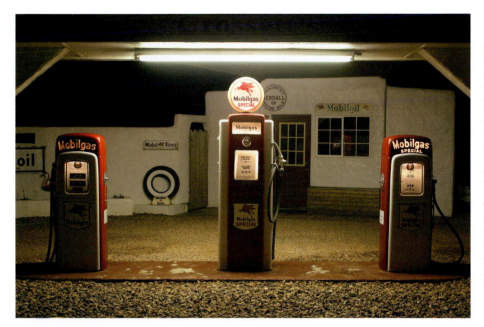

Figure 5.22 Simple artificial light sources figure prominently in Doug Clark's night-time photography, serving almost as a human presence in these figureless environments. The artist states, "I want the viewer to interact with these scenes that might normally go unnoticed. When the subject is removed from the context of its surroundings, it is no longer a document of a specific place but rather an open-ended narrative that can be finished by what the viewer brings to the image. The actors in this play are the viewers themselves. Working in a digital environment allows me to build these images from their parts, as a construction, with the end result being something that looks hyper-real."

© Doug Clark. *Mobil*, from the series *Illumination*, 2005. 12 × 18 inches. Inkjet print.

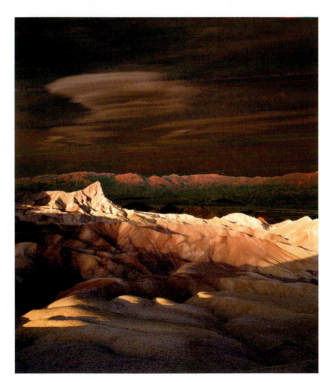

Figure 5.23 This dynamic image was created by making a composite of four negatives—one of the sky and three separate exposures of the same landscape composition under different lighting situations. "I take the most compelling passages of changing light throughout an extended duration of time and weave them into a single composition," says John Paul Caponigro. "The result is a dramatic lighting effect never before seen at one time. Yet, a similar sequence of experience has been witnessed countless times."

© John Paul Caponigro. *Oriens*, 1999. Variable dimensions. Dye-destruction print.

Problem Solving

Sky Gazing

After looking at a bright portion of the sky, close your eyes for a few moments and allow them to recover from the glare. The color-sensitive area of our vision is easily saturated by intense light and, without short rest periods, our eyes are unable to distinguish subtle color differences. An intriguing way to study specific portions of sky is to use a small mirror held at arm's length. Face away from the area of sky you want to observe and use the mirror to inspect that region. By holding the mirrored image against a neutral background of your choice, you can compare the colors of different portions of the sky. The backgrounds also can be of other colors or even different shapes and textures, and these combinations can be photographed to alter our traditional way of thinking about the sky. For more information, see *Color and Light in Nature* by David K. Lynch and William Livingston (Cambridge: Cambridge University Press, 2nd ed. 2001).

The Seasons

The position of the sun varies depending on the time of year. This has a great impact on both the quality and quantity of the light. Learn to recognize these characteristics, and look for ways to go with and against the flow of the season to obtain the best possible photograph.

Winter denotes a diminished number of daylight hours. Bare trees, pale skies, fog, ice, rain, sleet, and snow all produce the type of light that creates muted and subtle colors.

Spring brings on an increase in the amount of daylight and the introduction of more colors. Extended summer light offers the world at its peak of color. Harsh summer light can offer a host of contrast and exposure problems for the photographer to deal with. Fall is a period of transition that provides tremendous opportunities to show color changes.

The Weather and Color Materials

There is no such thing as bad weather for making photographs. Fog gives pearly, opalescent, muted tones. Storms can add drama and mystery. Rain mutes some colors and enriches others while creating glossy surfaces with brilliant reflections. Dust softens and diffuses color and line. Bad weather conditions often provide an excellent opportunity to create pictures full of atmosphere and interest. With a few precautions to yourself and equipment, you need not be just a fair-weather photographer. If the metering looks like it is going to be tough, bring along and use a gray card as a guide. Before going out into any unusual weather conditions, be certain to check how many exposures you have remaining. If only a few are left, reload your memory card or film while everything is still dry and familiar.

Problem Solving

Time of Day/Type of Light

Set your digital camera or use a standard daylight color slide film (E-6 process) which has an ISO of about 100. In clear weather, photograph at least two of the following suggestions. Use only available light. It is not enough to show just the differences in the quality of light at the different times of the day. Concentrate on color relationships and experiment with a variety of viewpoints. Make strong simplified composition that brings forth the emotional, formal, informational, and/or symbolic connotations of the subject to your viewer.

1. Photograph a subject at six different times of the day, in six different locations.
2. Photograph a subject at six different times of day in the same location. Vary your composition. Do not make the same photograph each time.
3. Make a photograph at a different location at six different times of the day. Do not add anything to the scene. Work with what is given.

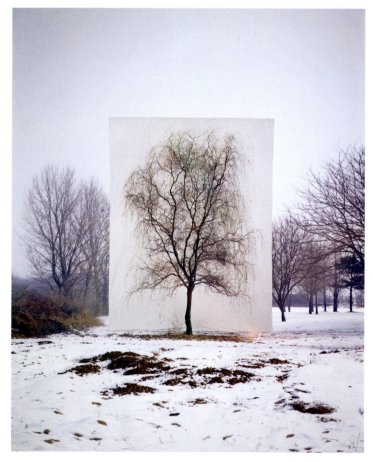

Figure 5.24 Myoung Ho Lee works with a large team of assistants to build his outdoor sets and to help address any surprises that weather and wind may present. Together, they erect life-size canvases behind selected trees and then photograph the isolated subjects in the larger context of the landscape. With this work, Lee inserts man-made fabrication into the natural environment, to reflect on the intersection of science and art, nature and technology, and reality and fiction.

© Myoung Ho Lee. *Tree #3*, 2006. 39½ × 31½ inches. Inkjet print. Courtesy of Yossi Milo Gallery, New York, NY.

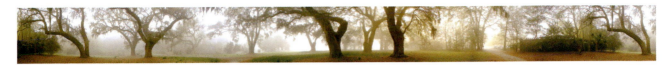

Figure 5.25 When photographing under foggy conditions the diffused light can tend to have a cool (blue) cast. To bring out warmer tones, shoot in the late afternoon or in the early morning, as Steven P. Mosch did with this image shot at sunrise.

© Steven P. Mosch. *Trees and Fog, Spring Island, SC*, 2002. Variable dimensions. Inkjet print.

Fog and Mist

Fog and mist diffuse the light and tend to provide monochromatic compositions. The light can tend toward the cool (blue) side. If this is not acceptable, alter your white balance, use an 81A warming filter, or photograph in the early morning or late afternoon when there is the chance to catch some warm-colored light. If the sun is going in and out of the clouds, wait for a moment when a shaft of light breaks through the clouds. This can create drama and break up the two-dimensional flatness that these cloudy scenes often produce.

Because the light is scattered, both colors and contrasts are made softer and subtler. If you want a sense of depth in the mist, try not to fill your frame completely with it. Attempt to offset it with a dark area. To capture mist, expose for the highlights or use an incident light meter. Bracketing is crucial.

In fog, take a reading from your hand in light similar to that which is on your subject. Then overexpose by ½ to one f-stop depending on how intense the fog happens to be. Bracket and review your exposures.

Rain

Commonly, rain tends to mute and soften color and contrast, while bringing glossy reflections into play. Include a warm accent if contrast or depth is desired. The shutter speed is important in the rain. The faster the speed, the more distinct the raindrops will appear. At speeds below 1/60 of a second, the drops blur. Long exposures will seem to make them disappear. Experiment with different shutter speeds to see what you can achieve. Review and make adjustments as you go. The aftereffects of rain can make certain colors and surfaces more vibrant.

When working in wet conditions, keep your camera in a plastic bag with a hole for the lens. Use a UV filter to keep the front of the lens dry. Hold the camera inside your jacket when it is not being used. If are going to be constantly wet, get a waterproof bag to hold your equipment. Camping stores sell inexpensive plastic-bag cases that will allow you to photograph in wet conditions without worrying about ruining the camera. Carry a bandanna to wipe off any excess moisture. Some manufacturers produce underwater camera housings and/or cases to protect the camera in difficult weather conditions while allowing free access to the controls.

Dust

Dust can be a bitingly painful experience to a photographer and equipment. Use a UV filter, plastic bag, and lens hood to protect

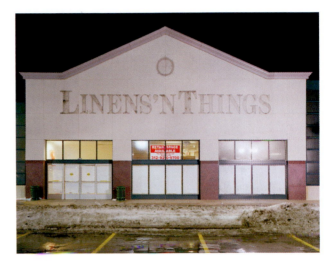

Figure 5.26 To shoot this scene, Brian Ulrich made a 30-second exposure around midnight in an empty parking lot. His biggest challenge was dealing with the elements. He was able to overcome the elements "by using the trunk of the car to block the snow and rain from hitting the lens and also shielding the camera from the wind." Ulrich began this series to analyze the intersection of consumerism and patriotism shortly after September 11, 2001, amidst threats of economic collapse. Ten years later, he tells us, "In the recent economic downturn some of the very stores I photographed at the beginning of the project are now emptied and laid barren in the hulking empty architecture of the big box mall or store."

© Brian Ulrich. *Linens' N Things*, from the project *Copia*, 2009. Variable dimensions. Chromogenic color print.

the camera. Avoid changing lenses or opening the camera back in dusty situations. Dust is the bane of digital sensors, producing unwanted spots and specks, so avoid changing lenses or opening the camera back in dusty situations or you may need to have your camera professionally cleaned.

Use the same shutter speed guide for snow (see page 88) to help determine how the dust will appear. Dust in the sky can produce astonishing atmospheric effects. If turbulence is to be shown, expose for the highlights. This causes the shadows to go dark and the clouds will stand out from the sky. A polarizing filter may be used to darken the sky and increase color saturation. If detail is needed in the foreground, use the camera to meter for one-third sky and two-thirds ground, and bracket one f-stop in either direction.

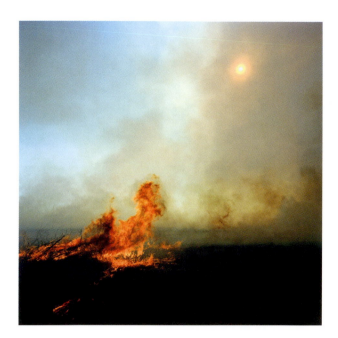

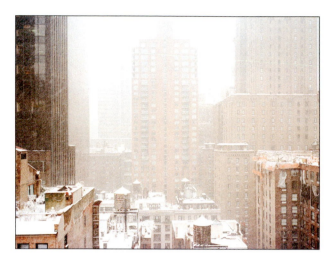

Figure 5.28 In order to capture the subtle color, tones, and sense of space present during a snowstorm, David R. Allison slightly overexposed the film to ensure sufficient detail in the negative.

© David R. Allison. *New York, NY*, 1999. 16 × 19¾ inches. Chromogenic color print. Courtesy of Kathleen Ewing Gallery, Washington, DC.

Figure 5.27 In his book *On Fire* (2003), Larry Schwarm takes advantage of dramatic lighting effects and adverse environmental conditions such as the controlled fires that occur every spring in the Flint Hills of east-central Kansas. "Fire is an essential part of the prairie ecosystem. Without fire, this prairie would have been forested. Over time, what started as a natural phenomenon became an annual event controlled by man."

© Larry Schwarm. *Leaping Flames, Lyon County, Kansas*, 2009. 48 × 48 inches. Chromogenic color print. Courtesy of Robert Koch Gallery, San Francisco, CA.

Heat and Fire

Heat and/or fire are often accompanied by glare, haze, high-contrast, and reflection. These factors can reduce clarity and color saturation, but if handled properly they can make colors appear to stand out. In extremely bright situations, a neutral density filter may be needed to cut down the amount of light that is striking the film.

Do not point the camera directly into the sun, except for brief periods of time. The lens can act as a magnifying glass and ruin internal parts, including the sensor and/or film. Store the camera, especially if using film, in a cool place. Heat and humidity can ruin the color balance of film, so refrigerate it whenever possible, both before and after exposure. Let the film reach room temperature before shooting, to avoid condensation and color shift. Avoid carrying unnecessary equipment if you will be doing a good deal of walking in the heat. Do not forget a hat and sunscreen.

Snow

Snow reflects any predominant color. Blue casts and shadows are the most common in daylight situations. Use a UV filter to help neutralize this effect. If this proves insufficient, adjust your white balance or try a yellow 81A, 81B, 81C, or even an 81 filter. This

technique also works well in higher elevations, where the color temperature of the light is higher (bluer).

Brightly lit snow scenes tend to fool the meter because there is so much reflected light. The meter thinks there is more light present than there actually is and tells you to close the lens down too far, producing underexposed results. Avoid this by using your exposure compensation dial and/or Snow Mode or taking an incident light reading, and then overexpose by 1/2 to one f-stop to get shadow detail. If this is not possible, then meter off the palm of your hand. Fill the metering area with it, being careful not to get your shadow in it. Next, open the lens up one to two f-stops from the indicated reading to compensate for both the snow and the fact that the palm tends to be one f-stop lighter than a gray card. To bring out the rich texture of snow, photograph when the sun is low on the horizon. Bracket when in doubt and learn which exposure works the best. Many DSLRs and SLRs have a Snow mode and/or an exposure compensation function that may be helpful in this situation.

Snow Effects

Slow shutter speeds can make snow appear as streaks. Fast speeds arrest the action of the flakes. Flash can also be employed. For falling snow, fire the flash from the center of the camera. The snow will reflect the light back, producing flare and/or spots. Using a synchronization cord and holding the flash at arm's length off to one side of the camera can illuminate the snowflakes. This stops the snow and provides a scene comparable to the ones produced inside a snow globe. Try setting the camera on a tripod, use a lens opening of f/8 or smaller plus a shutter speed of 1/8 of a second or longer, and fire the flash during the exposure. This stops the action of some of the falling snow while letting the rest of it appear blurred. Review and/or bracket the

exposures until enough experience is obtained to determine what will deliver the type of results you are after.

Battery Care in Cold Conditions

Check the batteries for all your camera gear before going out into cold conditions, and carry spares. Systems using lithium batteries have better cold weather performance, having an operating range of −40 °F (−40 °C) to 150 °F (65 °C). However, at temperatures of 20 °F (−6.7 °C) or lower, there is a danger that many battery-powered devices, especially in older cameras, will become sluggish. Shutters are affected first, with shutter speeds slowing and producing exposure errors. For instance, if a battery-powered shutter is off by 1/1000 of a second, and if you are attempting to stop the action of a skier speeding downhill at 1/1000 of a second, then the exposure would be off by one f-stop. This would not present a serious problem unless you are shooting above 1/125 of a second. In cold conditions, make use of the middle and slow ranges of shutter speeds whenever possible, to avoid this difficulty.

Carry a warm, spare set when working in cold weather, since all batteries tend to drain rapidly in low temperatures. Keep spare batteries warm by putting them next to your body in an interior pocket. Whenever possible, make use of rechargeable batteries. If the conventional batteries appear to have expired, do not write them off until they are warmed up and tested again.

Cold Weather Protection

Simplify camera operations as much as possible. Remove any unneeded accessories that cannot be operated with gloves, or add accessories that permit easier operation. If possible, preload cameras with memory card or film before going outside. Avoid using LED screen or power accessories to conserve power. Do not take a camera that has condensation on it out into the cold until the condensation has evaporated; the condensation may freeze, causing the camera to cease operation and the inner components to be ruined. Once outside, avoid touching unpainted metal surfaces with ungloved hands, face, or lips because your skin will stick to the metal. Metal parts can be taped to prevent this from happening. Wear thin gloves so that you can avoid contact with the cold metal but you can operate the camera with ease. Do not breathe on the lens outside to clean it because your breath might freeze on it.

When bringing a camera in from the cold, let it warm up before using it, so condensation does not damage its working gear. Condensation can be avoided by placing the camera in an airtight plastic bag and squeezing out the air. This prevents the camera from being directly exposed to the warmer air. Condensation forms on the outside of the bag instead of on the lens and camera body. After the equipment has reached room temperature, remove it from the bag.

Static and Film

With film, static can occur anytime the air is cold and/or dry. Avoid rapidly winding or rewinding the film, as this can produce a static charge inside the camera. You will not know this has happened until the film is processed and discover a lightning storm of static across the pictures. Take it easy and rewind the film slowly. If possible, don't use the motor drive or auto rewind in these conditions, to prevent those indiscriminate lightning flashes from plaguing your film. Keep film warm as long as possible in cold weather since it can become brittle at very low temperatures.

Cold Weather Lubrication

Mechanical shutters in film cameras also slow down in the cold because the viscosity of the lubricants thickens as the temperature drops. Such a camera can be relubricated with special cold weather lubricants if you are doing a great deal of work in extremely cold conditions. These lubricants must be replaced when the camera is used again in normal conditions. Most cameras perform well in cold weather when they are not kept out in the elements longer than necessary.

NOTES

1. Wassily Kandinsky, *Point and Line to Plane* (first published in English, New York: Solomon R. Guggenheim Foundation for the Museum of Non-Objective Painting, 1947; reprinted with a Preface by Hilla Rebay, Mineola, NY: Dover Publications, 1979).
2. Wright Morris, *Time Pieces: Photographs, Writing, and Memory* (New York: Aperture Foundation, 1989), p. 145.

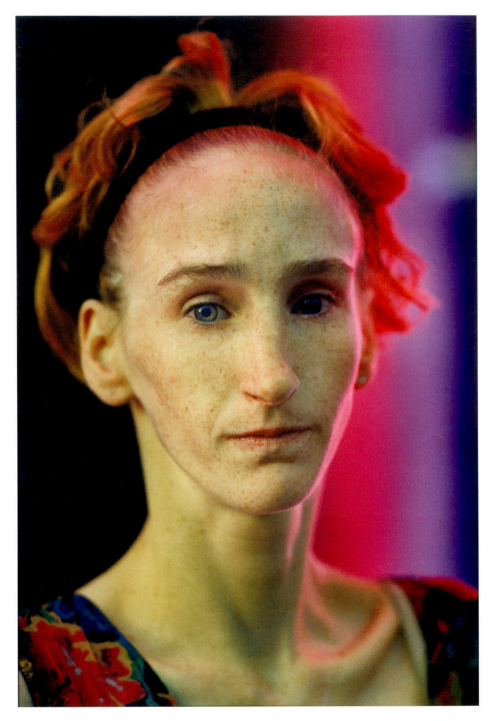

When pressed about his way of working, Robert Bergman paraphrases Plato: "Sound reason crumbles in the presence of the poetry of madmen," clearly align-
ing himself with the latter. He has stated that his "ambition is to subvert types and to absent myself so the essential particularity of a person shines through.
I have no preconceptions, no intelligible goals. I value *not* knowing and operate according to animal instinct." Relying on the language of vision, shape, form,
and color palette, Bergman considers his close-up, expressionistic portraits to be a "collaborative act" between himself and the strangers he encounters on the
street. He relies on his intuition to intimately reveal an often-profound internal solitude, frequently coupled with sorrow.

© Robert Bergman. *Untitled*, 1993. Chromogenic color print. Courtesy of the artist and Yossi Milo Gallery, New York, NY.

The Visual Language of Color Design

Seeing Is Thinking

Seeing is thinking. Just as you can think out loud, you can think in pictures. Thinking involves taking random pieces of our private experience and putting them together in an orderly manner. The act of seeing is no less an act of construction, a way of making sense of the world.

We like what is familiar to us and tend to back away from the unusual. Becoming more visually literate makes us more flexible. Some people only use photography as a means of recording and categorizing objects. For them, a photograph is like a window through which a scene is viewed or a mirror that reflects a material reality. However, a photograph is nothing more than two-dimensional representation on a surface. It may show us something recognizable, but sometimes it shows us only lines, shapes, and colors.

> A work of art encountered as a work of art is an experience, not a statement or an answer to a question. … Art is not about something; it is something. A work of art is a thing in the world, not just a text or commentary on the world. A work of art makes us see or comprehend something singular.[1]

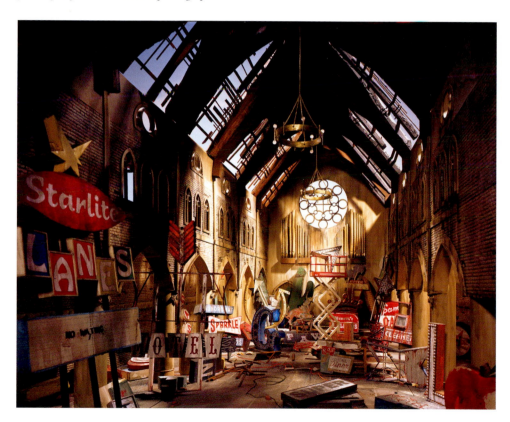

Figure 6.1 Instead of documenting an existing scene, Lori Nix builds and photographs her own constructed environments, here focusing on the remains of an urban landscape. She tells us, "I have chosen the spaces that celebrate modern culture, knowledge, and innovation: the theater, the museum, and the vacuum cleaner showroom. Here the monuments of civilization and material culture are abandoned, in a state of decay and ruin, with natural elements such as plants, insects, and animals beginning to re-populate the spaces. This idea of paradise lost, or the natural world reclaiming itself, becomes more forceful as we face greater environmental challenges in the world around us."

© Lori Nix. *Church*, March 18, 2009. 48 × 60 inches. Chromogenic color print. Courtesy of ClampArt Gallery, New York, NY.

What Is a Good Photograph?

How do you make a good photograph? All photographers ask this question, but in the end, there is no easy answer. Still, it is a question that we must constantly ask ourselves, even if we do not have "the" answer. This book offers a number of ideas that may be of help, though at times they might get in the way. The only solution is to keep looking. The search will reveal there are many answers to this question. Contemplate what Paul Strand said: "No matter what lens you use, no matter what speed the film, no matter how you develop it, no matter how you print it, you cannot say more than you see."[2]

Discovering What You Have to Say

Good intentions do not make good photographs. The first and most important step in determining what makes a good photograph is to empty our minds of all images that have bombarded us on screens and in print. All these images belong to someone else. Throw them away. Next, toss out the idea that we know what a good photograph is. We know what is customary: that a good photograph is supposed to be centered and focused; that

the subject is clearly identifiable and right-side up; that it is 8 × 10 inches and has color (unless it is "old," then it is black-and-white); that the people are looking into the camera and smiling; that it was taken at eye level; and that it isn't too cluttered or too sparse. In short: It is just right. And we have seen it a million times before. It is known, safe, and totally boring. Toss all these preconceived ideas into the dumpster and start fresh by defining what it is you want to communicate. Most artists make their best work when they have something to prove or say.

Making an Effective Photograph that Communicates

An effectual photograph can pictorially awaken the mind, arouse curiosity, and communicate an experience to another person. Such a photograph allows viewers to recognize and connect with the subject and has its own history—past, present, and future—that does not require any outside support. It can stand alone, as a statement, and will convey something in a way that would be impossible to do in another medium.

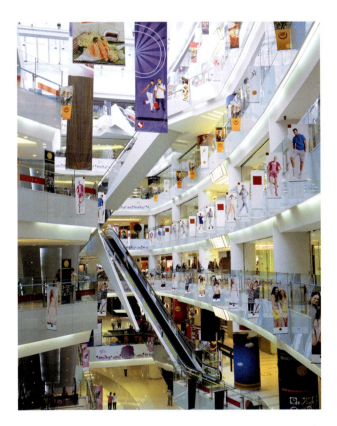

Figure 6.2 Matt Siber took this photograph on Fuji Provia 100 film and, after scanning his negatives, manipulated the image in Photoshop. He eliminated all the lettering and constructed a complementary image consisting only of signage, using Photoshop's Text and Pen Tools. He says, "With the removal of all traces of text from the photographs, the project explores the manifestation of power between large groups of people in the form of public and semi-public language. The absence of the printed word not only draws attention to the role text plays in the modern landscape but also simultaneously emphasizes alternative forms of communication such as symbols, colors, architecture, and corporate branding. The isolation of the text from its original graphic design and accompanying logos, photographs, and icons helps to further explore the nature of communication in the urban landscape as a combination of visual and literal signifiers."

© Matt Siber. *Untitled #46*, from *The Untitled Project*, 2009. 50 × 80 inches. Inkjet prints.

Photography is a matter of visual organization. The photographer battles the physical laws of universal entropy by attempting to control disorder within the photograph. The arrangement of objects within the pictorial space determines the success of the photograph. Order is good composition, which, as Edward Weston said, "is the strongest way of seeing" the subject. The basis of composition is design.

Design includes all the visual elements that makeup a composition. Visual design is the synchronization of materials and forms in a certain way to fulfill a specific purpose. Design begins with the harmonization of parts into a coherent whole. An effectual photograph is an extension of the photographer that produces a sustained response in the viewer. If the intentions are successfully communicated, the design of the photograph must be considered effective or "good."

Figure 6.3 Swinging and tilting the lens and film back of her 4 × 5-inch view camera allows Susan Wides to make deliberately focused photographs that depict simultaneously specific and ambiguous scenes. In this work, she revisits sites made immortal by the Hudson River School painters of the nineteenth century, examining how our view of the American landscape has changed since then. In considering how we think about nature, manifest destiny, technology, and progress, Wides explores "the subtlety and complexity of images that fuse feeling and thought, requiring us to slow down and contemplate where we are—and thus the very 'why' and 'how' of our being."

© Susan Wides. *Hudson River Landscape 10.14.07 (Sunset Rock North Mountain)*, from the series *Kaaterskill/Mannahatta*, 2007. 50 × 40 inches. Chromogenic color print. Courtesy of Kim Foster Gallery, New York, NY.

Putting It All Together

Anything touched by light can be photographed. Since it appears so easy when starting out in photography, many of us try to say too much in a picture. We often overcrowd the confines of the visual space with too much information. This can create a visual chaos in which the idea and motivation behind the pictures become confused and lost. Do not assume that anything that happens to you is going to be interesting to someone else. Learn to be selective. Making a choice that is comprehensible to others is at the core of being an effective photographer.

Working Subtractively

When making photographs, start by working minimally and subtractively. A painter starts with nothing, and through the process of addition a picture comes into being. On the other hand, a photographer begins with everything. The photographic process is one of subtraction. The critical power of a photographer is in the choosing of what to leave out of the picture, showing that omission is a form of creation. Ray Metzker said: "The camera is nothing but a vacuum cleaner picking up everything within range. There has to be a higher degree of selectivity."

President John F. Kennedy stated, "To govern is to choose." Composing a photograph is an act of governing, and choice is everything. Use subtractive composition and go directly for what you want to include in the picture, and then subtract anything that is unnecessary. This editing method can help you learn the basic visual vocabulary that consistently produces effective images. A good photographer is like a magician who knows how to make all the unwanted objects on stage disappear, leaving only the items necessary to create a striking image. For this to regularly happen, a photographer needs to have a point of departure.

Point of Departure

If you go out to photograph something deliberate, the possibility of encountering the significant and the useful is greater than if you stand on the corner hoping and waiting for something to occur. Do not be like the photographer George Bernard Shaw described, who, like a codfish, lays a million eggs in the hope that one might hatch. Start with a specific direction, but remain flexible and open to the unexpected. A work that continues to say something visually over time has staying power. It usually takes years to cultivate this ability, which has little to do with the technical means of producing a photograph. The integrity of an image is found in how we feel about something. When this feeling is embedded in the picture, something of significance is expressed and can be experienced by viewers. Such an image possesses meaning. For much of what we see, there are no words of explanation. After all, if we comprehended life's enigmas, there would be no need for pictures.

The Photographer's Special License

When you go out with a camera, society grants you a special license. Learn to use it. If you went to a football game and started crawling around on the ground like a snake, people would at the

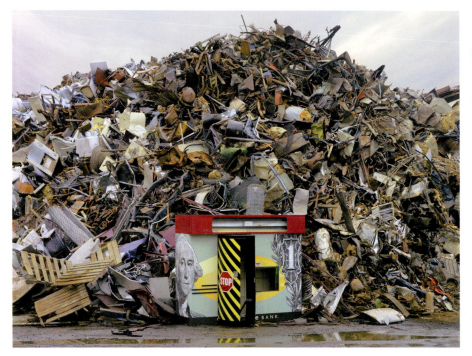

Figure 6.4 Chris Jordan makes photographs that communicate his views on consumption and waste by using an 8 × 10-inch view camera, arrangements of discarded objects, and his own sense of color theory. He states, "The pervasiveness of our consumerism holds a seductive kind of mob mentality. Collectively we are committing a vast and unsustainable act of taking, but we each are anonymous and no one is in charge or accountable for the consequences. I fear that in this process we are doing irreparable harm to our planet and to our individual spirits. As an American consumer myself, I am in no position to finger wag; but I do know that when we reflect on a difficult question in the absence of an answer, our attention can turn inward, and in that space may exist the possibility of some evolution of thought or action. So my hope is that these photographs can serve as portals to a kind of cultural self-inquiry."

© Chris Jordan. *E-Bank, Tacoma*, 2004. 44 × 59 inches. Inkjet print. Courtesy of Kopeikin Gallery, Los Angeles, CA.

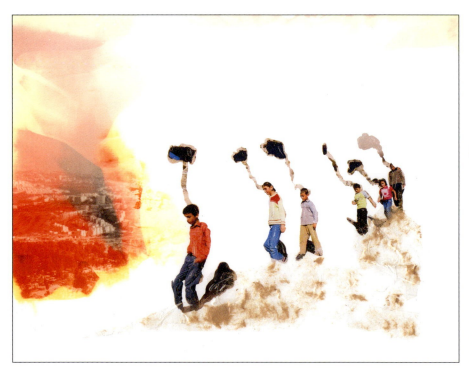

Figure 6.5 Working subtractively for Curtis Mann involves putting found photographs through a process of creative erasure. He applies clear acrylic to these found images and then selectively bleaches sections, thereby creating a new layer of information. He explains, "I am constantly trying to force the medium to function outside of its initial utility and use its malleable nature as a way of coming to an ulterior understanding of the complex and the unfamiliar. This new reading attempts to shift and expand the limits on how we perceive and understand the fragmented world that the photograph attempts to represent."

© Curtis Mann. *descending, imagining (somewhere, Israel)*, 2006. 11 × 14 inches. Chromogenic color print with bleach.

very least find you strange. They may even become alarmed. You might be arrested and hauled off in a strait-jacket, labeled as an unfit member of the group.

Now imagine the same scene, only this time you have a camera. People's responses are different when they see the camera. In this case, they identify you by the camera and dismiss your behavior by saying, "Oh, it's a photographer," or "Look at that photographer trying to 'get' a picture." They may even come over and offer suggestions or give technical advice. Since photography is omnipresent in our society, everyone thinks they are photographers. Use this mindset to your advantage. It is not an excuse for irresponsible behavior or to harass people as the paparazzi do. Learning to strike up a conversation with people is an excellent way to discover what they are doing and why they are doing it. Most people enjoy talking about themselves and can be very accommodating if you learn how to engage them. You can get people to be in your picture, to get out of your picture, to hold equipment, or to just leave you alone. It all depends on the attitude that you project. Consider Diane Arbus's observation: "I don't press the shutter, the image does."

The Language of Vision

The language and tools of vision make use of light, color, contrast, line, pattern, shape, similarity, texture, and movement. Through these formal visual elements, it is possible to make photographs that alter and enlarge our ideas of what is worth looking at and what we have the right to observe and make pictures of. Photography can transform any object and make it part of our experience by changing it into something that can fit into your hand or onto your computer screen to be studied later at your convenience. Influential photographers provide the visual tools that express the ideas and stories of their time. Memorable photographers redefine the medium by inventing new tools for the rest of us to use. In 1947, Edward Weston had this to say concerning his own experiments in color: "The prejudice many photographers have against color photography comes from not thinking of color as form."

In the *Philebus of Plato*, Socrates reflects on form: "I will try to speak of the beauty of shapes, and I do not mean, as most people would suppose, the shapes of living figures, or their imitations in painting, but I mean straight lines and curves and the shapes made from them, by the lathe, ruler or square. They are not beautiful for any particular reason or purpose, as other things are, but are eternally, and by their very nature, beautiful, and give a pleasure of their own quite free from the itch of desire: and in this way colors can give similar pleasure."

These eternally beautiful geometric forms of which Plato speaks can be measured or presented in analytical form. They have proved useful to science and engineering, and since these fields have dominated the intellectual landscape for over the past 150 years, they have also had a tremendous influence on imagemaking.

The following categories are offered to provide the basic vocabulary that is needed to communicate in the photographic language.

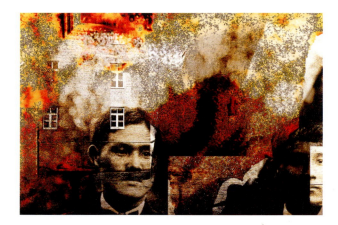

Figure 6.6 To make this photograph, Brian DeLevie combined three-dimensional forms made in Illustrator with images taken with a Holga. In creating a composite image he establishes his personal language of design. This work, DeLevie states, "brings together a variety of imagery to illustrate an atmosphere of interrupted introspection … Socio-historical and personal photographs are artfully manipulated within the framework of each piece to withstand a definitive narrative shape; rather, the imagery is balanced within its setting to create a beautifully 'anti-cohesive' representation of fragmented moments cycling within the recurrent and reconstructive process of remembrance."

© Brian DeLevie. *The Mind's Rapture*, 2008. 13 × 20 inches. Inkjet print.

Line

Line carves out areas of space on either side of it. Any line, except one that is perfectly straight, creates a shape. Closing a line creates a shape. Lines can be majestic, flowing, or undulating. Lines can be used as a conceptual, cultural, or symbolic concept. They can show you contour, form, pattern, texture, directional movement, and emphasis.

Line, *per se*, does not exist in nature. It is a human creation, an abstraction invented for the simplification of visual statements for the purpose of symbolizing ideas whose psychological properties are rooted in both nature and culture. Nature contains mass (three-dimensional form), which is portrayed in photography by the use of line as contour (a line that creates a boundary and separates an area of space from its background).

Shape

Shapes—areas having a specific character defined by an outline, contrast, color value, or texture with the surrounding area—are created by a closed line. There are four basic types:

- Geometric shapes include the square, triangle, rectangle, and circle.
- Natural shapes imitate things in the natural world: human, animal, and plant.
- Abstract shapes are natural shapes that have been altered in a certain way so that they are reduced to their essence. The source of the shape is recognizable, but it has been transformed into something different. This is usually done by simplification, the editing of all non-essential elements.

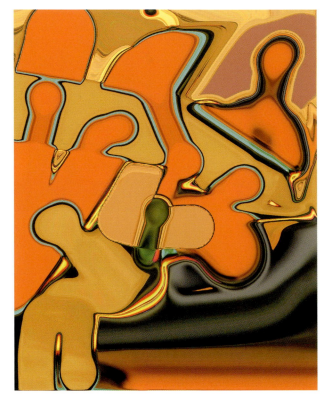

Figure 6.7 Experimenting with Photoshop's Liquefy Filter enabled Douglas Prince to explore the possibilities of abstract line in his work. Though his final images do not attempt to represent external, recognizable reality, his source materials—found images of flowers—are representational. Prince states that browsing digital images online is "much the same process as exploring the 'real' environment with a camera. While acquired images from the web or printed materials are static and two-dimensional, they offer an exciting diversity and global range of accessibility. I see myself using the monitor in much the same way as I use the viewfinder in my camera."

© Douglas Prince. *Bachelors Navigating the Orange Field*, from the series *Post Neo-Abstraction*, 2008. 9⅝ × 12 inches. Inkjet print.

▌ Nonobjective shapes do not relate to anything in the natural world. Usually, we cannot put specific names on them. They are for the eyes, not the intellect, and represent the subjective part of our being.

Space

Space is an area for you to manipulate in order to create form. There are three kinds of space:

▌ Actual space is the two-dimensional area enclosed by the borders of the camera's viewfinder and the surface on which the image later appears. Three-dimensional spaces are inside and around or within an object.

▌ Pictorial space is the illusionary sense of depth that we see in two-dimensional work such as photography. It can vary from appearing perfectly flat to receding into infinity.

▌ Virtual space exists within the confines of a computer screen. It may or may not exist in any concrete form.

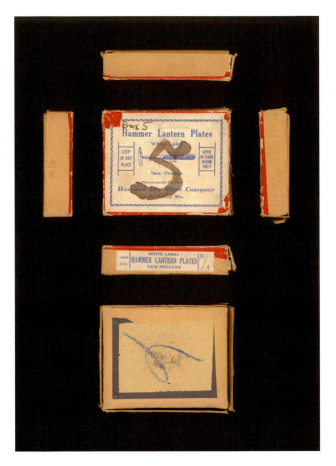

Figure 6.8 A scanner functioned as Tom Patton's camera, letting him record each side of this antique box of lantern slides, which he later joined together to create a composite image. The cruciform shape into which he arranged the components lends a level of religious symbolism to the image, and the cultural and historical references that are made plain introduce an aura to the object. Patton states, "My work relies on the camera (or scanner's) ability to transform even the most ordinary artifact into an extraordinary object whose enigmatic presence may be worthy of contemplation. Cultural observation blended with personal muse becomes the basic subjects of my art. Yet, despite the seemingly seriousness of these works and these words meant to clarify them, I hope that the playfulness, wit, and humor that is also a part of these images also shines through."

© Tom Patton. *Hammer Lantern Slide Boxes #1–5* (detail of #5), from the series *Icons and Artifacts: Crosses*, 1995. 15 × 10½ inches. Inkjet print.

Texture

Generally, smooth textures tend to create cool sensations and rough textures make for warm sensations. Texture and pattern are intertwined. A pattern on a piece of cloth gives us a visual sense of texture, letting us feel the differences in the surface with our eyes, even though it does not exist to the touch. Texture offers changes in sensation, to either hand or eye.

Artists have purposefully introduced three-dimensional texture into media that was once considered to be exclusively two-dimensional. In the twentieth century, the cubists integrated other materials, such as newspapers and sand, into their

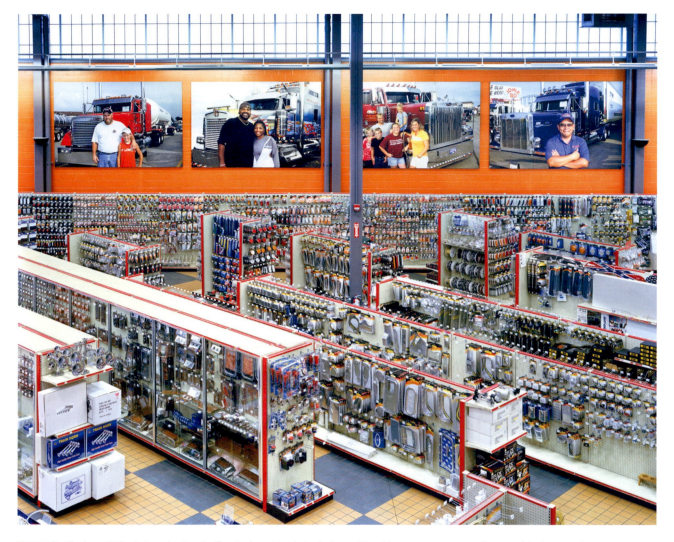

Figure 6.9 The Iowa 80 Truckstop advertises itself as the largest truckstop in the world, and it encompasses a sprawling complex where travelers can consume fast food, play games, and peruse wares. Mitch Epstein captures the extensive space housed in this structure by photographing from a slightly elevated perspective, which enabled him to include numerous rows of merchandise. This work is part of Epstein's *American Power* project, which "examines how energy is produced and used in the American landscape. Made on forays to energy production sites and their environs, these pictures question the power of nature, government, corporations, and mass consumption in the United States."

paintings. This technique is now known as collage, from the French word *coller*, meaning "to glue." Since then, other artists have added three-dimensional objects into their work. Known as constructions, they are the textural element taken to the limit. The two kinds of texture that we need to be familiar with are tactile and implied, texture created by value or changes in light.

"Tactile" is a term that refers to changes in a surface that can be physically felt. Such changes possess three-dimensional characteristics and can be rough, smooth, hard, soft, wet, or dry.

Variations in light and dark produce an implied two-dimensional texture, which is an illusion produced by the eye. The relationship of color placement within the composition and the use of depth of field can also determine the sense of visual texture. Implied or visual texture is two-dimensional and smooth to the touch.

Pattern

Pattern is the unifying quality of an object. It is an active interplay among colors, shapes and space that forms a recognizable, repetitive, and/or identifiable unit. As pattern unifies a composition, it can establish a balance among diverse elements or create a sense of rhythm and movement.

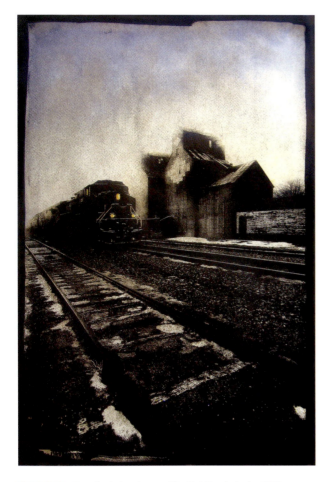

Figure 6.10 Gumoil printing, invented by Karl Koenig in the 1990s, can bring out rich textural details in the subject and remains the artist's process of choice for investigating architecture, aging, and nurturing. Koenig tells us, "I devote considerable thought and experimentation in choosing the best method, the optimal combinations of textures and colors, and appropriate size for each image."

© Karl Koenig. *Richardton, ND*, 2009. 24 × 18 inches. Gumoil print. Courtesy of Albuquerque Museum, Albuquerque, NM; State Capitol Art Collection, Santa Fe, NM; and Princeton University, Princeton, NJ.

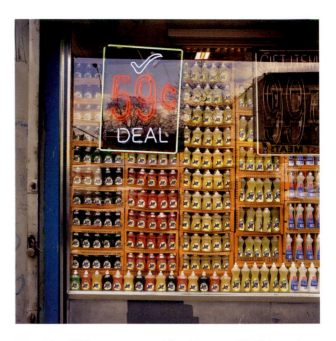

Figure 6.11 Phil Bergerson captured the wide range of highlights and shadows of the orderly pattern of consumer products in this shop window with a medium-format Hasselblad. He eliminated the window reflections by holding up a black cloth, minus a hole for the lens, in front of the camera. Bergerson tells us, "I am interested in photographing the way people display and what they display; how they represent and how they try to speak through signs to each other about what disturbs them and what touches them. Often, the display maker, sign maker, or object maker produces his presentations without knowing the ironic or ambiguous nature of what he presents. I am drawn to these messages, these mixed messages, these quirky elements in the social landscape."

© Phil Bergerson. *Untitled, Brooklyn, New York*, from the series *Shards of America*, 2002. 15½ × 15½ inches. Chromogenic color print. Courtesy of Stephen Bulger Gallery, Toronto, ON.

The major difference between texture and pattern is one of degree, but avoid confusing them. While pattern can possess visual texture, not all texture contains a pattern. A single board has texture, but it takes an entire row of boards to form a pattern. Pattern can be found in the repetition of design. In this case, a distinctive look is made possible by a repeating quality in which no single feature dominates, which is also referred to as a motif. This type of pattern generally serves well as a background.

Surprises are possible when working with pattern. When a variety of elements are placed in repetition with other elements over a large area they may result in a pattern that was not foreseen. Called a motif, this often is created by negative space, that is, the unfilled space around and/or playing through the design. The shapes formed by the interplay of the negative space become interesting in themselves. Within the new pattern, these shapes become apparent and may begin to dominate, so much so that the space or spaces become the prevailing visual factor.

Unity and Variety

A composition devoid of any unifying element usually seems either haphazard or chaotic. A totally unified composition without variety is usually monotonous. Unity and variety are visual twins. Unity is the control of variety, yet variety provides visual interest within unity. The ideal composition is usually one that balances these two qualities—diverse elements held together by some unifying device.

The repetition of shape, pattern, or size plus the harmony of color and texture are visual ways of creating unity. The more complex the composition, the greater the need for a unifying device. Variety can be introduced through the use of color, size, and texture, but in photography contrast is a major control—light against dark, large against small, smooth against rough, hard against soft. Dramatic lighting accentuates these contrasts, while soft lighting minimizes these differences.

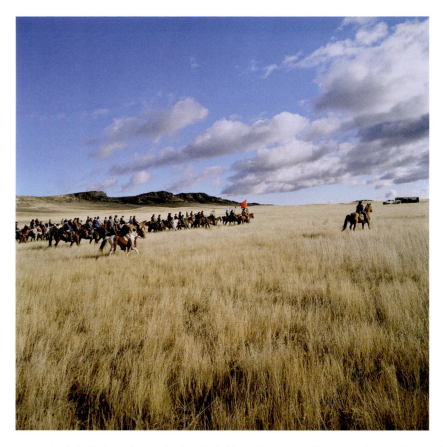

Figure 6.12 Ken Marchionno created unity in this image by capturing horseback riders as they formed a line against the monochromatic landscape. This series looks at an annual, 300-mile trek through South Dakota. Run by the Lakota (Sioux) Indians in South Dakota, the ride starts at Sitting Bull Camp and tracks the trail that some of the Indian chief's followers took to Wounded Knee Creek, which was the site of the last armed conflict of the American Indian Wars. Marchionno has led a group of teenagers from nearby Indian reservations, teaching them how to take pictures during the ride. Working in a digital format allows the photographers to quickly and easily upload their images from the field.

© Ken Marchionno. *Cross Country to Red Owl Springs*, from *The Oomaka Tokatkiya, Future Generations Ride*, 2005. 20 × 20 inches. Inkjet print.

Introducing changes in color, orientation, and scale to a repeated motif is another way of achieving variety.

Rhythm

Rhythm is the flow accomplished by repetition, which can be evenly spaced points of visual stress/weight. It acts as a unifying device within the composition.

Balance

Balance is the visual equilibrium of the objects in a composition. Some categories of balance are as follows:

- Symmetrical, bilateral, or two-sided balance. If you draw a line through the center of this type of composition, both sides will be an equal mirror image. Symmetrical balance tends to be calm, dignified, and stable.
- Asymmetrical balance. Such a composition has equal visual weight, but the forms are disposed unevenly. Asymmetrical balance is active, dynamic, and exciting.

- Radial balance. This type of balance occurs when a number of elements point outward from a central hub, such as the spokes of a bike wheel. Radial balance can be explosive, imply directional movement, and indicate infinity.
- Balance through color. The weight of a color can become the focal point in a picture. Warm colors (red, magenta, yellow) tend to advance and/or have more visual weight than the cool colors (blue, green, cyan). The majority of landscape is composed of cool colors. Warm colors appear mainly as accents (flowers and birds). A small amount of red can be equal to a large area of blue or green. Much of the landscape in the American West is an exception. There are few trees and the predominant colors are the warm earth tones. During daylight hours with fair weather, the proportion of sky included in the frame can control the amount of cool color. The time of day and weather conditions also affect the amount of cool and warm colors, as the color temperature of the light changes.
- Texture. A small area of texture can balance a much larger area of smooth surfaces.

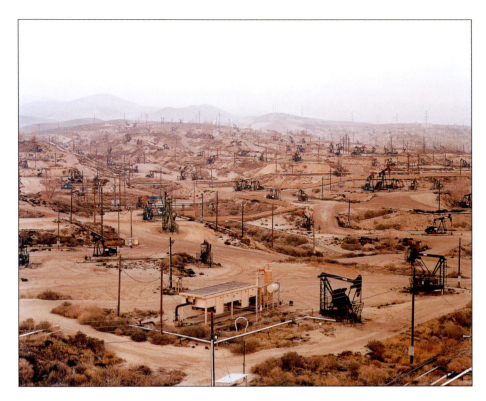

Figure 6.13 Edward Burtynsky's images of manufactured landscapes are "metaphors to the dilemma of modern existence; they search for a dialogue between attraction and repulsion, seduction and fear." Often Burtynsky reinforces the melancholic atmosphere of such images with asymmetric compositions that are weighted to the bottom of his picture frame.

© Edward Burtynsky. *Oil Fields #13, Taft, California*, from the series *Exploring the Residual Landscape*, 2002. 40 × 50 inches. Chromogenic color print. Courtesy of the Nicholas Metivier Gallery, Toronto, Canada.

Figure 6.14 Photoshop's Contact Sheet II plugin allowed Keith Johnson to create a captivating rhythm throughout this grid of symbols. He states, "My photography is about my travels, which I do a lot; sometimes to interesting places, sometimes not. I travel with my camera expecting to see things of interest photographically; I am rarely disappointed. I am interested in the way we have shaped the landscape, entertaining juxtapositions, color, and stuff. At its root, it is about entertainment."

© Keith Johnson. *Cuneiformatic*, 2009. 30 × 40 inches. Inkjet print.

Emphasis

Most photographs need a focal point or points that provide visual emphasis. There must be something that attracts the eye and acts as a climax for the composition. Without this, your eye wanders and is never satisfied. Focal devices to keep in mind are color, contrast, depth of field, isolation, light, position, perspective, and size.

Proportion

Proportion deals with the size relationships within a composition. Shapes are proportional to the area they occupy within the composition. An example can be seen when making a portrait. If the circle formed by the head is 2 inches in diameter on a 4-inch background, it will be more disproportional than if it were placed on a 10-inch background.

Correct proportion is generally based on what society deems to be real or normal. Just because something is disproportionate does not make it wrong. On the contrary, it is often attention-getting and unique. Because of this, photographers deliberately change the proportions in a composition to create impact. The position of the camera and the distance of the subject from the lens are the easiest ways to distort proportion. Digital technology makes it easier to make postvisualization modifications such as alterations in proportion and scale.

Golden Ratio

The ancient Greeks developed a set of ideal proportions called the Golden Ratio or the Golden Mean, which they converted into ratios that could be applied to draw the perfect body or build the perfect architectural structure. You can calculate this proportion by dividing a straight line in two so that the ratio of the whole length to the larger part is the same as the ratio of the larger part to the smaller part. The result, 1:1.618, is the Golden Ratio. Mathematically, it is a ratio of 1 to $(1 + \sqrt{5})/2$, a proportion that is considered to be particularly pleasing to the eye and

Figure 6.15 To locate a visual emphasis among the patterns inside this empty store, Ardine Nelson took advantage of the perspective lines throughout the space and centered her composition on eye-catching red elements. Abandoned shops serve as regular subject matter for Nelson, who here photographed them in the City Center Mall in Columbus, Ohio. She states, "This body of work is much like a landscape or garden where regeneration, reuse, new growth in the spring is (hopefully) about to occur. This is not part of what could be seen as a normal recycling timetable for such structures, however, it is perhaps an early indication of the cultural and financial crisis we are now experiencing."

© Ardine Nelson. *City Center Mall, Columbus, OH-987,* 2009. 26½ × 40 inches. Inkjet print.

Figure 6.16 Anne C. Savedge used a waterproof Canon Sure Shot and 400 ISO film to make this photograph of a busy outdoor water park. After processing, she scanned five of the negatives and combined them to make a composite image. To create the unusual proportions in this image, she changed the settings in the Photoshop Image Size menu, resulting in elongated forms. Savedge states, "The exploration of the relationship between people and water leads me to find the abstract in the figure as well as in the meaning of the pieces. I am interested in the distortions caused by reflection and refraction of light, as well as the color and texture of the water itself. The drenched people inside the watery world create an insular environment. The viewer is called upon to feel the timelessness of the immersion into another place and to evoke personal meaning."

© Anne C. Savedge. *Seattle*, 2004. 20 × 36 inches. Chromogenic color print. Courtesy of 1708 Gallery, Richmond, VA, and E3 Gallery, New York, NY, and Agora Gallery, New York, NY, and AIR Gallery, New York, NY.

can be found in natural growth patterns in nature. Its modular repetition has facilitated its use throughout the history of design and can provide a good starting point for experimenting with proportion and its close cousin, scale.

Scale

Scale indicates size in comparison to a constant standard, the size something "ought to be." By showing objects to be larger or smaller than normal, the viewer is made to see the form in a new way. This encourages the audience to come to terms with it on a new level. Taking the familiar and making it unfamiliar/unusual can allow the viewer to see things that were once not visible.

Symbolism

We communicate through the use of symbols all the time. A symbol is anything that stands for something else. Usually a symbol is a simplified image that, because of certain associations in a viewer's mind, represents a more complex idea or system.

Lines that form letters, words, or musical notes are symbols. A photograph is a symbol. A photograph of a person is not

Problem Solving

Color Kitchen

At the beginning of the twentieth century the Clarence H. White School of Photography fostered many photographic careers. One assignment the school gave was to build a still life made from objects found in a kitchen. In a current version of this assignment, use any photographic means to create a series of still-life images using only items found in a common kitchen that emphasize the language of vision fundamentals, such as line, shape, and texture. Don't forget what's inside the refrigerator.

that person but a representation of the person. It stands for the person, which makes it a representative symbol or icon, which directly reflects the thing it signifies.

Symbolism can be a powerful aid in photography. Symbols are the shorthand of the artist. They are tools for sorting information and drawing inferences that can permit the

1:1.618

Figure 6.17 The ancient Greeks observed the Golden Ratio, sometime known as Phi, offered an aesthetically balanced and harmonious proportion of sides of a rectangle. This was applied by Renaissance artists such as Leonardo da Vinci in the classic publication *Divine Proportion* (1509). It can be seen in diverse situations from the structure of the inner ear, the spiral of a hurricane, the construction of the Parthenon, and the beauty of the *Mona Lisa*. Some software programs offer visual overlays based on the Golden Ratio.

communication of enormously complicated, often abstract ideas with just a few lines or shapes. Photography is a sign language. Learn to recognize and use the signs to your advantage. For details see: www.cs.indiana.edu/~port/teach/103/sign.symbol.html.

The following categories of symbols are offered to get you thinking about what they can represent. Symbols are not absolute terms. They all have multiple readings based on factors such as cultural background, economic status, gender, psychological state, and political, religious, and sexual preference. The subsequent symbols and their conceivable meanings are provided only as a starting point. Symbols are highly complex and each image requires its own reading. Reading and decoding images is a fluid process. Based on their set of experiences, different people give different readings, and your own reading also can change as you have new life experiences.

Color Associations—Some Traditional Effects and Symbolism

Along with shapes, color has symbolic associations that have come down through ages in Western cultures.

▌ Blue signifies sky, thinking, the day, the sea, height, depth, heaven, innocence, truth, psychic ability, and spirituality.

Figure 6.18 Emphasizing the dimensional relationship between the figure and the tree in this image enabled Colleen Plumb to call attention to the unusual scale at work. Using a medium-format Hasselblad on a tripod with Fuji 160 film, the artist was able to capture the museum-like space in this corporate lobby. Plumb states, "I am interested in how people interact with the land in all of its forms. For many people, viewing a majestic natural landscape is an awe-inspiring and uplifting experience. On the other hand, if we see a pristine landscape altered by humans, it can be viewed as ugly or threatening. I am fascinated by the vast spectrum of ways in which landscapes can be interpreted."

© Colleen Plumb. *Lobby with Trees*, from the series *Toward the Sky Again*, 2003. 23 × 23 inches. Inkjet print. Courtesy of Jen Bekman Gallery, New York, NY.

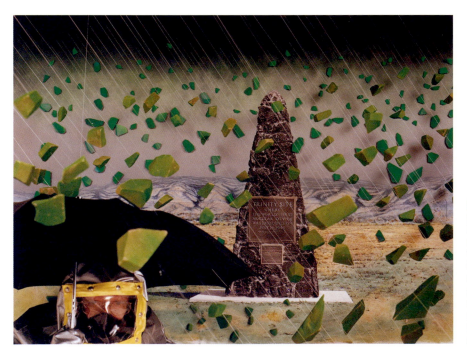

Figure 6.19 Nagatani's montages combine powerful symbols of the traditional Hopi Indian culture with those of the contemporary military culture. Here he manufactures a scene that humorously voices the activities of human beings attempting to ward off their fear of nuclear destruction.

© Patrick Nagatani. *Trinitite, Ground Zero, Trinity Site, New Mexico*, from the series *Nuclear Enchantment*, 1988–1993. 17 × 22 inches. Chromogenic color print. Courtesy of Andrew Smith Gallery, Santa Fe, NM.

- Green depicts the earth, fertility, sensation, vegetation, water, nature, sympathy, adaptability, and growth.
- Orange shows fire, pride, and ambition.
- Red portrays sunrise, birth, blood, fire, emotion, wounds, death, passion, anger, excitement, heat, physical stimulation, and strengthening.
- Violet marks nostalgia, memory, and advanced spirituality.
- Yellow indicates the sun, light, intuition, illumination, air, intellect, royalty, and luminosity.

Common Symbols and Some Potential Associations

Consider how the meanings of these symbols have evolved in our society and, in turn, how you can utilize and/or push against them in your work. To avoid stereotypes, deconstruct your use of symbols in order to discover their hidden internal assumptions, contradictions, and meaning that can subvert their apparent meaning.

- Air symbolizes activity, masculinity, creativity, breath, light, freedom, liberty, and movement.
- Ascent indicates height, transcendence, inward journeying, and increasing intensity.

Figure 6.20 A scanner served as Tom Jones's camera for this work, which he made by placing several plastic Indian toys directly on the scanner glass. The imagemaker intends for the objects to serve as symbols, which he achieves by arranging the figurines in a standing position, thus capturing only the undersides of their bases and abstracting the toys' forms. Jones explains, "This series is drawn from a current controversy in contemporary American Indian art that positions artists that claim their Native ancestry against those that prefer to minimize or even deny their Native heritage. I question if a denial of one's cultural background is generated by mainstream Western art norms or if it is a form of identity genocide. This series addresses the tensions and multiplicity of identity referents currently at play in the context of our perceived 'post-race' country."

© Tom Jones. *Fire Pit Target*, 2008. 40 × 40 inches. Inkjet print. Courtesy of Sherry Leedy Contemporary Art, Kansas City, MO.

- Centering depicts thought, unity, timelessness, spacelessness, paradise, the Creator, infinity, and neutralizing opposites.
- The cross portrays the tree of life, axis of the world, ladder, struggle, martyrdom, and orientation in space.
- The dark illustrates the time before existence, chaos, and the shadow world.
- Descent shows unconsciousness, potentialities of being, and animal nature.
- Duality suggests opposites, complements, and pairing.
- The earth suggests femininity, receptiveness, solidity, and mother.
- An eye illustrates understanding, intelligence, the sacred fire, and creativeness.
- Fire represents the ability to transform, love, life, health, control, spiritual energy, regeneration, the sun, God, and passion.
- Food stuffs represent abundance and thanksgiving.
- A lake represents mystery, depth, and unconsciousness.
- Light stands for the spirit, morality, all, creative force, the direction east, and spiritual thought.
- The moon presents the feminine and fruitfulness.
- Mountains demonstrate height, mass, loftiness, the center of the world, ambition, and goals.
- The sun indicates the hero, knowledge, the divine, fire, creative and life forces, brightness, splendor, awakening, healing, and wholeness.
- Unity signifies spirit, oneness, wholeness, centering, transcendence, harmony, revelation, supreme power, completeness in itself, light, and the divinity.
- Water denotes feminine qualities, life, and the flow of the cycles of life.

Problem Solving

Color Code

To convey the symbolic significance of color, Christian Widmer shows his students at Arizona State University the United States Homeland Security web page and then conducts a discussion about the color-coded Homeland Security Advisory System (HSAS) used to alert the public to the perceived level of a terrorist attack: Red = severe risk of terrorist attacks, Orange = high risk, Yellow = elevated risk, Blue = guarded risk, and Green = low risk of terrorist attacks. Next, they are assigned to make a group of at least five photographs with the subject of each picture being one color from the HSAS, in order from green to red. Each photograph has to connote the threat level, e.g., the green photograph must somehow convey a feeling of low risk, peace, and serenity, using the psychological power of the color. Images should emphasize subtlety, symbol over sign; the use of certain clichéd subjects such as yellow caution tape, orange safety cones, and fruit, is prohibited. Attention is also directed to the editing and sequencing of the photographs (see Chapter 8). The resulting images are then critiqued to determine how effectively they communicate their intent.

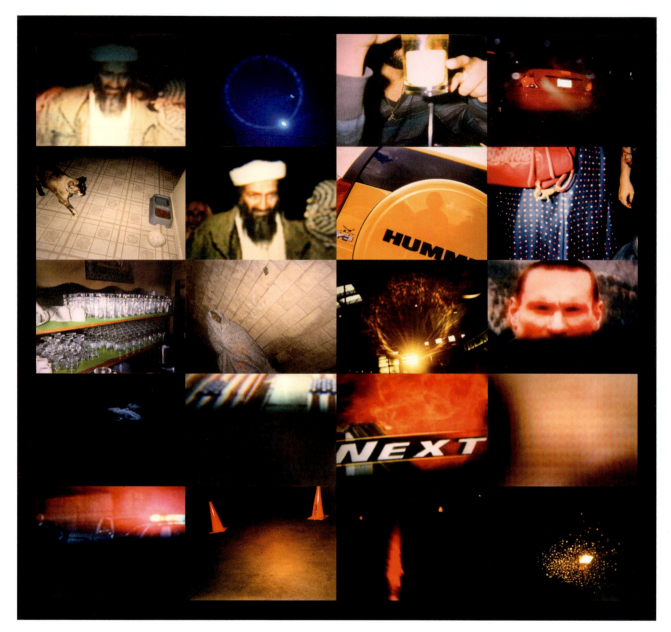

Figure 6.21 In 2007, Katie E. Lehman was one of Christian Widmer's students at Arizona State University. One of his course requirements was a Homeland Security Advisory System assignment, in which one was to make five prints that correspond to each of the five threat level color codes. The usual presentation is a straight line, but Lehman, who saw the images as relating directly to 9/11, went "above and beyond" and made a giant grid.

© Katie E. Lehman. *Security*, 2007. 80 × 80 inches. Chromogenic color prints.

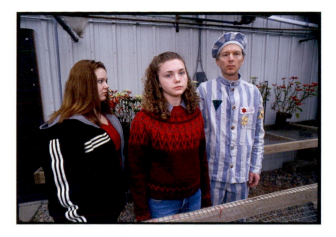

Figure 6.22 James Friedman overcomes his use of such volatile symbols as a Nazi concentration camp prisoner's uniform by sharing his personal history with his subjects and encouraging them to collaborate in the making of the images. His use and understanding of how a 20mm lens can see a scene enabled him to not look through the viewfinder while photographing. The negative was scanned and adjusted in Photoshop to achieve the desired color-contrast and quality.

© James Friedman. *Discussing my life on the run after escaping from Dachau (Germany) concentration camp and eluding my captors*, from *Self-Portrait with Jewish Nose Wandering in a Gentile World #775*, 2000. 24 × 36 inches. Inkjet print.

General Symbols
The following are some general symbol categories:

- Cosmic symbols such as yin and yang (yin: feminine, dark, cold, mystery wetness; yang: masculine, light, heat, dryness), the zodiac (stands for the forces that are believed to govern the universe), and the four humors within the body that control the personality (blood, phlegm, choler (bile), and melancholy).
- Commercial symbols dispense information and/or advertise a service or product to be sold. Examples include three balls symbolizing the pawnbroker, the red-and-white pole signifying the barbershop, international road signs, and logos such as Apple, MTV, and Shell Oil.
- Cultural symbols are mythological or religious concepts that have been changed and incorporated by a culture and become symbolic for a cultural event: St. Nicholas, a tall serious fellow, is now a fat, jolly, and highly commercialized Santa Claus.
- Magical symbols include the Christmas tree, which originated in Rome as a fertility symbol, an emblem of plenty with fruits and nuts decorating it. Cave painting was used to help ensure a successful hunt. Tribal masks were employed for getting the desired results in battle, love, and the search for food. Masks let the wearers both disguise themselves and represent things of importance. This allows

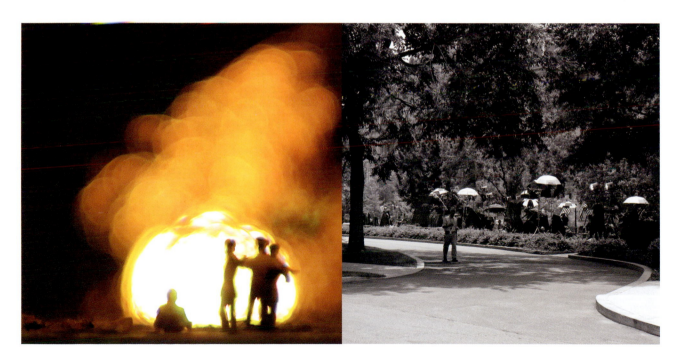

Figure 6.23 In his *Vivaria* series, Michael Bosworth examines the symbology of security by combining photographs of secure areas of the White House with images inspired by the surrounding Washington, DC, neighborhood. He states, "Everyone perceives a relationship between themselves and Washington, a perception with a spectrum from control to disenfranchisement that can alter radically after an election. A chief pursuit of the government has always been the interpretation of documents and symbols, the explanation of their meaning and the construction of supporting narrative." Creating montages of documentary and studio photographs, as Bosworth does here, allows for the creation of a new version of truth.

© Michael Bosworth. *White House, Press Corral*, from the series *Vivaria*, 2008. 20 × 40 inches. Inkjet print.

people the freedom to act out situations according to the desires of their inner fantasies.

▌ Patriotic and political symbols in the United States include the Statue of Liberty, the bald eagle, the flag (stars and stripes), political parties (elephant and donkey), and Uncle Sam. At a glance they provide a wealth of information and express certain concerns and opinions.

▌ Personal symbols are created by artists to meet their particular needs. Some photographers whose works reflect these concerns include Man Ray, László Moholy-Nagy, Barbara Morgan, and Jerry Uelsmann.

▌ Psychological symbols offer a system for investigating the conscious and unconscious processes of the human mind. Sigmund Freud's *The Interpretation of Dreams*, and Carl Jung's *Man and His Symbols* are two watershed works that deal with these ideas. Filmmakers such as Ingmar Bergman and Francis Ford Coppola have emphasized the psychological side of human nature in their works.

▌ Religious symbols, such as the Buddha, the Cross, and the Star of David, stand for the ideas behind the religion such as faith, generosity, forgiveness, hope, love, virtue, and the quest for enlightenment.

▌ Status symbols indicate exact status or station in life of the owner: wedding rings, military insignia, coats of arms, cars, and clothes.

▌ Traditional patterns have been woven into the visual arts for thousands of years. While the pattern remains the same, the context and meaning can change according to the group using it. The swastika is a good example of how this can happen. It has been used as an ornament by the American Indians since prehistoric times, and has appeared as a symbol through the old world of China, Crete, Egypt, and Persia. In the twentieth century, its meaning was totally perverted, from one of well-being to that of death, when the German Nazi Party adopted it as the official emblem of the Third Reich.

Shapes and General Symbolic Associations

Shapes can also have symbolic meaning. Some possible interpretations follow:

▌ The circle is associated with heaven, intellect, thought, the sun, unity, perfection, eternity, wholeness, oneness, and the celestial realm.

▌ The maze delineates the endless search or a state of bewilderment or confusion.

▌ The rectangle often denotes the most rational and most secure. It is used in grounding concrete objects.

▌ The spiral can illustrate the evolution of the universe, orbit, growth, deepening, cosmic motion, the relationship between unity and multiplicity, spirit, water, continuing ascent or descent.

▌ The square may represent firmness, stability, or the number four.

▌ The triangle can represent communication between heaven and earth, fire, the number three, the Trinity, aspiration, movement, upward, return to origins, sight, and light.

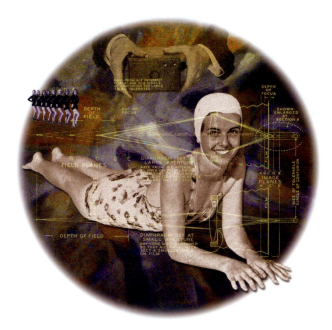

Figure 6.24 Darryl Baird used layers of symbols to "build a narrative to talk about photographic conventions and their origins" and to comment on "the complexity, confusion, and contradiction between pictures and text within an image-conscious culture." Admiring the work of László Moholy-Nagy, Baird worked with "the round image form as a reference to the eye and to photographs, which are round before being cropped in the camera."

© Darryl Baird. *Aqueous Humor # 14*, 2001. 18 × 18 inches. Inkjet print.

Problem Solving

Discover Your Own Interpretation

Now that you have become familiar with symbols and some of their possible meanings, choose one or more of your own pictures and make a list of the symbols you discover in them. Write a description that decodes their meaning for others to consider. Remember, viewers do not have to accept your implied meaning, known as intentionalism. Although the opinion of the maker can and should help provide clues for understanding the work, your interpretation is not the only factor that determines the meaning or sets the standard for other interpretations. Consider what Marcel Duchamp, a co-founder of the Dada group said: "It is the spectator who makes the picture."

NOTES

1. Estelle Jussim, "The Real Thing," in Susan Sontag (ed.), *The Eternal Moment: Essays on the Photographic Image* (New York: Aperture, 1989).

2. Paul Strand, "Comments on the Snapshot," in Jonathon Green (ed.), *The Snapshot, Aperture*, 1974, 19 (1): 49. Also published as a separate book.

RESOURCES

Cirlot, Juan Eduardo. *A Dictionary of Symbols*, 2nd ed. Mineola, NY: Dover Publications, 2002.

Dondis, Donis A. *A Primer of Visual Literacy*. Cambridge, MA: MIT Press, 1973.

Hornung, C.P. *Hornung's Handbook of Design and Devices*, 2nd ed. New York: Dover, 1946.

Jung, C.G. *Man and His Symbols*. Garden City, NY: Doubleday, 1964.

Jung, C.G. *The Red Book*. New York: W.W. Norton & Company, 2009.

Lunde, Paul, ed. *The Books of Codes: Understanding the World of Hidden Messages—An Illustrated Guide to Signs, Symbols, Ciphers, and Secret Languages*. Berkeley, CA: University of California Press, 2009.

Matthews, Boris, trans. *The Herder Dictionary of Symbols: Symbols from Art, Archaeology, Mythology, Literature, and Religion*, rev. ed. Brooklyn, NY: Chiron Publications, 1993.

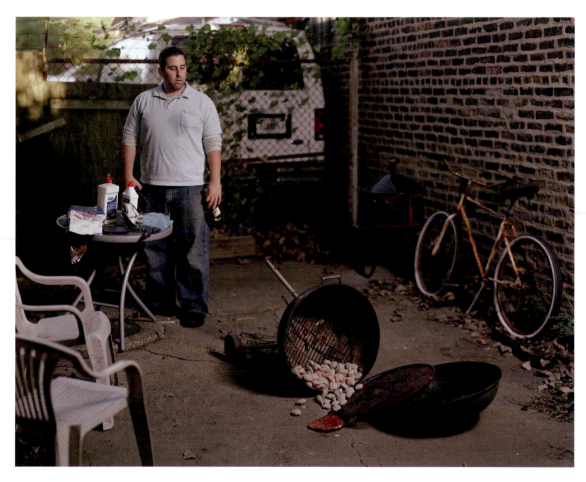

Nathan Baker utilized an 8 × 10-inch camera, to achieve maximum detail, with a 360mm lens, to flatten the image space and produce a static sense of time. Strobe lighting was employed to balance the outdoor exposure and to emphasize specific parts of the composition. Baker recalls, "I set out to conceptualize a scenario depicting the absent, almost unrecognized moment between accident and response—a moment that could illustrate a loss of contrived social identity, which was the crux of the work's meaning. I did this by directing the model to be absolutely static and appear mindless and expressionless, while engineering an incident that seemed both candid and dynamic, but static enough to be photographed."

© Nathan Baker. *T-Bone,* from the series *Rupture, Part One,* 2006. 48 × 60 inches. Inkjet print.

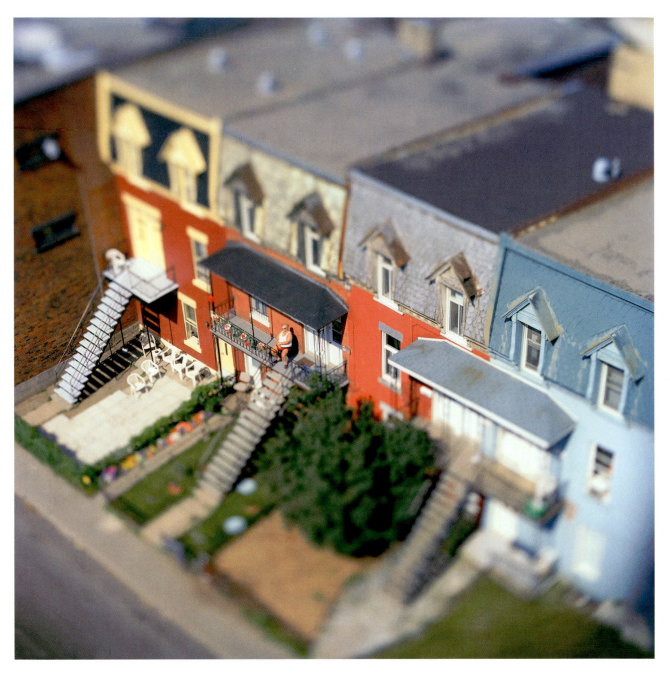

"The most fascinating aspect of photography for me is how it so closely resembles reality … In this series I try to play with this illusion of real and fake in the landscape by utilizing a shallow depth of field to make some parts of the image soft and others in sharp focus. The colors are tweaked to look like old postcards in order to recall a certain American dream, an idealized view of an immediate future typical of the 1950s," Toni Hafkenscheid tells us. Using a Hasselblad Flexbody, which has a tilt-shift feature, enabled the artist to create the narrow depth of field that prompts his exploration of the intersection of reality and fiction.

© Toni Hafkenscheid. *Man Suntanning, Montreal*, 2006. 48 × 48 inches. Chromogenic color print. Courtesy of Birch Libralato Gallery, Toronto, ON.

Working Color Strategies

The Angle of View

One of the major tasks of photographers is to define exactly what the subject is. This capacity to compose and mold content is what gives clarity and cohesion to the artist's experience. The angle of view, or vantage point, is one of the most important basic compositional devices that any photographer has to work with in determining how the image will be presented. It is such an elementary ingredient that it is often taken for granted and overlooked as a tool, even though the angle of view lets the photographer control balance, content, light, perspective, and scale within the composition. In color photography it also determines the intensity or saturation of the hues and whether or not they form color-contrast or harmony. This chapter is designed to encourage you to remove some of the self-imposed limits on visualization and to break away from the accepted, standardized conventions, formulas, and procedures of representation.

Breaking the Eye-Level Habit and Wonderment

Many people just raise the camera to eye level and push the button. A photographer explores the visual possibilities of the scene to find a way in which to present the subject in accordance with the desired outcome.

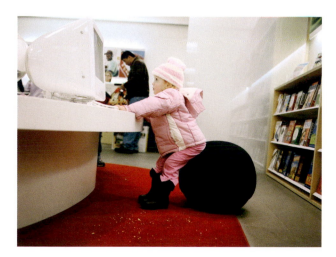

Figure 7.1 Balancing a candid photograph with a composition that required some planning demanded that Brian Ulrich alter his angle of view. He tells us that he was able to take the picture successfully by using "a waist-level viewfinder, which allowed me to be a lot more candid when posing and focusing."

© Brian Ulrich. *Skokie, IL*, 2004. Variable dimensions. Chromogenic color print.

Altering the camera's position does not cost anything or require any additional equipment, yet doing so can transform a subject by allowing it to be presented in a new and different perspective. An unusual camera position can give the viewer more information, let the subject be seen in a way that was not possible before, and/or introduce an alternate point of view. It can make the difference between seeing and sleepwalking through a scene.

Many times we sleepwalk through life because it is so habitual. We walk down a hall without seeing it because we have done so a thousand times before. We are somnambulists visiting familiar territory. We know what to expect; everything is in check and in place. There is no opportunity for surprise, no chance for the unexpected to enter.

To see, you must be awake, watchful, and open to wonderment. Peter de Bolla, in his book *Art Matters* (2001), says: "Wonder requires us to acknowledge what we do not know or may never know, to acknowledge the limits of knowledge. It is, then, a different species of knowledge, a way of knowing that does not lead to certainties or truths about the world or the way things are. It is a state of mind that, like being in love, colors all that we know we know."[1] Wonderment can be experienced in both ordinary and extraordinary situations, and it brings a sense of amazement, astonishment, and awe. Being able to visually communicate these powerful feelings is a surefire way of engaging viewers.

When seeing, you are letting things happen and not relying on past expectations and clichés to get you through the situation. Seeing involves being conscious of color and space, and learning to organize these elements in a convincing manner. The more you look, the more you can experience and comprehend the subject, and in turn are able to see even more clearly and deeply.

Methods of Working

Select a subject that inspires wonderment and proceed to discover how angle and light affect your final visual statement. Here is a suggested method of approach:

- Begin with a conventional horizontal shot at eye level, metering from the subject. Walk around the subject. Crouch down, lie down, stand on tiptoes, and find a point that raises the angle of view above the subject. Notice how the direction of light either hides or reveals aspects of the subject. Move in closer to the subject and then get farther back than the original position. Now make a shot at a lower angle than the original eye-level view. Try putting the camera right on the ground. Look through the camera; move and twist around and see what happens to the subject. When it looks good, make another picture.

- Think about changing the exposure. What happens if you expose for highlights? What about depth of field? Will a small, medium, or large f-stop help to create visual impact? How is the mood altered? All kinds of questions should be running through the photographer's mind at this stage as part of the decision making process. Answering them requires independent visual thinking. Try not to compete with others. Competition tends to lead to copying of ideas and style. Copying means no longer discovering anything on your own. Watch out for envy as it can also take away from your own direction. The best pictures tend to be those that are made from the heart as well as the mind.

- Make a vertical shot. Decide whether to emphasize the foreground or background. How will this decision affect the viewers' relationship with the subject?

- Get behind the subject and make a picture from that point of view. How is this different from the front view? What is gained and what is lost by presenting this point of view?

- If possible, make a picture from above the subject. How does this change the sense of space within the composition?

- Change the focal length of lens that you are using. See what changes occur in the points of emphasis and spatial relationships due to depth of field.

- Move in close. Henri Matisse said, "It's like when you pass a cake shop, if you see the cakes through the window, they may look very nice. But, if you go inside the shop and get them right under your nose, one by one, then you're in business." Look for details that reveal the essence of the entire subject and photograph them. This method of simplification should speak directly and plainly to the viewer.

- Move back. Make an image that shows the subject in relationship to its environment.

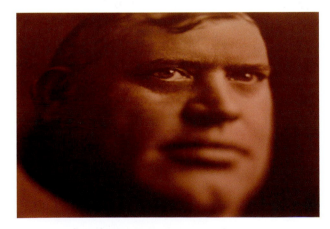

Figure 7.2 In her *Statesmen* project, Sybil Miller reconstructs the portraits of those who once governed our states. "Working close, I was able to isolate the essence of the face. By using an oblique camera angle, I could emphasize the massive head and jaw of my subject. The bronze color results from a mixture of tungsten and daylight sources illuminating the original black-and-white photograph."

© Sybil Miller. *Juneau, Alaska*, from the series *Statesmen—Pictures in the Fifty State Capitols*, 2001. 15 × 22 inches. Chromogenic color print.

- Now do something out of the ordinary. Using your instincts, make some pictures of the subject without looking into the camera. This can be a very freeing experience and can present composition arrangements that your conscious mind had been unable to think of using.

- Do not be shy about conveying your sense of wonderment. The camera is society's license to approach the unapproachable in a manner that otherwise would be deemed unacceptable in a normal social situation. Use this license to make the strongest possible statement without being irresponsible or infringing on the rights of others (see The Photographer's Special License section in Chapter 6).

Working the Angles

Here are five basic shooting angles and some of their general characteristics to consider:

- The bird's-eye view is photographed from high above the subject and can be very disorienting. Since we normally do not see life from this perspective, the subject or event may initially appear unidentifiable, obscure, or abstract. The height of the shot enables the viewer to hover over the subject from a God-like perspective. The subject appears insignificant, reinforcing the idea of fate or destiny—that something the subject can't control is going to happen. Film-makers such as Martin Scorsese combine overhead views, ambiance, and action into a seamless atmosphere of expectation. Wide-angle lenses often are employed to further exaggerate the effects.

- High-angle shots, though less extreme than bird's-eye views, can provide a general overview of the subject by emphasizing the importance of the surrounding environment. However, as the angle increases, the importance of the subject is diminished, and the setting can overwhelm the subject. This can indicate vulnerability, a reduction in strength, or the harmlessness of the subject. It also can deliver a condescending view of the subject, by making the subject appear helpless, entrapped, or out of control. A high-angle shot reduces the height of objects and the sense of movement and therefore is not good for conveying a sense of motion or speed. It can be effective for showing a situation that is wearisome or oppressive.

- Eye-level shots are more neutral, dispassionate, and less manipulative than high- or low-angle ones. The eye-level shot tends to let viewers makeup their own minds about a situation. It presents a more ordinary, normal view of how we see the everyday world. This shot is a favorite style of visual/realistic photographers because it puts the subject on a more equal footing with the observer. A normal focal length lens is usually used when working in this mode.

- Low angles have the opposite effect of high ones. They increase the height of the subject and convey a sense of verticality. The general environment is diminished in importance, as the ceiling or the sky becomes more predominant. At the same time, the importance or visual weight of the subject is increased. A person can become

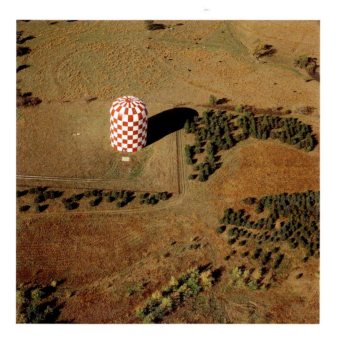

Figure 7.3 The photographer's vantage point can add information to the composition and increase the viewer's desire to spend time looking at the image by presenting work in a way that is not familiar. This image is from an aerial survey of the nature of the prairie from Canada to Texas done during a Guggenheim Fellowship. Photographing from both the air and the ground, Terry Evans's intent is to "tell the prairie's stories, past and present, through visible facts and layers of time and memory on the landscape to reveal its use, abandonment, and care."

© Terry Evans. *Silo, North Platte, Nebraska*, 1998. 19 × 19 inches. Chromogenic color print. Courtesy of Catherine Edelman Gallery, Chicago, IL.

more heroic and bigger than life. Or, a larger figure can dominate the space and become looming, making the viewer feel insecure. Photographing a person from below can inspire respect, awe, or fear. A low angle also tends to present an added dimension to the sense of motion. In a landscape, it can help to create a sense of greater spatial depth by bringing added importance to the foreground.

▌ Oblique angles occur when the camera is tilted, making for an unlevel horizon line. They throw everything out of balance, because the natural horizontal and vertical lines in a scene are forced to become unstable diagonals. A person photographed at an oblique angle appears to be falling to one side. Oblique angles are disorienting to the viewer. They may suggest anxiety, the imbalance of a situation, impending movement, tension, or transition, thus projecting precariousness or imminent change. Haptic/expressionistic photographers often favor shots made from extreme angles. They confine the audience to a particular point of view, which may be very subjective.

Selective Focus

As the keystone of photography has traditionally been based on subject matter, the majority of photographers strive to make pictures that are sharp so that the subject detail can be studied at leisure. The issue of focus was critical in defining serious nineteenth-century artistic practice. During the 1860s, Julia Margaret Cameron's work helped to establish the issue of selective focus as a criterion of peerless practice. The making of "out-of-focus"

Problem Solving

Make a photograph that relies on selective focus to create significance. Consider the following when making your image:

▌ Use the lens's largest aperture, such as f/2.8, to minimize depth of field.

▌ Utilizing manual focus, select the part of the scene you want to be sharp. Ask yourself: What is the most important aspect of the scene? What do you want to emphasize or de-emphasize? What do you want viewers to look at first?

▌ Select a normal or telephoto focal length, as a wide-angle focal length has more depth of field at any given aperture.

▌ Get close to the subject. The nearer you are to the subject, the more critical focus becomes.

▌ Practice focusing back and forth as though you are tuning a string instrument. Go past the point you think works and then come back.

▌ Try tilting the camera and see what an oblique angle does to the focus.

▌ Experiment using slower than normal shutter speeds while handholding the camera.

▌ In a dimly lit situation, try making a series of exposures with the shutter set on the B or bulb setting while using a flash. Holding the shutter down for a few seconds creates a single image with two exposures. The exposure from the flash will be sharp while the ambient light exposure resulting from holding the shutter open will be soft and fluid.

▌ Make use of a selective focus lens such as Lensbaby (www.lensbaby.com).

▌ Utilize a tilt-shift lens or the swings and tilts on a view camera.

▌ Use imaging software such as TiltShift, which emulates a view camera's tilt/shift functions and allows you to simulate the bokeh effect. This refers to the appearance of out-of-focus areas in an image produced by using a shallow depth of field, and with software is done by selecting a focal point and then blurring the background. The effect is especially noticeable in the highlight areas and can be useful in diminishing distractions and emphasizing the primary subject. It also can be simulated with post-production software like Photoshop with Lens Blur, Defocus, or Gaussian Blur Filter.

▌ Manipulate the image focus when making the print.

Figure 7.4 Working with a 4 × 5-inch view camera on the street, Bill Jacobson makes "diffused photographs to explore issues around memory, as opposed to making precise rendering of a scene or moment. I produce images that are analogous to how the mind works, often recording images in fragments or traces that suggest we remember little of the information we are exposed to every day. The images relate to poetry as opposed to narrative, hinting at what we hold on to and what we let go of as we travel through life."

© Bill Jacobson. *Untitled [#3566]*, 2000. 30 × 36 inches. Chromogenic color print. Courtesy of the Julie Saul Gallery, New York, NY.

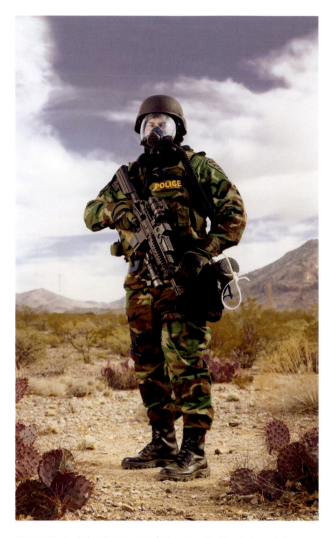

Figure 7.5 Paul Shambroom amplified contrast in this photograph by digitally manipulating the color and tonality and by superimposing the sky from a different negative into this scene. Shambroom's work examines the role of security and fear in our twenty-first century lives. His investigation takes him to "facilities, equipment, and personnel involved in the massive government and private sector efforts to prepare for and respond to terrorist attacks within the nation's borders. First responders and law enforcement officers train in large-scale simulated environments such as 'Disaster City' in Texas and 'Terror Town,' an abandoned mining community in New Mexico purchased with funds from the Department of Homeland Security. Training scenarios, by necessity, involve simulated environments and threats. This blurring of fiction and truth mirrors the difficulty we have discerning between legitimate safety concerns and hyped-up fear."

© Paul Shambroom. *Police SWAT, Camouflage (Tucson, AZ Police Department SWAT, "Terror Town" Playas Training Center, New Mexico)*, from the series *Security*, 2005. 63 × 38 inches. Inkjet on canvas with varnish.

images was considered an expressive remedy that shifted the artificial, machine-focus of a camera toward a more natural vision. Cameron stated that when focusing she would stop when something looked beautiful to her eye, "instead of screwing the lens to the more definite focus which all other photographers insist upon." The Pictorialists, who placed importance on how a subject was handled rather than the subject itself, utilized soft focus to evoke mystery and de-emphasize photography's connection with reality, which helped their work fit into that era's definition of what constituted art. Recently, more photographers have been experimenting with how focus can control photographic meaning.

Contrast with Color

In black-and-white photography contrast is created by the difference between the darkest and lightest areas of the picture. When working with color materials, the intensity and the relationship of one color to another play a vital role in creating contrast.

Complementary Colors

Complementary colors, opposite each other on the color wheel, produce the most contrast. The subtractive color wheel combinations of blue against yellow, green against magenta, and red against cyan form the strongest color contrasts. When looking at the reflected colors of a final print, some people prefer to use the pigment primary combinations of red against green, blue against orange, and yellow against purple as the basis of their discussion. This allows the photographic print to be examined with the same language as the other visual arts, such as painting.

 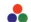

It is thought that complementary colors create such contrast because of fatigue in the rods and cones of the retina. This is because the human eye cannot accommodate each of these wavelengths at the same time. Think of it as a zoom lens that is going back and forth between its minimum and maximum focal lengths, while attempting to maintain critical focus. This is what the eye tries to do with complementary colors.

Warm and Cool Colors

Warm and cool colors can be used to create contrast. Warm colors tend to advance and are called active colors, while cool colors tend to recede and are generally more passive. Dark colors against light ones produce contrast, too. Desaturated colors played next to a saturated one make for contrast. Pastel colors can provide contrast, if there is enough separation between the colors on the color wheel.

Figure 7.6 Gary Goldberg used a Nikon DSLR to capture this antique game arcade window in Brighton, England, photographing it multiple times over the course of the day to determine how best to deal with the reflection in the glass. He tells us, "You can see a hint of a self-portrait in the picture but I was more interested in the warm colors in the lower half contrasting with the cooler colors in the upper portion. I was also intrigued by the ambiguous use of space. There is something mysterious about this photograph, where am I in time, is this real, and why do her eyes follow me wherever I go?"

© Gary Goldberg. *Fortune Teller, Brighton, England*, 2009. 9 × 6½ inches. Inkjet print.

Creating Color Contrast

Color contrast can give emphasis to a subject photographed against a complementary background. Areas of contrasting colors can create a visual restlessness that imparts a sense of movement within the scene. Active and passive colors can flatten the visual space and bring patterns to the forefront. Warm and cool colors can be used to produce a sense of balance within the picture. Dynamic tension can be built by placing active colors next to each other in the composition.

Color Harmony

Harmonic colors are closely grouped together on the color wheel and present a limited group of colors. Any quarter section of the color wheel is considered to show color harmony. The simplest harmonic compositions contain only two colors that are desaturated in appearance. The absence of any complementary colors makes it easier to see the subtle differences in these adjacent hues. Evenness in light and tone can help bring out the harmonic color relationship. Saturated colors that are close to each other on the color wheel can still produce much contrast and interfere with the harmony.

Color harmony is found everywhere in nature. Passive colors tend to be peaceful and harmonize more easily than the warm, active hues.

Problem Solving

Make photographs that incorporate one of the following color-contrast effects:

▪ Complementary contrast. Use colors that are opposite one another on the color wheel, such as a yellow building against a blue sky.

▪ Active and passive contrast. Use a warm color against a cool one. The proper proportions of each are critical in making this work.

▪ Primary contrast. The juxtaposition of two primary colors can make for a bright, vibrant, and strong sense of feeling.

▪ Low contrast. A quiet, easy, restful mood can be achieved by using a neutral background as a staging area. A simple, dark backdrop can be employed to offset a light area and slow down the visual dynamics of the picture.

▪ Complex contrast. Complex contrast uses many contrasting primary colors and requires careful handling, or the point of emphasis can become confused or lost in an array of colors. With the proper treatment, the multicolored use of contrast can cause tremendous visual excitement and provide a strong interplay of the objects within a composition while connecting seemingly diverse elements.

Refer to your instantaneous image display to see how the image is functioning and respond to it by making changes as you work.

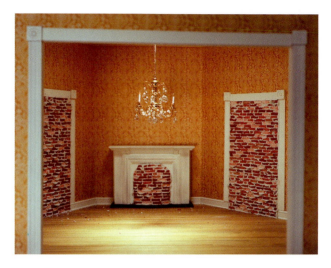

Figure 7.7 Christine Shank used a 4 × 5-inch camera to make multiple exposures on one sheet of film, and then scanned the resulting negative and outputted the image as a LightJet print. The complementary colors that dominate this image lend a sense of calm to the scene, which the artist constructed to show the outcome of a devastating event. She explains, "The disasters depicted in the images—a room overflowing with crumpled paper, bricked up passageways, oceans of sand, and car headlights on an abandoned mattress —allude to past events, and the potential of events awaiting us in our future. These spaces have a constructed history that is manufactured in order to tell a story of human feelings and experiences. I titled these images with a line from a story that I feel can be interpreted on different levels and directs the viewer in the image while allowing room for personal interpretation."

© Christine Shank. *They chose to smile and pretend nothing had changed*, from the series *Interiors*, 2005. 24 × 30 inches. Chromogenic color print.

Harmony Is Subjective

Harmony is a subjective matter, and its effectiveness depends on the colors involved, the quality of light, the situation, and the effect that the photographer wants to produce. The actual visual effect depends on the colors themselves and the quality and intensity of light striking them. Blue and violet are adjacent to each other on the color wheel and therefore, by literal definition, in harmony. The effect created tends to be visually subdued. Go to the other side of the wheel and take orange and yellow. These two colors harmonize in an animated fashion.

Harmonic effects can be reinforced through the linkage of colors by repeating and weaving the harmonic colors throughout the composition. This places importance on patterns and shapes within the picture. Soft, unsaturated colors in diffused, subdued light have been a traditional way of creating harmonious relationships of colors. Avoid brilliant lighting, as it makes harmonious colors more cacophonous. Special attention in framing the picture is necessary. Be aware of exactly what is in all corners of the frame. Eliminate any hue that can interfere with the fragile interplay of the closely related colors.

In an urban, human-made environment there is a strong likelihood of encountering discordant, unharmonious colors. This happens when contrasting colors are placed next to each other in such a way to create a jarring, or even unpleasant,

combination to view. Care in the use of light, the angle of view, and the right mixture and proportions of these discordant colors can introduce balance and vitality into a flat or static composition.

Methods to Create Harmony

Basic techniques to orchestrate a mood of unison include using a slight amount of filtration in front of the lens that matches the cast of the color of the light in the scene, desaturating the hues through the use of diffused light, or using a soft filter in

Problem Solving

Select one of the following areas and make a calm, peaceful, harmonic color photograph. Look for those in-between, undramatic moments and subjects that often go quietly unnoticed.

- Color harmony as found in nature. Pay close attention to the compositional location of the horizon line. Make a landscape that does not follow the traditional compositional rule of thirds. Photograph a scene with little or no sky. Make a skyscape with little or no foreground. Be on the lookout for symmetry in nature. One way to get repetition is to include reflections. This can be especially useful when there is water in the picture. If the harmony produced by cool colors is too uninviting or stand-offish, try to add a small area of a muted complementary color. This can draw warmth and interest back into the scene. Look for a detail from the landscape that can provide what you are after in a simplified and condensed manner. Showing less can let the viewer see more.

- Urban color harmony. Find a place where people have consciously and deliberately made an effort to blend human-made creations into an overall scheme. Flat lighting can be used to play down the differences in the various color combinations within an urban setting. Smooth, early morning light can be employed for the same effect. Try to avoid the visual hustle and bustle that tends to bring forth visual chaos. Finding scenes of calmness and stillness within a busy cityscape will help to achieve harmony.

- Still-life is a perfect vehicle for creating a working color harmony. The photographer can assume total responsibility for controlling the selection and arrangement of the objects, the background, the quality of light, and the camera position to ensure a harmonic composition. The sparing and subtle use of filters can enhance the mood of harmony.

- Harmonious portraits can be created by simplifying the background, selecting clothes and props to go with the subject, and integrating neutral colors and similar shapes. Soft directional lighting can minimize complementary colors. Placing tracing paper, at a safe distance to prevent fire, in front of any light source is a simple and inexpensive way to diffuse the light and gain control. A bare bulb, ring light, or diffused flash can be valuable in a situation of this nature.

front of the lens. Incorporating neutral areas, which provide balance within the picture, can de-emphasize differences in diverse colors. Both contrasting and harmonic colors can be linked together by working with such basic design elements as repeating patterns and shapes. Look for common qualities in balance, rhythm, texture, and tone to unite the colors. Also, the white balance mode can be adjusted to produce a warmer image and various filter effects can be applied after image capture.

Dominant Color

Dominant color occurs when the subject of the picture becomes color itself. The painter Paul Cézanne observed, "When color is at its richest, form is at its fullest." Painting movements such as Abstract Expressionism, Color Field Painting, and Op Art have explored different visual experiences that are created through the interplay of color. Works that make use of this method tend to use color itself to express emotions or mood. The color relationships can affect all the ingredients that makeup a picture. Colors

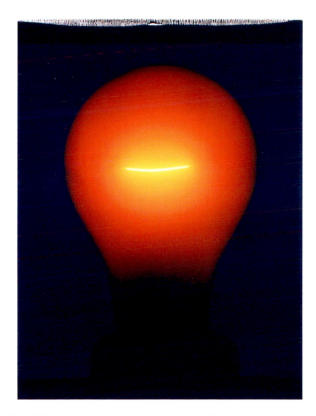

Figure 7.8 Amanda Means combined a 60-watt GE tungsten bulb and an Aristo cold light placed behind it with Rosco filters and a variety of exposure times to express the organic nature of the mundane. Means says, "This bulb is full of hot coals—the coals remain when the flames have died down. Its deep blue-black background provides another hot/cold juxtaposition. The filament here is a smile. A bulb smile. A coal smile. A hot smile."

© Amanda Means. *Light Bulb 00050C*, 2001. 24 × 20 inches. Diffusion transfer print. Courtesy of the Gallery 339, Philadelphia, PA.

can be used to create calm or tension. They can create the illusion of depth or make things appear flat.

Simplicity

When putting together a composition, keep things simple. Beware of incorporating too many colors into the picture as this can create visual confusion when the different colors are in competition to dominate. Let one hue clearly predominate. The proportions of the colors in the scene will determine which is the strongest. A small area of a warm color such as red can balance and dominate a much greater area of cool color such as green.

Dominance may be achieved with a small area of a bright color against a field of flat color. A large area of subdued color also can be dominant. The value of a hue is a relative quality and changes from situation to situation (see section on color description in Chapter 1).

Maintaining a Strong Composition

The dominant color must retain a working arrangement with the main point of interest in the picture. If color is not the subject, then it should reinforce and enhance the subject. Do not let the two clash, or the viewer may have a difficult time determining what is the purpose of the picture. A conflicting message can confuse the audience, so be directorial and provide a well-marked visual path for the eye. Employ strong colors to attract the viewer's attention. Once you have it, do something with it. Use tight, controlled framing to make strong graphic effects. Pay attention to shape. Get close and eliminate the nonessentials.

Isolated Use of Color

The energy and the visual spark of a hue depends more on its placement within a scene than on the size of the area it occupies. Imagine a scene of cool, harmonious colors that are even, smooth, and unified. Now add a dot of red. Pow! The contrasting color surprises the eye and instantly becomes the point of

Problem Solving

Plan and execute a photograph that uses dominant color(s) to reveal form at its fullest and to create a sense of space. Fill your composition in a way that allows viewers to experience the perceptual and physical space of the color(s). Think of the sense of sound you get when listening to music on a high quality music system or when wearing good headphones. It's the same when you are reading a good book; you give yourself over to the experience that the artist is creating. In this case, convey that feeling through your use of color. Experiment with various White Balance and filter settings. Do they generate new emphasis and meaning or artificially interfere with your objective?

Figure 7.9 The use of isolated color in this image heightens conflict between reality and fabrication in the scene dealing with the US invasion of Iraq. David Levinthal has used toys and figurines throughout his career, viewing them as ideal components for building alternate realities. Through these constructed environments, he investigates myth and truth in American society, here focusing on the impact of the Iraq War. He states, "I have always viewed toys as both an abstraction and as a tool by which a society and a culture socializes itself. The choice of which and what kind of toys are created, how they are posed, and what they are attempting to represent reflects assumptions about a society's views."

© David Levinthal. *I.E.D. 124*, from the series *Iraq*, 2008. 43⅛ × 55⅝ inches. Inkjet print. Courtesy of Stellan Holm Gallery, New York, NY.

emphasis, with its solitariness standing out as a point of concentration. Its individuality also introduces needed variety into the picture space.

Most colors have the greatest luminance when they appear against a neutral setting. Warm colors visually step forward, adding depth and sparkle into a picture that was flat. On an overcast or dusty day in which everything looks and feels of the same dimension, add a small amount of a warm hue, and contrast, depth, drama, emphasis, and variety will appear out of this sameness. Warm colors also can be used as dynamic backgrounds that offset and/or balance monochromatic subject matter. Do not underestimate the power an individual color can have on the entire composition.

Executing a Plan: Being Prepared

Often getting this single color in the right place at the right time requires a photographer to be ready in advance. Anticipating the moment greatly increases the chances of this happening. Being prepared also enhances the likelihood of something useful happening. Coordinating the light, background, and proportion of the isolated color means the photographer needs to feel comfortable and confident with the equipment and techniques used. Practice and readiness are the prerequisites that let the image-maker take advantage of chance opportunities.

Check out the situation carefully. Ask in advance, which focal length or lens is needed to get the correct proportion of that single color into the composition? Be ready to improvise.

If the lens's focal length isn't long or short enough, will getting closer or backing away make it work? Approach each new situation with openness, allowing adaptation and accommodation to enter into the picture-making process.

Getting the right amount of a unified color background is generally one of the first items necessary to catch this touch of color in the picture. Next comes the actual placement of that hue. Third is being sure of the correct exposure.

For example, a monochromatic sky is the backdrop and the spot of warm color is located on ground level in the shadow area. There are numerous exposure possibilities available, depending on the desired outcome. If detail is to be retained in both areas, take a meter reading from the sky and one from the foreground and average them together. If the sky is f/8 and the ground is f/4, the exposure for that situation would be f/5.6. If detail in the foreground area is critical, meter for the key shadow area by getting in close or tilting the camera downward, so the sky is not included. Or, if the light is similar where you are standing, take a reading off your hand. Also, try switching metering patterns, such as from Average to Spot. In any case, the sky will receive more exposure than necessary. Review your exposures and correct as necessary. Additional corrections, such as dodging and burning, can be made during the printing process.

Movement can initiate visual excitement. Placing the camera on a tripod and using a slow shutter speed to introduce a warm object in motion against a static monochrome setting can produce it.

Monochrome

Some people think that a good color photograph must include every hue in the spectrum. Often reducing the number of colors in the composition is more effective than assaulting viewers with a rainbow.

A narrow definition of a monochromatic photograph would be one that uses only a single hue from any part of the spectrum. In a broader sense it can be a photograph that achieves the total effect of one color, even though there are other hues present.

When putting together a monochrome picture, a photographer can call into play knowledge, judgment, and understanding of composition that have been developed in black-and-white photography (Figure 7.11).

The Personal Nature of Monochrome

Monochromatic photographs can create powerful moods. For instance, when we feel down, we say we are blue; we don't say we feel yellow or orange. Utilize such associations in building your image. Monochrome simplifies the composition so that we tend to react more subjectively and less rationally. The photograph is

Problem Solving Box

Use one or more of the previous suggestions to make a photograph that employs isolated color to achieve its effect.

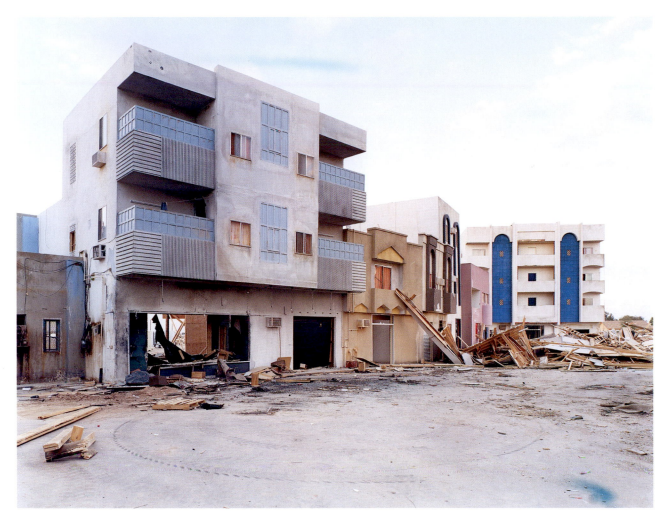

Figure 7.10 Getting this photograph was a race against time for Andrew Phelps, as he happened upon the location when the sun was about to set and the structures were about to be demolished. Fortunately, he had his large-format camera ready and just enough sheets of film left to take the picture. The scene is a movie set for a film that takes place in Riyadh, Saudi Arabia, but was being filmed outside of Higley, Arizona. This intersection of disparate locations addresses "current, critical political issues in the Middle East, as much of the Western world's experience in Iraq is one steeped in misunderstanding and misconceptions. Why do we believe what we choose to believe?"

© Andrew Phelps. *Baghdad Suite 03*, 2008. 20 × 24 inches. Chromogenic color print.

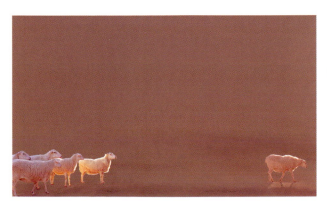

Figure 7.11 Allison Hunter used a 35mm SLR to photograph sheep at the Houston Zoo. She then scanned her negatives and digitally manipulated the composite image to remove the background and draw out a monochromatic palette. Hunter explains her process: "I am interested in making people think about how they perceive and respond to the elements of the world around them that are often marginalized or overlooked. I approach this problem in my artwork by taking things out of context to show their beauty, grace, and uniqueness. My effort is not to add but to remove elements from the original image to allow the viewer to focus more intently on the process of displacement and reinterpretation."

© Allison Hunter. *Untitled #14*, 2007. 30 × 50 inches. Chromogenic color print.

taken not so much as a document to be read for information but as an event that elicits a subjective sense of time and place. It can alter the normal flow of time and flatten the sense of visual space.

Exposure is critical to maintaining a fragile color and atmosphere. Monochromes need not lack contrast. Subdued colors and harmonious colors can be employed to give monochromatic impressions. Analyze your exposures and fine-tune while you work.

Environmental Color Contamination

When dealing with a monochromatic image, beware of what is called environmental color contamination. This occurs when a colored object within the scene reflects its color onto other items within the picture area. It also can be caused from outside the frame, such as when a photographer's bright plaid shirt reflects back onto the subject. Color contamination is most noticeable when working with white items. It is even possible for a white object to make another white object appear to be off-white. Careful observation of the scene and the arrangement and selec-

tion of objects to be photographed is the best way to avoid this problem. Post-capture correction can be attempted when color balancing before final output.

Aerial Perspective

Aerial perspective occurs when the atmospheric scattering of light mutes colors in distant scenes, so the tones appear progressively paler as the landscape recedes. The blending and softening of colors in this condition can help to create a monotone rendition of a scene. Be aware that aerial perspective also makes distant objects bluer. A UV filter is recommended with film. A slight warming or yellow filter can also be used at pre- and/or post-exposure to compensate.

Perspective

Perspective allows the artist to give two-dimensional work the illusion of the third dimension and controls the illusion of depth. Light and shadow begin to provide depth, but the actual illusion

Figure 7.12 Robert Glenn Ketchum made this aerial photograph from a bush plane. He used a Pentax 645 camera and Fujichrome film, which he then scanned and printed digitally. Guided by a moral imperative to protect the environment, Ketchum has been using photography as an advocacy tool for decades. His work has influenced the conservation movement, and he states that no matter his subject, "I have always been engaged by the practice of photography in all of its marvelous forms, and my image library has always been based in nature."

© Robert Glenn Ketchum. *The Allen River Enters Lake Chauekuktuli*, 2001. Variable dimensions. Chromogenic color print. Courtesy of Fahey/Klein Gallery, Los Angeles, CA.

Make a photographic image that uses the monochromatic color concepts to create its visual force. Direct the mono-chromatic effect to elicit a mood. The following situations offer starting places for monochromatic pictures in which both the color and detail are simplified: early morning, late in the day, storms, rain droplets, dust, pollution, smoke, iced or steamed windows, plus scenes that contain diffused light and lower-than-average contrast. Other techniques that can be employed to mute colors include deliberate "defocusing" (putting the entire image out of focus) or selective focus-ing, moving the camera while the shutter is open, soft focus methods such as a diffusion or soft focus filter or a piece of window screen, and the use of filters both before and after capture.

Figure 7.13 Making this digital montage required Richard Koenig to distort the vantage point of the various elements so that the perspective appeared "correct" throughout the composite image. Koenig's process of rephotog-raphy serves "as a way of exploring the inherent tension that exists within photography—provided by its capacity to both depict and deceive, concur-rently. In this work, space, planes, and objects themselves are presented in such a way as to underscore photography's ability to tell untruths. In this way I coax the viewer to question the nature of photography itself—by making them aware that they are looking at, and perceiving, a photograph, not looking at the subject matter of the photograph."

© Richard Koenig. *Untitled (Gallery 2)*, from the series *Photographic Prevari-cations*, 2007. 9½ × 14 inches. Inkjet print.

that one item in the composition is closer to the front than the other is brought about through the use of perspective.

Basic Types of Perspective Control

The following are eight basic types of perspective control com-monly used in photography:

- Aerial perspective is the effect in which colors and tones become blurred, faded, and indistinct over distance due to atmospheric diffusion. The colors in the foreground are brighter, sharper, and warmer and have a darker value than those farther away. There is a proportional decrease in lu-minance and warmth with distance, which can be reduced with a UV and/or warming filter such as the 81A and 81B.
- Diminishing scale creates depth by using the fact that we assume that the farther an object is from the viewer, the smaller it seems. By composing with something large in the foreground and something smaller in the middle or background the photographer can add to the feeling of depth. It also is possible to trick the viewer's sense of depth by reversing this order.
- Linear perspective happens when parallel lines or planes gradually converge in the distance. As they recede, they seem to meet at a point on the horizon line and disappear. This is called the vanishing point.
- Limiting depth can be accomplished visually by incor-porating a strong sense of pattern into the composition, which tends to flatten the sense of space in the picture.
- Overlapping perspective occurs when one shape in the picture is placed in front of another, partially obscuring what is behind it. This is a good compositional device to indicate depth.
- Position makes the visual assumption that objects, when placed in a higher position within the picture, are farther back in space than those toward the bottom of the frame. The same rules that apply to diminishing scale apply to position.

- Selective focus is another method open to photographers to create the illusion of depth. To the eye, a critically focused object set off by an unsharp object appears to be on a dif-ferent plane. Employing the maximum lens opening is a way to separate the foreground from the middle ground and background. Since the depth of field is extremely limited, whatever is focused on appears sharp, while the detail in the remainder of the picture is destroyed. Utilizing a wide-angle focal length and placing a lens so near a subject that it cannot be sharply focused encourages viewers to actively search the picture for something sharp. Using a longer-than-normal focal length lens reduces the amount of depth of field at any given f-stop. The longer the focal length of the lens, the less depth of field it will have at any given aperture.
- Two-point linear perspective can be achieved by photo-graphing the subject from an oblique angle (an angle that is not a right angle, meaning it is neither parallel nor perpen-dicular to a given line or plane). This is most easily seen in a subject that has vertical parallel lines such as a building. When viewed from a corner, two walls of the building seem to recede toward two vanishing points rather than one. The closer the corner of the building is to the center of your composition, the more a sense of depth, distance, and space is attained. If the building is placed in one of the corners of the frame it flattens one of the walls while mak-ing the other look steep.

Figure 7.14 Jeff Van Kleeck approaches perspective by using swings and tilts on his 4 × 5-inch view camera to decrease depth of field. By having a narrow plane of focus, he is able to manipulate a large landscape to create the appearance of a miniature scene. Van Kleeck tells us, "I am interested in the difference between how we create meaning from what we actually see and what we bring to the experience from our memories. In this series I am interested in the differences between how much information is needed in an image for a viewer to understand the landscape and how their own memories inform their experience."

© Jeff Van Kleeck. *Harpers Ferry*, 2001. 16 × 20 inches. Dye-destruction print.

Converging Lines

A common problem photographers encounter when dealing with perspective is converging vertical lines. For example, when trying to make a picture of the entire front of a tall building, it is possible that the camera may have to be slightly tilted to take it all in or that a wide-angle lens is necessary; both of these options cause the vertical lines to converge. Convergence can be visually pleasing because it emphasizes a sense of height.

If you need to maintain correct perspective and keep the vertical parallel and straight, a perspective-control shift lens is required on a 35mm camera. On a larger-format camera raising the front or tilting the rear allow for perspective correction. It is possible to minimize this effect by moving farther away from the building and using a longer focal length lens. This often is not possible in a cramped urban setting. With a digital image,

post-capture corrections can be applied. If negative film is being used, there is another course of action available. In the printing stage, tilt the easel upward to correct the converging vertical. If the enlarger permits, tilt the lens stage as well to maintain image sharpness. Use a steady prop to make sure the easel does not move, focus in the middle of the picture after the easel is in position, and use the smallest lens opening possible to get maximum depth of focus.

Problem Solving

Make a photograph that utilizes one or more of the perspective control methods in this chapter to make a strong visual statement.

 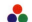

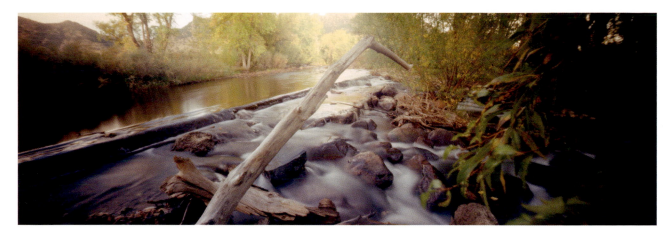

Figure 7.15 Todd Dobbs used a pinhole camera and a long exposure to emphasize the converging lines in this Colorado landscape. He enjoys using pinhole cameras for their simplicity and the manner in which they closely connect the photographer with the source of visual experience. He says, "Pinhole cameras give me the freedom to escape the demands of an instant society; they force me to stand and wait while light is gathered onto the film's surface. The subject matter I am attracted to is a welcome contrast to the technologically heavy spaces I typically inhabit. The combination of camera and subject provides a meditative space that allows me to slow down and reflect."

© Todd Dobbs. *South Boulder Creek*, 2008. 12 × 36 inches. Inkjet print on canvas.

Subdued Color

Subdued color photographs tend to possess a uniform tonality and contain unsaturated hues. Soft, flat light mutes colors. Subdued colors can often be found in aged and weathered surfaces. Color can be subdued by adding black, gray, or white through the use of lighting or exposure, or by selecting desaturated tones. Delicate colors can occur in failing evening light, when shadows add gray and black. Low levels of light reduce saturation. Any form of light scattering, such as flare or reflection, introduces white, thus desaturating the colors. Choice of backgrounds can make certain colors appear less saturated. A limited or low range of tones mutes color and can be used to induce drama, mystery, sensuality, and the element of the unknown.

Figure 7.16 A subdued sense of color dominates this image, a gumoil print made with layers of hand-applied oil paint. Karl Koenig explains that he deliberately matches his subjects with the appropriate photographic process. "For large, rather impressionistic images, I depend mostly on gumoil, a full palette of oil paint for pigment, and cold press cotton paper ... I try to make pictures that are beautiful at first blush and somewhat more disturbing upon reflection."

© Karl Koenig. *Wall Street*, 2000. 14 × 10 inches. Gumoil print. Courtesy of Albuquerque Museum, Albuquerque, NM; State Capitol Art Collection, Santa Fe, NM; and Princeton University, Princeton, NJ.

Working Techniques

Consider these techniques when working with subdued color:

- Use light that strikes the subject at a low angle.
- Expose for the highlights, which allows the shadows to be dark and deep. Bracket the exposures until you can judge the final effect.
- Minimize background detail by using a higher shutter speed and a larger lens opening.
- Intentionally use the subject to block out part of the main source of illumination. This produces a rim lighting effect, which also reduces the overall color-contrast and tonal range.
- Employ a dark, simple, uncluttered background.
- Select a major color scheme of dark hues.
- Work with a diffused or weak source of illumination. This often occurs naturally in fog, mist, or storms. The effect also reduces the scene's tonal range.
- Use a diffusion filter. If you do not have one, improvise with a stocking or a piece of cloth or apply one with post-capture software.
- Work with a limited color palette.

Figure 7.17 Janyce Erlich-Moss used a 4 × 5 view camera to photograph this landscape, which she constructed with Mylar. She explains, "I manipulated color, form, and emotional tone to confuse viewers into accepting these synthetic scenes as real, but somehow alien. I used contrasting cool and warm tones, often complementary, with selectively placed tungsten lights and colored gels, to create a sense of depth and dynamic tension and thus alter viewer reaction. While the gestalt of the image suggests a common natural subject, further inspection reveals the unfamiliar and evokes the ambiguous nature of reality."

© Janyce Erlich-Moss. *Complex*, from the series *Reflected Realities*, 1985. 16 × 16 inches. Chromogenic color print.

Problem Solving

Make use of at least one of the previous working techniques to produce a photograph that relies on subdued color for its impact.

Opposites: Colors Attract and Repel

Everyone responds positively to certain colors and negatively to others. This also applies to combinations of colors. Think about what colors are included most often in your own work. Do these colors appear regularly in other areas of your life, such as in the colors of the clothes you wear or in how you have decorated your living quarters? Which colors do not make many appearances in your work? Are these colors also avoided in other aspects of your life?

Overcoming Color Bias

After making the pictures in the problem solving box below, look at them and see what associations their colors created for you. What effect does changing the natural color of an object create? Working with a color that you dislike may still lead to something beautiful and meaningful. Awareness of this alerts us that our preferences and dislikes in color and in life often result from prejudices, which are a manifestation of inexperience, lack of insight, and the failure to think for ourselves. Do you really hate the color orange or was it your mother's least favorite color? Question yourself about these things. Keep your possibilities open so that you can explore your full potential.

Pairs of Contrast

Use color to make pictures that express pairs of contrast. The object of prime visual importance is not only the actual subject matter in the scene but the colors that makeup the scene. It is the colors themselves that should be used to express the ideas of contrast.

Problem Solving

Possible pictures to make with colors that attract and repel you include:

- Make one picture that emphasizes your favorite color or combination of colors. What are the qualities of these colors that are appealing to you?

- Make another picture that deals with colors that you have an aversion to. What is it about these colors that you find off-putting?

- Change the color and/or color saturation of a known object through the use of light or paint at the time of exposure, or by means of unnatural color balance or filter pack when outputting.

- Present the results as a diptych.

 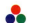

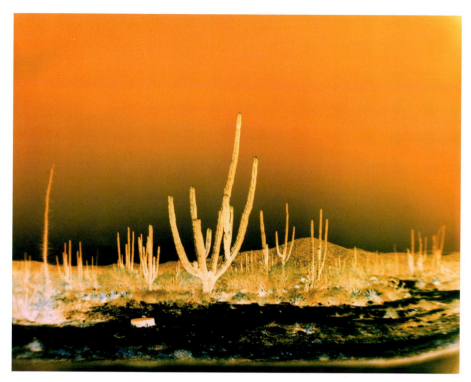

Figure 7.18 A home-made pinhole camera constructed in a vintage Volkswagen van serves as Jo Babcock's imaging device of choice. The van, which has a 42-inch lens mounted like a periscope on its roof, functions as a gigantic solar enlarger. Babcock made a six-second exposure of this desert scene during late morning, producing a paper negative that reveals colors opposite of what the viewer expects to see. He states, "These solar enlargers on wheels birth unearthly landscapes, distorted roadside attractions, and scenes of destruction. I view my van cameras as postmodern versions of the horse-drawn photographic wagons previously driven by early western photographers."

© Jo Babcock. *Desierto Central, Baja*, 2001. 40 × 70 inches. Paper negative. Courtesy of Steven Wolf Fine Arts, San Francisco, CA.

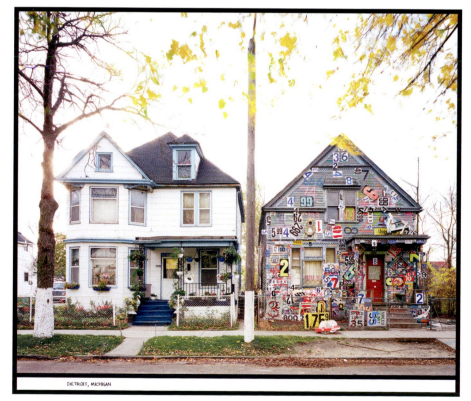

DETROIT, MICHIGAN

Figure 7.19 Jim Stone scanned his 120 color negative film in order to digitally retouch and print this image, choosing to use a drum scanner for its ability to accurately process the grain of color negatives. The resulting print depicts counterpoints in the form of a neatly kept house with a manicured lawn and its next-door neighbor, a home with a more adventurous exterior decoration scheme. Stone tells us, "No work of fiction, nothing in a personal fantasy, could be as endlessly compelling and fascinating as the real world around us … The investigations represented here hinge on what can be inferred from the visible and are made more complex by the invisible but unmistakably non-neutral presence of the artist as an observer. By triangulation, subject/artist/audience, these photographs reveal how divergent interests actually unite us."

© Jim Stone. *Detroit, Michigan*, 1996. 24 × 30 inches. Inkjet print.

Counterpoints

Consider these counterpoints: ambivalence and decisiveness, bright and dull, calm and stormy, evil and good, fast and slow, female and male, happy and sad, hate and love, high and low, individual and group, intimacy and distance, large and small, mature and young, old and new, peaceful and warlike, seduction and horror, and soft and hard. Counterpoints also can be purely visual in nature—angular and flowing, or sharp and circular—or more conceptual, relying on the play of opposites, such as inner and outer reality or the natural and the fabricated. They also may be political and/or social in nature.

NOTE

1. Peter De Bolla, *Art Matters* (Cambridge, MA: Harvard University Press, 2001), p. 143.

Problem Solving

Make a photograph that deals with the use of pairs, or counterpoints, such as those listed in the previous section, as its major theme. What are your reactions to these pairs of color contrasts? Are they what you expected? When shown to an audience, do the reactions to the color associations seem to be consistent or do they vary widely from person to person? What does this tell you about the nature of color response? What is the effect if the pairs are represented simultaneously?

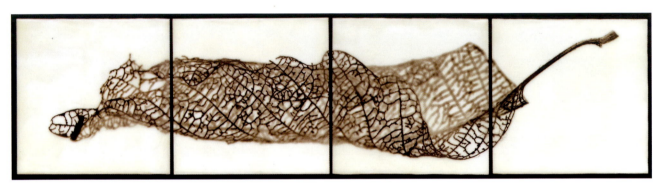

Showing how artists can shift between electronic and handmade methods, Christa Kreeger Bowden utilized a flatbed scanner to capture this leaf that was then digitally inverted, split-toned, and finally painted with wax. She tells us, "Inverting the image to a negative allows me to explore a subject's line and form, akin to drawing. I like to push my work beyond the computer, and involve tactile process with finished piece. I accomplish this by cutting the finished prints into sections, mounting them on wood panels, and painting them with encaustic wax. I have found the encaustic wax creates a new surface and sculptural dimensionality to the work, and readily plays off the shallow depth of field attained with the flatbed scans."

© Christa Kreeger Bowden. *Skeletal Leaf*, 2009. 10 × 40 inches. Inkjet prints on wood panels with encaustic wax.

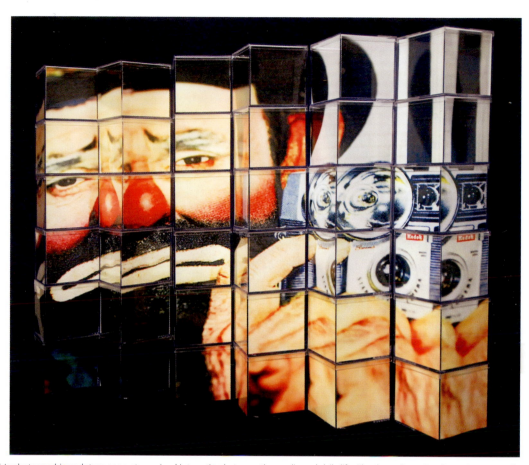

Robert Hirsch's photographic sculpture generates a visual interaction between the media and daily life. The three-dimensional mosaic contemplates the camera's societal role during the 1960s. Hirsch states, "It is a Socratic process that allows me to engage in a philosophical and visual dialogue with other times, places, and makers. This allows me to act as a photographic etymologist who makes inquires into the metaphysical contradictions and opposing social forces that swirl around the evolution of how pictures are understood."

© Robert Hirsch. *Emmett Kelly and his Kodak Brownie,* from the series *The 1960s: A Cultural Almanac 2009.* 40 × 72 × 24 inches. Laser prints and plastic cubes. Courtesy of CEPA Gallery, Buffalo, NY.

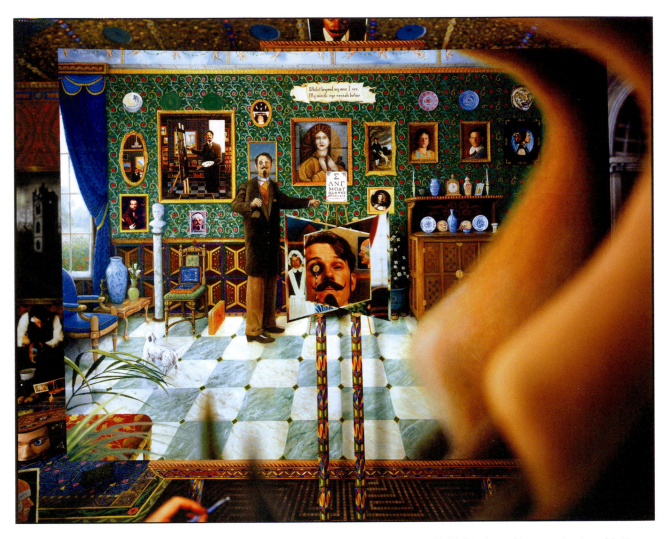

Bill Adams builds photographs out of existing photographs, using an 8 × 10-inch view camera to capture his fabricated sets of images and scale models. He stages the scenes and plays all of the characters, producing what may initially appear to be straightforward photographs, but upon closer inspection reveal a more complex image. In doing so, the artist simultaneously tells the narrative depicted in the photograph and exposes the story of making the picture. Adams tells us that this composite image "represents the visual perspective of a nineteenth-century artist and amateur scientist who attempts to paint an eye test, closing one eye to assist him in realistically rendering what the subject sees, including his own large blurry nose … It is intended to challenge photography as a standard of realism by proposing it as someone else's inadequate standard of realism."

© Bill Adams. *Trompe L'Oeil #3*, 2006. 28 × 38 inches. Chromogenic color print.

The Interaction of Color, Movement, Space, and Time

The Search for Time

Most of us, like the philosopher/theologian St. Augustine, think we know what time is until someone asks us to explain it. Even for contemporary scientists, the nature of time remains mysterious. In 1905, Albert Einstein's Special Theory of Relativity revealed that commonly held concepts concerning time were not always true. For instance, Newton's notion that time moved at a constant rate was proved wrong when it was demonstrated that time passes more slowly for rapidly moving objects as compared with slow ones. The conviction that two events separated in space could happen at precisely the same time—simultaneity—was shown to be false. Since whether two events appear to happen at the same time depends on the viewer's vantage point, no one observer has any intrinsic claim to be the authority.

Einstein's work produced even more fantastic conclusions about time. For example, clocks run faster at the top of a building than in the basement. Succinctly, Einstein tells us there is no universal time or no master clock regulating the essence of the cosmos. Time is relative and it depends on motion and gravity. Time and space are not simply "there" as a neutral, unchanging backdrop to nature. They are physical things, malleable and mutable, no less so than matter, and subject to physical law.

The Flow of Time

When the majority of us think of a photograph, we tend to think only of a tiny slice of time, removed from the flow of life with a frame around it. Everything is still, there is no sense of movement, and that brief instant of time is there for examination. This

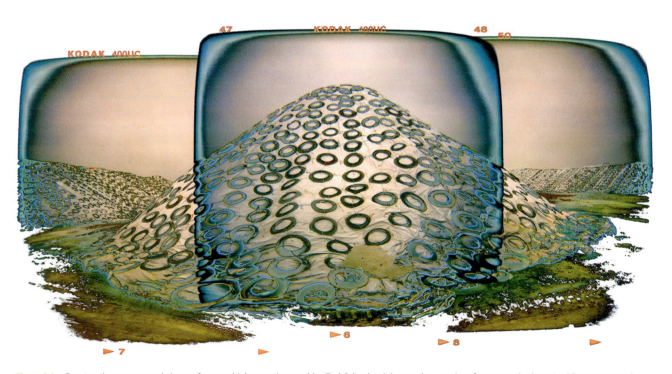

Figure 8.1 Constructing a panoramic image from multiple negatives enables Ted Orland to join together a series of moments in time. Avoiding automated stitching programs, he prefers to make his composite images manually, by performing a variety of layering and blending functions, in order to maximize his decision making process as an artist. In making these pictures Orland uses a plastic Holga camera, explaining that "technically, I think we all look for tools and techniques that become a natural extension of our own spirit. With a single-element plastic lens that filters out excessive sharpness so that realism doesn't get mistaken for reality, the Holga pretty much sees the world the same way I do. So I just carry it with me most everywhere, and then photograph whatever crosses my path. My theory is that if you lead an interesting life, you'll make interesting art. How could it be otherwise?"

© Ted Orland. *Just Another Tired West Coast Landscape Photograph*, 2005. 19 × 36 inches. Inkjet print.

Western convention of reality, based on Renaissance perspective, has come to dictate that photographic representations be presented like evidence at a trial—clear and sharp. "The more readable the detail, the better the picture," is a photographic maxim that has been the standard of a picture's worth for many people. This has been based on the assumed modeling of the camera, with its lens and recording material similar to that of the human eye's lens and retina. Some critical thinkers have challenged this concept, stating:

> The notion that a photograph shows us what we would have seen had we been there ourselves has to be qualified to the point of absurdity. A photograph shows us "what we would have seen" at a certain moment in time, from a certain vantage point if we kept our head immobile and closed one eye and if we saw things in Agfacolor ... By the time all the conditions are added up, the original position has been reversed: instead of saying that the camera shows us what our eyes would see, we are now positing the rather unilluminating proposition that, if our vision worked like photography, then we would see things the way a camera does.[1]

This chapter calls into question basic photographic axioms dealing with the representation of time and space. It asks you to consider photographic time as a collection of distinct, captured moments, which when combined generate a flowing visual stream of human experiences. This notion is not meant to discourage photographers from working in a traditional mode but to encourage exploration in unfamiliar territory. Topics discussed emphasize a cross-pollination of analog and digital processes. With all topics, when working with a digital camera, rely on its image display to make adjustments as you photograph.

Mastering Digital Layers

Layering combines multiple elements into a single photographic work, altering time by depositing new data upon previous data. Historically, photographers have worked with physical layers, such as multiple exposures, optical filters, and texture screens, as well as dye and paint, to extend a photograph's creative potential. Digital layers are an aesthetic equivalent, and thus mastering their use is a key function in the unity of digital and silver practices.

Digital layering allows photographers to freely add, subtract, and manipulate an image without damaging the original image files. Software tools, such as History, Merge, and of course Undo, allows one to time-travel and change the past. Additionally, there are thousands of effects that can be applied in countless layers that can alter the original time capture. Using layers allows you to experiment, pause, study, rework, and form good image-building work habits, revealing that technological advances have not affected the underlying creative process.

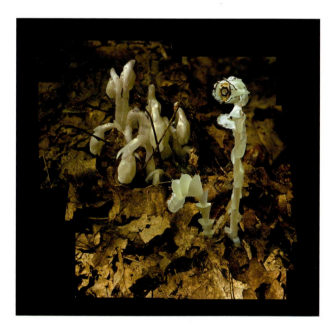

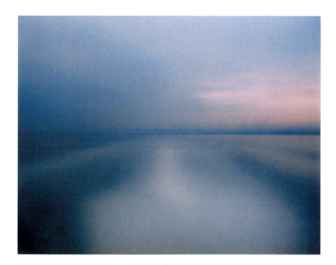

Figure 8.2 Stefan Hagen captured the flow of time by taking one photograph over the entirety of each of 24 consecutive rides on the Staten Island Ferry in a single day. Individually, his time-based images record the duration of a journey, while collectively they give a stylized interpretation of the cycle of light, reminding us that often we retain only indistinct details of an event. "Each photograph creates an image that contains all time and place experienced during the travel experience using the unique ability of the photographic process to collect light."

© Stefan Hagen. *Crossing the Upper New York Bay-One Day, 8:46 AM–9:03 AM, Manhattan-Staten Island*, 2001. 22 × 28 inches. Chromogenic color print.

Figure 8.3 Using a Nikon DSLR with a micro lens to closely focus on each angle and part of this plant enabled Kathryn Vajda to make dozens of photographs, which she then layered in Photoshop to create a composite image. She manually color-corrected and layered the photographs into a single readable image to maintain control over the outcome. She tells us, "The only way to preserve the detail of Indian Pipes and to print them two to three times their height was to combine many detailed close-up photographs. They are composed to maximize clarity and interest through subtle light and temperature shifts."

© Kathryn Vajda. *Indian Pipes and Other Parasites 2*, 2009. 28 × 27 inches. Inkjet print.

Controlling Photographic Time

While relativity mathematics shows how the rate of time differs depending on velocity, it does not explain why time seems to pass more slowly or rapidly, depending on how tedious a given activity is or how eagerly we anticipate a future event. This chapter encourages the photographer to engage great riddles that stumped even Einstein, such as the glaring mismatch between physical and psychological time. Surely Einstein would admire imaging software that can selectively alter photographic time in an existing image file through various motion techniques.

The major ramification of relativity is that time is not a series of moments—some not yet having occurred — but rather a block in which we exist at a specific position, much the way we exist at one point in space. The rest of the universe exists even though we are in only one place at one time; perhaps the remainder of time already exists even though we have not visited the future. Since Einstein, physicists have generally rejected the notion that events "happen," as opposed to merely existing in the four-dimensional space/time continuum. The discrepancy between the frozen "block time" of physics and the flowing subjective time of the human mind suggests the need to rethink our concepts about time. Most humans find it impossible to relinquish the sensation of flowing time and a moving present moment. It is so basic to our daily experience that we reject the assertion that it is only an illusion or misperception. During the early days of moving pictures, the practice of "reversing," or running the film backwards, provided a uniquely photographic experience that altered a basic concept of how we were taught to perceive our world. Digital imaging software has further altered our realities of photographic time and how it is managed and applied. As many of Aristotle's theories point out, personal experience and/or intuition is by no means a trustworthy guidepost to scientific understanding. This is regularly demonstrated when people convicted of a crime on the basis of eyewitness testimony are freed after DNA analysis scientifically proves them innocent. By letting go of our ingrained notions about photographic time, we can begin to incorporate new ways of enquiring into and portraying time using photo-based images, with or without digital intervention.

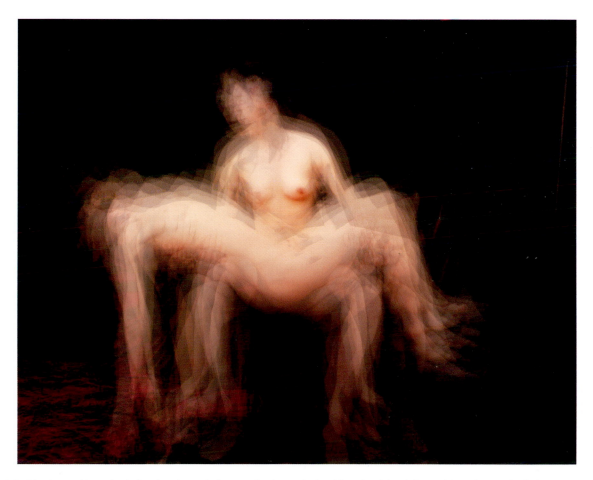

Figure 8.4 A background in mechanical engineering and a longstanding interest in the philosophy of time influenced Atta Kim to make the long exposures that define his *On-Air Project*. To capture these images, the artist leaves the shutter open for an hour or more, condensing an expanse of time into a single photograph. Here, Kim references Michelangelo's *Pietà*, a Renaissance image that he injects with dynamism, life, and the passage of time.

© Atta Kim. *Maria*, from the *On-Air Project*, 2005. 74 × 91¾ inches. Chromogenic color print.

Breaking Away from 1/125 of a Second

By adjusting the shutter to a slower speed and thus increasing the time of exposure, we can increase the amount of time encompassed by the photograph. When the amount of time incorporated into the image is increased, more events become involved in the structure of the composition. This extended play of light on a subject can have spectacular results. As light is recorded over a period of time a new fascination with color emerges as the hues swim together and blend into new visual possibilities. A new way of seeing and experiencing is presented to the viewer. Past conditioning has ingrained the concept that the photograph is supposed to be a single frozen moment (the "Decisive Moment"). Maybe the photograph isn't only a distinct, isolated moment, but made up of many moments. The simplest way to begin to break away from the standard 1/125-second mentality is by working with the different methods of dealing with motion.

Breaking into Digital Blur and Motion Effects

The basic blur effects in most software programs are located in the top Menu Bar under Filters and found in the Blur tool set. Effects such as Motion Blur, Radial Blur, Shape Blur, and Lens Blur are found here, and their names reflect established photographic naming conventions. Select all or any part of a digital image file and apply whatever blur effect is desired. All blur effects will give the option to control the blur level, blur distance, and blur direction. The advantage of digital blur techniques is that you can selectively apply more than one blur technique to a single image, which is impossible with analog methods.

Stop Action

Stopping the action of an event can be achieved by using a fast shutter speed or flash in conjunction with a high ISO. Freezing motion offers the viewer the opportunity to see something that happens too quickly for the eye to fully comprehend. It also offers a way to stop an event at a critical point of the action for further analysis and study, thereby providing the viewer with a new way of visualizing a situation.

Anticipation and timing are crucial to the capture of the climax of an event. Whenever possible, watch and study the action before shooting. Become familiar with how the event takes place. When shooting a stop-action photo, select the appropriate vantage point and lens, and then preset both the exposure and focus, taking care to use the smallest possible aperture to attain maximum depth of field. A wide-angle focal length allows more room for error because it provides more depth of field at any given aperture than a normal or telephoto lens.

The telephoto focal lengths can be used to isolate the action. A minimum depth of field separates the subject from the background. Prefocusing or using autofocus lock becomes critical, because any inaccuracy results in the subject being out of focus.

The shutter speed needed to stop motion depends on the speed of the subject, its direction and distance from the camera, and the focal length of the lens (see Box 8.1). The nearer the subject or the longer the lens, the higher the shutter speed

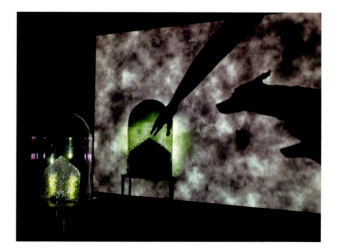

Figure 8.6 Heidi Kumao creates video installations that she documents by employing stop-action techniques. She first composes video pieces with After Effects software by montaging found and original photo stills and movie excerpts, and then she projects the video onto objects, such as a bell jar and an envelope, and the wall behind them. She freezes time by pausing the DVD player in order to photograph moments from the video. Kumao explains that *Timed Release* is a "series of intimate image theaters about surviving confinement. Generated from the interplay between projected animations, household objects, and their shadows, these video sculptures are inspired by historic and contemporary individuals that have developed a creative refuge in order to endure extreme physical containment."

© Heidi Kumao. *Correspondence*, from *Timed Release*, 2008. Video projection and mixed media.

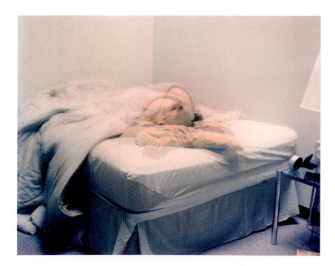

Figure 8.5 Brian Moss combined long exposures and multiple f-stops to make portraits of his own body over many hours of sleep during the night. His images capture an aspect of everyday life that is not typically observed. "The images allude to several contradictory aspects of being: life and death, movement and stillness, darkness and light."

© Brian Moss. *5-24-01*, from the series *Dormire (Where am I when I'm asleep?)*, 2001. 24 × 30 inches. Chromogenic color print.

Box 8.1 Shutter Speed Needed To Stop Action Parallel To The Camera With Normal Focal Length Lens

- 1/125 second: most everyday human activities, moving streams and rivers, tree in a slight wind

- 1/250 second: running animals and people, birds in flight, kids playing, balloons and kites, swimmers, waves

- 1/500 second: car at 30 miles per hour, bicyclists, motorcyclists, baseball, football, tennis

- 1/1000 second: car at 70 miles per hour, jet airplanes taking off, skiers, speedboats, high-speed trains

needs to be. A subject moving across the frame requires a higher shutter speed than one approaching head-on or at the peak of its action.

Another way to stop action is with imaging capture software, which allows individual frames of moving images from DSLR HD (high-definition) video or on a disk to be singled out for use. In all cases, use your camera's image display to make adjustments as you photograph.

Dim Light and Flash

In dim light, flash rather than shutter speed can be used to stop action. The ability to stop movement is dependent on the duration of the flash. A normal flash unit usually gives the equivalent speed of between 1/200 to 1/500 second. Fractional power settings can supply much faster times, up to 1/10,000 second.

Blurred and Out-of-Focus Images

Blurred and out-of-focus images are as inherent to photographic practice as those that are clear and crisp. The blur interjects the suggestion of movement and uncertainty into the picture. This bends the traditional concept of photographic time, producing a miasmatic image capable of representing a sense of the past, the present, and the future. The blur can eliminate traditional photographic detail, revealing a subject's physical and emotional essence while destroying the notion of a discrete parcel of framed time depicting the past. By confronting viewers with change itself, the blur can provide a sense of suspension in the eternal process of becoming. The lack of focus frees the images from the confines of photographic exactitude by offering a different representation of reality.

Begin your experiments by determining what shutter speed is needed to stop the subject's movement in relation to the camera position. A slower shutter speed causes more blur and consequently more contrast between the moving and static areas. This effect can isolate a static subject from its surroundings. Consider which details are crucial and need to be retained. Decide whether it will be more effective to blur the background or the subject. Continue to draw on your camera's image display to make modifications while photographing.

Figure 8.7 Bill Armstrong experiments with blur and focus by making collages of found photographs and reworked photocopies and then rephotographing them. Using various distances and random slow shutter speeds, he sets the focusing ring of his camera at infinity to intentionally blur the collage into an integrated, seamless image. "This sleight of hand allows me to conjure a mysterious trompe l'oeil world that hovers between the real and the fantastic. The nature of visual perception intrigues me: How the eye continually tries to resolve these images, but is unable to do so, and how that is unsettling. This technique enables me to blend and distill hues, creating rhapsodies of color that are meditative pieces—glimpses into a space of pure color."

© Bill Armstrong. *Portrait #302*, 2000. 30 × 36 inches. Chromogenic color print. Courtesy of ClampArt Gallery, New York, NY.

The Pan Shot

The camera can be intentionally moved while the shutter is open to create a blur. One of the most effective ways to convey lateral movement, while freezing the subject and blurring the background, is the pan shot. Rangefinder cameras are easier to use for this because, unlike most DSLRs and all SLRs, they contain no moving mirror to black out the viewfinder during exposure. With practice, most cameras can be used with success.

Begin with a subject whose movement and speed are consistent. To accomplish the pan shot, use a slow ISO, holding the camera comfortably in the horizontal position. Prefocus on the spot that the subject will cross and set the needed shutter speed. For example, 1/15 of a second can be used to pan a vehicle

moving at 30 miles per hour and 1/30 of a second for 60 miles per hour. Correlate the aperture setting with the shutter speed, using the smallest aperture to get maximum depth of field. Frame the subject as soon as possible. Do not tighten up or hold the camera with a death grip; stay loose. Make the pan even and smooth by following the subject with your entire body, not just with the camera. Gently release the shutter as the subject fills the frame and continue to follow through with the motion. Generally, take care not to crowd the subject. Leave it some space to keep moving unless containment is the object. After you learn this technique, try incorporating some variations such as panning faster or slower than the object in motion. Using a slow shutter speed and intentionally moving the camera in nonparallel directions from the subject can make further motion effects.

Many random elements enter into these situations that involve long exposures. The result becomes a deliberate combination of prepared intent and chance, with the unpredictability of these situations adding to their fascination. Through practice and use of the camera's monitor, one can shape the outcome.

Moving the Film

Film movement can achieve the effect of blending colors in motion. Put the camera on a tripod and hand crank the film (by depressing the film rewind button) past the shutter during exposure using a speed of 1/8 of a second or slower. Note: Only older manual film cameras that require the film to be manually rewound can achieve this effect.

Equipment Movement

Equipment-induced movement can provide an exaggerated sense of motion. Consider the following ideas:

- Use a wide-angle focal length. This produces dramatic feelings of motion when employed to photograph movement at close range and at a low angle. The exaggerated sense of perspective created by this lens produces distortion and causes background detail to appear smaller than normal, thereby losing visual importance. Conversely, foreground objects seem larger and more prominent.

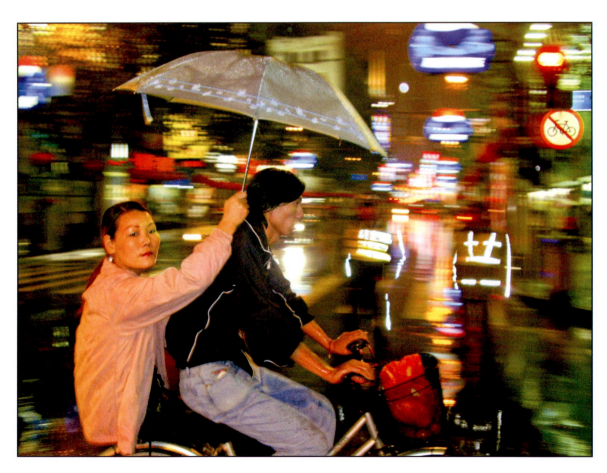

Figure 8.8 Pan shots allow Pedro Meyer to explore photographic time manipulation. Here he captures a couple riding a motorcycle by following their steady speed with his camera and representing their movement with a blurred background. Meyer appreciates the experimental possibilities of photography, stating, "I would hope that we are at a stage when we can actually liberate photography and unleash its great creative potential in order to make great documentary fictions that make us see the world in new ways."

© Pedro Meyer. *Looking Out After Her Man, Shanghai, China*, 2006. Variable dimensions. Inkjet print.

- A multi-image prism that fits in front of the lens is another possibility. Its use requires care because it has been overused. When a piece of equipment is used in place of an idea, the result is a gimmick. If a photographer has to resort to gimmicks, control of the situation has been lost. However, when equipment is used to strengthen and support an idea, an imagemaker is working with a technique.

- The zoom lens is one of the most popular and useful pieces of equipment available to photographers, but it falls into the same danger category as the prism. When used as a tool, the zoom lens can extend the range of photographic vision. One of its most common uses is zooming during exposure to create the illusion of motion. In this method blurred streaks of color come out of the center of the picture. It is a way to give a stationary subject the feeling of momentum. Put the camera on a tripod, set the lens to its longest focal length, and focus on the critical area of the subject. Start at 1/15 second and then make a series of exposures using even longer times. Be sure to change the aperture to compensate for changes in speed. Zoom back to the shortest focal length as the shutter is tripped. Varying the zoom speed and/or stopping and starting the zooming operation will produce different effects. Be prepared to make a number of attempts. Use your metadata or write down the exposure information so that you know which combination produced each picture. Do not depend on your memory. Part of any learning experience is the ability to use the acquired skill in future applications. It helps to practice the zooming technique before making any exposures so the operation becomes second nature. Once you learn the basic method, it can be combined with other techniques.

- The pan zoom technique requires a photographer to pan with the subject while zooming and releasing the shutter. The camera needs to be on a tripod with a pan head. One hand is used to zoom while the other works the panning handle and shutter. A cable release is helpful, as is an assistant to fire the shutter at your instruction.

- The tilt zoom technique needs a tripod with a head that can both pan and tilt. Follow the same basic zoom procedure, but use longer exposure times (start at 1 second). Try tilting the camera during the zoom while the exposure is being made, and then try working the pan into this array of moves. The long exposures give the photographer the opportunity to concentrate on a variety of camera moves.

Free-Form Camera Movement

Colored sources of illumination at dusk and after dark give a photographer the possibility of weaving line and pattern into a still composition. With a stationary light source, try using slow shutter speeds (starting at 1/8 second) while moving the camera in your hand. Start by making simple geometric movements with the camera while visualizing the effect of the blending and overlapping of color and line. If the camera being used is a DSLR or SLR, try to sight above the viewfinder or to not look at all, going by feel and instinct. Using a wide-angle focal length should make this easier. If the camera is jerked and waved about too much, the resulting color patterns and lines tend to become confusing.

Moving lights can put color and motion into a static environment. With the camera on a tripod, use small apertures to make exposures at 10, 20, 30, or more seconds. Try not to include bright, nonmoving lights because they will become extremely overexposed and appear as areas with no discernible detail.

Flash and Slow Shutter Speed

The combination of flash with a slow shutter speed permits the incorporation of stillness and movement within the same scene. It is an impressionistic way of increasing ambiguity and mystery. The effects can be varied depending on the amount of flash to ambient light and by the amount of movement of the camera (if it is handheld) or the subject or both. Check your manual for specific details about how to operate your flash.

Start work in the early morning, evening, or on a cloudy day when the ambient light level is low. A neutral density filter or slow ISO rating is needed when shooting in brighter light. A basic working technique is to cut your standard ISO rating by one-half and use this new rating to take a normal exposure reading of the scene (ambient light). Set your flash with the same modified ISO rating. Determine the flash exposure based on the distance of the key object(s) in the composition. If the ratio of flash to ambient light is the same, the color palette will be soft. As the ratio of flash to ambient light is increased, the color palette tends to become more saturated. Use an exposure speed of 1/4 second or longer. The flash exposure freezes the subject and the length of exposure time determines the amount of movement that is apparent in the image. Bracketing your exposures and movement is a good idea until you gain a sense of how this interplay works.

Extended Time Exposures

Using the B or T setting, long exposures can be made over a period of time with the camera attached to a tripod. Utilize a cable or electronic release to avoid camera shake. Employ a small lens aperture or a slow ISO to make the exposure longer. For even longer exposures, put neutral density filters in front of the lens. Avoid bright static sources of light. Reciprocity law failure causes a shift in the color balance. Film remains an option for extended exposures, as digital cameras can be affected by image noise and battery drain under these circumstances. If desired, post-capture software can be applied to reduce the image noise.

Clouds, lighting, wind, and passing lights can introduce a sense of motion and create a mood. Other atmospheric effects, such as moonlight and star trails, can be achieved with exposures starting at about 30 minutes and up (see Table 8.1). Wide-angle focal lengths are recommended for increased coverage, and the location needs to be away from ambient light sources. Generally include a foreground reference, such as a building or a tree, for scale and sense of place. For maximum star trails, make long exposures on clear, moonless nights. If the moon is too bright, the star trails will not be visible and the image can begin to resemble daylight, although the light from the

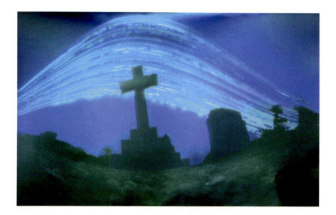

Figure 8.9 Justin Quinnell made this solargraph by exposing photographic paper in a pinhole camera for a period of three months, scanning it into his computer without development, and then digitally printing the image. The resulting photograph captures both the static elements of the landscape, such as the gravestones, and the constantly moving components, such as the sun. During this extended passage of time, in addition to being a part of the deaths of the strangers whose graves appear here, Quinnell experienced both deaths and new life in his immediate family. He says, "The image not only contains the exact time of my father's death but also the time of my daughter's first steps and all the other events of a three-month period."

© Justin Quinnell. *3 Months in the Death of Grace, Blance and Dorcus*, 2008. Inkjet print.

TABLE 8.1	**STAR TRAILS EXPOSURES AT F/2.8, ISO 50**
	Exposure Time
No moon	1½ hours minimum
Quarter moon	1 hour
Half moon	30–60 minutes
Full moon	10–20 minutes

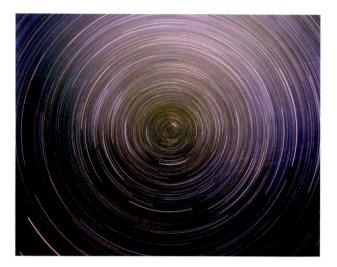

Figure 8.10 Trevor Paglen, an artist and geographer, tracks satellite trails instead of star trails. This photograph is a 4-hour time-lapse exposure of the sky over the Sierra Nevada that records the orbits of at least nine American and Russian reconnaissance satellites. Paglen explains, "I use the stars as reference points to align a computer-controlled telescope mount, but they are not the focus of my attention. Instead, I'm interested in far more obscure astronomical objects: The nearly 200 classified American spacecraft gliding through the skies. The satellites I'm interested in are 'secret' in the sense that there is little or no official acknowledgement of their existence."

© Trevor Paglen. *Nine Reconnaissance Satellites over the Sonora Pass*, 2008. 60 × 48 inches. Chromogenic color print. Courtesy of Altman Siegel Gallery, San Francisco, CA, and Galerie Thomas Zander, Köln, Germany.

moving moon may fill in the shadows that would otherwise be cast by the sun in a daylight photograph. An FL-D filter can cut the garish green color cast from the fluorescent light in office buildings that may be included in nocturnal cityscapes. Also, experiment with various White Balance settings. Some digital cameras have a Night or Star mode. Others have a B (Bulb) or T (Time) mode that allows you to keep the shutter open. Some cameras have optional remote controls and releases for optimum control. Also, if your camera has a mirror lock, use it to reduce vibration.

Rephotography

Rephotography is when a photographer returns to a subject that had been previously photographed and attempts to make the same picture again to show how time has altered the original scene. Precise records are maintained so the returning photographer can more easily duplicate the original scene. The original

photograph and the new one are usually displayed next to each other to make comparison easy.

In another form of rephotography, the photographer returns to the same subject over a period of time. Examples of this would range from making a picture of yourself every day for a week to Alfred Stieglitz's photographs of Georgia O'Keeffe that span decades. The relationship of the photographer and the subject is pursued over a period of time. The results should represent the broad range of visual possibilities that can be produced from this combination due to changes in feeling, light, and mood.

Multiple Exposures

Making more than one exposure on a single frame offers another avenue of exploration. Try it out in a controlled situation with a black background. Light the setup, mount the camera on a tripod, prefocus, and calculate exposure time based on the number of exposures planned. A good starting point is to divide the metered time by the number of planned exposures. For example, if the normal exposure is f/11 at 1/4 second, two exposures would be f/11 at 1/8 second each. The total exposure time should equal the metered time. Certain digital cameras have a Multiple Exposure Mode. A film camera with automatic exposure control can do the

Figure 8.11 Before working on location, Mark Klett and Byron Wolfe do extensive fieldwork online to track down archival photographs. They then analyze, manipulate, and layer the images together to create a montage that spans a period of decades. On location, in this case in the Grand Canyon, the artists use Leaf digital backs attached to Mamiya 645 medium-format cameras to capture the scene in the twenty-first century. Klett and Wolfe's final composite images explore the possibilities of rephotography "to envision a location over multiple periods of time by layering images from different eras along with our own into one combined scene. Being able to do this onsite allows us to compare our experience of the place to what we had imagined from the historic photographs that led us to the location."

© Mark Klett and Byron Wolfe. *Reconstructing the view from El Tovar to Yavapai Point using nineteen postcards*, 2008. 44 × 144 inches. Inkjet print. Courtesy of Etherton Gallery, Tucson, AZ, and Lisa Sette Gallery, Scottsdale, AZ.

same thing by multiplying the ISO by the number of exposures and then resetting the meter to that new speed. For instance, if the ISO is 400 and you want to make two exposures, change it to 800.

Try varying the amounts of individual exposure times. This can give both blurred and sharp images as well as images of different intensity within one picture. Repeated firing of a flash provides multiple exposures when the camera shutter is left open on the T or B setting. Move the subject or the camera to avoid getting an image buildup at one place on the film.

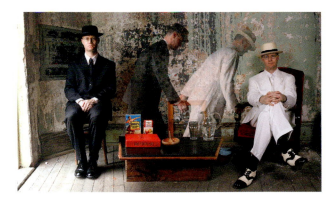

Figure 8.12 Pamela de Marris composited this photograph from four negatives, the first taken with natural light and the subsequent three with artificial light. She used double exposures with some of the negatives to emphasize her subject's various personalities. de Marris tells us, "This image visually describes a man who grew up in Scotland and works in the arts as a museum director. The space where the image was made is an abandoned third-floor meeting place in the 1930s and 1940s for upper class men. Props were carefully selected, with some having been shipped directly from Scotland for authenticity."

© Pamela de Marris. *Graeme*, 2005. 72 × 42 inches. Inkjet print on canvas.

Layering Multiple Images Together

Since photography's invention, photographers have utilized either physical or digital layers to build a photographic work. A simple way to work with more than one film image is to sandwich a transparency or negative film together into a single film holder and print. Working digitally, you simply Copy and Paste several digital files into a new image document and control the opacity of each digital layer. With film and traditional color printing, transparent color tints can be added to create physical layers to modify the atmosphere. These tints can be made from any transparent medium or by photographing discrete portions of any subject, such as the sky or a wall, and sandwiching these images of color with other images. When working digitally you can create extra tinted or textured layers that will work together with the image layers. Bracketing camera exposures also provides a range of color choices from high-key to supersaturated.

Expose the Same Roll Twice

Another multiple exposure idea is to run the film through the camera twice or to import multiple images into a single document file, creating digital image layers that can be manipulated individually. For film, cut the ISO rating of the film being used by one-half. Try photographing the same subject, from a different point of view, at a different time of day, closer up, or farther away, or photograph an entirely different subject. If you want the frames to line up, mark or cut a small V-shaped notch on the edge of the film. Make a pencil mark inside the camera body, below the film plane, which will serve as a guide to realign the film. A similar result can be obtained with Layers in your imaging software. Make a contact sheet of the roll and examine it carefully. What new ways of seeing and composing has the unexpected provided? How can this new knowledge be applied

to other, maybe more controlled shooting situations to expand your visual limits?

Painting with Light

Using light as a paintbrush requires setting the camera on a tripod with a medium-to-small lens aperture. Start with a subject against a simple backdrop in a darkroom. Prefocus the camera, and then use a small pocket flashlight with a blind to control the amount and direction of the light. Leave the lens open (use the T setting or the B setting with a locking cable release). By wearing dark clothes, one can quickly walk around within the picture and draw with the light without being recorded by the sensor or film. Imagine how the light is being recorded. Since the final effect is difficult to anticipate, make a series of exposures, and review as you work. Vary the hand gestures used with the light source to see what effect will be created. Colored gels can be applied to any light source to alter its color output. The gels can be varied to introduce a range of hues into the scene. As experience is gained, more powerful light sources, such as strobes and floods, can be used to cover larger areas, including outdoor scenes. Digitally, this effect can be accomplished using several layers with the Neon Glow effect and the Brush tool.

Slide Projection

A digital or analog projector with a zoom lens can also be used to paint a scene with light (by placing a colored gel or gels over the lens) or to project an image onto a scene to create a layered visual effect. Try using old images/slides, making new images/slides of the same subject, using black-and-white slides, appropriating images or text from other sources, projecting more than one image, projecting different images into different parts of the composition, or using the zoom lens to vary the size of the projection. For a naturalistic color balance, make certain the White Balance setting or film type matches the color of the light source. Filters in front of the camera lens may be necessary to make color corrections.

Postvisualization

After image capture, the darkroom and digital studio offers one an opportunity to expand and induce movement and time into a still scene. Application of these postvisualization methods can break down the photographic notion that time is a mirror rendering the appearance of nature into the hands of humans. These methods let one increase the possible modes of exploration within the image. Possibilities include the interaction between positive and negative space, between different aspects of the same event, between static structure and movement, and between the viewer and the object being viewed. Be ready to experiment and rely on your visual knowledge and insights. Although many of the methods in this section are analog, they can also be accomplished with Layers using any digital imaging software.

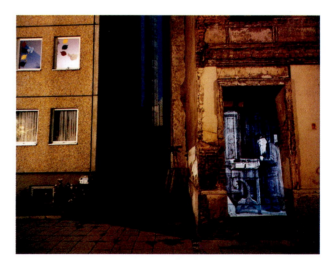

Figure 8.13 Laurie Tümer produced the series *Oil Exploration: Not in My Backyard* as part of the Galisteo Basin Photography Project, which aimed to raise awareness about the environmental devastation of oil drilling in New Mexico. The ancient rock art in the Galisteo Basin inspired Tümer to include contemporary graffiti in her images, even becoming an honorary member of a graffiti crew. Taking these photographs under dim light allowed the artist to incorporate light painting into the work. She tells us, "As a photographer, it became apparent that what I do is write with light, so although I learned to stencil and spray paint, the final works were realized by my camera and penlights to 'write my name'."

© Laurie Tümer. *Graffiti Artist Against Vandalism*, from the series *Oil Exploration: Not in My Backyard*, 2008. 16 × 24 inches. Inkjet print. Courtesy of Photo-Eye Gallery, Santa Fe, NM.

Figure 8.14 Walking the streets of Berlin, Shimon Attie kept asking himself, "Where are all the missing people? What has become of the Jewish culture and community that had once been at home here? ... I wanted to give this invisible past a voice." Attie projected prewar photographs of Jewish street life in Berlin onto the same location 60 years later in order to introduce fragments of the past into the present. Using photography as an archaeological tool, he explores the presence of absence. "By attempting to renegotiate the relationship between past and present events, the aim of the project was to interrupt the collective process of denial and forgetting."

© Shimon Attie. *Almstadstrasse/Corner Schendelgasse, Berlin: Slide projection of former Jewish religious book salesman (1930)*, 1992. 20 × 24 inches. Chromogenic color print. Courtesy of Nicole Klagsbrun Gallery, New York, NY.

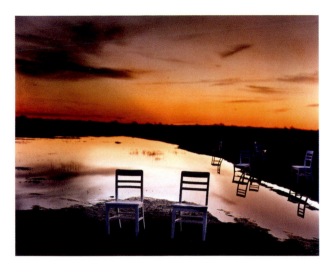

Figure 8.15 By incorporating long exposures and painting with light through the use of multiple handheld flashes, Christine Shank transforms a natural landscape into a surrealistic scene. The long exposures bring out the changing colors of the sky, and the chairs are individually lit with the hand-held flashes, elevating the everyday object to a level of personification.

© Christine Shank. *Untitled*, from the *visual dramas* series, 2002. 20 × 24 inches. Chromogenic color print.

Moving the Easel

When moving the easel, prepare to print in the normal fashion. Calculate the proper exposure and initially give the print 75 percent of that figure. Make a second exposure of the remaining 25 percent while moving the easel during this time. This ratio may be altered to achieve different results. The easel may be tilted during the exposure or the paper can be curled and waved outside of the easel for additional effects. The easel can be placed on a device such as a "lazy Susan" and spun to create circular motion. This same effect can be accomplished digitally by copying and pasting an image file several times on to a much larger-sized blank picture file to create a unique pattern with the images. Apply different kinds of blur effects to each layer to create the desired effects.

Moving the Fine Focus

Moving the fine focus control on the enlarger is a method of expanding the picture. Give the print two-thirds of its required normal exposure time. For the remaining one-third exposure time, move the fine focus adjustment on the enlarger. Give yourself more time to manipulate the fine focus control by stopping the lens down and increasing the exposure time. The outcome will be determined by how fast the fine focus control is moved, how long it is left at any one point, and the proportion of stationary exposure to moving exposure.

Painting the Print with Light

Painting the print with light can be accomplished with a small penlight fitted with a handmade opaque blinder. The blinder acts as an aperture to control the amount of light. If this is done during the development stage of the print it produces a partial Sabattier effect (see Chapter 12). Different transparent filters can be placed in front of the flashlight to alter the color effects. This technique often can be effective when combined with other methods, including the masking of specific portions of the image.

Multiple Exposure Using One Negative

Exposing one negative a number of separate times onto a single piece of printing paper can vastly alter the perception of time within the picture. Many variations are conceivable:

- Reduce the size of the picture and print it a number of times on a single piece of paper. Let parts of each picture overlap to form new images.
- Vary the size of the picture as it is printed on the paper.
- Change the exposure times in order to create a variety of densities.
- Print the full-frame on part of the paper and then print different parts from the negative onto the paper.

Combination Printing

Printing more than one image on a single piece of paper jettisons the traditional picture vision and embraces a far more complex image of reality. This is commonly done by switching negatives in the enlarger or by moving the paper to another enlarger and easel that has a different negative set up for projection. Opaque printing masks are used to block out different parts of the paper in order to control the areas of exposure.

Combination printing can also involve combining a negative with a photogram or varying the exposure time of different parts of the print. Determine the proper exposure and give a percentage of it to the paper, and then mask certain areas and give the remainder of the exposure. Digital software also permits the compositing of an infinite number of digital files to form a new photographic work.

Multiple Filter Packs

Making use of more than one filter pack can transform the picture's sense of time. Start with an image that contains a basically monochromatic color scheme and simple linear composition. Print one area of the picture with the normal filter pack while holding back the exposure on another part of the print. Now change the filter pack.

Consider working with complementary colors. Print in the area that was dodged out during the first exposure while holding back that part of the print that was already exposed.

The Cinematic Sequence

The cinematic mode of picture-making, in which each new frame implies a new episode or another step, modifies the way photographic time is perceived. It is concerned with the interaction among the objects of the composition. The space between objects can become part of the same structure as the objects. Forms actually reverse themselves. The topics covered in this section also can be done using either film or digital methods.

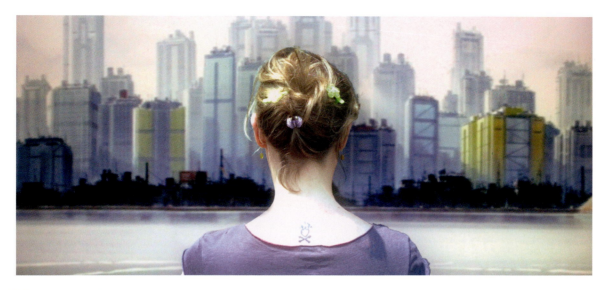

Figure 8.16 The cinematic format is integral to Martin Kruck's *Xcape* series. The imagemaker photographs his models and backdrops separately, which are intentionally lit differently to create an effect of separation between them. The results are combined in post-production to formulate a panoramic image having a 4:1 aspect ratio. He tells us that this series "considers that the twenty-first century landscape is exhausted, overdeveloped, and charted, and that access to notions of the grand, sublime landscapes promoting America's early western expansion may not only be found in finite fragments. Here, plumes of smoke from a car fire, evening storm clouds photographed from an apartment balcony, or ocean vistas copied from video games replace the awe-inspiring open country depicted in early American painting and developed by Manifest Destiny."

© Martin Kruck. *Xcape: City*, 2007. 20 × 48 inches. Inkjet print.

The vitality of movement can be conveyed through the use of traditional still pictures linked together to form a cinematic sequence of events. This set of pictures is designed to function as individual images but as a group. The sequence must be able to provide information that a single image would be incapable of doing. A sequence can tell a story, present new information over an extended period of time, or supply a different point of view.

The Matrix-Grid

The grid can be used as a device to lead viewers through the details and visual relationships of a scene. Photograph a person or object in a way that the pictures have to be combined to make a complete statement. The pictures do not have to be made from one frozen vantage point but rather from a general point of view. It is possible to incorporate a number of variations of the subject into one single statement. Imaging software has greatly simplified the process of making picture grids. This type of picture, which cannot be taken in all at once, invites viewers to linger by creating the sense that time is fluid. The viewer must take many separate glimpses and build them up into a continuous experience, much as we see the actual world around us.

Many Make One

"Many make one" describes the visual process of photographing a scene in numerous individual parts and then fitting these single pieces of time together to create one image. The single pictures of the original scene are not made from a specific vantage point but a general one. This encompasses different points of view over an extended period of time.

The focus may also be shifted to emphasize important elements of each single frame. Take all the prints and spread them out on a big piece of mat board. Begin to build an entire image out of the many components. It is okay to overlap pictures, discard others, and have open spaces and unusual angles. Try not to crop the single pictures because a standard size seems to act as a unifying device. When the arrangement is satisfactory, attach the prints to the board. They do not have to be flush.

This method of picture making can expand the sense of space and time that is often lost in an ordinary photograph. It breaks down the edges of a regular photograph by moving the frame beyond the conventional four perpendicular edges and bringing the viewer right into the picture. Digitally, one can copy and paste all image files into a larger separate blank image file and position the layer into a final design.

Contact Sheet Sequence

The contact sheet sequence is a modified technique of using many single contact-size images to make a statement. Pick a scene and imagine an invisible grid pattern in front of it. Photograph that scene using this invisible pattern as a guide. Process the film, then arrange the negatives into your desired grid pattern, and contact print them to form a complete image. Imaging software allows this process to be automated, but don't think that it ends there. Cut out the digital prints, rearrange and attach them on a neutral-colored board to form a collage, which can then be scanned or rephotographed to produce a montage.

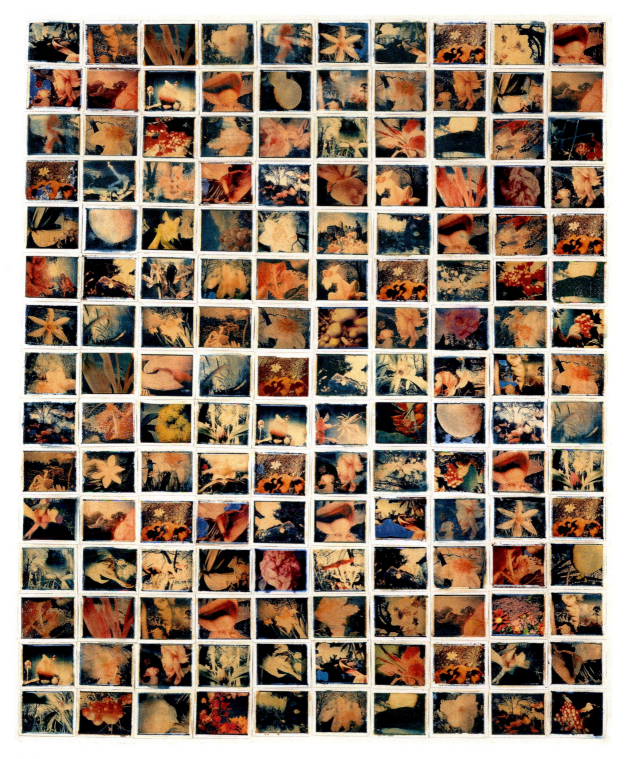

Figure 8.17 To construct this collage, Barbara Crane printed 150 35mm color transparencies to Polaroid Polacolor film, and then transferred each to a sheet of watercolor paper. After hand coloring each with colored pencils, she placed the images in a grid layout and adhered them to a single sheet of watercolor paper. Crane explains, "Images that result from picture-taking may precede my comprehension of them. Each new series can take many years as I adjust to unfamiliar pictures and ideas in order to accept my imagery as purposeful … It is the intensity of the unknown and the process of growth that is most rewarding."

© Barbara Crane. *Visions of Enarc III*, 1991. 57 × 48 inches. Polaroid image transfers. Courtesy of Avon Corporation, New York, NY.

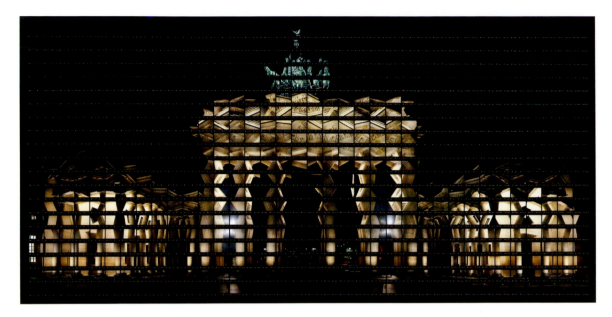

Figure 8.18 Assembling contact sheets whose thumbnail photographs combine to read as full images demands elaborate planning. Thomas Kellner begins by sketching the scene or building that he wants to photograph, establishing a number of frames as a parameter, and determining the most important aspects of his subject to capture. Depending on the number of frames, the artist's process can take up to four hours. Kellner states, "Often when people see my images published they imagine them as giant enlargements. But of course they are not, they are contact prints, and the size is only a question of how much film I use. The bigger the image gets—that is, the more film I use—the more the building itself disappears; the more you begin to see the picture itself rather than an image of something."

© Thomas Kellner. *Berlin, Brandenburg Gate at Night*, 2006. 27¼ × 53¼ inches. Chromogenic color print. Courtesy of Stephen Cohen Gallery, Los Angeles, CA.

Joiners

Joiners are produced when a number of images of a scene are combined to make a whole. The subject can be divided into separate visual components and photographed individually. Each part provides information about the subject that could not have been included if the subject was captured in a single frame. These additional exposures should alter how the subject is perceived. This includes its relative position in time and space, changes in vantage point and angle, and variations in subject-to-camera distance. Single prints are made, laid out on a mat board, arranged, fitted or trimmed, and then attached into place.

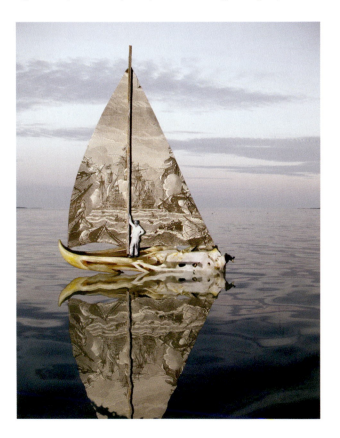

Figure 8.19 In his series *Vehicles for Ancient Dreams*, François Deschamps explores the mythology of boats by collaging original and found maritime photographs. He first constructs a model boat, photographs it in his studio, and digitally joins it with a seascape image by manipulating multiple layers. Deschamps states, "Making convincing reflections was the challenge and required playing with the wave filters, curves applied to the reflection layer, and transparency adjustments."

© François Deschamps. *Sea Battle Boat*, from the series *Vehicles for Ancient Dreams*, 2007. 14 × 11 inches. Inkjet print.

Slices of Time

Slices of time occur when a single scene is photographed a number of separate times to show the visual changes that can occur over a period of time. Intentional alterations in light and placement of objects can be made each time the scene is photographed. Prints can be butted together, overlapped, or cut into slices and pieced together.

With practice the pieces may be cut into a variety of different sizes and shapes. Keep each cut picture separate. Select one of the pictures to be the base print. Arrange it on a mat board and begin to incorporate the slices from the other prints into the single base image. When complete, attach the slices to the board. Digitally, the images can be composed on the computer screen and then outputted.

Composite Pictures

Composite photographs occur when visual elements from various sources and mediums are separated and then intertwined on a common support material before being rephotographed to

obtain the final image. If the assembled image is not rephotographed, it is considered to be a collage. Pictures of astonishing paradox can be produced using this method, especially when manual and digital techniques are used in tandem.

Photographic Collage

A photographic collage is made when pieces cut or torn from one or more photographs are pasted together, sometimes with three-dimensional objects and/or other disparate elements, to produce a final picture. This technique makes no attempt to hide the fact that it is an assemblage; it is not rephotographed. Collage demonstrates how multiple images can be integrated to make a new, single work that reaches beyond a traditional narrative plot by mining the boundary between fiction and nonfiction. It is not reportage but commentary on a subject. Meaning is formed through the interrelationships of images rather than a summation

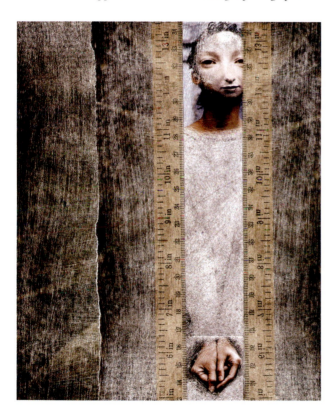

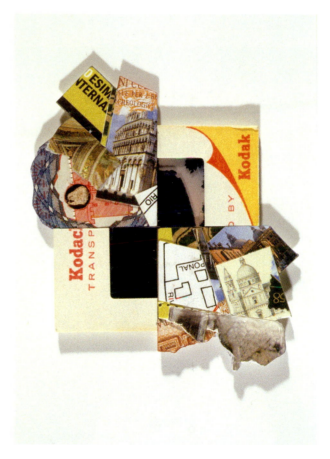

Figure 8.20 Working both manually and digitally, Ambler Hutchinson integrates broken fragments taken out of time to craft tangible realities that reveal complex psychological spaces dealing with self-identification. She paints and draws on found objects, scans the manually altered images, and then creates composites in Photoshop. She tells us, "The process of digital collage allows me the freedom to constantly alter my images until they intuitively feel 'right'."

© Ambler Hutchinson. *Untitled (Measuring Up)*, 2003. 15 × 12 inches. Inkjet print.

Figure 8.21 Gerald Mead's passion for collecting is evident in this collage, in which mixed media, found objects, and photographic images serve as components. Here he assembles a carefully curated selection of maps, currency, stamps, tickets, and photographs to represent Italy, and he presents them in an actual 35mm slide format, bringing to mind travel slideshows. This microcosmic collage, Mead states, "metaphorically reduces an entire country or region to a miniature conglomeration of recognizable icons and symbols."

© Gerald C. Mead Jr. *Italy*, from the *Euroquad* series, 2006. 3 × 3 inches. Mixed media.

of the content of individual images. The essential ingredient of collage is editing, which is a key instrument of postmodern artistic practice, especially digital imaging. Through the act of selection an artist can recontextualize images and synthesize an open, flexible, and meditative practice that is closer to reading a text than interpreting a conventional camera-made image with a fixed frame.

Three-Dimensional Photographs

Three-dimensional photographs can be made by emphasizing one attribute of a subject—color, pattern, shape, or texture —and having it physically come off the flat picture surface. This can be done through collage and/or cutting into the print itself. This exaggeration in time and space calls attention to that aspect of the subject while de-emphasizing its other qualities.

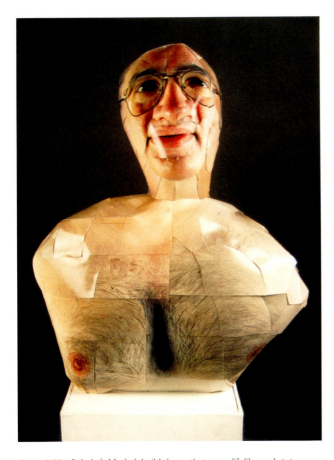

Figure 8.22 Rebekah Modrak builds busts that seem lifelike and statuesque but have all the details and scars of daily life. "Piecing together figures allows me to work sculpturally, to construct fragile and fantastic beings, to include photographic minute details, and to simultaneously question the static representation offered by conventional reality through a viewfinder."

© Rebekah Modrak. *Portrait (Arnold)*, 2000. 30 × 24 × 12 inches. Chromogenic color prints and mixed media.

Photo-based Installations

Photo-based installations comprise an entire arrangement of objects—not just a group of discrete images/objects to be viewed as individual works—presented as a single work. Installations provide viewers with the experience of being in and/ or surrounded by the work, often for the purpose of creating a more intense sensory realization, and may include still and moving images, computer screens, music and sound. Precedents for installations can be found in the Pop Art era of the late 1950s and 1960s, such as Allan Kaprow's "sets" for Happenings or Red Groom's theatrical environments such as Ruckus Manhattan (1975). Most installations are unsalable and generally are exhibited and then dismantled, leaving only photographic documentation of their existence.

Public Art

Art history is filled with more examples of public than private art, ranging from the frescoes and sculpture of religious centers to the commemorative statuary of public squares. The dissolving of modernist notions of purity of form along with the rise of government initiatives, such as the percent-for-art programs that set aside a certain percentage (usually one percent) of a construction budget for art, has led to a variety of artists' projects in the public sector. A combination of changing attitudes by artists willing to forgo the absolute control of the studio and new technologies has made it easier to take artworks outside the traditional context of museums and galleries and into daily life. Work is shown in public spaces such as transportation centers, city streets, and work places, and is seen by people beyond the art and academic worlds. Part of the fun and power of public art is its ability to enter into everyday life and catch its audience by surprise, which often accidentally disrupts the status quo.

Appropriation: Where Does Art Come From?

Working imagemakers know picture-making is an adaptive evolutionary process and that our cultural heritage is founded on a practice of transformative art and the premise that nothing is original. The exchange of ideas is a powerful tool for promoting excellence in the visual arts and accomplished work can mentor and promote new visions. This process entails borrowing, sharing, re-borrowing, and amending—the full range of ways new art learns from, builds on, and emerges out of the existing models. Consequently, artists travel in and out of time looking for "good stuff" (existing models) to inform their endeavors. Don DeLillo's novel, *Point Omega* (2010), was inspired by watching Douglas Gordon's *24 Hour Psycho* (1993), a video installation of Alfred Hitchcock's movie *Psycho* (1960) slowed down to two frames a second, so that it lasts for an entire day. In terms of popular culture, consider *Steamboat Willie*, the 1928 Walt Disney cartoon that introduced Mickey Mouse. *Steamboat Willie* is based on Buster Keaton's 1928 silent film *Steamboat Bill, Jr.*, which itself borrowed from a 1910 song, *Steamboat Bill*. Disney snatched creativity from the life around him, mixed that with his own talent, and then

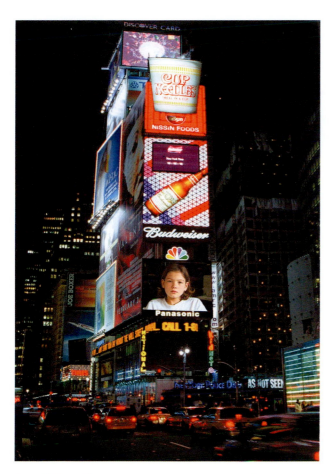

Figure 8.23 In *Video Portraits*, people gaze at the camera for one hour, and, by extension, at the viewer. After their initial self-consciousness passes, the subjects sink into a meditative state and the camera reveals barely perceptible changes in mood and emotion. Thomas Struth's restrained use of the medium combines the stasis of painting with photography's embrace of the flecting. The final 59th minute of each *Video Portrait* hovers over the endless movement of Times Square, reducing the vocabulary of art to its simplest premise: to look, to see, and to reflect. The videos invite discernment, receptivity, and calm consideration.

© Thomas Struth. *Video Portrait: Raphael Hartmann, from The 59th Minute: Video Art on the Times Square Astrovision*, February 4, 2003–June 30, 2003. Variable dimensions. Time projection. Presented by Creative Time, New York, NY. Photo © www.charliesamuels.com, 2003.

imprinted that mixture into the character of our society. In photography a similar progression can be witnessed in how John Thomson's nineteenth-century ethnographic studies in Asia and London helped to establish social documentary practice that begot August Sander's twentieth-century objective sociological study of the German people. This gave rise to Lisette Model's sardonic, allegorical approach to human foibles that influenced Diane Arbus' sensational coverage of people on the fringe of society. Select an art practice and you will find this 1–2–3 combination of snatch, mix, and imprint.

In an age of digital sampling and point-and-click downloading, any data we Google can be a starting matrix for new creations

as well as a starting point to consider usage and copyright. In an artistic context where the truthfulness of a captured moment is not the principal function, is there any difference between photographing a building or a web page? Both physically exist as completed objects and as potential raw material for ingenious directions. As a machine that makes no distinction between subjects, a camera doesn't care about what is in front of it and can capture anything that is touched by light. This is at the nucleus of the Shepard Fairey case involving his Warholization of a photograph of Barack Obama. Made by Associated Press photographer Mannie Garcia, the photograph was posted online and used by Fairey to make his Obama "Hope" campaign poster. Regardless of the legal ramifications or what you think about Fairey's actions, the poster is indicative of how individuals constantly draw on the experiences of others and infuse that existing data to meet their needs. The more we know about how art is made, the more derivative and evolutionary we recognize art to be. For creative individuals everything is grist to be transformed into something else. The physical world is both our rightful cultural inheritance and a visual testing ground. The distinction between an innovative artist and a plunderer is the capacity to think, imagine, and act independently, and in turn to express notions differently from previously recognized views of a similar subject. We can identify inventiveness when a maker acts authentically and transforms subject matter by giving it new meaning, which provides a clear demarcation separating imitation from fresh, resourceful endeavors. Thus artists strive to recompose the world by making it "special" through creating astounding, extraordinary, heightened experiences that deliver satisfaction and pleasure which reality fails to provide. Hence, picture-making is an act of assertion, control, and organization over a situation. Each generation of imagemakers confronts the same challenge: How to retell and make memorable pictures that convey their times.

Mashup: Collaborative Images

Mashups combine multiple sources from established genres, such as audio, graphics, images, text, and video, which usually have no relevance with each other to create a new configuration. The first mashups involved music, such as Danger Mouse's *The Grey Album* (2004), which blended a cappella version of rapper Jay-Z's *The Black Album* (2003) with instrumentals created from unauthorized samples from The Beatles' LP *The Beatles* (a.k.a *The White Album*, 1968). Literary mashups like David Shields' *Reality Hunger* (2010) form what he calls a "recombinant" work

Problem Solving

Working from the premise that challenging picture-making generates tension with accepted practices, select a specific theme that offers an abundance of visual examples and reimage them through an amalgam of materials, processes, and tools to graphically explore the topic in a fresh manner. Consider compositional and optical means, such as focus, depth of field, and lighting, as well as digital and hand-altered approaches. Remember there is no correct first version of how an image should look.

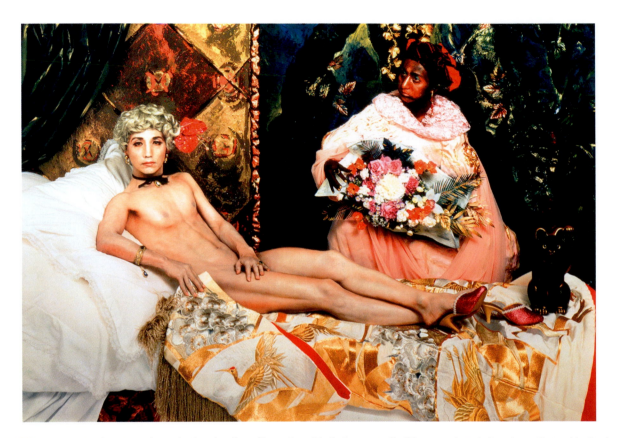

Figure 8.24 Yasumasa Morimura's gender- and culture-bending self-portraits satirically decontextualize Western art icons by inserting an Eastern identity. In the tradition of Kabuki theater, in which men play female roles, Morimura masquerades in costumes, wigs, and makeup. Here he challenges stereotypes and unequal power relations by posing as both the servant and the reclining courtesan in Manet's *Olympia* (1863), thereby interrupting the conventional masculine gaze. In an age of mass-produced images, Morimura's photographs also question the authenticity of a work of art.

© Yasumasa Morimura. *Portrait (Futago)*, 1988. 82¾ × 118 inches. Chromogenic color prints. Courtesy of Luhring Augustine, New York, NY.

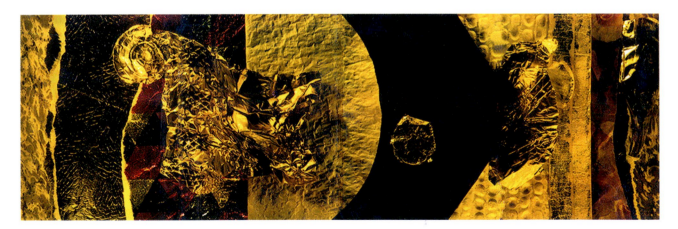

Figure 8.25 Chiarenza states, "My photographs are made from collages that I construct specifically to be photographed. My process creates form and subject simultaneously. The collages are means to an end and are discarded after the photographs are completed. The photographs do not look like the collages from which they were made. The photographs are transformations that refer to (and, perhaps, 'represent') the extensive manipulation of both collage materials and lighting. But once the photographs are completed, what they refer to and represent are visual sensations that I know only from a mix of past encounters with other pictures, music, the world, dreams, and fantasies. Once they leave the studio however, the viewer brings completion of meaning."

© Carl Chiarenza with digital modification by Robert Hirsch. *Untitled Polacolor Quartet 215–203, 1996–2009*. 4½ × 14 inches. Diffusion transfer prints.

made up of 618 fragments, including hundreds of quotations from other writers such as Saul Bellow, Joan Didion, and Philip Roth. Shields stakes out his position by asking us: "Who owns the words? Who owns the music and the rest of our culture? We do—all of us—though not all of us know it yet. Reality cannot be copyrighted." While some may find this frightening, others see it as a conduit to unfettered creative freedom.

Photographically, digital imaging allows artists to modify existing works and/or create new ones from a mixture of content and/or elements from multiple sources. It also offers a new way for artists to collaborate. For instance, in Figure 8.25 Carl Chiarenza sent the author a scan of his original Polaroid piece, which Hirsch manipulated in Photoshop and then e-mailed back to Chiarenza. This process was repeated multiple times until Chiarenza was satisfied with the results. Such methodology uproots photography from its connection to the real and its traditional job of documenting and remembering. With mashups, fixed time and space vanishes, all becomes malleable, multi-layered, and multi-voiced, with expanded connotations. Take

into account what filmmaker Jean-Luc Godard said: "It's not where you take things from—it's where you take them to."

Penetrating the Photographic Mirror

Being able to understand and make innovative representations of photographic time involves penetrating the habitual mirror of reality. Whenever traveling into the unknown we can hope to be rewarded with understanding. Ironically, the information that is brought with you may prove to be invalid in new circumstances. As T.S. Eliot said, "Time the destroyer is time the preserver." Be ready to expand your previous concepts of how reality can be composed.

Often the most important aspects of a scene can remain hidden due to their familiarity and simplicity and our own lack of knowledge. When urban dwellers drive by an apple orchard they see a group of apple trees. Farmers driving by the same scene see something entirely different. A farmer is able to identify the

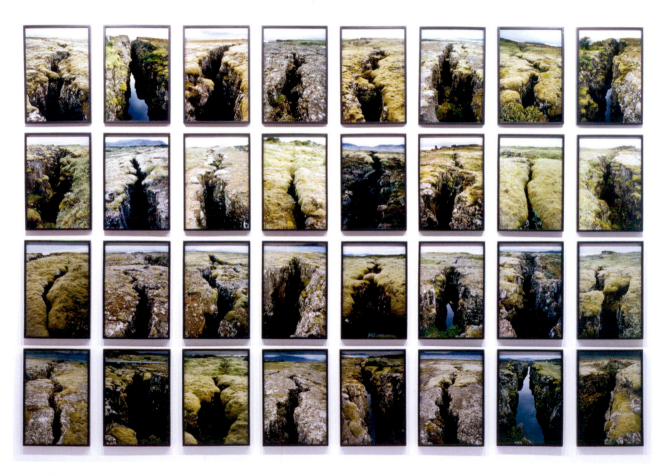

Figure 8.26 Olafur Eliasson creates relationships by photographing specific geographic phenomena in his native Icelandic environment. The grid of images becomes more than the sum of its parts as the rhythmic orchestration abstracts nature into a bodily illusion, encouraging viewers to look harder, see more, feel wonder, and expand their concepts of what makes up reality.

© Olafur Eliasson. *The Fault Series*, 2001. 103½ × 146 inches. Chromogenic color print. Courtesy of Tanya Bonakdar Gallery, New York, NY.

types of apples, know their condition, and how the orchard is faring. Both sets of viewers see the same scene, but a farmer's broader knowledge and understanding of what is there allows for a reading of more visual clues. This provides the farmer with a more accurate and richer account of the scene.

By extending our picture-making endeavors we create new ways to look at the world and enlarge our understanding of its complex system of interaction. As you speculate, keep in mind what Einstein said, "the distinction of past, present and future is only a stubbornly persistent illusion."

Problem Solving

Select one of the methods discussed in this chapter and render it using only chemical and handmade methods. Then pick another topic and complete it using only digital techniques. Now select a third topic and execute it by combining both approaches. Compare the results. What differences do you see in the final images and how might this affect viewer response? What are the advantages and disadvantages of each way of working?

NOTE

1. Joel Snyder and Neil Walsh Allen, "Photography, Vision, and Representation," *Critical Inquiry*, 1975, 2 (1): 163-4.

RESOURCES

Detailed information about many of the processes discussed in this chapter is available in:

Hirsch, Robert. *Photographic Possibilities: The Expressive Use of Equipment, Ideas, Materials and Processes*, 3rd edn. Boston, MA: Focal Press, 2009.

For information concerning time and space see:

Falk, Dan. *In Search of Time: The Science of a Curious Dimension*. New York: Thomas Dunne Books, 2008.

Hawking, Stephen W. *The Illustrated Brief History of Time: From the Big Bang to Black Holes, Updated and Expanded*. New York: Bantam, 1996.

Morris, Richard. *Time's Arrow: Scientific Attitudes Toward Time*. New York: Simon and Schuster, 1985.

Russell, Bertrand. *The ABC of Relativity*, 4th edn. New York: New American Library, 1985.

Sheldon, James L. and Reynolds, Jock. *Motion and Document, Sequence and Time: Eadweard Muybridge and Contemporary American Photography*. Andover, MA: Addison Gallery of American Art, Phillips Academy, 1991.

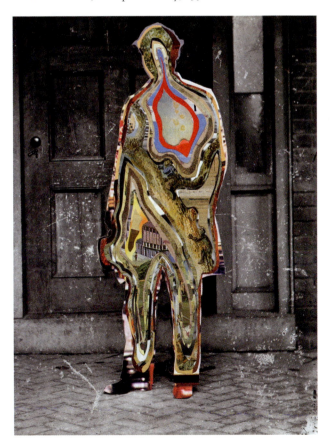

Kevin Charles Kline relies on a scanner to optimize surface detail and to retain the tactility of his cut-throughs, in order to investigate the role that photography plays in our culture and constructions of our present reality. He aims "to recontexualize and subvert visual systems to disturb the original narrative. My image interventions question the conventions and authority of the source material. The works I create from these remains explore the different roles/controls that narrated images play in our constructed and normalized identities over time."

© Kevin Charles Kline. *Historical Cut-Through #12*, 2008. 14 × 12½ inches. Inkjet print.

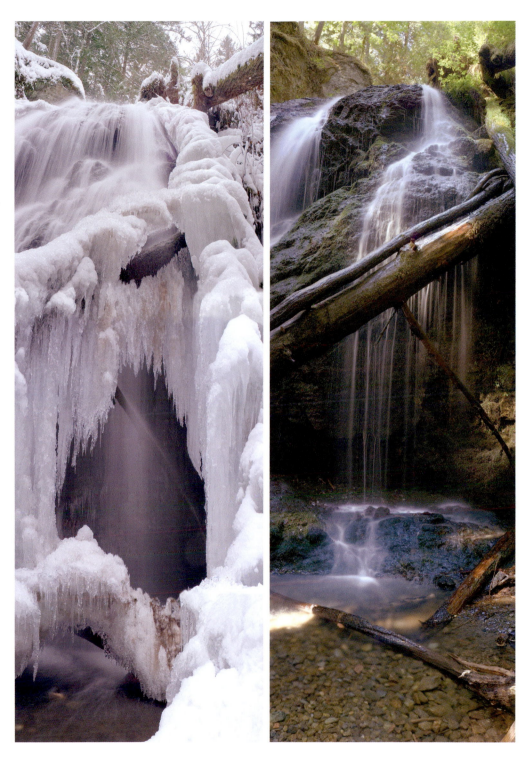

To visually account for the passage of time under diverse lighting conditions as well as the verticality of the subject, Dennis DeHart used his camera's HDR mode and Photoshop to construct each image. He observes how "the compression of multiple instances of time into a single frame open up new possibilities for experiencing the natural phenomena of light, water, and wind. Here I am observing the ebbs and flows of time by pairing the falls in both a frozen and fluid state."

© Dennis DeHart. *Cascade Falls, Winter/Summer* (diptych), 2009. 12 × 38 inches each. Inkjet prints.

By means of a scanner, Deborah Tharp digitally collaged and selectively colorized images from camera magazines from the 1940s and the 1950s. This process enabled her to examine the evolution of photographic craft, juxtaposing eras and methods. Tharp states, "I create fictions that challenge traditional visual perceptions. Fictions that hopefully speak to or dramatize some of the thoughts, questions, curiosities, and emotions that make us human."

© Deborah Tharp. *Self-Portrait*, 2007. 18 × 22 inches. Inkjet print.

Digital Input

Digital Photography: An Introduction

Photography is no longer a singular experience involving the interrelationship of a subject with light and value as practiced by Paul Strand, nor is it about Henri Cartier-Bresson's "Decisive Moment." The medium has evolved into a threading together of human experiences to formulate complex iconographic patterns. Today, many photographers have become image-gatherers, using various digital means to collect and make images, discarding the strict real-world, observational, photographic practices of the past. This new, explosive digital aesthetic blurs the imagistic positions among commercial work, fashion, journalism, popular culture, and snapshots in both print and on the Web. Historically, this can be compared to the Dada movement that was born of anti-war sentiments in First World War-era Europe during a time of radical social change driven by rapid technological achievements. Dadaists such as Marcel Duchamp, Man Ray, and László Moholy-Nagy investigated the arts without regard to the walls traditionally separating drawing, graphic design, painting, printmaking, sculpture, and theater. Their new conceptual directions, as personified in Duchamp's *Fountain* (1917), proclaimed that anything artists called attention to could be thought of as ART. Indirectly, the Dadaist championing of ordinary objects called into question one of art's central premises—the Aesthetics of Beauty—by proclaiming a philosophy of the banal and mundane as the chosen High Art practice.

The rapid public embrace of digital photography has facilitated a similar approach to photo-based imagery. This evolutionary process can trace its roots to the late nineteenth century when the expanded use of photomechanical reproduction processes, such as halftone photoengraving and photogravure, shifted photography away from its native means of reproduction. These non-silver photo-based developments were increasingly deployed in newspapers and magazines to meet a strong demand for inexpensive, mass-produced images and text. In the late twentieth century, this same aspiration drove the development of digital images.

The digital revolution got into full swing during the 1990s and has challenged the fundamental aesthetics, ethics, meaning, and vocabulary of the photographic image. Digitization has dramatically changed our image-reproduction processes as the photographic image has been extended to the Internet and assorted disk formats. The cross-pollination of film and digital cameras, still and moving images, gelatin silver and digital prints has created a new awareness about what photography once was, now is, and will be. Digital imaging eliminates the darkroom experience by transferring the chemical and physical creative activities to the computer screen. Image-editing software facilitates the processes of photo enhancing, retouching, and collage that alter and disconnect photographic results from its original camera-based reality. Now, as digitization has replaced silver-based photography as our primary source of camera-generated imagery, it is a good time to stop, evaluate, and explore some of the key artistic, conceptual, and social issues affecting digital imagemaking in the context of photographic history. The digital revolution is not only about the increasing ease of digital capture and output, but also about its accessibility to the general public. Additionally, the lack of formal training has affected the role and financial bottom line of the professional photographer and how images are being made, circulated, and understood in our society. It is the realization of Henry Fox Talbot's dream of everyone becoming his or her own publisher, but with some unforeseen consequences.

Truth and Illusion

The word photography has Greek roots; it derives from *photos* (light) and *graphos* (drawing), establishing the notion of "light drawing" that was first attributed to the camera obscura around the 1500s. The premise of photography has not changed since Talbot invented the negative/positive photographic process in the 1830s. Its purpose remains to provide a means of using light to capture and make permanent what one sees, in a manner similar and acceptable to that of human vision and Western representational systems. A camera with lens focuses light onto a flat, light-sensitive material that is electronically stored or chemically processed, permanently capturing the various densities for later reproduction. Ultimately, it makes no conceptual difference whether images are captured on paper, glass, film, or digital sensors.

Traditional photographic film is a chemical-based emulsion made up of light-sensitive, silver halide grains applied to a support base. These grains become the individual receptors for light, which are later processed to create a permanent image. Although it may first appear that these silver halide grains are the same size and evenly distributed, on the microscopic level you can see that they are of various sizes and randomly dispersed. The emulsions for both film and paper contain the same microscopic, various-sized and randomly distributed silver halide crystals that when used together to produce photographic images have a distinctive physical look that we have come to embrace as photographic "realism" or "truth." It has been said that the nineteenth century began with people believing what was rational to be true and ended with people believing what was in a photograph to be true. Now that stable silver images have been replaced by easily changed pixels, people don't know what to believe.

Digital imaging has a native makeup different than silver photography, based on a complex microchip composed of electrical receptors, known as sensels. It takes a color array of red, green, and blue sensels to gather the color information needed to create a single picture element, known as a pixel, with the proper color and value. Technically, cameras and microchips do not have pixels *per se*—most use a Bayer color sensel array for

Figure 9.1 Koya Abe reconsiders photographic truth and illusion by merging images of European portrait painting, originally painted for an exclusive audience, and modern commercial presentation, made for a mass audience. He photographs showrooms with a medium-format camera, scans the negatives, and combines them with scans of old master paintings. He creates a seamless composite by adjusting color, contrast, and texture. He tells us, "Digital technology is not limited by the physicality of canvas and frame, but can include diverse and highly complex methods of demonstrating a concept. When the display becomes the primary object, the medium becomes secondary; its value depends upon its ability to translate the idea into a visual physicality … Categories of art, whether they are painting, sculpture, or photography become unimportant as classifications, but represent only different ways of display. This represents a fundamental shift in the history of art."

© Koya Abe. *After Supper at Emmaus*, from the series *Digital Art Chapter 3: Display*, 2005. 30 × 40 inches. Chromogenic color print.

data capture. Even though one pixel is the result of sampling many sensels, manufacturers talk about pixels rather than sensels because, as one of the tiny points of light that make up the image on a computer screen, pixels are the smallest individual picture elements created. When sensels are exposed to light, an average charge is generated. These charges are then transferred to a microprocessor, where they are converted and saved into a binary code (a series of zeros and ones) that is seen as a pixel. The code operates like a light switch in two states—*on* and *off*—and allows the digital image to be easily manipulated, stored, and displayed. Each switch, usually a tiny silicon transistor, represents a binary digit or "bit." The greater the number of switches, the bigger the numbers that can be represented. Groups of these "bits" are combined to create pixels. The more bits that make up a pixel (8, 16, 24, and 48), the more image information the pixel contains. Typically, a photographic image is made up of millions of pixels, with each receiving a different amount of charge from an exposure. In a fraction of a second, the camera's microprocessor converts these charges to a digital file which lays out the pixels like an industrial grid of small squares or hexagons and defines the structure and look of a digital image in ways different from that of a film image.

As the technology has improved, the visual disparity between film and digital imagery is no longer the major issue it once

was. The differences are now subject to personal interpretation, though critics still contemplate their underlying psychological and sociological effects. The key to silver-based photography is the fact that the print is made from a negative, a physical object that possesses a direct historical link to the place and time of its recording and thus gives a real space/time connection to the print. It is precisely this specific corporeal witnessing that has allowed people to embrace photographic truth. Photographers wanting to maintain this indexical space/time connection rely on digital methods to only enhance rather than alter the content of their images, just as Ansel Adams or Edward Weston used the chemical darkroom to bring forth the underlying meaning in the subject matter of their photographs. For such photographers, the emergence of the digital studio is more evolutionary than revolutionary. On the other hand, the disconnection from the physical is what makes the digital image so psychologically effective for building realistic illusions. The binary codes of digital technology can easily be manipulated and thus readily transform an image into something it originally was not.

In addition to their connection to space and time, silver-based paper photographic processes, from calotypes to chromogenic color prints, possess a subtle yet distinguishing visual depth that is difficult to duplicate digitally. The image of a gelatin silver photograph is formed on the underside of the top gelatin layer, which means that the physical image resides between the top surface of the paper base and the underside of the top gelatin layer. This creates a purely photographic look that allows you to "look into" the print's surface because of the way the light reflects and refracts within the silver particles of this sandwich. Sometimes called transparency, this look visually contains the image and objectifies the views, helping to promote the notion that believability is built into photography. In contrast, digital imagery, with its reliance on inks and resolution, is more akin to the mechanical reproduction processes of relief printing, engraving, and etching. Images made from these processes rest on the top of the surface and therefore remove a sophisticated marker that historically made silver-based photography a surrogate for truth.

Now, even this distinction is fading as new digital output materials become available. In the past, digital printers could produce images on only a limited number of paper stocks. Today there are papers, canvas, cloth, film, and vinyl materials that can draw the ink into their surface, giving these materials not only the transparency that once was possible only in a gelatin silver print but also the ability to survive outdoors for periods of time without fading.

As these remaining differences between these media disappear, digital technology reflects our society's search for a definitive surrogate of truth as well as a source of meaningful art. Digital technologies simultaneously make it easier and faster for some photographers to continue to act as surrogate keepers of the truth, while encouraging others to expand the boundaries of the medium.

Digital and Silver Merge

The introduction of moderately priced, full-frame (24 mm × 36 mm) sensors in DSLRs at a resolution of 24 megapixels has allowed silver and digital to merge, taking the 35 mm camera full

circle since its introduction in the early twentieth century. These full-frame digital sensors allow results that can look and feel similar to that to which we have become acculturated over the past century. The use of full sensor lenses will now follow the "angle of view" conventions we have grown accustomed to, but more important, it restores the depth of field conventions that were lost with the smaller sensors.

Selective focus or limited depth of field was the native photographic way of controlling the sharpness of your foreground, middleground, and background by f-stop selection. However, first, second, and third generation sensors were not full-frame sensors. This effectively eliminated selective focus as smaller sensors produce greater depth of field than full-frame sensors at any given f-stop. In terms of depth of field, an f/2.8 lens setting with a small digital sensor might deliver visual results similar to those of an f/32 lens setting with a full-frame sensor. As full-frame sensors become standard on digital devices, depth of field will once again play a direct (in-camera) and clear-cut role in the photographic lexicon (see Lens Coverage and Depth of Field section, page 162).

The Comparative and the Cultural Eye

In the Newtonian scientific sense of forming broadly applied principles, the comparative eye and the cultural eye offer imagemakers two ways of thinking about digital and chemical methods and their relation to the desired outcomes. The comparative eye encourages an imagemaker to compare, contrast, and evaluate ways of making photographs. Its purpose is to establish the "value" of a photograph based on its native attributes, such as color saturation, depth of field, and sharpness. This procedure allows photographers to discover the medium's inherent advantages and limitations, and how to work within those parameters. In his seminal work "The Work of Art in the Age of Mechanical Reproduction" (1936), writer/philosopher Walter Benjamin discussed how the means of production of a piece of art changes the reaction of the audience toward that artwork.[1] According to Benjamin, when a work of art is produced by mechanical means, the "aura" of the art, which is tied to the mystique of the artist, is changed (some say lost). In this sense, the comparative eye emphasizes the craft and skill that photographers bring to their work.

In a digital work environment, the traditional handcraft procedures of photographic printing are controlled by machines (computer and printer), making these operations digital imaging's greatest asset as well as a source of criticism that can separate digital work from the time-honoured, hands-on art discourse. Modern media have caused the aura of the personal mark of the artist to fade and be replaced with the ubiquitous, unsigned, mechanical-dispenser of technology: the computer. Some people still imagine that a computer can magically make them creative imagemakers. Thoughtless reliance on the computer's preprogrammed solutions only removes the human fingerprint from the decisions that artists customarily want to control. Computer art is no different from other art forms, in that evocative work requires human guidance and an investment of time, effort, and thought. The computer is a powerful and transformative

tool and as with any other tool you have to learn how to use it effectively.

The cultural eye determines "significance" based on the expressive aesthetic, historical, and social qualities that give a photograph its context or cultural content. The camera and the computer are mediated ways of seeing. Customarily, the camera has had a covenant with society as an automatic, objective observer of nature. The digital image, because of its provisional makeup, cannot make this pledge. Informed viewers understand that the digital image is about fabrication and transformation. A computer can provide a junction between photography, illustration, music, painting, and video in ways that change a viewer's response to each medium. That the digital transformation allows a photographic image to resemble an oil painting, a watercolor, or almost anything requires a different interpretation. Previously, surrealistic artists distorted perspective and scale while juxtaposing commonplace objects in unusual contexts. Such images ask viewers to make connections they would not ordinarily make. The computer artist, by changing the context or content of images, also can ask viewers to make associations that normally are not possible or are difficult to produce with conventional photographic methods. The net effect of this convergence is that cultural value can no longer be easily determined through surface distinctions or quick overall impressions.

Although the paths between chemical and digital arts continue to blur, overlap, and vanish, the two methods often ask fundamentally different questions about how reality is constructed and interpreted. It is up to imagemakers to learn what approach possesses the attributes that are most suitable for conveying their intentions and how to utilize them.

Immateriality and the Digital Image

Since camera-based images were being made centuries before the invention of photography, the medium can be viewed as a progression in the evolution of camera images. Although the digital image shares many of the characteristics of the silver-based photograph, its technology is intrinsically different because the digital image exists as numerical data and never has to be represented as a physical entity. This immateriality places the digital image in a state of constant flux, a condition of never knowing whether it is in a final form or just waiting to be changed into something else. Even a print from a digital file can be considered a representation of an image at only that particular moment in time, one subject to possible reinvention the next time it is printed.

A Digital Conundrum

Before the invention of photography, the value or aura of an artwork was tied to its uniqueness, the distinctive talents of the artist who made the piece, and the fact that there was an original image. Printmaking began to change that notion by being able to produce many "original" copies. Photography pushed that envelope even further and now digital imaging has turned originality on its head. When a digital file is duplicated, the specific binary code that describes the image is copied exactly, allowing the digital image to be perfectly and infinitely

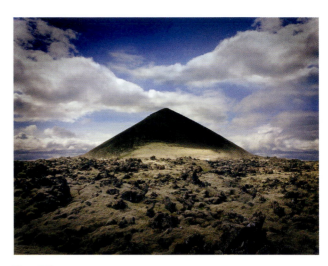

Figure 9.3 In his *Mountains* series, Stephen Hilyard fabricates photographs of geological formations almost too perfect to be real. His starting place is Iceland, where he photographs lava cone formations with a Fotoman 4 × 5-inch camera. After scanning the transparency film, he digitally manipulates the images to make the mountains more symmetrical. Referencing the influence of the sublime, Hilyard states, "My work is inspired by the fact that the human mind has always longed for this quality, has always struggled to encapsulate it in its creations. Yet so often this fails, so often we fail to experience the sublime, and we fail in our attempts to express it to ourselves or to others … For me there's something tragic in this yearning for such an un-presentable concept, maybe even pathetic, but there's also something heroic in the persistence of the sublime impulse."

© Stephen Hilyard. *Mountain 4*, from the series *Mountains*, 2009. 57 × 72 inches. Chromogenic color print. Courtesy of Platform Gallery, Seattle, WA.

reproduced. This can produce a conundrum. Since there is no physical difference between copies of digital images, every image can be considered an original. If every image is an original, then every digital image is also a reproduction since there is no verifiable way to determine which version came first, resulting in a renewed questioning of the meaning and value of the original. This impressive contradiction grants digital imaging an authoritative way of being paradoxical by acknowledging the pleasure of the doppelganger (the twin), even when we are unable to apprehend it.

What Constitutes Reality?

Since the invention of the daguerreotype, people have been altering photo-based images. Every day we are bombarded with modified images in print and on the screen. Knowledgeable observers know that the way a photographer selects subject matter and then frames and crops the images shapes the "reality" of a photograph. A photographer's decision about these matters can change an image and therefore its meaning. Typically, viewers have been taught to trust photographs, especially those presented by the media, as accurate representations of reality, but digitization has led viewers to become less naive and question the truthfulness of images. The first public outcry occurred when *National Geographic* digitally moved the Egyptian Pyramids closer together to accommodate the format of its vertical cover on

Figure 9.2 Lori Hepner explores the immateriality of the digital image in her work on binary code. For her series *Code Words*, she translates the first word of the image's title into binary code and refers to the second word of the title for the layout of the ones and zeroes on the silk. In doing so, she analyzes the rapidness of communication in the digital age and our increasing demands for speed. Hepner says, "Our language is transformed into binary code, which is sent through a computer and comes out at the other end, hopefully, as we sent it. Mathematical information theory suggests that there's a certain probability that the code will mutate and arrive changed, but we are unable to know if this occurs, since we are unable to decode the underlying binary language that we now invisibly communicate with. This lack of comprehension in the raw data of computers is what has inspired me to look at possible degradation and mutations of the meaning held within digital messages."

© Lori Hepner. *Fabricated: Edifice*, from the series *Code Words*, 2007. 30 × 24 inches. Inkjet print.

its February 1982 issue. The print media has reacted to such digital manipulation with internal rules, proposed ethics codes and image labeling, but despite ongoing accounts of photographic deception, many people continue to believe in the authority and veracity of photographs.

Digital images, which look like traditional photographs, can betray that trust because the separation between art and media has been removed. For example, in 1994 *Time* darkened the face of O.J. Simpson before his murder trial to make him appear more menacing; during the 2003 US-led invasion of Iraq, a photogra-

pher for the *Los Angeles Times* was fired for combining two of his photographs to form a new composite view; and in 2009 a Ralph Lauren advertisement slenderized model Filippa Hamilton down to a size zero, making her waist appear smaller than her head. Such cases have led both British and French lawmakers to propose controversial legislation, like disclaimers for all retouched images, to reduce attacks on conventions of photographic reality. In America, the National Press Photographers Association (NPPA) has an ethics code for visual journalists at www.nppa.org/professional_development/business_practices/ethics.html.

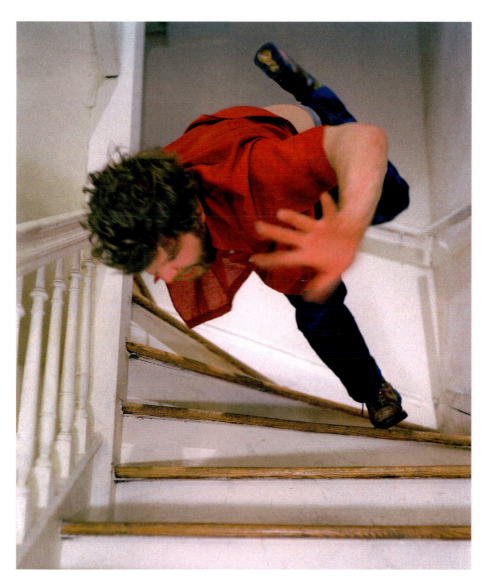

Figure 9.4 Kerry Skarbakka's work questions photographic reality by capturing staged scenes of himself in improbable positions. Drawing on his background in rock climbing and martial arts, the artist poses himself mid-fall, on the verge of tumbling out of the frame onto the viewer. Though he works with tungsten color negative sheet film and a view camera, the imagemaker relies on digital retouching to create his final look. Skarbakka tells us, "From cropping and spot removal to color manipulation and erasing erroneous elements from my scene, this is where the image takes shape. I try to keep the image as original or indexical as possible, but the strength of my work lies in its believability. I consider Photoshop a tool that helps me achieve that."

© Kerry Skarbakka. *Stairs*, from the series *Struggle to Right Oneself*, 2002. 72 × 60 inches. Chromogenic color print. Courtesy of Irvine Contemporary, Washington, DC.

Digital Differences

An early criticism of the digital image was that it was made by the actions of a program writer as opposed to an imagemaker. This phenomenon was not without historical precedent. The camera has shaped our system of photographic representation. Its monocular vision, seeing the world from a single linear viewpoint, is a construct at the heart of logical, systematic Aristotelian reasoning and thinking. The development of the handheld camera and flexible roll film defined an entire way of seeing, and it leaves a highly identifiable imprint.

An issue that new computer users face is their inability to apply real-world intuition to the machine. Although computer programmers attempt to simulate a tactile experience with tools that replicate an airbrush, paintbrush, or pencil, these programmatic tools are still imitations that respond differently from the originals. When working with any new tool, users must develop a set of intuitive actions based on their experience of the machine. Many digital tools were created to suit someone else's needs or designed for general use. Nevertheless, creative imagemakers always find ways to make tools and materials fit their personal vision. Programs are available that give digital imagemakers the ability to author software and customize imagemaking tools, giving them the flexibility of their analog cousins.

Just as with a film negative, one must be aware that the digital data displayed on a computer screen often carries more information than can be outputted, making an understanding of the

final product essential for deciding when an image is finished. Knowing why you started making the image is another indicator of comprehending when it is finished. The adage "less is more" can also be applied to digital images, as there comes a point when further alterations confuse what one is trying to convey. Since many viewers will be looking for the digital changes, alterations should have a purpose that furthers the image's content/context as well as aesthetics.

Finally, we have been culturally habituated to accept the gallery wall on which an image is displayed as neutral space. Under this paradigm the wall should not affect how the viewer reads the content/context of a piece. Work that exists on a computer screen does not operate under this assumption. The physical apparatus of the machine has an entirely different set of connotations that include all of the other uses of a computer (word processor, telephone, movie screen, and public forum/space). Work that resides on a computer screen has to overcome this limitation. Digital images that are printed out as photographs or lithographs take on the skin, the characteristics, and the connotations of those media.

Appropriation, Stock Images, and Copyright Issues

Since ancient times people have "borrowed" from other sources to produce new work. As in any recorded medium, art is based on knowing and building from itself. The current artistic environment, which actively promotes the mining of preexisting materials, along with the ease with which digital data can be copied and pasted, has brought the issue of appropriation to the forefront. The use of source material should be examined on an individual basis, taking into account the concepts of fairness, originality, content, and the motivation of the artist. When appropriating images, ask yourself: Does the appropriation create significant new meaning and/or context for people to ponder? Legally, an idea cannot be copyrighted; only the expression of an idea may be protected. Generally, in the educational and artistic arenas, we can assume that if an appropriated image is contextually removed from the original, is unrecognizable, or has been substantially altered, then a new image has been created (see Chapter 8, page 144).

Appropriation can sometimes be a political/social act. Artists like Richard Prince, Sherrie Levine, and Barbara Kruger have used appropriation to challenge the notion of authorship, originality, power, and sexism. In these cases, while the original work was referenced directly, the ideas expressed through the appropriated images differed from the originals. This added layer of meaning validates and legitimizes the new work in a postmodern art world.

When images are made for commercial purposes, copyright becomes a more complicated and thorny issue. Photographers who make and sell photographs for their livelihood have fought to define the legal status of the photographic image. In the United States, copyright usually belongs to the person who presses the shutter. This includes copyright of stock images that are available on disks or downloadable from the Web. Many stock image packages include reproduction and alteration rights in the cost of the disk; others require usage fees and may not

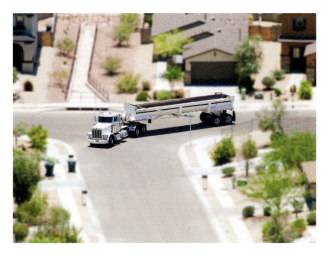

Figure 9.5 Joseph Labate asks viewers to question the level of reality conveyed in his photographs. This work appears to be a straight photograph at first glance, but upon closer scrutiny it reveals selective blurring and sharpening, which adds a layer of creative fabrication to the image. Labate, a long-time darkroom photographer, considers digital technology to be critical to introducing the "made-up" to the "real." He tells us, "I am most interested in that space between the traditional definition of photography and the imagery of the newly emerging digital arts. I am not trying to replicate traditional photography with digital tools, yet I am trying to maintain some connection to it, drawing on the history and practice of both analog and digital technologies."

© Joseph Labate. #6157913, from the series *View from a Mountain*, 2009. 30 × 40 inches. Inkjet print.

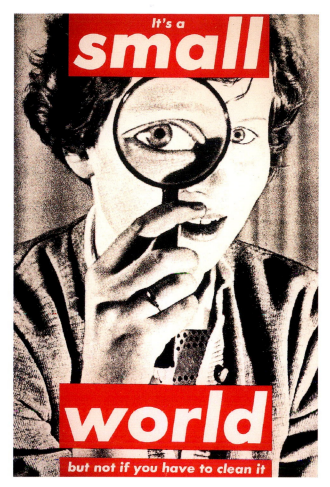

It's a
small
world
but not if you have to clean it

Figure 9.6 Drawing on the methods and strategies of advertising, Barbara Kruger appropriates studio-type images and text to deal with capitalism, patriarchal oppression, and consumption. Kruger attempts to deconstruct consumerism, the power of the media, and stereotypes of women by showing how images and words can manipulate and obscure meaning. About her work, Kruger states, "The thing that's happening with photography today vis-à-vis computer imaging, vis-à-vis alteration, is that it no longer needs to be based on the real at all ... Photography to me no longer pertains to the rhetoric of realism; it pertains more to the rhetoric of the unreal rather than the real or of course the hyperreal."

© Barbara Kruger. *Untitled*, 1990. 143 × 103 inches. Photographic silkscreen on vinyl. Courtesy of Mary Boone Gallery, New York, NY.

allow image alterations. In other situations, such as the many photojournalists who "work for hire," the image may belong to the newspaper or client who paid for its production. Bear in mind that aside from certain exceptions, such as educational fair use and parody, using of copyrighted images without permission is illegal. Also, celebrities such as the Rolling Stones own the rights to their images and you are legally obligated to pay them a royalty to use their likeness for any commercial purposes.

For additional information see US Copyright Office, Library of Congress, www.loc.gov/copyright, or contact an intellectual property rights attorney.

Dr. Frankenstein's Found Image Collage

Similar to the Scan-o-gram (see page 171), artist and photo educator Liz Lee of SUNY Fredonia, asks you to consider composition, positive and negative relations, proximity and pictorial space, but instead of making pictures of actual things, you will use found images to create a new image; i.e. none of the images used to compose the final image may be made by you. Instead, think like a digital Dr. Frankenstein and find images on the Internet, in books, e-mails, and magazines; any images made by someone else are fair game in the quest to create a single new visual body out of others people's picture parts. Within your final creation there should not be any bitmapping or moiré effects, and you must work within the original image's resolution and size limitations. If you want to use an image within the collage and it is too small, then it must remain too small, or you do not use it. You may not increase image size and thus resolution. If an intended image is too big for your project, then you are in luck—you can always scale down. You may also scan images from any source and at any size or resolution required, but there should not be any noticeable imaging issues like moiré patterns unless it is compositionally or conceptually incorporated into the piece.

Become familiar with "fair use" and "copyright violation" by listening to Laurence Lessig's Free Culture Presentation (30 minutes) at: http://randomfoo.net/oscon/2002/lessig/free.html. Then visit: www.copyright.gov to learn about US copyright law and regulations. Now research well-known examples, such as Andy Warhol's celebrity images, Sherrie Levine's "After Walker Evans" series, and Shepard Fairey's Barrack Obama's "Hope" poster. As the "fair use" doctrine allows one to use other people's imagery as long as the image's nature is dramatically changed through artistic transformation, how much change constitutes transformation? What insights does this give you into the creation process?

Pixels and Silver Crystals

Since its invention, film has provided inexpensive, easily retrievable, sharp, continuous-tone pictures. In contrast, electronic sensors (digital film) use pixels, at a variety of resolutions, to create the illusion of continuous tone (see Figure 9.7). The image produced by a camera lens is in analog form, meaning there is a continuously variable scale not unlike the volume control on your MP3 player or radio, which has a smooth progression from soft to loud. Likewise, a film image has a continuous scale of tones from light to dark.

A debated question is: How many pixels are needed for a digital camera to match the microscopic silver crystals in film? Technically speaking, there are the equivalent of approximately 20 million pixels in a typical high-quality 35mm color negative.

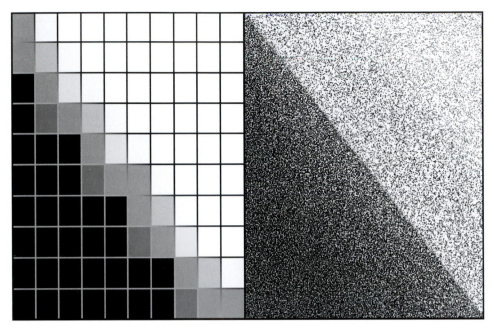

Pixels Silver Crystals

Figure 9.7 How pixels and silver crystals optically capture light.

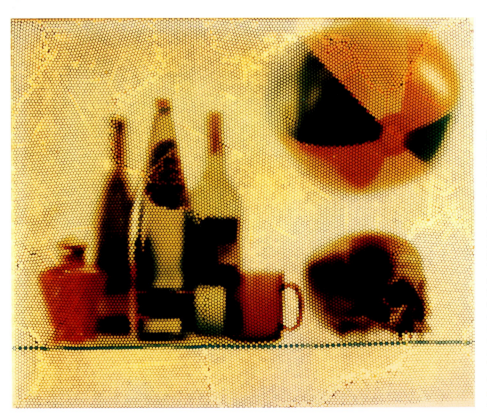

Figure 9.8 Mick Farrell and Cliff Haynes built a handmade camera out of 23,000 black drinking straws. A wooden frame holds the straws in place, a sheet of clear Perspex in the frame positions colored gels, and the camera back holds a sheet of light-sensitive paper. The team exposes their subject using flash, processes the paper to make a paper negative, and then contact prints the image to make a color photograph. The camera uses no lenses; rather, the straws capture the light and color in their line of sight as a dot. The artists explain, "At a time when digital technology has for the most part replaced analog working practices, it is interesting to use an analog system that produces an image that appears to be constructed from pixels."

© Mick Farrell and Cliff Haynes. *Still Life*, 2007. 20 × 24 inches. Chromogenic color print.

The difference of opinion is over how small and how close pixels and dots have to be for our eyes to recognize continuous tone. Analog prints are continuous in tone; the key in making digital prints is the number of values present in a digital image file to create the illusion of continuous tone. Human vision can differentiate between 180 and 200 neutral values from white to black. This means that for a grayscale or a digital image to appear continuous in tone, it must contain at least 180 individual neutral values for the human eye to think it sees a continuous tonal scale. When there are fewer than 180 values, banding occurs (the grouping together of values in linear bands). This is particularly evident in areas with long, gentle tonal gradation, such as sky. This is why 8-bit image capture became the early standard. Eight bits of data produce 256 values, enough to satisfy the 180-level benchmark. Less than eight bits of data is not enough to successfully produce an image that will be perceived as continuous in tone. As digital technology has advanced, 16- and 32-bit capture are commonplace, which allows for more tonal manipulation. This is an updated version of the old photographic dispute of whether you need a small- or large-format camera to make high-quality pictures. The real question is not how many megapixels one needs to make realistic photographs, but what are the aesthetic and technical requirements for the final image to serve its intended purpose. Just as the size and quality of a film negative determine the character of a gelatin silver print, so the quality and size of your electronic sensor (input), regardless of its source, is the critical factor in influencing the look of the final output.

Digital Cameras

Digital cameras have an image sensor, positioned in place of the film in a conventional camera, which transmits electronic pulses to the camera's onboard computer for processing. CCD (Charge-Coupled Device) and CMOS (Complementary Metal Oxide Sensor) are the most common types of light-sensitive chips used for image gathering. CCD sensors are devoted to light capture only and require the onboard camera computer to complete the imaging process into bits. CMOS sensors include light sensors with digitization circuits so that the chip directly outputs digital bits to the camera computer, requiring less camera circuitry.

An image sensor array has tens of millions of light-sensitive sensels that make up millions of sensor elements arranged in an array or grid. When an exposure is made, the lens focuses light on the individual sensor and its array of sensels. Each single RGB sensor array is made up of nine sensels that are involved in the calculation of a single (target) pixel. For a video demonstrating this concept visit "How a Pixel Gets Its Color" at http://digital.mediumformatcamerasite.com/96/how-a-pixel-gets-its-color-bayer-sensor-digital-image/. Once the image is recorded (digitized) into millions of pixels, the imaging software can be used to select and adjust the color, brightness, and position of any one pixel.

Although digital cameras resemble film-based cameras, there are major differences that can significantly affect the image. The human eye can accurately record detail in light intensities within a camera range equivalent of about 15 to 30 f-stops in a scene. By comparison, color transparency film captures a range of light intensities of about five f-stops. Most digital cameras capture a range of light intensities of about eight to nine f-stops—not as good as the human eye, but almost twice as much as color film—while high-end cameras can capture about 11 f-stops. This increased range of sensitivity makes it possible for digital cameras to photograph in extremely low light without a tripod or additional artificial light. Many digital image sensors also can capture blues, dark greens, and fluorescent colors more accurately than film.

Digital cameras do away with the darkroom, using imaging software to create pictures. Digital and film cameras are fundamentally alike; it will be the choice of optics, format, cost, and features that determine which works best for you. Once you have mastered the proper camera setting, digital cameras can match the quality of film cameras, bearing in mind that quality is a relative term. With pixels and silver halide crystals on equal footing, it is critical for imagemakers to gain a personal knowledge of the differences digital and film cameras offer in their recording and output capabilities. Quality is not intrinsic but determined by individual aesthetic choices and reproduction needs. This chapter and the next one discuss the aesthetic and technical differences imposed by your digital choices.

High Dynamic Range Photography

High Dynamic Range (HDR) photography provides the means to create a single photographic image of a scene that exceeds the dynamic range, the ratio between the maximum highlight (white) and darkest shadow (black) of your digital or film camera capture, from a series of bracketed exposures. The photographic dynamic range is usually measured as a ratio and/or f-stops. For example, a typical scene on an overcast day has a dynamic range ratio of 6:1, or the difference of three f-stops between the highlights and shadows, while the same scene on a cloudless sunny day could have a ratio of 24:1 or 12 f-stop difference (see Figure 9.9).

Roughly, the human eye has a dynamic range of 10,000:1, allowing the pupil to open and close to accommodate changing light conditions. This wildly surpasses top digital cameras having a single exposure capture range of about 14 f-stops and the best extended-range film having a maximum range of seven f-stops.

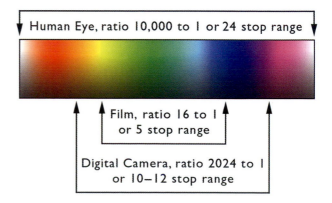

Figure 9.9 Dynamic Range Chart.

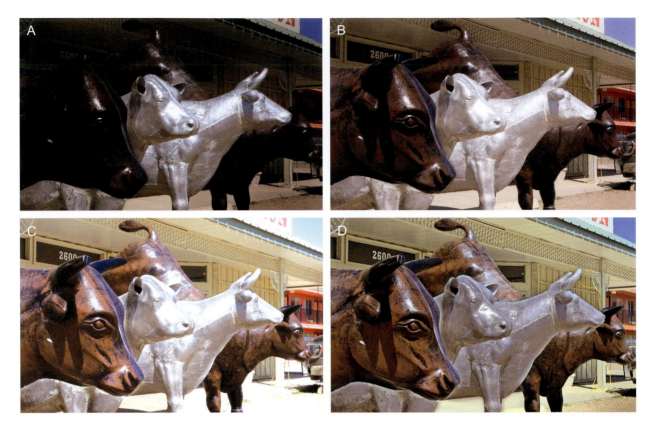

Figure 9.10 Del Scoville photographed this HDR sequence of these metal steers with his Canon Digital EOS XLS using Creaceed-Hydra HDR plugin for Aperture. The extreme range of value created between the bright unfinished aluminum and dark patina in full-sun made this shot ideal for HDR. (A) One-stop under-exposed, (B) normal exposure, (C) one stop over-exposed and (D) HDR composite.

© Del Scoville. *Metal Steers*, 2010. 6⅜ × 10 inches. Chromogenic color print.

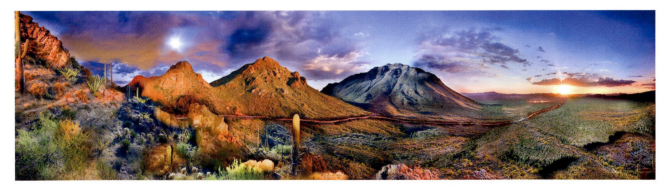

Figure 9.11 William Lesch used a Mamiya 645 with a digital back and colored gels to make multiple exposures of this landscape at various times of day and night. He constructed a high dynamic range (HDR) photograph by stitching together 50 of these images. Lesch tells us that this work "involves time-lapse exposures covering from one day to several weeks or months, sometimes hundreds of exposures from the same location. I am learning to think of them more like paintings or long-term projects than photographs; they are about the passage of time and flow and change through the land or the city. I am dealing with challenges such as learning to think less like a photographer who looks for a decisive moment, fortuitous light, or an unexpected angle, and working more like a painter who creates a canvas out of what happens over time."

© William Lesch. *Gates Pass, Dawn to Sunset to Night, Time-Lapse Exposure Over Two Days*, November 2008. Variable dimensions. Inkjet print. Courtesy of Etherton Gallery, Tucson, AZ.

Figure 9.12 Dots appear as a continuous line when the human eye can no longer differentiate between the spaces and the dots.

The eye does not produce instantaneous results, but rather it delivers data to the brain, which then must calculate and adjust for changing light situations. For instance, suppose you are outside at night looking at the moon and then walk directly into a brightly lit room. Your brain will require several seconds to adjust to this new data. The variable nature of our seeing process allows us to see detail both in the darkness outdoors and in a well-lit room, but not necessarily in unison, thus making extreme lighting situations an either/or condition. Like Ansel Adams' Zone System (see Appendix 3), HDR is another evolutionary step on the path to making photographs that more closely replicate how we actually see the world.

HDR images can be made with any digital or film camera that has manual controls and can be mounted on a tripod. Subject and/or camera movement will affect the clarity of the outcome, but feel free to experiment. HDR software allows one to compile multiple bracketed digital image files or negatives (by scanning) into a single digital file for printing or screen display. Essentially, this is accomplished by making three separate exposures: (A) underexposure of one f-stop for highlight detail; (B) normal exposure; (C) overexposure of one f-stop for shadow detail and (D) HDR composite image of all three. Once image capture is complete, then HDR software can be used to render these different files into a single image file. Some HDR software allows more than three digital files to be merged into a single image. Many digital cameras have a bracketing mode, a.k.a. Tone Mapping, which allows the camera to internally carry out this procedure. In the future, digital sensors may equal the dynamic range of the human eye with a single exposure, eliminating the need for electronic flash and special software while maintaining accurate highlight and shadow detail.

For additional information see David Nightingale's *Practical HDR: A Complete Guide to Creating High Dynamic Range Images with Your Digital SLR* (Boston, MA and London: Focal Press, 2009).

Visual Acuity and 300 DPI

Visual acuity is the capability of the human eye to resolve detail, but this power of human vision to recognize fine detail has limits. When it comes to digital imaging, the point where dots, lines, and spaces are seen as continuous tone to the human eye is approximately 300 dots per inch (dpi). This is why photographic high-quality printers have resolutions of 300 dpi and higher. There are many variables, such as individual differences in visual acuity, lighting conditions, and viewing distance, but generally 300 dpi is considered acceptable for mimicking continuous tone. An 8 ×10-inch digital print viewed at 12 inches (30 cm) easily allows the dots to be seen as a continuous tone to the average eye. As prints are made larger, the necessary viewing distance increases, which theoretically means the dpi could be reduced. Modern printers create images in a variety of ways. Depending on the way a printer lays down its dots on a page, a print made at 200 dpi on one printer can look finer than a print made at 400 dpi on another. Regardless of what printer you use, 300 dpi has become the standard for amateur photographers wishing to display personal snapshots. The more demanding critical eye, such as professionals intending to greatly enlarge their digital files and still maintain continuous tone quality at close viewing distances, will require 600 to 8000 dpi output (see Figure 9.12)

Digital Camera Features

Resolution

When choosing a digital camera, a key feature to consider, after optical quality, is the resolution. This is measured in millions of pixels, known as megapixels. Generally, 1-megapixel digital cellphone cameras can create 2 × 1-inch prints at 300 dpi, without cropping, that are almost indistinguishable from 100 ISO 35mm film (see Chapter 11, page 000). Three- and 4-megapixel digital cameras can make indistinguishable prints up to 5 × 7 or even 8 × 10 inches. Five-megapixel cameras and higher have no problem producing 8 × 10-inch prints that are almost indistinguishable from film prints. The main advantage of choosing a digital camera with more megapixels is that it allows you to crop more freely to produce high-quality 8 × 10-inch prints from selected areas of your image file. The camera only records resolution; it is the imaging software program that calculates the dpi and corresponding print dimension, when the image file is first opened. Generally, by default, images are displayed at 72 dpi (Web quality) with their corresponding print dimensions. This can be a problem as the standard for photo-quality images is an output of 300 dpi, not 72 dpi. Achieving photo-quality output requires converting the default 72 dpi to 300 dpi, which will reduce the default print dimensions (see Table 9.1). Being able to make the proper conversion from 72 to 300 dpi is essential for photo-quality printing and a simple conversion to make. Figure 9.13 illustrates this relationship between megapixels, pixel dimensions, and print size. Notice that the image must be doubled in megapixels to significantly increase picture size at 300 dpi.

The resolution of both digital and film cameras is determined by the edge sharpness or detail found in the actual digital file or film image. Digital resolution is determined by the number of light-sensitive sensels that convert light into electrons in the camera's image sensor. A sensel is the photodiode that records and averages the brightness and the color of the light striking it; the greater the number of sensels, the higher the number of pixels created. Film resolution is determined by its light-sensitivity or ISO rating. However with film, the lower the ISO number, the greater the resolution because the silver grains are smaller and form a tighter pattern when developed.

For instance, a resolution of 1600 × 1200 indicates that the digital camera produces images at a maximum of 1600 horizontal pixels by 1200 vertical pixels, or a grid of about 2 megapixels (1,920,000 pixels). A resolution of 6000 × 4000 indicates that the digital camera produces images at a maximum of 6000 horizontal pixels by 4000 vertical pixels, or a grid of 24 megapixels. A 24-megapixel camera has over 10 times more resolution than a 2-megapixel camera. Roughly, 35mm film has the digital equivalency of between 16 and 24 megapixels.

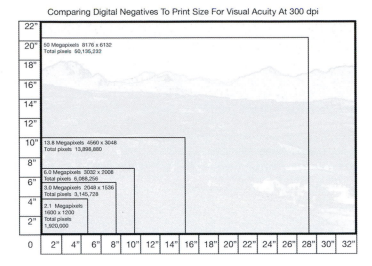

Comparing Digital Negatives To Print Size For Visual Acuity At 300 dpi

50 Megapixels 8176 x 6132
Total pixels 50,135,232

13.8 Megapixels 4560 x 3048
Total pixels 13,898,880

6.0 Megapixels 3032 x 2008
Total pixels 6,088,256

3.0 Megapixels 2048 x 1536
Total pixels 3,145,728

2.1 Megapixels
1600 x 1200
Total pixels
1,920,000

Figure 9.13 Digital negative by pixel dimensions.

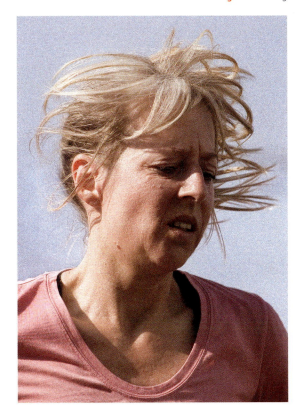

Figure 9.14 Using a high-resolution digital camera allowed Nathan Baker to rapidly photograph thousands of people's facial expressions as they ran past him. He states, "This project would have been impossible with a film camera, since I was plucking individuals from a marathon and had very little control over the compositional accuracy of each exposure. I found that using a digital camera with a 200mm lens provided a way to quickly expose thousands of images in rapid succession while ensuring adequate optical resolution and proper pre-editing composition." After processing and color-correcting the images, Baker prints them on life-size vinyl banners.

© Nathan Baker. *Untitled #654*, from the series *Ugghhh*, 2009. 85 × 60 inches. Inkjet print on vinyl banner.

Tomorrow's Cellphone and Digital Information Appliance

The convergence of technology has produced digital information appliances, such as smart phones and personal digital assistants (PDA), which all provide similar functions. These handheld, wireless devices, embedded with voice, text messaging, video conferencing, and Internet access, are not only changing the ways we communicate, but also how we shoot high-quality pictures and video. Current cellphone cameras are the descendants of amateur Instamatic and Polaroid cameras, yet advances in digital technology and optics are allowing professionals to set aside their DSLRs and use information appliances in certain photographic situations. Nowadays, using an "all-in-one" digital information appliance with global positioning, a photographer can locate a petroglyph in the mountains of northwest New Mexico, photograph it, and upload the images to a Facebook page, then take a break, watch the news on CNN, and finally phone friends to let them know when she or he will be home—all on the same device.

LCD Monitor

Digital cameras have an LCD (liquid crystal display) monitor on the back of the camera that shows the image the lens focuses on. This allows you to compose the image without using the optical viewfinder and lets you see previously recorded images in the camera's memory card, so you can review your work as you make it. However, LCDs can be difficult to see in bright light or at particular angles (optional hoods are available), they use a great amount of battery power, and cannot be relied on as an accurate guide to color or focus.

Lens Coverage and Depth of Field

Unless the image sensor is the exact size of a comparable film format, the image area covered by your lens will be different for a digital camera than for a 35mm film camera. Generally manufacturers list their conversion equivalencies, based on the size of their sensor chip. Most pocket digital cameras have image sensors smaller than 35mm film, which decreases the area of coverage, or field of view, in a scene. A 10mm lens on a digital camera might show the same field of view as a 50mm lens on a

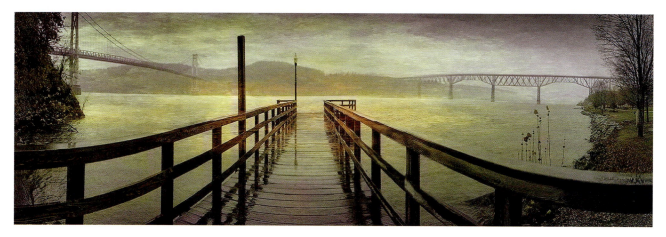

Figure 9.15 An iPhone serves as Dan Burkholder's camera, processing and production station, and output device. Like a plein-air painter, he assembles his tools, sets up his workstation, and builds his image while in the field. After taking a dozen or more photographs of a scene, the artist stitches them together to create spatial relationships not possible with a single image capture. From there, Burkholder moves from one iPhone application to the next, colorizing, texturing, and cropping. Once complete, the artist outputs his photograph by e-mailing or sharing them online. He says, "This fluid workflow makes for a creative arc that is much more exciting than when there is an artificial void between the time of capture and the interpretive steps involving software or darkroom techniques. This is the purest interpretive photography I've experienced, where camera and artist's intent blend naturally and creatively."

© Dan Burkholder. *Two Bridges Near Poughkeepsie*, 2010. 5 × 15 inches. Inkjet print.

TABLE 9.1 RESOLUTIONS AND IMAGE SIZE

Digital image	Screen image	Printed image
Image Resolution	= Screen size at 72 ppi (pixels per inch)	= Image size printed at 300 dpi (dots per inch)
640 × 480	= 22.58 cm × 16.93 cm (8.889 in. × 6.667 in.)	= 5.42 cm × 4.06 cm (2.133 in. × 1.6 in.)
800 × 600	= 28.22 cm × 21.17 cm (11.111 in. × 8.333 in.)	= 6.77 cm × 5.08 cm (2.667 in. × 2 in.)
1024 × 768	= 36.12 cm × 27.09 cm (14.222 in. × 10.667 in.)	= 8.67 cm × 6.5 cm (3.413 in. × 2.56 in.)
1280 × 960 (1.3 megapixel)	= 45.16 cm × 33.87 cm (17.778 in. × 13.333 in.)	= 10.84 cm × 8.13 cm (4.267 in. × 3.2 in.)
1600 × 1200 (2.1 megapixel)	= 56.44 cm × 42.33 cm (22.22 in. × 16.665 in.)	= 13.55 cm × 10.16 cm (5.333 in. × 4 in.)
1800 × 1200 (2.3 megapixel)	= 63.5 cm × 42.33 cm (25 in. × 16.665 in.)	= 15.24 cm × 10.16 cm (6 in. × 4 in.)
2048 × 1536 (3 megapixel)	= 72.25 cm × 54.19 cm (28.444 in. × 21.333 in.)	= 17.34 cm × 13 cm (6.827 in. × 5.12 in.)
2400 × 1600 (4 megapixel)	= 84.67 cm × 56.44 cm (33.333 in. × 22.22 in.)	= 20.32 cm × 13.55 cm (8 in. × 5.33 in.)
3032 × 2008 (6 megapixel)	= 106.96 cm × 70.84 cm (42.111 in. × 27.889 in.)	= 25.67 cm × 17 cm (10.107 in. × 6.693 in.)
4560 × 3048 (13.89 megapixel)	= 160.87 cm × 107.53 cm (63.333 in. × 42.333 in.)	= 38.61 cm × 25.81 cm (15.2 in. × 10.16 in.)
6236 × 4124 (24 megapixel)	= 219.99 cm × 145.49 cm (86.11 in. × 57.278 in.)	= 52.8 cm × 34.92 cm (20.78 in. × 13.74 in.)
8176 × 6132 (50 megapixel)	= 288.43 cm × 216.32 cm (113.55 in. × 85.16 in.)	= 69.2 cm × 51.9 cm (27.25 in. × 20.44 in.)

35mm camera, enhancing the telephoto capabilities of the lens at the expense of wide-angle coverage. Such cameras often require an auxiliary wide-angle lens attachment to achieve wide-angle capabilities.

The smaller image sensors and smaller lenses of digital cameras tend to create a much smaller circle of light formed by a lens, known as a "circle of confusion" (see Chapter 13, How the Camera Works: Circles of Confusion, page 251). This smaller circle of confusion is therefore sharper with a smaller digital sensor than those formed by 35mm film cameras. This can make obtaining a shallow depth of field, the range of distance between the nearest and farthest points from the camera that is rendered acceptably sharp, very problematic. For instance, many digital cameras make it extremely difficult, if not impossible, to create the soft-focus background that is accepted practice in portraiture and nature photographs. In these instances, one can attempt to achieve shallow depth of field by using the longest focal length and the largest f-stop possible. Even then, the results will be less dramatic than with a 35mm film camera. The smaller image sensors and lenses of inexpensive and pro-consumer digital cameras will dramatically increase the depth of field, which can make a digital f/4 the equivalent of f/22 on a 35mm film camera. This necessitates using post-capture software to create simulated selective focus.

Depth of field can be more effectively controlled on a full-frame DSLR camera by using a large lens aperture and a tilt-shift lens.

Figure 9.16 Though he initially photographed his *Tucumcari* series with a medium-format film camera, Jeremiah Ariaz has begun to incorporate digital work into this project. He finds that a Canon DSLR provides the ease of a small camera yet allows him to work with a standard lens and a tripod. The artist makes use of the camera's LCD screen by referencing its live view mode, which enables him to zoom in to check detailed areas of his composition. He also streamlined the process of moving between analog and digital by creating a mask for the LCD screen that replicates the format of his original film camera. Ariaz tells us, "By revisiting the town and photographing the same scenes, I convey the sense of time passing. Though the project began in a documentary style, it has evolved into a more visionary approach to encompass a larger, more personal story."

© Jeremiah Ariaz. *Chris's Auto Repair, 1421 East Route 66*, from the series *Tucumcari*, 2009. Variable dimensions. Inkjet print. Courtesy of Dolphin Gallery, Kansas City, MO.

Figure 9.17 Liz Lee utilizes very shallow depth of field and digitally constructed Polaroid Type 59 film to question the rules of photography. Each image in this series incorporates a word ending in –tion, pronounced "shun," to examine the intentions and distortions of language. Lee says, "Political parties and news media outlets use a language of simple description that, when isolated from context, references an entirely different meaning from its original intent. The superimposition of 's/tion' words is a semiotic ploy to draw attention to the misappropriation of words by political figures and the mainstream media, an attempt to 'shun' the practice of using language with such simplistic force. As digital constructions, each image places a fabricated photograph within a photograph in order to further comment on the relationship between image and reality."

© Liz Lee. *"Homegrown" Terrorism*, from *Grassroots (the 'shun' series)*, 2007. 15⅜ × 12¼ inches. Inkjet print.

Digital ISO

Digital cameras, like their film counterparts, allow the user to adjust for different lighting conditions by changing the aperture and the shutter speed. In addition, film camera users can change the type of film in the camera. The ISO (International Standards Organization) designation is used to describe the sensor's or film's sensitivity to light and its resulting effect on an image. The higher the ISO setting, the more sensitive to light the means of capture becomes, but there is a corresponding increase in digital picture noise and film grain (see next section).

A digital camera cannot change the size of its photodiodes (the digital equivalent to a grain of silver halide) in its imaging sensor. To compensate for varying light levels, digital cameras adjust the electrical gain of the signal from the sensor. Increasing the gain amplifies the power of the signal after it has been captured on the image sensor. This is the digital equivalent of "push processing" film in low-light situations. The major advantage of digital ISO is that the user can change the ISO of any individual frame. For example, frame 9 can be exposed outside at ISO 100 while frame 10 may be exposed indoors at ISO 800. Digital camera manufacturers have made an effort to align the digital ISO settings with film ISO ratings, but while they may be close, digital ISO numbers should be used only for reference.

Although changing the ISO in a digital camera is more effective than push processing film, it is not without side effects. The higher the ISO setting, the more likely it will be that pictures contain "noise" that appears as random, off-color pixels and banding, unpredicted bands that appear in areas with no detail. Advances in digital noise-reduction technology have made cameras having ISO ranges up to 12,000 with low noise interference and sharpness possible, something unattainable with silver technology.

In low-light situations, image stabilization and motion detection features can help to compensate for the effects of camera shake and subject movement to provide sharper results.

White Balance

Digital cameras can automatically or manually adjust the color balance of each frame electronically according to the color temperature of the light coming through the lens. Most cameras have a variety of settings for different lighting sources that can include any of the following: daylight, cloudy, shade, incandescent, and fluorescent (see Table 9.2). High-end digital cameras also offer white balance bracketing for mixed lighting sources as well as custom white balancing. Learning how to adjust and control the white balance can mean the difference between capturing that spectacular sunset or having the camera automatically "correct" it down to gray sky. Using RAW allows one to adjust the white balance after capture. Film cameras have only two options for color balance at the time of exposure: Choosing between daylight and tungsten film, and selecting a filter to place in front of the lens. Other color corrections may be made during printing.

Digital Camera Color Modes/Picture Controls

Digital cameras have image-processing algorithms designed to achieve accurate color, but variables within these programs and within the scene may produce distinct color variations. Professional cameras offer a range of application modes that are referred to differently by each manufacturer. For instance, one mode might be optimized to set the hue and chroma values for skin tones in portraits. Another mode could be Adobe RGB

ISO 200, no noise ISO 1200, noise

Figure 9.18 Greg Erf uses a flash to photograph people at close range during the late evening hours. This dramatizes the individual in the foreground while de-emphasizing the background as the light from the flash does not travel much beyond 12 feet. The initial digital picture was taken at ISO 200. The second example has been enhanced to better illustrate what the digital noise would look like had the scene been photographed at ISO 1200.

© Greg Erf. *Main Street*, 2000. 8 × 10 inches. Inkjet print.

TABLE 9.2	COMMON DIGITAL WHITE BALANCE CONTROLS

▪ Auto: White balance is automatically measured and adjusted.

▪ Preset: White balance is manually measured and adjusted in the same lighting as the subject (gray card is recommended as a target). This is useful under mixed light conditions.

▪ Daylight: Preset for daylight. Subsets let you make the image either more red (warm) or blue (cool).

▪ Incandescent: Preset for incandescent (tungsten) light.

▪ Fluorescent: Preset for fluorescent light. May have subsets for FL1 (white), FL2 (neutral), or FL3 (daylight) fluorescent lights. Check the camera owner's manual for the correct setting designations.

▪ Cloudy: Preset for cloudy or overcast skies.

▪ Shade: Preset for shade.

▪ Flash: Preset for flash photography.

▪ Bracket: Makes three different white balance exposures (selected value, reddish, and bluish).

gamut-based, which gives a wider range of color for output on six- or eight-color printers (see Color Management in Chapter 11, page 208). Additional modes can be optimized for outdoor landscape, nature, or night work. Some cameras also offer Standard, Neutral, and Vivid color modes, plus Monochrome, along with customization for each setting. Variations in monitors and viewing situations will affect the image color. Use both your camera monitor and histogram to judge color accuracy during image capture. The RAW format allows users to adjust color after exposure.

Optical and Digital Zoom

Digital cameras are equipped with optical zoom, digital zoom, or both. Optical zoom physically magnifies the subject by moving the lens elements to the desired magnification. Digital zoom magnifies the image by increasing the number of pixels until the desired magnification occurs through a process called interpolation. Interpolation is a set of mathematical logarithms automatically applied when the original pixel dimensions are changed for resizing (see Interpolation in Chapter 11, page 194). Digital zoom interpolates, or constructs, pixels that were not in the original to programmatically zoom in on the image rather than the actual subject, which degrades the overall image quality.

Memory Buffer

Most digital cameras have a memory buffer for the temporary storage of images during shooting. After releasing the shutter, the image's data is processed in the camera and then transferred/written to the storage card. To speed up this process and reduce the time between exposures, the memory buffer temporarily stores the data before transferring/writing it to the memory card. The recording time can be seconds or minutes, depending on the buffer, and exposures cannot be made during this time. Most digital cameras have relatively large memory buffers, allowing them to operate as quickly as a film camera in Continuous (a.k.a. burst) mode.

Removable Camera Memory Storage

Digital cameras provide limited amounts of internal storage capacity and use removable memory cards to store images. When the removable memory becomes full, the data can be transferred to a computer or printer for output. There are numerous reusable types and sizes of removable memory, and the selection is based primarily on the latest technology and your working equipment.

High-Definition (HD) Video

Many recent DSLRs include HD video capability that permits a photographer, when using a high-speed memory card, to also capture and edit video footage. The DSLR's image sensor is larger than a typical camcorder and in turn delivers higher image quality and high ISO performance during low-light shooting, along with a motion picture look and effects not possible with standard digital video equipment.

Common Digital Camera File Formats

The digital file uses a binary code to electronically record data, such as an image or text, and allows it to be stored, processed, and manipulated in a computer. Although all images are written in binary code, there are a variety of file formats for saving and for images. Each format has a unique method of translating the resolution, sharpness, value, and color of a digital image, and each has its uses, advantages, and limitations.

Most digital cameras provide several file format options, such as JPEG (or JPG), TIFF, and RAW, plus a range of quality settings that can be set to meet the needs of a particular situation. These basic file format options can be loosely compared to different types of film in terms of grain. RAW provides the most flexibility, provided your imaging software supports the RAW format. The quality settings, such as low, medium, and high, can be loosely equated to film format size, such as 35mm, 2¼ × 2¼, or 4 × 5 inches, and the look one gets when these are contact printed. To get predictable results from your digital photography you must understand the differences between various file formats and quality settings, along with the final print size.

Compression Algorithms: Lossless and Lossy

Digital cameras can "compress" images to save file space on the memory card. Compression algorithms, a set of mathematical program instructions, are designed to reduce the original file size to create extra storage space or to speed up file transfer over a network. It is essential to understand the differences in methods of digital information storage to obtain the desired final image. Although there are numerous file compression types, they all fit into two basic categories: lossless and lossy. Lossless compression indicates a compressed file's ability to recover all the original data when the file is uncompressed. Lossy compression permanently reduces a file by eliminating redundant data or data not visible to the average eye; this data cannot be recovered. This results in a loss of image quality that is proportional to the amount of compression. Most lossy file types give options to determine how much compression is desired. Different file types are best for different applications (see Box 9.1).

JPEG

JPEG, Joint Photographic Experts Group, is the default file format used on most digital cameras because it allows for the maximum number of pictures per megabyte of memory. JPEG is a compression format with great control over file sizes using the Basic/Small, Normal/Medium, and Fine/Large settings on your camera to manage final output quality. JPEG is an excellent file format, but images cannot be restored to their original file size because information has been permanently eliminated. The JPEG image file format uses a lossy compression scheme and is commonly used for low-resolution continuous tone images on the Web. JPEG compression also allows the creator to decide between file size and image quality; as the file size increases, so does image quality. JPEG files should not be opened and resaved multiple times because the images will slowly deteriorate (due to the lossy compression scheme) and become soft and pixelated. Compression has been likened to crushing an eggshell and gluing it back together. During the rebuilding process tiny pieces are lost, the glue smears, and the shape is not quite smooth. The more you crush, the more noticeable the defects, such as abrupt color highlights graduations, loss of sharpness, jagged lines, and swirling patterns known as artifacts. When you download from the Web or open JPEG files from your camera you should save them immediately as a TIFF or PSD or PNG (see Box 9.1) and work from this new file format. It is always best to go back and work from your original new file format (TIFF, PSD, PNG) when remaking JPEG files to avoid image degradation.

TIFF

TIFF, Tag Image File Format, is the current standard in the graphics and printing field. TIFF files are used to exchange files between applications and computer platforms, and for high-quality printing. Known as an interchange format, TIFF is easily opened on any platform and has long been considered one of the most universally accepted high-resolution file formats. TIFF may use a lossless compression algorithm.

RAW, Post-Processing and the Latent Image

As JPEG is a lossy file format that throws away unneeded data, if the capture is not as you desire, making corrections can be difficult or unfeasible. If you don't mind doing computer work after image capture, RAW will give you the most latitude in making adjustments. The RAW file format is a type of raw data storage used to import/export file sensor information rather than a completed visual image file. The RAW file format can be considered a pure "digital negative" because it contains straight binary files (0s and 1s) with information pertaining only to individual pixels from the image sensor. When a RAW image format is captured (shutter released) only the sensor data is saved, creating an unprocessed image stored as data. In silver photography this undeveloped or unprocessed film image is called the latent image, which is simply silver particles that have been exposed to light but not yet processed to form a visible image. In all digital image formats, except RAW, visible images are processed upon exposure in the camera using whatever settings have been determined beforehand, such as color balance, color depth, compression, size, white balance, sharpening, and file format.

The RAW file format is exposure data only (the latent image) that has not been processed or formatted for any specific

> ## Box 9.1 Other Major Digital File Types
>
> - GIF, Graphics Interchange Format, is a lossy format used primarily for the Web. While excellent for flat color graphics, it is not ideal for photographs.
>
> - PNG, Portable Network Graphics, is a format designed to supplant the older GIF format and can substitute for many common uses of the TIFF format. The PNG file format supports transparency, truecolor (16 million colors) while the GIF supports only 256 colors. The PNG file excels when the image has large, uniformly colored areas. The lossless PNG format is best suited for editing pictures, and the lossy formats, like JPEG, are best for the final Web distribution of photographic images, because JPEG files are lossy and smaller than PNG files.
>
> - EPS, Encapsulated Postscript, files are designed for saving high-resolution documents, illustrations, and photographs for electronic prepress for page layout software in the printing industry. EPS files can only be read by postscript enabled devices.
>
> - PDF, Portable Document Format is a file format for representing two-dimensional documents, including images, independently of the application software, hardware, and operating system.
>
> - PICT is encoded in Macintosh's native graphics language. PICT files are lossless, can be opened on the Windows platform and saved in most software applications. PICT file format is no longer used on contemporary Macintoshes.
>
> - BMP is the standard Windows image format. It is lossless and designed for pictures or graphics.
>
> - Program Specific file types, such as Photoshop (.psd) or Illustrator (.ai), are native file formats that contain the maximum amount of information about an image for use in its own native program. Sometimes these native files are much larger than similar common file formats because program specific features are saved only in native file formats. When saving the image to a common file format, which is sometimes called a non-native file format, the image's layers may have to be combined, and certain formatting information may be eliminated.

application. The main advantage of these pure unprocessed RAW files is that they are uncompressed, small in size, and now can be post-processed to create any file type needed. Opening RAW files requires using a separate software application or a plugin module added to your image-processing software before importing. Once you import/open the RAW file format using your RAW application, the image is ready for post-processing. Now is when you make your decisions about exposure, white balance, image size, resolution, and sharpening. Essentially, RAW moves all the pre-controls and settings you normally set on the camera before image capture to *after* image capture. This

RAW post-production workflow gives you maximum control about converting your image into whatever file format or using whatever settings you want.

File Headers: Opening Files

Regardless of the type of file you are working with, all computer files have what are called file headers, which is the portion of the file that tells the computer what the file is, what program created it, the date it was created, and so on. Although the files themselves can easily go back and forth between various computer systems, the file headers do not always work properly. When you double click on a file, the computer reads the header and attempts to guess what to do with the file. Sometimes it guesses wrongly. If you have trouble opening a file, open it within the application.

Storage Media for Final Image Files

Besides hard drives, there are many expandable and portable devices that can aid in the storage and transportation of information. From the 1970s to the early 1990s, the 5¼-inch floppy disk and later the smaller 3½-inch floppy disk were the standard for storing files. Each disk held respectively 400–800 kilobytes (KB) and 1.4 megabytes (MB), or 1433 KB, of information. At that time, a typical word-processing file might require 8 KB, but today an image file can easily exceed 100 MB (100,000 KB), requiring gigabytes of storage space. Storage devices are continually being developed and improved. The following are some that have made a major impact on the digital medium.

Compact Disk (CD) and Digital Versatile Disk (DVD)

These inexpensive metallic disks, coated with a clear resin, use laser technology to optically record data, and are standards for reliably distributing large quantities of information, including text, images, sound, and video. CDs hold approximately 700 MB of information and DVDs can hold from 4.7 GB up to 8.5 GB, depending on the type. CDs and DVDs can be written on once

(CD-R, DVD-R) or be rewritable (CD-RW, DVD-RW). Recordable dual layer (DL) DVDs and recordable Blu-Ray discs are available that can hold up to 50 GB. There are many competing formats for DVDs, so be sure to select the format that suits your needs and works best with your system.

Mechanical Storage: Hard Drives

Mechanical storage is the most common and least expensive type of storage device. Situated both internally and externally, hard drives are metal disks coated with iron oxide that spin and rely on a synchronizing head to read/write digital information. The head floats just above the surface and magnetically charges the oxide particles to store the digital data.

Internal Hard Disk Drives

Internal hard drives are where a computer's programs and files are stored. When the computer is turned off, all saved data remains on the hard drive, which comes in a variety of sizes measured in gigabytes and terabytes.

External Hard Disk Drives

Small and portable, external hard drives connect directly to a computer through various internal ports headers, such as USB 3.0, FireWire 400 and 800, and eSTAT, which all determine data transfer speed. They are an ideal solution for transferring large digital files and backup of valuable data. These drives are hot swappable, allowing them to be connected or disconnected without turning off the power.

Solid-State Storage: Hard Drives, USB Drives, and Flash Memory Media

Neither magnetic, like hard disk drives, nor optical, like CDs or DVDs, solid-state storage is electronically erasable, RAM-like memory that is available for both internal and external applications. Access time is faster than with a disk because the data can be randomly accessed and does not rely on a read/write head searching for data on a rotating disk. Additionally, this type of storage uses less power and is shock resistant, though it has a higher cost per megabyte of storage than mechanical storage.

Figure 9.19 Barry Frydlender constructs panoramic images by compositing dozens of photographs of the same scene, taken over a period of time and from several different angles. This image of an intersection in New York City is composed of 40 photographs, which merge together in a time and space manipulation. Frydlender's images are indicative of how digital imaging has altered the definition of photographic truth by mimicking and therefore undermining traditional photojournalistic methods. He tells us, "It's not one instant, it's many instants put together, and there's a hidden history in every image."

© Barry Frydlender. *57th and Sixth Avenue*, 2008. 26 × 108 inches. Chromogenic color print. Courtesy of Andrea Meislin Gallery, New York, NY.

The most common solid-state storage devices are the flash memory cards used to record images in digital cameras and USB drives. They come in a wide variety of names, physical shapes, and storage capabilities. Flash memory cards require special adapters, known as card readers, which plug into standard computer ports. USB drives require only a USB port and are smaller than a pack of chewing gum. Although mechanical storage is more prone to failure than solid-state storage, always back up all files because all storage devices will eventually fail.

Scanners

Scanners are input devices that digitize information directly from printed or photographic materials in a method similar to photocopiers. Aside from digital cameras, scanners are the most common type of equipment used for getting images into a computer. Light is reflected off or through an image or object and interpreted by light sensors. Color scanners use RGB filters to read an image in single or multiple passes. After the scan is complete, software can be used to make color and contrast corrections and to crop and adjust image size. Although manufacturers use their own software, there are some basic scanning features and procedures (see Table 9.3).

Flatbed and Film Scanners

Flatbed scanners, capable of digitizing images in a variety of resolutions, are the most common tools for digitizing documents. These devices allow users to preview the image and make minor corrections before scanning. Although designed to digitize prints, some flatbed scanners can handle film.

Film scanners are specifically designed to capture the minute details of small negatives and transparencies by transmitting light through an image, making them more expensive than flatbed scanners.

Digital Camera Backs

Digital scanning camera backs are designed for commercial applications. Available for 120 and 4 × 5-inch film cameras, they offer unparalleled image capture, but are expensive.

Drum Scanners

Drum scanners generally offer the most accurate way of digitizing flat media. An image is read on a glass drum while being spun at several thousand revolutions per minute. Scans of both prints and transparencies made on these comparatively expensive devices are more precise and translate images with greater detail than do regular flatbed scanners. However, some high-end flatbed scanners are capable of scanning prints, 8 × 10-inch transparencies, or film at a quality that can rival drum scans.

Scanning Guidelines

Although there are numerous types of scanners, some basic principles are applicable in most scanning situations. Scaling and resolution must be set at the time the image is scanned. The input settings draw reference from the original image, producing the

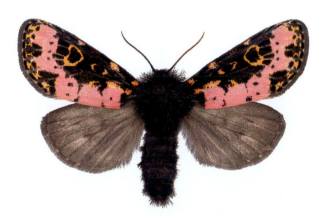

Figure 9.20 Digital scanning technology allows Joseph Scheer to create very high-resolution images of tiny moths. After collecting moths from distant locations, the artist scans the actual specimens multiple times, utilizing an extended focus method of varying levels, and then digitally combines the images. Scheer states, "How we see and know things in our world and the ways in which the images gather meaning is fundamental to my working practice. I believe that we live in a time in which it is highly critical to promote our respect for, and redefine the delicate relationship to, the many living things on our planet. I have chosen moths to study and create work from because of their diversity (approximately 14,000 species found in the United States) and their rich mythology in history."

© Joseph Scheer. *Xanthopastis regnatrix*, 2007. 34 × 47 inches. Inkjet print. Courtesy of David Floria Gallery, Aspen, CO.

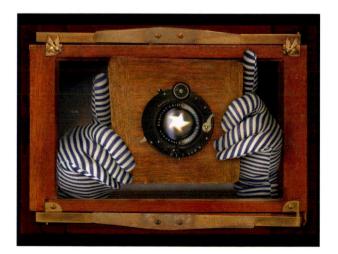

Figure 9.21 J. Seeley had used alternative film processes for most of his photographic career, deliberately avoiding the digital realm, until he suddenly felt he had run out of ideas. Using a flatbed scanner and an inkjet printer prompted him to realize that he could continue to push the limits of his artistic practice with this technology. A scanner now serves as Seeley's primary camera. He says, "The scanner's myopic vision is fascinating. As the light bar passes over objects it sees them in a very different way than a lens camera. It seems to favor certain types of surfaces, such as metal, glass, and skin. Some subject details are emphasized, while others are rendered only as a soft suggestion of their reality. The result is an image that is simultaneously hyper-realistic and gracefully stylized."

© J. Seeley. *Self-Portrait Camera*, 2009. 14 × 18 inches. Inkjet print.

TABLE 9.3 SCANNING RESOLUTION	
Use	**Scan resolution**
Internet	72 dpi
Newspaper	150 dpi
Glossy magazine	300 dpi
Photo-quality print	300 dpi
Large fine art print	4000 dpi and higher

Box 9.2 Formula for Determining Input Resolution

Printer resolution	×	Scaling	=	Input resolution
300 dpi	×	400%	=	1200 dpi

best-quality scan. A common mistake is to allow the software to automatically set the final size (scaling) and resolution, which may force interpolation to occur and degrade the final image. Select the appropriate resolution based on the intended use (Table 9.3).

Determining the best resolution for continuous-tone prints is based on the maximum dpi of the printer being used. Good scanning software will allow a user to input a scaling factor into a dialog box and then do the file-size math automatically. If your software does not do this, use the simple formula in Box 9.2 to calculate input resolution based on printer resolution and the scaling of the image. For example, if you are using a 300 dpi printer you will need to scale a 4 × 5-inch print at 400 percent to make a 16 × 20-inch digital print, requiring an input resolution of 1200 dpi. Typically, you should scan at a higher resolution than necessary for final output to allow for flexibility in processing and cropping.

Box 9.3 Scanning Steps

1. Open the scanning software. Often this can be done through imaging software, such as Photoshop, under File>Import>Name of the scanning software. Many scanners use an independent software application to drive the scanner. In this case, open the independent application and proceed to the next step.

2. Set the scanner for Positive or Negative. Many scanners are dual use, with the ability to scan photographic positives (reflective) and negatives or slides (transparent). Make sure the scanner is properly physically configured for reflective or transparent materials and set to the proper media before scanning.

3. Grayscale or Color. Even though scanning in grayscale is possible, scanning in color often provides superior results because the scan is occurring in three channels (red, green, and blue) instead of one. If black-and-white is desired, simply change the image to grayscale in the imaging software *after* it is acquired.

4. Place the image/negative or object in the scanning bed. For flat artwork, be sure to place the image squarely on the scanning bed, as this will reduce the amount of post-scanning scaling and rotating.

5. Perform a preview scan of the entire scanning bed. This will permit you to see the entire scanning area and the image to be scanned. Use the marquee tool to select the target area as closely as possible.

6. Make tonal adjustments. Most good scanning software will create a preview of the image based on the area you selected with the marquee tool. All scanning software has settings to control the contrast, brightness, and color balance of images. Change these settings to get the previewed image color balanced as closely as possible before scanning. The most important adjustment to make is contrast. An image that has excess contrast contains less information about tonal values. Slightly flat contrast images contain more information in the highlight and shadows and generally provide better results in post-scan processing. After scanning, use your photo-editing software to make final color and contrast adjustments to an image.

7. Set File Size. Before scanning, decide what size your final print is going to be. Scanners display and define size in two ways: image size and resolution. Most scanning software will display the size of the area being scanned, multiplied by a scaling factor. Increasing the scale of the image will increase the dimensions of the final scanned image. Increasing the resolution of the scan will increase the potential quality of the image. Both operations will increase the file size. As a general rule, the larger the file size, the more options you have when working with the finished scanned image.

8. Scan image.

9. Save file. Once your image is scanned, immediately save the file. Keep these scans safe, and do all future work only by making copies of these files.

Problem Solving

Scan-o-gram: Scale and Spatial Effects

Utilize a scanner to create an image made from found objects. Practice scaling the composition by following the formula in Box 9.2 to make the found objects larger than life. Start by placing a piece of clear acetate on the scanner glass to protect it from any sharp or rough objects. Then start collecting a variety of two-dimensional and three-dimensional objects that will fit comfortably on your scanner to create a 4 × 5-inch composition. Next, create a background using a piece of any colored material cut to 4 × 5 inches or a photograph approximately that size. First, arrange the found objects face down in the middle of the scanning bed and then place the 4 × 5-inch background material on top of the objects. Close the scanner top, preview the scanning bed, and select a scanning area that includes the 4 × 5-inch cut material that has been used for the background. Once you are satisfied with the composition, set the scale at 200 percent to produce a final image that will be enlarged and printed to 8 × 10 inches. Now, determine the printer resolution, calculate the input resolution needed and set it before final scan. Finally, make a series of prints increasing both the scale and the input resolution (see Box 9.2), and compare the differences in the various prints. Look specifically for how scale changes the spatial relationship between the viewer and objects, now that they are much larger than life.

Other curious cameraless effects are possible using analog methods (see Photograms section in Chapter 13).

NOTE

1. See *Walter Benjamin Illuminations*, edited and with an introduction by Hannah Arendt, translated by Harry Zohn (New York: Schocken Books, 1969), pp. 217–51.

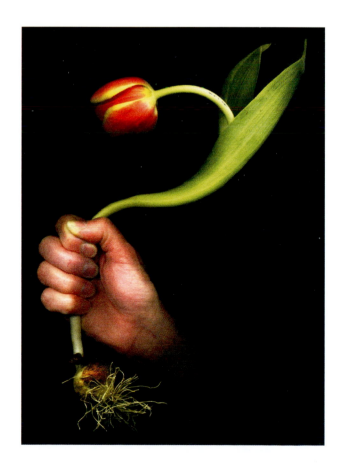

The Latin phrase *memento mori* has long been used to describe works of art containing visual and symbolic references to death. Kitty Hubbard made the scans for this series just prior to her father's death and completed the work about eighteen months later. She reflects, "Living in a time of war, we know that death can be near, we are hyper-sensitized to this in our post- 9/11 consciousness. In this series the flower signifies the counterpoints of beauty and decay, life and death, order and chaos, and mourning and hope."

© Kitty Hubbard. *Memento Mori #8*, 2008. 10¼ × 8 inches. Inkjet print.

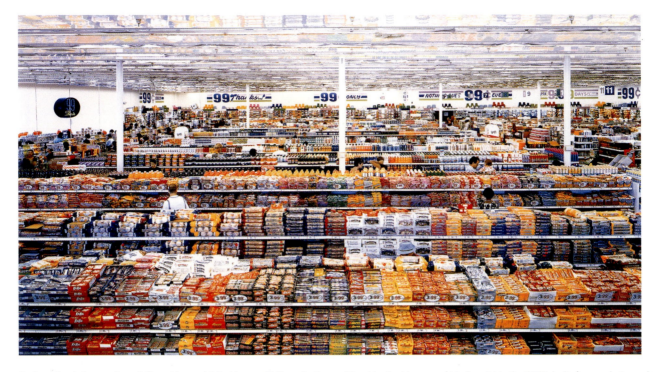

Andreas Gursky's super formalistic and hyper-detailed images fit the collecting mold cast by the Museum of Modern Art in the 1970s by its former photography curator John Szarkowski. The major difference is that today a computer is used to add data, resulting in a picture that appears more real than reality itself. Peter Galassi, MoMA's current photography curator who trained under Szarkowski, declares Gursky's large-scale hybrids as finally giving photography the quality to compete with painting. Gursky's premeditated Olympian-sized spectacles of color and pattern present subjects not as they are, but as we think they should be. The gigantic work continues the belief in photographic detail, whose fundamental premise is that more information is better because clarity is the way we build our truths and it represents how we want to see the world. Gursky maintains the position that photography is best suited as a cataloger of outward appearances because detail is emblematic of truth.

© Andreas Gursky. *99 Cent*, 1999. 81½ × 132⅝ inches. Chromogenic color print. Courtesy of Matthew Marks Gallery, New York, NY.

Analog Input: Color Films

Transparency Film

Characteristic Advantages

The old photographic rule holds true: The fewer generations an image goes through to reach finality, the better the ultimate quality. Color transparencies, also known as color slides, are positives that are made on reversal film. Each slide is an original piece of film that was exposed in a camera. For viewing purposes, what you see is what you get. Prints, on the other hand, are second-generation images, made by enlarging a negative onto color printing paper. Transparencies are what communication theorist Marshall McLuhan referred to as a "light through" medium, viewed by transmitted light that passes through the image only one time. Prints are a "light on" medium seen by light that is reflected from them. The light bounces off the base support of the print and passes through the image in the emulsion twice, coming and going. This effect doubles the density, which in turn reduces what can be seen within the print itself. Due to this "double density effect," transparencies have certain advantages over prints made from negatives, which include having a sharper grain structure, maximum color separation, better color saturation (intensity), and greater subtlety in color and detail.

Figure 10.1 Images made on transparency or slide film can be directly translated into digital form on a scanner. Annette Weintraub experimented with an early version of Photoshop to layer fragments from multiple slide and video images. This work, from a series dealing with artificial light and vernacular elements of urban architecture, "explores a distorted world of exaggerated and unnatural color, reflected light, and fragments of illuminated signage that appear like messages sent out into an uninhabited world … The light references the illumination of media, movies, and other entertainment, which implies the presence of spectators on the deserted strip, while the falsely 'cheerful' color and iconic signage underlines a disquieting rupture from nature."

© Annette Weintraub. *Spiral Nebula*, from the series *Night Light*, 1992. Variable dimensions. Inkjet print.

The viewer can distinguish a wider tonal range in transparencies because they are viewed by transmitted light. A high-contrast transparency can have a "readable" tonal range, from the whitest white to blackest black, of about 400:1 when projected, and even more when viewed directly. This ratio is an indicator of how well the detail and color saturation are clearly separated in the key highlight and shadow areas. A color print viewed in normal room light can have a tonal range of only about 100:1. It is usually closer to 85:1 due to light scattering caused by the surface of the print. It is said that an "average" daylight scene has a brightness range of 160:1 or higher. This means that transparency film can do a superior job of capturing a fuller range of tones in many situations. Also, since transparency film provides greater luminosity, which is the perception of brightness, a well-shot slide can appear more luminous than the actual subject and evoke a visual response even more intense than the original does. This can be an effective aesthetic device that utilizes the subjective nature of color to create the impression that a subject is emitting light.

Transparency film's wider tonal range translates into higher contrast, which gives the slide increased color saturation (most noticeable in the slower films) and boosts its ability to differentiate details in the highlight areas. This enhancement is most observable in the difference between diffused and specular highlights. The classic test is a white flower with water droplets, where the petals reflect light in all directions (diffused highlights) and the water droplets directly reflect light as a bright catchlight (specular highlights). Transparency film clearly shows the difference between the two, while a print often obscures the subtlety of the separation.

Usually, transparency film is exposed to produce acceptable detail in the key highlight areas of a scene. Both color saturation (vividness) and density increase proportionally with less exposure. For this reason, many photographers intentionally underexpose their slide film by adjusting the standard ISO (International Standards Organization) rating or using exposure compensation. For example, a film rated by the manufacturer at ISO 64 could be modified in the range of ISO 80 to 120. Experimentation by bracketing in 1/3 or 1/2 f-stops is desired (see Film Speed Tests, Addendum 3).

The processing of slide film provides the user with a finished product without printing or any other additional steps, and therefore can be done at home or in a school darkroom without a great deal of specialized equipment. Their small size makes transparencies easier to edit, index, and store than negative film. Also, the final cost per image is 20 to 30 percent lower. Before the advent of digital images, transparencies were the choice for photographic reproduction because printers could make color separations directly from them. They continue to be ideal for direct digital translation via a film scanner.

Disadvantages of Transparencies

Despite their good points, transparencies do have disadvantages. Small and difficult to see, they generally require a projector and screen for proper viewing. The final image is contained on the film base itself, making each slide a unique object that must be handled with care to prevent damage when being viewed. While both of these characteristics can make slides less convenient to use than prints, their major disadvantages lie in their post-exposure limitations.

Unlike negative film, the range of contrast for transparencies can be manipulated only slightly through development, which directly affects the color balance of the film. Worse yet, there is no second chance to make corrections with slides, as there is when making a print. Transparency film has a much narrower exposure latitude than negative film. An error of even 1/2 f-stop can ruin the picture since both the color and density of the completed picture are determined by exposure. Overexposed highlights become chalky white with no detail, while underexposed shadows are bulletproof black. Nor is slide film as versatile as negative film in mixed light situations. It is possible to make some corrections by recopying or scanning the slide, but this adds contrast and takes away the initial advantages of slide film. Also, fast slide film (ISO 400 and above) tends to be much grainier than equivalent speed print films.

If a print is made from a slide via color internegative film, which produces a negative from a positive, there are twice as many color and tonal distortions to deal with as when working with negative film. Prints made through a direct-positive process, such as Ilfochrome Classic, can suffer from color distortion due to the lack of a corrective mask on the slide film. Such prints tend to be more contrasty than normal, possibly requiring a contrast reduction mask to print correctly.

How Transparency Film Works

Transparency film makes a positive, rather than a negative, image. Most films use the "tri-pack" structure (although a few have a "quadpack" design), a sandwich of three gelatin layers that contain light-sensitive silver halides. During exposure, each layer records one of the primary colors of light. White light, which is a balance of red, green, and blue, creates a latent image on all three layers. Colors other than the primaries make latent images only in the areas sensitive to those colors. For instance, yellow light, which is a mixture of red and green, makes a latent image only in the corresponding layers; the blue layer does not record it. Imagine a large red ball. In the final picture it appears red because the dyes of the colors complementary to green and blue were formed in two layers of the film during development. When the slide is viewed in white light, the green and blue are subtracted from the light, which leaves only red to be seen. Slide film, unlike negative film, has no color mask to correct inherent imperfections of the red-sensitive and green-sensitive layers of the film.

Technical advances in color negative films have been applied to slide materials as well. For example, in each of the three color-sensitive emulsion layers of Fuji's Provia 100F film are at least three sublayers that contain different sizes and shapes of silver halide crystals to enhance color quality and improve gradation and tonal rendition. Provia also is the first slide film to use developer inhibitor-releasing (DIR) couplers, compounds that work during the first development to boost saturation, control contrast, and improve sharpness. Also, the film's granularity value is even lower than other current ISO 25 films and its grain is very consistent in size, which makes it appear even finer.

E-6 Processing

All the major color transparency film manufacturers use a standard Kodak chromogenic development process (E-6) to produce the cyan, magenta, and yellow dyes in their three-layer emulsion structures. There are other manufacturers, such as Arista, Beseler, Hunt, and Tetenal Colortec, and each has variations in its version of the E-6 process. The label on the film box or cassette will state if it can be developed by this method.

In E-6 chromogenic development the first step is similar to black-and-white processing (Table 10.1). A silver-grain negative image is developed in each layer of the emulsion. The silver appears where the film has been struck by light. White light affects all three layers, while red, for example, forms silver only in the red-sensitive layer. No colored dye is formed during this stage of the process.

Next, the first development is halted and the film is "fogged," either through chemical action or exposure to light, so that silver grains can be formed throughout all layers of the emulsion.

During color development the remaining silver is developed and the subtractive primary dyes are produced in the emulsion layers in proportion to the amount of silver that is formed. These dyes makeup the final image. At this stage the film looks black because it has metallic silver in all the emulsion layers and color dyes in many places.

To be able to see the dye-positive image, the film has to be bleached. The prebleach has agents that enhance image stability. The bleach transforms all silver into silver halide crystals. Next, the fixer removes all silver halides from the film, leaving only a dye-positive image. Some processes combine the bleach and the fix into one step.

The wash clears away the remaining fixer. The last step is the final rinse, which is mainly a wetting agent used to reduce water spotting and prompt even film drying. Its concentration can be varied to accommodate different drying conditions.

Temperature Control

All color processes are extremely sensitive to time, temperature, and agitation. Technical advances, such as multi-layered coating, mean the latest generation of slide films are even more "process sensitive" than their predecessors. Time and temperature are critical to obtain correct color balance and density. For optimum results, correct temperature range must be maintained throughout the process. If this is not possible, have a professional lab develop the film.

TABLE 10.1	KODAK E-6 PROCESS	
Step	**Time (minutes)***	**Temperature (°F)†**
The first three steps must be carried out in total darkness		
First developer	6‡ (1) and (2)	100.4 ± 0.5
Wash	2	92–102
Reversal bath	2	92–102
The remaining steps can be carried out in room light		
Color developer	6	100.4 ± 2
Prebleach	2	92–102
Bleach	7	92–102
Fixer	4	92–102
Wash	6	92–102
Final rinse	1	92–102
Dry	as needed	up to 140

Note: Before beginning to process, read and follow all manufacturer's safety, mixing, and disposal instructions to ensure your health and that of the environment.

*All steps include a 10-second drain time.

†For best results, keep all temperatures as close to 100°F as possible.

‡Development times change depending on the number of rolls that have been processed. Check the instructions for the capacity of solutions. Mixed solutions have a limited life span. Follow manufacturer's recommendations for storage and useful time limits of all solutions. Times also will change when film is processed in a rotary processor.

(1) Initial agitation: For all solutions, tap tank on a 45-degree angle to dislodge any air bubbles. No further agitation is needed in the reversal bath, prebleach, or final rinse.

(2) Additional agitation: Subsequent agitation is required in all other solutions. After tapping the tank, agitate by slowly turning the tank upside down and back again for the first 15 seconds. For the remaining time of each step, let the tank rest for 25 seconds and then agitate for 5 seconds. Keep the tank in a water-tempering bath to maintain temperatures for both the first and color developers.

With noninvertible tanks, which cannot be turned upside down, tap the tank on a 45-degree angle to remove air bubbles, and rotate the reels at indicated times to achieve proper agitation.

Figure 10.2 Diane Bush used a macro lens to photograph this image on a television screen. When she developed the Ektachrome 400 film, she pushed it one stop. After printing, the imagemaker dripped household bleach onto one side of the print, washed off the bleach, turned the print, and repeated the process until she achieved the desired effect. Instead of a representational image, here Bush made an abstract image to comment on a social problem. She states that as she worked, "I was reminded of women who have had acid thrown in their faces, with the resulting blindness and disfigurement. I do not wish to show photos of these women's faces, which is what other photographers have done. Instead I want to create attractive, saleable work that can raise money for Doctors Without Borders, who can, as an organization, help these victims of these horrendous hate crimes."

© Diane Bush. *Im-BLEACHment #1*, 2009. 49 × 73 inches. Chromogenic color print with bleach.

In the Kodak E-6 process, the developing steps are the most sensitive. Tolerances for consistent results are as follows:

First developer

 Time: plus/minus 5 seconds

 Temperature: plus/minus 0.5 °F (0.3 °C)

Color developer

 Time: plus/minus 15 seconds

 Temperature: plus/minus 1.1 °F (0.6 °C)

Water Bath

To maintain these critical temperatures, a water bath is recommended. Fill a deep tray or pail with water to a depth equal to that of the solution in the storage containers. Bring the water temperature slightly above the actual processing temperature (100.5 °F/38 °C) to allow for cooling due to ambient room temperature. Let the containers and loaded film tank stand in the water until they reach operating levels. Measure the temperature inside the solution containers with an accurate thermometer. Do not allow it to touch the container wall. When not agitating, keep the processing tank in the water bath. Keep the wash temperature the same as the bleach and fixer.

Handling and Agitation

Load film in total darkness. Handle the film only by its edges and ends. Use a light-tight processing tank so that processing can be done under room light.

Agitation is crucial with all color processing. Too little or too much agitation causes uneven or unusual color balance and/or density effects in the processing of the film. Correct agitation can be accomplished by inverting the tank, rotating the tank, or rotating the reels. Follow agitation instructions based on the type of tank used. If only one roll of film is being processed in a multi-reel tank, place the loaded reel in the bottom and fill the tank with the empty reels.

Stainless steel tanks and reels are recommended because they can be inverted, offer a clean and even agitation pattern,

do not absorb chemicals, are easy to clean, and are durable. However, they are more expensive, initially harder to load, and require practice to put the film correctly onto the reel.

The final rinse can be mixed with distilled water. Shake the loaded film reel over the sink to break the surface tension. This will permit the final rinse to flow freely and run to the lower end of the hanging film. A lint-free, disposable paper wipe, such as a PEC★PAD, can be gently used on the shiny, non-emulsion side of the film. Then allow the film to hang and naturally air dry, undisturbed, in a dust-free environment.

E-6 ISO Processing Adjustments

Most E-6 process films can be exposed at different speeds and still produce acceptable results if the first developer time is adjusted to compensate (Table 10.2). Use the standard times for all other solutions. Adjustments in processing can allow certain films to be successfully push-processed or can save film that has been

TABLE 10.2 STARTING POINTS FOR FIRST DEVELOPER TIME COMPENSATION	
Camera exposure time*	First developer (minutes)†
One stop overexposed	4
Normal exposure	6
One stop underexposed	8
Two stops underexposed	11½
Three stops underexposed	16

*Color slide film that is more than one f-stop overexposed or more than two f-stops underexposed will not deliver normal color balance or density.

†Time based on first roll in fresh solutions.

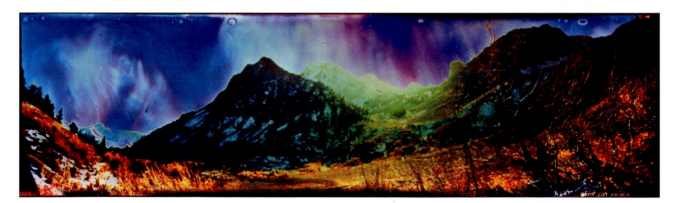

Figure 10.3 Claudia Wornum experimented by using expired Ektachrome 100 film and developing it in Acufine. After fixing the film, she immersed it in equal parts E-6 and C-41 color bleaches, washed it, and developed it as a color negative. Wornum explains her use of chance: "My pinhole camera doesn't have a viewfinder or a tripod mount. The Sierra scene was spectacular but I had no way of knowing if the camera could 'see' it as I did. The light was erratic as well, and I prefer full sun for pinhole exposure. I took my best shot and hoped for the best … By experimenting with different developers, dilution, and timing, the resulting image picks up saturated colors and becomes chemically solarized in high-contrast areas."

© Claudia Wornum. *McGee Vista*, from the series *Acceleration*, 2000. 2¾ × 7 inches. Chromogenic color print.

exposed at the wrong ISO rating. However, when regular film is push-processed it can suffer a color balance shift, a change in contrast, and a decrease in exposure latitude. Highest quality is achieved when normal speed rating(s) and processing are observed.

Special Processing

Generally, transparency material can be identified by a brand name that carries the suffix "chrome." The majority of transparency films, such as Ektachrome and Fujichrome, can be processed at most laboratories or on your own. Custom labs will do push processing. The quality of these laboratories varies tremendously. Check them out before giving them any important work to do.

E-6 Troubleshooting

Table 10.3 lists some common E-6 processing problems, their probable cause, and possible corrective actions. Follow all safety recommendations when handling chemicals.

Diversity of Materials

Brands

Transparency film is available in many brands and in different speed ranges. Each manufacturer uses its own dyes, yielding noticeable variations in the colors produced. Some brands emphasize certain colors, while others may have an overall cool (blue) or warm (red and yellow) bias. This allows a choice of color palette. Brands also differ in their contrast, grain structure, saturation, and overall sharpness. Some films are designed for specific applications, such as portraits, which allows you to match film to your purpose. Be aware that different lenses, especially older lenses, deliver distinct color rendering. Multi-layer coating techniques allow modern lenses to provide a greater standardized color response. Since these characteristics cannot be compensated for during a secondary step like printing, it is important that the photographer choose a transparency film whose bias fits both the aesthetic and technical concerns of the situation. If you plan to scan your film, choose an emulsion that has been optimized for scanning.

Manufacturers constantly are making changes in almost every film they market. For this reason, it is pointless to attempt describing film characteristics that will be rapidly outdated. Visit the major film manufacturers' websites (Box 10.1) for information on their current products. The only way to keep up is to use the different films and evaluate the results for yourself. You can read test reports and talk with other photographers (especially online), but choosing a film is a highly personal matter. Experience is the best guide. Try different films

TABLE 10.3 E-6 TROUBLESHOOTING GUIDE	
Problem	**Cause and correction**
Improper color balance	Solution contamination. Clean all equipment thoroughly. Organize and label solutions to ensure proper sequencing
Overall blue color cast	Improper color developer mixing or incorrect color developer alkalinity (pH). Use reverse-osmosis treated water or add 1 ml/l of sodium hydroxide per 5 units more yellow wanted in color balance (equivalent to about a CC05Y filter). Be sure to adhere to safety rules for working with sodium hydroxide
Green shadows	Exhausted reversal bath. Replace with fresh solution
Overall green color cast	Reversal bath omitted
Red specks	Improper bleaching. Rebleach in fresh solution
Overall red color cast	Insufficient bleach aeration. Rebleach with vigorous agitation
Overall yellow color cast	Improper color developer mixing or incorrect color developer alkalinity (pH). Use reverse-osmosis treated water or add 1 ml/l of sulfuric acid per each 5 units more blue wanted in color balance (equivalent to a CC05B filter). Follow all safety rules when handling sulfuric acid
Yellow or muddy highlights	Exhausted fixer. Refix in fresh solution and repeat wash and final rinse steps
Images appear both negative and positive, or very light color	Developer exhausted. Replace with fresh solution. Color developer temperature too low. Check thermometer. Process at correct temperature
Images too dark	Underexposed film. Check camera meter and review exposure methods. Or first developer time too short, temperature too low, or lack of proper agitation
Images too light	Overexposed film. Check camera meter and review exposure methods. Or first developer time too long, temperature too high, or overagitation. Color developer temperature too low
Dirt, dust, and spots	Mix final rinse with distilled water. Hang in dust-free area and allow to air dry undisturbed. Gently wipe non-emulsion side of film with a soft, disposable, lint-free paper towel
Light crescents	Kinked film. Practice loading developing reels with unwanted film. Don't force film onto reels
Streaks or blotches	Make sure film is properly loaded on the reel. Poor agitation. Follow correct agitation methods for each step
Dyes fade after short time	Prebleach step skipped

in noncritical situations to learn their strong and weak points. After some experimentation you will most likely discover that there is one type of film you prefer. It is worth the time to work with one film and learn its characteristics and personality, because this will be helpful in obtaining consistent and pleasing results.

Film Speed

Each brand offers a selection of different film speeds. The speed, or light sensitivity, of a film is determined from a set of procedures established by the International Standards Organization (ISO). Films can be divided into four basic categories based on their speed: (1) slow films are rated below ISO 100; (2) general-use films are ISO 100 to 200; (3) fast films are ISO 200 to 400; and (4) ultrafast films are above ISO 400 and often are designed for push processing.

In general, slower film speed means greater color saturation, tighter grain structure, and better color contrast, all of which make the image appear sharper. Slower films also have less tolerance for exposure error. Faster films look grainier and do not have as much color contrast or saturation. They have a greater ability to handle small exposure errors and limited mixed lighting conditions. In low light conditions faster slide films are able to capture a greater variation in hue and tone than print film, by sacrificing grain and sharpness. Your choice of film should fit the situation and personal color preference. For instance, a slow, enhanced-saturation slide film may make the reds and blues in a scene pop out, but its overly warm and contrasty nature may not be suitable for traditional portraiture.

As the speed of a film increases there is a drop-off in quality (color rendition, grain, sharpness). These effects are more noticeable with slide film than print film. At ISO 400, slide film remains superior, but in the ISO 1000 to 1600 range, print films have a decided edge. This is because print films use ingredients such as developer inhibitor-releasing (DIR) couplers to prevent overdevelopment and grain buildup. The DIR technology is now in use with some of the slow slide films. Print film also uses integral masks, which are dyes that help to improve color saturation and cancel out unwanted color shifts.

Technical innovations bring film improvements on an ongoing basis, so it can be useful to try new films as they are released. Choose film with care, so that it will work for your situation. Try to avoid getting into the position of having to make the film fit the circumstances.

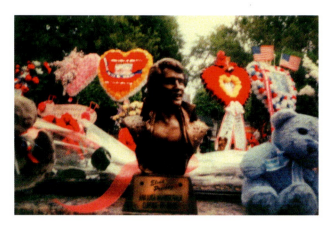

Figure 10.4 To make this picture, Tosh Tanaka used a Leica with a pinhole body cap and Kodak Supra 800 film that he rated at ISO 3200. A desire to photograph without a tripod prompted the artist to experiment with matching film sensitivity to aperture, in order to produce shorter exposure times. Pushing the film allowed him to make bold, saturated prints. Tanaka states, "I strive to capture pinhole images in a documentary style, whose color saturation would also mimic my mind's eye … Using a rangefinder camera body has been a handy tool since the lens is not used to compose. I work with a mixture of envisioned and intuited composition; many times I won't use the viewfinder to frame but rather [I] hold the camera and make a picture when I feel compelled to release the shutter."

© Tosh Tanaka. *Graceland 1*, from the series *Road Work*, 2003. 6 × 9 inches. Chromogenic color print.

Amateur and Professional Films Compared

Both amateur and professional films have similar color quality, grain characteristics, image stability, and sharpness. The main difference is in the color balance of the films. As color film ages, the characteristics of its color balance change.

An amateur photographer typically buys a few rolls of film at a time. The film might remain in the camera at various temperatures for long periods of time before it is processed. Allowances for this type of use are built into the film during manufacturing. For example, if a film's color balance shifts toward yellow as it ages, the color balance of the emulsion is made in the complementary direction, blue, to compensate. This allows time for the film to be shipped, stocked, and to sit in the camera. By the time the film is finally shot and processed, its color balance still should be close to optimum.

Professional films are manufactured at their optimum point for accurate color balance and consistent speed. These films are designed for refrigerated storage by both the dealer and user, and processed immediately after exposure.

Daylight, Tungsten, and Type A Films

The color performance of a film varies depending on the lighting conditions in which it is used. Slide materials work best when properly matched to the type of light under which they are exposed (see Chapter 3). Daylight films work best in daylight and with electronic flash. Tungsten slide film is balanced for use

with photo floodlights. Type A film is balanced for 3400 K bulbs, Type B film for 3200 K bulbs.

The latest generation of tungsten films, such as Fujichrome T64 Professional and Kodak Ektachrome 64T Professional, can deliver accurate reproduction of subtle color gradations and are particularly suited to product photography, interior and other architectural work, as well as the reproduction of art work. Typically, they have an exposure range of up to 1/125 of a second to 2 minutes that requires no exposure compensation or color balance corrections. Exposures lasting longer than 4 minutes are subject to reciprocity failure, and thus require exposure and color balance corrections.

Make certain the film type used matches the light under which it is exposed, because any mismatch between film and light source will be dramatically evident. Daylight slide film exposed under floods or household bulbs comes out an orange-yellow-red and tungsten slide film shot in daylight comes out blue. This imbalance can be corrected at the time of exposure through the use of the proper filter over the lens (see Chapter 4).

Under mixed light conditions, situations illuminated by daylight and artificial light or scenes lit with both tungsten and fluorescent bulbs, there is no way to simply color-correct the scene if the slide is the finished product. Even if a print is made or the film is scanned, corrections will probably be limited in scope.

In open or deep shade, or in overcast daylight, the film may record the scene with a cool, bluish cast. A warming filter, such as an 81A, can be used to correct this.

In contrasty lighting, slide film can produce bleached-out highlights and dark, inky shadows.

Transparency Viewing and Duplication

In order to judge critically the quality of a color transparency, it is necessary to have a viewing light source (illuminator) that possesses a correlated color temperature of 5000 K (see Chapter 4). Light sources that range in color temperature from 3800 K to 5000 K are satisfactory for general viewing by the public, if they emit adequate amounts of light in the red, green, and blue portions of the spectrum. A transparency viewed with a tungsten light source will have a red–yellow color bias; one viewed against a blue sky likely will be biased in the blue direction.

Ideally, transparencies should be shown using a projector with a high-intensity, color-corrected lamp. For correct viewing, hold the slide in its proper orientation (how the original scene looked), turn it upside down, and drop into the slot in the tray; the film's emulsion-side should face the lens and screen.

Transparency Duplication

Once transparency film has been exposed and processed, the major method to make corrections and/or modifications is by slide duplication. It is possible to change colors and combine images for effect, but at the expense of an increase in contrast and loss of subtle detail. For making your own "dupes," most 35mm cameras accept a slide duplicator, which is a rigid-tube copying accessory with its own lens. After placement in front of a light diffuser within the copying tube, the slide is lighted

by either daylight or electronic flash. Thin plastic CC filters are used to adjust or modify the color balance. Copying slides can be an excellent means of experimentation, especially when naturalistic color rendition is not a priority. Making your own color-accurate dupes can be difficult and requires a number of test rolls to determine correct exposure and filtration. Unless you make dupes frequently and in large quantities, you are better off having them made by a professional lab.

Commercial duplication makes use of a specialized copying stand with diffused electronic flash and built-in color filters, and should be done with special low-contrast duplicating films. When accurate copy slides are required, use only a first-class professional lab because the quality of dupes can vary greatly (also see the section on copy work in Chapter 15).

A transparency also can be scanned, digitally corrected, and outputted as either a new transparency or digital file.

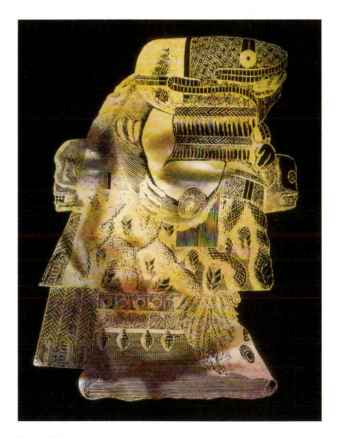

Figure 10.5 Exploring issues of Chicana ideology is of primary importance to Delilah Montoya. "In my own evolving ideology I question my identity as a Chicana in occupied America, and articulate the experience of a minority woman in the West. I work to understand the depth of my spiritual, political, emotional, and cultural icons, realizing that in exploring the topography of my conceptual homeland, Aztlan, I am searching for configurations of my own vision." For this image Montoya sandwiched a piece of Kodalith film and a 4 × 5-inch transparency, producing a moiré pattern, and rephotographed the result on a slide duplicator.

© Delilah Montoya. *Sapagonia*, 1995. 9½ × 14⅛ inches. Chromogenic color transparency.

Color Negative Film

Color Negative Film Characteristics

Color negative film is the first part of a flexible two-stage process for making prints on photographic paper. Film development is similar to that used for transparency production, except that it is processed into a negative instead of a positive. This means that on the processed film those areas that were dark in the original subject appear as light, and colors appear as their complement (opposite). Color negative film possesses an orange integral mask (a color mask) to correct for deficiencies in the red- and green-sensitive layers of the film.

Color negative film is easier and quicker to process than transparencies. It is convenient because once you have the necessary equipment for printing, unlimited production is possible. Moreover, negatives are easy to digitize by scanning. Additionally, prints can be displayed without further necessities such as a slide projector, screen, and darkened room. Prints allow intimate contact with the work, enabling the viewer time to become deeply involved with the image.

Negative films are versatile, offering greater exposure latitude—the ability to provide acceptable results with a less than optimum exposure—than slide films, as well as giving the photographer another opportunity to correct an inadequate exposure. Both the color saturation (degree of color intensity) and density increase with more exposure, which is the opposite of transparency film. Negative film should be exposed to produce acceptable detail in the key shadow areas. When in doubt about the proper exposure, it is usually best to slightly overexpose the film. Many photographers intentionally overexpose their negative film as part of their normal working procedure by decreasing the manufacturer's ISO film speed rating. For example, a film with an ISO of 100 might be rated at 80, while an ISO 400 film could be exposed at 200. Bracket in 1/2 f-stops to discover what works best for your situation. Slight overexposure also can produce a tighter grain pattern. This is because the final image is made up of color dyes rather than silver (see Addendum 3).

Negative film has wide latitude for overexposure, often up to four f-stops, which can be corrected when the print is made. If the film is greatly underexposed, more than two f-stops, the result is a weak, thin negative that produces a flat print lacking in detail and color saturation/richness. Changing the color balance, contrast, density, and saturation is possible during the printing process, which allows for production of a final piece that is a more accurate reflection of the photographer's concerns. For these reasons, negative film tends to work better in contrasty and mixed light conditions, and for people pictures where wide varieties of skin tones can be adjusted during the printing process. For available-light shooting, high-speed color negative film (ISO 800) delivers a tighter speed-to-grain ratio than comparable slide film. Beware of using a film with a higher speed than necessary for the conditions, as this can result in the loss of highlight detail in the final print.

Negative film can record a tremendous amount of information, which can be digitally reworked. At the time of processing, professional labs also can scan the negative film to provide both analog and digital versions of your images. In addition, you can have small, inexpensive prints made that provide more information than a contact sheet.

The major disadvantages of color negative film are that more time and equipment are required to get the final image and the range of obtainable color is not as high as transparency film. If a normal print and a slide of the same scene are compared, the transparency will have more brilliance, greater detail, deeper saturation, and more subtle color because the film itself is the final product and is viewed by transmitted light. The negative requires a second step, printing, to get to the final image, resulting in a loss of quality because the print paper is viewed by reflected light. The paper absorbs some of the light, known as the double density effect, causing a loss of color and detail. Still, if a print is the desired end product, the negative/positive process offers the most accurate color rendition. This is because the negative film contains an integral mask (a color mask) that corrects deficiencies in the red- and green-sensitive layers of the film.

Negative Film Construction

Like reversal film, color negative film can be thought of as a sandwich that is constructed atop a single piece of bread. The bread in this case is called the base, on which three different silver halide emulsions that are sensitive to red, green, and blue light form what is called the tri-pack (see Figure 1.10).

Each emulsion layer is coupled to the potential dyes—cyan, magenta, and yellow—that are used to form the color image.

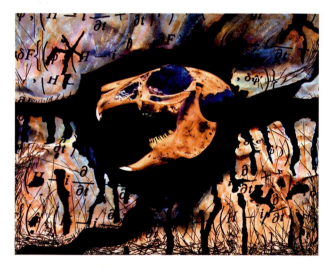

Figure 10.6 This image is the result of negative manipulation in which Jeff Murphy mimicked the method used to make a normal color negative: 4 × 5-inch black-and-white film was shot, processed, and then hand-colored with color markers. The final colors are complements of the color applied to the negative; thus orange becomes blue, and cyan becomes red. The background of the skull is a crumpled photocopy, and the black lines are scratch marks made directly on the negative. This series evolved when Murphy learned a close friend was terminally ill. The work reflects upon the complexities of hope, longings, and desire in the rational and spiritual questioning of death. For Murphy, the skull (bones) has developed a renewed spiritual quality in an attempt to suspend the finality of extinction.

© Jeff Murphy. *Rabbit Skull*, 1990. 24 × 30 inches. Chromogenic color print.

These dyes are the complements of the red, green, and blue hues that made up the original scene. When the film is exposed, a latent image is created in each layer. As an example, red light is recorded in the red-sensitive layer of the tri-pack, but it will not affect the other two layers. Colors that are made up from more than one primary color are recorded on several layers of the tri-pack. Black does not expose any of the emulsion, while white light is recorded on all three layers (see Figure 1.10).

Type S and Type L Films

Some manufacturers design films specifically for different exposure situations. For example, Kodak's "Professional" color negative films come in two versions: Type S, for short exposures, is balanced for daylight and designed for an exposure time of 1/10 to 1/10,000 of a second; Type L, for long exposures, is balanced for tungsten light (3200 K) and for exposure times of 1/50 to 60 seconds. Tungsten negative film is now also available in 35mm and 120 formats. If exposure time and/or the color temperature of the light do not match the film, filters are necessary to correct the color temperature. Small mismatches can be corrected when making the print.

C-41 Process: Chromogenic Development of Negative Film

During the chromogenic development process both the full-black silver image and the color dye image are formed simultaneously in the tri-pack. Next the film is bleached, which removes the unwanted black silver image. This leaves the three layers of dye showing the scene in superimposed cyan, magenta, and yellow, each one being a complement and a negative of the red, green, and blue from the original scene. Now the film is fixed, during which the unexposed areas of the emulsions are made permanent. Washing then removes all the remaining unwanted chemicals. Last, it is stabilized for maximum dye life and then dried (see Figure 1.10). The final color negative has an overall orange mask. The orange color is due to colored couplers that are used to improve color reproduction by reducing contrast and maintaining accurate color during the printing of the negative.

All the major current brands of negative film can be developed in the C-41 process (Table 10.4). If you are not sure that the film you are using is compatible in C-41, check the box or cassette. Many of the latest films are extremely process-sensitive and require very accurate temperature control, otherwise color shifts, lack of color saturation, changes in contrast, and increase

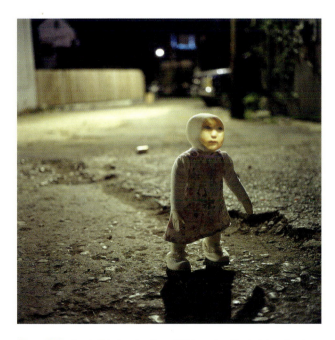

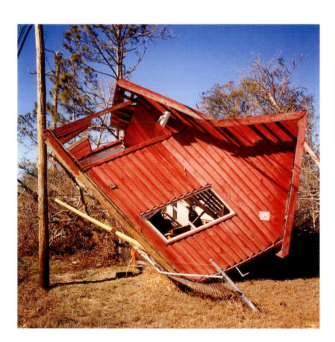

Figure 10.7 Ursula Sokolowska chose 120 tungsten film to take advantage of a larger film format and match the color temperature of her light source, streetlight. This saved time in the darkroom because she did not have to make drastic color-corrections. Sokolowska made use of a second light source, a 35mm slide projector, to create a face for the figure by projecting slides that her father took of her as a child. In doing so, the artist "examines the trauma and uncertainty carried from childhood … Typically, the perception of children handed down by my elders was that children did not have a choice. I am attempting to give these children voices."

© Ursula Sokolowska. *Untitled #32*, from the series *Constructed Family*, 2006. 30 × 30 inches. Chromogenic color print.

Figure 10.8 David Graham is known for traveling the United States with his Hasselblad and color negative film in search of recording the colorful, sometimes surreal, and often-bizarre American landscape. By chronicling the American scene with his unique sensibility and acknowledging popular forms of American photography—the snapshot, the family portrait, and vacation pictures—Graham brings relevance to the creativity, dreams, and tragedies of the ordinary person. Here he documents one of the weirdly altered structures left behind in the aftermath of Hurricane Katrina.

© David Graham. *Waveland, MS*, 2006. 19 × 19 inches. Chromogenic color print.

TABLE 10.4 KODAK C-41 PROCESS		
Step	Time (minutes)*	Temperature (° F)†
The first two steps must be carried out in total darkness		
Developer	3¼‡ (1) and (2)	100 ± 0.25
Bleach	6½	100 ± 5
The remaining steps can be carried out in room light		
Wash	3¼	75–105
Fixer	6½	100 ± 5
Wash	3¼	75–105
Stabilizer (3)	1½	75–105
Dry	As needed	Up to 140

Note: All times and temperatures are for small tanks—not more than four reels. If using a rotary-type processor, changes in time will be necessary.

*All steps include a 10-second drain time.

†For best results, keep all temperatures as close to 100°F as possible. When not agitating the solution, keep the processing tank in water bath. Before processing, warm the tank in water bath for about 5 minutes. See Temperature Control, Chapter 12, page 224.

‡Development times change depending on the number of rolls that have been processed. Mark the number of rolls processed on the developer storage container. Check the capacity of the solutions with the instructions. Mark the mixing date on storage bottle. All solutions have a limited storage life. Check the instructions to determine how long solutions will last under your storage conditions.

(1) Initial agitation: For all solutions, tap the tank on a 45-degree angle to dislodge any air bubbles. No further agitation is needed in the stabilizer.

(2) Additional agitation: Subsequent agitation is required in all other solutions. After tapping the tank, agitate by slowly turning the tank upside down and back again for the first 30 seconds. For the remaining time in the developer, let the tank rest for 13 seconds and agitate for 2 seconds. Since the time in the developer is short, proper agitation is a must or uneven development results. For the remaining time in the bleach and fixer, let the tank rest for 25 seconds and agitate for 5 seconds. When using noninvertible tanks, which cannot be turned upside down, tap the tank on a 45-degree angle to remove air bubbles, and rotate the reels at indicated times to achieve proper agitation.

(3) Stabilizer may be mixed with distilled water. Shake your loaded film reel over the sink to break the surface tension. This allows the stabilizer to flow freely and run to the lower end of the hanging film. A lint-free, disposable paper towel, such as a PEC*PAD, can be gently used on the shiny, non-emulsion side of the film to remove excess stabilizer, dust, and processing debris. Allow film to hang undisturbed and naturally air dry in a dust-free environment.

in grain may result. Read and follow the sections in this chapter on temperature control and handling and agitation. Read and follow all manufacturer's safety, mixing, and disposal instructions to ensure a safe and healthy working environment. C-41 negative films are stored and handled in the same manner as E-6 slide films (see Chapter 12). Major manufacturers, such as Kodak, provide Material Safety Data Sheets on their websites.

C-41 Troubleshooting

Table 10.5 identifies some of the basic C-41 processing problems, their probable cause, and their possible correction.

How the Chromogenic Color Print Process Works

A chromogenic color print is made when light is projected through a color negative onto color printing paper. The light is filtered at some point before it reaches the paper. The paper, like the film, has a three-layered tri-pack emulsion composed of silver and dyes that are used to form the image. Each layer is sensitive to only one color of light, which is complementary to the dyes found in the negative. When the print is made, the colors from the negative are reversed. For instance, a red ball would be recorded in the cyan layer of the negative. When light passes through the negative, only green and blue light are transmitted. This exposes only the layers in the paper emulsion that are sensitive to green and blue light, releasing the complementary magenta and yellow dyes in the paper. The magenta and yellow dyes recreate the red ball from the original scene. Where there is clear film in all the emulsion layers, white light produces a latent image in each of the layers of the print emulsion. This produces black when the print is processed.

Developing the Print

When the print is developed, each of the three layers of the exposed emulsion develops into a positive black-and-white silver

TABLE 10.5	C-41 TROUBLESHOOTING GUIDE

Problem	Cause and Correction
Negatives too dark	Overexposure. Check camera and meter. Review exposure methods. Overdevelopment. Time too long or temperature too high. Check thermometer for accuracy. Review temperature, time, and agitation procedures. Contaminated or incorrectly mixed developer
Negatives too light	Underexposure. Check camera and meter. Review exposure techniques. Underdevelopment. Time too short or temperature too low. Check accuracy of thermometer. Review temperature, time, and agitation procedures. Developer exhausted, incorrectly mixed, or contaminated. Check mix date, number of rolls processed, and storage conditions. Out-of-date film
Dense with high-contrast	Bleach time too short. Unaerated bleach. Bleach temperature too low. Bleach incorrectly mixed or overdiluted
Clear film with no edge marks	Bleached before development. Film was not a C-41 process film
Clear film with edge marks	Unexposed film
Dark crescent-shape marks	Kinked film. Practice loading unwanted film on reels. Only handle the edges and ends of the film. Do not force film onto reel
Unusual color balance and contrast	Solution contamination. Dump and remix contaminated solutions. Clean all processing equipment after each use. Mix and store all solutions in clean containers. Clearly label all containers. Return chemicals to proper containers
Dust, dirt, and spots	Mix stabilizer in distilled water. If water is extremely hard, follow stabilizer bath with Kodak PhotoFlo 200 Solution mixed in distilled water. Allow film to dry naturally in an undisturbed, dust-free environment. To facilitate the free flow of the stabilizer, shake your loaded film reel over the sink to break the surface tension. A lint-free, disposable paper towel may be used to gently wipe the non-emulsion side of the film.

image that represents the third of the spectrum it recorded (red, green, or blue). Wherever the silver is deposited, dyes that correspond to that color are formed. For example, where blue light strikes the paper, only the yellow layer of the tri-pack, which is complementary to blue, is affected. The blue light forms a positive silver image and a directly corresponding yellow dye. After development, the paper contains the exposed tri-pack of positive silver and dyed images. Next the print is bleached. This converts the silver to silver halides, which the fix then removes. Usually the bleach and fix are combined so that this process takes place more or less at the same time. This leaves only a positive dyed image that is washed and then dried. Since the image is formed by dyes, these prints are called dye coupler prints.

The colors in the resulting image are those that are reflected back to the eye from the light falling on the print. An object that is red looks red because the yellow and magenta dyes in the print emulsion absorb the blue and green wavelengths from the light falling on it, reflecting back only the red.

C-Print Misnomer

Prints made from negatives in the C-41 process use chromogenic development to produce the cyan, magenta, and yellow dyes in their emulsions. The term "chromogenic" was coined by Rudolf Fischer, who patented the use of color couplers in 1912 and 1914 (see section on subtractive film and chromogenic development in Chapter 12). Prints from these processes are commonly called chromogenic color prints (there also is a black-and-white process; see later section on chromogenic black-and-white film)

or dye coupler prints. Color prints also may be referred to by the specific paper they were made on, such as Ektacolor. The opposite method for making color prints is the dye-destruction process, or silver dye-bleach method, in which all the color dyes are built into the emulsion and selectively removed during processing (see sections on dye-destruction process and Ilfochrome Classic in Chapter 12).

Many people and organizations still refer to modern color photographs as Type C prints. However, this widely used misnomer does not accurately describe current materials. While some people think the "C" is shorthand for chromogenic or color coupler print, Type C is not a generic term but a specific product – Kodak Color Print Material, Type C – introduced in 1955. Three years later Kodak introduced Ektacolor Paper, Type 1384 to replace Type C in photofinishing applications. Type C continued to be available for professional use for some time, but has been off the market for many decades. Today, "C-print" is a slang term that refers to just about any color print made from a color negative, thereby distinguishing it from prints made from a slide.

Film Speed, Format, and Grain

The look of a final print is linked to the film speed and format size of the negative. The relevant characteristics of color film to bear in mind are that slower films appear sharper with less apparent graininess, possess greater color saturation, and exhibit a fuller tonal range; faster films appear less sharp with more apparent graininess, and have less color saturation and a reduced

tonal range; and the larger the film format, the less apparent the visible grain.

Processed black-and-white film is made up of particles of metallic silver called grain. Graininess is the subjective perception of a mottled random pattern. The viewer sees small, local-density variations in an area of overall uniform density. Although color negatives and transparencies contain no silver, they do exhibit graininess. This is because undeveloped color films contain silver compounds, which are removed by the bleach and fix, that help form the color dyes as they are developed. As the color dyes are created, dye clouds form around the silver particles and remain even after the silver is removed, retaining the silver grain pattern. These clouds of dyes form the grain in a color negative or transparency. The Kodak Print Grain Index (PGI) subjectively evaluates the perceived print graininess from color negative films by using a uniform perceptual scale based on a diffusion enlarger. For details about this assessment, visit the manufacturer's website, www.kodak.com, and download its publication E-58.

Many photographers intentionally overexpose color negative film by 1/3 to one full f-stop to improve shadow detail and saturation, and to reduce graininess. Others take advantage of the two-step process and purposely slightly overexpose and overdevelop in order to heighten contrast for dramatic effect. Slight to moderate overexposure of color negative film, unlike black-and-white, creates larger dye clouds in each of the emulsion layers. As the dye clouds expand, they overlap and fill in from layer to layer, lending the appearance of less graininess.

Chromogenic Black-and-White Film

Ilford XP2 Super is an ISO 400 film, available in 35mm and 120 roll, and is the latest generation of monochromatic negative material to make use of chromogenic color coupler technology. Special DIR couplers yield ultra fine grain, high-acutance (sharp) images. Ilford XP2 Super, like regular color negative materials, produces finer grain when overexposed. This film has wide exposure latitude (ISO 50 to 800), which allows it to record subjects with a broad brightness range while producing excellent highlight detail with no grain.

Ilford XP2 Super is processed in standard C-41 chemistry alongside all other color negative films. No special handling is required because times and temperatures remain the same and the film will not contaminate the chemistry in any way. After processing, the negative is composed solely of stable dyes and is completely silver-free. This means that this film may be processed and printed by any lab offering C-41 service. XP2 Super can be printed on either color or black-and-white paper. If prints show a slight color cast on regular color paper, have the printer correct the color shift by using an unexposed strip of processed color film to provide the missing orange mask that is part of the basic construction of color negative film. Generally, having your local color printing center process any chromogenic black-and-white film will produce slight color shifts.

Other chromogenic black-and-white films include Kodak's Porta 400 and Professional T400CN. Porta 400 is a multi-purpose film intended to be printed on color paper, including machine prints, and has been optimized for scanning. T400CN

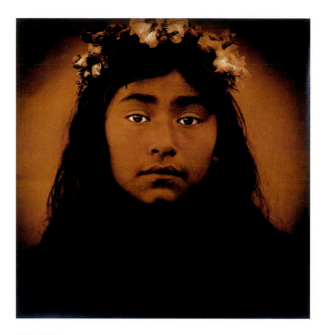

Figure 10.9 Luis González Palma recreates the look of old black-and-white photographs to give his images a sense of history. He uses chromogenic black-and-white film because it is a convenient way to get black-and-white negatives (and prints) through color processing. González Palma then prints and sepia tones the photographs, and paints them with bitume (tar).

© Luis González Palma. *Esperanza*, 2001. 20 × 20 inches. Gelatin silver print with paint. Courtesy of Schneider Gallery, Chicago IL.

can be printed on black-and-white, color, or inkjet paper. For more information, download Kodak Publication CIS-274 (*Printing Black-and-White Images without Kodak Black-and-White Papers*). T400CN film is for printing on silver halide photographic papers and may be preferable for those who use manual enlargers for printing to conventional black-and-white papers, as it provides a brighter image on the enlarger easel. Both films have ample exposure latitude and are pushable.

Scanning Negatives

Film negatives can be scanned with a desktop scanner or a high-end drum scanner. Unfortunately, no standards exist to define the colored filter sets that film scanners use to capture the red, green, and blue (RGB) information of the film image. Therefore, each scanner has its own characteristic output that depends on its sensitivity to the dyes in the film, which is determined by the spectral distribution of the colored filter sets and/or the spectral sensitivity of the charge-coupled device (CCD). Additionally, each scanner's output depends on the look-up tables or matrices that the scanner uses to output information. These tables or matrices are part of either "plugin" programs, updateable firmware included with the equipment, or fixed algorithms for calibrating and color balancing the equipment.

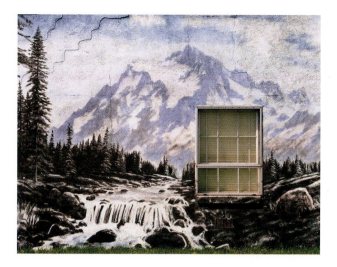

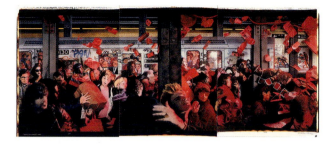

Figure 10.11 Patrick Nagatani and Andrée Tracey fabricate environments in order to photograph them. This allows them to densely pack recognizable symbols from our society into a controlled situation that permits elaborate commentary from the artists.

© Patrick Nagatani and Andrée Tracey. *34th & Chambers*, 1985. 24 × 60 inches. Diffusion transfer prints. Courtesy of Andrew Smith Gallery, Santa Fe, NM.

Figure 10.10 Alexis Pike used a Pentax 67 medium-format camera and FujiPro 800 color negative film to take this photograph. She prefers to use film instead of working digitally because she finds that it generates more choices about how the final print can look. Occasionally she merges the two modes of working, however, by scanning her negatives, digitally retouching them, and printing them as chromogenic prints onto Fuji Crystal Archive paper. Pike also visually combines two worlds in her photographs, uniting the natural landscape of the American West with insertions of the man-made. She states, "I am exploring in this work the way communities and individuals stake claims on the picturesque landscape and place it within the conventional structures of the community. By making photographs of these claimed territories, I am staking my own claim to my heritage, the Western landscape."

© Alexis Pike. *A Teton—St Anthony Idaho*, from the series *Claimed: Landscape*, 2005. 50 × 40 inches. Chromogenic color print.

The generic "color negative film" channel designation, available with each scanner's software, is just a point of departure. An image's final color balance, brightness, and contrast usually have to be adjusted during pre-scan operations or with imaging software after input. For more information see the Scanners section in Chapter 9.

Instant Photography

Most people associate instant films with family snapshots, but one can make beautiful, intimate, and unique color photographs with these films. They are convenient and provide immediate feedback in any shooting situation. Polaroid pictures are wonderful icebreakers to give away when photographing people, and it is always a thrill watching the image come up.

The artistic use of instant color photography helped it gain acceptance as a valid medium for self-expression. Late in his life, Walker Evans became quite rhapsodic about the SX-70 camera and in an interview with *Yale Alumni Magazine* said: "I've now taken up that little SX-70 camera for fun and become very interested in it. I'm feeling wildly with it. But a year ago I would have said that color is vulgar and should not be tried under any circumstances … [I use it to] extend my vision and let that open up new stylistic paths I haven't been down yet … A practical

photographer has an entirely new extension in that camera. You photograph things that you would not think of photographing before. I don't even yet know why, but I find that I'm quite rejuvenated by it." Evans went on to comment that the SX-70 process put all the responsibility on the photographer's mind and eye, leaving nothing to be added by technique.[1]

Instant Formats: Fuji, Polaroid, and The Impossible Project

Fuji makes an ISO 100 instant daylight film in 3¼ × 4¼-inch (8.5 × 10.8-cm) and 4 × 5-inch (10.2 × 13.1-cm) formats, either glossy or silk finish, which are designed for Fuji PA-145 and PA-45 instant-film holders. Designed for use at temperatures between 50 °F and 95 °F (10 °C and 30 °C), the film yields best results at 77 °F (25 °C). Development time depends on temperature, with a normal working range of 60–270 seconds. Additionally, Fuji makes a daylight film (ISO 800) in a variety of sizes for use in its amateur Instax cameras.

The Spectra System, introduced by Polaroid in 1986, was a group of automatic handheld cameras with a few manual overrides. The Spectra film was ISO 640, took 3 minutes to develop at 70 °F, and produced an image area of 3.6 × 2.9 inches (9.2 × 7.3 cm). Before going bankrupt, Polaroid also made a variety of cameras that used the 600-type film. Currently, another manufacturer produces this system under contract.

In 2010, The Impossible Project began marketing instant color and monochrome (sepia) films as well as new and used instant cameras (see: www.the-impossible-project.com).

Diffusion-Transfer

The basis for self-processing instant photography materials is the diffusion-transfer method, which is self-developing in natural light. After the shutter is pressed the material is run through a set of rollers that break a pod of reagent located at the bottom of each piece of film. Development is then automatic and requires no timing, and can take place in daylight because the

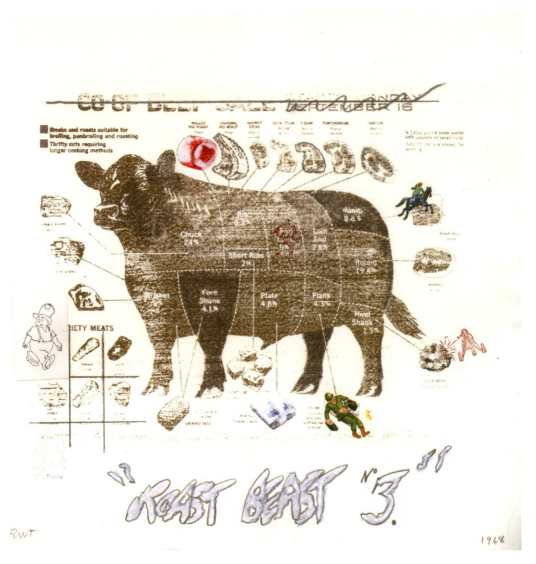

Figure 10.12 Robert Fichter tells us, "While I almost always carry a monocular camera with me to snap pictures, I almost always end up making some sort of collage. Over the years I shot photographic still lifes (the most transparent mode of collage) and made a large set of negatives and positives to create a cast of characters. *Roast Beast* is one that I printed using non-silver processes: cyanotypes, gum printing, silkscreen, Inko dye, and photocopy equipment. The Verifax machine (a crush off, diffusion-transfer process) offered me yet another way of pursuing my interest in pulling together a set of symbols and signifiers that pointed to and dealt with the human condition. In part, it is my love of seeing how something works and how many different marks I can make that drives the work."

© Robert Fichter. *Roast Beast 3*, 1968. 15⅝ × 12¾ inches. Verifax transfer with rub-downs, stamping and crayon. Courtesy of the University of Maryland, Baltimore County.

light–sensitive negative is protected by opaque dyes in the reagent. Both the positive and negative images are contained within each sheet of film.

As the picture forms, a number of things occur simultaneously. First the silver halides are reduced to metallic silver in the exposed areas of each of the three additive primary light-sensitive layers. As this happens, the complementary subtractive primary dye developers move through the layers of the negative and the opaque reagent to form a white background for the picture. Now

the dye developers are prevented from moving up to the positive image area by the developing silver. This layer will now only pass certain colors through. For example, the blue layer blocks the yellow dyes but not the cyan and magenta. Within a few minutes all the dyes that have not been blocked travel through the white opaque layer and become visible. The process automatically completes and stabilizes itself, resulting in a completed dry print.

These films are balanced for daylight and electronic flash, but they can be exposed under any light source by placing CC filters

in front of the lens of the camera or the exposure sensor in the case of automatic cameras. It is also possible to correct for differences in color balance from one pack of film to another with the CC filters.

Changes in time and/or temperature alter the outcome of the final print. An increase in temperature makes the colors appear warmer, while decreasing temperature produces cooler hues. Extending the development time can increase color saturation and overall contrast. A drop in development time can flatten or mute the colors while reducing contrast.

Store film in its sealed box. Keep it cool and dry. For prolonged life, this film can be refrigerated above 34 °F (1 °C), but do not freeze. Let film warm to room temperature before use.

Instant Image Transfer Method

The transfer process allows a previously made image to be relocated onto another receiving surface. Magazine transfers, the kind often done in grade school, are the most familiar. Postmodern trends have brought about a renewed interest in transferring images. The Polaroid transfer method is capable of producing soft, fully rendered images or fractured, partially rendered images. Other postvisualization methods, such as hand coloring, can be incorporated into the process of transforming the image to provide a more subjective response to the subject. FujiFilm FP-100C delivers consistent transfer results. Note: Inkjet printers also can be used to be to make transferable images.

The instant image transfer process can be carried out under ambient light. A few simple safety precautions are in order, since the films were not designed for this purpose. Wear gloves as protection against the film's caustic developer gel. If you get any developer on your skin, immediately wash it off. For this reason, this process is not recommended for children. For detailed information about the latest instant image transfer methods and emulsion transfers (see next section) visit: www.alternativephotography.com > Processes—How To > Process Step-by-Step.

Instant Image Emulsion Transfer

Emulsion transfer is a process for removing and transferring the top image layer of an instant film, such as FujiFilm FP-100C, onto another support surface. European imagemakers began experimenting with the process during the 1980s, but it did not gain access into American photographic practice until the 1990s. Basically, an exposed sheet of instant film is submerged in hot water until the emulsion can be separated from its paper support and then transferred onto another surface, including ceramics, fabric, glass, metal, and wood. Three-dimensional surfaces also can be used. The process removes the image from its normal context and destroys the traditional frame while adding a sense of movement and elements of the third dimension into the image.

Emulsion transfers can be made onto any clean, smooth surface, including glass or sheet metal. Fabric support should be stretched and mounted, since folds in the material can produce cracking when the emulsion dries. The emulsion can be transferred in sections by tearing it with your nails or cutting it while soaking. The print also can be cut into pieces before its first submersion. All steps may be carried out under normal room light.

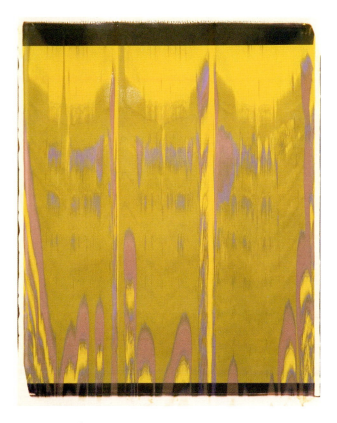

Figure 10.13 Ellen Carey approaches color photography as picture-making rather than picture taking. She states, "Color has broad, universal appeal, as does the language of photography. A concentrated interest in color as subject *and* object, material *with* meaning, and process *in* photographic art has led me through uncharted territories along a path of discoveries and surprises. With new possibilities and arrangements, I found that my need to rely on traditional photographic colors faded away. They were displaced by imagined, chemically created colors, which I conjured up by using gel-colored light or no light at all instead of exposing my lens to a view in front of my eyes."

© Ellen Carey. *Multichrome Pulls* (detail), 2008. 80 × 22 inches. Diffusion transfer print. Courtesy of the artist and Jayne H. Baum Gallery, New York, NY.

Special Films and Processes

Cross-Processing/Slides as Negatives

Cross-processing is the developing of color film in non-compatible chemistry. Normally, transparency film is developed in E-6 chemistry while negative film uses C-41. Cross-processing involves switching film and chemistry combinations, thus processing color slides in C-41 and color negative film in E-6.

Processing negative film in E-6 usually produces muted, pastel-like colors with very low contrast. By comparison, processing slide film in C-41 can dramatically increase color saturation and produce a pointillistic grain structure *à la* Georges Seurat, the French neo-impressionistic painter. Contrast will be greatly increased, as in all push processes. A scene of low-contrast will come out as one of at least average contrast. A scene of high-contrast will come out looking like it was shot on litho film. There will be a noticeable increase in color saturation. Colors

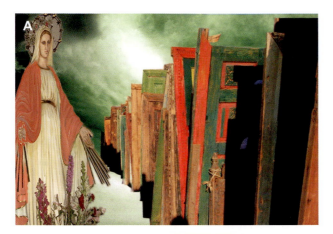

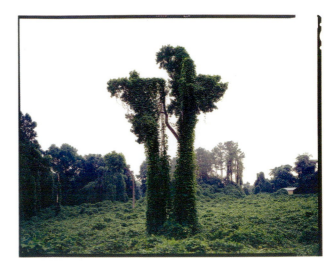

Figure 10.15 This Kudzu portrait, a weed that grows out of control in places in the American South, was made using a 8 × 10-inch camera that was contact printed onto reversal paper. In this case, out of concern for the high cost of film, Harris Fogel used film that was almost out of date. By making sure to keep the film frozen while in storage before use, he was able to achieve excellent results. Current versions are scanned and printed on inkjet paper.

© Harris Fogel. *Kudzu Near the Great Park, Atlanta, Georgia*, 1989. 8 × 10 inches. Dye-destruction print.

Figure 10.14 Kathleen Pompe used a Daylab to convert her digital montage (top) into a Polaroid from which she did an emulsion lift (bottom) onto different types of cotton rag papers. Pompe says, "The small size of the new image and its unpredictable edge creates a feeling of intimacy and helps transport the viewer into a fragile, magical landscape."

© Kathleen Pompe. [A] *Doors of Perception*, 2000. 10 × 13 inches. Inkjet print. [B] *Doors of Perception*, 2002. 3 × 4 inches. Diffusion transfer lift.

Problem Solving

1. Use Kodak Ektachrome 200 Professional film, underexposing by 1/2 f-stop and one full f-stop, and then process in C-41.

2. Expose any color negative film and process in E-6. To increase contrast, bracket in the plus direction and/or push process the film two to three f-stops.

3. Scan film and then adjust the results with your imaging software.

4. Simulate cross-processing with your imaging software by manipulating contrast/brightness, hue/saturation, and curves. Numerous online tutorials are available.

Compare and contrast the results. These poster-like colors tend to cry out to be printed bigger than normal, so consider making larger prints. What differences do you see in color contrast and saturation? What major differences are evident between the analog and digital methods? What combination do you prefer? Why?

can begin to vibrate, look very intense, take on a "Day-Glo" appearance, and become deeper and more brilliant. The grain will appear quite oversized. You can literally pick out the different points of color.

Overall, the composition will tend to become more abstract, bold, impressionistic, and striking. The process is not suited for a situation that requires clarity and sharp detail, but is great for creating a mood. It should offer an opportunity to see things in a different manner.

Litho Film: Bas-Relief

Litho films offer photographers a wide array of possibilities in altering and enhancing their vision. One of the most common is bas-relief, a technique that creates the illusion of the third dimension in a two-dimensional photograph by emphasizing the shadow areas of the picture. The effect is achieved by placing a normal continuous-tone negative in contact with, but slightly out of register with, a high-contrast positive of the same negative. Variation in the registration method alters the intensity of the effect. The negative and positive are then placed into the

enlarger together and printed with a single exposure onto a piece of color paper.

The tonal range can be sharply reduced to produce extremes in the highlight and shadow areas. The final print will be a simplified version of the original scene; there will be no subtle details. The image will be graphic. Line and shape become the key compositional elements while colors appear bold, bright, and striking.

For more details see J. Seeley's *High Contrast* (Boston, MA: Focal Press, 2nd edn, 1992).

X-Ray Equipment at Airport Security

X-ray equipment, such as that used in airport security systems, can fog unexposed film. Film fogging can occur around any radiation source, including doctors' offices, medical labs, hospitals, and factories. The effect increases with the intensity of the x-ray, the cumulative number of inspection exposures, and the sensitivity of the film. Films having an ISO film speed rating of 800 or higher are more susceptible than slower films. Ask for a hand inspection of your camera equipment. Visual inspection is

the only protection against high-dose x-ray machines. Pack film without canisters in a clear plastic zip-lock type bag for quicker hand inspection.

Screening equipment will not affect digital camera images, film that has already been processed, slides, videos, picture CDs, or memory cards. As long as airport security remains in flux, it is best to check websites, such as the Transportation Security Administration (www.tsa.gov) and view the Traveling with Film section for the latest information and advice on getting photographic equipment safely through airport and other security networks. Beware that non-US airports have their own rules.

NOTE

1. Jerry L. Thompson and John T. Hill, eds. *Walker Evans at Work* (New York: Harper and Row, 1982), p. 235.

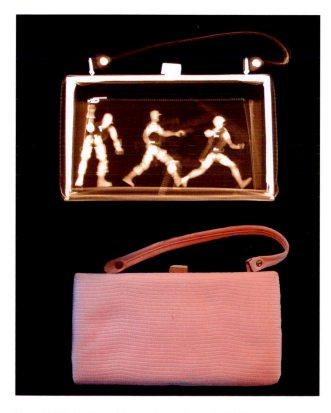

Figure 10.16 In a time of increased airport security, Pat Bacon uses x-ray technology to question the startling contrast between ordinary objects found inside common traveling bags and the heavy scrutiny they undergo through advanced surveillance technology. By substituting images of war, violence, and power for the mundane objects typically found inside a woman's handbag, Bacon calls attention to the false sense of comfort she suggests America has fallen into as a result of technologies we take for granted.

© Pat Bacon. *Pink Handbag*, 2003. 17 × 13 inches. Inkjet print.

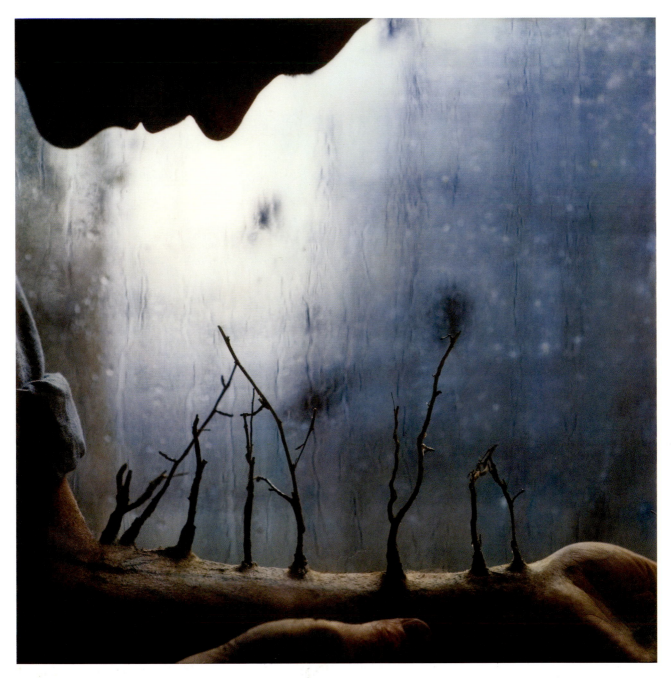

Robert and Shana ParkeHarrison achieve the painterly quality that defines their *Counterpoint* project by using a Hasselblad to capture their fabricated sets, which merge theatrical devices, technology, nature, and photography. The team exposes onto transparency film, which they then drum scan, digitally output, mount to Dibond aluminum panel material, and enhance colors with acrylic paint and varnish. This work "offers insight into the dilemma posed by science and technology's failed promise to fix our problems, provide explanations, and furnish certainty pertaining to the human condition."

© Robert and Shana ParkeHarrison. *Winter Arm*, 2008. 60 × 60 inches. Inkjet print on Dibond with acrylics and varnish. Courtesy of Jack Shainman Gallery, New York, NY.

Digital Output

Digital Printing Technology

Pixels and silver crystals are on equal footing as affordable digital cameras allow us to produce photographic files equal to or superior to the conventional film images of the late twentieth century. However, as digital cameras increase their ability to capture more pixels, so too must the capabilities of the printers used to output these images.

Chemical color photographic printing produces continuous-tone images that are made up of random dots of color dye that form around microscopic pieces of silver. Unlike their analog counterparts, digital prints can be made on a variety of papers with toner, pigmented inks, and laser light on conventional photographic papers. Prints also can be made with pigments that are sublimated

into a gas and blended to form images, or they can be etched into a metal plate and printed with lithographers' inks. What most of these methods share is the initial conversion of the image by means of a computer into a series of dots. The differentiating and limiting factors in printing digital images is the way these dots are mechanically placed on a surface and the size of the smallest dot the device is able to produce. There are many printers, from low to high resolution, capable of simulating continuous-tone photographs. Some can make digital prints that are indistinguishable from chemically made prints, while others can produce images with a color and/or smoothness not possible with traditional photographic processes. Figure 11.1 shows the differences in how a continuous-tone image is formed from film, digitally on a screen, and by ink.

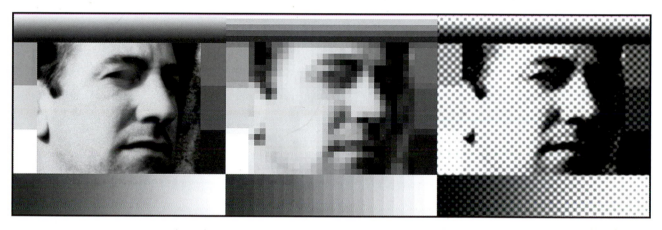

Figure 11.1 Forming a continuous-tone image from film (grain), digital (pixels), and ink (halftone).

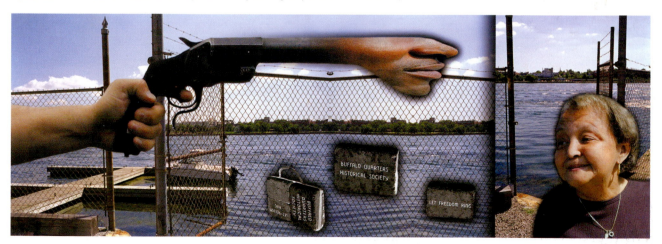

Figure 11.2 In Stephen Marc's digital composite image dealing with the Underground Railroad, "the arm of a man holding an antique pistol, with a gun barrel that morphs into a partial profile of a black man's face, has been placed in front of the Niagara River shoreline on the Canadian side where ferryboats landed at Fort Erie. The stones are commemorative bricks for Buffalo's Broderick Park, which is seen in the distance. This span of water was significant because Buffalo and Detroit were the two major crossing sites for freedom seekers who entered Canada. There were times when the river froze over, and they were able to walk across. The female figure on the right is Arlene Olden, a grandniece of Harriet Tubman."

© Stephen Marc. *Untitled*, from *Passage on the Underground Railroad*, 2000–2001. 9 × 26 inches. Inkjet print.

Displaying the Image

Screen Resolution (ppi) and Dot Pitch

Screen resolution, pixels per inch (ppi), and print resolution, dots per inch (dpi), are two different measurements and often are incorrectly interchanged. However, they must be understood clearly in order to properly scan, scale (image size), and prepare images for the Web or to print. Screen resolution (ppi) is the maximum number of pixels per linear inch a monitor can display at any one time. Ppi is determined by the manufacturer and cannot be changed. It is usually between 72 and 95 ppi, but varies slightly from monitor to monitor. The dot pitch (Figure 11.3) rating of any screen determines only the quality of the display monitor. Dot pitch is measured in millimeters (mm) and, theoretically, the lower the number, the sharper the image. Although cathode ray tube (CRT) and liquid crystal display (LCD) screens

are mechanically different, the dot pitch rating is still the same and (slightly) affects only image size on a screen, not print size.

Print Resolution (dpi)

Print resolution, expressed as dpi or dots per linear inch, refers to the number of dots a printer can apply within one linear inch on paper. Dpi is variable, and many inexpensive printers average 1200 dots per linear inch.

Image quality is increased when more and smaller dots are contained within the same inch of physical space on the paper or material. The most common color printer for photographs is an inkjet printer, which sprays tiny dots of color to create an image from a digital file. The more dots per linear inch, the more continuously toned and photographic the image will appear.

Since screen resolution (ppi) and printer resolution (dpi) are two different measurements, they can become confusing when scanning, scaling, or resizing your digital photograph for printing. Figure 11.4, originally a photograph made by Greg Erf, demonstrates what happens to an image that is scanned at a dpi higher than the screen resolution of 72–95 ppi and viewed on the screen at 100 percent. The screen image will appear larger than you anticipated, requiring scrolling of the screen image.

Figure 11.4 was scanned at 300 dpi with a print dimension of 3⅛ × 2⅞ inches. Notice that the screen rulers now show the image to be larger than 3⅛ × 2⅞ inches when viewed at 100 percent. The computer correlates each printer dot (dpi) as one screen dot (ppi), making the initial image appear much larger on screen because of the physical limitations of dot pitch. Now it requires 300 screen pixels (ppi) to represent the 300 printer dots (dpi) on-screen. This would be considered a 4:1 ratio in regard

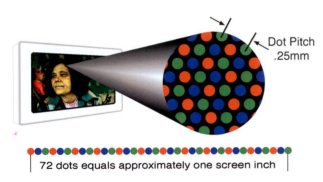

Dot Pitch
.25mm

72 dots equals approximately one screen inch

Figure 11.3 Screen dot pitch.

300 dpi @ 100% (RGB)

100% Doc : 3.55M/3.55M

Figure 11.4 Scanned at a dpi higher than the screen resolution of 72–95 ppi and viewed on the screen at 100 percent [300 dpi @100% (RGB). The screen image will appear larger than you anticipated, requiring scrolling or zooming of the screen image].

© Greg Erf. *High Street*, 2003. 8 × 10 inches. Dye-destruction print.

to the image's scale on screen when compared to the actual print size. The image will still print 3⅝ × 2⅞ inches even though it looks much larger on the screen.

In Figure 11.5 the same photograph was rescanned at 72 dpi at the same dimensions, 3⅝ × 2⅞ inches. Notice that the picture

and rulers now closely approximate one inch of actual length and width when viewed at 100 percent in the photo-imaging software. With this 72 dpi scan the screen size and print size will be similar because the screen dot pitch (ppi) closely resembles the true physical inch when output to paper. This would be considered a 1:1 ratio in regard to scale when viewing at 100 percent on a computer (see Figure 11.4 again). Remember the actual dimensions of the on-screen ruler will depend on the monitor display (dot pitch).

The Image Window

To help keep track of all the variables in a digital file, software programs display many key pieces of information about the image. Figure 11.6 identifies this data that surround the working image and describes their meaning.

Sizing a Digital File

As previously discussed, file size in megabytes (MB), screen resolution (ppi), and print resolution (dpi) are three different measurements that need to be understood to be able to properly scale, scan, and prepare images for printing, electronic publishing, or the Web. Although closely related, MB, ppi, and dpi are not a true measure of the actual image size when outputted to paper or viewed on the screen.

The picture size and quality are both determined by the user. Picture size is determined by the resolution (width and height), and the number of pixels affects the quality. The original

Figure 11.5 72 dpi @100% (RGB). With this 72 dpi scan, the screen size and print size will be similar because the screen pixel pitch (ppi) closely resembles the resolution (dpi) dots per inch. This would be considered a 1:1 ratio in regard to scale when viewing at 100 percent on the computer screen.

Figure 11.6 Image window [image psd @ 16.7% (Layer 1, RGB)].

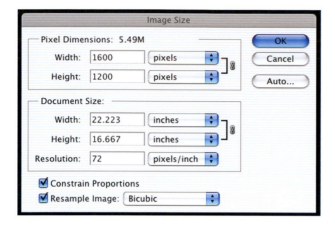

Figure 11.7 Image size, 72 dpi and pixels dimensions of 1600 × 1200, which will make the print size 22.222 × 16.667 inches at 72 dpi.

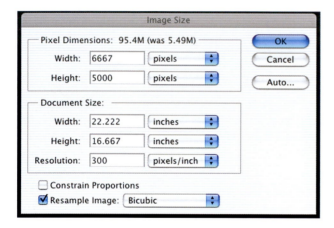

Figure 11.8 Image size, resolution box changed to 300 dpi.

exposure or scan settings are absolutely crucial toward determining levels of quality for the final print. Digital cameras record images based on similar common resolution settings of Large/High, Medium/Fine, Small/Normal, and Basic. Low-resolution settings, such as Small for the camera or 72 dpi for scanning, will produce a file usually of under one megabyte that is suitable only for images appearing on the computer screen or on a Web page. Small, Normal, or Basic camera settings will produce the smallest picture sizes at the lowest pixel count.

Once the file is captured/scanned, changing the resolution will affect the file in different ways, depending on how the change is made. For example, a digital camera using the Medium/Fine setting might produce an image file of 1600 × 1200 pixels. Depending on the camera and software, this image may import into your software program at a default resolution of 72 dpi and pixel dimensions of 1600 × 1200, which will make the print size 22.222 × 16.667 inches (see Figure 11.7).

The print size is very large at 72 dpi and when outputted to paper would produce a pixilated image with only 72 dots per

linear inch for an image to be printed 16.66 by 22.22 inches. In this image, changing the default 72 dpi up to 300 dpi by using the image size dialog box in your image-editing software will *not* result in seemingly better visual acuity, but will result in adding 90 million more pixels to the image, if width and height dimensions are left unchanged by leaving the Resample checkbox on (checked). The computer has to resample, also known as interpolation (see below), by placing extra pixels into the image in order to reach the 16 × 22 inch size with 300 dots per inch needed by the printer. The computer does this by looking at adjacent pixels and placing new pixels between them that are based on an average of the original two, making the image look softer and out of focus. On the other hand, if you leave the Resample checkbox off (unchecked), the image will scale down proportionally, matching the set resolution (dpi), and be sized to the optimum uninterpolated document print size, based on the file size.

Desired image resolution should first be set in the camera. Although not recommended, when changing the resolution (dpi) to an existing file, one can simply change the number in the resolution box to 300 dpi (see Figure 11.8). This change will affect the image file size, but *not* the print size, nor will it improve the print quality because resampling/interpolation will occur if the Resample checkbox is left on (checked). The file size will change from 5.59 MB to 95.4 MB with no increase in detail. The original uninterpolated 72-dpi image file and its new 300-dpi interpolated counterpart will print with poorer quality. There will be no gain in the detail of the interpolated image file. The effect will be similar to what one gets with digital zooming, in which no optical resolution is gained in the process. Reshooting at a higher pixel dimension is the only way to truly get the necessary fine detail required at larger print sizes.

Interpolation or Resampling

Interpolation is a set of mathematical logarithms automatically applied when the original pixel dimensions for resizing occurs. Interpolation cannot add or subtract detail; it only randomly adds or subtracts pixels, making a "best effort" when resizing the original pixel dimensions. There are many interpolating logarithms that perform slightly different mathematical computations, but the end result is still degradation of the original image file that will affect image quality, as the computer literally makes up the digital information. These limitations make it clear how crucial it is for photographers to pay close attention to the input resolution of their image, whether in a camera or a scanner. Cropping a portion from a larger image can result in some of the same problems because, while the full-frame photograph may have enough resolution for a large print, the cropped photograph may not have enough image information for that same size print.

The three most common resampling modes that appear when the Resample Image box within the image size window is checked are: Bicubic (with three options), Nearest Neighbor, and Bilinear. Use Bicubic interpolation because it gives the smoothest results. Although Bicubic takes longer to compute, the speeds of today's computers make the time difference negligible. Nearest Neighbor is the fastest interpolation method and produces the most noticeably jagged results, while Bilinear splits the difference between the two.

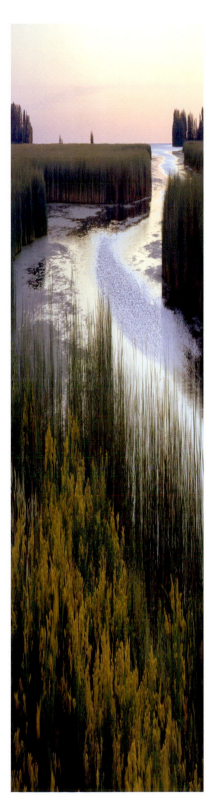

Figure 11.9 John Pfahl used a Horseman field camera with Kodak 160VC film to capture this landscape scene. After scanning his 6 × 12-inch negative, he resized the image to eight times its initial height. Pfahl states, "For the last 40 years, I have been thinking about and photographing the natural landscape, bouncing my ideas and images off movements and examples in the history of art. This latest work was motivated by my fondness for traditional Asian art; particularly Chinese and Japanese landscape scrolls."

© John Pfahl. *Autumn Lagoon*, 2006. 84 × 21 inches. Inkjet print mounted on Plexiglas, with polycarbonate laminate. Courtesy of Janet Borden Gallery, New York, NY.

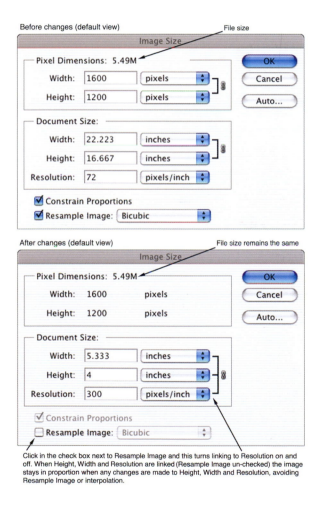

Figure 11.10 Image resampling, before and after.

Figure 11.11 The digital negative and interpolation.

The Digital Negative and Interpolation

1600 Pixels, number should remain constant

1200 Pixels, number should remain constant

Only scale proportionally to pixel dimensions

Only scale proportionally to pixel dimensions

Print Resolution (dpi)	Digital Negative	Pixel Dimensions	Total Pixels	Print size
72	Uninterpolated	1200 x 1600	1,920,000	16.6 x 22.2 in.
150	Uninterpolated	1200 x 1600	1,920,000	8 x 10.6 in.
150 *	Interpolated	600 x 800	4800,000	4 x 5.3 in.
300	Uninterpolated	1200 x 1600	1,920,000	4 x 5.3 in.
300 *	Interpolated	2400 x 3200	7,680,000	8 x 10.6 in.
600	Uninterpolated	1200 x 1600	1,920,000	2 x 2.6 in.
1200	Uninterpolated	1200 x 1600	1,920,000	1 x 1.3 in.

* Both these interpolated files will show pixelization, but the file with less than
the total original pixels will show less pixelization and appear sharper.

COURTNEY, ELIZABETH, MEGAN, EDWIN, AND GLENN MT. RUSHMORE, SOUTH DAKOTA

Figure 11.12 Working digitally allows many old boundaries to be crossed or disregarded. Drawn to physical displays of the ironic and its implications, Jim Stone uses an unusual Cornfield 6 × 7 camera to stress "photography's descriptive powers that allow us to question our nature as social beings." Stone drum scans the resulting negatives to make full-resolution prints without interpolation to fully appreciate what can be interred from the visible. His titles, previously made with a litho film mask, are now done from a font created from his own handwriting.

© Jim Stone. *Courtney, Elizabeth, Megan, Edwin, and Glenn, Mt. Rushmore, South Dakota*, 2002. 24 × 30 inches. Inkjet print.

Equivalent Image Size

When first learning to control camera exposure with film you come to understand the concept of equivalent exposure. This model states that when you change from a slow shutter speed (1/60 of a second at f/11) to a faster shutter speed, you must compensate by using a larger aperture (1/125 of a second at f/8) to maintain the same exposure. The reverse is also true. A similar equivalent concept holds true for changing the sizes of digital images. Figure 11.10 shows two Image Size windows for the same image, which can be found under Image in the top Main Menu Bar categories. Linking the document sizes by checking the Constrain Proportions box (default on) and unchecking the Resample Image box allows you to change the resolution of an image without interpolation occurring to it, thereby maintaining the original pixel dimensions.

Unchecking the Resample Image box links the proportions of the width, height, and resolution. Once the variables are linked, when the value of one is altered the program automatically compensates by increasing or reducing the other two, just as the light meter model automatically adjusts f-stops to maintain equal exposure when the shutter speed is changed. Before and after pictures (Figure 11.10) demonstrate equivalency: When we increased Resolution in Document Size, the software program automatically decreased Width and Height to maintain file size. Notice that nothing has changed in Pixel Dimensions.

The Real Size of a Digital Negative or Image File

A good way to understand the relationship between picture size, pixel dimensions, and dpi is to think of pixel dimensions as representing the "digital negative." The digital negative or image file reflects the fixed number of pixels that are available to produce uninterpolated images. A 12-megapixel digital camera or a 300 dpi scan at 10 × 13 inches are both capable of producing a digital negative of 12,000,000 pixels. Figure 11.11 illustrates the relationship between dpi, interpolation, and print size. Note: As the print resolution increases from 72 dpi to 1200 dpi, the print size is decreased proportionately to maintain the original number of pixels in the digital negative. Also notice two exceptions (150 and 300 dpi), the interpolated files will print less than optimal because pixels were randomly added or subtracted to compensate for altered dpi or print dimensions, which did not remain proportional to the original 12,000,000 pixels.

Box 11.1 shows how to make sure that the original pixel dimensions (ppi) correlate exactly to the final output size (dpi) in regard to length and width. The pixel dimensions should always remain constant as the digital negative is enlarged or reduced. For example, when using a 12-megapixel camera on the Fine/Large setting, an image file of 3000 (H) × 4000 (W) pixels equaling 12,000,000 total pixels is made. These 12,000,000 pixels now represent the physical size of the image and become the limiting factor when resizing the image for optimum results. Since 300 dpi is considered the acceptable printing resolution to create digital pictures similar to film photographs, you divide 300 into the original pixel dimensions to determine the optimum output print dimensions, which is 10 × 13 inches for this example (Box 11.1). To avoid pixelation related to interpolation it is best to adjust the

print size by changing the target dpi. Increasing the target dpi will make the printed image smaller and decreasing the target dpi will make the printed image larger. This method ensures that the pixel dimensions will remain constant, avoiding any interpolation.

Keep in mind that interpolated images are created when changes occur to the original pixel dimensions. These interpolated images can be acceptable and can be used in many applications but the best quality results will come from uninterpolated digital files. Resizing down is fine but may require sharpening. Note: Pixelation or loss of sharpness is sometimes attributed to interpolation that is a result of improper scaling or sizing.

Achieving Photographic Quality

Inkjet Printers: Dpi to Dots to More Dots

Photographic-quality inkjet printers are needed to produce prints that have the look of continuous-tone. Their print-head design allows them to spray minute amounts of ink onto the receiver material at resolutions of 1440 × 720 pixels and higher. Inkjet printers also can deliver subtle detail with more accurate and saturated colors and print on a wider variety of materials than their less expensive office counterparts. These quality printers can use more permanent inks and include additional colors, greatly increasing the range of colors (color gamut) beyond traditional color photography.

Inkjet printers use various amounts and methods of applying inks to create photo-realistic images. General-purpose quality inkjet printers use four inks—cyan, magenta, yellow, and black—while higher-end photo-quality inkjet printers can easily exceed four colors by adding orange, green, and lighter versions of cyan, magenta, and gray. Creating photo-quality prints is dependent upon not only how many droplets fit within an inch (dpi) of space but also the size and pattern of the ink droplets. When a photo-quality inkjet printer creates an image from a 300 dpi file, it does not apply just one droplet of ink for each pixel (ppi) or dot (dpi), but rather it places four or more droplets of ink to represent each pixel. Currently eight-color inkjet printers use hundreds and hundreds of nozzles to apply varying degrees of color and value to "fool" the human eye into seeing many more colors.

Inkjet printers are rather complicated printing devices that must control all those nozzles accurately to create droplets of ink that can convince the eye of continuous-tone. The best inkjet printers are capable of delivering excellent photo quality between the ranges of 150 and 360 dpi. Although these printers are capable of resolutions up to 2880 dpi, it generally wastes printing time and storage space to produce image files greater than the visual acuity of the human eye. The generally accepted definition of visual acuity with normal (20/20) vision is the ability to see continuous-tone from a dot pattern at a distance of between 8 and 24 inches. Other factors also affect visual acuity, such as defects in the eye's lens, the pupil size, the level of illumination, the duration of exposure to subject plus a host of others.

Paper: Uncoated and Coated

Uncoated (porous) printing papers are the most readily available papers and are best identified as the inexpensive copy, inkjet, or

Figure 11.13 Betsy Schneider uses a medium-format Mamiya, scans her Kodak Portra NC 400 film after processing, and prints onto high-quality Moab Entrada inkjet paper. She travels far and wide to photograph, and she makes sure to always have her camera ready and loaded with film. She tells us, "I have to be willing to stop the car and jump out and make the pictures when I see something compelling. With this particular picture it was a major wind and sand storm and the rain came as I was making the pictures. It was one of those rare moments where everywhere you look there is something compelling. I shot many pictures until it was raining and my kids were begging me to get back in the car."

© Betsy Schneider. *Utah State Line*, from the series *Secret Landscapes*, 2006. 24 × 28 inches. Inkjet print.

Box 11.1 General Image Correction Steps

These steps are an outline for getting started and with practice you will find your own working path to achieve the same results. Remember to always work from a duplicate file, saving the untouched original file for future use.

1. Open Imaging Software. From top Menu Bar go to File/Import/Filename or open your file in usual manner.

2. Preparing for Output. From top Menu Bar go to Image/Image Size and set Resolution and Document Size. Set your Resolution to 72 for Web and 300 for Print. Checking Constrain Proportions will keep image in proportion to the original, but interpolation will occur, which is not a major concern for Web images. Set Document Size depending on desired dimensions. When setting resolution to 300 ppi for printing, make sure Resample Image is unchecked. To produce utmost print quality, document size will be adjusted according to ppi chosen, thus ensuring no interpolation will occur. Keep in mind: The higher the ppi, the smaller the document size.

3. Auto versus Manual Functions. From top Menu Bar go to Image/Adjustments and find Auto Levels, Auto Contrast, and Auto Color, which deliver quick average preset control. Auto functions apply predetermined algorithms, which offer no personal control and are destructive to the image files. Therefore, it is good practice to use manual controls, such as Levels, Channels, Color, Saturation and Desaturate, for precise artistic control.

4. Setting Overall Value. From top Menu Bar go to Image/Adjustments/Levels. Using Levels is similar to Brightness and Contrast controls, but offers more flexibility. Notice the Levels slider bar controls the highlights, middle, and darker values; adjust to desired values. Using Levels is preferred over the more destructive Brightness and Contrast controls.

5. Selective Value Control. Using the Marquee tool or Magic Wand from the Tool Bar select any area within the picture for fine-tuning. After selection, make a new adjustment Layer and go to Image/Adjustments and continue making changes to the selected area with the chosen function. If a mistake is made, Trash that layer and start over.

6. Burn and Dodge Tool. The Burn and Dodge tool is fine for beginners or small tasks. However, it is often better to use advanced lighting and darkening techniques that are less destructive and provide more creative control. This is done by first selecting the area to be adjusted, creating a new layer and then use Levels or Curves. This is less destructive and provides more creative control, including the use of Brush tools.

7. Sharpening. Before saving image, go to Filter/Sharpen to give a single sharpened effect to the overall image. Do not over-use the Auto Sharpen effect. Unsharp Mask will allow you to manually control sharpness.

8. Save Image. Go to File/Save image and save the image file in the format or extension specific to the software application. Safely store image file for use as original digital negative or image file. Working from RAW image files provides more options. Always start with this file to make other file formats. Working from the original digital file will minimize image degradation, which is important when saving as JPEG file formats.

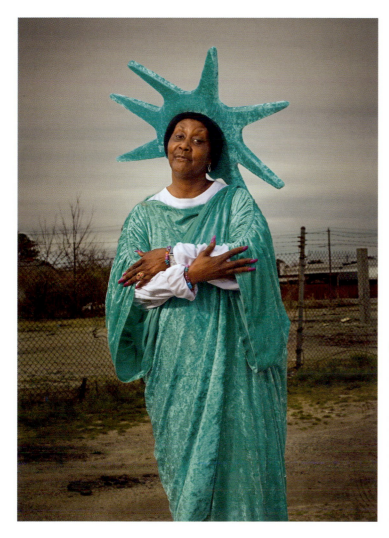

Figure 11.14 For this project, Greta Pratt photographed the wavers who work for Liberty Tax Service in Norfolk, VA, dressed in Statue of Liberty costumes to encourage passersby to step inside the business. Pratt says, "I was first drawn to the wavers, as everyone is, by the unexpected sight of someone dancing on an urban street corner dressed as the Statue of Liberty. But after hearing their stories I became interested in them as individuals. To portray these people with personal dignity and in their role depicting the Statue of Liberty, I photographed them from a slightly low angle, underexposed the background, and used an off-camera strobe to light them. Later I used Photoshop to blur and soften the background." To present this work, Pratt makes inkjet prints and displays portraits as a series.

© Greta Pratt. *Michelle Washington*, from the series *Liberty*, 2009. 49 × 35 inches. Inkjet print.

laser-jet papers used primarily for text. Structurally, these papers are raw cellulose wood fibers bleached and processed into standard letter- and legal-sized formats. These papers are less uniform in their brightness, surface texture, absorbency, and pH level than coated papers. Because they are uncoated, they absorb more ink, allowing them to print and dry fast to the touch. However, these materials are susceptible to fading due to environmental factors and exposure to light.

Coated papers (micro-porous) have special coatings that either modify or completely cover the cellulose fiber, making the paper achieve superior print results and archival qualities. Designed to resist fading, these papers can have somewhat longer drying times. Coated papers are available in a variety of traditional photographic surfaces including high gloss, semi gloss, flat matt, and luster, as well as in many canvas-like textured surfaces. Nonporous materials are polymer or vinyl-based printing materials for banners or decals. The smart advice is to check the kind of coating or surface that exists with the printing material to be used and choose the appropriate type of ink, making sure the printer you use can handle the combination. Many different special use papers, such as canvas, textured, and watercolor, can also be used, but may require a printer that permits straight-path hand-feeding.

Transparency film can also be used for a multitude of applications including the making of large negatives for contact printing for use with alternative processes such as gum and platinum/palladium.

Inks: Dye and Pigment Based

Inks can be grouped as: water-soluble, dye-based, and pigment-based. Inexpensive inkjet printers employ water-soluble dye inks and should be used only when permanence is not a concern, for example for color proofing and short-term use. Photo-quality inkjet printers can use pigment-based inks, which contain pigments that make the inks more fade resistant.

Print Permanence

There has not been enough independent empirical testing to accurately predict the permanence of inkjet prints, and the

equipment and materials have been in flux. To maximize longevity, use coated (micro-porous) papers and the best-quality pigment-based inks currently available. When permanence is a major concern, it is best to evaluate the current array of inks and papers before buying a printer to make sure everything is compatible and capable of producing the desired results. Mixing papers and inks from different manufacturers is not recommended because manufacturers only test, rate, and guarantee permanence based upon their own system of papers, inks, and printers. Choosing papers and inks from different manufacturers may produce the visual results you are looking for, but be sure the combination has been tested for maximum longevity (see Chapter 15, page 307 for factors affecting permanence).

Printing Methods and Output Issues

Thermal Printing

Dye-sublimation printers work with RGB, CMYK, and grayscale images. In this process the pigments, contained in thin plastic sheets, are turned into a gas and transferred onto a piece of specially coated paper. The colors are not laid side by side, as in a halftone process, but are blended to create a continuous-tone print. Depending on the support material (paper base) and storage conditions, these prints can last up to 10 years before fading is noticeable.

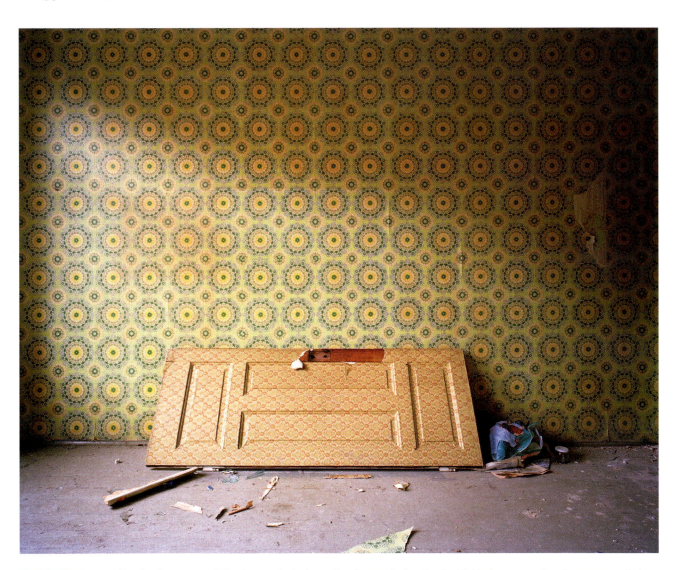

Figure 11.15 Photographing the phenomenon of abandonment in the former East German city Dresden, Fredrik Marsh uses a medium-format camera. He later scans his 120 negatives to process and print his images digitally. He uses a wide format printer, digital fine art rag paper, and his own custom paper profiles for output. He elaborates, "This body of work is printed on matte surface papers with matte black ink. Primarily, I do not wish the colors to appear too saturated or overly intense as they may in a luster photo surface paper. Using matte surface paper gives me just the right balance of intensity and tactility."

© Fredrik Marsh. *Abandoned Apartment, Buchenstraße, Dresden*, from *Transitions: The Dresden Project*, 2005. 31 × 38 inches. Inkjet print.

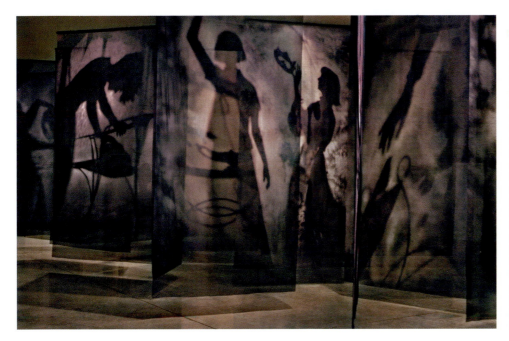

Figure 11.16 Susan Kae Grant created this work by printing CMYK files, outputting them to dye-sublimation paper murals, and heat transferring them to chiffon. Because the vapor of the dye transferred onto the fabric, the image appears to be printed on both sides of the chiffon. Grant explains that she was inspired by dreams, memory, and the unconscious, and collaborated with a sleep laboratory specialist in order to realize this work. "Using herself as subject, the artist was tape-recorded for a series of nights while awakened from REM sleep and immediately questioned in detail. Grant used the audio tapes of these dream narrative interviews as inspiration to create the imagery for the series."

© Susan Kae Grant. *Night Journey*, 2000. 4 × 8 feet. Dye sublimation prints on chiffon. Courtesy of Conduit Gallery, Dallas, TX.

Thermal-wax printers are similar to dye-sublimation printers, melting thin coatings of pigmented wax onto paper. Some can print on a variety of papers, but the life span of these prints is shorter than that of dye-sublimation prints.

Desktop Inkjet Printers

Desktop inkjet printers are inexpensive and use water-soluble inks and plain copy paper to make color prints. Better quality paper will yield higher quality images. Some dye-based inkjet printers produce prints that are impermanent and can, without protection, fade within months. There is a wide variety of inkjet models, and some have pigment-based inks and professional features.

LightJet

LightJet or Lambda are brand names for printers that expose a digital image directly to color or black-and-white photographic paper using red, green, and blue laser beams. The resulting images are processed in regular photographic chemistry and therefore possess the same surface and permanence properties as traditional photographic prints. LightJet prints are extremely sharp and very close to continuous-tone because the LightJet's apparent resolution would exceed 4000 dpi when compared with conventional halftone printing.

Iris Print

The Iris printer was the first printer used in digital fine art reproduction. Iris prints are a type of inkjet print produced by spraying millions of fine dots of ink per second onto paper. Created on a spinning drum, these gallery-quality prints can be made on virtually any material that will accept ink. The Iris printer uses dye-based inks that produce some of the most vibrant and widest tonal values available. Depending on the type of ink, paper, and coating, such prints could have a life span ranging from as little as six months, but generally Iris prints are made to last decades. Once the standard for high-quality fine art reproductions, Iris prints have become a special-purpose niche process. Nevertheless, Iris prints continue to be the standard measure for digital prints.

Giclée Printing

Giclée, French for spray or spit, is a chic phrase for inkjet printing. Technically, even an inexpensive inkjet printer produces giclée prints. Giclée was first associated with Iris printers, which initially defined the digital fine art print market. It was used to appeal to print connoisseurs who expected state-of-the-art inkjet printing with a certain level of permanence, but the term is not regulated and hence carries no warranties of any sort.

Mural-Size Prints

Creating photographic high-quality digital images is a reality for both the consumer and the professional, and can be seen in the art world's embrace of mural-size prints. Even though digital cameras can exceed the sharpness of 35mm film cameras, the enlarging limitations remain constant. Digital photography is not a magic bullet for making large prints from small cameras. A blow-up from any type of 35mm-equivalent media will show a loss of sharpness due to the increase in pixelation or grain in proportion to the size of the enlargement.

As affordable digital image sensors become available in medium and large formats, film is becoming obsolete. Until this

occurs, some photographers still prefer using large-format film, scanned at the highest possible resolution to make large fine art prints. Such prints require film scans of between 4000 dpi and 8000 dpi, coordinated with a professional printer. Making digital prints exceeding the maximum capabilities of most desk-top printers—13 inches in height, up to 40 inches in width—entails floor-model, photo-quality inkjet printers. Many of these printers are capable of producing prints up to 64 inches in height and in widths as long as the roll of paper, which can exceed 100 feet.

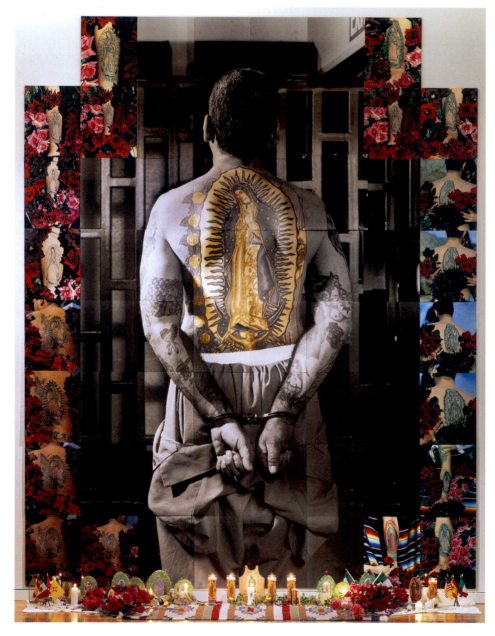

Figure 11.17 Delilah Montoya made this mural-size print by enlarging an 8 × 10-inch negative to 20 times its original size. She gridded the negative into 43 sections and printed each on a separate sheet of paper. She also made several additional color photographs of Guadalupe tattoos, which she incorporated into the central image of an inmate at a detention center. The artist then assembled the prints, mounted them to foam core, and installed them on the wall with Velcro tape. Montoya tells us that she created this image in homage to the Guadalupe, a significant icon in Chicano culture, for an installation in a French basilica. She says, "I aimed to reintroduce this image as a cultural icon that would demonstrate the Chicano vernacular. The intent was to bring back to Europe the Guadalupe as a container of the underpinnings of a colonial dark side that foregrounds captivity, oppression, and servitude."

© Delilah Montoya. *La Guadalupana*, 1998. 180 × 120 inches. Chromogenic color prints.

Mixed Digital Media

High-quality, large-format printers and a wide variety of printing materials allow for exploration with digital mixed media. Photographers have experimented with the surface of the print, some by applying pigment to the surface, others by collaging images and materials onto the print. These methods can be brought together using the digital print too. Besides traditional glossy paper, manufacturers have developed materials similar to traditional support bases, like artist canvas, which can be run through a digital printer and then painted on with acrylic or oil paints like a conventional canvas. Media such as Polysilk cloth can be printed on and then waterproofed, which allows them to be exposed to the elements or even washed. Other materials include translucent and transparent films that can be used as backlit prints, as photographic negatives, or in multi-layered images.

Preparing the Digital Print for Mixed Media

New developments in digital media are being driven by the advertising industry. Most of the store displays, such as ads found in supermarkets, are now produced on large-format printers. Artists need to be aware of commercial demands when using these new materials. Advertisers want their materials to be sturdy enough to be walked on or displayed outdoors, but they are not necessarily interested in images that will last for more than a few months. Luckily, many of the same qualities that allow an image to last 25 months outdoors mean those same prints may last years, or even decades, when they are properly displayed indoors (see Chapter 15, page 307).

One thing that imagemakers can do to protect their images from the damages of UV, or when preparing images for mixed media applications such as acrylic or oil paint, is to seal the surface with a spray or liquid coating. These coatings are water- or solvent-based and can be used with water-sensitive inks. Since many of the coatings can yellow or crack over time, researching and testing a particular combination before use is recommended.

Your Local Digital Printing Centers

If you want an inexpensive alternative to inkjet desktop printing, then consider your local photo centers, including Walmart or Walgreens, which can offer excellent results when image files are configured to their specifications. Typically, these local digital printers require JPEG file format (.jpg) and offer standard print sizes on luster or glossy paper. The advantages of these services

Figure 11.18 Joseph Labate considers the camera, the studio, and the computer as his private laboratory. "I use tape, wire, screws, and nails to set up the objects for photographing with a digital camera in the studio using White Lightning Monolights. From the studio, I upload the images from the digital film into my computer. With imaging software tools, I use virtual tape, wire, nails, and screws to complete the constructions that began in the studio. I'm left with a body of work where the 'real' collides with the 'made-up'."

© Joseph Labate. *Prototype*, 2003. 29 × 22 inches. Inkjet print.

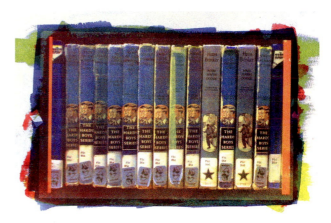

Figure 11.19 Brian Taylor incorporated both analog and digital methods by making a digital photograph and printing it with the nineteenth-century gum bichromate process. After importing his digital image, the artist separated the colors into distinct channels, produced three monochromatic digital negatives, and printed them onto Pictorico overhead transparency film. He then contact-printed each negative onto watercolor paper and hand-altered the print with watercolor pigments. Taylor says, "I try to imbue my images with a hand-made, organic essence by brushing non-silver photographic emulsions directly onto watercolor paper. I enjoy the texture and beauty of archival nineteenth-century processes, for they require the artist to slow down and better honor the image being printed. In this fast-paced, modern age of digital prints and service bureaus, I savor the tactile pleasures of making art by hand."

© Brian Taylor. *The Hardy Boys*, 2009. 12 × 18 inches. Gum bichromate print. Courtesy of Modern Book Gallery, Palo Alto, CA.

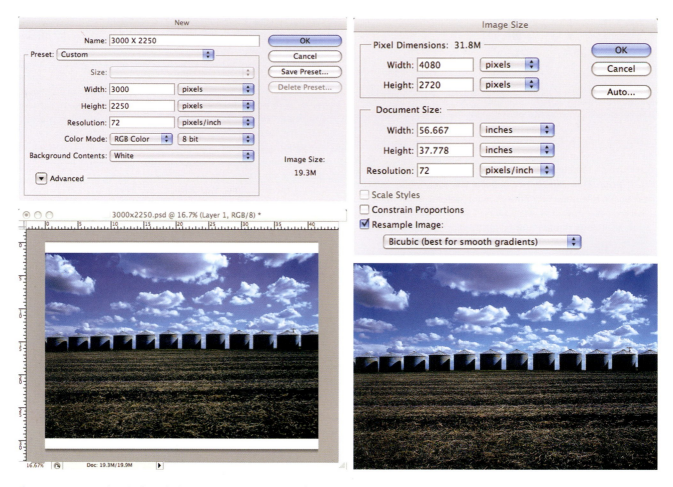

Figure 11.20 Greg Erf originally made this image on 120 transparency film and scanned in at a very high resolution for creating large-scale digital inkjet prints for exhibition. This image was reduced in resolution, sized, and converted into a JPEG file format for 8 × 10 output. Erf used a local digital photo center to also create exhibition quality Type C silver prints on a smaller scale and at a greatly reduced cost.

© Greg Erf. *Silos*, 2006. 7 × 10 inches. Chromogenic color print.

include: local and online access; affordable prints on conventional photographic paper; no need to buy and maintain expensive printing equipment and supplies; and the results are quickly available. Their indiscriminate cropping can be challenging when composition is critical, but this can be managed with imaging software (see Figure 11.20).

Today's Walmart and Walgreens digital printing centers utilize the Fuji Frontier Digital Lab systems, which can process and scan 35mm color film or work directly from JPEG files. They produce high-quality, color, silver digital prints at reasonable prices using RGB lasers that make exposures directly onto photographic paper, eliminating optical degradation of the image.

A key problem is these automated systems crop your prints to standard default sizes, such as 4 × 6, 5 × 7, or 8 × 10 inches. This is a concern because neither digital camera files or 35mm film are proportional to these default sizes and will therefore be enlarged and cropped to fit these proportions.

As these digital printing labs are automated, this still happens whether you apply online cropping tools or ask the store operator not to crop or enlarge. One can avoid this snag by digitally configuring your images to the programmed defaults of your location. For the sake of consistency, use the same store and construct your digital files in an identical manner each time. At under a dollar per 8 × 10-inch print, expect a few technical surprises.

Service Bureaus

The hardware necessary for many output options is expensive; using service bureaus with knowledgeable technical support is a viable option for photographers and graphic designers not doing high-volume work. Service bureaus also offer excellent online printing services. Commercial printers, copy centers, professional photography labs, and service bureaus can scan and print

Problem Solving

Working at Your Local Digital Printing Center

The most popular digital printing machine at the large chain stores is the Fuji Frontier Digital Lab system, which has a default resolution of 2250 × 3000 pixels for all 8 × 10 print options. Making full-frame, 8 × 10-inch images will require using your imaging software to generate a new image template file at 2250 × 3000. Regardless of the orientation of your image, landscape or portrait, you will need to use the landscape orientation for printing full-frame correctly. Once this is done, Copy and Paste your picture file into this landscape template before e-mailing or taking the file to your local digital photo center. As there are several digital lab systems, check your location for their default resolution settings for making 8 × 10 prints, adjust accordingly, and use that resolution to make your full-frame uncropped pictures following the steps below.

1. Using your imaging software go to File/New and make a new landscape picture file at 2250 pixels vertical × 3000 horizontal. This file will become the landscape template for sizing all your image files to make uncropped images, including your portrait images. Set Resolution to 72 ppi because by default your imaging software will open all picture files at 72 ppi. Making the new file template at the same default resolution of 72 is for simplicity when copying and pasting. Notice at 72 ppi the image size is quite large, around 33 × 27 inches. The digital lab system only recognizes pixel dimensions, not document size, and thus will automatically convert this picture template file to 300 ppi for excellent results at 8 × 10 inches. All the steps are designed to work with the digital lab system's preset default parameters, so be sure they are correct.

2. Open the existing picture file you wish to print. Copy and paste this picture into the 2250 × 3000 landscape pixel template. This picture now creates a new layer. If you, Copy and

Paste a portrait image, just rotate to landscape position and continue to size horizontally. Cropping vertical portrait images while in the horizontal landscape mode is not intuitive but a neccessary work around for the local photo centers to get the desired cropping. While holding the Shift key to constrain proportions in the new layer, scale your picture file so it touches both right and left vertical sides of this new template image file. This will leave white space on the other two sides, which can be trimmed later. The image is now formatted to print full-frame. Do not forget to make any additional image corrections, such as adjusting levels, color balance, and image sharpening, to achieve your desired print. See Box 11.1: General Image Correction Steps.

3. Title and save this new copied and pasted image template picture file in a file format specific to the software application you are using, not as a JPEG at this time. Store this uncompressed image file in a safe place and use it as the original digital negative file to make later changes if required. It is sound practice to save and re-make all new JPEGs from this original digital negative file. Local digital photo centers accept only JPEG files, so you need to learn how to manage these files effectively.

4. Make JPEGs from only the original digital file. Using the original template image digital file go to File/Open and save as a new JPEG file format. When making any changes, always go back to the original digital file and save again as another JPEG. If you continually save, make changes, and save again with the same JPEG file, the quality begins to degrade. You will be continually testing, changing, and reprinting picture files as you experiment, therefore, it is best to work from only your original picture file and save as a new JPEG file each time before sending to your local photo center.

images to your specific needs. Many specialize in high-quality and large-scale digital reproductions with the latest technology. The quality of the output always depends on the skill of the staff and the maintenance of the equipment, but as a general rule, if it is not done to your satisfaction a service bureau will make it right.

Film Recorders

Although you may have digitized an image and manipulated it on a computer, you can convert that image back into the traditional photographic realm. A film recorder, often available at a service bureau, transfers a digital image onto ordinary color or black-and-white film that you can view, project, print, and store as traditional silver materials. For color imaging, the device

exposes regular photographic film through red, green, and blue filters to provide image data in raster or bitmap form.

Working with a Computer

As a camera renders a three-dimensional scene into a two-dimensional representation, the computer seamlessly combines different media into a virtual representation, retaining the qualities of some and eliminating those of others. Anything that can be done with a camera, paintbrush, or drafting set can be simulated on a computer.

Large, high-resolution images require extra processing time and plenty of available hard drive space to operate efficiently. A 100 MB file should have at least five times that amount (500 MB)

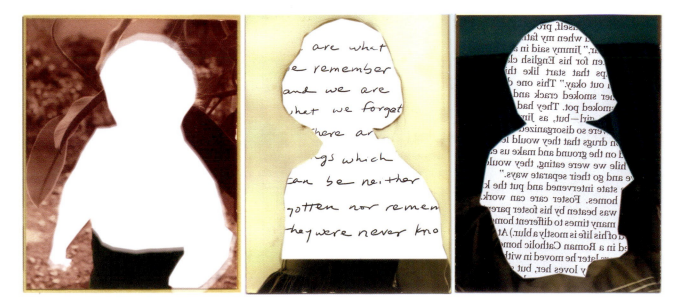

Figure 11.21 Making use of a scanner as her camera, Carol Flax imported photographs and texts to create a composite image. To emphasize its painterly appearance, she wanted to print the image on canvas. The artist worked with her service bureau, Nash Editions, to print the triptych on three separate 30 × 40-inch canvases. Flax tells us, "As an artist, I am interested in those delimiting spaces where the personal and the social come together, where boundaries shift and nothing is quite certain. As an adoptee, I have spent most of my life caught in the transitional state between knowing and not knowing. For years my work has broached questions of uncertainly in my own identity, extended outward to include larger issues of social and cultural identities. I have used various strategies, sometimes working in the intense private realm, sometimes in the vulnerable and exposed public domain, and various approaches, from computer-altered print work to Web, multimedia, and installation work. In each of my projects, questions of memory, both personal and cultural, help to shape my approach."

© Carol Flax. *3 Sisters*, 1997/2002. 30 × 120 inches. Inkjet prints on canvas. Courtesy of Center for Creative Photography, Tucson, AZ.

of free hard drive space to make use of the imaging software tools and the filters.

The computer is a powerful tool for experimenting with ideas and design, but it is not always best for producing an image. Images stored on silver-based film continue to provide a tremendous amount of permanent information that is easy to access and economical to store.

Stitching and Authoring: QTVR Panoramas

Panoramic views, including Daguerre's diorama, were created from a belief that 360-degree views were the closest thing to actually being there, giving a greater sense of reality than any single image

could. Early photographic panoramas were made by taking a series of still pictures while rotating a tripod-mounted camera within the scene being photographed. The result was a sequence of single images, shown side by side, giving the impression of a continuous panoramic view. The desire to photographically achieve this "being there" realism dates back to panoramic cameras that were patented as early as 1843 and forward to today's IMAX theaters that create a total immersion experience by providing viewers with the illusion of being on a roller-coaster ride or a white water rafting trip.

In the past, camera designers made costly panorama cameras that include a swing-lens camera, a full-rotation camera, and a fixed-lens camera with wide field view. Now most digital or film cameras equipped with a wide-angle lens can produce a

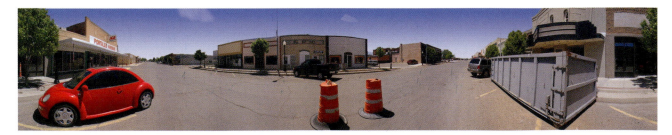

Figure 11.22 Greg Erf used a Nikon D70s with a 24mm lens to photograph 12 vertical images, using a good panhead tripod to distribute the images equally, in creating this panorama. All 12 images had a 30% overlap to allow the stitching software to create a single panoramic image. Erf used Apple QuickTime VR Authoring Studio to generate this panoramic image.

© Greg Erf. *Main Street*, 2010, 7 × 38 inches. Inkjet print.

360-degree view with panoramic photo-stitching software. Sophisticated digital cameras have built-in photo-stitching capabilities that overlay images of any scene to form a single seamless panoramic picture file.

One of the most widely used computer programs is Apple's QuickTime Virtual Reality (QTVR), which is based on their QuickTime movie format. After the individual images are stitched together, an interactive 360-degree QTVR movie

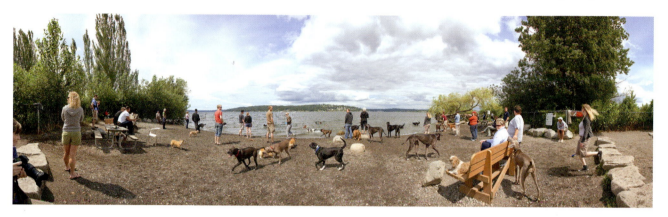

Figure 11.23 While this image may appear to be a straightforward, single panoramic photograph, Paul Berger produced it by stitching together several distinct images. Using a digital camera and a tripod that allows for rotation, the artist took seven photographs, covering a range of about 240 degrees. He then used Autodesk Stitcher Unlimited to merge the photographs into a cylindrical digital space. Berger refers to the image as "bovine vision … the camera vision of choice for those who scan the horizon wide, eschewing the specificity of the pointed gaze for the more generalized awareness of a uniformly focused peripheral vision."

© Paul Berger. *Dog Beach-407*, from the *Panoramas Series*, 2009. 24 × 60 inches. Inkjet print.

Problem Solving

Stitching Panoramic Views and Creating QTVR Movies

Equipment

Any digital or SLR camera with a 28mm or wider lens can be used on a sturdy tripod with the ability to put the optical center of the lens over the center of the rotation point in portrait mode. A simple bracket usually can be fabricated. Visit: http://blog.makezine.com/archive/2006/08/how_to_build_a_panoramic.html.

Taking the Pictures

It is essential to be able to rotate the camera 360 degrees and expose 12 equally-spaced, portrait-format images. Since all 12 frames need to be made at the same exposure for ease of stitching, use the manual exposure setting and select an average exposure that is the same for all shots. Do not use auto exposure, as the exposures will vary. Each of the 12 exposures needs about a 30 percent overlap on each side for the stitching software to seamlessly blend the images together into a single 360-degree file.

Stitching the Pictures

Obtain stitching software. Commercial and freeware stitching programs, such as PixMaker Lite for PC and a trial version of Panoweaver for Mac, are available. The latest version of Photoshop includes stitching functions. Some computer skills are needed, but the learning curve is quick. A powerful computer with lots of RAM is needed to generate a single panoramic file from the 12 images.

Creating the QuickTime Virtual Reality (QTVR) Movie

A separate application is needed to create a QTVR movie from the single PICT file generated from the 12 images. It is usually included with the stitching software. Some computer skills are needed, and the learning curve is moderate.

QTVR Programs:

www.outsidethelines.com/EZQTVR.html

www.apple.com/quicktime/resources/tools/qtvr.html

www.worldserver.com/turk/quicktimevr/QTVRlinks.html

can be authored and viewed on any computer screen or web-site (see Figure 11.6). QTVR software also creates a blended, 360-degree picture file that can be further manipulated and conventionally printed to produce spectacular panoramic views, thereby eliminating the need for expensive, specialized panoramic cameras.

The Color Monitor

All monitors use an additive RGB color system (see Chapter 1, page 6). Increasing the value of these light RGB primaries will make the image lighter. Since transmitted light forms an image, the colors tend to be luminous and saturated. The printed image uses a CMYK subtractive system to form an image on a sheet of paper. Light is reflected from the pigment on the paper. A greater pigment density adsorbs more light, thus reflecting less light and resulting in an image that appears darker to the eye.

There is an inherent visual difference between images seen on your monitor, other monitors, and output devices. Sophisticated monitors allow for color correction as well as contrast and brightness adjustments, but these only affect how the image appears on your monitor and not on other monitors and/or paper output. Color-management hardware and software is available to help control the color balance between monitors and output.

How Monitors Show Color

Depending on the monitor size and the amount of video memory (VRAM), it is possible to see and manipulate millions of colors with image-processing programs. All video monitors represent color by displaying minute RGB pixels, which are displayed on the monitor as pure color. All other colors shown on-screen are a mixture of pixels used to approximate the color needed. In addition to full color images, grayscale images can be produced, with 256 shades of gray, as can bitmap images, which are purely black-and-white.

What Is Bit Color?

Bit depth describes the number of bits (the smallest unit of information on a computer) assigned to each pixel and refers to the number of shades of gray or the number of colors that can be represented by a single pixel. The greater the number of bits (2, 4, 8, 16, 24, 32, or 64), the greater the number of colors and tones each pixel can simulate. The bit depth of your computer's display is the number of different colors it can show at any given time. The size of the display and the amount of video RAM you have on the graphics card controls bit depth. 64-bit color is the highest level of color a computer can produce, although anything at 24 bits and above creates color variations that are well beyond the range of human perception. Even though human perception is limited to 24 bits and below, 32- and 64-bit color can improve color accuracy and correction on-screen.

In imaging software such as Photoshop, images contain either 8, 16 or 32 bits of data per color channel. In an RGB file an 8-bit/channel image has an overall bit depth of 24 bits (8 bits × 3 channels = 24 bits); a similar CMYK file has a bit depth of 32 bits (8 bits × 4 channels = 32 bits). Images that have 16 bits of data per color channel have a much greater color depth, translating

to greater distinctions in color. In this mode, RGB files have a bit depth of 48 bits (16 bits × 3 channels = 48 bits) and CMYK images have a bit depth of 64 bits (16 bits × 4 channels = 64 bits). Currently, working in 16-bit/channel mode severely limits the software's and the imagemaker's ability to manipulate an image. In 16/32-bit channel mode many image filters and image adjustment functions are unavailable because of increase in bit data. However, 16 or 32 bits of data per color channel allows for much more color adjustment before banding or under-sampling to the continuous-tone qualities of the image occurs. It is a good idea to perform color corrections on an image in 16 bits/channel or higher. You can then convert it to 8 bits/channel to make all the tools and functions accessible in your imaging software program. Constant improvement in software design gives more functionality to working with larger bit-depth images. These larger file sizes will also extend the time needed to send an image to print, save it, or transfer it to another storage medium.

Color Management (ICC Profiles)

In 1993 a group of eight software and digital-output device manufacturers formed the International Color Consortium (ICC) to establish and maintain a set of international color standards. The

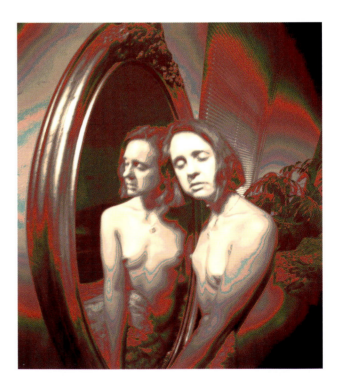

Figure 11.24 Dan McCormack blends opposites by using an oatmeal box pinhole camera to produce 8 × 10-inch black-and-white negatives that he scans and colorizes. Ignoring standard color-management profiles, he pulls curves in each of the color channels and reworks the color balance until the color feels right. This results in an image "rooted in sixteenth-century optics juxtaposed with twenty-first-century digital technology."

© Dan McCormack. *Melissa N 4-26-09-7BC*, 2009. 12½ × 11 inches. Inkjet print.

group introduced a standard device profile format, known simply as ICC, to define how different color devices, often made by different manufacturers, produce color images. An ICC profile is a file that describes how a particular device (printer or monitor) reproduces color. These profiles map onto an image file the characteristics of different output devices with their limited color ranges, making the output of images from varying devices predictable and observable.

Profiles, Profiles, and More Profiles

In the digital environment every workstation has a unique color range or "printable color space," sometimes known as color gamut. ICC profiles are small digital files that help the computer determine the actual viewable and printable color space of the device. These files are sometimes preloaded in an image or software program, but many need to be loaded based on the device or the media being printed on. Color space is determined by everything that goes into making the image, including the camera or scanner (input), the type of monitor (viewable color space), and the printer, along with its specific combination of inks and paper (output). The ICC profiles "remap" or reassign a new color value to a digital image when color values are detected outside the viewable or printable color space. Sometimes the shift is not severe or even detectable. The standard ICC profiles, called generic profiles, are designed as a "best guess" method of normalizing many variables over the widest variety of possible environments and can do a good job. Factory ICC profiles are best and can reduce time and effort when color-correcting, though not always.

Anyone with conventional color darkroom printing experience will see the same functionality between determining the correct filter pack and using ICC profiles. In conventional color printing, a series of cyan, magenta, and yellow filters is used to correct color balance based on the type of film, light source, paper, temperature, and chemicals. The ICC profiles are the digital equivalent of a filter pack tailored for a specific product. In a controlled working environment with well-maintained equipment, a good understanding of ICC color-management can minimize the color-correction process with digital images. Just as in conventional color printing, "tweaking" the color balance is a continuous process. ICC profiles are based on the monitor settings, such as contrast, brightness, color temperature, tint, and RGB, and have their place in making critical work. In a controlled working environment with the proper software and color calibration equipment, the color calibration of the monitor to the printer can be done very precisely. In a group lab environment where the monitor controls and room lighting are inconsistent, it is often easier and quicker to first print a digital image file that contains both a grayscale and color scale chart. This print is then compared directly to the monitor and the necessary adjustments are made to match the monitor to the print, in this closed loop systematic approach. This style of color-management is not ideal for an individual or office set-up, but works well to compensate for the numerous unexpected changes that constantly occur in a group work environment. Also, regardless of what a calibration program states, color response is subjective and it is our eyes that ultimately determine whether a color print achieves its desired results.

Other Digital Colors

Many software applications allow for the manipulation of color according to its hue, saturation, or luminosity (HSL), or through a licensed color system such as Truetone or Pantone. Both of

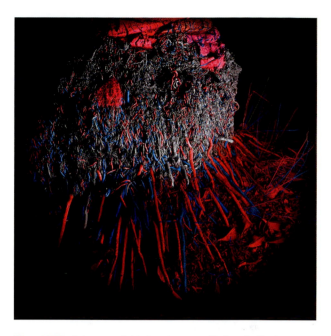

Figure 11.25 Color enters Robin Dru Germany's black-and-white images in the form of synthetic hues. She photographs plants using 120 black-and-white film, which she prefers for its starkness and ability to reveal intriguing shapes and textures. The artist colorizes and vignettes the photographs in Photoshop, enhancing the images' references to bacteria, viruses, and electron microscopy. Germany explains, "Ultimately I am interested in the resemblance between the images of what is inside our bodies and what is outside, and the degree to which we are deeply connected, physically and psychologically to the natural world … Nature has preceded us. We see ourselves within it; its shapes look like our shapes, its vines like our veins, its patterns like our cancers, yet we persist in denying the likeness as if it were a vice. It remains beyond our reach and we strive to maintain a safe distance."

© Robin Dru Germany. *Subterranean Roots*, from the series *A Difficult Nature*, 2005. 24 × 24 inches. Chromogenic color print on Plexiglas.

these systems allow for the most understandable method of computer-based color manipulation. The traditional printing method of lithographic printers, process color, or CMYK, is based on the subtractive primary colors. Note that many output devices cannot print all the colors a computer is capable of processing. Some software packages will warn you if a particular device cannot print a selected color. Computer users can make color separations for printing using the CMYK mode. When switching from RGB to CMYK the computer dulls the screen colors to simulate a subtractive print. High-end multicolor printers rely on RGB to manage all their possible color options. Duotone effects, applying a second accenting color, are also possible.

Image Processing/Editing

Adjusting Color Balance with Curves

Analog and digital photography both record color by layers with similar means. Color film has three chemically sensitive layers that separately record red, green and blue (RGB) light to capture

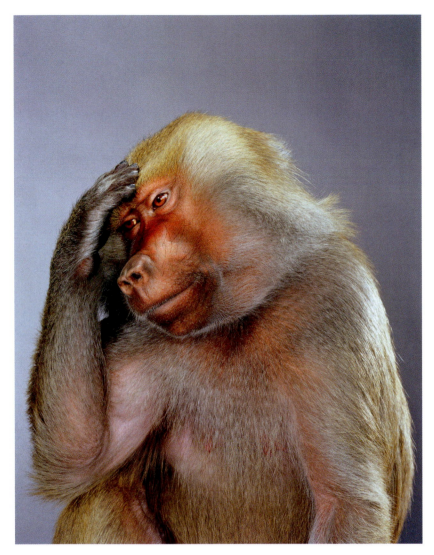

Figure 11.26 Known as the Manipulator, Jill Greenberg has amassed extensive experience with digital image-processing and editing. Though she uses a film camera and spends significant time arranging lighting, makeup, and hairstyling before a photo session, it's not until she digitizes her photographs that she perfects them. In post-production, the artist adds a painterly finish to her work by adjusting curves and color balance, dodging and burning, and creating filters. A portrait photographer who generally concentrates on human subjects, Greenberg has begun to introduce monkeys and bears into her work, giving these new portraits her distinctive look. She states, "I'm not sure how much a portrait really is a real reflection of a person anyway. In lots of ways it's more like the reflection of the photographer onto that person."

© Jill Greenberg. *Headache*, 2006. 42 × 50 inches. Inkjet print. Courtesy of ClampArt Gallery, New York, NY.

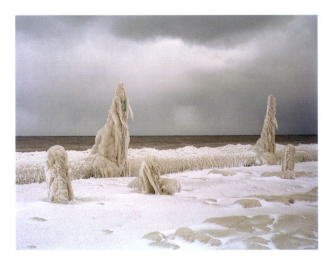

Figure 11.27 Scanning and processing her 4 × 5-inch negatives in order to make large prints encouraged Lisa Robinson to delve further into digital adjustments. She now color balances her photographs with extreme precision, with the knowledge that a single point of color can create a noticeable color shift in the final print. Robinson's snow-related work explores memory and the sublime. She tells us, "*Valhalla* is an image of transformation at a precise dramatic moment … In this moment, the connectedness between states of life and death, earth and heavens, reality and poetry is revealed. Water exists here in its multiple states, as ice, water, snow, and clouds. It is a remarkable convergence. The underlying tension that quietly rests beneath the surface of so many previous images has finally broken free. The stillness becomes something else entirely, something from another world."

© Lisa Robinson. *Valhalla*, from the series *Snowbound*, 2006. 28 × 36 inches. Chromogenic color print.

the full range of color (see Figure 1.10). Digital photography also separately records RGB light but uses electronic RGB image sensors to separate the light into three RGB layers to capture color.

The most efficient way to make digital color corrections is by accessing the individual red, green, and blue layers through your imaging program. In a production environment, making color corrections and adjustments can be a tedious proposition. However, for artistic purposes, where an individual makes these decisions, one can achieve their goals with the following basic steps in a way that does not damage the original image file.

Getting to Red, Green, and Blue Layers

At the top menu of your imaging software go to Windows and then to the Layers Window. Click on the black-and-white circle icon at the bottom center of the Layers Window, the Create New Fill, or Adjustment Layer button. Clicking on the black-and-white circle, select Curves, and the Curves Window will appear with a diagonal line.

Using RGB Curves

Directly above the box in the Curves Window there is a drop-down menu, which gives you direct access to individual RGB layers. Move the end points of the diagonal line or click anywhere on this line to adjust selected layer. Using this technique allows you to specifically adjust individual RGB data.

Helpful Curve Tips

If an image is too warm, minor adjustments to the diagonal line will be needed. Go to the drop-down menu and select the red layer. Drag the top end point of the diagonal line down along the right edge to remove only red from the image, and stop when the proper amount of red has been removed.

Another approach is to add cyan, rather than remove red, to achieve the desired result. Go to the drop-down menu and select the cyan layer. Dragging the top end point of the diagonal line across the top to the left will allow you to add cyan to the image; stop when the appropriate amount has been added.

Making color corrections is an either/or proposition that involves subtracting the dominant color or adding the opposite color with Curves. Final color determination depends on how the addition or subtraction of different colors affects other parts of the image. If you are not pleased, put the layer in the Trash and start anew.

Understanding these subtle differences requires practice and a well-trained eye. Using the Auto button located at the top right of the Curves window will apply color correction in an instant to this layer. Use the Auto button and see how it operates, and then undo and set your own end points if not satisfied.

Software and Imaging Applications

While the computer is a potent tool, it is an empty vessel, dependent on the instructions contained in software applications. Images created on a computer need not be solely photo-based. The program's own internal tools, coupled with devices such as pressure-sensitive graphic tablets, let the user simulate the effects of other media as well as create unique digital images.

Figure 11.28 Kim Abeles and Ken Marchionno worked together to create this installation with a Wacom drawing tablet and Illustrator, producing large-scale, hand-drawn prints. The team incorporated Marchionno's photographs into Abeles' graphic drawing, and they embedded Abeles' videos behind faux walls. With this work, Abeles and Marchionno examine how contemporary society views Native Americans. "The installation employs full-scale drawings of three bedrooms that are mounted as wallpaper, each room representing a different stage in life—child, adolescent, adult. With embedded videos and images taken from pop culture and documentary practice, the rooms combine to offer a trajectory of representation."

© Kim Abeles and Ken Marchionno. *Based on a True Story*, 2009. 96 × 228 × 168 inches. Inkjet print, video, and sound.

Different software packages may be used at different stages in the imagemaking process. A single application can provide adequate tools for an imaging project, but it is often necessary to combine the strengths and tools of other software to create desired effects.

Raster/Bitmapped Software

Most programs that process photo-based pictures operate with raster (bitmapped) images. The advantage of the bitmapped image is its ability to be edited pixel by pixel. Photo-based or raster image programs, such as Photoshop, do not keep individual objects as separate entities. Items must be applied to a layer, at which time any alteration will affect surrounding areas by replacing data or leaving holes. Remember that increasing the size of an image leads the software to interpolate the image, thereby increasing the number of pixels, spreading data, and reducing image quality. Reducing image size eliminates pixels, which also degrades image quality.

Vector Software

Vector graphics (object-oriented) programs offer a wide range of options for manipulating lines and polygons. Vector images define curves, colors, and lines by mathematical formulas and define the digital file itself as a group of objects instead of pixels. Vector graphics programs see objects as points on a grid, treating them as separate entities that can be colored, reshaped, stacked, or moved, without affecting the background or any other object. Such programs allow objects to be endlessly scaled with no loss of image quality and therefore remain sharp and hard-edged. Designed for drafting and illustration purposes, vector software is not ideally suited for photo-realistic images. New versions of raster/bitmapped imaging software allow for both the import and export of both vector and raster files with some limitations.

Basic Digital Imaging Categories and Tools

Top Main Menu Bar Options

Regardless of the imaging program, there are common and unique categories located in the top Main Menu Bar that offer access to many functions for editing images. The most common categories are File, Edit, View, Insert, Layer, and Filter (see Figure 11.29). Within these categories there are hundreds of selections that, when used in combination with the toolbar, can create several thousand ways to manipulate an image.

Cut and Paste Function

Located in the Edit category in the top Main Menu Bar, Copy and Paste give the ability to replicate and move information. Both are essential and powerful functions of the computer. Cutting-and-pasting is possible between files made on different pieces of software, as well as between documents made on the same software. Sometimes the data structure of the information is not compatible. Most well-developed software applications have a set of procedures, usually located under File or Edit in the top Main Menu Bar, for converting and opening files produced by different applications.

Using Layers

"Layer" is a term used when two or more images are stacked on top of each other to create a new single work. Film-based photographers have long done this by stacking negatives and/or transparencies on top of each other in the enlarger's negative carrier to produce a new single image. Digital Layers not only allows you to stack endless image files together, but also offers far greater creative control than in the analog past. To try it out, go to the top Main Menu Bar in your software program and open the Layers Window. With the Layers Window open Paste or import a new image file; each time you do this a new layer is automatically generated. Highlight the layer you wish to control and apply the effects and/or filters to this active layer. If a mistake is made to any Layer you simply put it in the Trash and start anew (see Chapter 8 for more information and applications).

Scale and Distort Function

Located in the Edit category, in the top Main Menu Bar under Transform, Scale and Distort are the primary clues to depth perception that are manipulated to change the context or to create an image that challenges the viewer's assumptions. An image, either in its entirely or its parts, can be foreshortened to simulate perspective, or stretched vertically or horizontally to fit into a defined area.

Overall print-sizing controls are usually located in the Image category in the top Main Menu Bar under Image Size or Canvas Size. Both these functions make the image larger or smaller when outputted. Altering the canvas size allows for the creation of blank drawing space around the image (or crops the image), while altering the image size affects the overall dimensions of the image.

Digital Filter Function

An image also can be manipulated through a wide variety of functions called filter effects, located in the top Main Menu Bar category called Filter. All programs offer a wide variety of built-in common filter effects, such as Blur, Distort, Mosaic,

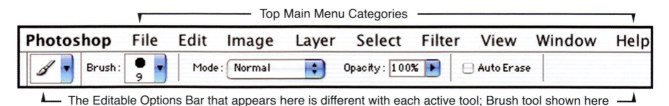

The Editable Options Bar that appears here is different with each active tool; Brush tool shown here

Figure 11.29 The top main menu categories and editable tools options.

Figure 11.30 To make this composite, Deena des Rioux incorporated digital photographs, scanned objects, and found images. She merged these components in Photoshop using multiple layers. In the digital age, when identity theft is a regular occurrence, the artist says, "these photo-based images not only swipe facial features that jump from one figure to the next, but also transform the subjects into hybrids, somewhere between organic and still-life."

© Deena des Rioux. *Identity Theft #1*, 2009. 36 × 38 inches. Inkjet print. Courtesy of Wozownia Art Gallery, Toruń, Poland.

Pixelate, Reticulation, Sharpen and many other artistic effects. In the nineteenth century, photographers turned to the aesthetic strategies of painting for guidance. Today, third-party software manufacturers have done the same, producing filter effects known as plugins that further transform the common digital tools used to simulate drawing and painting. There are also filters that mimic the color and grain patterns of film. As imagemakers continue to discover an original digital aesthetic, there will be less reliance on older media and filters that simulate them, allowing an authentic digital syntax to emerge and grow.

Toolbar Icons for Additional Photo Editing

Many of the common editing tools began in Photoshop and have since migrated to other programs. The various tools are located in a floating toolbar that defaults to the side of your screen. Refer to the manufacturer's manual or the application's Help Menu for complete and detailed descriptions of all tools. Many of the visible tools on the toolbar have hidden options that are revealed by simply using Click-Hold or Option-Click on the visible icon, or right click, depending on the program. Also, each tool has edit options that are usually displayed in an Options Bar underneath the top Main Menu on the screen when the tool is active. The Options Bar is useful for changing many options related to the active tool, such as brush size, type of gradient, font size, transparency, and colors.

Figure 11.31 Referencing her background as a studio artist, Lauren Peralta employed extensive digital retouching to produce this painterly photograph. She used a Gaussian Blur filter to reduce background lines, layer-masking techniques to enhance color, and adjusted curves and levels to enhance certain areas of the image. To avoid moving too far into the realm of painting, Peralta ultimately had to set limits for herself, ensuring that the photograph still retained the appearance of a photograph.

© Lauren Peralta. *The Apple*, 2009. 8½ × 11½ inches. Inkjet print.

Common Toolbar Icons from Photoshop

When a black arrow appears in the lower right-hand corner of a tool icon, there are more similar tools to be found by clicking and holding the mouse button on the icon.

Select and Move Tools

Marquee Tools

The Marquee Tools are used for creating simple geometric selections in your images (rectangle, elliptical, and single-row selections are all similar options). Since a computer cannot read your mind, use the Marquee Tools to indicate the area you want to work with. Once an area is selected, any adjustments, tools, or filters will be applied only to the selected area. The Shift key is a modifier that allows you to make a square or circle of a rectangle or ellipse when using the Marquee Tool. The Option key allows you to draw a rectangle or ellipse starting from the center.

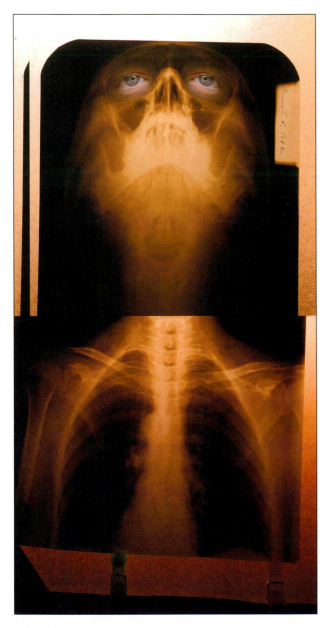

Move Tool

One of the most useful innovations in the development of Photoshop was the inclusion of Layers found under Window in the top Menu. Using the Layer mode, imagemakers can move or copy pixels on one layer to another layer. Layers can then be altered independently. The Move Tool allows you to move selections or the entire contents of one layer to another for unlimited image control.

Lasso Tools

The Lasso is a freeform selection tool. Unlike the Marquee Tool, the Lasso allows you to draw both straight-edged and irregular selections. The Lasso Tools has three similar modes: Freeform Lasso, which draws complex irregular selections like a drawing pen; Polygon Lasso, which draws simple straight segments; and Magnetic Lasso, which follows the closest edge in an image. Using the Option key allows one to draw with the Freeform Lasso and the Polygon Lasso alternately within one selection.

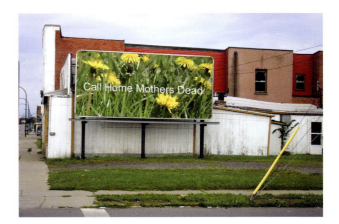

Figure 11.32 Mark Lewis Essington creates digital collages using personal photographs, donated x-rays, and appropriated images. Working subtractively, he uses Photoshop to selectively erase unwanted elements during his process of making composite images. The artist tells us, "My images are about pain, paranoia, humiliation, self-image, and the effects of sexual abuse and the associated disorders resultant on the psyche ... My images are created as therapy; created to make the viewer feel, as best as possible, like I do, and see the demons I face everyday. I try to cast them off and banish them to a printed page. They are to be disturbing, strange, and occasionally funny simultaneously. I want the viewer to have to look but never be sure they really want to."

© Mark Lewis Essington. *Stoic* (detail), 2009. 16 × 8 inches. Chromogenic color print.

Figure 11.33 Adriane Little digitally manipulated this photograph in Photoshop, adding layers for the dandelion image and the text. She became fluent with the Polygonal Lasso Tool, which she used to trace the outline of the billboard and various elements within its borders in order to change the opacity of that area. Constructing this image using traditional darkroom techniques, the artist notes, would likely have been near impossible and would certainly have been much slower and less accurate. About this series, Little says, "The conceptual framing of my work originates from an investigation of ritual, excess, and trauma, most often through a presence and absence of the maternal body ... Within my work, ritual is under the burden of grief and trauma, most often in response to the structural death of the mother and cultural rupture ... In this case it becomes a solitary act and an attempt to build a different kind of community—one that lacks familial history in a concrete way but instead is embedded within instinct, or what I am calling the matrilineal ghost."

© Adriane Little. *Resuscitation #86*, 2004. 24 × 36 inches. Chromogenic color print. Courtesy of Peak Gallery, Toronto, ON.

Magic Wand Tool

The Magic Wand selects all pixels of a color or tone similar to a chosen pixel. The tool selects pixels within a certain tolerance that ranges between 0 and 255 tones. A tolerance of one (1) will select only pixels of that same color. A tolerance of 100 will pick all pixels that are 50 tones lighter and 50 tones darker than the pixel selected.

Crop Tool

The Crop Tool is used to draw a rectangle around a portion of an image and discard all image information outside that area. The size of the rectangle can be adjusted before cropping and also can be tilted, rotated, and distorted by using control points on the edges of the selected object.

Drawing Tools

Brush and Pencil Tools

The Brush Tool allows you to paint with a selected color. The size, shape of the brush, and edge sharpness can be changed in the options palette. The blending mode, opacity, and flow of the brush also can be changed. The Pencil Tool allows you to draw a line in a specified pixel size. The Pencil Tool creates sharper edges than the Brush Tool because it leaves out the anti-aliasing (softening of edges) that the Brush Tool employs. Use of the Option key while the Pencil or Brush Tools are selected allows the user to sample a color within the existing image file as a paint color.

Retouching Tools

Healing Brush and Patch Tools

The Healing Brush Tool is used to sample an area of an image and copy that sample to another area. The tool is useful for removing imperfections from images because the tool matches the colors of the sampled pixels with the area around the target imperfection. In addition to matching the color of pixels, the Patch Tool matches the lighting, texture, and shading of the sampled pixels to the target receiving area.

History Brush Tool

This tool is similar to the History Window, which provides unlimited undos. History Brush is an extremely powerful tool that provides a free-form and selective way to undo and return to the previous state of any area within the image. The advantage of the History Brush Tool is you can use the same options provided with the Brush Tool such as airbrush settings, brush size, and opacity to creatively return to any stage of the build.

Clone Stamp Tool

Like the Healing Brush, the Clone Stamp Tool is used to sample pixels in one part of an image and clone (copy) them to another

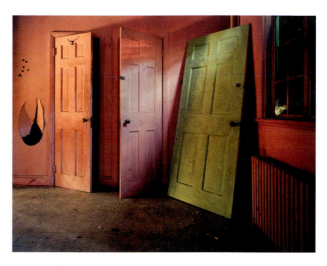

Figure 11.34 Digitally processing and printing his analog photographs enables Vincent Carney to make minor compositional changes. After analyzing the negative of this image, he noticed an area of bright light that he found distracting. Using the Photoshop Clone Stamp Tool, the artist was able to eliminate this area, creating a tighter image. Carney tells us that in this body of work, which he photographed in an abandoned hospital, he aims "to capture the interaction between light and the spaces themselves, how the light sweeps and fills, how it obscures and highlights, how it takes shape and helps to describe each individual space. To an extent, chance plays an important role in the success of this body of work, and many times this has proven to be the case working only with natural light. I am constantly reminded of the fact that chance favors the prepared mind."

© Vincent Carney. *Three Doors*, 2008. Variable dimensions. Inkjet print.

part of an image. As in the case of the Brush Tool, the size, blending mode, opacity, and flow can be tailored to suit the task. The Clone, Healing, and Patch Tools are excellent for removing dust spots and repairing damaged photographs.

Eraser Tools

The Eraser Tools delete or alter pixels. When working on the background layer or with the layer transparency locked, the pixels will be changed to the background color. In other situations the pixels are erased and become transparent. The Background Eraser samples the color in the center of the brush (indicated by a brush shape with a cross hair) and deletes that color in the target area. The Magic Eraser changes or erases all similar pixels within a certain tolerance (tonal range).

Fill Tools

The Paint Bucket Tool fills an area with the foreground color. As with other tools operating within a tolerance, setting the Paint Bucket will replace all of the adjacent pixels that fall within the specified tolerance range. The Gradient Tool works with the foreground and background colors to create a gradient (progression) between the two colors.

Dodge and Burn Tools

As in the darkroom, the Dodge Tool and the Burn Tool are used to lighten or darken areas of the image. The size of the tool, the range (highlights, midtones, or shadows), and the exposure can be defined.

Type Tools

The Type Tool is used to create horizontal or vertical type anywhere in an image, or to make a Type Mask in the shape of type. Any font that is properly installed and available to your operating system can be created. The font size, color, leading, kerning, and justification can be set in the tool's control panel. The Type Tool creates vector-based text but can be converted or rasterized into pixels.

Dropper (Color Picker) Tools

The Eyedropper Tool samples the color of selected pixels from the existing image or another image that is currently open to designate a new foreground or background color.

Zoom Tool

The Zoom Tool increases or decreases the screen magnification of images. Changing the size of the image on the screen allows the imagemaker to see the image in greater or lesser detail, but does not change the printed size of the image.

Changing Mouse Pointer

When tools are selected, the mouse pointer matches the tool icon. Many of the drawing and painting tools are circles that can be changed in preferences, which represent the selected width of the mark the tool will make. Each cursor has a hot spot where the effect begins. For example, the tail of the looped rope is where the selection begins for the Lasso Tool.

Option /Alt, Shift, and Command Keys

Knowing when to use the Option, Shift, or Command keys in conjunction with the active tool is necessary to use many of the tools and their functions. For example, using the Option (Mac) or Alt (PC) key with the Zoom Tool changes the mouse pointer to a plus or minus, allowing you to zoom in or zoom out of the image on screen. Also, using the Shift key with the Magic Wand allows you to add to your previous selection so that you can group many selections. Try using the Shift, Command, Option or Alt keys with various tools to see how they modify the tool's behavior.

Digital Memory

RAM

When a program begins, its contents are loaded into random access memory (RAM). Instructions the computer needs to perform its tasks are stored and processed in RAM chips, sometimes called memory chips, which come in a variety of sizes, pin configurations, types, and formats. The amount of RAM a computer has directly affects its performance and capabilities and is easily expanded. Most software applications include minimum memory requirements on their printed material. However, to effectively run the program may require much more RAM, so it is prudent to research programs before purchasing them.

ROM

Permanently installed in the computer, read-only memory (ROM) contains the basic instructions the computer needs to start up and to draw objects on a screen. ROM, unlike RAM, is unalterable.

Hard Disk

The hard disk, usually installed inside the computer, is where applications and files are stored. Since image files are often larger than the available RAM, some software applications use the hard disk to temporarily store information. The program shuffles information from the hard disk (the scratch disk) into RAM, where it is processed. This enables the program to complete complex operations and functions, such as Undo and Preview. The scratch disk can take more than five times as much space as the original image because it stores several different versions of the image. The computer's hard disk must have enough free space to accommodate these temporary files. Very large image files require more scratch disk space for the program to run efficiently.

The Computer as Multimedia Platform

Moving images, or video, address time in a different way than a still image. With video the viewer tends to be involved within the flow of events, while the still image is an abstract entity that calls for a more concentrated viewing and interpretation. The assembling and editing of video images on a computer is known as nonlinear video. Software packages edit video by creating fragments called clips. A clip of video can be previewed, altered, and combined with sound.

Cell-animation programs, many of which are vector-drawing programs, manipulate discrete objects and create the illusion of movement by showing sequential frames with incremental motion. The cell elements can be independently controlled, allowing the background to remain stationary while objects in the foreground display motion.

QuickTime movies generate a series of compressed files and allow moving images and sound to be created, stored, and viewed. QuickTime movies compensate for the speed of your computer, keeping the sound properly synchronized with the picture.

Three-dimensional modeling programs are vector-drawing programs that have the capability to render an object and simulate the effects of light. The completed object can be viewed from any angle and direction. These programs are often coupled with an animation component that allows the piece to be presented as a movie.

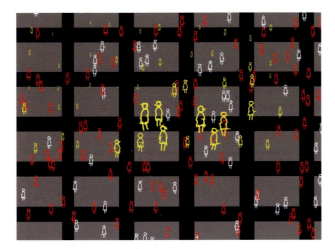

Figure 11.35 Jody Zellen created this image by making a screenshot of an animated applet that she produced with the open source program Processing. To construct this applet, the multimedia artist wrote a series of commands to draw stick figures that moved in what she saw as an abstraction of urban space. Zellen was inspired to make this work by a desire to incorporate drawing into her digital work. She says, "I became interested in if and how the computer could make figurative doodles like the ones I would draw on the edges of my notebooks. I directed the computer to connect line segments that formed the shape of a figure. Soon the figures began to animate, moving according to specific behaviors. Applying the rules used in gaming with respect to how objects move in relation to each other, I was able to create figures that moved in urban spaces."

© Jody Zellen. *Movement through Urban Space 3*, 2009. 20 × 24 inches. Inkjet print.

The Internet and the World Wide Web as a Virtual Gallery

The Internet is a series of networks developed in the early 1970s as a decentralized Cold War communication system between government, academic, and private research labs. Today, through a modem, any computer user can send digital data via the Internet or can directly send data to any other user who has a modem. Online services allow the user to download an image file and electronically mail it to other users. The advantages of this method are that both users can receive and send material, even if the other person's computer is turned off. The downside of the Internet continues to be the time it takes to transmit data, and compatibility issues, especially with image files.

The World Wide Web (WWW) and other virtual spaces offer a unique environment for sharing information, images, and other media. Digital galleries on the Internet have become major presentation venues for displaying images. Some of these virtual spaces even mimic the conventions of the traditional gallery by creating virtual frames and walls.

Viewing images in a gallery setting is a separate experience from looking at images on a computer monitor or in a book. A 4 × 5-foot image carries a distinctly different message from one that is 8 × 10 inches in size. The computer screen changes these circumstances by making all images roughly the same size, and having them viewed by transmitted light. The aura of a gallery

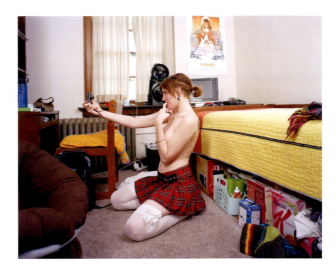

Figure 11.36 Evan Baden's *Technically Intimate* series, which he photographs on 4 × 5-inch film and processes and prints digitally, looks at how technology and the Internet are changing how the "tell-all" generation of teenagers view themselves and their relationships. The artist says, "Young people have become accustomed to posting and sending sexually charged images of themselves via the Internet and cell phones … I use images found online as source material and recreate the moment that the original image was captured. I am attempting to put the original image into a context, to give the viewer an idea of what was happening during the creation of the found image. In the found images it is the act of creating the picture that is important, because the 'act,' not the 'image,' represents the shift in how young people understand, enact, and experience sex and intimacy. The acts that are performed in these images and videos are acts that would be private to many of an older generation. Instead, these once private acts are now being viewed by millions."

© Evan Baden. *Bethany*, from the series *Technically Intimate*, 2009. 40 × 50 inches. Inkjet print.

setting is replaced by the appearance of the desktop. Efforts by major art auction houses, such as Sotheby's, to hold online art auctions have met with limited success because converting Internet audiences into collectors has been a task intrinsically unsuited to the computer screen—a medium that severely limits the opportunity to experience works of art. In other cases, work made specifically for major museums and galleries, such as the Guggenheim Museum, which has been commissioning and collecting online art for its permanent collection, has been embraced by Web users. As more imagemakers utilize the video functions now incorporated into many cameras and cellphones, Internet sites like YouTube have become vital presentation venues for people to share videos.

The Chemical, the Dry, and the Hybrid Darkroom

The reasons for working with any process should be embedded in the context of the imagery. Camera-based imagery has evolved into three distinct categories: silver, digital, and hybrid. The silver process offers the familiarity associated with the

chemical darkroom that dates to the origins of photography. Digital methods allow speedy and precise image creation within the convenient environment of a dry darkroom. The hybrid approach combines the desired characteristics from both worlds to obtain unprecedented image control.

The problems associated with both dry and hybrid print technologies include the overall expense and the constantly changing knowledge base. The cost of high-end scanners and printers needed to produce premium digital prints far exceeds the cost of the best-equipped chemical darkroom. Inkjet printing technology for black-and-white or color prints is affordable, but still problematic, with continuous debate about what methods are best. The hybrid printing approach using LightJet or Lambda technology, which uses photographic paper for final output, is not available for home use because of the high cost of the printers. The hybrid approach requires you to send files to a high-end professional lab for final output, and with that comes a loss of artistic control.

It is not possible, without becoming academic and esoteric, to aesthetically compare digital prints with conventional silver prints because visually they are now equal. Only in extreme cases will a viewer need to be aware of the technological differences between a digital and silver print to appreciate the image. Ultimately, it is the artistic powers of the imagemakers and their use of subject matter that really counts, although from an artist's point of view as an end user, digital technology still is far from being considered a mature visual medium.

Digital artists continue to spend enormous amounts of time dealing with technical and computer issues: transferring, backing up, converting files, tweaking printer profiles, replacing ink cartridges, making test prints, sharpening, cleaning, curve-adjusting files, dealing with driver issues, and calibrating scanners, to mention only a few complex issues. What digital imagemakers need to remember is that these same issues and arguments were made about color photography a generation ago. During the first few decades of chromogenic color photography the materials and equipment were out of the reach of most photographers, making them dependent upon technicians in commercial labs to print their images. Major art museums questioned the permanence and artistic merit of color photographs. The Museum of Modern Art in New York, for example, refused to add color images to its photography collection until 1976, when it granted its first solo color photography exhibition to William Eggleston (see Chapter 2). At that time, many in the art establishment considered color photography to be the realm of tacky advertising and family snapshots. Photographers themselves were some of the harshest critics of color photography. Walker Evans called color photography "vulgar," and Robert Frank claimed: "black-and-white are the colors of photography."

In the coming years, artistic, economic, and environmental pressures, along with changing audience expectations will relegate silver-based photography to the status of being an alternative process. Digital has made it perfectly clear that photographs are but raw ingredients for an endless cycle of variation. However, as digital tools advance they can also help photographers return to the essence of photography by providing them with simpler means for "correcting," as opposed to altering, the content of their vision. As the quality and variety of digital images expand,

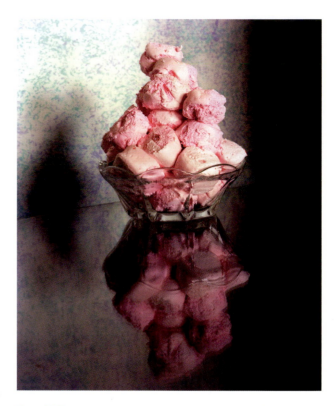

Figure 11.37 Rebecca Sittler makes her photographs on 4 × 5-inch film, which she scans and then digitally corrects. A traditional darkroom printer, she now utilizes a hybrid combination of analog and digital processes to preserve her dialogue with light in order to produce high-quality prints. Sittler explains, "The domestic interior, with its potential for subtle observations of light passing through and around everyday spaces, provides a stage for this object-based performance. As the light changes, I alter the subjects physically, change their spatial relationships, or give them personalities within a suggested narrative. The resulting image evokes a sense of play that engages references from still-life traditions in both painting and photography while encouraging viewer participation in the construction of meaning."

© Rebecca Sittler. *Divinity*, from the series *A Spectacle and Nothing Strange*, 2005. 51 × 41 inches. Chromogenic color print.

photographers will find new applications in art, business, and science, creating new pathways for the digital image to travel and making it an even more ubiquitous part of daily life.

RESOURCES

Evening, Martin. *The Adobe Photoshop Lightroom 3 Book: The Complete Guide for Photographers.* Berkeley, CA: Peachpit Press, 2010.

Freedman, Michael. *The Complete Guide to Digital Photography*, 4th edn. London: Sterling Publications, 2008.

Grey, Tim. *Color Confidence: The Digital Photographer's Guide to Color Management,* 2nd edn. Hoboken, NJ: Wiley Publications, 2006.

Long, Ben. *Complete Digital Photography*, 3rd edn. Hingham, MA: Charles River Media, 2009.

Mitchell, William J. *The Reconfigured Eye: Visual Truth in the Post-Photographic Era*. Cambridge, MA: MIT Press, 1992.

Evening, Martin. *Adobe Photoshop CS5 for Photographers: A professional image editor's guide to the creative use of Photoshop for the Macintosh and PC*. Boston, MA and Oxford: Focal Press, 2010.

Spalter, Anne Morgan. *The Computer in the Visual Arts*. Reading, MA: Addison–Wesley, 1999.

Tapp, Eddie. *Practical Color Management: Eddie Tapp on Digital Photography*. Sebastopol, CA: O'Reilly Digital Media, 2006.

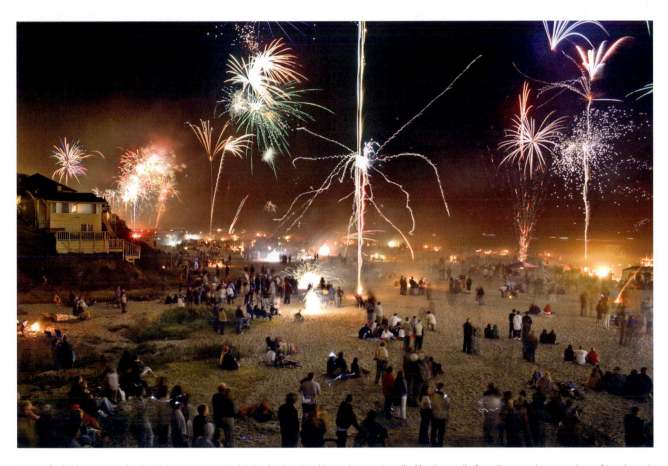

Known for his humorous, visual social commentary, Ted Orland quips, "Nothing quite says Amerika like the smell of marijuana and gunpowder wafting through the night air—and Santa Cruz, CA, is the ideal spot to commemorate that libertarian spirit." To extend the picture time, the photographer placed his Holga camera on a tripod and then made numerous ten-second exposures over a span of about fifteen minutes from the same vantage point. He scanned the resulting negatives, assembled them in Photoshop, and digitally outputted the results. Orland says, "Building an image in this manner is only feasible if you're working digitally—if you were using film, it would be utterly impossible to register the fifteen overlapping images accurately."
© Ted Orland. *Fourth of July Fireworks, Santa Cruz, CA*, 2005. 19 × 36 inches. Inkjet print.

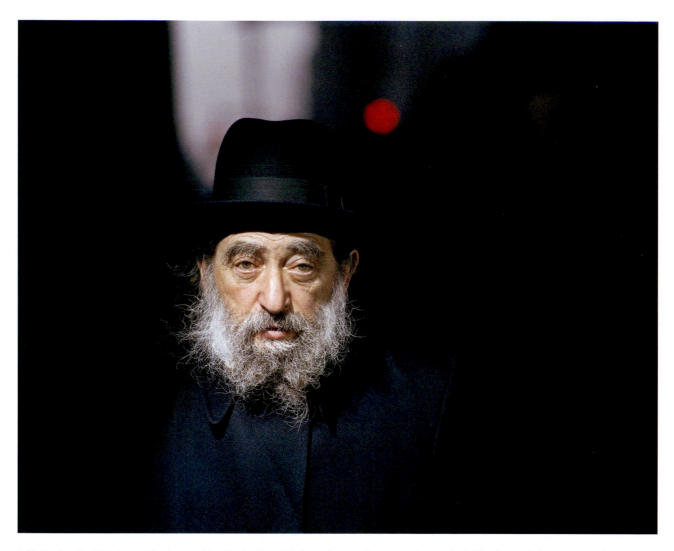

In his *Heads* series, Philip-Lorca diCorcia reconsiders the classic, straightforward approach to street photography by blending semi-documentary and semi-manipulated methodologies. To make this picture, the artist set up lights under scaffolding on a New York City sidewalk with a trip light. When passersby stepped onto the designated spot, an exposure was made. The bright, concentrated light imparts a divine light that is suggestive of religious paintings. This tactic also eliminates the background and focuses viewer attention directly on the face against a dark ground. This combination of chance and deliberate composition reveals intriguing interpersonal relationships and moments of introspection within the randomness of daily life.

© Philip-Lorca diCorcia. *Head #13*, 2001. 48 × 60 inches. Chromogenic color print. Courtesy of the artist and David Zwirner, New York, NY.

Analog Output: Color Printing

Basic Equipment and Ideas for Color Printing

Some people believe that color printing is difficult, but if you can make a successful black-and-white print, you can do the same in color. However, there are some differences between working in color and black-and-white that you need to know. The methods presented here are designed to teach the basic concepts and techniques needed to make a chemical-based color print with a minimum of equipment.

Enlargers

There are three basic types of enlargers used to make chemical color prints: condenser, diffusion, and digital.

Condenser Enlarger

A condenser enlarger uses one or more condenser lenses to direct the light from the lamphouse into parallel rays as it goes through the negative. This type is widely used in black-and-white printing because of its ability to produce greater apparent sharpness and because it matches the standard black-and-white contrast grades of paper extremely well. Condenser enlargers are easily adapted to make color prints using color printing filters.

Diffusion Enlarger

In a diffusion enlarger, which is commonly employed in making color prints, the light is mixed in a diffusing chamber. With this type of enlarger the light is traveling in many directions (diffused) as it reaches the negative. The diffusion process ensures the proper mixing of the filtered light, offers a contrast suitable for color printing, makes defects in the negative less noticeable,

Figure 12.1 Working in the straightforward fashion of a studio photographer, Andres Serrano looks closely at subjects most people would prefer to ignore, thereby confronting our anxiety concerning scopophobia, the fear of being looked at or of being seen. Serrano is not interested in transcending his literal subject matter. Rather, his images are about what he photographs, and any allegorical capacity hinges on the significance of what is before the lens. He favors the dye-destruction process because it is "particularly well suited for such colors as reds and yellows, which coincidentally have figured prominently in my work."

© Andres Serrano. *The Morgue (Infectious Pneumonia)*, 1992. 49½ × 60 inches. Dye-destruction print with silicone, Plexiglas, and wood frame. Courtesy of Paula Cooper Gallery, New York, NY.

and softens the final print. There are black-and-white and color diffusion enlarger light sources.

Both condenser and diffusion heads offer advantages and disadvantages. When the opportunity presents itself, try each type, compare, and see which characteristics you favor and when one type may be more advantageous than the other.

Digital Enlargers and Digital Print Heads

A true digital enlarger relies on a "digitized" negative that can be sized, exposed, and processed on conventional color chromogenic paper. Film is scanned by the enlarger and then can be corrected for color, density, contrast, sharpness, and exposure. Dust and scratches can also be corrected using imaging software. Then the images are digitally sized and exposed onto conventional photographic paper using red, green, and blue lasers. Images can also be entered into the enlarger via a disk or a camera memory card. Due to equipment cost, training, and maintenance, these enlargers generally are available only at professional labs. They provide a bridge between the chemical and digital processes and are excellent in terms of repeatability and for making large-scale prints. Additionally, there are enlargers that have only a digital print head, which exposes images onto color photographic paper.

Dichroic Systems for Printing Color

The preferred color enlarging system is the dichroic colorhead, which is a self-contained diffusion system containing adjustable cyan, magenta, and yellow filters, a color-corrected, high-intensity light source balanced for color papers, a light-mixing chamber, a UV (ultraviolet) filter, heat-absorbing glass, and a white-light switch (Figure 12.2). Collectively, the filters are known as the color pack. They are used to adjust the color of the white light during printing in order to properly color balance the print. This colorhead normally contains three filters (cyan, magenta, and yellow) made with metalized dyes. These enable the printer to work more accurately. The dichroic head also enables you to make moderate changes in the filter pack without affecting the printing time. Most modern dichroic systems are in diffusion-type enlargers. Black-and-white printing can be done on any color enlarger by dialing the filter setting to zero.

Converting Black-and-White Enlargers

Many black-and-white enlargers can be converted to color by replacing the black-and-white head with a dichroic head. A less expensive method is to use CP and CC filters.

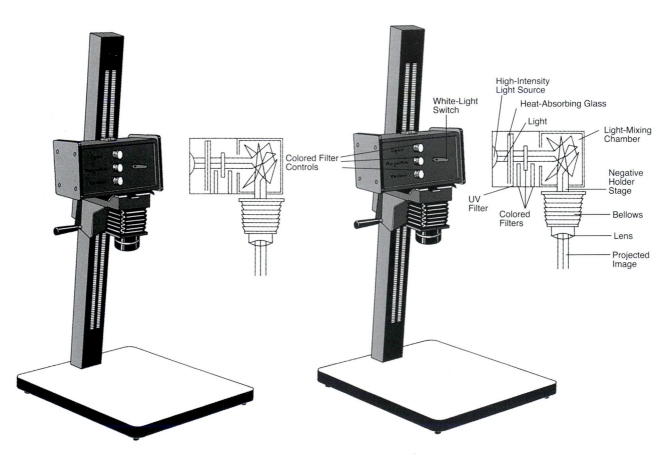

Figure 12.2 A composite dichroic diffusion color enlarger is a self-contained system that features separate colored filter controls, a color-corrected high-intensity light source, a UV filter, heat-absorbing glass, and a white-light switch.

The Filter

CP Filters

CP (color print) filters can be used with enlargers that contain a filter drawer. The CP filters change the color of the light before it reaches the negative. They are only available in the subtractive primary colors and are not as optically pure as the CC filters, but they do cost less. The major advantage of the CP filters is they go above the lens, eliminating the focus and distortion problems associated with CC filters, which are located below the lens. A UV filter and heat-absorbing glass are needed with both CC and CP filters to protect the film and shield the paper from UV exposure. Both filters can be used with either condenser- or diffusion-type enlargers but not with a cold-light enlarging head. The cold-light system uses coils or grids of gas-filled glass tubing that produce a colored light which is not suitable for color printing.

CC Filters

CC (color correction) filters are optically pure gelatin acetate filters that are placed in a filter holder under the enlarging lens. CC filters are available in both additive and subtractive colors and in a wide range of densities. CC filters change the light after the image has been focused, which can cause problems in loss of image contrast, distortion of the picture, and a reduction in overall sharpness. Economical use of filters (e.g., one CC20 filter, not four CC05 filters) helps to alleviate these problems. Wear thin cotton gloves when handling these filters to prevent the filters from getting dirty and scratched. Avoid leaving the enlarger light on when it is not needed, because prolonged exposure to light causes the filters to fade. The use of CP filters under the lens is not recommended because they will likely overly diffuse the image.

The disadvantages of using nondichroic filters include the need to recalculate your exposure after changing filters and their susceptibility to scratching and fading.

The Voltage Stabilizer

Regardless of the type of enlarger or filter system, a voltage stabilizer (Figure 12.3) is needed. Some of the dichroic systems have a voltage stabilizer built in. Any changes in the voltage to the enlarger during exposure produce changes in the color balance. To reduce the likelihood of this occurring and to obtain consistent results, a voltage stabilizer is connected between the timer and the power outlet.

The Enlarging Lens

Use the best enlarging lens you can afford. Inexpensive lenses, with four or fewer elements, may not produce a flat field of focus, thus making it impossible to get both the center and edges of the image sharp. They also may not be accurately color-corrected. Poorly made lenses can produce spherical aberrations, which lower image definition and cause focus shift. This causes a loss of image sharpness when the lens f-stop is changed from wide open (during focusing) to its stopped-down position (for exposure). High-quality lenses have six or more elements and are better corrected for color. The best are labeled APO (apochromatic). Make sure the lens is clean and there is no light flare from light leaks around the enlarger. Most enlarging lenses provide optimum sharpness when stopped down two to three f-stops from their maximum aperture (f/8 or f/11).

The Easel

Most easels are painted yellow by the manufacturer, which works well for black-and-white printing because the yellow color reflected onto the paper during exposure does not affect it. This is not the case with some color papers, which can be sensitive to the reflected yellow light; the papers can be fogged by it. However, papers with opaque backings, such as Ilfochrome Classic, are not affected by reflected color. The problem of paper being fogged by a yellow easel can be solved by spray painting the easel baseboard with a flat-black enamel or covering it with opaque paper.

The Safelight

The standard OC black-and-white safelight fogs chromogenic color paper, so a #13 filter is used in the safelight when printing

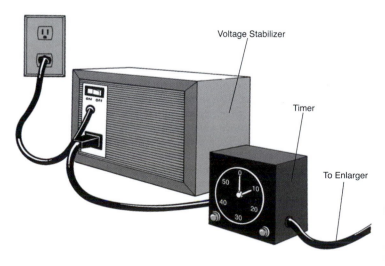

Voltage Stabilizer

Timer

To Enlarger

Figure 12.3 A voltage stabilizer is needed when making color prints because power fluctuations during exposure may produce changes in the color of the light source. This may cause changes in the color balance of the print, making corrections and consistency difficult to achieve.

#13 Amber
Safelight

Opaque piece of paper that acts as an
aperture control device for the penlight.

Figure 12.4 Because color paper is sensitive to a wider range of wave-
lengths of light than black-and-white paper, it requires a different safelight
in order not to fog the paper. A small pocket-style flashlight, with an
opaque piece of paper wrapped around it to act as an aperture control, can
provide additional light for setting up at the enlarging station.

from negatives (transparencies are printed in total darkness with-
out a safelight). The #13 filter can be used with any type of
safelight that has a screw- or slide-in filter slot. The LED (light-
emitting diode) color safelights provide even more light. Since
color paper is sensitive to all colors of light, safelight handling
should be kept to a minimum; it is possible to fog your paper
even under a #13 filter. Safelight fog first appears as a cyan stain
in the white borders and highlight areas of the print.

A small pocket flashlight with an opaque paper shade is a
great help in getting about and setting things up at your work
station (Figure 12.4). For a modest investment, there are mini-
battery-powered safelights that can be worn around the neck.

Multiple station darkrooms are places of collective activ-
ity and require responsible behavior to protect the efforts of all
concerned. As color materials are extremely sensitive to light, it
is necessary to exercise care when pointing a flashlight or turn-
ing on any white-light source in the darkroom. Do not turn on
the enlarger light if the head is raised. If an individual darkroom
is available, printing can be done in total darkness when a #13
filter is not available and the paper can be processed in a drum
under full illumination.

Ambient Light

Color paper has a broader spectral sensitivity than black-and-
white paper, thus it is more prone to fogging and color shifts
caused by ambient light. Ideally, the walls and ceiling around the
color enlarger should be a matte black. Ambient light may come
from such sources as light leaks in the enlarger negative stage,

illuminated timers having both digital and luminous readouts,
electrical devices with red "on" lights and/or illuminated dials,
and reflections from shiny apparel and/or other darkroom
equipment, including burning and dodging tools. Illuminated
digital devices, such as cellphones and iPods, can also produce
color shifts and fogging in color materials.

Mask all potential ambient light sources with black felt,
black tape, or opaque weather stripping. Make certain timers are
safe or cover them or turn them away from the easel area. Make
all darkroom tools out of opaque materials.

The Drum Processor

A drum processor (Figure 12.5) rotates with the appropriate
chemicals inside the drum and is the best alternative to an au-
tomatic color print processor. Processing can be carried out in
room light with a minimal amount of chemistry. When using
a processing drum, be sure it is clean and dry. When load-
ing the drum, place the base of the exposed paper against the
wall of the drum, with the emulsion-side curling inward upon
itself. Be certain the lid is secure before turning on the white
light. Process on a flat, even surface covered with a towel for
good traction as the drum rotates with the chemicals inside (see
Figure 12.5). There are different types and styles of drums and
bases available. Check them out and see which you prefer. Use
a drum that rolls easily on a level surface. A motor or roller base
can aid in attaining proper agitation and consistency, which in
turn will make printing easier, simpler, less costly, and more
enjoyable. Drums are available in different sizes starting from
8 × 10 inches. More than one print can be processed at a time
in a drum. Film also can be processed in a drum. Read the man-
ufacturer's suggestions for use, processing times, and amounts
of chemicals. Kodak publications usually refer to the drum as
a tube.

Temperature Control

Temperature control is necessary for most color processes. Being
off by as little as 0.5 °F can cause a change in the color balance.
Check your thermometer against one known to be accurate. A
conventional Weston or high-quality digital thermometer with a
probe can provide an excellent standard of comparison. Correc-
tions can be made if yours is off. If the standard reads 100 °F and
yours says 101 °F, simply process at 101 °F instead of 100 °F based
on your thermometer's reading.

The least expensive method of temperature control is the
water bath (see Chapter 10). Chemicals are put into cold or hot
water until they reach operating temperature. The temperature
must be maintained, which requires constant monitoring. This
method makes accuracy and consistency difficult to maintain.

If possible, purchase a temperature control storage tank, or
make your own using a fish tank heater and a beverage cooler.
The consistency of the results, plus their convenience, offsets
the cost. If you are fortunate enough to work in a lab with an
automatic print processor, it takes care of temperature control,
replenishment rate, and processing.

Bring the chemicals to their operating temperature in their
sealed bottles in a water bath before exposing the paper. Small,

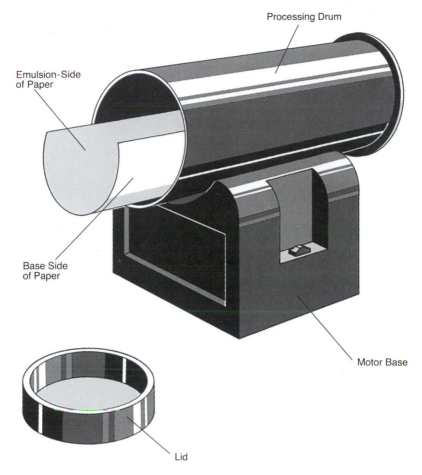

Processing Drum

Emulsion-Side
of Paper

Base Side
of Paper

Motor Base

Lid

Figure 12.5 A processing drum mounted on a motor base is a convenient and inexpensive tool for making color prints. The base of the paper is placed in contact with the interior wall of the drum, with the emulsion-side of the paper curling inward.

clean glass jars make good one-shot chemical containers when using a tabletop drum. Put tape on the side and label a separate jar for each step. Make a mark on the side of the jar to indicate the proper amount of chemical needed for each step. Avoid contamination by always using the same bottles for the same solutions. Have a container ready for proper disposal of chemicals. Check and maintain proper temperature or your results will be chaotic and not repeatable.

Color Printing Notebook

Regardless of the process or method, keep a notebook to record final print information. This establishes a basic starting point that will make it easier to produce a print when a similar situation occurs with a certain type of film. It also makes reprinting quicker. Commonly recorded information is provided in Box 12.1. Making copies of this, perhaps two or three to a page, punching the sheets with a three-hole paper punch, and inserting the copies into a loose-leaf binder can establish a simple but effective color printing notebook.

Box 12.1 **Color Printing Notebook**	
Date:	Type of film used:
Subject or title of print:	Negative number:
Type of paper used:	Enlarger used:
Enlarger lens:	Enlarger height or print size:
f-stop of the lens:	Exposure time:
Yellow filtration:	Magenta filtration:
Cyan filtration:	Burning and dodging instructions:

Each color enlarger has its own time and filtration differences, but the information in your notebook will help you to arrive at a final print with more ease. In a group darkroom, find an enlarger that you like and stick with it. Learn its quirks and characteristics so that you are comfortable working with it.

Safety

Follow the manufacturer's instructions and the guidelines found in Safety Addendum 2. Wear Neoprene gloves, which repel acids and bleach, when handling chemicals. Obtain Material Safety Data Sheets (MSDS) from each manufacturer. Work in a well-ventilated area. Avoid breathing any chemical fumes. If you are sensitive to fumes, wear a protective organic vapor mask. Be proactive and protect yourself.

Principles of Subtractive Printing: The Qualities of White Light

White light is made up of red, green, and blue wavelengths, known as the additive primary colors. The three colors that are produced by mixtures of the paired additive primaries are cyan (blue-green), magenta, and yellow, called the subtractive primary colors. We will work with the subtractive method because it is the most widely used.

Each subtractive primary is the complement of an additive primary and can be made by subtracting its complementary additive primary from white light. Thus, cyan equals white light minus its complement of red, magenta equals white light minus its complement of green, and yellow equals white light minus blue.

When you determine your filter combinations for printing, think of all the filters in terms of the combination of subtractive colors. This means that red equals yellow plus magenta, green equals yellow plus cyan, and blue equals magenta plus cyan.

Additive colors are converted to their subtractive equivalents in the following manner:

10 Red = 10 Magenta + 10 Yellow
20 Red = 20 Magenta + 20 Yellow

Filters of the same color are added and subtracted normally:

10 Magenta + 10 Magenta = 20 Magenta
30 Magenta − 10 Magenta = 20 Magenta

Neutral Density

Whether you work with the dichroic, CC, or CP filters, they all contain cyan, magenta, and yellow. Each of the three subtractive filters blocks out one of the three components of white light—red, green, and blue. If all three filters were used at once, not only would the color balance be changed, but also some of all three would be eliminated. This also builds extra density (gray), which requires extended printing time. This effect is known as neutral density. The same color changes can usually be achieved without affecting the print density by using only two of the subtractive filters.

The general rule for printing color negatives is to use only the magenta and yellow filters. Leave the cyan set at zero. This also eliminates one-third of the filter calculations and makes printing faster and easier. Whenever possible, subtract colors from your filter pack rather than add them. Most printing materials deliver their optimum response with a minimum of filtration.

Figure 12.6 shows what happens as white light is passed through the different subtractive filters.

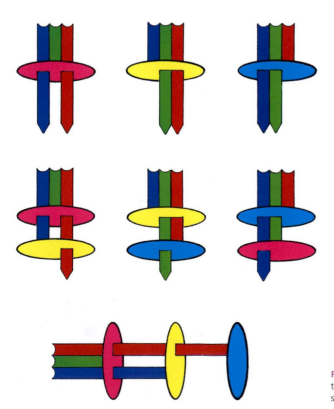

Figure 12.6 A graphic presentation of how white light is affected as it passes through the subtractive primary color filters, illustrating the basic principles of subtractive color printing.

Color Paper Selection

There are fewer choices of color printing papers than black-and-white papers, and none are fiber-based papers. All the regular color materials are resin-coated (RC), with a thin, water-resistant, plastic coating that facilitates rapid processing and drying. Some special-use materials have a heavier polyester base. You will want to experiment, since each manufacturer's paper delivers differences in contrast, color balance, and surface texture. Papers come in glossy, matte, semi-matte (also known as luster or pearl), and textured finishes. The glossy surface is highly reflective and gives the impression of greatest color saturation,

contrast, detail, and sharpness. It also reveals any surface defects, especially fingerprints.

Color papers are generally available in only a limited range of contrasts. Typically there is an all-purpose version for general use, a lower-contrast paper for portrait work, and a slightly higher-contrast version. The difference in contrast is equal to only about half a grade of black-and-white paper-contrast. No variable-contrast papers are available, so contrast is most easily controlled by the initial exposure of the film and its subsequent developing time (see Addendum 3). Papers are compatible with both optical and digital printing devices.

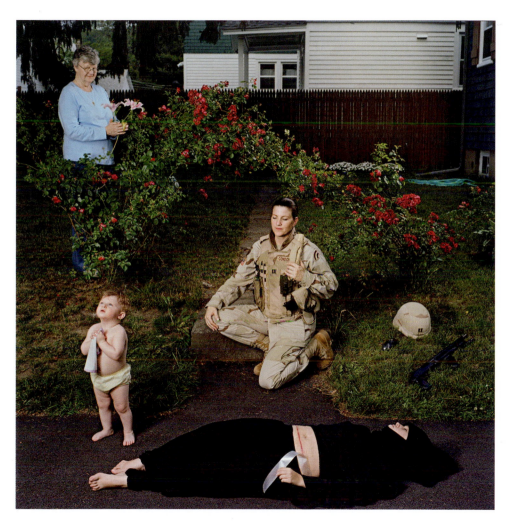

Figure 12.7 Reading about numerous instances of combat stress and post-traumatic stress disorder among American soldiers returning from Iraq and Afghanistan prompted Jennifer Karady to embark on this project. In an interview with Chuck Mobley at SF Camerawork, the artist explained, "I work with real people to dramatize their stories through both literal depiction and metaphorical and allegorical means. Though photographers and artists have depicted physically injured veterans, my project seeks to portray invisible war wounds through narrative means. Formally, the intrusion of the past into the present reality is suggested through use of hyperreal lighting and color, surreal juxtapositions, and mannered poses and gestures; the role of the family members in the veteran's story are evoked through careful composition, spatial relationships, and symbolic actions. Often, the precise location is chosen to convey a specific aspect of the veteran's story metaphorically."

© Jennifer Karady. *Captain Elizabeth A. Condon, New York Army National Guard, Veteran of Operation Iraqi Freedom, with Daughter, Kate, and Mother, Elizabeth, Troy, NY,* from the series *Soldiers' Stories from Iraq and Afghanistan,* June 2008. 48 × 48 inches. Chromogenic color print.

Paper Handling

Handle the paper by its corners and from the base side with clean, dry hands. Touching the emulsion will leave a fingerprint good enough for Homeland Security to identify you. If problems continue with fingerprints, get a pair of thin cotton gloves to wear when handling the paper. Be sure to wash and/or replace the gloves regularly.

Determining the Emulsion-Side of the Paper

In total darkness, it can be difficult to determine which is the emulsion-side of the paper. Here are some ways to tell which side is the emulsion and which is the base:

- The emulsion-side of the paper looks dark bluish-gray under the safelight.
- The paper generally curls in the direction of the emulsion.
- Most paper is packed emulsion-side up in the box. Packaging may include a piece of cardboard, which will be facing the emulsion side of the paper.
- Use the glow from a luminous timer dial or a strip of luminous tape on the darkroom wall to determine whether a side of the paper reflects light. If it does, this is the non-emulsion side. This test will not fog the paper.
- Slightly moisten your thumb and index finger, and then grip the one small corner of the paper. The side that sticks to a finger is the emulsion-side.
- If all else fails, cut an edge from a piece of the paper and look at it under white light to determine the emulsion-side.

- If the paper looks white under the enlarging light, you have probably printed on the wrong side; throw it away and start again. Printing and processing through the wrong side of the paper results in a fuzzy, reversed image with an overall cyan cast.

Changes in Paper Emulsion

Each batch of color paper has different characteristics that affect the exposure and filtration. Because of this, the paper is given an emulsion number that is sometimes printed on the package. Each time the emulsion number changes it usually is necessary to make adjustments to your exposure and filter information. To avoid these problems, buy paper in as large a quantity as is affordable. It is more convenient and economical to purchase a 100-sheet box of paper than four 25-sheet packages that may have been made at four different times.

Storage

Color paper keeps better when refrigerated. It can be frozen if you do not expect to use it for some time. Allow enough time for the paper to reach room temperature before printing or inconsistency will result. It takes a 100-sheet box of 8 × 10-inch paper about 3 hours to warm up.

Check the expiration date on the paper box before buying. Purchase paper from a source that regularly turns over its stock. With a permanent marker, write on the box the date that you acquired the paper. Most properly stored paper lasts at least 12 to 18 months after opening. Keep paper away from high temperature and humidity. Chromogenic color paper that has started to deteriorate will produce ivory borders instead of white.

Box 12.2 General Printing Procedures

Take your time. Do not worry about making mistakes. It is part of the learning process.

1. Select a properly composed and exposed negative.

2. Clean the negative carefully. Use film cleaner and soft, lint-free paper products such as Pec*Pad photo wipes. If there are problems with dust or static, use an antistatic brush or device, such as a Zerostat antistatic gun, which is sold in music stores. The static pistol and a good sable brush will get the job done and eliminate unnecessary spotting of the print later. Using canned air may create more problems than it solves. The propellant may fly out onto the negative, making a bigger mess than was already there. If you use canned air, carefully follow the manufacturer's working guidelines. Use a product that is environmentally safe, containing no chlorofluorocarbons.
 If the film has been improperly processed or handled and is noticeably scratched, apply a liquid no-scratch substance such as Edwal No-Scratch. Clean the negative and paint No-Scratch on the entire non-emulsion side. If the negative is badly scratched, paint it on both sides. This treatment diffuses the image slightly. After printing, be sure to remove all the No-Scratch with film cleaner and lint-free wipes. If you lose the little brushes that come with the No-Scratch, cotton swabs are an excellent substitute.

3. Turn on the power to the enlarger.

4. Remove all filters from the light path. Many dichroic enlargers have a white light switch that will do this automatically.

5. Open the enlarging lens to its maximum aperture. Having as much white light as possible eases composing and focusing, which has to be done through the orange mask of the negative film.

6. Set the enlarger height, insert the negative carrier, and focus using a focusing aid. Have a piece of scrap printing paper at least the same size and thickness as the print in the easel to focus on. This makes composing possible on a black easel and ensures the print will have maximum sharpness.

7. Place the starting filter pack, based on past experience or the manufacturer's suggestion, into the enlarger. If you forget to put the filters back into the enlarger after focusing and then print with white light, the print will have an overall reddish-orange cast.

Box 12.2 General Printing Procedures—cont'd

8. Set aperture at f/5.6.

9. Set timer for 10 seconds.

10. Place the unexposed paper, emulsion-side up, in the easel.

11. Have an opaque sheet of cardboard that is at least the same size as the printing paper. Cut away one-quarter of it. It should look like an oversized L (Figure 12.9). Place it firmly on top of your printing paper. This one-quarter is now ready to be exposed.

12. Expose this first quadrant at f/5.6 for 10 seconds.

13. Move the cardboard L to uncover a different quadrant while covering the one that was just exposed. Stop the lens down to f/8 and expose for 10 seconds.

14. Repeat this process two more times until you have exposed each of the four quadrants one time at a different aperture for 10 seconds. Upon finishing this process there will be four different exposures. They will be at f/5.6, f/8, f/11, and f/16, all at 10 seconds, which is the ideal exposure time for a color negative.

 Any setting within the 8- to 20-second range is fine. Color paper can suffer reciprocity failure during extremely short or long exposure times. Whenever possible, adjust the aperture so that the exposure time is as close to 10 seconds as possible, to avoid color shifts due to reciprocity failure. Changes in the number of seconds used for the exposure are more likely to produce shifts in color than changes made by using the aperture. Some timers are inaccurate at brief exposures. If there appear to be inconsistent exposures, check the timer against one that is known to be true.

15. Follow the instructions for whichever process you are working with. The current standard is Kodak's RA-4.

16. Dry and evaluate. When drum processing, a handheld blow dryer speeds drying of test prints but can leave drying marks. If this is a problem, air-dry the final print by hanging it from one corner on a wire line in a clean, dust-free area. Do not try to determine any accurate information about the print until it is completely dry. Color balance is not correct while a print is wet. It usually has an overall blue cast and the density appears darker until after it is dried. There are a number of common problems that occur in the processing of prints. The troubleshooting guide (Table 12.1) and the manufacturer's instructions can help solve these difficulties. The Kodak RA-4 process (Table 12.2) provides a standard by which you can compare the other negative-to-print processes in a drum processor. Many institutions have small print processors that may operate with different chemicals, times, and temperatures. The automatic print processors offer ease and reliability by providing constant processing times, temperatures, and replenishment rates. Whatever the process, be consistent so that repeatable results are achieved. It is necessary to have clean working conditions or you run the risk of contaminating the chemistry.

TABLE 12.1 TROUBLESHOOTING PRINTS FROM NEGATIVES

Problem	Possible Cause
Unrealistic color	Incorrect filter pack
Overall red-orange cast	Exposure with white light
Reddish fingerprints	Emulsion touched prior to processing
Light crescents	Paper kinked during handling
Very light print	Emulsion facing wrong way in drum
Light and dark streaks	Pre-wet not used
	Not enough agitation in developer
	Drum not on level surface
	Paper stuck in machine rollers
Light streaks or stains in paper feed direction	Paper feed tray damp
Blue or magenta streaks	Stop bath is not working
Pink streaks	Water on print prior to processing
Red streaks	Lack of pre-wet
Bluish-appearing blacks	Developer is too diluted
	Developer time is too short
	Not enough drain time after pre-wet

(Continued)

TABLE 12.1 TROUBLESHOOTING PRINTS FROM NEGATIVES—cont'd	
Problem	**Possible Cause**
Black specks and marks	Tar buildup in developer
Cyan stain	Dirty drum
	Developer contaminated by bleach-fix
	Paper fogged by safelight
Overall reddish cast	Developer heavily contaminated by bleach-fix
Pinkish highlights	Developer temperature too high
Yellow-greenish highlights	Presoak too hot
Dark specks or spots	Rust in the water supply
Lack of contrast	Developer temperature is too low
	Developer is too diluted
	Development time is too short
	Lack of agitation
	Not enough developer solution
	Developer is exhausted
	Chemicals outdated
Cream-colored borders	Developer temperature too high
	Development time too long
	Improper mixing of developer
Bluish magenta stain	Stop bath exhausted
	Wash rate is too slow
Grayish-purple metallic haze	Bleach-fix exhausted
Scratches to print emulsion	Paper put into processor emulsion-side up
Ivory-colored print borders	Paper has expired

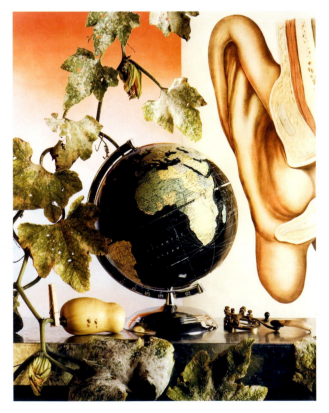

Figure 12.8 Using a 4 × 5-inch camera and straight negative printing methods, Jo Whaley blends the languages of photography and painting to evoke a theatrical state between the imaginary and the real. Under the guise of the still-life genre, Whaley's *Natura Morta* (Dead Nature) series reflects the anxieties that exist between our civilization and the natural world. Whaley states, "Through Western art historical references and the juxtaposition of the beautiful and the unexpectedly morbid, or the serious and the whimsical, the work explores the ironic tensions between these two worlds and the time bomb inherent in that conflict."

© Jo Whaley. *Within Earshot of the Foreshadow*, 1994. 20 × 24 inches. Chromogenic color print. Courtesy of Photo-Eye Gallery, Santa Fe, NM.

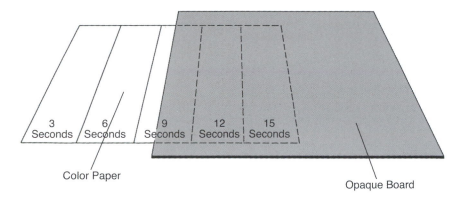

Figure 12.10 Some people do not like the oversized L method for determining exposure for a contact print and instead use an opaque piece of board to block the light. In this method, like in black-and-white printing, the exposure time is varied while the f-stop remains unchanged. Once exposure is calculated, it is adjusted to be in the 10-second range. Any additional exposure changes are made by adjusting the f-stop.

Box 12.3 Contact Print Steps

1. Place a neatly trimmed strip of paper, emulsion-side up, under the enlarger. Make sure the enlarger is high enough that the beam of light will completely cover the paper of the full contact print evenly. If you are using a color print processor, be sure the paper is big enough to go through the machine's rollers without jamming. When making an 8 × 10-inch contact print set the enlarger to the proper height used to make an 8 × 10-inch print. This will give a closer idea of the actual enlarging time for the finished print.

2. Place the film emulsion-side down on top of the paper. Cover with a clean, scratch-free piece of glass or use a contact printing frame. If safelight conditions are dim or nonexistent, leave the negatives in their protective sleeves. Check the protective sleeves to make certain they do not affect the clarity and color balance of the contact print, or the filter information from the contact may not be correct when it is applied to making the final print.

3. Set the starting filter pack (based on filtration determined from previous experience, manufacturer's guidelines, or standard test negative). If you have no previous information, use 40M and 50Y as a starting point.

4. The oversized L can be used to determine correct exposure, following the method previously outlined, in making the

print. Some people do not like using the stout L for contact prints. Instead, a piece of cardboard is used to block the light. Move it across the paper to create six separate narrow bands of exposure increments, as in black-and-white printing (see Figure 12.9). Try exposing at f/8 in 3-second increments (3, 6, 9, 12, 15, and 18 seconds). If the entire test is too light, open the lens to f/5.6. If it is too dark, stop the lens down to f/11 and repeat the procedure.

5. Process, dry, and evaluate.

6. Pick the area that has the best overall density. To avoid the color shifts of reciprocity failure, recalibrate the time so it is in the 10-second exposure range. For example, if the best time was f/8 at 6 seconds, adjust the exposure to f/11 at 12 seconds. Make any changes in the filter pack based on the information obtained in the area of best density. Try to maintain exposure times in the 8- to 20-second range.

7. Make a new contact print of the entire roll based on these changes.

8. Process, dry, and evaluate.

guiding mantra is whatever color you see on the sheet is the color you add to the filter pack. If the selection looks too magenta on the contact print, add more magenta before making the first test. This step begins the process of making that perfect print even more rapidly. In general, the information obtained from an 8 × 10-inch contact print (exposure and filtration) can be transferred as a starting place for the creation of the 8 × 10-inch enlargement. If you decide the ideal exposure is f/8 at 10 seconds with a filter pack of 40M and 50Y, then apply that to make your print. Standardizing film and processing will keep printing variations to a minimum, often within 5 units.

Print Evaluation

People often ask about the correct type of light for evaluating prints. The answer is: That depends. A print may be deemed color correct in normal daylight conditions, but when displayed under artificial light, the color balance may not appear acceptable. For the most accurate results, the print should be examined under lighting conditions similar to those that the finished print will be viewed under, which are often mixed light conditions. For prints to be viewed under average daylight conditions, a print viewing area can be constructed that has two 4-foot 5500 K

TABLE 12.2	KODAK RA-4 DRUM PROCESSING: EKTACOLOR RA-4 DRUM PROCESSING STEPS AT 95 °F	
Processing step	**Time[a] (min:sec)**	**Temperature (°F)**
Pre-wet	0:30 ± 0:05	95 ± 2
Developer	0:45[b]	95 ± 0.5
Stop	0:30 ± 0:05	95 ± 2
Wash	0:30 ± 0:05	95 ± 2
Bleach-fx[c]	0:45[b]	95 ± 2
Wash[d]	1:30[e]	95 ± 2
Dry	As needed	Not over 205

[a]Each step includes a 10-second drain time.
[b]Changes in time of 1 second less or 5 seconds more than normal may produce color shifts.
[c]After bleach-fix, paper can be handled under room light.
[d]When possible, remove print from drum and wash in a tray or print washer with a continuous water flow that provides a complete change of water at least every 30 seconds.
[e]Longer wash times are acceptable and even desirable to remove unwanted chemicals.

Making a Contact Print

Making a contact print is recommended because the orange mask of color negative film makes "reading" color negatives difficult. The contact print provides one with the opportunity to see the negative in a print form. Examine your contact sheet and determine which negatives worked well and what needs aesthetic and/or technical improvement. You can see things that you may have missed when examining the negative, and it can point the direction toward the pursuit of a new idea or improvement of a technique.

Photographer Richard Avedon said: "I learned from [Alexey] Brodovitch to learn from myself, from my accidents and dreams. Your next step is most often in your false step: Never throw away your contacts. The photographs you took when you were not thinking about taking photographs—let them be your guide."[1]

Reading the Contact Sheet/Determining Correct Exposure

Making a good contact sheet is important; the information it contains will assist in selecting the best images to print. The

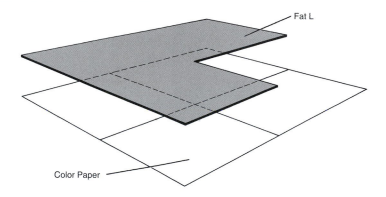

Fat L is moved so that each quarter of the paper is uncovered for its own separate exposure.

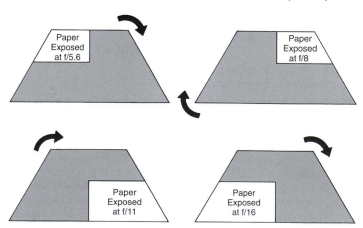

Figure 12.9 The oversized L is used to find the proper exposure of color paper. Each quarter of the paper is exposed using a different f-stop with the same exposure time for all four exposures. Changes in the amount of exposure time may cause changes in the color balance.

1. Make sure the paper is completely dry. Is the exposure correct? First determine the best overall density because changes in it will affect the final color balance. It is troublesome to determine correct color balance in a print that is over- or underexposed. The ideal exposure is determined by being able to distinctly discern the edge of the film from the black of the paper. Also, look carefully at sensitive areas such as facial and neutral tones. This helps to determine which exposure will give proper treatment for what you have in mind. Disregard extreme highlights and shadow areas; these will need burning in or dodging. Underexposure makes areas of light tones lose detail and appear white. Overexposure of light tones produces unwanted density, a loss of color separation, and an overall grayish look.

2. After deciding what is the best density, determine which color is in excess. It is easier to see the incorrect color in a middle-tone area. If there is a face in the picture, often the whites of the eyes are a key spot one can examine to make this determination. Avoid basing the color balance on shadow areas, extreme highlights, and highly saturated colors.

3. The most effective way to tell which color is in excess is by using a color print viewing filter kit such as the one made by Lee Filters (see Figure 12.12). One side of the filter set is designed for negative printing and the other side for positive (slide) printing. Use the appropriate side.

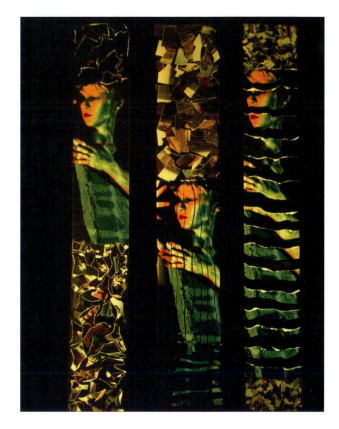

Figure 12.11 Joyce Roetter slide-projected an image onto the model and photographed the image. She then made prints from the slide film, which she processed in C-41 chemicals. Roetter collaged the prints onto clear acrylic with a matte gel and used a sharp object to scratch patterns directly into the emulsion of the prints.

© Joyce Roetter. *Split Triptych*, 1990. 1 × 8 feet each. Chromogenic color prints on acrylic. Courtesy of Caruso-Whittman Collection, Los Angeles, CA.

full-spectrum fluorescent lamps about 4–5 feet from the viewing surface. When printing for gallery viewing, 3200–3400 K bulbs can be used instead.

Methods for Using Viewing Filters

There are a number of different ways to use viewing filters. One or a combination of the following methods should be helpful in determining the color balance of the print.

Filters Next to the Print

Under lighting conditions similar to those under which the final print will be seen, place a piece of white paper next to the area of the print to be examined. The filters are available in six colors: magenta, red, and yellow (the warm colors) and blue, cyan, and green (the cool colors). Deciding if the print is too warm or too cool can immediately eliminate half of these filters. Then glance rapidly back and forth between the key area and the white piece of paper to see if the color in excess can be determined.

The white paper is a constant to avoid color memory (see section on color memory in Chapter 1). If this does not work, take the green filter and place it on the white paper at a 45-degree angle so that the light passes through the green filter and strikes the white paper, giving it a green cast. Glance rapidly back and forth between the color that the filter casts onto the white paper and the key area being examined in the print in order to see if the color cast matches. If it does, the excess color is green. If it does not, follow the same procedure with the blue filter. If the blue does not match, try the cyan. If there is a problem deciding between green and blue, it is probably neither. It is most likely cyan, the combination of blue and green light. Printing experience has shown that cyan is in excess more than either blue or green. Notice if one color appears regularly in excess in your printing, and be on the lookout for it.

Now use the viewing filter to determine the amount of excess color by judging which of the three filter strengths the color cast comes closest to. Is the excess slight (a 5-unit viewing filter), moderate (10 units), or considerable (20 units)? If the change is moderate, requiring a 10-unit viewing filter, make a 10-point correction in the filter pack.

The dichroic head makes it possible to fine-tune a print with small changes in the filtration of two or three points. With the head, moderate changes in filtration of 10 to 20 units generally will not affect the print density. When working with CC and CP filters, compensate for changes in filtration by adjusting

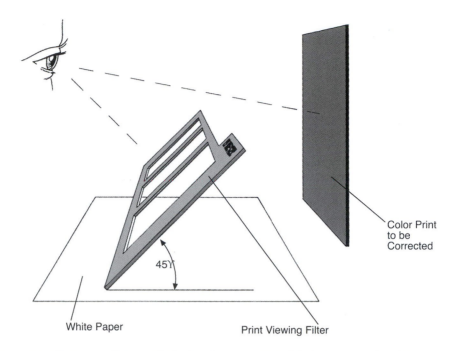

Figure 12.12 Colored print-viewing filters are an effective method to learn how to recognize all the basic colors used in color printing and may be employed to make visual corrections of color prints. The correction method shown here demonstrates one technique for determining which color is in excess. Be certain the light striking the correction filter and the print is of equal intensity and quality.

the exposure time. An increase in filtration requires an increase in exposure to maintain proper print density. Use the manufacturer's suggestions until experience is gained.

Filters over the Print

Another method of making filter corrections with color print viewing filters involves looking at the print through the filter that is the complement (opposite) of the color that is in excess. To use this method, flick the filter over the print and look through it at the key examination area. Keep the filters about 6 inches from the print surface. Do not put your eye directly against the filter because it will adapt to that color. Do not let the light that is illuminating the print pass through the filter on its way to the print. Whichever filter and density combination neutralizes the excess color and makes the print appear normal is the combination on which to base the corrections. If the print looks too blue, it should appear correctly through a yellow filter. Make the determination as rapidly as possible. Do not stare too long because once the brain's color memory takes over it will fool you into thinking the scene is correct (an example of color adaptation). The brain knows how the scene is supposed to look and will attempt to make it look that way, even if it does not. When in doubt, go with your first judgment.

The Color Ring-Around

The color ring-around is a traditional method of color evaluation in which a neutral print is compared to a series of standard selections (Figure 12.14). Its purpose is to promote an understanding of the thought process that goes into making properly exposed and balanced prints, including the effects of the use of additive and subtractive primary colors. The typical ring incorporates

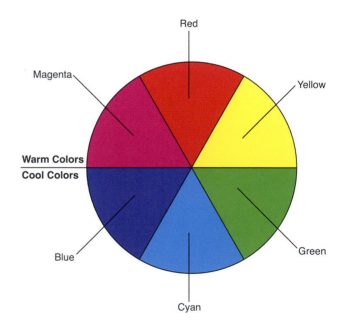

Figure 12.13 The color wheel.

a "correct" print with a series of "incorrect" prints made from the same negative. This includes a perfectly neutral print and prints made with each of the six primary colors in varying degrees of excess color. The ring-around should be printed from one of your typical negatives on your usual paper choice.

Color Ring-Around Procedure

The key to this assignment is to make your "perfect" print and then carefully follow through, applying a high degree of craft to the remaining prints. Set the enlarger height to make a small enlargement (about 3 × 2½ inches) and stop the lens down to about f/11. Determine your perfect exposure (which will remain constant for each image) and color balance. Using a copy of Table 12.3 record your exposure and color balance information in the top two lines (for example: f/11 at 5 seconds with 40 Magenta, 35 Yellow, and 0 Cyan) and then calculate and write your filter changes into the chart. Use that data to expose the prints for your ring (exposure time remains the same for all). For comparison purposes, also make one print with the white light setting. Then, trim and attach the 14 prints to a black, gray, or white mat board. Assemble the wheel in the manner of Figure 12.13, with the complimentary colors opposite each other: Cool colors on one side, warm colors on the other. After attaching them to the board, label each one.

Discover the Method that Works for You

Customarily, the ring-around has been used because it seems to be an empirical way to learn how to tell the differences in color balance. The problem is that, due to the psychological and subjective components of color classification, we do not necessarily learn to recognize color differences in a logical manner. Regardless of methodology, the way to overcome the color learning curve and clarify this process of recognition is to make and evaluate prints. Nothing substitutes for experience and most of us can learn just as rapidly by plunging into printing. Our ability to absorb new information remains high when we continue to print from a variety of stimulating negatives. Ultimately, it makes no difference which method of print evaluation is used. Seeing is a slippery business and we each see things in our own way and time. Experiment with one of the above methods; if it does not work, try another. Discover which suits you. You may even come up with a better way.

Françoise Gilot, the French painter and printmaker, wrote in *Life With Picasso* (1964):

> I had to find my own path toward artistic freedom. This did not mean having less regard for the gods and demigods atop Mount Olympus, but simply recognizing that, each human experience being unique, each artist has the burden and the privilege to bear witness, thus adding something to the wealth of human culture. Since for generations women have been notoriously silent, it was incumbent upon me and my female contemporaries to revel an as-yet-unfathomed side of the planet—the emergence of a sunken continent of thoughts, emotions, and wisdom.

In color printing, each one of us must find our own way.

Changing the Filter Pack

When modifying the filter pack (Figure 12.15) a filter of the same color can be added, although it is more desirable to subtract a complementary filter. The paper responds better to a minimum of filters, which also helps to keep the exposure time in the desired 10-second range. Avoiding extremes of exposure prevents reciprocity failure. In most cases, use only the yellow and magenta filters and leave the cyan set to zero. Do not use all three filters in the pack together; doing so produces unwanted neutral density (gray).

Box 12.5 provides the answers to the six most commonly asked questions in color printing. Memorizing it is helpful because this information is needed every time a change in the filter pack takes place.

Burning and Dodging

Just as in black-and-white printing, burning in—giving the print more exposure—makes it darker, and dodging—giving the print less exposure—makes it lighter. In color printing,

TABLE 12.3 **COLOR RING-AROUND CALCULATIONS**			
Exposure Time	f/____	_____ seconds	
Perfect Color Balance	_____ Y	_____ M	_____ C
White Light Setting	Leave the setting the same and expose using white light.		
Perfect + 10 Red (−10 Y −10 M)	_____ Y	_____ M	_____ C
Perfect + 20 Red (−20 Y −20 M)	_____ Y	_____ M	_____ C
Perfect + 10 Green (+ 10 M)	_____ Y	_____ M	_____ C
Perfect + 20 Green (+ 20 M)	_____ Y	_____ M	_____ C
Perfect + 10 Blue (+ 10 Y)	_____ Y	_____ M	_____ C
Perfect + 20 Blue (+ 20 Y)	_____ Y	_____ M	_____ C
Perfect + 10 Cyan (+ 10 Y +10 M)	_____ Y	_____ M	_____ C
Perfect + 20 Cyan (+ 20 Y +20 M)	_____ Y	_____ M	_____ C
Perfect + 10 Magenta (−10 M)	_____ Y	_____ M	_____ C
Perfect + 20 Magenta (−20 M)	_____ Y	_____ M	_____ C
Perfect + 10 Yellow (−10 Y)	_____ Y	_____ M	_____ C
Perfect + 20 Yellow (−20 Y)	_____ Y	_____ M	_____ C

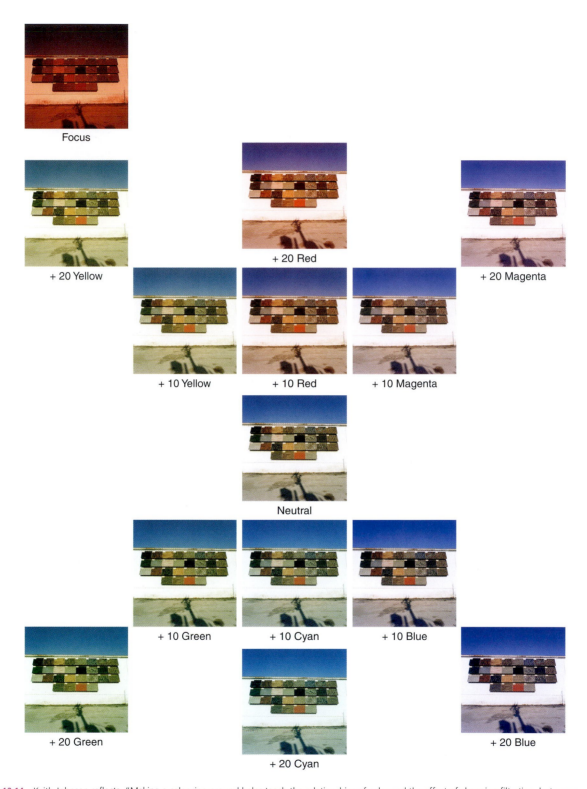

Focus

+ 20 Yellow

+ 20 Red

+ 20 Magenta

+ 10 Yellow

+ 10 Red

+ 10 Magenta

Neutral

+ 10 Green

+ 10 Cyan

+ 10 Blue

+ 20 Green

+ 20 Cyan

+ 20 Blue

Figure 12.14 Keith Johnson reflects, "Making a color ring-around helps teach the relationships of color and the effect of changing filtration, but more importantly, it emphasizes the craft of color printing and presentation. Displaying the completed ring-around in a working area can be useful for students to refer to when color printing because it enables one to see warmer or cooler prints and be able to make informed decisions."

© Keith Johnson. *Avon, NY*. 2000. 7 × 7 inches. Chromogenic color prints.

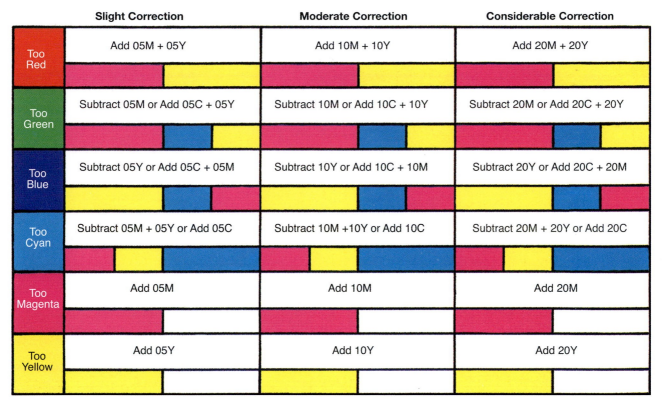

	Slight Correction	Moderate Correction	Considerable Correction
Too Red	Add 05M + 05Y	Add 10M + 10Y	Add 20M + 20Y
Too Green	Subtract 05M or Add 05C + 05Y	Subtract 10M or Add 10C + 10Y	Subtract 20M or Add 20C + 20Y
Too Blue	Subtract 05Y or Add 05C + 05M	Subtract 10Y or Add 10C + 10M	Subtract 20Y or Add 20C + 20M
Too Cyan	Subtract 05M + 05Y or Add 05C	Subtract 10M +10Y or Add 10C	Subtract 20M + 20Y or Add 20C
Too Magenta	Add 05M	Add 10M	Add 20M
Too Yellow	Add 05Y	Add 10Y	Add 20Y

Figure 12.15 The basic rules for making changes in the filter pack. (a) First determine from the color wheel whether the print is a cool or warm color, and then decide which color is in excess. Using the colored print-viewing filters, decide how much correction is needed. (b) The chart is a reference to determine which and how much filtration must be used to make the desired correction.

Box 12.5 **Basic Subtractive Filtering Rules**

- To reduce magenta, add magenta filtration.
- To reduce yellow, add yellow filtration.
- To reduce red, add yellow and magenta filtration.
- To reduce cyan, subtract yellow and magenta.
- To reduce green, subtract magenta.
- To reduce blue, subtract yellow.

burning and dodging can affect not only the print density but also the color balance of the areas treated. Such changes can have either a positive or negative impact on your overall photograph. If you burn in an area with extra yellow light, you reduce the amount of yellow in that portion of the print. Waving a CC or CP filter below the enlarger lens during exposure is another way to change the color balance for a specific area. For instance, a yellow filter can be waved across the projected sky area to make the sky bluer or a blue filter can be waved across the color shadow areas of a projected image to make it warmer (more yellow). Start with 10 units of whatever color

you want to work with. Be prepared to add exposure time to compensate for denser filters. Remember, too much burning and/or dodging can cause an excessive color shift to take place in those areas.

A "dodger" can be made by cutting a piece of opaque cardboard in the shape of the area that will be given less exposure and attaching it to a dowel, pencil, or wire with a piece of tape (Figure 12.16). Keep the dodger moving during the exposure or an outline will appear on the print. A ballpark range for dodging is about 10 to 20 percent of the initial exposure. An area being dodged can seldom tolerate more than a 30 percent dodge before the differences between the overall exposure and the area being dodged become apparent. For example, a black area will turn gray with a color cast.

A "burning" tool can be produced by taking a piece of opaque cardboard that is big enough to cover the entire print and cutting a hole in it to match the shape of the area to be given more exposure (Figure 12.17). Keep it in constant motion during exposure to avoid the outline effect. Generally, burning in requires more time than dodging. Bright highlight areas, such as skies, often require 100 to 200 percent of the initial exposure time. Reciprocity failure can occur while burning in, producing color shifts that may require a change in the filter pack for the area being given the extra time.

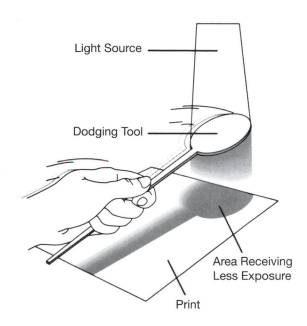

Figure 12.16 A "dodger" is employed to give an area less exposure than the rest of the print. It is necessary to keep the dodger in motion during exposure to avoid creating an outline of the tool.

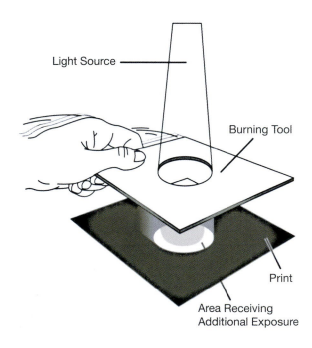

Figure 12.17 A "burning" tool is used to give an area more exposure than the rest of the print. It must be kept in motion during exposure or a dark halo effect will be visible around the edges of the area receiving more light.

Labels in Figure 12.16: Light Source, Dodging Tool, Area Receiving Less Exposure, Print

Labels in Figure 12.17: Light Source, Burning Tool, Print, Area Receiving Additional Exposure

Save These Tools

After a while your collection of opaque burning and dodging tools will meet most printing needs, saving construction time and speeding darkroom work. Some photographers do most of their burning and dodging with their fingers and hands. Others prefer to purchase commercially prepared tools. As always, do whatever works best for you.

Final Decisions and Cropping

Once the correct filter pack and exposure are determined, check the print for exact cropping. A handy way to determine whether the print has been cropped properly is to cut out a pair of Ls from a piece of white board. Practice overlaying these Ls with one another on top of the print to determine the exact cropping of the final picture.

Also, reconsider standard notions of what makes a good photograph by enlarging only a small portion of your original negative and/or experimenting with different planes of focus.

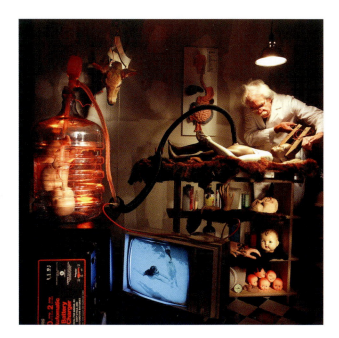

Figure 12.18 A dark room served as the setting for this photograph, and Pamela de Marris used an ambient light meter to calibrate time for lighting the scene with multiple sources. She made the picture with a single negative and printed it onto Duraflex RA Print Material, which allowed her to make large and rugged prints with the presence of a painting on a wall. de Marris states, "The series *Suburbs of the Subconscious* represents creating very personal photographic images that involve the active participation of others. Sets are built in my studio or found spaces, depicting scenes dealing with gender roles, family relationships, and pastimes. The subjects act out their dreams, fantasies, alter egos, and feelings not often expressed in their everyday lives."

© Pamela de Marris. *Mad Scientist*, from the series *Suburbs of the Subconscious*, 2007. 40 × 40 inches. Chromogenic color print.

Look at the Print in a Mirror

If the print still does not look the way you wish, try a classic painter's method for seeing the work in a different fashion: Look at the print in a mirror. Reversing the image allows you to momentarily forget your original idea and see the work as a viewer might or in a different manner than before. This could provide the clue to the direction you need to take to let the picture deliver its message to its future audience.

Internegatives

A color print can be made directly from a transparency using a separate positive printing process or with a regular color negative print processing method by first making an internegative. An internegative is a negative made from a transparency, usually by projecting the image onto sheet film. For a modest cost, many labs will make standard internegatives that deliver acceptable results for most general daylight situations. If you are not satisfied with the way that a transparency has printed (see the next section), try making an internegative from the slide and see if it delivers more desirable results. For critical work, a custom internegative is probably necessary. However, since internegatives are a generation removed from the original, they tend to produce prints that do not match the color accuracy and/or sharpness of a print made directly from an original camera negative.

Display and Print Materials

Kodak Professional Endura Transparency Digital Display Material is made for digital film and paper recorders for the production of large-scale color transparencies directly from digital files, color negatives, and internegatives. It is sturdy and translucent, making it ideal for backlit transparencies on illuminators without diffusers. Ilford makes a similar product called Ilfotrans Digital print

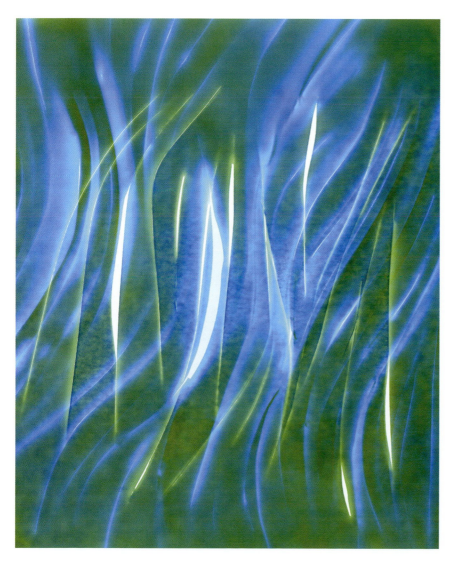

Figure 12.19 Seze Devres makes photograms, or what she calls "painterly, cameraless light drawings" that are composed on sheets of transparency film, using the light provided by a color enlarger. "Visually they are a lyrical merging of painting and photography." By projecting the photograms onto negative film, Devres makes an internegative that allows her to print multiple reproductions of what would otherwise be a unique work.

© Seze Devres. *SZ06-0820D*, from the series *Waveforms*, 2006. 30 × 40 inches. Chromogenic color print.

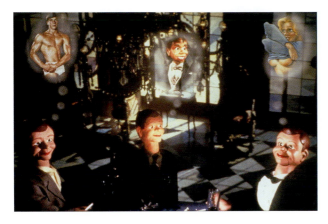

Figure 12.20 "During the later part of the 1980s," Laurie Simmons says, "I was dealing with the superficiality [often utilizing dollhouse-size figures] of the exterior mode we inhabit, with the confusion between ourselves and our possessions: A self-image based on what we do and where we live and how we function and certain kinds of cold disappointments in terms of truth and lies. One of the things I'm working on in my new work is imagining the daydreams and the night dreams and the fantasies of the characters that I've created. Now I'm concerned about what's going on inside … It's important for me to address their inner lives."

© Laurie Simmons. *Cafe of the Inner Mind: Dark Cafe*, 1994. 35 × 53 inches. Dye-destruction print. Courtesy of Metro Pictures, New York, NY.

film. Kodak Professional Endura Transparency Optical Display Material is a clear-based transparency material for use on illuminators with built-in diffusers. A comparable product is Ilfoclear Digital display film.

Ilford Ilfoflex Digital is designed for making prints on a polyester base that delivers a stable, high gloss surface, similar to Ilfochrome, in digital enlargement devices. Ilfocolor Ilfovinyl is a color negative or digital file print material that is useful when a banner or durable image base is required. Typically these materials are used for commercial applications, but artists favor these materials to make large prints because of their sturdiness. These display materials are processed in a regular RA-4 setup, but some may require longer processing times than normal RA-4 papers (see specific online product instructions). These materials should be handled in total darkness and may be intermixed in the same chemistry as other color print materials without any ill effects.

Making Prints from Color Transparencies

The Sabattier Effect/Solarization

The Sabattier effect, often referred to by the misnomer of solarization, is the partial reversal of an image caused by exposing it to light during development. The result contains both negative and positive colors and tonalities.

This effect was first observed in the making of daguerreotypes in the 1840s. Armand Sabattier, a French scientist, documented what caused this phenomenon in 1862. The process is one that is still not completely understood by scientists today.

The results of this effect are never the same. Many photographers have been attracted to this process because of the expressive uniqueness of each image, the influence that chance plays in the creation of the picture, and the mysteries that continue to surround, defy, and frustrate rational scientific explanation.

The Sabattier effect can be carried out on either negatives or prints. This section deals only with prints since this process does not put the original negative at risk and offers many picture possibilities for someone attempting the method for the first time. Negatives that have been sabattiered do tend to produce

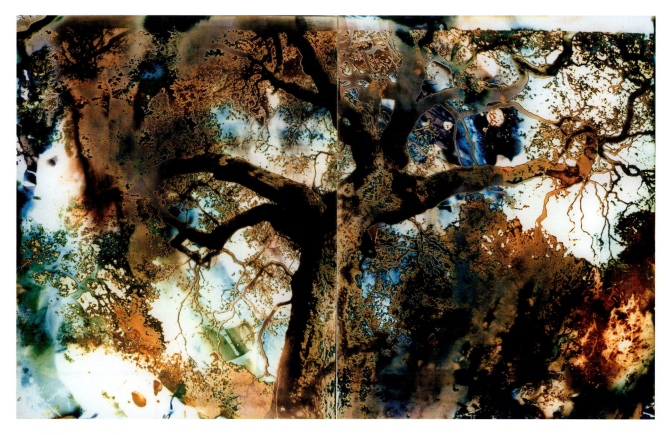

Figure 12.21 Claudia Wornum made this photograph using a large-format pinhole camera with expired film, which she processed and contact printed onto a sheet of Ortho Litho film. She solarized the duplicate negative by flashing the film with a strobe light and an incandescent bulb while processing it in a variety of exhausted developers and diluted fix. Wornum explains her *modus operandi*: "My method is dependent on spontaneous decision making as the chemicals are applied to the film during solarization. I cannot completely control what the outcome will be, and often it is a swirly, muddy mess. If I play it safe and go too slowly, the result is boring. My solution is to work in volume: Have plenty of fresh litho contact sheets at the ready to try many variables and be open to different rhythms during this phase. I determine a successful outcome intuitively: I know it when I see it."

© Claudia Wornum. *Berkeley Botanical Garden Oak*, from the series *Solarized Trees*, 2007. 8 × 10 inches. Solarized ortho litho print.

more dramatic results than those made directly on a print from an unaltered negative. In order to preserve the original negative, those wishing to sabattier the negative often make copy negatives from the original. The copy negatives are sabattiered at various times and distances in order to produce a wide variety of effects.

The Sabattier effect occurs when a burst of light strikes the paper or film during the development cycle. This fogs the paper or film and reverses the colors and tones. By controlling the duration and intensity of the burst of light, it is possible to control the extent of the effect. Too much exposure produces black by converting all the silver halides to silver. Too little exposure does not change enough of the silver halides to produce the desired results.

A definite demarcation, known as a mackie line, is produced at the boundary between the reversed and unreversed areas. If it were not for these lines, the print would appear to be a positive version of a very dense and fogged negative.

What to Look For

Scenes that contain higher-than-normal contrast and possess a wide range of tonal differentiation are good candidates with which to begin experimentation. Images that have a strong sense of pattern or have distinct shapes will show noticeable changes. This will also make up for the loss of detail and subtlety of tone that accompanies this process. Since light-colored subjects contain more unconverted silver halides than darker ones, they generally respond more strongly to re-exposure. When this technique is successfully carried out, the image can appear more graphic with light glowing areas competing against dark mysterious spaces that contain a surreal sense of place, space, and time.

Sabattier Procedure

The Sabattier effect can be produced without any special chemicals or equipment. The print should be developed in a tray because it offers the greatest control, but a drum can also be used. Make the print on the highest-contrast paper obtainable. Mix chemicals to regular strengths, but add a tray of water between the developer and the bleach-fix. Expose the print normally. Develop it for about one-half to three-fourths of the normal time. The print should contain essential shadow detail without full development of the highlights or midtone areas. At this point,

remove the print from the developer and place it in a tray of water for up to 30 seconds with agitation. This dilutes the developer tremendously, but it does not completely stop the action of the developer. Next, take the print out of the water bath, drain it, and place it on a clean sheet of Plexiglas, glass, or an unribbed darkroom tray. Squeegee the excess water from the print and put it and the backing under a light source for re-exposure.

Sources of Re-exposure

A variety of light sources can be used for re-exposure. Plug the light into a timer for accurate re-exposure control. A small light, such as an architect's lamp with a 15-watt bulb, placed about 4 feet above the print works well. The enlarger can also be used as an accurate, controllable, and repeatable source of re-exposure. It also presents the opportunity to easily work with either white light or, by dialing in filters, colored light. Coloring the light source increases the range of effects that it is possible to achieve. Place a towel on the baseboard of the enlarger to catch any dripping water. Remove the negative from the carrier before re-exposure. Refocus the enlarger if the negative is returned to make another print. An electronic flash with a diffuser may also be used as a light source.

Degree of Effect

The degree to which the Sabattier effect takes place is determined by when the re-exposure takes place and its duration. The earlier the picture is re-exposed and/or the longer or brighter the light, the more intense the reversal becomes in the final print. Re-exposure time is a matter of seconds or a couple of bursts from the flash. A digital timer allows exposures to be made in fractions of a second, providing even greater control.

Procedure after Re-exposure

After re-exposure, the image can sit for up to 30 seconds. This can serve to improve the overall contrast and enhance the edge effects that are created along the borders of the different densities.

Now place the picture back into the developer and continue to process normally. The results cannot be judged until the entire process has been completed.

Trial and error is the rule. Nothing is predictable. Not all pictures are suited for this technique. Do not force the method onto a picture. Wait for a situation in which this technique can be used to enhance the statement. Some control can be gained by using a constant light-to-image distance from a timed light source, but careful record keeping of exact working procedures, experience, and experimentation provide the main guideposts.

The Dye-Destruction Process

When a high-quality print is wanted directly from a color transparency, one can either scan the film and make a digital inkjet print or a LightJet RA-4 print, or utilize the dye-destruction/silver dye-bleach process (see Chapter 2). In this method, all the dyes are present in the emulsion and those not needed to complete the final image are destroyed in processing. Many who make color prints believe that the dye-destruction process offers superior color, resolution, sharpness, and greater dye stability.

Ilfochrome Classic Deluxe, first introduced in 1963 as Cibachrome, is a three-bath process noted for producing vivid color intensity, with exaggerated red sensitivity. It is exposed with a color enlarger and usually processed in an automatic tabletop processor or drum with P-30P or P3X chemistry (see Table 12.4). The latter allows for high processing temperatures, which gives shorter total processing time. Tray processing is not recommended due to the likelihood of a temperature drift of more than ± 0.5 °F, which will produce color shifts.

Basic Reversal Printing Guidelines and Procedures

Making a color print from a transparency is very similar to making a color print from a negative, though there are some key differences to bear in mind. The most important is the selection of an "ideal" transparency since the results are predicated on it. The key to making high-quality Ilfochrome prints is critical exposure. Sometimes, a slide with greater-than-normal color saturation, having been slightly underexposed by 1/3 of an f-stop, can produce superior prints. For best results, run a test on push-processed film, which helps to increase color saturation without making the image too dark. An overly dark slide or one with too much contrast is difficult to print because the printing process itself adds contrast to the finished photograph. A slide that normally might be considered somewhat flat, such as a scene photographed on a cloudy day, often will print surprisingly well. Transparency films such as Fuji Velvia or Kodak E100VS, which are designed to produce very high color saturation, print marvelously on Ilfochrome Classic.

Since transparency film does not have the orange mask to compensate for inadequacies in the negative/positive system, and because color negative film has more exposure latitude, expect to lose some detail and tonal subtlety in the color of the Ilfochrome print. To help control color balance, serious Ilfochrome printers often make a contrast reduction mask to match the contrast range of a transparency to the Ilfochrome paper. The light sensitivity of Ilfochrome does not permit the use of a safelight and therefore must be handled in total darkness until loaded in the processor.

Making a Print

To make a print, remove the slide from its mount and clean it carefully because dust spots will appear as black spots on the final print, making spotting difficult. Insert the slide into the film carrier (special 35mm slide carriers are available for certain enlargers). Tape may be applied along the sprocket holes to keep the piece of film in place and flat, especially when working with film larger than 35mm. Now follow the previously listed procedures for making a print from a negative (see Box 12.2).

Determining the Emulsion-Side of Ilfochrome Paper

When first making Ilfochrome prints, many people find it difficult to determine the emulsion-side of the paper in total darkness. Here are five ways to tell which is the emulsion and which is the base side of the paper:

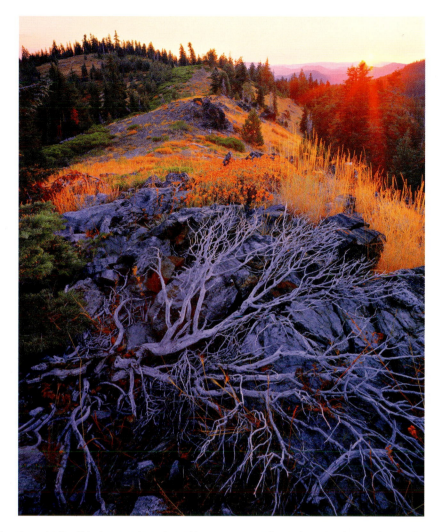

Figure 12.22 Planning the minute details of his photographs, such as taking a compass reading to determine the sun's location for a sunrise, allows Ford Lowcock to capture dynamic, vivid landscape scenes. Technique has become so ingrained into the way he photographs that he is able to forget about it as he works. He elaborates, "Thinking about technique as you work will nearly destroy creativity." Lowcock uses a 4 × 5-inch field camera to expose transparency film that he prints on Ilfochrome, which he prefers because color dye is manufactured into the paper and allows the image to be under the surface of the paper, giving the print more depth.

© Ford Lowcock. *Spread*, 2005. 24 × 20 inches. Chromogenic color print. Courtesy of Harry Ransom Center, University of Texas, at Austin and Los Angeles Public Library Photo Collection, Los Angeles, CA.

1. The paper has a tendency to curl with the emulsion on the inside of the curve.
2. Use the glow from a luminous timer dial or a strip of luminous tape on the darkroom wall. The paper reflects light on the non-emulsion side. This will not fog the paper unless you get right up to the timer face.
3. Ilford suggests rubbing both sides of the paper while holding it up to your ear. The emulsion-side makes a different sound than the base side. If this method is used, be careful not to damage the paper, and have clean hands to avoid leaving fingerprints. With Ilfochrome papers, the emulsion comes facing the label on the inner light-tight package.

4. Some printers will gingerly touch the paper to their lips or fingertips. The emulsion-side will feel sticky to the moistened lip or a fingertip.
5. If all else fails, cut an edge from a piece of the paper and look at it under white light to determine the emulsion-side.

Evaluating a Print

Compare the fully dried test strip (wet Ilfochrome is overly red) with the original slide or a similar slide of the same subject. Look at it in the same type of light that you expect to view your finished print. Pick the exposure that you like the best and check for color balance in key areas. If possible, look at a white or

Step	Time
TABLE 12.4 REVIEW OF DRUM ILFOCHROME CLASSIC PROCESS P-30P	
For making an 8 × 10-inch print at 75 °F with 2.5 ounces of chemical per step in a drum	
1. Presoak	30–60 seconds
2. Develop	3 minutes
3. Rinse	30 seconds
4. Bleach	3 minutes
5. Rinse	15–30 seconds
6. Fix	3 minutes
7. Wash	3 minutes minimum
8. Dry	As needed

neutral area when deciding which color is in excess. Use the Lee Color Print Viewing Filters kit, with the black side facing you, as previously discussed (see page 233-34). Expert Ilfochrome photographer/printer Ford Lowcock (see Figure 12.22) suggests curling the print so its backside, which is a clean white, is next to the area being evaluated. This provides a neutral white to evaluate color shifts, gives density in a highlight area for determining both color shifts and exposure, and covers other colors surrounding the area being evaluated, which can confuse the eye with false colors.

The guideline for determining proper density is to print for the key highlight area, thus ensuring the retention of highlight detail. If there is more than about a six f-stop difference between the key highlight and the key shadow (a brightness range of 1:64), burning by opening the lens aperture will make the shadows brighter and provide more detail. Another point to consider is that slide films were designed for projection and not

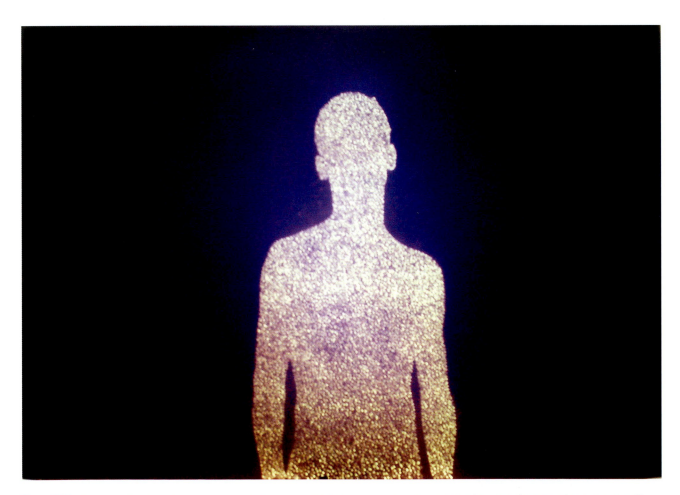

Figure 12.23 Christopher Bucklow relies on the sun, a pinhole camera, and Ilfochrome paper to make his spectral portraits. The artist makes a tin cutout of his silhouetted subject, pierces it thousands of times, and places the plate inside a large-scale homemade pinhole camera. Bucklow elaborates, "I can use more than 25,000 pinhole apertures to make my images, and the plate size can be as large as 100 × 40 inches. I shoot directly onto Ilfochrome paper. I only shoot the sun—the paper in the camera becomes the actual work. The thousands of images of a sun's disc are the only photographic part of my process."

© Christopher Bucklow. *Tetrarch*, 2006. 40 × 60 inches. Dye-destruction print.

Box 12.6 **Essential Reversal Printing Rules**

Keep in mind that more exposure gives you a lighter print, not a darker one. So when looking at your test strip, the darkest strip actually has had the least amount of exposure.

- To lighten an area, give it more exposure (burning).

- To darken an area, give it less exposure (dodging).

- To make a print lighter, give it more exposure.

- To make a print darker, give it less exposure.

TABLE 12.5 REVERSAL FILTER PACK CHANGES

Print is too	Add	or	Subtract
Blue	Yellow		Cyan and magenta
Yellow	Cyan and magenta		Yellow
Green	Magenta		Cyan and yellow
Magenta	Cyan and yellow		Magenta
Cyan	Yellow and magenta		Cyan
Red	Cyan		Yellow and magenta

Box 12.7 **Using the Aperture of the Enlarging Lens to Control Exposure**

- If the print is slightly dark, open the enlarging lens about 1/2 f-stop.

- If the print is dark, open the aperture of the enlarging lens about one f-stop.

- If the print is slightly light, close the enlarging lens about 1/2 f-stop.

- If the print is light, close the aperture of the enlarging lens about one f-stop.

for printmaking. Ilfochrome is not capable of retaining the total range of density and color of the original slide, especially when photographing in a high-contrast situation such as direct sunlight. Experienced Ilfochrome printers always expect to do plenty of burning and dodging.

The main thing to remember when printing from slides is that all the rules of negative printing must be turned around (Box 12.6). This could prove to be a bit confusing if you have been negative printing. Take a little extra time and think before you act. It could save time, money, and some frustration. They don't call it reversal for nothing.

Color Correction Procedures

To remove the excess color cast from a print, remove that color from the filter pack. This means all the negative printing filter rules also apply in reverse. Depending on the process, cyan filters may be employed. Be sure to have only two colored filters in the pack at once or unwanted neutral density will be produced. Refer to Table 12.5 to avoid confusion.

Work in units of about 5 to 10 for a slight change in color, 10 to 20 for a moderate change, and 20 to 40 for a considerable effect. Generally, changes of 5 units or fewer are hardly noticeable in reversal printing until you get close to your correct exposure and color pack or for high-key images. Ilfochrome's response is sluggish and needs to be jump-started in the early stages of testing, so be much bolder with corrections than in negative printing. A general rule is to double the corrections in reversal printing, based on your negative printing experience. Leaps of 10, 15, or even 20 units at a time are not unusual. "Creeping" up on the correct color/exposure combination wastes time and money. For an 8 × 10-inch print, start by making a test strip by setting your enlarger timer for 15 seconds and then make five exposures by changing the f/stops from f8 to f8.5 to f11 to f11.5 to f16.

Fine-tune the exposure by making small adjustments to the time and f/stop combination. Changes in time will alter the print's color balance, especially in the highlights, becoming about 2–3 points yellower for a 10-second increase. An alternative is to use an enlarging exposure meter, such as the Ilford EM-10, to accurately make changes in f/stops rather than time. After making the appropriate modifications, make a new test print and reevaluate following the same procedures.

Local Color Correction

If you have access to a digital enlarging device, make necessary corrections using your imaging software. With an analog enlarger it is possible to selectively add colors to a print during exposure. This is done by slowly waving a color printing (CP) filter under the lens so that it covers the area you wish to alter. A CP filter can be cut into smaller pieces and attached to a support wire to filter smaller areas of a print. The amount of filtration depends on the effect desired. With reversal papers, filter densities up to 50 units may be used for dramatic effects.

Variations

Ilfochrome Classic material can be exposed directly in a view camera, resulting in a direct-positive color image. Filters can be placed in front of the lens at the time of exposure to make color corrections and changes. Another possibility is to print color negatives instead of slides. The outcome is a negative color print instead of a positive color print. With intense precision work, masks can be made to control color, highlight density, and to increase print sharpness. Black-and-white slides can also produced with the help of www.dr5.com/.

Processing Problems

There are a number of common mistakes that occur when working with Ilfochrome Classic materials. The troubleshooting guide (Table 12.6), the manufacturer's instructions, and Tabletop Processor Troubleshooting (Box 12.8) should help you to get back on the right track.

TABLE 12.6 TROUBLESHOOTING ILFOCHROME CLASSIC

Print problem	Possible cause
Black with faint image	Bleach defective Bleach step omitted
Black with no image	Exposed through back of print (glossy)
Blue border/gray highlights	Developer contaminated
Brown-red borders	Bleach carried over into fixer Not fixed long enough
Cyan stain	Processor not clean, over-replenished bleach, evaporation losses in bleach
Dark, dull-fogged	Print fixed before it was bleached
Dark with red-orange cast	Exposed through back of print (lustre)
Dull and milky	Bleach time too short
Flat contrast and dark	Development time too short
Gray highlights	Bleach exhausted Bleach too cold Bleach time too short
Greenish borders	Outdated paper, paper improperly stored
Image too dark	Bleach contaminated with developer, mix new bleach
Image too dark, contrast reduced	Bleach contaminated with fixer, mix new bleach
Image too dark, yellow contrast reduced	Developer too concentrated (over-replenished), add water
Image too dark, cyan highlights	Bleach too concentrated, add water
Image too dark, dull blues	Developer under-replenished or weak, add replenisher
Image too light, tendency to high-contrast	Bleach too dilute or under-replenished
Light flare	Paper fogged
No blacks and light	Development time too long
Orange cast/blacks bluish	Developer contaminated with fixer
Pink-magenta borders	Overagitation
Print is black	Development step skipped, Developer exhausted
Reddish cast	Light fog from stray (red) light
Reticulation	Inconsistent temperatures or final wash water is too soft (add magnesium)
Uneven tones/gray areas	Not enough chemicals
White, yellow, or bluish streaks across print	Processor not properly closed
Yellowish Highlights	Final wash water temperature is too low
Diffuse yellow stains	No agitation in the bleach or oxidation inhibitor used up (add 3BZ)
Yellow edges	Lack of agitation
Yellow and Flat	Print not fixed

Box 12.8 Tabletop Processor Troubleshooting

Tabletop processors should be monitored for the following:

- P3X chemicals operate at 96°F, so the water content in the chemicals can quickly evaporate. This can be monitored with a hydrometer for measuring the specific gravity of each solution.

- An overconcentration of bleach.

- The replenishment rate must be monitored to ensure consistent output quality.

- Wash water temperature and flow rate are critical points for maintaining accurate color and density.

- Lack of use. Use 3BZ to recharge.

NOTES

1. Richard Avedon, *American Photography*, 1991, 2 (4): 60.

At an intersection of analog and digital technologies, Susan E. Evans manipulated a 35 mm Kodak color transparency film cassette to allow light to pass through the velvet strips on to the film over several days. The film was then processed normally, scanned, and projected as a final piece. She reflects, "Photography is evolving and this change directly mirrors the changes made in painting when it was no longer necessary to make paintings to document or record history. With the responsibility to document transferred to photography's digital side, I explore the materials themselves: film, chemistry, light, subject matter, and the inherent flatness in ephemeral moments, abject time, proximity, and consequences."

© Susan E. Evans. # 232, 1993. Variable dimensions. Projected chromogenic color transparency.

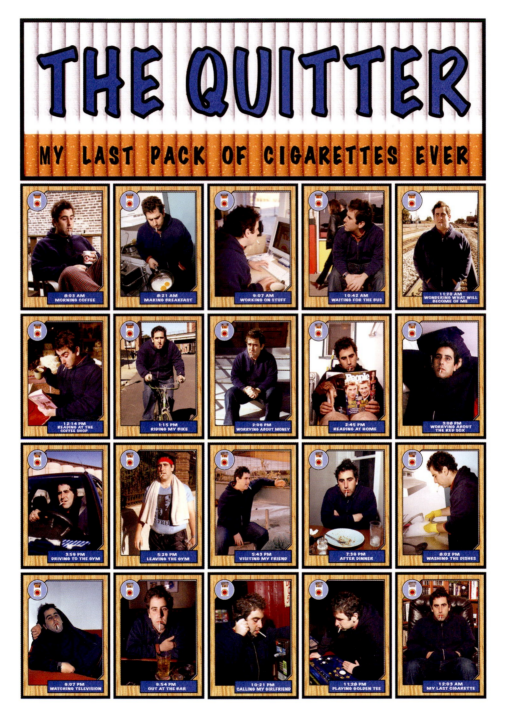

Jonathan Gitelson condensed an entire day into a single image to tell the story of his process of quitting smoking. To construct this poster, the artist first formed 20 graphic frames by scanning baseball cards and replacing the photographs of the baseball player with ones of himself. He took the self-portraits with a Mamiya 645 camera and scanned the negatives into Photoshop. The pack of cigarettes superimposed over each photograph functions as a countdown to the artist's final cigarette. Gitelson says, "I began to create my posters in spring 2004 as an extension of my artists' books. This poster is often accompanied by a video of the same title. The video consists of two Super 8 films shown simultaneously; the first depicts my last cigarette before quitting in 1999, and the second is a reenactment staged in 2005 when I attempted to quit again."

© Jonathan Gitelson. *The Quitter*, from the series *Posters*, 2005. 63 × 44 inches. Inkjet print. Courtesy of Galerie f5,6, Munich, Germany.

Color Projects

The Camera

The camera is the key component that makes up photographic vision. The job of the camera has been to make an "acceptable" and recognizable depiction, based on established visual conventions, of what was seen. The early camera, called the camera obscura, was designed to imitate the visual ideas of perspective and scale that were formulated during the Renaissance. Even today, the combination of camera and lens, whether digital or film, determines many of the basic characteristics of the final photographic image, including field of view, depth of field, sharpness, and tonal range. A knowledgeable viewer can often identify the fingerprint of the camera used to make an individual image. Because the camera plays such a vital role in the formation of the final picture, photographers must be sure the type of camera being used supports their personal aesthetic goals. No single camera can produce acceptable results in every situation. This is because the standard of what is acceptable is dependent on a variety of factors, including the subject being photographed, the audience, the purpose for which the picture is being made, and the desires of the photographer. Photographers should learn about the differences in cameras, their strengths, and their drawbacks, so they are able to make intelligent choices to achieve the desired outcome, and when possible, experiment with different types of cameras. "A photograph can only look like how the camera saw what was photographed. Or, how the camera saw the piece of time and space is responsible for how the photograph looks. Therefore, a photograph can look any way. Or, there's no way a photograph has to look (beyond being an illusion of a literal description)."[1] Although a camera may shape the construction of an image, it is the private individual response to a situation that gives an image its power. Always keep in mind: The best camera is the one you have with you.

Camera Formats

Besides the familiar DSLR and SLR, there are a number of other types of cameras to work with, including the following:

- Cellphone cameras have replaced point-and-shoot and video cameras for covering daily life and making pictures where photography was once prohibited. Their omnipresence, small size, and ease of use make users potential instant digital reporters and image distributors.
- Disposable cameras, which provide an inexpensive way to experiment with different imagemaking devices, including waterproof, underwater, and panorama apparatus as well as in-camera panoramic software.
- Electronic Viewfinder Interchangeable Lens (EVIL) cameras are small, mirrorless, finderless devices that can fit in a pocket and outperform bulky DSLRs.
- Homemade cameras that you can construct to suit your own way of seeing.
- Medium formats, such as the 6 × 4.5 cm, 6 × 6 cm, 6 × 7 cm, and 6 × 9 cm, which provide a larger image while still retaining the convenience and versatility of a handheld camera.
- Open-Source cameras, still in development, would allow users to download applications to their digital cameras as they download applications to their iPhone, allowing people to add/change features that are not pre-installed by the manufacturer.
- Panoramic cameras, which are used to expand the ordinary photographic viewpoint.
- A special apparatus that can be attached to a microscope permits a camera to make photomicrographs.
- Pinhole cameras rely on a small opening, rather than a lens, to form a soft image with infinite depth of field (see next section).
- Rangefinder cameras have two separated viewfinder windows: One is coupled to the focusing mechanism and moves as the focusing ring is turned, bringing the two separate images together on a ground glass viewing screen. When lines of the subject being focused are precisely aligned into a single combined image, the subject is in focus. This system can be useful in low-light or action situations.
- Sequence cameras, which make a series of exposures over a specific amount of time, on either one piece of film or consecutive frames.
- Single-lens reflex (DSLR or SLR) cameras employ a semi-automatic moving mirror system that permits one to see exactly what the digital or film capture will be. Generally, DSLR and SLR cameras allow upright and laterally correct viewing by means of a pentaprism that is located in the optical path between the reflex mirror and viewfinder. Light coming through the lens strikes a movable mirror where it is reflected upwards into the pentaprism where it is again reflected multiple times until it aligns inside the viewfinder. When the shutter is released, the mirror moves out of the light path and the focused light falls directly onto the imaging sensor or film where the exposure is made.
- Stereo cameras allow the imagemaker to work with the illusion of depth.
- Telescopes equipped with a clock drive and a camera body attachment mount can be used to make images of the sky at night.
- Toy cameras, such as the Diana, Holga, and the Lomos, challenge the accepted standards of image quality and encourage playfulness and simplicity.
- Twin-lens reflex cameras utilize a pair of nearly identical lenses: One acts as a viewfinder and the second forms the

image that is recorded. The lenses are aligned with the viewing lens just above the taking lens. The viewing lens projects an image onto a hooded viewing screen, which is seen by peering down from above. Some models offer a reflex head that attaches to the viewing screen so the camera can be used at eye level.

▪ Underwater cameras, which allow the camera to be used in wet conditions or submerged in water.

▪ View cameras, such as the 4 × 5 inch, 5 × 7 inch, and 8 × 10 inch, which offer the largest film area and the greatest amount of perspective control, but do require the use of a tripod.

Whenever the opportunity presents itself, try to work with a camera format different from the one you normally use. Compare the results. Notice how the camera itself affects what you look at and how you see it, and interpret the results. Also, the look of the toy cameras can often be replicated with imaging software.

For more information on cameras see Ansel Adams, *The Camera* (Boston, MA: Little Brown, 1983) and Robert Hirsch, *Photographic Possibilities: The Expressive Use of Equipment, Ideas, Materials and Processes* (Boston, MA: Focal Press, 3rd edn, 2009).

The Pinhole Camera and Birth of the Camera

Enter into a dark room and make a small round hole in the window shade that looks out onto a bright outside scene. Hold a piece of translucent paper 6–12 inches from the hole and you will see what is outside. This optical phenomenon, which dates back to the ancient Greeks, provides the basis for making pinhole (camera) photographs. Note that the image will be upside down, the same as in our eyes before our brain turns it right-side up.

This optical observation led to the invention of the camera obscura — Latin for *dark room* — which is a drawing device used to project an image onto a flat surface where it can be traced. By the sixteenth century the camera obscura was in common use by artists such as Leonardo da Vinci. In 1658 Daniello Barbaro placed a lens on the camera obscura. This combination helped lead to an understanding of the concept and uses of perspective, which had baffled artists, scientists, and scholars for centuries. Daguerre's camera was an uncomplicated camera obscura with a lens.

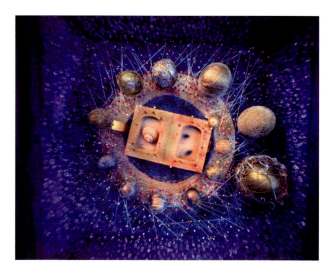

Figure 13.2 Nancy Spencer and Eric Renner made this photograph with a 1½-inch Leonardo 4 × 5-inch pinhole camera. Their subjects in this series are assemblages dealing with human rights, religion, and stereotypes that the duo built 20 years ago, hung on their wall, and incorporated into their daily life. After living with them for 10 years, the artists returned to the assemblages and began photographing them. Spencer and Renner tell us, "In making the photographs and concentrating on small details, we realized there was the possibility of an altered context in making two-dimensional images of our three-dimensional assemblages. The pinhole images make use of color shifts due to long exposures (6–8 minutes), vignetting, and altered perspectives enhanced by our choice of placement of the wide-angle pinhole camera."

© Nancy Spencer and Eric Renner. *Thirteen Moons*, from the series *on deaf ears*, 2002. 24 × 30 inches. Inkjet print.

Figure 13.1 By attaching a child's microscope lens to a 4 × 5-inch camera and extending the bellows all the way, Jennifer Formica was able to capture microscopic images on film. Enlarging the images on 20 × 24-inch paper made "the small details of nature transform themselves into something monumental and symbolic."

© Jennifer Formica. *Stem*, 2000. 24 × 20 inches. Chromogenic color print.

How the Camera Works: Circles of Confusion

An optical image is made up by what is known as tiny circles of confusion. They are the major factor in determining image sharpness and the limiting factor of depth of field. When these circles are small enough to form an image they are called points, and the image is considered to be in focus. The pinhole camera has infinite, or universal, depth of field because all of the circles of confusion it creates are tiny, about the same size as the pinhole. These circles of confusion are small enough to be considered points of focus that have enough resolution to form a coherent image. This means that everything from the foreground to the background appears to have the same degree of sharpness. This uniformly soft, impressionistic image is characteristic of pinhole photographs. Adding a lens makes smaller points of focus and thus creates a much sharper and more detailed, coherent image.

Building a Pinhole Camera

For a couple of dollars and a few hours of time, you can build a simple pinhole camera. Many photographers find it gratifying to use their hands to build a camera that in turn forms the basis of their photographic vision. Working with a pinhole camera removes you from the expensive high-tech environment and the standard formats of automatic cameras and returns you to the basic function of vision.

You can make a pinhole camera out of any structurally sound light-tight container (avoid shoeboxes). A 4 × 5-inch film box (100 sheet size) makes a good first pinhole camera with a wide angle of view, because the closer the light-sensitive material is to the pinhole, the wider the field of view and the shorter the exposure. Oatmeal boxes and coffee cans also are commonly used. Or you can build one from scratch. See the materials list in Box 13.1.

Making the Pinhole

Get a thin (0.002-inch) piece of brass or aluminum about 2 inches square from an automotive or hardware store. Also obtain a sharp, unused size 13 sewing needle for a 4 × 5-inch film box (the smaller the pinhole, the sharper the image and the longer the exposure time). Since the distance between the front and back of the box is short, a larger needle hole could result in exposure times that are too short.

Hold the needle between your thumb and index finger and gently drill a hole in one side of the metal. Then turn the metal over and drill the other side. Do not stab a hole into the metal. Use very fine sandpaper to remove any burrs around the hole. Repeat this procedure until the opening is the same size as the diameter of the needle. By drilling, sanding, and slowly expanding the hole, you should end up with an almost perfectly round aperture without any burrs. The more perfectly round and burr-free the pinhole, the sharper the image will be.

Shutter

After completing the drilling operation, find the center of the front of the camera box. At this center point, cut a square opening equal to half the diameter of the metal plate (1 inch square).

Save this cutout for use as a shutter. Center the drilled metal inside the box and secure it with black tape.

Darken the cutout on all sides with a black marker. If necessary, put black tape around the sides so it fits snugly back into the camera front, over the pinhole. Let a piece of tape stick out to act as a tab-type handle. This handle will allow the cutout to form a trapdoor-style shutter that can be removed and replaced to control the exposure time. Another option is to simply use the black plastic top from a film container and hold it in place with your hand or tape. Aluminum foil and tape also work.

The Aperture Formula

To determine the f-stop of your pinhole camera, simply measure the distance from the pinhole to the film plane and divide by the diameter of the pinhole. The formula for calculating the f-stop is: $f = v/d$ where f equals aperture, v equals distance from pinhole to film or paper, and d equals pinhole diameter. For example, a 0.018-inch pinhole (d) at a distance of 2 inches (v) from the paper (focal length) produces an f-stop of 111 (f).

Starting Exposure Times

Begin by exposing color photographic enlarging paper outside in daylight. Typical daylight exposures with a film-box camera can run from 1 to 15 seconds, depending on the time of day, the season, the size of the pinhole, and the focal length (the distance from the pinhole to the paper).

After making the exposure, process the paper using normal RA-4 methods. If the paper negative is too dark, use a shorter exposure next time. If it is too light, give it more exposure time. Trial and error should establish a paper negative with proper density within three exposures. When you get a good negative,

Box 13.1 Pinhole Camera Building Materials

- Sheet of stiff mat board or illustration board at least 1/16 inch thick. One side of the board should be black. This will be the inside of the camera. The black helps to reduce internal reflection.

- Sharp X-Acto (number 11 blade is good) or mat knife.

- A 2 × 2-inch piece of brass shim or aluminum. An offset plate, obtained from a printer, is ideal. You can also use an aluminum pie pan or TV dinner tray.

- Glue. Any household white or clear glue is fine.

- A ruler. Steel-edged or plain straight-edged rulers deliver a far more accurate and close cut than cheap plastic or wooden ones.

- Size 10 or 12 sewing needle.

- Small fine file or number 0000-grit sandpaper.

- Ballpoint pen.

- Black photographic pressure tape or black electrical tape.

Figure 13.3 Cindy Sherman's use of self-portraits reveals her secret hopes, ambitions, dreams, and fantasies within the framework of a media-image-saturated society. This work also shows the fun of dressing up and play-acting before the camera.

© Cindy Sherman. *Untitled #131*, 1983. 34½ × 16½ inches. Chromogenic color print. Courtesy of Metro Pictures, New York, NY.

dry it, and then contact print it (emulsion to emulsion) with a piece of unexposed paper. Light will penetrate the paper negative. Process and then evaluate the paper positive. Make exposure adjustments and reprint until you are satisfied. After experience is gained, it is possible to expose any type of photographic material in the pinhole camera.

Converting a 35mm Camera to a Pinhole Camera

You can convert a DSLR camera to a pinhole camera by covering a UV filter with opaque paper in the center of which you have made a good pinhole. Attach the covered filter to the camera's lens and it becomes a pinhole camera. You also can convert an old snapshot-type or disposable camera to a pinhole camera by removing its lens and replacing it with a pinhole aperture. Zero Image Company (www.zeroimage.com) makes the Zone Plate, a modified body cap with a laser-cut pinhole that fits various film and digital cameras. They also make wooden pinhole cameras.

Self-Portraits

Since the time of Albrecht Dürer (1471–1528), artists have expressed many inner concerns through self-portraits. They have shown awareness of their own appearance and traits, producing durable evidence of the complexity of their lives. Their portraits continue to gaze back at viewers from another time and place. Self-portraits can show you as you are or may reveal an aspiration to be something other than your ordinary self. These pictures often reveal a secret self. Recently, some artists have been using the self-portrait as a means of assuming historical guises to confront and challenge archetypes and stereotypes that have been formulated about the roles men and women play within society.

View From Within/Portrait as Social Identity

There has been much interest in using photography to represent groups that in the past had their visual identity created by external authorities rather than from within their own social group. Historically, photography has played a major role in shaping how different groups of people are perceived. Beginning with nineteenth-century ethnological studies, such as John Thomson's *The Antiquities of Cambodia* (1867) and *Illustrations of China and Its People* (1873–4), outside observers have brought back exotic images that reconfirmed the preexisting attitudes, prejudices, and stereotypes of those in power. Thomson made pictures for people who considered "the other" to be primitive and inferior. His work reflected the values of the British colonial system, which believed it had the right and the duty to govern other lands and enlighten the natives to Christianity and the Queen. Such practices helped to objectify and exploit the native populations, which had no control over how they were pictured or the context in which their pictures were deployed within society at large.

Making a Self-Portrait

With these ideas in mind, make a self-portrait. The photograph should express self-awareness and reveal something that is important for others to know about you. A good way to reacquaint yourself with yourself is to sit down in front of a mirror, alone, without any outside distractions. After studying your image in the mirror, get a pencil and paper and make a series of contour drawings. To make a contour drawing, look into the mirror and draw what you see and feel without looking at the paper until you are finished. Based on what you learned from making the contour drawing, make a photographic self-portrait that projects your inner potencies and/or frailties without navel-gazing or being self-indulgent and needlessly obscure.

Portrait of Another Person

Next, make a photographic portrait of someone you know following these same guidelines. This photograph should present information to the viewer that shows something important about this person's character (Figure 13.4). Try photographing yourself and another person in the same surroundings. Compare the resulting differences and similarities.

Environmental Portrait

Make a portrait that shows a viewer how the individual interacts with his or her environment. Concentrate on the individual rather than the setting. Consider showing only one part of the sitter's surroundings so as not to diminish the person's physical importance within the scene.

Portrait of an Object

Compose a photographic portrait of an object that tells your audience something about your feelings and relationship toward it. Make at least one image using daylight as your only source of illumination, another with artificial light, including flash, and a third with a combination of both.

Ideas Make Photographs

Think before starting to make this series of images. Develop an idea and let it lead you through the process. Edmund Carpenter said, "Technique cannot conceal that meaningless quality everywhere characteristic of art without belief." Techniques well learned can help us to speak, but some of the greatest thoughts have been expressed by the simplest means. Ideas, not equipment, create powerful photographs.

Figure 13.4 Tina Barney's photographs are elaborately staged tableaux, echoing the daily lives of the close circle of family and friends who serve as her subjects. She works with a 4 × 5-inch camera and makes richly colored large-scale prints of the kinds of mundane scenes we are used to seeing in photo albums and scrapbooks. Her photographs comment on the daily rituals and customs of upper-class, Anglo-American life.

© Tina Barney. *Sunday New York Times*, 1982. 48 × 60 inches. Chromogenic color print. Courtesy of Janet Borden, Inc., New York, NY.

Figure 13.5 To make this portrait, Steve Davis used a Calumet 8 × 10-inch view camera and a reflector to bounce light onto the subject's face. Due to the camera's bulk and slow manual operation, the artist could make only a small number of exposures during a session. He planned his exposures carefully and scanned his negatives in order to digitally correct defects. Davis, who made this series of work at the Rainier School, a Washington state-operated institution for the developmentally disabled, tells us, "I intended this photograph to present a man with a serious mental disability with integrity, elegance, and without apology. A large-format camera is unforgiving but contributes to my sense of time and the overall economy of the photo session. My camera favors introspection and deliberation over speed and high-volume image capture."

© Steve Davis. *John* from the series *The Rainier School*, 2006. 40 × 50 inches. Inkjet print. Courtesy of James Harris Gallery, Seattle, WA.

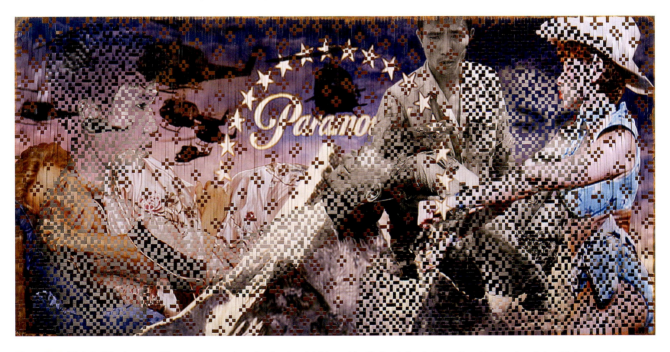

Figure 13.6 Dinh Q. Lê's photographic weavings are about "trying to establish my identity in relation to the culture I have entered. As a Vietnamese living in a Western society, educated in Western institutions, and surrounded by Western popular culture, I am a product of both East and West. Through my work, I explore the exchange and interweaving of cultures and identities from a bicultural perspective."

© Dinh Q. Lê. *Paramount*, 2003. 33⅜ × 66¾ inches. Chromogenic color print with linen tape. Courtesy of Shoshana Wayne Gallery, Santa Monica, CA, and Gene Ogami.

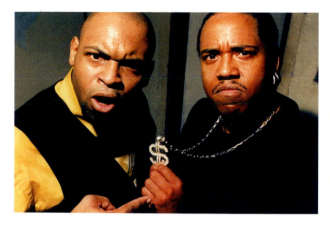

Figure 13.7 Thomas McGovern's series of images depicting young people who live their fantasies of greatness through professional wrestling illustrates how photography can create identities and blur fiction into fact. "But look beneath the surface of their bravado and there are signs of the vulnerable and slight young person, trying desperately to find his or her way in a world where image rules."

© Thomas McGovern. *Under Pressure and Iceman John Black*, from *Hard Boys and Bad Girls*, 2002. 15 × 22 inches. Chromogenic color print.

Problem Solving

Working in the arena of social identity raises some difficult questions. First, who has the right to speak for/represent a particular group? Must one be African American to make work about slavery or gay to comment about sexual preference? Second, does having a strong identification with a specific group better give one the ability to make images about that group? Third, is it possible to have a memory of something you never experienced? For example, can Jews born after World War II produce compelling commentary about the Holocaust? And finally, who determines the validity of such experiences and bestows the credentials to make legitimate images?

Ponder these issues and then examine how the practice of photography can become part of the process of dismantling preconstructed notions and shape a new portrait that more closely reveals how a group currently would like to represent itself. Then begin making images of members of your specific cultural subgroup(s) or of those with whom you have an affinity or share similar circumstances. The purpose is to provide a contextualized reading from the point of view of that private experience within your particular subculture. Discover ways to express an understanding of the social rituals of your group that allows you to deliver intimate, firsthand accounts of the group's values. This offers a view from within rather than a gaze from without. There should be a sense of comfort, ease, and openness between the subject and the photographer. These pictures will be a result of the photographer's bond to the group, which provides an innate sense of trust with the subjects. Through such work groups can begin to reclaim control over their own image by modifying misrepresentations that have been previously placed in circulation.

Try concentrating on specific rituals that provide your group with a common, cohesive experience. Ritual is an act of bonding. It provides a way for us to forge a loyalty that transcends our individuality. It is a uniting force that allows us to blend into a community that shares common ambitions, despairs, dreams, passions, and values. It reveals how the act of photography can supply the power of ownership over how our visual image is defined.

Make photographs that question historical depictions and in turn realize and discover your group's stories. Reject being embarrassed by cultural features that do not fit into mainline esteem. Examine a heritage that may have been intentionally concealed out of shame and ridicule. Ask the question: What does it mean to be a member of this specific circle?

The results are often private stories, based on personal involvement within a specific community, that have the capacity to expand outward, encompassing the universal in a narrative tradition that embraces the collective of human nature. Such work can function as an act of reclamation and provide a new telling by recognizing that the earlier legends were incomplete. It also implies that community is an ongoing process that requires the participation of each new generation to keep the story alive and relevant. The picturing and preserving of rituals extends the time that the participants can spend celebrating and contemplating their own values. Your images can proclaim that what is of worth is of our own creation, thus recognizing differences through the process of deconstructing myths. This picturing of core experiences can provide an infrastructure of social events that becomes part of the group's consciousness. This alteration in self-perception can help provide the strength and confidence necessary to reformulate a community's social identity.

The Human Form

The human body has proved to be a challenging and controversial subject since the beginnings of photography. Some of the interest in the human body has been solely prurient, as in the making of pornography. But the nude has long been a venerable subject for artists. The vitality of the genre can be seen in the diverse ways that the human form has been portrayed: beautiful, delicate, soft, whole, inviting, sculptural, hard, unavailable, horrific, broken, fractured, faceless—the list goes on.

In the early nineteenth century, the traditional male nude became a taboo subject. Photographers, like other artists, began to concentrate on the female form. It was considered objectionable to show pubic hair or frontal male nudity, a convention that is still enforced in many areas. The male form has been reintroduced into the public arena only relatively recently, often with much outcry.

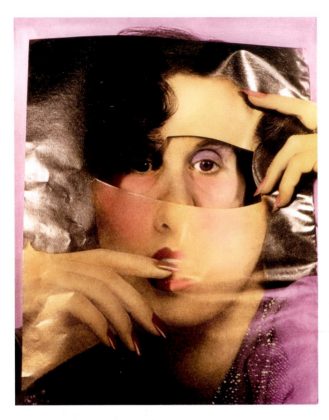

Figure 13.8 Judith Golden created a composite mask in which her own face peeks through a partially torn and crinkled fashion magazine photograph to explore the effects of advertising on popular beliefs and fantasies about women. She thus points to the way women are defined by youth culture and the fear of aging. Her layered technique generates a sense of temporality in relation to personal history, implying that the construction of the present self is the result of past actions.

© Judith Golden. *Rhinestones*, from the series *Magazine Makeovers*, 1976. 14 × 11 inches. Gelatin silver print with oil paint and glitter.

Problem Solving

Study how photographers such as John Coplans, Lee Friedlander, Nan Goldin, and Edward Weston have approached the human form. Observe how they reference the figure according to cultural, political, racial, and sexual orientation. Then select whether to work with a female or male, young or old model. What environment will you place your model in? Decide what is important to reveal and how you can go about it. Do you want to show the entire figure or part of it? Is it going to be realistic or abstract? Should the color scheme be cool or warm, high key or low key? Is the sense of texture important? Will soft, indirect light, good for revealing subtleties of form through tonal graduations, be effective? Or would stronger, directional light, creating more contrast, darker shadows, and a bolder, more graphic mood, meet your intentions? What mood do you want: innocent, dramatic, sensual, romantic, erotic, secretive, provocative, vulnerable, loving? How can choice of lens focal length and position be employed to create this psychological effect? Should focus be sharp or diffused? What type of background will work? Will you include props, and if so, what is their purpose and meaning? Pick a human form that personifies your idea. Establish a good working rapport with the model(s). Explain to the model what you are looking for, what message you want to convey? Offer direction, but be willing to take suggestions. Leave any hidden agendas or expectations somewhere else and concentrate on making photographs.

For more information on the human form see William Ewing (ed.), *The Body: Photographs of the Human Form* (San Francisco: Chronicle Books, 1994); Michael Gill, *Image of the Body: Aspects of the Nude* (New York: Doubleday, 1989); and John Pultz, *The Body and the Lens: Photography 1839 to the Present* (New York: Harry N. Abrams, 1995).

Landscape Defined

The term landscape originates from the Dutch word *landschap*, meaning "landship." It represented a segment of nature that could be taken in at a glance, from a single point of view, and encompassed the land as well as animals, buildings, and people. In *Discovering the Vernacular Landscape* (1984), John Brinckerhoff Jackson defines the landscape as an artificial collection of man-made spaces on the earth's surface that have been devised to meet the human need of organizing space and time.[2] Since the nineteenth century there has been an aesthetic movement to separate nature from humanity. The images from publications such as those of the Sierra Club, that glorify a pristine, unpeopled, and transcendental nature, have come to be the publicly accepted definition of the landscape. John Szarkowski, former Curator of Photography at the Museum of Modern Art in New York, said that people are thankful to Ansel Adams because his pictures stirred our collective memory of what it was like to be alone in an untouched world. This may be, but such a view does not address the kind of everyday landscape in which most people live.

Traditional Viewing Concepts

Many people still see the landscape through the English-gentleman concepts of the sublime, the beautiful, and the picturesque as presented by Edmund Burke and John Ruskin.[3] The *sublime* reminds us of our own mortality in a larger and often frightening world. Briefly, some of its major aspects include astonishment,

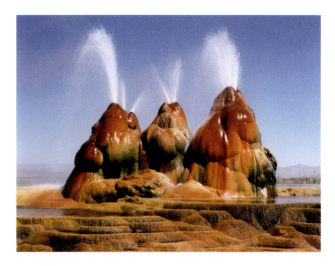

Figure 13.9 For decades, Peter Goin has been using photography to explore human presence in the American landscape. He tells us, "The process of making these photographs has become for me a journey of rediscovery. Having spent more than 20 years traveling into the Black Rock Desert in Nevada, I have come to realize that this arid, often inhospitable, and unforgiving landscape possesses a character both spiritual and sublime … At any moment, there may not be one person within 10 square miles, yet every step reveals human history."

© Peter Goin. *Fly Geyser*, from the series *Black Rock*, 2005. 16 × 20 inches. Chromogenic color print.

confusion, darkness, infinity, monsters, obscurity, silence, solitude, terror, and vastness, with its major colors being blacks, browns, and deep purples. The quality of light can be intense and directional with great play between the shadows and highlights. The *beautiful* was less strong, being rounded, smooth, and well proportioned without surprise or terror and reminds us of fertility and life (the pastoral). It was admirable but was not as capable of arousing such great passion. The colors of beauty tended towards the warm hues and favored a softer, more diffused light. A series of motifs used by artists wishing to elicit known responses from the audience, the *picturesque* provided a structure for seeing what in nature would make a good picture. Far less threatening than the sublime, it provided a more complex view of nature based on the then-popular ruin of the world theory. Typical picturesque subject matter featured shattered trees, rotten stumps, overgrown foliage, rushing brooks, and tumbled-down structures. Detail and texture were of paramount concern when used within the confines of compositions conforming to academically approved rules of painting.

For over a hundred years, Gustave Courbet's so-called realistic landscapes, emphasizing subjects of immediate, preordained appeal, served the public as the exemplifier of many of these notions, including the one that nature had to be improved upon in the interest of the ideal. Although Courbet stated "painting is an art of sight and should therefore concern itself with things seen (Show me an angel and I will paint one)," it nevertheless was considered vulgar to portray what one saw. In *Landscape Into Art* (1956), Kenneth Noland cuts through the numerous falsehoods surrounding Courbet's concentration on the tangible reality of things with his observation that Courbet "cheerfully substituted a false sensation for a real one, and the remarkable thing is that his false sensations are exactly those which have satisfied the popular eye ever since."[4] Such academic guidelines of "good taste" continue to influence us today with models and expectations of how photography should be judged.

Photography and the American West

Beginning with Solomon N. Carvalho's (now lost) daguerreotypes made on the 1853 Frémont expedition, photography has been the instrument that awakened America to the sublime and mysterious landscape of the "West." Throughout the twentieth century and beyond, photography has been the keeper of the flame, shaping the ideas and perceptions of the Great American West. The major religions of the Western world were all born in the wildness of the desert. In *The Satanic Verses* (1988), Salman Rushdie harkens back to the ancient Hebrew idea of the desert as a place of purification, testing, and revelation when he observes: "God is in the desert."[5] So too in America, God must be in the West. The American West has become a visual concept for a spacious, waterless, wonderland of repeating geometric shapes, dominated by a horizon line where the earth meets the sky. It is a place of personal freedom that is also cruel, harsh, bright, clean, sharp, and completely unforgiving; one wrong move and you could be in serious danger. This wild and tough image that dominates the American psyche and character has been generated by photography and has become a major cultural export.

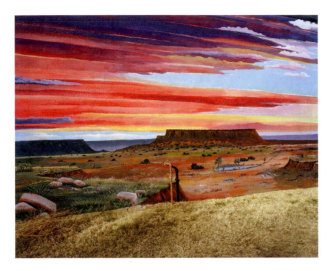

Figure 13.10 Jeremiah Ariaz uses a medium-format Mamiya 7 to explore the once prominent Route 66 stopping point of Tucumcari, New Mexico, which travelers can now bypass on Interstate 40. The artist tells us, "These photographs were made along the transportation routes—railroad, highway, and interstate—that brought prosperity to the high plains settlement. Each new route has made the one before obsolete … I have created a portrait of this New Mexico town by weaving together images of the people and places along these prominent pathways. The phenomenon of dislocation and depopulation is common in towns across America, but in Tucumcari the loss is particularly acute. Though focused on one town, I strive to tell a larger story, one of westward expansionism, struggle, and hope."

© Jeremiah Ariaz. *Sunset, Main St between 3rd St and 4th St*, from the series *Tucumcari*, 2008. Variable dimensions. Inkjet print. Courtesy of Dolphin Gallery, Kansas City, MO.

The Landscape Today

Contemporary landscape has broader parameters than in the past. The successful landscape can convey a sense of time, place, and human experience. Some pay homage to the beauty and grandeur of nature by making views that give the audience a sense of actually looking at the scene without any political message. Today many photographers specialize in recording how the landscape is shaped by human presence (the social landscape), combining ethics and aesthetics. More and more, the landscape becomes a site to express the personality, ideas, and social/economic/political concerns of the photographer. Here the quest becomes making the unsavory truth, the thing we would like to ignore, into something that challenges the viewer and provokes thought within the landscape tradition. In his book *Why People Photograph* (1994), Robert Adams comments:

> If the state of our geography appears to be newly chaotic because of heedlessness, the problem that this presents to the spirit is, it seems to me, an old one that art has long addressed. As defined by hundreds of years of practice—I think history is vitally important—art is a discovery of harmony, a vision of disparities reconciled, of shape beneath confusion. Art does not deny that evil is real, but it places evil in a context that implies an affirmation; the structure of the Creation, suggests that evil is not final.[6]

These are all legitimate means in which to consider the landscape. Regardless of which approach you take, there are a number of basic considerations to think about.

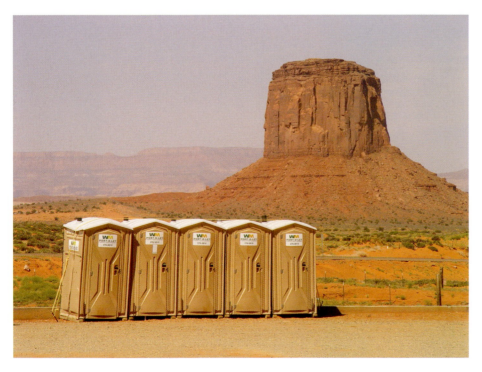

Figure 13.11 Bill Owens made this photograph examining the theatrical elements of everyday life during one of his cross-country road trips. Working loosely in the vein of documentary photography, he makes seemingly straightforward images that explore the often-humorous contradictions of American culture. Here, through the use of juxtaposition, Owens presents the ridiculous human decision to place portable toilets directly within a sublime landscape.

© Bill Owens. *Monument Valley*, 1998. Variable dimensions. Inkjet print.

Problem Solving

Basic Working Considerations

Decide what your landscape subject is, and then spend time looking at the subject and determine the essential qualities you want to convey. Now consider these points:

What type of light and recording media will best realize your ideas? Would low, directional light, revealing pattern and/or texture, be effective or would a clear, hard, contrasty midday light show the qualities you find essential?

Identify the key colors and decide the most effective method to convey them.

Would a short, wide-angle length, emphasizing a great deal of depth with an exaggerated foreground, be effective or would a long telephoto focal length, concentrating on detail, compressing and foreshortening the space, do the job? Would a detail shot or a panorama better express your idea?

Should the point of view be horizontal, vertical, or oblique?

Using your camera position, how should you compositionally control the spatial relationship of the foreground, midground, and sky? Should the sky or the ground dominate? Do you want a dramatic or naturalistic point of view?

How can perspective be applied to draw the viewer into the scene?

How does setting up spatial relationships affect the psychology of the picture?

Which key elements will be used to determine how to control the exposure? Will a filter, such as a polarizer, add strength to the image?

How will you convey a sense of scale? Do you want to use a human figure as a contrast to the size of natural forms? Or would it be better to play natural shapes off one another? Remember, the human figure is visually very powerful and immediately attracts the viewer's eye.

What type of focusing techniques will be employed? Will you go for maximum depth of field or make use of selective focusing to direct the interest of the viewer? Is it necessary to clearly separate the subject from busy or confusing surroundings?

How should the print be made? What would happen by increasing or decreasing the exposure time? What about burning, or dodging, including edge burning?

Is one image enough or would a group or collage/montage/PowerPoint/website be more effective?

How will presentation affect the viewer's response?

Follow up: Make and carry out all your initial decisions. Then return to the same subject and begin to reconsider your first thoughts. For instance, how would changing the angle of view or extending the exposure time affect the outcome? Make a new group of pictures based on your second group of thoughts. Compare the two. Are your first ideas always the best? What did you learn from the second effort? What would you do differently if you photographed the scene a third time? Keep asking questions and trying new ideas until the results are satisfying. When we think of making landscape photographs, we think about traveling somewhere, taking a voyage. The curiosity of exploration has been responsible for many of the concepts we hold about the landscape. But what do such images reveal about the inner journey of the photographer? Do we go outside in an attempt to discover what is within?

For additional information see Estelle Jussim, with Elizabeth Lindquist-Cock, *Landscape as Photograph* (New Haven, CT: Yale University Press, 1985); Simon Schama, *Landscape and Memory* (New York: Alfred A. Knopf, 1995); and Peter Pool (ed.), *The Altered Landscape* (Reno, NV: University of Nevada Press, 1999).

The Power of Nature: Visceral vs. Theoretical

Most photo-based imagemakers do not spend much of their time discussing Hegel, Descartes, or Derrida. What they do discuss is what work gets shown in the major venues and what work is ignored. Over the past few decades photography's critical dialogue has been dominated by European academic theoreticians whose postmodern philosophies appear to maintain that there is greater value in the role of the interpreter than that of the maker. Intolerant of nonpolitical interpretations and any nonmaterial focus, such deconstructionists disallow any firsthand experience of aesthetic pleasure. Their theories are a continuation of the mechanical philosophy of the seventeenth and eighteenth centuries in which people are viewed as isolated (alienated) observers and not as active participants in the cosmos. Their aloof academic approach deconstructs American mythology but replaces it with nothing, leaving a void without a sense of community or hope. Theirs is the art of elite specialists, divorced from the public, who delve into the relationship between art and the idea of art, but not art as a revelation of nature. For them, art is not an investigation of nature, but an investigation into the nature of investigation.

The mainline puritanical underpinning of American culture and politics makes it vital for artists not to throw up their hands and say they have no answers, for to do so is to cede societal and spiritual issues to old school principles. Under such circumstances, it is imperative for artists to offer countermeasures that deploy their essential humanistic strengths and engage in deploying the power of nature as an effective weapon against blaming, stereotyping, and pretentious, hypocritical standards.

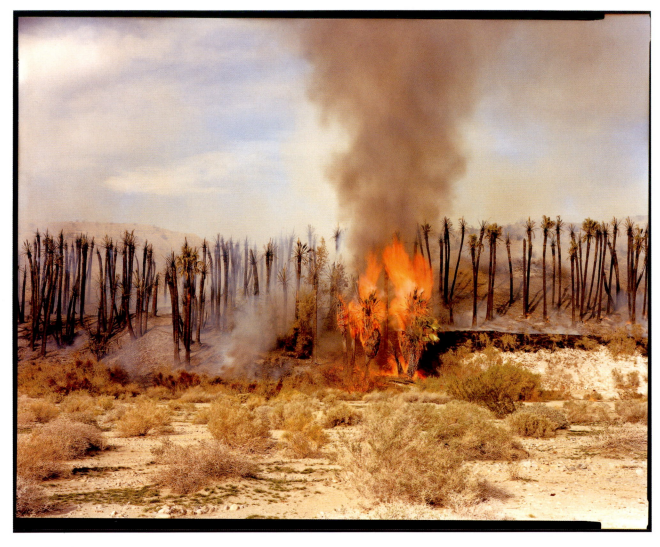

Figure 13.12 Moving away from the tradition of landscape photography that sets out to idealize and glorify our ideas of nature, Richard Misrach's images of desert fires focus on the dueling forces of destruction and restoration to document the permanent and often negative effects that human intervention has on the landscape.

© Richard Misrach. *Desert Fire #1*, 1983. 20 × 24 inches. Chromogenic color print. Courtesy of the Catherine Edelman Gallery, Chicago, IL.

Problem Solving

Launch a cognitive and holistic investigation stressing a full participatory relationship with your subject as a way of knowing. Concentrate on a visceral rather than a theoretical approach to the work. Engage your body as well as your mind and celebrate the intimate connections between humans and nature. Search for methods that blend the emotional, intuitive, sensual, spiritual, and intellectual. Stop, think, and savor the beauty and strangeness of things. Strive to represent the great metaphysical struggle of our culture: reconciling our mind with our spirit.

Inspect how artists, such as Andy Goldsworthy, David T. Hanson, Rachel Rosenthal, and Tim Rollins, expand the ecological perspective, reclaim archetypal and mythic spiritual resources, and engage a revitalized sense of community.

Now turn it around and represent the same subject emphasizing the theoretical point of view. Which approach works better for you? How does the audience response differ? Under what conditions does one approach work better than the other?

Still Life

A photographer can undertake exciting explorations without traveling to exotic, far-off places. The studio can provide a setting for contemplating visual problems. The tradition of still-life was established in the beginning of photography by Daguerre and Talbot and can be traced back to sixteenth-century painting. Today still-life is pursued in both the artistic and commercial photographic communities and has laid the infrastructure for advertising and product illustration photography. The challenge is to build an image, from the camera's point of view, that delivers a distinct outcome.

Close-Ups: The Macro Lens

Some people wanting to flatten the pictorial space photograph still-life setups with a DSLR or SLR camera equipped with a macro lens and find the results unsatisfactory. This is because a macro lens with its flat-field optics, which are designed to give a nearly flat image surface to accurately match the sensor or film surface at the focal plane, lack depth of field. They would likely achieve what they are looking for with a slight telephoto lens (85–135mm) set at an open or moderate aperture. The macro lens is excellent for doing flat-field work, such as copying original prints, but even stopped down to f/32 it will probably lack the depth of field often deemed critical in still-life work. However, it has been used successfully in food photography. The shorter focal length macro lenses (in the 50–60mm range) provide more depth of field at any given aperture than their longer focal length (100mm–plus range) counterparts. The same depth of field problem also will be encountered when using add-ons such as a close-up lens, reversing ring, or extension bellows. If this is not acceptable, consider using a view camera because its adjustments, swings, tilts, and rising front, allow precise management of depth of field.

The macro lens also can serve as a postmodern tool. Try re-photographing small sections of images using intrinsic photographic methods such as angle, cropping, focus, and directional light to alter the original's context and meaning. These new images also can be digitally manipulated.

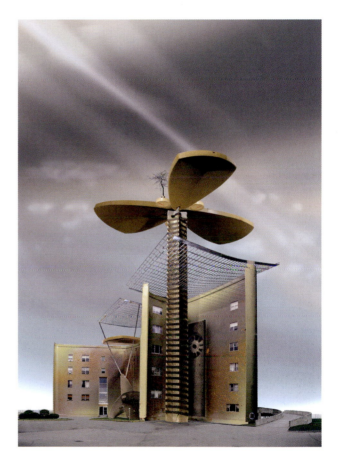

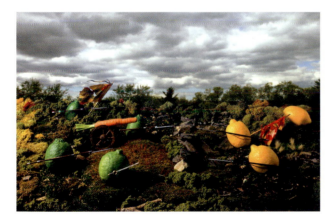

Figure 13.13 This still-life was constructed from two images: A foreground that includes a lemon-and-lime military diorama and a background landscape built with railroad models. Jeffu Warmouth used a large-format camera and studio lights to photograph the foreground, which he digitally combined with a background landscape captured with a Nikon DSLR and available light. Warmouth states, "Humor is a defense against fear; the ironic and the ridiculous allow us to challenge and subvert oppressive systems, and to assert our own humanity. I use puns, gags, and comic twists to stimulate and challenge the viewer's expectations, to reveal the gap between our structuring of the world and our experiences of living in it, and above all, to poke fun."

© Jeffu Warmouth. *The Battle of Lymonsburg*, 2008. 16 × 24 inches. Inkjet print.

Figure 13.14 Relying on focus stacking, which joins multiple images taken at different focal lengths to create a composite image with a greater depth of field, David Trautrimas utilizes a macro lens to make his still-life photographs. He photographs individual machine parts and components in his studio, using 500-watt work lights to illuminate his basic set. The artist then layers the images in Photoshop to create a composite image, drawing from his archive of architectural and landscape images taken throughout Toronto for the structural and background details. Trautrimas tells us that his *Habitat Machines* work "alludes to a greater architectural doctrine" and explores "strikingly original structures that are paradoxically familiar by virtue of their origins."

© David Trautrimas. *Space Heater Place*, from the series *Habitat Machines*, 2008. 20 × 28 inches. Inkjet print. Courtesy of Photo-Eye Gallery, Santa Fe, NM, and LE Gallery, Toronto, ON.

Problem Solving

Still-Life Deliberations

Search the Web to look at work done for artistic and commercial purposes by photographers and artists using other media, especially painting. Analyze what attracts and repels you to certain images. Consider taking a simply done advertisement and duplicating it to learn some of the basic technical problems of making a still-life. Now formulate your own still-life vision. Select a theme that will provide structure for your entire undertaking.

Still-life affords the opportunity to control all the elements within the composition. You can work entirely alone, setting your own pace, without the distractions and problems characterized by working with live models. Working with still-life can provide a sense of privacy and meditation that permits a great deal of concentration. Collect and organize your objects and props. Think about how to best organize these objects to create an effective color relationship that will generate emphasis. Select a location. It can be the corner of a room or a larger studio space. It can be beneficial to use a spot where the setup can be left undisturbed. This allows you the time to study, linger, and interact with your construct before shooting. It also lets you go back and make adjustments after the first round of photographing has been completed. Pick the background setting. It may be a seamless paper or a personal construct. Play with the objects. Stay loose and try different compositional arrangements. Look for combinations of colors, shapes, and textures that promote the theme. Once the composition is set, decide what are the prime factors to be revealed.

Which recording medium's characteristics best suit the needs of this still-life? What role do camera and lens focal length selection play in the final outcome? Is precise detail important? If so, consider using a view camera because its adjustments, swings, tilts, and rising front can increase the control over the final image, especially controlling depth of field.

What type of lighting is required to accomplish your goal? Should you use natural, artificial, or a combination of both types of light? Will more than one light be needed? Start with only one main light. What direction should it come from—front, side, top, or bottom? Are reflectors or diffusers required? Use a second light only to bring out the background or reduce shadows. Watch out for double shadows when working with two lights, because overlapping tends to make visual confusion. What about filters or colored gels? What type of psychological atmosphere do you want to create? Where and how should your exposure reading be determined?

The direction and quality of light is determined by numerous considerations such as the mood, the message, and personal aesthetic tastes. The challenge in lighting is to reveal the natural properties of what is being photographed. Opaque, translucent, and transparent objects each require special considerations. How the combination of these properties is handled determines whether the composition seems to glow with a lifelike aura or whether it remains flat and lifeless.

How will the final piece be presented? Will postvisualization techniques, including digital enhancement, help to strengthen the message?

Extension Tubes

Extension Tubes permit a lens to focus closer than its normal fixed minimum focusing distance, thus magnifying the subject and therefore making them useful for macro work. They allow you to convert most lenses into a macro lens while maintaining the optical quality at less expense than buying a macro lens. The better quality models, such as Kenko, transmit all the exposure and focus data between the lens and the camera body.

Internal Color Events:
Evoking Inner Realities

Photography is the medium that is used to tell people about their world, and is the prime communicator of human emotion. Photography is with us in our daily lives through the Internet and traditional media sources. It reaches out in all directions, even encompassing those who do not want to be touched. Yet many people still seem to think of photography only for its documentary abilities.

For this project use the camera to probe the inner realities of your mind rather than the outer reality of the street. Do this by making images that *evoke* an interior state of consciousness and grapple with a subject beyond its external physical structure. This approach can be likened to the Japanese concept of *shashin*, which says something is only true when it integrates the outer appearance with the inner makeup of a subject. American writer Herman Melville referred to the purely surface view of reality as "a pasteboard mask." Such an intricate façade conceals the intuitive world of the *thing in itself*—a deep structure of cultural, political, and psychological models that inform the realities behind or beyond what we can detect with our five physical senses—an idea dating back to Plato's concept of delving into the complex, many-sided, interior panorama of the world. From this position, make images that suggest a sense of walking at sundown, observing that there is not an abrupt border between day and night. Strive to represent the complex and often-indistinct progression that is filled with twists and turns, a penumbra of counterpoints, subtlety, and false appearances—an infinite matrix of compound tales of the sensation of being human.

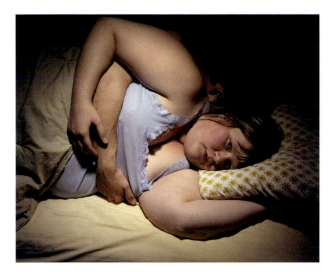

Figure 13.15 Jen Davis took this self-portrait using a long cable release that she carefully hid in the frame. To fabricate the scene, she staged a bedroom environment, lit from above, and used an extra tripod for additional height in the frame. Davis tells us that in this image, which evokes an inner reality, "I deal with my insecurities about my body image and the direct correlation between self-perception and the way one is perceived by others … In my photographs I aim to raise questions regarding beauty, desire, body image, and identity through a focused observation of my personal story … My work is partially based on personal experiences that I have re-constructed into a photograph, and the other part consists of made-up fantasies of what I imagine a physical relationship to be regarding intimacy, love, and desire."

© Jen Davis. *Fantasy No. 1*, from the series *Self-Portraits*, 2005. 24 × 20 inches. Chromogenic color print. Courtesy of Lee Marks Fine Art, Shelbyville, IN.

Fabricating Photographic Reality

The photograph is a major part of our decision making process. Its inherent ability to transcribe external reality enables it to present what appears to be an accurate and unbiased validation of a scene. While photography is expert at expressing events, it also subtly interprets events by constantly interacting and integrating with the current values of the society at large. In reality, the so-called impartial lens allows every conceivable distortion of reality to take place (Figure 13.16). Even in the Photoshop age people continue to believe in the authority of the photograph. Traditionally, we knew painters inserted objects or left things out of the original scene to depict a scene from their imagination and photographers were not supposed to do that. Digital imaging has blurred this profound psychological difference between photography and painting, yet we continue to bestow on the photograph the power of authenticity. We want to believe photography can recreate the original scene with absolute fidelity because this makes us feel better. It rescues and saves the past, often lending it dignity and romance, and makes us feel a little less mortal.

Make a photograph that uses the power of color to deal with each of the following themes:

1. Produce a picture of something that bothers you or that you find disturbing. Use your fears or neuroses for a chance at development and growth. Consider these possibilities: Can your pictures be used to confront something that makes you unhappy? Is it possible for the act of photography to lead to a new understanding of this situation? Can a picture increase your knowledge of the world? Can the act of picture making produce a change in your attitudes about something or make you more sympathetic to a particular cause? Do not be like the dog that runs in circles chasing its own tail. Use the picture-making experience to break out of your habits and routines and see anew.

2. Construct a photo of an inner fantasy. Let your creative energy spring from yourself. Your own ideas and experiences communicated directly to another are always more important, instructive, and powerful than the secondhand imitation of someone else's style. Let it out in your imagemaking. Keeping all this inside can make you aggressive, crabby, irritable, or depressed. People can become intolerable when they cannot be creative. Bring forth yourself.

3. Construct a photograph or a series of photographs that recall an important aspect of a memorable dream. It is okay to set things up to be photographed. You are the director. Do not accept what is given if it is not what you want. Take charge. Do it your way and do it right.

4. Use photography to politicize a social issue that you feel strongly about. Such topics can deal with war, the environment, women's issues, people of color, or illness. Address issues with which you have direct personal experience. Ask yourself if these images are being made solely to express your own feeling or do you want other people to seriously consider adopting your position? Approaches can be varied to meet the needs of specific viewing groups. Think about the type of response and reaction you want the viewer to have. This may be new material or something the audience does not completely understand. If you want them to be sympathetic, figure out a way not to alienate your audience. If this is of no consequence, then fire away.

5. Make use of photographic means to portray a psychological drama. What is it you want to suggest? Do you need a literate, explicit narrative or can your concepts be implied? Are you raising questions or seeking answers? What do you want your audience to realize?

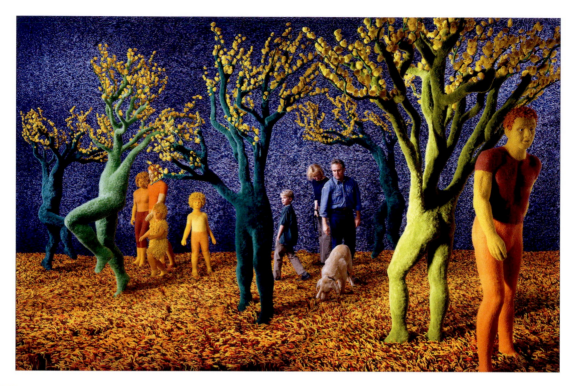

Figure 13.16 Sandy Skoglund, known for her photographic fabrications, tells us, "In this world of violent kitsch taking over and subverting our culture, I feel the most important thing that I can do as an artist is to communicate my touch, whether ironic or not. This work is a handmade landscape of continuously unfolding forms of softness, contradicting a disquieting forest made of artificial constructs. Within this landscape made of pipe cleaners and felted wool, there is a drama between people who constitute families. The boundaries of animal and plant hybridization arise in the form of trees that have legs and fur. The purpose is to create a one-time-only photographic event, constructed with the maximum amount of determinism and detail possible, as if to dare fortune to interfere with the relentless pursuit of perfection by the human will."

© Sandy Skoglund. *Fresh Hybrid*, 2008. Variable dimensions. Inkjet print. Courtesy of Galleria PaciArte, Brescia, Italy.

This raises an important issue confronting the contemporary worker. In the past, most photographers went out and "found" things to photograph in the natural world. Today a sizable segment of the photographic community has rejected this notion that the only "real" photograph is a found one. In order to achieve and show their concerns many people create and stage productions whose sole purpose is to be photographed. People, animals, and objects are collected and arranged, sets may be painted, and lighting can be altered and/or controlled. The photographs are made and the stage is struck, leaving no evidence, except the photograph, that the event ever occurred. The final result may not even be a traditional two-dimensional representation but rather a three-dimensional installation.

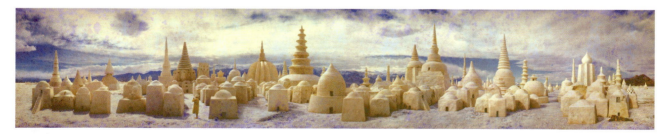

Figure 13.17 To fabricate photographic reality, Nicholas Kahn and Richard Selesnick constructed numerous small clay maquettes, arranged them on a set in Death Valley, and photographed them with a medium-format camera. They made three exposures of each scene to get the foreground, middle ground, and background, and then composited the images in Photoshop. Realizing that they had not made their fabricated city dense enough, the artists layered buildings from additional photographs into the digital amalgam. Kahn/Selesnick pose the question, "What lies beneath the city, beyond its ornate façade? Are not all cities the same, the transient crowd forever in motion, the bustling railway terminus or the airport desk, a place that is not a place, where there is no 'there' or 'here.' And yet, the lure is universal—can you not see it?"

© Nicholas Kahn and Richard Selesnick. *City of Salt*, 2001. 8 × 44 inches. Inkjet print. Courtesy of Yancey Richardson Gallery, New York, NY.

Problem Solving

Fabricate your own environment. Arrange the existing objects, rooms, space, and light to create an environment for the sole purpose of photographing the manipulated event. Digital software may be used to enhance your effect, but *not* as the source of creation. What questions does this raise in your mind about the role of the photographer, the use of the photograph, and the subjective nature of the medium? What impact has digital imaging had on the believability of the photo-based image?

For more information see Anne H. Hoy, *Fabrications: Staged, Altered, and Appropriated Photographs*. New York: Abbeville Press, 1987.

Words and Photographs

In Western culture we are surrounded by words. More and more through the media we find that the combination of pictures, screens within screens of images, and text simultaneously compete and play off each other. With separate sets of symbols the brain is forced to deal with contending sets of messages. This juxtaposition can be used to effectively convey additional straightforward information, humor, irony, and surreal spatial arrangements or to create conditions of fantasy and meaning impossible with only one set of symbols. The combinations give the artist more power to delve into psychological relationships, while also showing the major characteristic of photography—its adaptability in a multitude of situations. Notice how dependent the meaning of the image is on its accompanying text. Wright Morris, who spent more than 50 years investigating the wily synergy between words and photographs said: "The mind is its own place, the visible world is another, and visual and verbal images sustain the dialogue between them."

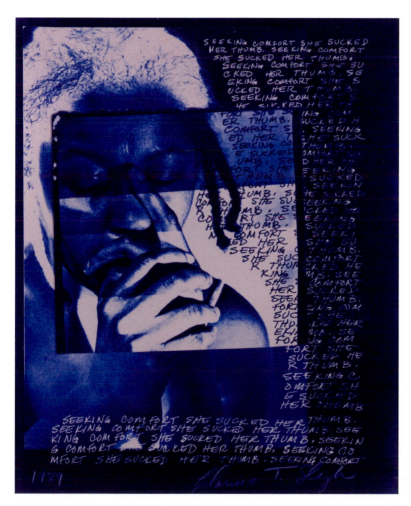

Figure 13.18 As the keeper of her family album, Clarissa Sligh began examining the differences between the accepted impressions of the family snapshots and her memories of the secrets hidden behind the public posturing. The combination of these visual memories with handwritten text becomes a way for Sligh to bridge that gap and examine the forces that shaped her identity. The obscuring of information demonstrates how we often must grapple to get the correct information. The process becomes one of empowerment, allowing the artist to push beyond the restraints of an identity projected by society onto her and other African Americans.

© Clarissa Sligh. *She Sucked Her Thumb*, 1989. 14 × 11 inches. Cyanotype with mixed media.

Problem Solving

Think of situations where text can be used with a photograph. A good way to practice and gain experience with this is by doing collages, both manually and digitally, and appropriating (using) found images and text. After completing this exercise, contemplate making your own image-and-text combinations. Analyze some classic graphic novels, such as Art Spiegelman's *Maus* (1986) and Charles Burns' *Black Hole* (2005), which resourcefully develop a corresponding relationship between images and words. Also, look at photo-based artists, such as Duane Michals, Barbara Kruger, and Shirin Neshat, whose work incorporates image and text.

Consider some of these ways to use pictures and text:

Include words within the original camera image.
Cut text from newspapers and magazines or generate on a computer and glue it on the photo.
Add text with press-on letters.
Use a rubber stamp set.
Write directly on the image.
Incorporate other digital or photographic methods for the addition of text.
Set the text separately from the image in the form of a caption or box of text.

Use text to expand the original meaning of the image.
Use text to drastically alter the original intent of the image.

What do you notice happening when you combine pictures and text? Does one overwhelm the other? Do you want to strike a balance between the two? Is there a blending or a duality of the two symbols? Should you give more weight to one than the other? How does the addition of text affect the direction in which you read the work? Which do you read first? In a literate culture which has more importance? How can you effectively play one off the other? If you want to ensure the supremacy of the photograph, use your words as a support and not as a crutch to hold up a weak photograph. Let them supply information that enhances your imagery. If this is not a concern, create arrangements that challenge the traditional relationships between pictures and words. How does the meaning of an image change when text is added or the original text altered? What role can different hues and saturation levels play? What differences in effect do you see between digital and manual ways of working? Finally, as a photographer, how important is it to be led by images, the internal visual impulse, as opposed to words?

The combining of images and text can be an attempt to get past the barriers between visual and spoken language. We tend to think in pictures, but in order to communicate we generally have to transform these images into thoughts and the thoughts into language. During this process the flexibility, plasticity, and texture of the image is often a casualty. This process is further complicated as viewers translate this collection back in their minds. Translation errors and personal bias make it unlikely the received message will exactly match what was sent. Marcel Proust believed we pack the physical outline of what we see with our own previously formed ideas so what we essentially recognize (or don't) is ourselves, and this is also why we fall in love with our own creations.

Photographs from a Screen

Making pictures from a television screen or monitor offers a photographer the opportunity to become an active participant in the medium instead of being a passive spectator. The camera can be used to stop the action on the screen or extend the sense of time by allowing the images to blend and interact with one another. The literalness of photographing directly from the screen is both its strength and weakness.

Hand-Altered Photography: Flexible Images

Digital imagery has furthered acceptance of the fundamental ideas of handmade photography, that the photograph is not necessarily authentic and that it may legitimately be manipulated to express a range of ideas. Artists working in these methods favor flexible, experiential methods that question conventional photography, to convey internal realities, and to critique history and the concepts of truth and self.

They find handwork attractive because it promotes inventiveness, allows for the free play of intuition beyond the control of the intellect, extends the time of interaction with an image (on the part of both the maker and the viewer), and permits the inclusion of a wide range of materials and processes within the boundaries of photography. They think that a flexible image is a human image, an imperfect and physically crafted one that possesses its own idiosyncratic sense of essence, time, and wonder.

The first color photographs made their appearance in the form of hand-colored daguerreotypes. This was done to correct for the fact that all the early photographic processes lacked the ability to record color. The demand for color was greatest in portrait work. Miniature painters, who found themselves increasingly unemployed by Daguerre's process, met the need by tinting daguerreotypes and painting over calotypes (the first photographic negative/positive process done on paper). In England the public seemed to have a preference for the "two penny coloured" pictures as opposed to the "penny plain." The hand coloring of black-and-white photographs continues to be practiced by commercial photographers, after more than 160 years.

Today, hand-altering the negative or print allows you to circumvent convention and explore ideas that would not normally find their way into current photographic process. It pushes the boundaries and limits of photography, enabling you to achieve a unification of materials, practice, and vision that is not possible in standard practices. Hand-altering lets you introduce

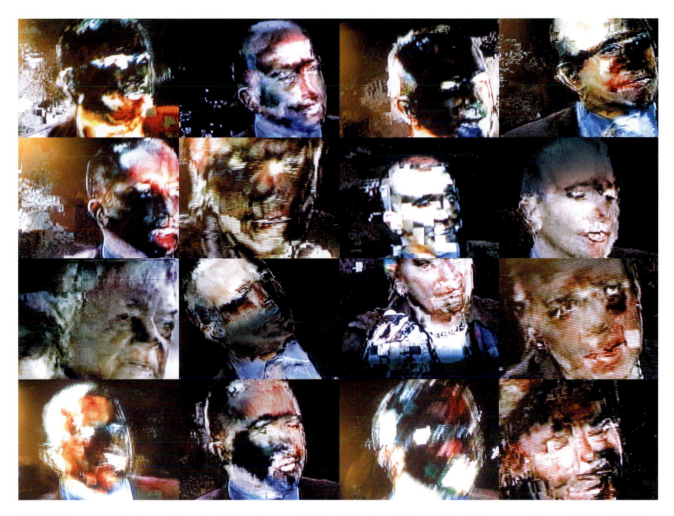

Figure 13.19 To create this photographic collage, Barbara Crane used a Nikon DSLR to shoot 20 pictures off a television screen. She assembled the individual images into a grid and printed the composite photograph. Crane says, "I enjoy not having total control, and embrace mistakes or technical accidents as treasures to pursue with seriousness. The subject matter plays an active rather than passive role in my picture-making. While technique and photographic equipment are a support for my visual ideas, the transformation of subject matter is of primary importance."

© Barbara Crane. *Heads Grid*, 2009. 25 × 32½ inches. Inkjet print. Courtesy of Stephen Daiter Gallery, Chicago, IL.

Problem Solving

Making Photographs from a Screen

To make pictures from a television or monitor screen try following these steps:

1. Make certain the screen is clean.

2. Place the camera on a tripod. A macro or telephoto lens can be used to fill the entire frame or to work with a small area of the screen and minimize the distortion produced by a curved screen.

3. Turn off the room lights and cover windows to avoid getting reflections on the screen. A black card put in front of the camera, with a hole cut in it for the lens, helps to eliminate camera and other reflections. If available, use a "hood" device (designed to capture images directly from a computer screen) with a camera attachment to cover the screen area and block out ambient light.

4. Adjust the picture contrast to slightly darker (flatter) than normal for an accurate, straightforward rendition.

5. Adjust the color to meet your personal considerations.

6. Most monitors generate a new frame every 1/30 of a second. If the shutter speed is higher than 1/30 of a second, the leading edge of the scanning beam will appear on the picture as a dark, slightly curved line. If you do not want this line, a shutter speed

Problem Solving—Cont'd

of 1/30 of a second or slower should be used. Experiments should be carried out with shutter speeds of 1/15 and 1/8 of a second since the shutter speeds of some cameras may be faster than indicated. If the image being photographed is static or can be "frozen" on the screen, try using the slower speeds to ensure the frame line is not visible. Cameras with a leaf-type shutter may synchronize better with the monitor's raster lines.

7. Once the correct shutter speed is determined, make all exposure adjustments by using the lens aperture.

With daylight-balanced color film, the resulting image will probably have a blue-green cast. This may be partially corrected by using a CC30R, CC40R, or 85B filter, with appropriate exposure compensation, at the time of initial exposure.

Experiment with different White Balance settings.

Different films deliver a variety in color renditions due to each film's spectral sensitivity and dye-image formation system. If color film is used to photograph a black-and-white monitor, the resulting image may have a blue cast.

If no screen lines are wanted, the image will have to be captured by using a film recorder that makes its image based on electronic signals rather than from a screen.

A DVD player gives the photographer the chance to be selective about the images on the screen and also provides the ability to repeat the image on the screen until it can be photographed in the manner that is desired. The disk player can be an effective visual arts teaching tool, as demonstrated by Quentin Tarantino, director and screenwriter of *Pulp Fiction* (1994) and *Inglourious Basterds* (2009), who used a VCR (videocassette recorder, predecessor to the DVD player) as a poor person's film school to instruct himself about filmmaking.

Alternative Modes

Nonstraightforward representations from the screen are possible using the following methods:

- Adjust the color balance of the screen from its normal position.
- Vary the horizontal and vertical hold positions from their standard adjustment.
- Use a magnet to distort the television picture. Be aware that this could put the television out of adjustment, requiring a technician to correct it. Try this on an old set that you no longer care to use.
- Vary the shutter speed from the standard 1/30 of a second.
- Make a series of multiple exposures from the screen onto one frame.
- Put a transparent overlay of an image or color in front of the screen. Make your own using litho film.
- Incorporate images into a picture by projecting a slide or slides onto a scene, rather than a screen, and then rephotograph the entire situation. A zoom lens on the slide projector can be useful in controlling the image size.
- Movie theater screens, including drive-ins, also can provide the photographer with a rich source of imagery to call upon.
- Create images using a digital imaging program.
- Incorporate the screen image within its surroundings or other events.
- Fabricate a situation to be photographed that includes a screen image.

nonrepresentational colors, lines, patterns, and shapes into the photograph. It interjects a physical presence into the work and also alters the sense of time, because hand alterations expand and prolong the interaction of the imagemaker within the process.

Methods

Some of the methods of modification of the negative and/or print include scraping or scratching with a stylus and drawing or painting directly onto the image surface. This can be done with a brush, spray paint, an airbrush, cotton balls, or other means of application. Colors can be either transparent or opaque. The medium can be acrylics, food coloring, dyes, ink, oil paint, or watercolors (Figure 13.20). Toners can be selectively applied to generate synthetic colors. Heat can be selectively applied to distort or destroy part of the image. Chemicals or chemical processes can be used to physically alter the appearance of the image. Optical distortion materials can be placed in front of lenses or light sources to dramatically change the image. Electronic signals can be employed

to create a pattern on a screen that is photographed or used to directly expose the film or the paper. The photo-based image can be combined with other media, including one of the many forms of printmaking, such as engraving, lithography, or silkscreening.

For details about these methods see Robert Hirsch, *Photographic Possibilities: The Expressive Use of Equipment, Ideas, Materials and Processes* (Boston, MA: Focal Press, 3rd edn, 2009).

Inkjet Transfers

Inkjet printers can be used to make transferable images by using a waxy paper, such as computer label sheets or a release paper that is used as a protective overlay in dry-mount operations, by using the procedure below. Additionally, commercial transfer films, such as Dass or Intelicoat, can be used by following their instructions.
1. Put the transfer paper, shiny side up, into the printer.
 Be sure to remove any labels that might be on the paper.
2. Adjust the image settings to print about 20 percent darker and 5 percent higher in contrast than normal.

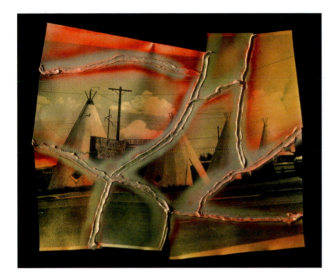

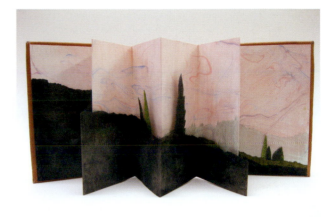

Figure 13.20 Thomas Barrow broke apart and rearranged this photograph, which he originally recorded with a Mamiya medium-format camera and printed on Ilford black-and-white paper. He sepia-toned the print to give it a warm ground and then sprayed it with warm colors. After tearing the print into sections, he reassembled the image with staples, silicon caulk, and automotive enamel. By agitating the photographic surface, Barrow provided a challenging model dealing with the complexity and the difficulty of deciphering any image.

© Thomas Barrow. *Caulked Teepees, Holbrook, Arizona*, 1979. 15 × 19 inches. Toned gelatin silver print with automobile enamel and silicon caulk.

Figure 13.21 Bea Nettles created this artists' book to convey the hilly landscape of Tuscany, Italy. She merged together several photographs taken with her Canon DSLR and printed the collage on text-weight paper. She then hand-altered the image by marbling and painting with watercolor, and bound it with a leather cover. Nettles tells us, "Throughout my career as a visual artist, I have explored various approaches to photography, including mixed media, alternative processes, black-and-white and color, as well as artists' books. Many of my photographic projects have found their final expression as books."

© Bea Nettles. *Via S. Margherita*, 2009. 6½ × 3¾ inches. Leather bound triple accordion book, paste paper, hand-marbled paper with attached digital images printed on a laser printer.

3. Select the highest-quality printing mode and print the image. The image will look very dull.
4. Briefly soak a piece of blank receiving hot-press printmaking or watercolor paper in a tray of water, remove, and blot excess moisture with a paper towel or cloth. If the paper is too wet, a dot pattern will result. Cold-pressed papers will deliver a softer effect.
5. Place the inkjet print face down onto the damp receiving paper. Hold firmly in place and gently rub the back of the transfer paper and then carefully lift it off.
6. A soft or foam brush may be used to blend and manipulate the inks.
7. Watercolor paints or pencils can be applied on either a wet or dry print. Pastel chalks may be used on a dry print.
8. Dry the print with a hairdryer or face-up on a plastic, air-drying screen.
9. Layers of images can be built through multiple transfers, one by one, onto a single sheet of paper. Let each dry before the next is applied.

Artists' Books and Albums

The idea of illustrating books with photographs appeared shortly after the invention of photography. Anna Atkins's *Photographs of British Algae: Cyanotype Impressions* (1843–53) and Henry Fox Talbot's *The Pencil of Nature* (1844–6) are examples of paper prints being hand tipped into books. The images had to be added by hand since there was no mechanical method for direct reproduction of photographs until the halftone process of the 1880s.

The *carte de visite*, French for visiting card, was a 2¼ × 3½-inch photograph, usually a full-length portrait, mounted on a 2½ × 4-inch card. It was introduced in the early 1850s and became a fad during the 1860s in America and Europe. Millions of "cartes" were made of individuals, celebrities, and tourist attractions. In practice, people did not use them to announce a visit, but exchanged and collected the cards, keeping them in albums with special cutout pages for easy viewing. The birth of the photo album can be traced back to this custom.

The mixed media work of Lady Filmer, who cut and pasted cards into designs that were interlaced with watercolor and text, is an early prototype of an artist-made book (ca. 1864).

The artist-made book can bring together a play between photographs, text, drawings, marks, and appropriated materials in a variety of formats. Since the late 1960s, photographers have been rediscovering the idea of the book as a way of working. They have dealt with themes of a narrative and diaristic nature as well as those of sequential time, dreams, friendship, and social and political issues. Many photographers who were denied access to the traditional outlets, such as museums and galleries, began to cut and paste and make use of quick-copy centers, rubber stamps, and old, unwanted printing equipment. The handmade book has provided an inexpensive artist-controlled, alternative method of getting the work out to a larger audience. There are

workshops, classes, conferences, online printers and distributors, and booksellers that specialize in artists' books (see Box 13.2).

Digital imaging can include elements of performance through moving images and sound. Interactive programs, found on CD-ROM, DVD, and on the Web, may require a viewer to make choices that determine the content, flow, or outcome of a work, which may be modified with each viewing.

In addition, special hinged paper, such as that made by Stone Editions, is designed for digital printing and has a companion digital album cover set, velvet paper, and binding hardware that simplify production. Many online printing services, such as Blurb.com, also provide templates for making books, which then are printed on-demand.

Problem Solving

Artists' Books and Albums

Create your own handmade book or album using digital and analog methods or a combination of the two. Begin by selecting a theme. If this is your first book, keep it simple, work with the familiar, and give yourself a time frame. For instance, decide to keep a diary of a trip. Use a personal digital device or a bound, unruled artist's sketchbook and a nonbleeding, permanent marker pen or soft-leaded pencil as your collection point. Include a map of your route, a written account of a conversation, or anything that grabs your interest, including sound bites from your journey. Photograph the people you are traveling with and those whom you meet. Collect local newspaper articles, business cards, menus, postcards, and tourist pamphlets. Use your photos or make drawings to help convey your impressions. Break with the single image concept. Shoot the foreground, middle ground, and background, and combine them on the page. It's okay to cut and paste. Craft a panorama or do a series and make a flipbook. Include signs. Show exteriors and interiors. Be spontaneous. As experience is gained, consider tackling other themes and altering the format presentation.

Select your own paper size and color, and bind them to make your own book. A simple binding method is to take a handheld hole punch and measure three equally spaced holes (on the left side or top) and punch. Using the first as a guide, punch the remaining pages in the same manner. Small metal key rings or heavy thread can be used as binders. As experience is gained, consider tackling other themes and altering the presentation format.

Individual Problem Solving

Wonderful photographs can be made when imagemakers pursue their own proclivities. Make the time to formulate those pictures you have been fantasizing about, and then assess your plan against what you accomplished.

Box 13.2 Sources of Photographic and Artists' Books

Aperture: www.aperture.org
Center for Book Arts: www.centerforbookarts.org
D.A.P./Distributed Art Publishers: www.artbook.com
Light Work: www.lightwork.org
Nazraeli Press: www.nazraeli.com
Photo-eye Books: www.photoeye.com
Printed Matter: www.printedmatter.org

Guide to Evaluation—Before Photographing

Before making any pictures, ponder and respond to the following:
1. Write a clear, concise statement of your specific goals.
2. List and describe your objective and subjective purposes, and how you plan to achieve them.
3. What problems do you expect to encounter and how do you propose to deal with them?

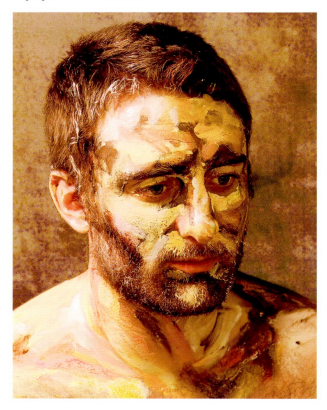

Figure 13.22 To begin her problem-solving process of creating a photograph that imitates painting, Kerri Dornicik perused images of paintings for inspiration. As a portrait photographer, the artist was drawn to the figural work of Lucian Freud. She viewed incorporating the painter's expressionistic marks into photography as a welcome challenge. Dornicik found that even lighting, color matching, careful application of paint to her subject, and subtle manipulations of curves and saturation in Photoshop produced her desired result—a painterly photograph.

© Kerri Dornicik. *Photography Imitates Painting*, 2009. 11 × 8½ inches. Inkjet print.

Guide to Evaluation—After Photographing

After making your pictures, answer these remaining questions:

1. Achievement: How many of the stated objectives were obtained? How well was it done? Are you satisfied? What benefits have been gained? Have new knowledge and skills been acquired? Have any attitudes been either changed or reinforced? Has the way in which you see things been altered?

2. The unforeseen: What were the unanticipated benefits and problems that were encountered? Did anything happen to alter or change the original plan? How do you think you did with the unplanned events? Was there anything that you should have done to make a better picture? How will this help you to be a better imagemaker in the future?

3. Aims compared with accomplishment: Compare the final results with the original list of goals. What did you do right and wrong? What are the reasons? What would you do differently next time? Were the problems encountered of an aesthetic or technical nature? Which were more difficult to deal with? What did you learn? How has it affected your working methods? Think of yourself as a teacher and measure how well the objectives of the assignment were met. What grade would you give a student on this project if you were the teacher? Why? Be precise.

Photograms

A photogram is a cameraless image created by placing a two- or three-dimensional object on top of any light-sensitive material, and then exposing the entire setup to light. After development the image reveals no exposure effects where an opaque object was in touch with the emulsion. Instead, it produces an outline of the physical object.

The early explorers for a workable photographic process, Johann Schulze in 1725 and Thomas Wedgwood and Humphry Davy in 1799, all began their experiments with cameraless images. The technique entered the art world in 1918, when Christian Schad, a Dadaist painter, used this method to make abstract images known as schadographs. Man Ray followed with his rayographs and then László Moholy-Nagy with what we now call photograms. For the digital equivalent, Scan-o-gram section in Chapter 9.

Chemigrams

The chemigram is a hybrid photographic process that relies on a chemical reaction, rather than light, to create an image. It is constructed in full daylight by the application of photographic chemicals—unusually developer and fixer—without the use of a camera, enlarger, or darkroom, sometimes to previously exposed photographic paper or film.

Non-silver Approaches

Besides digital imaging and silver-based photographic methods, there are older, commercially obsolete non-silver processes such

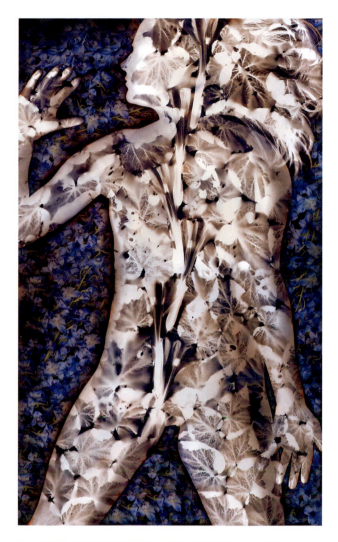

Figure 13.23 In her *Human Nature* series, Martha Madigan makes photograms that represent different ages, with the ultimate aim to portray all stages of human life, from newborn to 100. The artist has been marking her daughter's growth by making annual photograms of her and presenting them at actual scale. Using light-sensitive paper, she records the figure with a 5-minute exposure in the sun. Madigan then arranges a variety of plant forms on the paper, re-exposes it to the sun, and processes the print for permanence.

© Martha Madigan. *Graciela: Growth XII*, from the series *Human Nature*, 2002–2003. 40 × 24 inches. Inkjet print. Courtesy of Jeffrey Fuller Fine Art, Ltd., Philadelphia, PA.

as cyanotypes (blue printing) and gum bichromate (gum printing), to consider. Some artists combine old and new technologies by digitizing their negatives and adjusting them to the older processes to get the results they desire. These techniques permit the exploration and extension of the demarcation between the hand of the photographer, the subject, and the processes of photography. The ensuing images can expand the scope of photographic vision by opening new pathways in both ideas and working methods.

Problem Solving

Color Photograms

Color paper offers a starting place for beginning experimentation. Paper is easy to work with and it can be handled under a safelight, which enables you to see where to place the objects. It can be processed quickly, so the results are known almost immediately.

The choice of opaque or translucent objects for making photograms is endless. Give it some thought as the corporeal aspects of your choices will be the visual foundation of the piece. There are natural objects such as plants, leaves, flowers, feathers, grass, sand, and rocks. Consider using artificial objects such as colored glass, or make your own materials. These can include paper cutouts in a variety of colors and shapes. Areas left uncovered receive the maximum exposure and appear black, not recording any detail. Varying the angle and the distance between the light source and the object(s) affects whether the shadow lines appear hard or soft. A wide variety of tones and colors are produced where translucent objects were placed on the emulsion and where partial shadowing occurred under opaque objects that were not totally in contact with the emulsion. Explore different-colored light sources to make various color effects.

Challenge yourself to find interesting materials to experiment with. Use the open nature of the photogram to explore as many arrangements and uses of the materials as possible. Some additional ideas include:

The color enlarger can be used as the source of exposure. Try changing the filter pack to produce a range of colors. Another effect is created when you expose an area with one filter pack and another area with a different filter pack.

Use an electronic flash, filters, or transparent plastic to color the light.

Employ a penlight as the source of exposure. It also can be used to draw with and to emphasize certain areas. Attach it to a string and swing it above the paper to make an unusual exposure effect.

Move your materials during exposure to create motion, overlap, and translucent effects.

To maintain a naturalistic color balance when printing on negative paper (RA-4), put a clear, processed piece of negative film in the enlarger to make use of its orange mask.

Remember, all the regular guidelines for printing apply. This means areas may be burned and dodged during exposure.

Combine a negative that has been made with a camera with one or more of the cameraless techniques.

Liquid-colored inks, such as Dr. Martin's, can be put on a piece of thin glass and exposed through onto the paper. The thickness of the glass affects the outcome. Both inks and objects can be combined. Colored markers also can be utilized.

Rephotograph and/or scan the photogram and incorporate it with another camera or cameraless image.

For additional information see: www.photogram.org

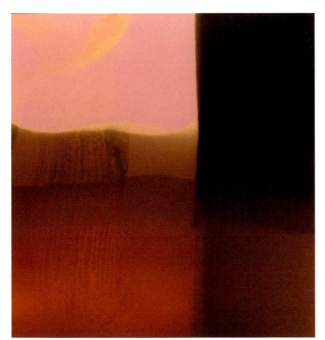

Figure 13.24 Douglas Collins makes chemigrams by applying Dektol and Ethol developers and standard fixer to black-and-white paper using rags and brushes. Once they are dry, he scans them and prints the images digitally. Collins says, "I have been interested in story—in establishing clues to a story that is perhaps nonexistent—through elaboration of simple abstract forms in a picture space. But the abstract forms themselves tell us nothing directly; they are no more than pointers, markers of rhythm to guide the visual imagination. They are not literal, for if they were, my project would be defeated. The results, purely visual, seem then to owe a debt to certain forms of abstract expressionism, while borrowing methods at times from the minimalist enterprise."

© Douglas Collins. *After Hours*, 2009. 14 × 14 inches. Inkjet print.

Problem Solving

Chemigrams

Selectively paint the developer on a blank piece of fiber-based, black-and-white paper with a brush and/or by dribbling and dripping the developer. By permitting time to elapse between exposure, painting, and fixing, limited color effects (yellow and reddish tones) can be produced as the photochemicals and the components of the emulsion oxidize.

Many workers utilize "localizing" products, such as oil, varnish, and wax, to create more complex forms. Basically, any product found in your kitchen, bathroom, or paint store that can adhere to emulsion paper may be used to make a chemigram.

Another option is to use a strong reducing agent such as thiourea and a base such as sodium carbonate as a painting medium before the image is fixed. Mixing these two chemicals produces a silver sulfide stain. This can create unusual juxtapositions in image makeup, contrast, and spatial relationships.

As the process is a balancing act between control and chance, explore varying the concentration, flow, and time of contact of the chemicals with the paper to manage color tone, the lightness, and composition of the image.

A frisket, such as rubber cement, can be applied to select parts of the image to keep the chemicals from penetrating to selected areas of the paper, allowing more control of your mark making and image creation.

Normal fixing and washing should render the image and colors permanent. Further effects can be achieved by toning.

Repeat the process using a photographic image printed on fiber-based, black-and-white paper as the foundation.

Repeat the process using a large-format, black-and-white negative as the foundation.

Consider scanning the final result and using image software to further manipulate the image.

For details about these processes see Robert Hirsch, *Photographic Possibilities: The Expressive Use of Equipment, Ideas, Materials and Processes*, 3rd edn (Boston, MA: Focal Press, 2009).

Postcards

The postcard format, about 3¼ × 5½ inches, first appeared in Europe in 1869. At the turn of twentieth-century America, rural free delivery, reduced rates for cards, small, handheld folding cameras, and the new postcard-size printing papers contributed

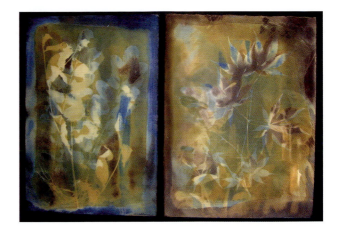

Figure 13.25 Laura Blacklow incorporated multiple non-silver processes in creating this image. To make a photogram, she placed plants in direct contact with historic emulsions and exposed them to the sun for 20 minutes. She processed the image first as a Van Dyke brown print and then as a cyanotype. Blacklow states, "The straightforwardness and forgiving nature of blue and brown printing plus the layer of many coatings seem right for creating imprecise evidence of one year's fleeting seasons as represented by traces and shadows of foliage with its own life cycles."

© Laura Blacklow. *Untitled*, from the series *Backyard Botanicals*, 2009. 15 × 22 inches. Cyanotype with Van Dyke brown print.

to making the photographic postcard immensely popular. Before the rise in technology led to widespread telephones and mass-circulation picture magazines, postcards were a fun and inexpensive way for people to keep in touch through text and images.

The postcard's form and style are in the folk art genre and throw to the winds all the sacred rules of picture-making. Many cards possess an amazing sense of irreverent good humor in how the subject is depicted. Originally the postcard was of a highly personal nature and often dealt with subjects of current importance in people's lives. While the photographs for some cards were made in the studios of professional photographers, many were based on amateur snapshots. Portraits were popular and included all members of the family from the new baby to the dog. These were then sent to friends and relatives. A current incarnation of this phenomenon is social networking websites.

At present, most postcards are commercially printed and mass circulated. They serve primarily as documentation, offering evidence of what you saw when you were in a certain place, at a certain time. The postcard is a simple form of communication that is quick, cheap, educational, and often entertaining. Being able to write a message on the back makes it more personal. Commercially printed postcards are used by the travel industry to provide pictorial stereotypes. They have become part of the tourist experience. People tend to value the kind of scenery that has been aesthetically validated in travel brochures, advertisements, and other mass media visuals. Often, when tourists encounter the original scene they want to confirm its "picturesque" value by making a snapshot or purchasing a postcard. Today, postcards are losing ground to digital communication, but they continue to be used by artists and galleries to announce exhibition openings.

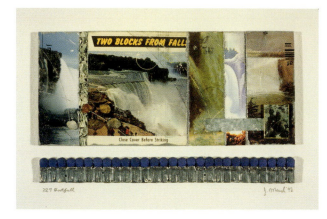

Figure 13.26 Working in the postcard format, Gerald C. Mead, Jr. used numerous depictions of Niagara Falls, including postcards, a matchbook cover, a chromolithograph, and a color Instamatic print he made of the falls as a teenager. "The inclusion of shredded US currency and barcoding refers to the commercialization of the Niagara Falls area. The title is derived from the fact that the average height of the American and Canadian Falls is 327 feet. The choice of scale is very deliberate. It invites close inspection and encourages a greater level of intimacy with the work."

© Gerald C. Mead, Jr. *327 Footfall*, 1992. 3½ × 5½ inches. Mixed media.

Problem Solving

Making Your Own Postcards

Look at postcards online or books listed in the resource section for some beginning ideas. Know what it is you want to communicate with your finished work, then create your own postcards following these instructions:

1. Start with the 3½ × 5½-inch size (larger-size cards require regular first-class postage). Cards can be different sizes and do not have to be rectangular, but unusually shaped pieces risk being damaged in the mail.

2. Print on one side, leaving the other side blank.

3. On the non-picture side, divide the space in half vertically with the word Postcard.

4. To the right of the word Postcard, address the card to the receiver and attach the correct postage.

5. On the left-hand side of the word Postcard, in the upper left-hand corner, write a title or description to go with the photograph.

6. Below this write a message for the receiver.

7. Beneath the message, give the photo credit: the copyright symbol, the year, and the name of the photographer.

8. Mail the completed card.

9. Post a digitized version of the finished card on your favorite social networking site. Compare the digital responses you get to those of the analog card. What are the advantages and disadvantages of each approach?

Postcard-sized paper is available for digital printers. Analog black-and-white postcard paper, such as Ilford Multigrade IV RC Portfolio, is available in 4 × 6 inches, in 100-sheet boxes, with a standard postcard layout printed on the back.

Porter's Camera Store (www.porters.com) sells Ready-To-Mail Postcarders, a self-sticking backing material cut to postcard size (4 × 6 inches), in packs of 25. Color photographs or any other paper prints can be attached to the self-stick surface.

Stereoscopic Photography

Sir Charles Wheatstone discovered the stereoscopic effect in binocular vision (using both eyes at once). In the 1830s he invented both the reflecting (mirror) and refracting (lens) stereoscopes for use with hand-drawn designs. Photography provided answers to many of the difficulties of these hand-drawn designs. Stereo pictures were tremendously popular from about 1854 to 1880 and again from about 1890 to 1919, with millions of cards and viewers sold. Recent 3-D developments in cinema and television have brought it back into public favor in the first decade of the twenty-first century.

How the Stereo Effect Is Achieved

Stereographs create a three-dimensional effect with two separate photographs of a subject taken from lateral viewpoints 2½ inches apart, which is the average distance between the human

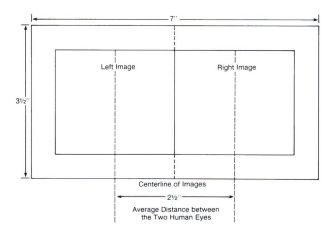

Figure 13.27 A model for making a stereograph that can be viewed in any standard refracting stereoscope. Both the left and right images must be of equal size. The left and right images are positioned so the distance between the center of each image is about 2½ inches. The distances to the top, side, and bottom borders surrounding the images need to be equal.

eyes. This usually is accomplished with a twin-lens camera that has an interlocked double shutter that makes two images of the subject at the same time, side-by-side on the sensor or film. Stereo cameras also can produce a three-dimensional effect by interlacing the images with one another through the use of a lenticular screen.

It also is possible to produce stereo pictures of subjects that contain no movement with a regular camera. This is done by making the first exposure of the subject and then shifting the camera exactly 2½ inches and making the second exposure. It may be moved to either the right or the left, but be certain to move it in the same direction every time. When this is not done, it can get confusing which is the right-eye view and which is the left-eye view, and if they are mixed up, the stereo effect will not work. There also are stereo devices that can be attached to the front of the camera lens and permit simultaneous exposures with a conventional camera.

Stereo images on a computer screen can be viewed with red and blue 3-D glasses. These can be made at home with medium-density red and blue cellophane (red lens over left eye and blue over the right). The results can be outputted (see Digital 3-D at the end of this section).

The Effect of Distance

The normal stereo effect starts at about 5 feet from the camera; it is exaggerated at closer distances. Stereo infinity is the distance that the stereo effect ceases. This can range from 200 to 1500 feet and is dependent on the number and variety of visual depth clues that are included in the view. The hyperstereo effect, in which the depth and size of the objects are exaggerated, occurs when there is too great a separation between the picture-taking viewpoints. It is generally noticeable in the foreground of the picture. Improper separation of the images on the viewing card also can produce this effect. Pictures up to 2½ inches wide can be mounted in a simple viewer with the proper distance between their centers. Larger images, having more than 2½ inches between their centers, need to be viewed in a stereoscopic viewer with a lens or prism to compensate for this distance, which is greater than that between human eyes.

Stereo Card Size

Following the model card in Figure 13.27, make a standard 3½ × 7-inch stereograph that is designed to be viewed in the basic refracting stereoscope. This style was devised by Sir David Brewster in 1849 and was improved into its current form by Oliver Wendell Holmes in 1861. It consists of a T-bar with a handle beneath the stereoscope body. A hood at one end of the bar contains two short-focus spectacle or prism lenses; a crossbar at the other end holds wire clips in which the stereograph is inserted. The crosspiece can be moved back and forth along the bar for focusing. An opaque divider extends partway along the T-bar between the lenses, preventing each eye from seeing the opposite image. The stereo effect can be seen without a viewer. A simple opaque divider can be placed between the two images, maintaining the focus of the left eye on the left image

Problem Solving

Guidelines for making stereographs include the following:

Think in three dimensions. Consider how the objects in the foreground, middle ground, and background will affect the final visual illusion. Provide the necessary visual depth clues to make the picture function in three dimensions. Use the depth of field to expand or contract the depth of the camera's vision.

Shift the camera exactly 2½ inches for the second exposure.

Match the print density of both images.

Use a 3½ × 7-inch support board on which to attach the images. Check to make sure the right image is on the right side before attaching the views to the card.

and the right on the right image. Inexpensive twin plastic lenses, held up to your eyes, are also marketed.

Digital 3-D

The following is a basic digital method used by artist/educator Michael Bosworth to make single, three-dimensional images that are viewed with special colored glasses like those used for 3-D movies.

Three-dimensional images can be digitally printed with red/blue or red/cyan ink. Seen through a red filter, red ink and white paper appear much the same. A red filter will block all blue color causing an image printed with cyan ink to appear black. Red and cyan overlapping images will be seen independently when viewed with cyan and red filters, creating the illusion of depth.

In his images of Niagara Falls (Figure 13.28), Bosworth used a single camera to make two exposures from different perspectives. A camera was placed on a tripod with a device allowing the camera to be moved side to side to create images from two perspectives. Stereo illusion works if the subjects of two images occupy nearly the same space in both images. If the subject changes position between exposures, the illusion will not work. Usually, a stereo camera uses two lenses to make two simultaneous exposures of the same scene. Although the water pouring over the falls was continually moving, a shutter speed lasting several seconds caused the water to take on a constant form. The smooth blur of the water occupied the same position in each exposure taken minutes apart.

After developing the black-and-white film, Bosworth selected and digitally scanned two negatives, producing a pair of grayscale images. Using Adobe Photoshop, a new CMYK file of the same resolution and proportions as the grayscale images was created. One of the grayscale images was copied and pasted into the cyan channel of the new file, while the other grayscale image was pasted into the magenta and yellow channels. With all channels displayed, the resulting image appears as a pair of red/cyan overlapping photographs. Printed in ink and viewed with cyan/red glasses, the image provides the illusion of depth.

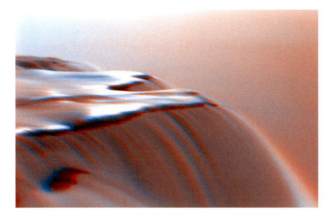

Figure 13.28 Harkening back to Gustave Le Gray's stop action wave photographs, Michael Bosworth observes, "The mighty Niagara River is both sublime and consistent, allowing it to be photographed in stereo with a single camera. Viewed without optical devices, the composition and form take on an abstracted quality. Glasses with red- and blue-colored lenses resolve the overlapping images to give an illusion of space, although one that is amorphous and lacking in a sense of human scale. This absence of distinction reflects the common struggle of art to describe the world in human terms while scientific definitions are often beyond human scale."

© Michael Bosworth. *Niagara XX*, 2001. 20 × 30 inches. Inkjet print.

Future Developments

During its brief history photography has subverted the hypothesis that art was fundamentally absorbed with the imitation of appearances. Photography has disrupted the single, ordered, consistent style of classic representation. By familiarizing us with a worldwide range of art and culture, photography has enlarged our realm of aesthetic experiences beyond those directly observed in nature.

The keystone of photography's egalitarian independent future potency lies in our willingness to tolerate the messiness of a diversity of practice. As the technical barriers between digital and analog vanish, the medium is in a unique position to make the most of its democratic tradition. Photography's shift, from its former intensive process orientation to a fusion of media and conceptual references, has allowed more voices to be seen, enhancing its aesthetic concerns, cultural impact, and overall growth.

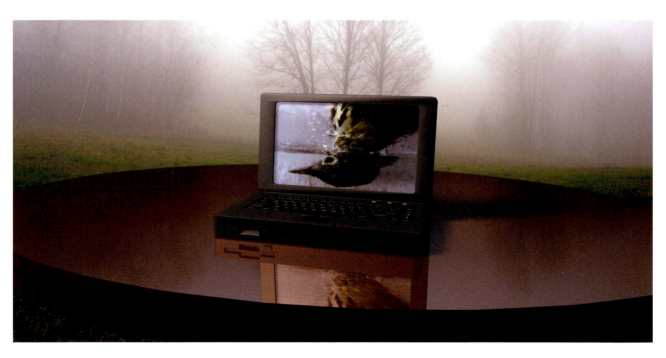

Figure 13.29 The collaboration known as MANUAL reflects, "One interpretation of this image raises questions regarding the ecological health of the foggy landscape. A second sees it as homage to nature in the age of electronic information. The image is a composite of several sources. The dead bird's head and background are from separate digital files made from a digital camera and the table and laptop computer have been rendered in a 3-D modeling program."

© MANUAL (Ed Hill/Suzanne Bloom). *Omen*, 2002. 18 × 33 inches. Inkjet print. Courtesy of Moody Gallery, Houston, TX.

NOTES

1. Garry Winogrand, "Understanding Still Photography," *Garry Winogrand* (New York: Double Elephant Press, 1974).

2. John Brinckerhoff Jackson, *Discovering the Vernacular Landscape* (New Haven, CT: Yale University Press, 1984).

3. John Ruskin, *The Works of John Ruskin*, vol. X. Edited by E.T. Cook and Alexander Wedderburn (London: George Allen, 1903–12), p. 201.

4. Kenneth Noland, *Landscape Into Art* (New York: Harper & Row, 1956), p. 167.

5. Salman Rushdie, *The Satanic Verses* (New York: Viking, 1988), p. 121.

6. Robert Adams, *Why People Photograph* (New York: Aperture, 1994), p. 181.

RESOURCES

Holleley, Douglas. *Your Assignment: Photography*. Rochester, NY: Clarellen, 2009.

Pinhole Cameras

General pinhole information: www.pinhole.org

Pinhole cameras: www.pinholeblender.com

Pinhole Resource: www.pinholeresource.com (for all things pinhole, including the *Pinhole Journal*).

Renner, Eric. *Pinhole Photography: From Historic Technique to Digital Application*, 4th edn. Boston, MA: Focal Press, 2008.

Shull, Jim. *The Beginner's Guide to Pinhole Photography*. Buffalo, NY: Amherst Media, 1999.

Hand-Altered Photography

Airey, Theresa. *Digital Photo Art: Transform Your Images with Traditional and Contemporary Art Techniques*. New York: Lark Books, 2005.

Digital Art Studio: www.digitalartstudioseminars.com/DigitalArtStudioSeminars/Home.html.

Enfield, Jill. *Photo-Imaging*. New York: Amphoto, 2002.

Schminke, Karin, et al. *Digital Art Studio: Techniques for Combining Inkjet Printing with Traditional Art Materials*. New York: Watson Guptill, 2004.

Artists' Book

Book Arts website: www.bookarts.uwe.ac.uk/

Bright, Betty. *No Longer Innocent: Book Art in America, 1960–1980*. New York: Granary Books, 2005.

Drucker, Johanna. *The Century of Artists' Books*, 2nd edn. Granary Books, 2004. (Available from D.A.P., see Box 13.2)

Lyons, Joan, ed. *Artists' Books: A Critical Anthology and Sourcebook*. Rochester, NY: Visual Studies Workshop Press, 1985.

Lyons, Joan, ed. *Artists' Books: Visual Studies Workshop Press, 1971–2008*, Rochester, NY: Visual Studies Workshop Press, 2009.

Parr, Martin and Badger, Gerry. *The Photobook: A History*, Volume I. New York and London: Phaidon Press, 2004. Volume II. New York and London: Phaidon Press, 2006.

Roth, Andrew, et al. *The Book of 101 Books: The Seminal Photographic Books of the Twentieth Century*. New York: Roth Horowitz, 2001.

Smith, Keith. *200 Books, An Annotated Bibliography*. www.keithsmithbooks.com.

Smith, Keith. *Bookbinding for Book Artists*. www.keithsmithbooks.com.

Smith, Keith. *The New Structure of the Visual Book*, 4th ed. www.keithsmithbooks.com.

Smith, Keith. *The New Text in the Book Format*, 3rd ed. www.keithsmithbooks.com.

Postcards

Bantock, Nick. *Griffin & Sabine: An Extraordinary Correspondence*. San Francisco, CA: Chronicle Books, 1991.

Bogdan, Robert, Weseloh, Todd. *Real Photo Postcard Guide: The People's Photography*. Syracuse, NY: Syracuse University Press, 2006.

Rosenheim, Jeff L. *Walker Evans and the Picture Postcard*. Göttingen, Germany: Steidl/New York: The Metropolitan Museum of Art, 2009.

Sante, Luc. *Folk Photography: The American Real-Photo Postcard 1905–1930*. Portland, OR: Verse Chorus Press, 2009.

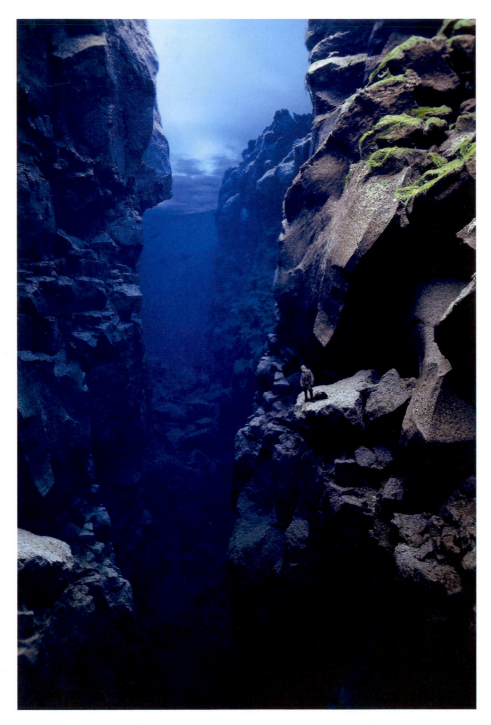

The glamour of risk inspired Stephen Hilyard's elaborately fabricated *Rapture of the Deep* series. Influenced by historical mountaineers who garnered significant media attention for both their feats and their deaths, the artist created photographs that simultaneously engage and celebrate danger and achievement. He captured the landscape components of the image below the surface of a lake in Iceland, using a digital camera outfitted with an underwater housing. The artist composited these underwater landscape images with studio photographs of himself modeling vintage mountaineering equipment while standing on a scaffold. Hilyard states, "'Rapture of the Deep' is a term first coined by Jacques Cousteau to describe what is medically called Nitrogen Narcosis. This is a form of euphoria that divers experience below a certain depth and that can lead to death … This speaks directly to the nature of the sublime experience and the sacrifices that are demanded of one who goes in search of it."

© Stephen Hilyard. *Dougal, Leysin 1977*, from the series *Rapture of the Deep*, 2009. 44 × 29½ inches. Chromogenic color print. Courtesy of Platform Gallery, Seattle, WA.

Photographic Problem Solving and Writing

Deliberate Practice

Think of talent not only as a characteristic but as a process that requires mental discipline. Talent is not just an innate ability but something each of us can develop through doing. The most accomplished individuals, from Beethoven to Tiger Woods, worked relentlessly to hone their skills. Being *good* at what one does involves sacrificing your time, money, and sleep in order to practice, practice, practice. Deliberate practice involves spending hours a day in highly structured activities to improve performance and overcome weakness. Psychologists at Florida State University have observed that it takes a minimum of 10 years of deliberate practice to excel in any field. It is not that we are without limits, but few of us are working at our potential and practice can improve one's performance, regardless of your current skill level. In his book *The Genius in All of Us* (2010), David Shenk says: "I assume that everything I write is rubbish until I have demonstrated otherwise. I will routinely write and rewrite a sentence, paragraph and/or chapter 20, 30, 40 times—as many times as it takes to feel satisfied."[1] Persistence and the will to create are what enable photographers to transcend illustrative literalness.

Getting ideas to solve visual problems entails becoming more aware and thinking independently. This also requires self-discipline and is accomplished by asking questions, acknowledging new facts, reasoning skeptically through your prejudices, and taking on the responsibility of gaining knowledge. It is necessary to believe in your own creativeness. Consider information from all sources. Do not attempt to limit your response to only the rational part of the brain; let your feelings enter into the process. Be prepared to break with habit and take chances. Listen to yourself as well as to others. If you are feeling stuck, loosen up by walking about and making pictures without using the camera's monitor or viewfinder. Another approach is to take an image, draw a grid on the back of it, cut it into equal pieces, put them in a bag, remove the pieces one at a time, and glue them onto a piece of paper in the order in which you selected them. What do you now observe that was not evident in the original? How can you apply this new data to move forward?

Dealing with Fear

Nothing blocks new ideas like fear, which takes on endless forms: The fear of being wrong, of being foolish, or of changing the way in which something has been done in the past. Fear can be brought about by a lack of preparation or reluctance to deal with the unknown. Creativity, which drives one to make changes, can be uncomfortable as its source is often dissatisfaction with a present situation. Its accompanying sense of apprehension deters creative development by misdirecting or restraining energy. Remember, it is okay to make mistakes. Do not insist that everything be absolutely perfect, as a mistake can open a window of new possibilities. In *The Act of Creation* (1990), Arthur Koestler wrote, "We find over and over again mishaps which are blessings in disguise."[2]

Beginners are not expected to be experts, so take advantage of this situation. Learning involves doing, so make that extra exposure; make one more print to see what happens. You are the one who will benefit.

Journal Keeping

Journal keeping, in analog or digital form, can be a method that helps one sort through life experiences and decide what might be an important issue to problem solve. The exercise of recording reflections about each day's events is an invaluable way to evaluate your performance, set standards, and find new ways to solve problems. Many people resist keeping a journal because they think that they are not good enough writers, that someone will read their innermost thoughts, that their thoughts are petty, or that they have more important things to do. Instead of thinking of a journal as a diary, a book in which you relate the day's events, think of it as a container for self-reflection, self-expression, and self-exploration. Retelling the day's events is not as relevant as the act of finding a way to express your thoughts. Be sure to include any imagery that grabs your attention.

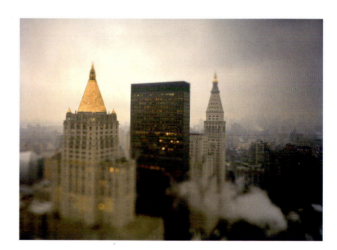

Figure 14.1 For over a decade Susan Wides has practiced to perfect her technique of tilting and shifting the lens board of her 4 × 5-inch view camera to make images having only a sliver of sharp focus. She works alternately in Manhattan and in the Catskill Mountains, exploring the possibilities of her method in both locations. Wides states, "Originally conceived as two separate projects developed simultaneously, *Kaaterskill/Mannahatta* documents the relentless transformation of our natural and urban environments. While framing bodily experiences, I subtly adjust the shape of buildings and of the natural landscape to form one larger entity of deliberate balance. I wish to convey the experience not merely of being in a place, but of connecting to that place on many levels of consciousness … I am not interested in presenting a distanced, miniaturized world but rather its opposite—an emotional and perceptual immediacy."

© Susan Wides. *Mannahatta 1.17.07 (from East 29 St 1)*, from the series *Kaaterskill/Mannahatta*, 2007. 40 × 50 inches. Chromogenic color print. Courtesy of Kim Foster Gallery, New York, NY.

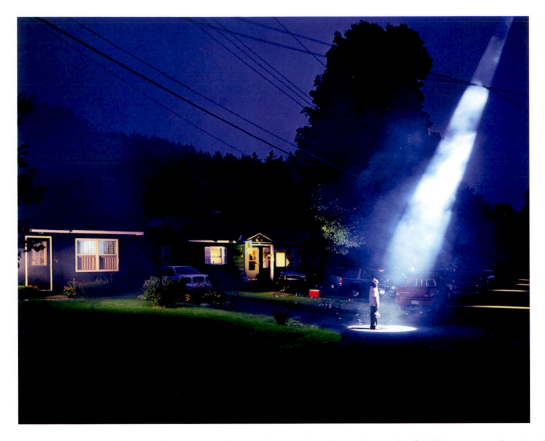

Figure 14.2 Gregory Crewdson thinks, "Twilight is this magic hour between day and night, when ambient and artificial light come together. It's a time of transcendence when extraordinary things happen." Influenced by filmmakers such as Alfred Hitchcock, David Cronenberg, and David Lynch, the construction of Crewdson's photographs can be likened to a film production, in that it can involve coordinating 35 assistants and technicians. This image, a fusion of documentary and fiction, is reminiscent of *Close Encounters of the Third Kind* (1977) and portrays an alien, exotic, and strange suburban landscape.

© Gregory Crewdson. *Untitled*, 1998. 50 × 60 inches. Chromogenic color print. Courtesy of Luhring Augustine, New York, NY.

Figure 14.3 Keeping a dream journal and analyzing these nocturnal thoughts inspired Amy Holmes George to create work exploring her fascination with dreams, biology, anatomy, and psychology. She mixes handmade and digital methods, first creating sets on paper with paint and pastels, and later photographing found objects and texts. She imports all of these images into Photoshop, where she constructs a composite image that resembles a theatrical still life. Her first body of work composed entirely digitally, George's *Awakening to a Dream* series presented a unique problem. She tells us, "A critical challenge for me was determining the point of completion, as there was no finite conclusion to the process itself but rather a myriad of exciting possibilities ... Working both traditionally and digitally ensured optimal precision."

© Amy Holmes George. *Pieces*, from the series *Awakening to a Dream*, 2005. 9 × 9 inches. Inkjet print.

Tolerating Failure: Photography Is a Lot Like Baseball

Photography and baseball are activities that require participants to be skilled in the precise placement of objects and the capture of moments in time and space, all within fractions of a second. Both involve periods of thoughtful contemplation, followed by bursts of intense activity, and then a return to quietness. And both require patience, practice, and study, which leads to high-level performance through control and the comprehension of a spatial language. But most of all, to be really good one must constantly play the game. Warren Spahn, the Hall-of-Fame pitcher and the winningest left-hander in Major League history, acknowledged that "Baseball is a game of failure." Even the best hitters in the big leagues fail about 65 percent of the time, while the best pitchers may lose 12 games in a season and hundreds over their careers. Yet statistics do not tell the complete story.

Like baseball, photography is a game of low percentages. If a photographer added up the number of frames exposed and compared it with the number of satisfying images produced, a typical photographic batting average might be about 1 percent. However, what an average does not reflect is all the intangible joys involved within the process of photography that require the integration of abstract ideas and concrete operations. Good photographers overcome their fear and make pictures. Don't be afraid of experience. Without risking failure, life would be banal. Being a skillful photographer involves making choices, being open to experimentation, and taking intelligent risks. Bear in mind that the failure of one image is restored by the success of another. From penicillin to stainless steel, innovation often has been a consequence of accident and the failure of an intended outcome. Choice defines who we are and what our work is about. Going to the plate and deciding when to swing the bat, even if it means striking out, is about making such choices. As Ansel Adams said: "Photography is a way of knowing."

The Problem-Solving Process

Getting ideas means finding ways to solve problems. The process is a continuous intermingling of events (Figure 14.5) that includes acceptance, analysis, definition, idea formation, selection, operation, evaluation, and results. Feel free to skip around or go back and forth between steps. There is no definite order; it is dependent on the pattern of your thinking.

Figure 14.4 To create this image of failure, Nathan Baker fabricated a scene that appeared candid yet remained static enough to be photographed. He used an 8 × 10-inch view camera to capture maximum detail and strobe lighting to generate a sense of naturalistic light in the space. Baker explains, "I had thought quite a bit about this tiny moment that arises when an accident occurs—this split second before one reacts, when the brain is trying to compute a response. This is perfect silence in the midst of a storm and, according to the German philosopher Martin Heidegger, our only opportunity to shed our socially contrived selves and approach a return to basic human instinct."

© Nathan Baker. *Medicine*, from the series *Rupture, Part One*, 2006. 75 × 60 inches. Inkjet print.

Figure 14.5 This is one representation of the problem-solving process as a continuous circle of responsible thinking. Thinking can happen in any order. Feel free to devise a method that is suitable to both the problem and problem solver. The steps outlined in this chapter can be thought of in linear terms, that is, of taking one step before the next, until the destination is reached. They also may be considered in a hopscotch manner of skipping around from one step to another, or by crisscrossing the steps. Don't be afraid to switch models.

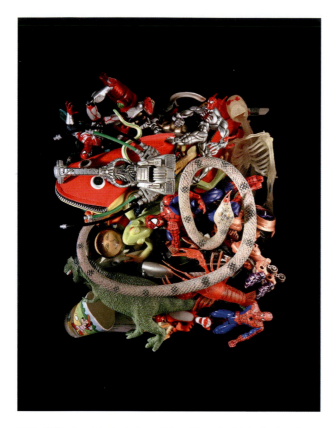

Figure 14.6 Gary Minnix challenged himself to make this body of work utilizing only analog photography. In his studio, he lit containers of his son's toys and photographed them looking straight down with a large-format camera. However, after working with the images for years, he came to the conclusion that this working method could not enable him to make his intended statement. Minnix solved this problem by scanning his film and digitally manipulating the image to concentrate on the form of the toys. He tells us, "Like an asteroid formed out of accretion as it travels through space, attracting and adhering to pieces of drifting debris from distant parts of the galaxy, these toys are debris of culture and cultural references taking new forms in the conglomerate of the toy box. My intention is to find a way to represent these objects both as a record of a moment in our culture and as a poetic statement at the same time."

© Gary Minnix. *Foodchain*, 2005. 40 × 30 inches. Inkjet print.

Birth of a Problem

Problems arise from every aspect of life. They can spring from our private world of friends, loved ones, children, pets, or parents. They may come from our work-life situations of bosses and co-workers. Others are thrust upon us from the outside world due to educational, economic, political, and even accidental circumstances. We cannot try to solve all the problems we encounter. We must be selective about which problems we decide to take on or be overwhelmed and unable to accomplish anything.

Acceptance

Acceptance means taking on a problem as a challenge and a responsibility by saying "Yes" to involvement and committing

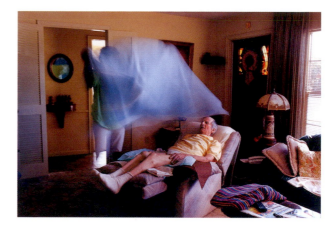

Figure 14.7 Joyce Culver's publication *A Change of Mind: An Alzheimer's Portrait* (2003) is the result of her documentation of her father and the feelings she had for him and her mother as they struggled with this debilitating disease. Culver remembers, "I kept on watching my father as he lay in his special chair, and I set up a tripod to make a slow-shutter speed photo of him under natural daylight in my parents' living room, when Joan the aide came along and began to cover him. I continued to photograph this unexpected event and was surprised when I saw the results. The blanket appeared to be an omen of a shroud that was to come, and I knew that it would not be long before he died."

© Joyce Culver. *Dad Being Covered*, 1998. 20 × 24 inches. Chromogenic color print.

your time and resources to solve the problem. It is like signing a contract that indicates the intention to take charge and see the project through to completion. We can either accept things the way that they are ("I do not know how to do this in color photography") or we can take on the responsibility for change ("I am going to learn how to do this").

Analysis

Analysis involves studying a problem and determining its essential features and feelings. The process will include breaking the problem down to its individual components, researching them, and working out their relationship to the whole. This procedure is the time to question everything and to generate all available possibilities, since there is no absolute way for how an image should look or be looked at, except with patience and an open mind.

Definition

Definition is getting to the main issues and clarifying the visual and conceptual goals to be reached. It necessitates non-limiting questioning. Ask yourself: What is the "real" problem? Do not get sidetracked by the symptoms of the problem. We must decide where problems may lie and narrow down the information uncovered while considering how the problem might be expressed visually. This stage defines the direction in which the action will be taken in order to solve the problem.

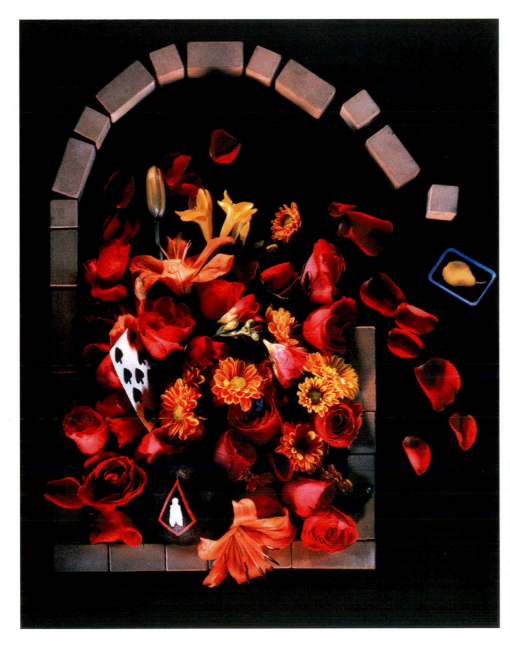

Figure 14.8 Olivia Parker's enigmatic work mingles pictorial clarity with thematic ambiguity. Through a process of recontextualization, Parker bestows "human implications" upon her constructions. By placing prosaic materials in unfamiliar situations and surprising juxtapositions, she allows viewers to infuse them with their own inventive meaning.

© Olivia Parker. *Exit*, 1991. 24 × 20 inches. Diffusion transfer print. Courtesy of the Polaroid Collection, Cambridge, MA.

Idea Formation and The Possibility Scale

Idea formation provides ways of reaching the stated goal. Do not become enamored with one idea or assume the answer is known before this process is started. Go out on a limb by deferring your judgment. Try techniques such as attribute listing, which tells all you know about the problem, or morphological synthesis, which explores the internal structure, patterns, and forms of a problem and breaks it down of its individual parts to find new approaches. Attribute listing also involves the search for various signs that occur in the problem and the possible arrangements of those signs. Put together all the solutions that have been considered, and keep an open mind to the alternatives. Look at the work of other artists who have tackled the same or a similar problem. Keep a list of the ones whose work seems close to your own goals and evaluate why.

This dovetails into what I call *The Possibility Scale*, which states there are no artistic impossibilities, only different levels of possibility. It grants you the freedom to act and determine an idea's usefulness by saying: "If I can visualize it, there could be a way to make it happen." This is the essence of inventive thinking that broadens our inventive capacity to test our limits of comprehension. Consider Leonardo da Vinci, Mary Shelley, Jules Verne, H.G. Wells, Marcel Duchamp, Karel Capek, Aldous

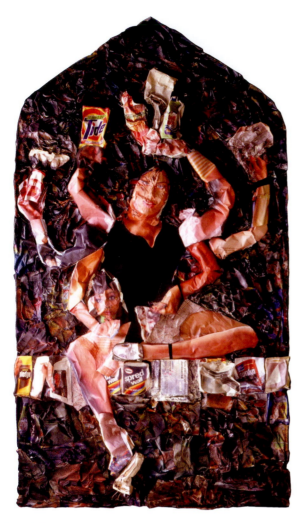

Figure 14.9 Robert Heinecken's inquiry into the limits of the photographic form helped redefine the boundaries of photographic practice by asking, Does one have to use a camera to make a significant photographic work? The artist stated, "This relief collage emanates from the saturation of media and the media-driven drama surrounding the social issues of the single mother." He recalled that "the most difficult technical challenge was creating a three-dimensional object out of two-dimensional magazine advertisements."

© Robert Heinecken. *Shiva Manifesting as a Single Mother*, 1989. 96 × 48 inches. Mixed media. Courtesy of Pace/MacGill Gallery, New York, NY.

Huxley, Arthur C. Clarke, Buckminster Fuller, and William Gibson, the father of cyberpunk science fiction: All created fantastical works that were situated beyond the margins of their era and anticipated future inventions and societal transformations. As the critic Robert Scholes wrote, "to live well in the present, to live decently and humanely, *we must see into the future.*" For photographers, living well means making purposeful pictures that awaken our sense of wonder and speculation, thereby helping to alter the social climate and make new ideas acceptable. Being a decisive photographer is about getting into a state of

mind I refer to as "The Attention Zone". In this situation, one relies on a single-mindedness to make those "special" images that depict, express, and engage viewers in a dialogue about the ambiguous and often contradictory makeup of human behavior.

Selection

Selection is the process of choosing from all the idea options that have been discovered. Now is the time to decide which way is best to reach the stated destination. Keep a backup idea in case a detour is encountered. Do not be afraid to experiment, to take chances, or to try something that has not been done previously.

Operation

Operation is putting the plan into action. The process of doing is as important as the final product. Do not seek perfection because it is an unattainable goal. If the selected idea is not working out, be flexible and attempt something else.

Make many exposures; use your camera as an artist would employ a sketchbook. These recordings act as starting places for your visual ideas. Keep thinking. Do not worry when every picture is not a masterpiece. Do not be concerned when you make gaffes—they will be dealt with in the next step of the process. Just keep working.

Evaluation

During evaluation the course of action is reviewed. Ask these questions: What was done? What worked? What didn't? Why did or didn't it work? What could be done to make a compositionally stronger and more emotionally engaging image? Pinpoint the source of any dissatisfaction. If the result does not meet your goals, it is time to "reshoot."

Look beyond the obvious. Kofi Annan, the former Secretary-General of the United Nations, recounted a lesson in remaining open to what is in front of our eyes. One of his teachers took out a large white sheet with a black dot in the middle, draped it over the blackboard and asked, "What do you see? We all answered: The black dot. He responded: What about the vast white space? He was reminding us to look beneath the surface, to bear in mind the larger picture. He was teaching us that there is more than one side to a story, and more than one answer to a question."

Do not latch onto only one idea, as absolutist beliefs can be crippling to creative problem solving. A large part of learning involves how to deal with failure. We learn more from our failures than from our successes. As Picasso said, "Even the great artists have failures."

Results

Good results render your ideas and intentions visible. A successful solution is one that fits both the problem and the problem solver. To make this happen, you must be ready to jump in—chance favors the prepared—and become a part of the process called photography.

The successful problem solver keeps a record of what has been done and how it was accomplished. This is empirical knowledge—repeatable results gained from experience.

 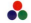

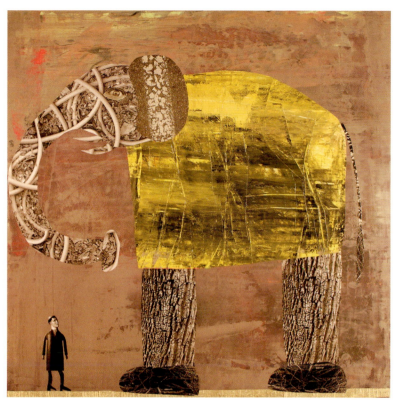

Figure 14.10 Holly Roberts tests the limits of photography with her hand-altered digital collages. She begins this work digitally, by importing photographs and scanning found images, and after manipulating size, color, and contrast, she prints the images. The artist then cuts and reforms the images, reassembling them on a prepared surface, and finally hand-paints the work to create a unified composition. Roberts's manual interventions reflect the Possibility Scale, which affirms that there are no artistic impossibilities, only different levels of possibility. By charting a new course and risking failure, Roberts pushes beyond conventions to declare, "If I can imagine it, there is a way to communicate it."

© Holly Roberts. *Man with Elephant*, 2009. 36 × 36 inches. Inkjet prints and mixed media.

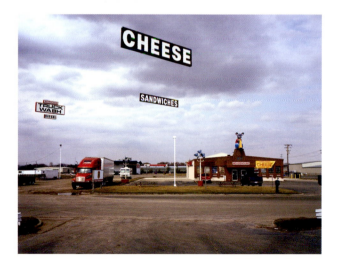

Figure 14.11 Matt Siber's *Floating Logos* project is characterized by his process of selection and removal. He captures images of signs on transparency film, which he scans in order to digitally manipulate them. Using the healing brush, clone stamping, masking, and patching tools, he retouches the support structures out of the image, leaving signs that appear to hover in the sky. Siber states, "Inspired by the proliferation of very tall signs in the American Midwest, *Floating Logos* seeks to draw attention to this often overlooked form of advertising … References can be drawn to religious iconography, the supernatural, popular notions of extraterrestrials, or science fiction films, each something that can profoundly affect our lives yet is just beyond our control and comprehension."

© Matt Siber. *Cheese*, from the series *Floating Logos*, 2006. 40 × 50 inches. Inkjet print.

Figure 14.12 Learning to communicate despite language and cultural barriers has enabled Antonio Mari to do photojournalistic work all over the world. He often operates under the motto "Photograph first and ask questions later." Mari advises, "In situations like this, your best tool to capture a spontaneous and interesting photograph is a smile. Over the years, in my ethnographic photography forays in faraway lands I learned that when people see a stranger approaching them with a big professional camera they assume an attitude that invariably will compromise the quality of your image … In my experience, whenever I try to take a photograph of a stranger, like that of a street dentist in India, I approach them with a smile and an attitude of respect and child curiosity. I photograph first to capture the magic of the decisive moment, and if they complain, I smile again and let them know that it was only a picture."

© Antonio Mari. *A Street Dentist in the Pink City*, Jaipur, Rajasthan, India, from the series Rajasthan Diaries, 2009. 51 × 75 inches. Inkjet print.

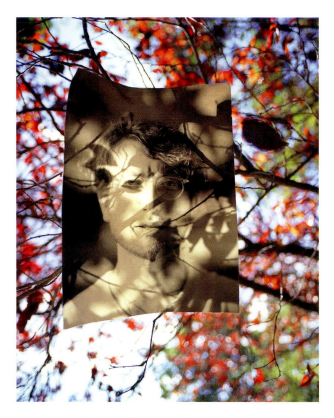

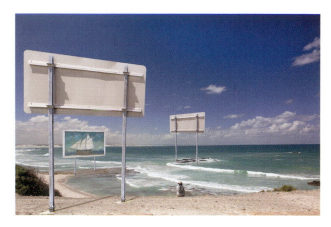

Figure 14.14 Compositing photographs taken in such disparate locations as the South African coast, along Interstate 90 in Massachusetts, and a field in Maine allowed Joan Barker to fabricate photographic reality. She states, "As the viewer navigates through the image, the unlikely but logical placement of objects requires a new assessment. This thought process transcends time and place as multiple locations and the past, present, and future are presented simultaneously … My photographs may be seen as the harmless beginnings of the usurpation of physical, spiritual, and mental space. The quality of our existence, and our ability to sustain the planet we live with, depends heavily upon the character of the spaces we create around and within us."

© Joan Barker. *Backwards Looking*, from the series *Constructed Landscapes*, 2009. 13 × 19 inches. Inkjet print.

Figure 14.13 Evaluation and reevaluation form the basis of Tim Hailand's rephotographed work. Instead of viewing his portrait photographs as completed works, the artist reintroduces them into his work, treating them as subjects and placing them in various locations. Hailand states, "In looking for a new way to treat the photograph as a more material object, as a subject in itself, I began to rephotograph my work in a new context, letting the work perform in the world. I often think of photographs as 'stopping points,' and with these works the pieces now have different points of completion: They continue their travels."

© Tim Hailand. *Carlton DeWoody in New York in Berlin*, 2008. 43 × 34 inches. Inkjet print. Courtesy of Beth Rubin DeWoody.

Problem solving means coming to grips with the true nature of the situation. Simplistic solutions to problems tend to offer clichéd answers for the lazy and the unthinking. Be skeptical of anyone who claims to have all the answers. Some people take a course in photography believing that techniques will make them photographers; this is not the case. To be a photographer, you must learn to intensely see and think a situation through to a satisfying conclusion based on personal experiences and needs that combine the "right" technique for your vision.

The quest for the "absolute" tends to get in the way of good photography. In his book *Perfect Symmetry: The Search for the Beginning of Time* (1985), the physicist Heinz R. Pagels said:

> Maybe there is some final truth to the universe I do not know. Yet suspending such beliefs opens us to new ways of exploring. Later we can compare our new knowledge and beliefs with the old ones. Often such comparisons involve contradictions; but these, in turn, generate new creative insights about the order of reality. The capacity to tolerate complexity and welcome contradiction, not the need for simplicity and certainty, is the attribute of an explorer.[3]

Understanding Photography's Roles

Problem solving and technical abilities communicate nothing to others unless attached to convincing personal beliefs. The big questions deal with the roles photography plays in our lives and society. What must be implicit is that photography's relationship to reality is paradoxical. Conscientious work can provoke without coercing, while providing pleasure that is mediated by the viewer's judgment. Some have read the works by artists such as Robert Mapplethorpe and Andres Serrano solely as calls to perform unnatural acts, instead of acknowledging that one of photography's functions can be to provoke controversial discussion about lifestyles and briefs. Other artists, such as Robert Heinecken, challenged the notion that it is even necessary to use a camera to make noteworthy photographic work. Critic Arthur C. Danto coined Heinecken a "photographist," which he defined as "an artist who uses photographs for artistic means and whose function is partly philosophical reflection on the nature of the kind of art it exemplifies."

Potent work is often ambiguous and requires interpretation by the viewer. Without being didactic, it can stimulate thinking that leads to an understanding. Such images allow us to be transported to explore other realms while remaining in our habitat, permit us to be transformed, and appeal to our personal freedom and individualism while reminding us of our collective investment in the group. Other times art can resist explanation, which is why it is called art. If an object could be explained in 87 words on an oversize wall label, you wouldn't need the object, just the curatorial text. Art is not social studies and it cannot be counted on to reveal its meaning at the end of a chapter. At some point it

can be perplexing, and it is this bewilderment that remains an unseen part of the art experience. For some this can create the "art jitters," the anxiety of not "getting it." Art appreciation is a complicated process and there can be no epiphanies without trials. One cannot expect to respond to every work of art, but one of the best things about hard-to-get art is that it allows you to create your own narrative, a drama-based allure, apprehension, bewilderment, the sheer pleasure of figuring it out, and telling others what you discovered.

Images created with integrity allow us to stretch our imagination and enter a dreamlike state where rational thought is suspended, all while retaining our faculty for judgment and reflection. It is possible to return from this journey to reflect on the choices that habitually define and restrain us. In *The Scandal of Pleasure: Art in an Age of Fundamentalism* (1995), Wendy Steiner writes: "Experiencing the variety of meanings available in a work of art helps make us tolerant and mentally lithe. Art is a

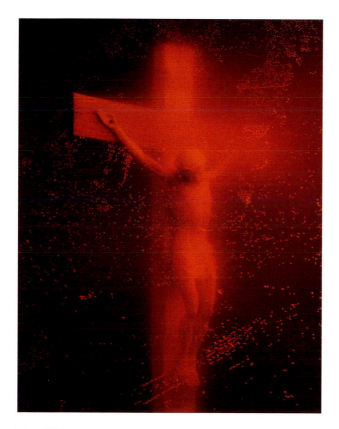

Figure 14.15 This photograph became a flash point for a conservative crusade to end National Endowment for the Arts (NEA) funding for individual artists and nonmainstream arts and cultural organizations. Why did this piece upset so many people? Was it what they saw, or what they read? Would anyone have been unnerved had this work been called *Untitled*? Andres Serrano's quandary with his faith also has produced worshipful images, such as *Black Supper, Black Mary,* and *Black Jesus.* Serrano refers to himself as "a former Catholic and … someone who even today is not opposed to being called a Christian."

© Andres Serrano. *Piss Christ*, 1987. 60 × 40 inches. Dye-destruction print. Courtesy of Paula Cooper Gallery, New York, NY.

realm of thought experiments that quicken, sharpen and sweeten our being in the world."

Writing About Images

Solving visual problems involves learning the language of photography. One way of expanding your visual vocabulary and learning to recognize its *semiotics* (signs and symbols) is to write about pictures, for this will deepen your insight into your own working methods, predispositions, and influences, and the diverse roles photography can perform. Begin by visiting online photographic collections or exhibition venues (see Box 14.1) and/or a brick-and-mortar library to browse through the photography and art books and periodicals. If you have access to exhibitions, plan on visiting a few different ones. Do not limit yourself to only photography; rather, select a variety of media, styles, and periods. Spend time interacting with the work and recording your thoughts. When permissible, photograph works that intrigue you and/or acquire exhibition publications, such as postcards and catalogs, for reference. Next, write a structured review having an introductory premise, a body of well-thought-out observations and evidence, and a conclusion based on the data you presented. Begin by selecting work you find affirmative, engaging, and stimulating. Relate your observations and opinions and support them with specific details derived from your experience with the work. Imagine you are in a court: Give direct evidence based on your first-hand account, not generalizations or unfounded information, and include illustrations. Consider including the following topics:

Describe the work: Description comprises the physical character, subject matter, and its form. Form entails how a subject is presented (refer to Chapters 5 and 6). Can you determine the color and/or composition key? How are figure–ground relationships used? How do these qualities inform the overall nature of the work and the persona it projects?

Evaluate the technique: What methods are employed? Is there anything unusual? Does the methodology work for you? Why or why not? Discuss exposure and use of light, along with printing and presentation methods used to generate the total visual effect. Would you do anything differently? Why or why not?

Personal reaction: Pay attention to your first reactions. What initially attracted you to this work? Did the magnetism last? Did the work deliver what you expected? Would you want to keep looking at this work over a period of time, as in your living space? Does the maker have a visual or haptic outlook (see Chapter 5)? How does this inform the nature of the work? Did you find yourself thinking or dreaming about the work later? Answer each question with a why or why not response.

Interpretation: Ask yourself: Who made it? What is the point of view of the imagemaker? What was the maker trying to communicate? Does the imagemaker succeed? What is the larger context of the work? Who was it made for? Do the images stand on their own merits, or do they require an accompanying statement or explanation? What is your interpretation of the work? Does it present a narrative account, or is it an open-ended visualization? Does it appeal to your emotions or your intellect? If the work is in a group or series, evaluate how selected images work individually and in terms of the group. Do single images

hold their own ground, or are they dependent on being seen in series? Does the imagemaker use any text? If so, toward which do you first gravitate, the image or the text? How does the text affect your perception of the image's meaning? How would your understanding of the piece be different if there were no text? Present clear, succinct, and persuasive arguments, giving evidence to back up your point of view.

Integrate new ideas: Examine and define the work's attributes that appeal to and affect you. Be specific and cite examples. Then consider how it might be possible for you to learn from and integrate these concepts into your way of thinking and working.

Do the opposite: Go back to the same body of work and select work(s) that you find disconcerting. Repeat the previous steps to uncover what adversely affects you. Identify specific

points, such as content, color, or composition, and ask yourself what you could do to avoid incorporating such unwanted characteristics into your work. Consider whether the disconcerting works have a greater impact than the pleasing works, and think about why?

Seek out knowledge: Seek out someone who is knowledgeable and involved in similar work. Present the work to that person and engage in a friendly discussion. What are that person's views? Does that individual agree or disagree with your assessment? Do your opinions hold together and make a convincing case? Identify your persuasive and ineffectual points. How can they be improved? Can you see another point of view? What new territory did this other person open for you? How does this affect the way you view the work now?

Box 14.1 Online Photographic Collections and Exhibition Sites

The American Museum of Photography: **www.photographymuseum.com/**

American Photography: A Century of Images: **www.pbs.org/ktca/americanphotography/**

American Suburb X: **www.americansuburbx.com/**

CEPA Gallery: **www.cepagallery.com/**

George Eastman House: **www.eastmanhouse.org/**

J. Paul Getty Museum: **www.getty.edu/museum/**

International Center of Photography: **www.icp.org/**

The Library of Congress Print Room: **www.loc.gov/rr/print/**

LOC: American Memory Collections: **memory.loc.gov/ammem/index.html**

Light Work: **www.lightwork.org/**

Luminous-Lint: **www.luminous-lint.com/**

Masters of Photography: **www.masters-of-photography.com/**

Museum of Modern Art: **www.moma.org/explore/collection/ photography**

New York Public Library: **www.nypl.org/digital/index.htm**

Photo-eye: **www.photoeye.com/**

The Photographers' Gallery: **www.photonet.org.uk/**

Smithsonian Institution: **www.si.edu/Encyclopedia_SI/Art_ and_Design/Photography.htm**

Women In Photography International: **www.womeninphotography.org**

Zone Zero: **www.zonezero.com/**

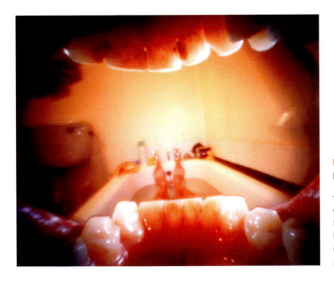

Figure 14.16 Justin Quinnell fashioned this self-portrait by placing a homemade pinhole camera, known as the Smileycam, in his mouth for the duration of the 15-second exposure. To light the inside of his mouth, he used two handheld flashguns. Quinnell writes, "The difficulty was in keeping my head still with a cushion whilst holding a flashgun in each hand, a camera clenched inside my mouth, and keeping my toes poked inside the bathtub faucets. The trickiest photo ever taken since Luna 3 photographed the rear side of the moon in 1959!"

© Justin Quinnell. *Bath Time*, 2002. Variable dimensions. Chromogenic color print.

Writing an Artist's Statement

When sending your work out for review or exhibition, it is necessary to include a statement that concisely explains the conceptual aspects of your approach. Essentially, an artist's statement explains why you do what you do and what your work is about. A precisely written statement can forge a connection between the artist and the audience, stimulating awareness and understanding of your work. Artists' statements vary in form, length, and substance. Take into consideration the following: your audience, your materials and medium, the subject of your work, the methodologies and theories that have influenced you, and your own background, purpose, and/or perspective. There are no simple formulas, but the subsequent steps have been put together with the assistance of imagemaker and educator Kathleen Campbell to provide a starting place for writing a concise, easy-to-read, one-page artist's statement.

Box 14.2 Artist's Statement

- The purpose of an artist's statement is to clearly and succinctly explain your ideas and give them credibility. Begin by listing what your ideas are and where they come from.

- Reflect upon your own work and find patterns of interest, and then ask yourself the following: What kind of work do you enjoy making and looking at? Do you photograph landscapes or people? Do you prefer to set up subject matter or find it directly from life? Do you gravitate toward cool or warm colors? Do you favor simple or complex compositions? Do you consider yourself to be a visual or haptic person? What ideas, themes, or common denominators can you discover?

- Select an artist whose work strongly appeals to you and find out what that artist has to say. Review the procedures from the previous section, Writing About Images.

- Do research. Ideas are built upon other ideas. Your work can share an idea with someone else and still be your own work. Artists get ideas from other artists, history, literature, philosophy, and politics. Where do your ideas come from? What ideas appeal to you? When you come across an idea or concept that is a magnet to you, write it down and then rewrite it in your own words, giving it your own personal perspective.

- Can viewers interpret your image, not knowing what you intended and not having had your experiences? Keep in mind that an image is not the same thing as an actual experience. Generally, it is a two-dimensional representation or projection of colors and shapes that is a symbol or a metaphor for an event or subject.

- Take into account that all images possess meaning. People will make interpretations, whether you want them to or not.

- Learn the difference between denotation and connotation. Denotation is what images appear to be on the surface, such as a picture of a river. Connotation is all the associations you can imagine people might "get" from the picture of the river. There are pictures of rivers and pictures of rivers. Are yours cool and intellectual or warm and romantic? Make a list of all the connotations and denotations you can see in your work. Show the work to others and see what they have to contribute.

- Use metaphors, statements that are representative or symbolic of something else, especially something abstract. Literal statements lead toward literal interpretations. You are not "illustrating" your concept or idea, step by step, but fashioning a metaphor that involves your use of form and process to convey it (even if you do not discuss these in your statement). For example, darkness can be a metaphor for atmosphere. Your statement does not have to hammer people with an intended meaning if the work creates an interpretable metaphor. Just as metaphors can have layers of meaning, so viewers can bring their own insights to your images.

- Provide a toehold for understanding the ideas behind your images. Do not tell viewers "what they should get" out of your work; rather, point them in a specific direction. By and large, images have more than one interpretation, so allow others the freedom to formulate their own explanation. On the other hand, this is not an excuse to avoid articulating your own analysis.

- Have your words agree with your pictures. Do not write about things that are not there. If your words and images do not agree, either change the words or change the images until they are consistent.

- Say it simply and specifically. Avoid making negative statements, writing too much, repeating or over-explaining, using vague generalities, making grandiose statements, or relying on jargon or incomprehensible language. Big words don't make up for weak ideas.

- Discuss the technical process only when it is integrally related to your idea or is unusual and requires explanation.

- Include a separate image checklist with the title of each work (if any), creation date, dimensions (height before width), and process (such as chromogenic or inkjet print). Include a general technical overview about the methods utilized to realize your vision. Provide detailed technical analysis upon request.

- Ask others familiar with your work to evaluate your statement. Review, rewrite, and recheck the spelling, grammar, and organizational flow of your document. Writing involves rewriting, and the process of rewriting will also help you gain insight into your work. An artist's statement is a flexible document. You may have more than one for different audiences, and each should be reviewed and revised every time you use it.

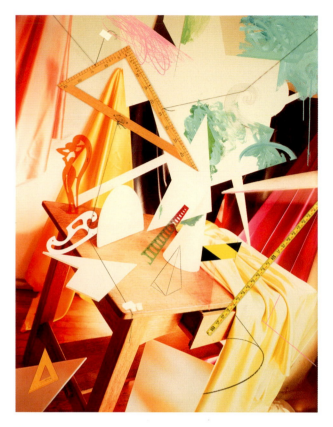

Figure 14.17 Monocular vision, seeing the world from a single, linear viewpoint, is a construct at the heart of classical Aristotelian thinking. This allows Westerners to position themselves at the center of their "uni-verse." Conversely, Native Americans traditionally saw the world as a "multi-verse" that accepts that there is not one truth, but many. By painting on photographs, Jayme Odgers hopes "to access a more 'whole world' way of seeing, much like the Cubists sought with their simultaneous viewpoints and layered thinking. I am seeking a way of working that not only transcends the usual Western dualistic thinking by unifying what we consider 'opposites'—classical vs. modernist and postmodernist sensibilities, photographic vs. painterly sensibilities, surface vs. implied depth, even work vs. play—but also by thematically unifying the masculine with the feminine, the primal and the classical with the contemporary, and the East with the West." As the poet Wallace Stevens observed, "Reality is not what it is. It consists of many realities which it can be made into."

© Jayme Odgers. *Construct #1*, 1991. 60 × 48 inches. Dye-destruction print with mixed media. Courtesy of Grahame Howe Collection.

NOTES

1. David Shenk, *The Genius in All of Us: Why Everything You've Been Told About Genetics, Talent, and IQ Is Wrong* (New York: Doubleday, 2010), p. 99.
2. Arthur Koestler, *The Act of Creation* (New York: Macmillan, 1964), p. 192.
3. Heinz R. Pagels, *Perfect Symmetry: The Search for the Beginning of Time* (New York: Simon and Schuster, 1985), p. 370.

RESOURCES

Barrett, Terry. *Criticizing Photographs: An Introduction to Understanding*, 4th edn. New York: McGraw–Hill, 2005.

Read, Shirley. *Exhibiting Photography: A Practical Guide to Choosing a Space, Displaying Your Work, and Everything in Between*. Amsterdam and Boston, MA: Focal Press, 2008.

Steiner, Wendy. *The Scandal of Pleasure: Art in an Age of Fundamentalism*. Chicago, IL: University of Chicago Press, 1995.

Turabian, Kate L. *A Manual for Writers of Term Papers, Theses, and Dissertations*, 7th edn. Chicago, IL: University of Chicago Press, 2007.

Volk, Larry, and Currier, Danielle. *No Plastic Sleeves: The Complete Portfolio Guide for Photographers and Designers*. Amsterdam and Boston, MA: Focal Press, 2010.

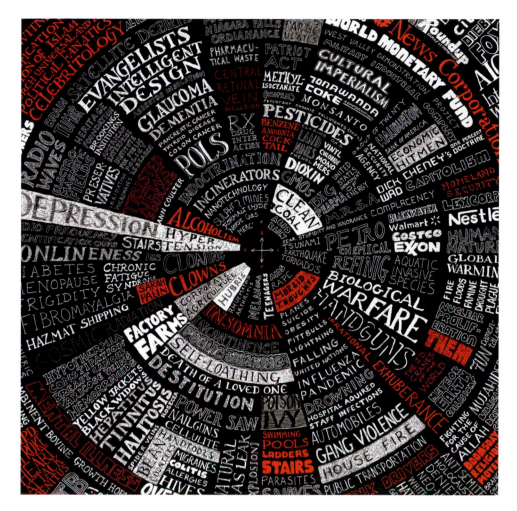

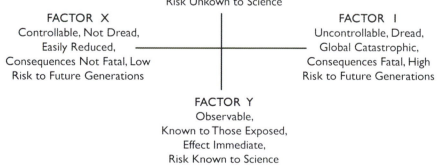

FACTOR 2
Not Observable,
Unkown to Those Exposed,
Effects Delayed, New Risk,
Risk Unknown to Science

FACTOR X
Controllable, Not Dread,
Easily Reduced,
Consequences Not Fatal, Low
Risk to Future Generations

FACTOR 1
Uncontrollable, Dread,
Global Catastrophic,
Consequences Fatal, High
Risk to Future Generations

FACTOR Y
Observable,
Known to Those Exposed,
Effect Immediate,
Risk Known to Science

Responding to recent developments in the science of *Risk Perception,* Adele Henderson documented and charted her own "perceptions of risk" on an x-y axis. The resulting drawing, originally created with pencil, pen, and ink, was subsequently scanned, adjusted in Photoshop, and outputted as a positive on to Pictorio film. The film was then exposed to a photo-positive lithography plate and hand printed. A second litho plate was made using similar techniques for the red layer, which was printed underneath the key image.

© Adele Henderson. *Perception of Risk,* 2009 (detail). 25 × 19 inches. (19 × 19 inches, detail). Lithograph.

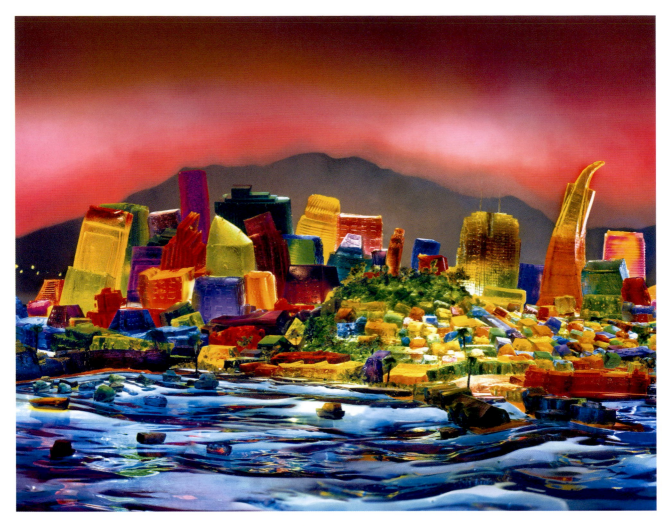

Liz Hickok fabricates Jell-O models of urban scenes and cityscapes, transforming these sites into something colorfully luminous and ephemeral. Here she used a view camera with color transparency film to record this construction, which she lit from below with daylight-balanced fluorescent lights and LED lights. The artist incorporated a variety of diffusion materials, such as paper, vellum, and plastic bags, to address the drastic contrast between light and dark areas of the scene. To construct a panoramic image and overcome narrow depth of field, she exposed a total of six pieces of film, which she scanned and composited in Photoshop. Hickok tells us, "With this particular image, the artistic challenge was to take an iconic view of San Francisco, a scene that most of us are familiar with, and make it into something unexpected and provocative. I used the fragile and gelatinous material to evoke uncanny parallels with the geological uncertainties of San Francisco's landscape."

© Liz Hickok. *View from Alcatraz* (detail), 2007. 26 × 84 inches. Chromogenic color print.

Presentation and Preservation

Once you decide that a color image is a keeper, you should start thinking about how to properly prepare it for presentation and storage for future use. Digital files need to be electronically corrected, spotted, or retouched *before* printing because the variety of output materials can require very specific corrections. Finished analog prints may have visual defects such as dust marks or scratches that can be corrected by spotting them with dye and a fine-point brush.

Your digital imaging software can also help you restore faded images as well as color negatives and transparencies (slides). Additionally, such software offers potent tools for retouching and repairing traditional photographic images. A moderately to severely damaged image can be scanned, electronically repaired, and then reprinted (see Figure 9.1). One advantage of digital repair is that, after the image is scanned, the original image is not touched and cannot be accidentally damaged further during the repair or retouching process. Some of the most useful software tools for image retouching and/or repair are described in Chapter 11.

In terms of presentation, consider whether the work will be best served by matting and framing. Special consideration needs to be given to unconventional formats, such as artists' books and installation pieces, which often require custom solutions.

Analog Spotting: Chromogenic Prints

Hand spotting is generally carried out before the photograph is matted or mounted. Good working techniques should keep spotting to a minimum. Although spotting is used to correct most minor print blemishes, there are other expressive avenues of manipulation that can be investigated. For instance, a very light area in one corner of the print can have density added to lower its luminance (light reflected from the surface) so it does not draw the viewer's attention away from the subject. A badly damaged photograph can be scanned, electronically repaired, and then reprinted. An advantage of this method is that after the image is scanned the original is not handled and cannot be damaged further during the repair or retouching process. The big difference between spotting color and black-and-white prints is that in color both the density and color balance of the area that is being spotted must be matched. To make this task as simple as possible obtain the materials in Box 15.1. Then to spot a color chromogenic print, follow the procedures outlined in Box 15.2.

Follow these procedures when spotting a color chromogenic print.

Box 15.1 Spotting Materials

Premixed color spotting dyes, including those made by Berg, Kodak, Marshall, and Photographic Formulary, are recommended. These dyes are designed to go directly into the emulsion, blend to a color similar to it, and leave no residue on the surface. Black-and-white spotting dyes, such as Marshall's and Peerless, also can be useful. Some people use watercolors, oils, and other types of dyes, but the problem with these materials is that they fade at a different rate than the dyes that make up the print. Over time the area that has been spotted with nonstandard materials can become distinctly visible from the rest of the photograph.

You will need the following materials to spot a print:

Sable brush with a good point, size number O or smaller.
Mixing palette. Enamel or plastic watercolor palettes work well. Some people prefer to mix on a piece of paper, clear acetate, or glass.
Container of clean distilled water.
A couple of sheets of white paper or white processed photographic paper (whatever you prefer to use).
Paper towels.
Clean cotton glove(s).
Good light source (5000K lamp, north light, or combination of cool and daylight lamps).

Repairing Scratches

You can repair surface scratches that have scratched through one or more dye layers of the paper emulsion by applying liquid dyes. For best results, make sure that the dilution of the dye is correct. Do not add neutral dye to the colored dye; added density is not necessary. A cross-section of color negative paper would reveal a top-down sandwich of cyan dye, magenta dye, yellow dye, resin coating, and paper base. A scratch that removes the top (cyan) dye layer appears red; to correct it, add cyan dye of the proper concentration to neutralize the red and match the adjacent area. A scratch that goes through the top two (cyan and magenta) dye layers appears yellow. To correct it, first add magenta dye, and then cyan dye, in the proper concentrations to match the adjacent area. After you apply the correct concentration of dye, use a finishing lacquer or a wax to restore an even surface.

Box 15.2 **Spotting a Chromogenic Color Print**

1. Put the print on a smooth, clean, and well-lit surface. Place a clean sheet of white paper over the print, leaving visible the area to be spotted. A window can be cut in the paper to spot through, offering additional protection to the print. Put the cotton glove on the nonspotting hand. This prevents the print from getting fingerprints and hand oil on it. Our bodies also contain and give off sulphur, which can stain the print. If necessary, glove the spotting hand as well. The paper provides a neutral viewing surface, which helps act as a visual guide in matching the color balance.

2. Place small amounts of the color dyes that will be used onto the palette.

3. Wet the brush in the water. Draw a line with it on a paper towel to get rid of the excess water and to make a fine point.

4. Dab the brush into the dye. Check the color by drawing a line on the white processed photographic paper or a separate sheet of white paper; after comparing the line with the area to be spotted, add other colors to the dye, including black-and-white, until it matches.

5. Once the correct color balance has been achieved, draw a horizontal line on the paper towel to remove any excess dye and water. The brush should appear dry, but inside it will remain wet and hold a small amount of dye. To apply the color

to the print, gently touch the tip of the brush with a small stroke to the surface. Practice on the processed white paper before working on your final print.

6. For very small spots, create a series of dots. This helps to match the grain structure that forms the image. Do not paint it in, as this will be noticeable since the print is made from points not lines (Figure 15.1). Make one pass using this dot method. Some areas of white should still be visible between the dots. Let the dye dry for a minute. Make another pass with the dot technique, filling in more of the spot. Let it dry and see if it matches. Repeat if necessary, but do not apply too much dye. Different movements will deliver different effects. For small areas and fine white lines, start the tip of the brush at the beginning of the line and make tiny side strokes, which blend the line into the surrounding area much easier. For wider spots, slightly bend the brush. For wide lines or for a dye wash, fan the brush (Figure 15.2).

7. When finished spotting, wash the brush with warm water and soap. Rinse completely, and carefully repoint the brush between the thumb and index finger.

A blob, a line, or an area that is too dark draws as much attention to the eye as the spot. Take your time and be subtle. Do not overdo it. This is not like painting a brick wall with a roller.

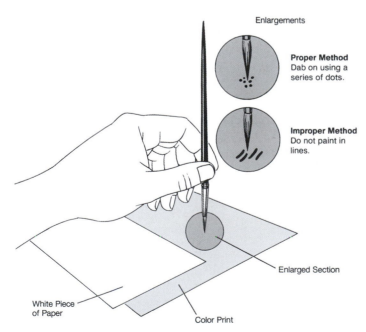

Enlargements

Proper Method
Dab on using a series of dots.

Improper Method
Do not paint in lines.

Enlarged Section

White Piece of Paper

Color Print

Figure 15.1 The method for properly spotting a print: A well-pointed brush containing the properly matched color dye is dabbed onto the print. A piece of white paper highlights the area to be spotted while protecting the remainder of the photograph. It also acts as a visual reference point, letting you see if the spotting dye is making the desired match with the surrounding area.

Figure 15.2 Sketch (a) For very small spots, just touch the brush to the photograph with a small stroke. Only the tip of the brush should touch the print, releasing the dye onto the emulsion. It is important to work with the tip of the brush in fine or small areas. The dye in the brush flows from the ferrule to the very tip of the brush, which is a single hair. (b) For white lines and small spots, prepare the brush with the correct color and make sure you have a good point. Place the very tip of the brush at the beginning of the line and make a series of mini-strokes instead of trying to fill it in with a single stroke. These short strokes will blend the line into the surrounding area more readily than a single stroke. (c) To cover a wider spot or to blend, slightly bend the brush. (d) To retouch wide lines or to make a dye wash, fan the brush.

Fixing Mistakes

If there is too much dye on the print, quickly remove it by letting a piece of paper towel absorb the excess. Do not rub or smear it.

If the color does not come out correctly or if too much dye is absorbed, attempt to remove the spot with a drop of 5 percent solution of ammonia and water. Apply with a clean brush. Let it sit on the spot for about 60 seconds, and then absorb it with a piece of paper towel. Let it dry before attempting to start spotting there again. If this does not work, let the spot dry, cover it with white dye, and start over.

If you are unhappy with the overall results, wash the print with room temperature water for 5 minutes, dry, and start over. If the dye does not come out, try putting a tiny amount of ammonia on the print, gently rub, and rewash. Drying can be done with a handheld hairdryer. Excess water can be removed by lightly patting the print with a lint-free towel.

Spotting Prints from Transparencies

When spotting prints from transparencies, the major difference is that the dust spots appear as black, not white. These black spots have to be covered with white before spotting them. Small black spots can be removed by etching the surface of the print with a sharp, pointed blade, such as a #11 X-Acto, until the speck is gone. This must be done with great care so that the surface of the print does not become too rough and visually objectionable. Color should be applied only with an extremely dry brush. Lacquer spray will probably be needed in both cases to eliminate the differences in reflectance between the spotted and nonspotted areas of the picture.

Ilfochrome Classic materials often will not respond to conventional retouching methods due to the way the product is manufactured and processed. Use one of the specially formulated retouching kits to correct color casts, reduce color densities, and bleach colored or black specks. The correct color then can be applied on the white spot. Large area color reductions, and even total bleaching, can be carried out. Special bleaching agents and solvents can be used to dissolve the cyan, magenta, or yellow emulsion layers.

Spray Lacquers

After the dyes have dried, there may be a noticeable difference in reflectance between the spotted areas and the rest of the print—especially with glossy paper—that some photographers treat with a spray lacquer. Available in glossy and mat finishes, print lacquers create an even reflectance over the entire photograph. However, there is considerable debate about the long-term stability of prints treated with spray lacquer, which over time can crack, flake off, and discolor the print surface. For these reasons, lacquers should not be used on fine art prints or photographs in museum collections. If a lacquer must be used, Lacquer-Mat lacquers and Sureguard McDonald Pro-Tecta-Cote 900-series noncellulose nitrate lacquers are recommended. For best results, read the manufacturers' instructions for proper application and handling of these materials. Work only in well-ventilated areas, and follow all safety guidelines.

Digital Retouching and Repair

After making a successful digital image, you may wish to physically present it, either on screen or as a physical print, and

Box 15.3 **Spray Lacquer Guidelines**

To ensure an even spray, follow these guidelines in a clean spray booth environment:

1. Remove any dried lacquer from nozzle opening.

2. Shake the spray can a few seconds before each use.

3. Keep nozzle perpendicular to the print surface.

4. Begin spraying with the spray directed *away from* the print surface.

5. Spray in light, even, overlapping strokes.

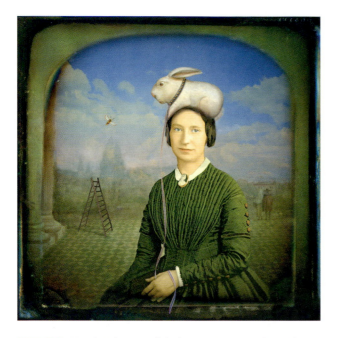

Figure 15.3 Maggie Taylor uses a flatbed scanner to capture nineteenth-century photographs and objects that she finds at flea markets or online. After importing these images, she layers them with her own photographs and drawings and then extensively retouches the digital collage. She tells us, "Often the biggest challenge of working with Photoshop is knowing when you are done with the image. I can work for weeks on rearranging parts of the image and adjusting all the colors." When complete, the collages can contain 30 to 60 layers and reveal a surreal blend of dreams and Victorian imagery.

© Maggie Taylor. *Everything She Wanted*, 2009. 15 × 15 inches. Inkjet print.

properly store it for future use. First, make sure that any visual defects, including dust marks, have been corrected before making final prints. Digital imaging software can also help to restore faded images as well as color negatives and transparencies (slides). Additionally, such software offers potent tools for retouching and repairing traditional photographic images. A damaged photograph can be scanned, electronically repaired, and then reprinted. One advantage of this method is that, after the image is scanned, the original is not handled and cannot be accidentally damaged further during the repair or retouching process. Some of the most useful software tools for image retouching and/or repair are described in Chapter 11. Unconventional formats, such as artists' books and installation pieces, require unique presentation solutions. For detailed information see: Ctein's *Digital Restoration from Start to Finish* (Boston, MA and London: Focal Press, 2nd edn, 2010).

Waxing a Print

Waxing can be done to protect the print surface, enhance luminosity, create a surface similar to that of a painting, build up a 3-D effect, or make a 3-D object. Wax can be heated to its melting point to make it easier to work with, but care must be taken to avoid its flash point (the temperature at which the vapor of a combustible liquid can be made to ignite), which for wax mediums is between 107 and 145 °F. Do not expose the wax to direct flame. Melt the wax in a double-boiler pan. Wax also comes "soft" and can be directly applied with either a buffing cloth or a small piece of cheesecloth to the surface of the photograph.

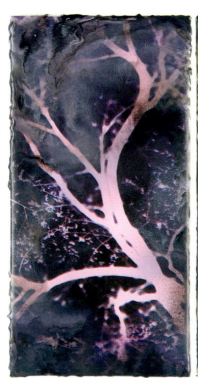

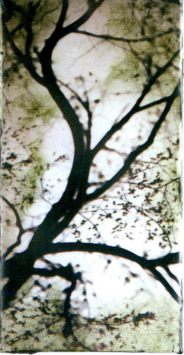

Figure 15.4 Waxing a print can be done for preservation and aesthetic purposes; Nicole Fournier's work realizes both. She begins with landscape photographs, which she digitally manipulates and outputs onto canvas as giclée prints. The artist mounts the canvas onto stretcher bars and finally paints layers of beeswax and pigmented encaustic wax onto the surface. She adds Damar resin to the beeswax to increase its strength and preservation abilities. Fournier explains, "This encaustic work reflects my interest in things we should, as a society, pay attention to, with issues such as deforestation and pollution. I like to add a human touch to the surface of the photograph, to capture a sense of a creative moment, beauty, and awareness."

© Nicole Fournier. *Tree Study, No.7*, from the series *Basis of Our Grounds*, 2009. 24 × 24 inches. Inkjet print on canvas with encaustic.

For protection, a small amount of wax the size of a dime will cover an 11 × 14-inch print. Afterwards the wax can be buffed to a sheen finish. Several coats of wax can be applied to simulate the surface of a painting, but you should allow several days or even a week between coats. A brush can be used to spread the wax and induce the brushstroke effects of a painting. A hairdryer can be used to keep the wax soft while spreading it on the print surface. The wax can be applied even more thickly to achieve a tactile 3-D look.

Prints can also be imbedded into blocks of paraffin wax to create a transparent 3-D presence. Wax mediums are generally available at professional art supply stores or online.

Archival Presentation

Although manufacturers readily use the term "archival," there is not an accepted criterion of what archival actually means. What we do know is that every image has a natural life span, and the length of that life span depends on the particular materials and process used and the conditions under which the image is cared for. The purpose of archival presentation is to protect the image from physical harm and to guard against elements that accelerate the aging process (see the section on Print Preservation later in this chapter). This ensures an image can last as long as physically

feasible. A skilled presentation job can enhance the visual appeal of a work, protect it, and send the message that this work is something worth-looking at and preserving. A partial list of major suppliers of archival materials mentioned in this chapter is provided in the Resources section at the end of this chapter.

Presentation Materials

Mat board is the long-standing choice for providing a stiff backing and basic protection for photographic prints. Making thoughtful choices is essential, as the color, quality, and texture of mat board will effect how viewers receive your images.

Mat Board Selection

To select the proper type of mat board, you should become informed about how various products affect paper support materials. Check with manufacturers for their latest products and their technical specifications. Then consider the factors listed in Box 15.4.

Window Mat

The window mat, the traditional enclosure for photographic prints, is made up of two boards, larger in all dimensions than the print. The top board, known as the *overmat*, has a window with beveled edges cut into it to keep the overmat from casting its shadow onto the print. This overmat is attached, with a linen tape hinge, along one side of the backing board. The print is positioned

Figure 15.5 Laurie Tümer relates, "My neighbor Mr. Martinez was obsessed with finding gold. Purchasing his magnifier at a yard sale intensified my own obsession for finding what I seek and value, and the triptych illustrates the inspection process of looking for a visual treasure. With this series, I felt the almost miniature prints had their greatest impact when placed on a page. I tipped each photograph into an area on 16 × 11½-inch Arches 140 lb. watercolor paper that I embossed with an etching press. I mounted each print with Gudy, an archival adhesive. This archival presentation contributes to the feeling of a small jewel nestled in a coffer. Ultimately, I designed a portfolio cover with handmade, earth-toned, and textured paper that housed these loose pages and made an edition of 10 *Planted* portfolio books, each containing 23 images."
© Laurie Tümer. *Planted: Under Mr. Martinez' Magnifier, Española*, 2002. 1½ × 7 inches. Chromogenic color print tipped into embossed watercolor paper.

Figure 15.6 Jonathan Long used a Hulcherama 120 rotating panoramic camera to make 360-degree photographs for his *Pre-Law Wastelands: Abandoned Mine Lands of Southern Illinois* series. He constructed a circular presentation enclosure to surround viewers and allow them to become part of the landscape, reminding us of the importance of environmental protection laws.

© Jonathan Long. *Untitled (Acid Mine Drainage #2)*, 2002. 48 × 552 inches. Installation size: circular 8 × 14 foot wall. Chromogenic color print.

Box 15.4 Mat Board Selection

Composition board is the most widely available and has the least longevity. Usually, composition board is made up of three layers: a thin top paper sheet, typically colored; a middle core layer, made of chemically processed wood pulp; and a bottom paper backing. The core layer is the product's weakness, because it contains a collection of acids and chemical compounds that break down and produce additional acid. These acids are transported in microscopic amounts of airborne water vapor onto the surface of your work. Here they begin attacking the image, often within a year or two, causing discoloration and fading. UV radiation from the sun and/or fluorescent lights can accelerate this chemical reaction. The same thing can happen when a work is backed with corrugated cardboard or Kraft paper. The acids in these materials invade the work from behind, and by the time it becomes apparent, the damage is irreversible.

Conservation-grade board consists of thin layers, all of the same color, known as *plies*. One type of board is made from purified wood pulp and is simply known as *conservation board*. The other type is made from 100 percent cotton fiber and is called *rag board*. Plain conservation board can be used for most archival operations, since it costs less, has equal longevity, and is easier to cut when making window mats. Most board is available in two, four, six, or eight plies. Four-ply board is good for most standard photographic presentations.

Acid-free board is recognized as the board of choice. Paper products having a pH of 7 or higher are considered to be acid-free. The pH scale measures the most acidic (pH 1) to the most alkaline (pH 14), with pH 7 being neutral. The "acid-free" label is an important criterion, but there are a number of factors to consider when making a selection. This is because the term *acid-free* can be misleading and at face value should not be considered the gold standard of a board's permanence. In fact, some manufacturers put only a piece of acid-free paper behind the wood pulp of composition board and then label their product "archival." Others add regular wood pulp that has been heavily treated with alkaline calcium carbonate and refer to it as "archival." This is in spite of the fact that, over time, the impurities in the board deteriorate and form acids and peroxides, thus producing or returning to a highly acidic board. When selecting acid-free board, be sure to find out if all the materials in the board are 100 percent acid-free, as this will offer your work the most protection.

Buffered and nonbuffered board is presently being debated in the conservation community. Since our physical surroundings are slightly acidic, and because paper tends to become more acidic with age, manufacturers of premium mat board have been adding calcium carbonate to offset this tendency. Current research indicates that certain papers may be affected by the presence of this alkali buffer, and that for longest life they should be mounted only on nonbuffered, acid-free board. This recommendation applies to all color chromogenic prints processed in RA-4 chemistry, including LightJet prints.

and attached to the backing board so it can be seen through the window (Figure 15.7). The mat gives the maximum protection to the print while it is being shown and also when it is stored. It provides a raised border to contain the work, and when the work is framed, it keeps the glass from directly touching the print surface. If the window mat is damaged or soiled, it can always be replaced without damaging the print. In storage, an acid-free tissue paper can be sandwiched over the print surface for additional protection.

A mat can be cut with a hand mat cutter, such as a Dexter or Logan, which requires practice for best results. Most people can cut a mat with a device such as the C & H mat cutter. For those who have only an occasional need of a mat, have a local frame shop make one for you or order one online. Keep in mind the type of light the print will be viewed under when selecting mat board. Daylight tends to have a blue cast, incandescent light is orange, and fluorescent light is generally greenish.

To make a window mat follow the steps in Box 15.5.

Dry and Wet Mounting

Traditionally, dry-mounting was the most common way to present a finished print for display. It is a fast and neat method to obtain print flatness, which reduces surface reflections and gives the work more apparent depth (see also the next section on Cold-Mounting). Prints can also be wet mounted with glues, paste (Gudy paste is archival), and liquid and spray adhesives, which can be useful when time is of the essence or when working with certain nontraditional materials.

However, numerous problems can result from dry-mounting (see Box 15.7) and therefore it is not recommended, except in special circumstances.

The Dry-Mounting Process

Dry-mounting tissue is coated with adhesive that becomes sticky when it is heated. This molten adhesive penetrates into the print and mounting board to form a bond. It is best to use a tacking iron and a dry-mount press to successfully carry out the operation; a home iron is not recommended because it can create unnecessary complications.

When mounting an inkjet or laser print, be certain that the dry-mounting tissue has been designed for use with that particular paper or the print may blister and/or melt. Usually a specially formulated, archival-grade, temperature-reversible adhesive tissue is recommended. It provides a safe bond that will not attack delicate items such as inkjet prints, silk, tissue, and rice papers. Check before proceeding.

Use four-ply mounting board so that the print does not bend. Keep the color selection simple. Use an off-white or a very

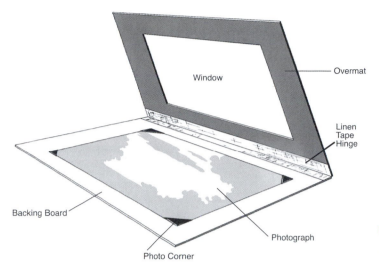

Window

Overmat

Linen
Tape
Hinge

Backing Board

Photograph

Photo Corner

Figure 15.7 The construction of a typical hinged window mat. The use of photo corners facilitates removing the photograph from the mat without harming it.

Box 15.5 Window Mat Guidelines

Clean your hands, working surface, and all materials.

Work under light similar to that under which the print will be seen.

Protect the cutting surface with a piece of mat board that can be disposed of after it gets too many cut marks. If you plan to cut mats on a regular basis, consider getting a self-healing cutting mat surface with a grid pattern and non-slip bottom.

Using a good, cork-backed steel ruler, measure the picture exactly. Decide on precise cropping. If you do not want the border to be seen, measure about 1/16 to 1/8 inch into the picture area on all sides.

Decide on the overall mat size. Leave enough space so as to not crowd the print on the board. Give it some neutral room so the viewer can take it in without feeling cramped. Box 15.6 offers a general guide for the minimum size board with various standard picture sizes.

Many photographers try to standardize their image sizes. This avoids the hodgepodge effect that can be created if there are 20 pictures to display and each one is a slightly different size. It also allows you to reuse mats by swapping prints. When the proper size has been decided, cut two boards—one for the overmat and the other for the backing board. Some people cut the backing board slightly smaller (1/8 inch) than the front. This eliminates the danger of it peeking out beyond the overmat.

In figuring the window opening, it is helpful to make a diagram (Figure 15.8) with all the information on it. To calculate the side border measurement, subtract the horizontal image measurement from the horizontal mat dimension and divide by two. This gives even side borders. To determine the height of the top and bottom borders, subtract the vertical picture measurement from the vertical mat dimension and divide by two. Then, to prevent the print from visually sinking, subtract about 15 to 20 percent from the top dimension and add it to the bottom figure.

Using a hard lead pencil (3H or harder to avoid smearing), carefully transfer the measurements to the back of the mat board.

Use a T-square to make sure the lines are straight. Check all the figures once the lines have been laid out in pencil.

Put a new blade in the mat cutter. The C & H cutter uses a single-edge razor blade with a crimp in the top. Slide the blade into the slot and adjust it so that it extends far enough to cut through the board. Hand tighten only, using the threaded knob at the end of the bolt.

Line the markings up with the mat cutter so that it cuts inside the line. Be sure to check that the angle of the blade is cutting at 45 degrees in the "out" direction for all the cuts, in order to avoid having one cut with the bevel going in and another with it going out. It helps to practice on some scrap mat pieces before working on the real thing. When ready, line up the top left corner and make a smooth, nonstop, straight cut. Make all the cuts in the same direction. Cut one side of the board, and then turn it around and cut the opposite side until all four cuts are made. With the C & H mat cutter, start the cut a little ahead of where your measurement lines intersect and proceed to cut a little beyond where they end. With some practice, the window will pop out with no ragged edges. If you continue to make overcuts, simply stop short of the corners. Then go back with a single-edge razor blade and finish the cut. Be sure to angle the blade to agree with the angle of the cut. Sand any rough spots with very fine sandpaper. Erase the guidelines with an art gum eraser so that the pencil marks do not get on the print.

Hinge the overmat to the backing board with a piece of gummed linen tape (see Figure 15.7). The mat will now open and close like a book, with the tape acting as a hinge.

Place the print on the backing board and adjust it until it appears properly in the window. Hold it in place with print-positioning clips or a clean smooth weight with felt on the bottom.

Use photo corners to hold the print to the backing board. They will be hidden by the overmat and make it easy to slip the print in and out of the mat for any reason (see Figure 15.7).

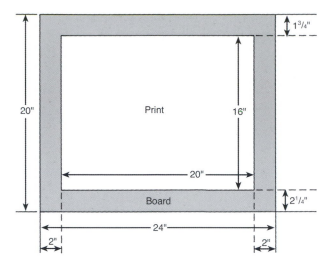

Figure 15.8 The dimensions of a window-type overmat for a 16 × 20-inch print on a 20 × 24-inch board. The side borders are generally of equal dimensions. To keep the print from appearing to visually sink on the board, more space is usually left on the bottom of the mat than at the top.

Box 15.6 Minimum Image and Mat Board Sizes

Image Size	Mat Board Size
5 × 7	8 × 10
8 × 10	11 × 14
11 × 14	16 × 20
16 × 20	20 × 24
All dimensions are in inches.	

Box 15.7 Dry-Mounting Concerns

A finished print can be ruined by dry mounting through accident and equipment or material failure.

After the print has been dry mounted, changes in heat and humidity, especially if the prints are shipped, can cause the print to wrinkle or come unstuck from the board. This happens because the print and the board do not expand and contract at the same rate. Since they are attached and the board is stronger, the print suffers the consequences.

The adhesives in most dry-mount tissue are not archival and can have adverse effects on the print, causing it to deteriorate. However, there is "archival-grade" dry-mount tissue made out of buffered paper.

If the print is dropped face down, the lack of an overmat offers no protection and the print surface can be damaged. If the board is damaged in any way, there is a problem. Conventional dry mounting is not reversible or water-soluble, so it is almost impossible to remove the print undamaged from the dry mount. This makes replacement of a damaged board extremely difficult. Some low-heat dry-mounting tissues claim to be heat reversible, but test it before mounting anything of importance.

Many papers, especially glossy inkjet paper, react negatively to heat. High temperatures can produce blisters, color shifts, mottling, loss of glossy finish, and/or smearing.

Other methods of dry mounting with spray mounts and glues are not recommended because the chemical makeup of these materials can have an adverse effect on all prints over time.

Curators and collectors no longer dry mount work that is received unmounted. It is also not advisable to dry mount unless you made the print yourself or there is a duplicate available. If you still want to dry mount after considering these problems, use only a matte surface paper and follow the guidelines in the next section.

light gray-colored board. The board should not call attention to itself or compete with the picture. To obtain maximum print life, use a nonbuffered, acid-free board. Regular board contains impurities that in time can interact and damage the print.

To maintain the integrity of large-scale prints, you may choose to dry-mount onto rigid material such as aluminum. This procedure can be done commercially using a special laminate.

Use these steps in the dry-mounting process. The necessary materials are shown in Figure 15.10.

Cold-Mounting

Cold-mounting (pressure-sensitive) materials allow for quick and easy mounting of digital prints without heat or electricity. The premium material can be positioned and repositioned for accurate alignment before it is adhered, but may require its own special applicator that might not work with certain receiving materials such as Fome-Cor. Mounting sprays also can be used

but must be applied with care because you get only one chance to exactly position the print on the receiving board. Cold and spray mounting are the least desirable methods in terms of their archival qualities. Little is known about how these adhesives might change over time, and they are difficult or impossible to reverse should future circumstances warrant removal. Therefore, they are suggested only when time is of the essence and long-term preservation is not a concern.

Floating a Print

Certain images do not look good matted or mounted. The board and/or borders interfere with the workings of the picture space. In such instances, "float" the picture following the guidelines in Box 15.9.

Figure 15.9 Joshua Lutz combined two negatives to create this image, exposing one for the highlights and one for the shadows. He scanned and digitally layered the two negatives, manually making a high dynamic range image to ensure that the result felt accurate to what he saw when photographing. He then wet mounted the final chromogenic color print for display. Lutz has been photographing the New Jersey Meadowlands for years, culminating in a book, *Meadowlands* (2008). He tells us, "For most people, the Meadowlands is a place to pass through and forget on their way to someplace else. Not unlike a neglected child, the Meadowlands has grown up without guidance, constantly unsure of what the future holds. It is this loneliness and solitude that continues to bring me back year after year."

© Joshua Lutz. *Untitled*, from the series *Meadowlands*, 2007. 30 × 35 inches. Chromogenic color print.

Frames

Often a print needs a formal frame to indicate its completeness and set up a ceremonial picture–viewing space. The purpose of a frame is to provide a recognizable, conceptual structure that accents the image and focuses attention inside the picture space. Custom frames can be ordered online. Inexpensive neutral frames made of metal or wood are available at big box discount stores. Used frames of all sorts, shapes, and sizes can be found in second–hand shops. Avoid overstating the frame, unless it is done for a specific purpose. Generally, any frame that draws and holds the viewer's eye, becoming its own point of focus, detracts from the image it is supposed to be presenting. Ask yourself, Where are your viewers' eyes going? Are they looking at the frame, or looking at your picture in the frame?

Unusual Frames and Presentations

Unlike traditional photography, digital imaging does not have a strict set of formal post-processing traditions. This lack of expectations allows makers and audiences to be more open to special–use frames, such as digital picture frames that allow you to upload a series of images and then play them back over and over on the frame's monitor. There also are times when makers purposely create images that are designed to be displayed in unusual containers or frames such as a magnetic frame or even a talking frame, which contains a mini recording device that allows

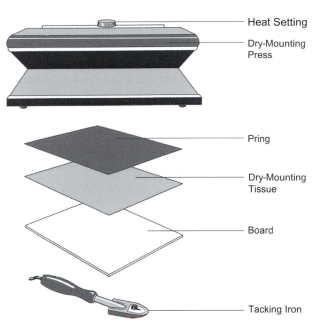

Heat Setting

Dry-Mounting Press

Pring

Dry-Mounting Tissue

Board

Tacking Iron

Figure 15.10 The basic materials for dry-mounting a photograph. To avoid damaging the photograph during the dry-mounting process, make certain the temperature setting on the dry-mounting press matches the manufacturer's recommendations for the materials being used.

Box 15.8 **Dry-Mounting Guidelines**

Make sure all materials and working surfaces are clean and level. Wipe all materials with a smooth, clean, dry cloth. Any dirt will create a raised mark between the print and the board.

Turn on the tacking iron and dry-mount press. Allow them to reach operating temperature. Check the dry-mount tissue package for the prescribed temperature, which varies from product to product, and set the press to that exact temperature. Using a temperature that is higher than recommended will damage the print.

Pre-dry the board in the press. This is done by placing a clean piece of paper on top of the board (Kraft paper is all right but should be replaced after each mounting operation). Place this sandwich in the press for about 15 to 30 seconds (depending on the thickness of the board and the relative humidity). About halfway through this procedure, momentarily open the press to allow water vapor to escape, and then close it for the remaining time. This should remove any excess moisture.

Place the print face down with a sheet of mounting tissue at least the same size as the print on top of it. Take the preheated tacking iron and touch it against a clean piece of paper that has been placed over the tissue in the center of the print. This one spot should be just sufficient to keep the print and the tissue together. Do not tack at the corners.

(Continued)

Box 15.8 Dry-Mounting Guidelines—cont'd

Trim the print and tissue together to the desired size. Use a rotary trimmer, a sharp paper cutter, an X-Acto knife, or a mat knife, and a clean, cork-backed steel ruler. If you flush mount the print, the corners and edges are susceptible to damage, and it cannot be overmatted unless you crop into the image area.

Position the print on the board. The standard print position has equal margins on both sides and about 15 to 20 percent more space on the bottom than at the top. If there is not more space at the bottom, the print appears to visually sink when displayed on a wall. Carefully make the measurements using a good, clean metal ruler, and mark the board in pencil to get a perfect alignment.

Align the print and tissue faceup on the board according to the pencil marks. Raise one corner of the print and, with the iron, tack that corner of the tissue to the board. Next, tack the opposite corner. Now do the remaining two. The tissue must be flat or it will wrinkle.

Put this sandwich of print, tissue, and board, with a cover sheet of clean paper on top, into the press. Make sure it is at the proper operating temperature for the materials. Close and lock the press and heat for the recommended time, usually about 30 to 45 seconds. Check the product for exact times.

Remove the sandwich and place it on a level surface under a weight to cool. Special metal cooling weights are made for this purpose.

you to record a brief sound message. Design companies, such as Umbra (www.umbra.com), offer many atypical display products.

Portfolios

Although most digital images remain forever in their virtual state, there are situations, such as when visiting a curator or going on a job interview, when one needs to show actual prints. While getting a digital print to look good is important, the size of the print is not of particular importance because once you arrive at a quality 8 × 10-inch print, making an equally good 11 × 14 or 16 × 20-inch version is not difficult. Contemplate building an 11 × 14-inch print portfolio of 20 images, something with turning pages and held in a good-quality case, which shows off the strength of your vision. Consider one that opens on three sides with clear, archival, heavyweight sheet protectors containing your images and a three-ring-binder mechanism on the spine. Strive to keep it simple, consistent, and up to date.

Self-Publishing: Print on Demand

The print on demand business, which started as a method for publishers to save money and resources, is becoming a tool for those who desire a bound presentation that documents their

work. Print on demand makes it possible to economically produce books singly or in small quantities, and new software simplifies the book design process. For people wanting something simple and straightforward, Kodak's EasyShare Gallery (www.kodakgallery.com) offers a way to produce your own simple books and/or put images on calendars, mugs, and tote bags. Various websites, such as www.blurb.com, supply free, easy-to-use software for individuals to design more elaborate books on coated paper that are bound with a linen fabric

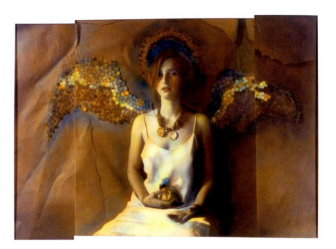

Figure 15.11 Dry-mounting allows Kathleen Campbell to preserve and present this assemblage in an intriguing way. To make the work, she pieces together gelatin silver prints and adds color to the collage by oil painting the surface, finally dry-mounting the completed image. With this work, Campbell states, "I am trying to touch on our society's simultaneous embrace and rejection of non-rational phenomena. We live in a world threatened with extinction by the underlying irrationality of the human species, yet we cling to a vision of ourselves as scientific rationalists and to the myth that we can comprehend and control both ourselves and the forces of nature."

© Kathleen Campbell. *Gilded Angel*, from the series *Photographs of Widely-Known Non-Existent Beings*, 1990. 29 × 36 inches. Hand-painted gelatin silver print.

Box 15.9 Print-Floating Guidelines

1. Decide on the final picture size.

2. Working on a clean, level surface, trim the print to these dimensions.

3. Cut a nonbuffered, acid-free backing board or acid-free Fome-Cor to the same size as the print. Acid-free Fome-Cor will not chemically interact with the picture and is cheaper than archival board.

4. Cut Plexiglas to size.

5. Sandwich together the print, board, and Plexiglas using a frameless device such as Swiss Corner Clips, and it is ready to hang.

6. Clean the surface with Plexiglas cleaner only, as regular glass cleaner can cause damage.

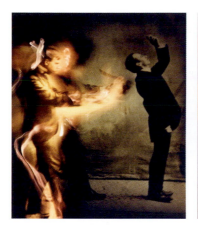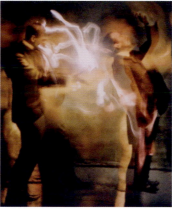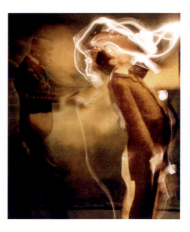

Figure 15.12 Robert Flynt captured this scene on tungsten film, using a slide projector and handheld flashlights as light sources. After projecting images found in hypnosis textbooks onto a model, he drew on and around the model with flashlights during the 20-second exposures. He had each of the three prints mounted onto aluminum and then installed them onto museum box mounts. Though each panel remains a separate work, the artist displays them as a triptych. Flynt states, "We look to images to find information: practical, aesthetic, erotic, and points between or overlapping. We are often seduced; we believe the photograph's illusory diorama of a point in time, the diagram or chart's authoritative organization of fact. My primary concern is to re-imagine the human body in relation to its own assumed or perceived structure, as well as to other bodies, spaces, or systems … Can we finally see more than we know?"

© Robert Flynt. *Untitled*, 2004. 24 × 60 inches. Chromogenic color prints.

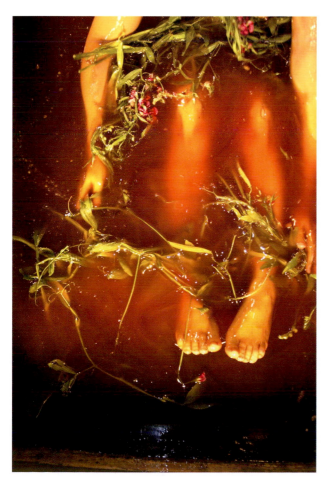

Figure 15.13 Linda Adele Goodine made this photograph with a Nikon DSLR at a honey farm. Using a minimum of post-production work, she printed the image onto fabric and presented it as a tapestry. With this picture, Goodine explains, "I felt that I was directly addressing memory and death, and how historically, photography has been understood to function as a rich medium that stills and freezes time. Conceptually, it creates and captures memory in a poetics of space. As I was exploring and crafting this body of work, I was reintroduced to Sylvia Plath's poems, and the links with my subject of bees, suicide, and childhood memory were hauntingly specific."

© Linda Adele Goodine. *Honey Dip*, from the *Seneca Honey Series*, 2006–2009. 40 × 60 inches. Inkjet on silk tapestry.

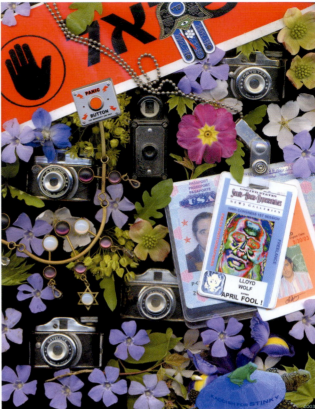

Figure 15.14 In the 1970s Lloyd Wolf started making an edition of April Fools' Day cards by using an electrostatic copy machine as a camera. "They are very different from my documentary work. There was and is no established aesthetic, no 'right way' of making work, which I find liberating and fun. It gives me reason to experiment and not worry about making art. I still make pictures by laying objects on glass, but now I do it on a flatbed scanner."

© Lloyd Wolf. *April Fool*, 1980. 11 × 8½ inches. Inkjet print. © Lloyd Wolf. *April Fool*, 2003. 11 × 8½ inches. Inkjet print.

hardcover and wrapped with a dust jacket. Available for purchase by anyone, the finished product is made to order. Another source is the combination printer and order-fulfillment house www.lulu.com, which prints both color and black-and-white books, places them with online book outlets like www.amazon.com, and fills the orders. This new industry has opened the previously closed and conservative business of publishing, turning the making of books into a means of expression that is less fixed, more interactive, and much more diversified in content. For more information on self-publishing, visit: selfpublishbehappy.wordpress.com.

Images on a Screen: Web Sharing

The display screen has generated a mind-boggling, democratic outpouring of images that is rapidly replacing the gallery wall and the book page as the major venues for looking at pictures. Moreover, projected images are becoming a more prevalent presentation method in contemporary imagemaking. Web

sharing can be a first step in freeing your images from your hard drive and getting them into visual circulation. Although websites such as www.smugmug.com cater to amateurs posting family snapshots, they also offer accounts with professional features that allow people to view, comment, and purchase watermark-protected images. The Web-sharing trend is also spinning off new ways of interacting with pictures. Image sharing has become commonplace on social networking sites such as www.facebook.com and www.flickr.com. Websites such as www.snapfish.com allow individuals to organize their pictures, make albums and digital scrapbooks, edit and order prints, and have them delivered by mail or at retail locations. Web-sharing sites also make it convenient for people to link their images to blogs, photoblogs, and social networking sites. Some people have explored *mashups*—an application or website, such as Google's map service (earth.google.com), that combines content from more than one source into an integrated experience—to "geo-tag" pictures and thus create travel albums with added context and location by pairing maps with photographs.

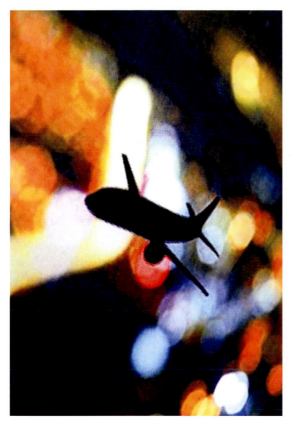

Figure 15.15 This image, part of Robert Hirsch's projection piece of some 300 pictures, was designed to be shown on a screen as Karen Engel read from her book, *Seeing Ghosts: 9/11 and the Visual Imagination* (2009) at the Burchfield-Penney Art Center, Buffalo, NY. The work is not illustrative; rather it is intended to integrate the outer appearance with the inner makeup of the 9/11 events to get to the heart of the experience. Hirsch states, "The story-telling within this projection piece is similar to taking a walk at sundown and observing that the day does not have an abrupt border with the night. Rather it is a complex and often-indistinct progression filled with twists and turns; a penumbra of counterpoints, subtlety, and false appearances; an infinite matrix of compound tales that confronts the enigmas of evil."

© Robert Hirsch. *Untitled*, from the series, *The Sky is Falling*, 2010. Variable dimensions. Digital file.

Website Design/HTML

When you are ready to set up your Internet presence you will need to decide whether to use a social network site/blog system or to create your own website. Artist/website designer Michael Bosworth offers the following suggestions to help you get started.

Each option has its advantages and disadvantages. Using an existing commercial system is faster to set up, requires less technical knowledge and software, and frequently offers the means to build an audience. However, many systems are constrained by the parameters of a structured configuration. Their templates limit the look and function you can achieve, and the provider can place advertising on your pages.

Building a website from the ground up requires a yearly fee to host your site, specialized software and technical knowledge, and the ability to design a site that is functional and visually pleasing. Websites range from simple to complex. Depending on the size and complexity of yours, a corresponding range of skills and software will be necessary to create and maintain the site. While you may already possess some of the needed software and knowledge, more is freely available on the Internet. Template-driven platforms, such as www.tumblr.com and Wordpress.com, make it easy to start and can be transferred to a hosted installation at a later date.

Even if your skills are limited, the important thing is to get started and make your presence known. Building a website is a learning and evolutionary process. No matter how sophisticated the presentation, a first site is likely to be only the beginning. It will give you focus and become the training ground for you to gain knowledge of and experiment with software, design principles, and effective webpage navigation.

The first step should be to secure a domain name and find a host provider. A domain name is a kind of shortcut that directs any web browser to the hidden numeric address for your Internet content. When available, register your own name or a professional descriptor for your domain name, which will become your "brand" and therefore should be something easy to remember. Many providers offer one-stop shopping that includes registration of your domain name, hosting space, and email addresses.

Many hosting companies will want you to create different variations of your domain name to increase traffic in case the name is typed incorrectly. The words in the domain name are one key element in the list of how search engines rank your site. Embedded HTML code and many other tricks of the trade can increase traffic to your site, but come at a price. Over the course of your career you will frequently rebuild websites, change hosting providers, or completely alter the system with which you present yourself, but your domain name will give you a continuous contact point. No one has a copyright on his or her name, so it may already be taken. The Internet Corporation for Assigned Names and Numbers (ICANN) is the governing body responsible for domain names and IP addresses. To see if a domain name is available, visit www.internic.net

There are a range of options for developing a website. Using HTML, a markup language, to build a website from scratch is one. This can make sense for a small, simple site, as HTML is not difficult to learn and requires only a minimal amount of software. This can make sense for a small, simple website, as HTML is not difficult to learn and requires only a minimum amount of software. Another option is to use software you may already own to generate a website. Adobe Photoshop and Bridge, for example, have an Automate feature to craft a web gallery from the images in a folder. Many Apple computers come with an application called iWeb, which works in conjunction with iPhoto to create web galleries. Adobe's Dreamweaver is popular for web editing. It has a steeper learning curve, but offers a wide range of languages and scripts. Finally, a Content Management System (CMS) features ease of use plus no need to purchase software. A server-based application that runs on either the computers of the company from which you lease the software or the computers that host your site, a CMS permits you to interact with an application through the Web rather than working offline. Depending on your needs, CMS is priced anywhere from free to thousands of dollars a year. Most systems allow the user to choose from pre-developed templates and then customize them with colors and images. Some systems have very extensive features. The benefits of CMS are that you do not need to purchase or install software on your own computer, the technical skills necessary to build such a site may be lower, and maintaining a site and working with others on the same site is simplified.

Lastly, a File Transfer Protocol (FTP) application will allow you to upload the files and folders that comprise your website from your computer to your web host. FTP moves files from one computer to another across the Internet. Just like file sharing on a Local Area Network, to transfer a file you will need the host address, a username, and a password. Once connected to the remote host, many FTP applications work by simply dragging files from your computer to the window of the application. Necessary for publishing websites, an FTP application also is useful to photographers who need to share image files that are too large to send as an email attachment.

Print Preservation

There are additional methods of displaying finished prints. Whichever process or material you use, your images can achieve their maximum natural life span if you exercise a few precautions and avoid materials listed in Box 15.11.

Factors Affecting Print Stability

All the commonly used color printing processes are fugitive, meaning they fade over time. The greatest enemy is light-fading, which is caused by all types of ambient light and UV radiation. Duration, intensity, and quality of the light are all factors in the rate of change. The second adversary is dark-fading, and it begins as soon as the image is made. Caused by ambient relative humidity and temperature, it occurs even if an image is sealed in a light-tight box. Both these processes affect the various color materials that make up an image—though not at the same rate—causing color changes and shifts over time.

Box 15.10 **Web Design Resources**

Adobe Dreamweaver: www.adobe.com/products/dream weaver

The Bare Bones Guide to HTML—lists every official HTML tag in common usage. HTML tags are a text string used in HTML to identify a page element's appearance, format, and type. These HTML markup tags tell the World Wide Web browser how to display the text: **werbach.com/barebones/**

Cascading Style Sheets—examples of how they can be used to control the look of Web content: **www.csszengarden.com**

FTP application for the Mac: **fetchsoftworks.com**

InterACT with Web Standards: A Holistic Approach to Web Design (Voices That Matter) by Erin Anderson et al. (Berkeley, CA: New Riders Press, 2010)

InterNIC Internet Domain Name Registration Services: **www.internic.net**

Overview of the entire process, go to: **www.webstyleguide. com/**

World Wide Web Consortium (W3C)—the international organization that develops Web standards: **www.w3.org**

Web Design: **en.wikipedia.org/wiki/Web_design**

Web training resource: **www.w3schools.com**

Box 15.11 **Materials Adversely Affecting Prints**

Animal glue

Brown envelopes or wrapping paper

Cellophane tape

Cardboard

Glassine

Masking tape

Rubber cement

Spray adhesives

White glues

Adhesive-coated pages and plastic covers in "magnetic" pressure-sensitive albums

Avoid contact with wood, shellac, varnish, and materials made with PVCs (polyvinyl coatings)

Do not write on the back of a print with a ballpoint pen or a Sharpie as they can bleed through and stain the print

Choose the correct materials for specific situations to ensure their longest useful life. For instance, since regular inkjet papers are not intended for display in the direct sunlight of a showroom or studio window, use the special materials that are designed for these conditions.

Color Print Life Span

How long will color pictures last? The answer is, we don't know. Information about this question remains under debate, and there is no reliable set of standards or a database that provides a definitive response. Henry Wilhelm, an independent

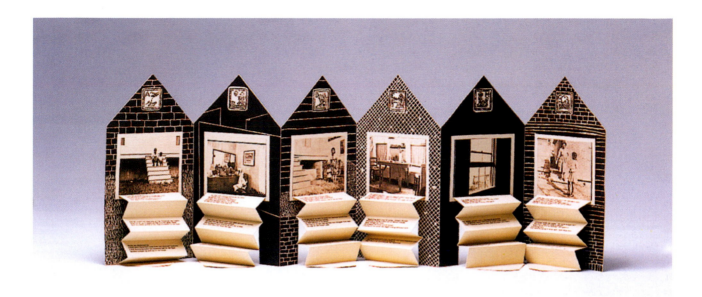

Figure 15.16 Clarissa Sligh works with various photographically-based prints, artists' books, video, audio, sculpture, and writing to explore the intersection of memory and history, reality and myth. "I am interested in the visual tensions which result from the integration of machine-generated and handmade image and text." Her starting points can be wide-ranging: a found photograph, a memory, a word, an interaction, a place—almost anything that resonates with her. From there she follows up with research in libraries and archives. "This leads me to shoot more photographs and conduct interviews." Sligh uses copiers, computers, drawing, and writing to combine repetitious elements of marks, words, and photographs into one frame. Successive and simultaneous time elements are brought into the present in one frame, one place, or one event.

© Clarissa Sligh. *What's Happening with Momma?* (interior view), 1987. 11 × 36 inches. Van Dyke brown prints.

researcher in the field of photographic preservation, provides published tests of many digital and conventional materials, but it should be noted that his findings have not been substantiated by other independent research. For his latest test information, see www.wilhelm-research.com.

What we do know is that inkjet prints can last for a few months or as long as other conventional color chromogenic photographs (RA-4 wet color print process), depending on the printer, ink, and paper, but they are often more vulnerable to degradation than standard prints, especially in terms of moisture. In terms of conventional photographs, Kodak claims that images on its latest chromogenic RA-4 color paper will be "acceptable" to most people after more than 100 years in a photo album, without extended exposure to light, and more than 60 years under normal ambient light conditions at home. Claims have been made that expensive, professionally produced pigment-based color prints, as opposed to dye-based inks, will last 500 years without fading. With the ever-changing combinations of inks and papers, it is a good idea to check the Web for the latest findings.

Print Display Environment

Avoid displaying prints for extended periods under any bright light, as ultraviolet rays, including sunlight and fluorescent lights, produce more rapid fading. Tungsten spots offer a minimum of harmful UV. Fluorescent lights can be covered with UV-absorbing sleeves. Some people have tried protecting prints with UV-filter glazing on the glass. However, Wilhelm advises that this will offer little or no additional protection for most types of color prints. To minimize damage, try to maintain display temperatures below 80 °F/27 °C; protect the print surface from physical contact with moisture and from fingers, smudges, or anything that might cause a scratch or stain; and take care in how prints are stacked in storage.

Storage Environment

Archival storage boxes, with a nonbuffered paper interior, offer excellent protection for color prints. Ideally, color prints should be stored in a clean, cool (50–60 °F; 10–15 °C), dark, dry, dust-free area with a relative humidity of about 25 to 40 percent. Avoid exposure to any ultraviolet light source. Use a sealed desiccant (a substance that absorbs moisture) if the prints are subject to high humidity. Keep photographs away from all types of atmospheric pollutants, adhesives, paints, and any source of ozone, including inkjet printers. Periodically check the storage area to make sure there has been no infestation of bugs or microorganisms. For long-term print protection, consider the following procedures.

Digital Archives

Digital data is a good candidate for long-term image storage because it can be easily and precisely duplicated. However, one must be aware of its shortcomings.

Figure 15.17 Prints made for public exhibition should possess the highest level of overall artisanship in technique and presentation. Cindy Sherman's widely-shown photographs have been credited with embodying the concerns of 1980s postmodernism. Ambiguous and self-conscious, her work has been called a nonliteral imitation of the world of film and television that surrounds and informs Western culture.

© Cindy Sherman. *Untitled, #119*, 1983. 17½ × 36 inches. Chromogenic color print. Courtesy of Metro Pictures, New York, NY.

Box 15.12 Long-Term Print Protection Guidelines

Make new prints of old images on the latest archival material.
Produce two prints of important images on stable material,
one for display and the other for dark storage.
Make copy prints or scans of all one-of-a-kind pictures,
including Polaroids.

Transferring Film–Based Images to a Digital Format

To make a complete digital archive of your work, scan any film negatives and prints before storing them. To be useful, the original scans need to accurately capture color and detail. Many consumer film scanners do not have the resolution necessary to capture all the information in a negative or print, especially highlights and shadow detail. It may be worth the extra expense to obtain a top scanner or get high-end scans done at a service bureau. Bring snapshots to a photo-processor with a high-speed scanner that quickly digitizes the images and burns them to a disk along with thumbnail printouts. Always back up the new files.

It is a wise idea to start using an image management program to organize your digital archive. There is an array of options available for sorting, cataloging, and archiving your digital images, from simple freeware to sophisticated professional programs such as Aperture, Lightroom, and Photo Mechanic. Check them out online to see what is appropriate for your needs.

Long-Term Storage and Migrating Digital Archives

For the short term, a convenient way to save and move select amounts of digital information, such as image files, is with a pocket flash drive. For long-term storage, while multiple external

Figure 15.18 Heide Hatry tells us, "I work with materials that even today are generally regarded as unconventional or somehow problematic ... When I create an image out of animal flesh and organs, I am prevailing upon this spirit, or expectation, to open the doors of perception to my work, perhaps in the manner of the Trojan Horse, or a Venus Flytrap. I want the innocent viewer to realize that there has been a trick, and to feel a sort of aesthetic panic. Most recoil never to return, though the image is already inside of them. I want the viewer to realize that the deconstruction of the image is a path to the deconstruction of beauty itself. Knowledge might be the death of innocence, but beauty without knowledge is empty, the luxury of a bygone day."

© Heide Hatry. *Madonna*, from the book *Heads and Tales*, 2008. 30 × 20 inches. Chromogenic color print. Courtesy of Elga Wimmer PCC, New York, NY.

hard drives with full backup programs, such as Time Machine, can store everything on a computer, currently, the most popular method is to store electronic data on CD-ROM and DVD. Many factors may contribute to the archival stability of the CD-R and DVD-R media, but their dye type is one of the more important ones. Disks containing phthalocyanine (pronounced *thalo-sy-a-neen*) dye performed better than other dye types. Specifically, phthalocyanine combined with a gold-silver alloy as a reflective layer tested consistently more stable than all other types of CD-R media. Disks using azo dye as the data layer showed less stability in light exposure and temperature/humidity stress testing. Media using cyanine dye performed well

when exposed to light but had problems when under temperature/humidity stress conditions. A few companies claim that their Gold CD-R, which uses a pure gold reflective layer to provide superior stability, has a life expectancy of at least 100 years. Check manufacturers' websites for the latest information. For a detailed US government report, "Care and Handling of CDs and DVDs—A Guide for Librarians and Archivists," see www.itl.nist.gov/div895/carefordisk/CDandDVDCareandHandlingGuide.pdf.

A major issue is whether a device that reads CDs will be available in 100 years. It is unlikely that current CDs and DVDs will be widely used 10 or 20 years from now or that current file formats will be compatible with software in the future. This is not justification to avoid digital storage. The ease with which digital information can be copied gives one a viable future option to migrate (copy) these images to newer and more archival hardware/software as it becomes available. Magnetic media, such as ZIP disks, are not recommended for long-term storage as they fade over time and can be damaged by heat, humidity, and magnetic and electrical fields. See Box 15.13, Guidelines for Handling Digital Media, and Box 15.14, Long-term Storage Recommendations for Disks. Also refer to the section on Storing Digital Images in Chapter 9.

Additionally, innovative and powerful external hard drives plus the latest SATA drives are impacting storage practices by allowing data to be kept at secondary sites, such as on a server, more economically and securely. Rapid change is synonymous with the digital world. What is important to bear in mind is that as technology advances, you need to migrate your digital archives to the most up-to-date system of materials and devices.

Post-Production Software

Aperture and Lightroom are two competing professional software programs that focus on photographic processing. The strengths of these programs are universal control over entire images with color correction, image density, sharpness, and contrast by means of intuitive interfaces. These programs focus on post-production for enhancing image files, including batch processing, after initial exposure. They also feature highly developed print and Web management tools for ease of sizing and selection of PPI or DPI.

Both of these programs are designed to work with RAW image files made directly from the camera, but they also can function with nearly any image file format. Both utilize a "nondestructive" approach to image-processing, allowing the image currently being corrected to be mirrored and set aside temporarily in the computer's memory where it is safely

Box 15.13 Guidelines for Handling Digital Media

Use a quality name brand to reduce risk of data corruption or other technical failures.

Leave disks in their packaging (or cases) to minimize the effects of environmental changes. Open a recordable disk package only when you are ready to record data on that disk.

Check the disk surface for dirt and imperfections before recording.

Handle disks by the outer edge or the center hole.

Do not touch magnetic recording surfaces.

Avoid bending or flexing the disk.

Use a non-solvent-based, felt-tip permanent marker to mark the label side of the disk. If possible, write only in the clear center portion of the disk, as the recording layer (the area the laser "reads") is very close to the labeling surface of a disk.

Do not use adhesive labels.

Do not use a ballpoint pen to label a disk or allow the label or underside to be scratched.

Keep dirt, food, drink, and all foreign matter from the storage media.

Store disks in a dust-free environment in a vertical, upright position (book style) in plastic cases specified for disk use.

Return disks to storage cases immediately after use.

Store disks in a cool, dry, dark environment in which the air is clean at between 60 and 70°F with a relative humidity between 35 and 45 percent.

Remove dirt, foreign material, fingerprints, smudges, and liquids by wiping with a clean cotton fabric in a straight line from the center of the disk toward the outer edge. Do not wipe in a circular pattern.

If a disk must be cleaned, use mild soap and water. Use disk-cleaning detergent, isopropyl alcohol, or methanol to remove stubborn dirt or material. Blot it dry with a clean, lint-free, absorbent cloth and avoid rubbing the surface. Never use chemical solvents.

Keep magnetic media away from strong electrical or magnetic fields.

Annually read a sampling of the digital information to check for degradation.

Copy the information to another disk or the latest new system every 4 to 5 years to refresh the data and migrate to newer, more archival software, hardware, and materials.

Have one off-site backup storage facility, such as an Internet archive service.

protected from being overwritten or lost while the file is being worked on. Aperture can save the steps applied to any image as actions that can be applied to other images for quicker production work.

Although most photographers will make their own custom adjustments, these programs can make automatic corrections to batches of images without even opening the image files, which is ideal for production work. The purpose and strength of these programs is to allow quick, automatic color corrections, auto sharpness, and other auto enhancements of the digital negative with a single click of the mouse or with auto batch-file techniques, thus putting quick and powerful editing enhancements in the hands of professional digital photographers. Both programs provide efficient workflow patterns for high-volume digital output, making common editing and organizational tasks extremely efficient.

What is missing from Lightroom and Aperture is the ability to add, change, duplicate, or alter the content of digital image files. Also absent are some advanced tools, special effects, and filters that give an imagemaker precise and localized control over content and individual pixels that have proven indispensable for some photographers. This type of imaging software is designed to enhancement of the "straight digital negative," whereas other existing professional imaging software has developed all the tools necessary to meticulously change and create new content, thereby producing imaginative photographic works.

Aperture and Lightroom are not yet likely to replace current advanced digital imaging software programs. Rather, they will concentrate on the differences in approaches to photographic imagemaking. Photographers making images to show the world as they find it—"straight" without overt manipulation—can be satisfied with these new programs. Imagemakers involved in creating more expressionist imagery through the use of multiple image files might not exclusively use these programs, but may use them in tandem with other ones made to alter or add new content to the image files. In the digital age, Aperture and Lightroom reopen photography's historic dilemma of how to best represent and communicate photographic reality and truth.

Cataloging Your Image Files

There are several programs, such as Portfolio 8.5 from Extensis, iView Media Pro from Microsoft, and Picasa, a free program from Google, which allow photographers to catalog their images. Both Aperture and Lightroom also provide excellent advanced cataloging features. These photographic cataloging programs furnish the ability to tag each image with keywords to help one instantly find, edit, and output any image in a computer and/or storage device. Each time one of these programs is opened, it automatically locates pictures and folders. The cumbersome organizational tagging task is streamlined with simplified image identification and easy drag-and-drop techniques for adding keywords. Pictures can be organized using visual catalogs and embedded metadata to instantly view, sort, and manage all your photos. These photographic cataloging programs recognize that digital images are just another form of digital information and can be managed by a single, multifaceted program.

For more on digital archiving, consult the following resources:

Martin Evening, *The Adobe Photoshop Lightroom 3 Book* (Berkeley, CA: Peachpit Press, 2010).

Peter Krogh, *The DAM Book: Digital Asset Management for Photographers* (Sebastopol, CA: O'Reilly Media, 2nd edn, 2009).

Dion Scoppettuolo et al., *Apple Pro Training Series: Aperture 3*. Apple Pro Training Series (Berkeley, CA: Peachpit Press, 2010).

Digital Print Stability

Since the dawn of digital imaging, the inkjet printer has been the mainstay of physical electronic output. When these printers became available to the artist market, imagemakers were impressed with the image quality but were disappointed with their image stability. In the 1990s, a cottage industry sprung up to market different inks and media for different applications, such as black-and-white printing, each one having its advantages and disadvantages.

Dye-based Inks

Dye-based inks were the first to be developed by printer manufacturers and are the standard inks supplied by computer and office supply stores. Generally these inks have excellent color and saturation but have a tendency to soak into paper, thus making the ink less efficient and subject to bleeding at the edges, producing poor print quality. Dye-based inks fade rapidly because they are inherently unstable and may contain solvents or be applied on specialized paper coatings to promote rapid drying. Prints made with dye-based inks must be kept away from moisture, as they can bleed, feather, or spot upon contact with liquids, or soften and bleed in conditions of high humidity.

Pigmented Inks

Pigmented inks contain other agents to help the pigment adhere to the surface of the paper and prevent it from being removed by mechanical abrasion. These inks are helpful when printing on paper because the pigment stays on the surface of the paper instead of soaking in, which means that less ink is required to create the same intensity of color.

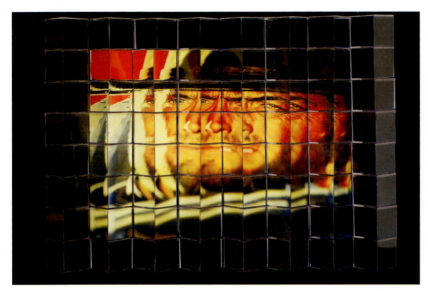

Figure 15.19 *The 1960s: A Cultural Almanac* is a sculptural anthology based on photographic reinterpretations of historic and personal images from the 1960s that have been selectively copied with a macro lens. It juxtaposes the competing social landscapes that shaped the American zeitgeist of that decade, from John F. Kennedy through the Civil Rights Movement and the Vietnam War to the Apollo Moon Landing, in relationship to the media, popular culture, and daily life. The results are presented in clear, 4 × 4 × 4-inch stackable cubes that echo the popular Kodak Instamatic photo cubes of the 1960s. This sculptural portrait of Clint Eastwood portrays the iconic "Man with No Name" of Sergio Leone's spaghetti western *A Few Dollars More* (1965).

© Robert Hirsch. *Clint Eastwood (A Few Dollars More)*, from the project *The 1960s: A Cultural Almanac*, 2010. 32 × 44 × 5½ inches. Inkjet prints in Plexiglas cubes. Courtesy of CEPA Gallery, Buffalo, NY.

Pigmented inks have a greater resistance to light-fading than dyes, but generally have lower color saturation. Since they are not absorbed into paper as readily as dye-based inks, they are prone to fingerprints, smears, and smudges.

While the prints tend to last longer and have good color saturation, both dye and pigment inks can appear mottled because of the uneven absorption of the ink. As dyes and pigments can absorb and reflect light differently (they have different spectral reflectance characteristics), they can appear to be a match in daylight but may look like different colors when viewed under tungsten or fluorescent light, a phenomenon known as metamerism.

Essentially, conventional inks are oil-based dyes, while pigment inks are made of tiny chunks of solid pigment suspended in a liquid solution. According to their advocates, the latest pigment inks offer improved, deeper, richer colors and have fewer tendencies to bleed, feather, or run. The archival qualities of pigment ink and acid-free paper combinations have been rated at more than 200 years by some testing laboratories. These labs performed accelerated fading tests, using high doses of light and varying humidity, to predict how long an image will last before fading becomes substantially noticeable. Their predictions have recently been called into question, however, because many did not take gas fading—a pigment's ability to withstand fading due to prolonged exposure to airborne contaminants such as ozone—into account. Ozone is created by a variety of sources—including cars, household cleaners, solvents, and inkjet printers—and can fade pigment inks in a matter of months.

A word of caution: Inks are constantly being updated and altered. Many companies produce inks that are compatible with name-brand printers, but they may not possess the same ingredients and archival characteristics as the original factory inks. Therefore, let the buyer beware. Make sure your printing materials are suitable for your consistency requirements and long-term expectations.

Printing Media

Contemporary printers can print on a variety of different media, including gloss and matte paper, acid-free rag, canvas, cloth, and vinyl, among others. The material a digital print is made on often has a greater effect on its longevity and color reproduction than the inks. While acid-free papers are considered the best for image longevity, frequently print life expectancy predictions are based solely on specific inks and paper combinations. Coated papers are available that can improve the color gamut of inkjet prints, make them dry faster, and make them water resistant, but these coatings can destroy an ink's ability to withstand long-term fading. Also, a number of pigment and pigmented inks are not compatible with certain gloss papers because of ink absorption problems. Media and inks formulations are changing rapidly. Check the latest information on specific inks and media before beginning your digital project, and consider reprinting images as new and improved materials become available.

Protecting Pigment Prints

With the present selection of inks and media, the best way to protect images is to keep prints made with pigments out of direct sunlight and present them under glass using only acid-free papers and matting materials. Proper framing can also reduce a print's exposure to harmful atmospheric contaminants.

Camera Copy Work

Preparing work for presentation often necessitates making photographic copies. Pictures to be copied can be positioned vertically on a wall or laid on a clean, flat surface. The camera may be tripod-mounted or handheld, depending on the light source and ISO sensitivity. Camera movement must be avoided to produce sharp results. For accurate and faithful results, be sure the camera back is parallel to the print surface and the lighting is uniform. Avoid shadows falling across the picture. Use a slow ISO

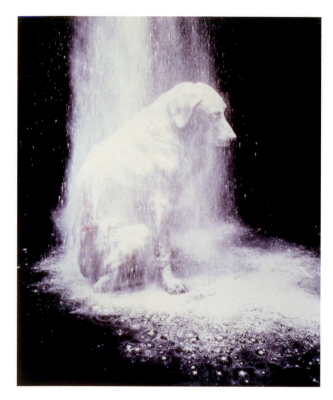

Figure 15.20 Selecting the correct medium is crucial to reaching your audience. In the 1970s William Wegman began incorporating his dog, Man Ray, into his real-time videos. In 1978 the artist started condensing these spare studio video performances onto large-format Polaroid material, resulting in the publication of *Man's Best Friend* (1982). In a time before home video players were commonplace, Wegman's switch to a nonmoving, easily reproduced format enabled his work to reach a broader public audience.

© William Wegman. *Dusted*, 1982. 24 × 20 inches. Diffusion transfer print.

setting (100) or film to obtain the most precise color rendition and maximum detail without digital noise or grain.

Lens Selection: Macro Lens/Mode

The selection of lens affects the outcome. With a DSLR or SLR, a normal focal-length macro lens is an ideal choice. The characteristics of a true macro lens include a flat picture field, high edge-to-edge definition, and the utmost color accuracy. This combination delivers uniform sharpness and color rendition, regardless of focus distance, from the center and the edge of the lens.

Zoom lenses with a Macro mode can be used, but may produce soft (not sharp) results. Bellows attachments, extension tubes, or auxiliary lenses, often referred to as diopters and usually supplied in sets of varying degrees of magnification, can convert a normal focal-length lens into a versatile copy lens.

A macro lens or Macro mode can also serve as a postmodern tool. Try rephotographing small sections of images using intrinsic photographic methods such as angle, cropping, focus, and directional light to alter the original's context and meaning (see Figure 15.19). Magnifying devices can also be used in front of a lens when traditional photographic values are not a concern.

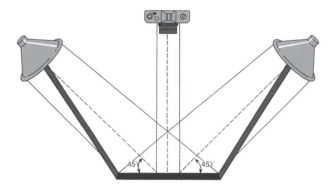

Figure 15.21 When copying work, set up a light at an equal distance from each side of the camera at a 45-degree angle to the work being copied. Meter from a gray card positioned in the center of the lighting set and not from the surface of the work being copied. Make sure the color balance setting of your camera or film matches the color temperature of your light sources. Polarizing filters can be attached to the lights and/or camera to control reflections and to increase color contrast and saturation.

Copy Lighting

Good results can be obtained easily by using a daylight color balance setting and shooting the pictures outside, on a clear day, in direct sunlight, between the hours of 10 a.m. and 2 p.m. This will avoid shadows, which can create an unwanted color cast.

If copying is done indoors, an ideal lighting source is photographic daylight fluorescent bulbs (5000 K), which do not get hot and thus keep both photographer and subject matter at room temperature. Conventional photographic tungsten floodlights (3200 K) can be used, but they do get hot and change color temperature as they age. Whatever your lighting source, be certain your camera's color balance setting or film matches the Kelvin temperature of the copy lights. For consistent results, place a light at an equal distance from each side of the camera and at a 45-degree angle to the picture being copied, which will produce even, glare-free light (Figure 15.21).

Exposure

Indoors or outdoors, take a meter reading from a standard neutral gray card for the most accurate results. Metering off the picture itself can produce inconsistent results. Let the gray card fill the frame, but do not focus on it. For close-up work, the exposure should be determined with the gray card at the correct focus distance. Try to let the image fill as much of the frame as possible, without chopping off any of it. Use a tripod or a shutter speed of at least 1/125 second to ensure sharp results. Review your exposures and make adjustments as needed; with film, bracket your exposures.

Presenting Work on a Disk

When sending digital images for review, make it simple for your work to be seen. Prepare files that open quickly on any platform. When appropriate, program the images to run as a slide show

that can be stopped to view individual images. Often, a review process will involve a number of people, and they may need non-virtual, concrete references. With this in mind, include thumbnail and/or contact size printouts of the disk's contents. Also provide hardcopy of any text documents. Do not expect reviewers to print your files. Include an image checklist that gives the title, date, size, and, when appropriate, type of output (such as inkjet print) of each image, so it can be easily identified. Make sure your name is on all materials, including the disk, and that they are sent in a clean envelope, along with your complete contact information.

Ensure a Good Reception

Digital files that are not properly made, correctly labeled and identified, or neatly presented will not receive a favorable welcome at a competition, gallery, school, or job interview. Viewing anyone's work via a disk is never better than an imperfect process; therefore, it is essential to put forth your best effort in presenting an accurate approximation of your work. Be sure to include a cover letter and appropriate support materials, such as your résumé, an exhibition list, and a concise statement concerning the work. Make sure each image is clearly identified so the person on the receiving end can easily distinguish which images are of interest. A separate checklist, referring to the titled or numbered images, should be included, providing each image's title, size, presentation size, and process (output method). Be selective, decide what is important, highlight important information, do not bombard the receiver with too much data, and do not inflate your documents with inconsequential, inaccurate, or misleading material.

Shipping

Put disks in clean disk envelopes or clear, nonbreakable cases. Put your name, return address, telephone number, e-mail address, and title of the body of work on the disk envelope or case. Do not send loose disks. Use a padded envelope or include a stiff backing board in the envelope so that your materials cannot be easily bent. Enclose a self-addressed stamped envelope (SASE), with the correct amount of postage, to help ensure the return of your materials. Write "Do Not Bend" on the front and back of the shipping envelope. Do not send original materials unless they are requested. Valuable and irreplaceable materials should be sent by first-class mail with delivery confirmation or via one of the overnight package services. Note that the insurance coverage provided by standard overnight parcel services only reimburses the material cost of making an image and not the value you place on it.

Copyright of Your Own Work

According to the US Copyright Office in Washington, DC, it is not necessary to place the notice of copyright on works published for the first time on or after March 1, 1989, in order to secure ownership of copyright; failure to place a notice of copyright on the work will not result in the loss of copyright. However, the Copyright Office still recommends that owners of copyrights continue to place a notice of copyright on their works to secure

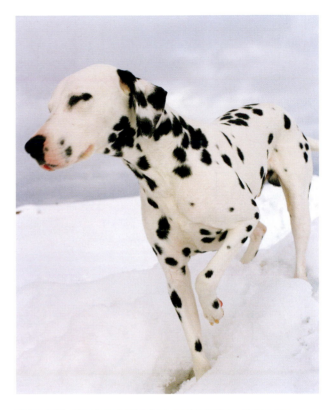

Figure 15.22 This photograph is from a series dealing with how Ron Jude's childhood hometown of McCall, Idaho, has been transformed into a popular resort destination. Once Jude entered this work into the public sphere, it took on its own identity and meaning and became a transcendent canine image with great public appeal, which was not the photographer's original intent.

© Ron Jude. *Untitled*, from *Near the 45th Parallel*, 1995. 38 × 30 inches. Chromogenic color print. Courtesy of Gallery Luisotti, Santa Monica, CA.

all their rights. The copyright notice for visual works should include three components: (1) the word "copyright" or the symbol for copyright, which is the letter C enclosed by a circle (©); (2) the name of the copyright owner; and (3) the year of the first publication of the image—for example, © Amanda Jones 2012. Copyright notice is not required on unpublished work, but it is advisable to affix notices of copyright to avoid inadvertent publication without notice. It is illegal for photographic labs to duplicate images with a copyright notice on them without written permission from the holder of the copyright. For additional information, see US Copyright Office, Library of Congress, www.loc.gov/copyright. Take into account that once an image is digitally available, it can easily take on a life of its own, regardless of whether it has been copyrighted or not.

Where to Send Work

There is intense competition for exhibitions, gallery representation, and commercial connections. Prepare to be persistent and steeled for rejection. Numerous publications and websites identify opportunities. These include Photographer's

Market (www.writersdigest.com) and *Art in America/Annual Guide to Museums, Galleries, Artists*, 575 Broadway, New York, NY 10012, both published annually; plus Art Calendar (www.artcalendar.com) and Art Opportunities Monthly (www.artopportunitiesmonthly.com). Furthermore, there are abundant blogs, such as marketingphotos.wordpress.com and www.lensculture.com/webloglc, which offer information about work calls, portfolio review events, as well as marketing advice.

RESOURCES

American National Standards Institute. www.ansi.org. [Request their catalog of photographic standards.]

Kaplan, John. *Photo Portfolio Success*. Cincinnati, OH: Writer's Digest Books, 2003.

Keefe, Laurence E. and Inch, Dennis. *The Life of a Photograph: Archival Processing, Matting, Framing and Storage*, 2nd edn. Stoneham, MA: Focal Press, 1990.

Krogh, Peter. *The DAM Book: Digital Asset Management for Photographers*, 2nd edn. Sebastopol, CA: O'Reilly Media, 2009.

Logan, David. *Mat, Mount, and Frame It Yourself*. New York: Watson-Guptill Publications, 2002.

Wilhelm, Henry, with contributing author Carol Brower. *The Permanence and Care of Color Photographs: Traditional and Digital Color Prints, Color Negatives, Slides, and Motion Pictures*. Grinnell, IA: Preservation Publishing Company, 1993. [Available as a free download at: www.wilhelm-research.com/book_toc.html.]

Sources of Presentation and Preservation Supplies

Conservation Resources International: www.conservationresources.com

Light Impressions: www.lightimpressionsdirect.com

TALAS Division, Technical Library Services: talasonline.com

University Products Inc.: www.universityproducts.com

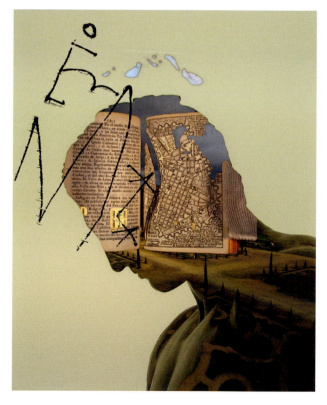

The images from this body of work are made of picture elements that are digitally composed and printed. Doug Prince inform us, "The digital process allows me to directly respond to new ideas as they evolve within the process of building images, which is driven by the pursuit of a transformative vision. In *Coalescence*, this is accomplished through juxtapositions, integrations, and altered contexts of image components: combinations that are graphically resolved on the picture plane in terms of color, form, and line. I'm searching for those surprising, unpredictable fusions that attain a state of emotional connection."

© Douglas Prince. *Coalescence—13*, 2007. 9½ × 12 inches. Inkjet print.

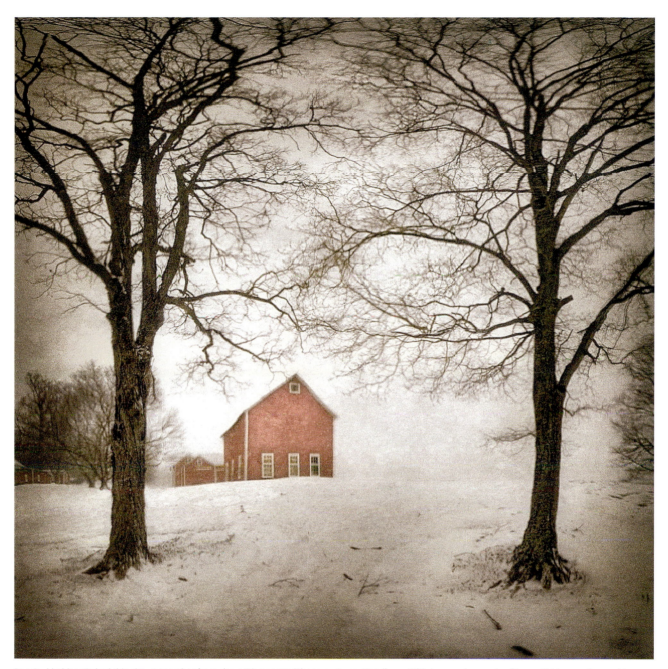

Dan Burkholder stitched this picture together from about 30 separate iPhone captures. He tells us, "This is a good example of how stitching can be used to create new spatial relationships. The foreground in this image is literally at my feet. In fact, a paved road was just a few inches out of frame at the bottom of the composition. As for the trees, they were literally over my head. You might get a sense for this when you examine the way the topmost tree branches are sort of compressed. This is because the iPhone was basically aimed straight up to capture the tops of the trees. Because it was snowing and the wind was blowing, there was movement in the tree branches between exposures. This movement can create artifacts in the final image and I'm okay with that. In fact, I love it when the photographic process shows its own hand."

© Dan Burkholder. *Barn and Trees in Snow,* 2010. 7 × 7 inches. Inkjet print.

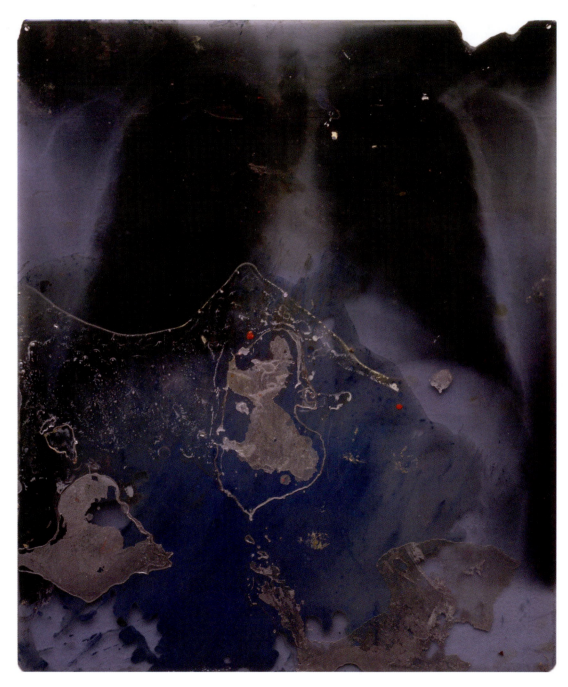

Cora Cohen states, "The conventional purpose of the x-ray is the investigation of ill health and disease. In my hand-altered x-rays, I utilize chemicals and color in such a way that they react with the exposed film, subverting a purported neutrality of use ... Decomposing the x-ray, these actions parallel the decay and evaporation of the body [this x-ray is of a person with AIDS]. They also invoke an empathic response to its transience. The colors become metaphors for the non-corporal, the immaterial, those aspects of the person the x-ray as a diagnostic device circumvented. The x-ray's power to make the internal visible is not neutral; it invokes terror. I do not allow the scientific/diagnostic to abolish the possibility of ecstasy which is on the other side of terror."

© Cora Cohen. R15, 1994. 17 × 14 inches. *Roentgenograph with aluminum, enamel, polyurethane, dust, and oil.* Courtesy of Michael Steinberg Fine Art, New York, NY.

Safety: Protecting Yourself and Your Digital Imaging Equipment

While the digital practice of photography does not expose an imagemaker to the hazardous chemicals or fumes of the analog darkroom, one should be aware of the possible health effects connected to working regularly with a computer. Just as in a darkroom, great care should be taken when printing, which we look at first. However, the biggest concern for long-term health effects may lie in the less obvious activity of spending extended periods in front of a computer screen. Discussion of these issues forms the body of this appendix.

Printer Safety

Keep your printer clean and do not have the fan facing you or anyone working nearby, as ozone is released during printing. Also, carbon dust that collects in a dirty laser printer can be blown into the air by the printer fan and breathed in or absorbed through the skin when changing cartridges. Some laser and ink colors contain heavy metals, which are an additional respiratory health hazard. As the ingredients are very fine, they can be very hard to see. Therefore, wear rubber gloves when changing cartridges and seal used ones in plastic before returning for recycling (see next section). Be sure to read the directions and if required, shake the toner cartridge correctly; doing so incorrectly can cause product leakage in the printer, on your hands, and/or into the air. If you get toner or ink on your hands, wash them thoroughly with soap and warm water. Material Safety Data Sheets (MSDS) can be found on manufacturers' websites, which contain safety information about materials such as physical, chemical, and toxicological properties, regulatory information, and recommendations to ensure safe handling.

Recycle Your Toner Cartridges

Hundreds of millions of toner cartridges end up in our landfill every year even though most toner cartridges can be recycled or remanufactured. Check with each manufacturer for their specific product recycling programs. Even better, find a local nonprofit toner cartridge recycler and support your community and the environment. If nothing is available locally try www.recycle4charity.com.

Ergonomic Workstations

Ideally, keep the temperature of your workspace between 68 and 72 °F (20–22 °C). Server and larger computer rooms are often kept cooler, 65–68 °F (18–20 °C), to maximize the equipment's longevity. If you cannot control the temperature, wear long sleeves and fingerless gloves to keep arms and hands warm and muscles relaxed.

Many desks and computer-related equipment have hard, angled leading edges that can come in contact with your arm or wrist. These hard edges can create contact stress, affecting blood vessels and nerves, possibly causing tingling and sore fingers. One can minimize contact stress by:

- Purchasing computer furniture with rounded desktop edges.
- Padding table edges with inexpensive materials such as pipe insulation.
- Properly using a wrist rest. A wrist rest should be used **only** when resting your wrists; it should **never** be used while typing. Wrists should be held in a neutral position— not bent up, down, or to the sides—with hands and arms floating gently and lightly over the keyboard. Work from the shoulder when typing—not the wrist—because these muscles/tendons are larger and stronger than those in the hands and wrists. Hands should be gently cupped (curved), not flat; type on the tips of your fingers. Keep your upper arms and elbows close to your torso, not splayed out, to avoid awkward positioning.
- Using a mouse on a touchpad (a.k.a. trackpad) close enough to the keyboard that you can easily reach it at the same level. Again, use your larger muscles, and move the mouse from the shoulder without bending your wrist to the right or left. Hold the mouse gently, as if it is a live animal you do not want to crush, letting the glide on the bottom do the work. If it is "sticky" clean the bottom, so it glides properly. Try different mice to find one that fits your hand comfortably, with functions located where you like them. Smaller hands need smaller mice. If you do not like using a mouse, consider a touchpad, which can be plugged into a desktop model. It should be handled like the mouse—gently, with only enough pressure needed for the function. Tap lightly.
- Using a keyboard at a level such that when you type, your forearms are at a 90-degree angle (parallel to the floor) or slightly lower (about 110 degrees). Keep the back of the keyboard slightly lower than the front. A wrist rest the width of the keyboard placed under the front of the keyboard works well and stays put. If the table is too high, either lower the table or get an adjustable keyboard drawer with a negative tilt capacity. The drawer should be wide enough to accommodate the mouse so that it is on the same level as the keyboard.

Some drawers have mouse trays that slide or fold out for use, if space is at a premium. Type gently; it is not necessary to hit the keys hard. If you need or like a keyboard that gives you feedback, find one with "click touch" response.

Monitor Emissions: ELF/VLF

Extremely low frequency (ELF) and very low frequency (VLF) emissions are types of electromagnetic radiation created by monitors. Some research studies have linked these emissions to an increased risk of cancer or miscarriage. Keep your eyes at least 18 inches away (arm's length) from the screen and avoid prolonged exposure. Use a low radiation emission monitor or install a screen filter. New, high-quality LCD monitors have lower emissions than older CTR monitors.

Eyestrain

Eyestrain can be reduced by working in a properly lit room and by keeping the screen free of dust and clear of reflections. Periodically shift your focus from the screen to an object at infinity to rest your eyes. Remember to blink often. There is a tendency to stare at the screen and forget to blink, which will dry out the eyes, produce itching, and contribute to eyestrain and blurred vision. When possible, close your eyes for a few minutes and allow them to relax. Every 20–30 minutes, refocus your eyes from close work by looking at a point in the room farthest from you, or get up and look out a window at something in the distance or on the horizon. If you like natural light, position your computer screen to the left or right of a window, but not directly in front of it. Use sheer curtains to filter the light and prevent glare. A hood around the monitor can also reduce eyestrain, as your eyes do not have to try and adjust to the monitor and ambient light at the same time. Free software is also available to remind you to periodically take a break.

Proper Posture/Lower Back Problems

It is worth investing in a high-quality chair appropriate for your size, needs, and tasks. Sit in a fully adjustable ergonomic chair with your feet flat on the floor or a footrest. When shopping for a chair, consider your size, height, and weight (many chairs are available in different sizes). If you like arm rests, make sure that they will fit fully under your desk, so your posture is not distorted while working. Spend at least 20 minutes in any chair you are testing for purchase, to make sure it fits your body properly. Before taking your chair home, ensure that you understand all the controls. Ask about the return and exchange policy, in case the chair proves unsuitable. Be advised that there is no legal or commercial criterion for the use of the word "ergonomic," so it is advisable to research any product using this claim as a selling point.

Monitor Position

The top of your monitor should be at eye level so that you are looking slightly down at the center of the screen, without tipping your head. Another option is to use a sit-to-stand desk that has adjustable heights so it is possible to work standing upright, which can greatly help those with back problems.

Repetitive Strain Injuries or Cumulative Trauma Disorders

Repetitive Strain Injuries (RSIs) or Cumulative Trauma Disorders (CTDs) are umbrella terms commonly used for a variety of injuries. These are multifactorial injuries, whose causes are often cumulative over time and may include poor task and/or workspace design, poor posture, insufficient rest breaks, lack of control over tasks, workflow, and deadlines, plus improper keyboard and mouse use. Carpal tunnel syndrome may be most familiar to readers, but is only one of several possible injuries. Early symptoms include muscle and general fatigue, and numbness and tingling in the wrists and hands. In advanced stages, these injuries can cause permanent nerve damage and chronic severe pain. Keep your wrists flat, straight, and aligned with your forearm to help prevent injury. The way to find "neutral" is to stand relaxed with good posture. Drop your arms to your side, with your fingers slightly curved. Then, raise your forearms so they are parallel to the floor and turn your wrists so that your palms face downward. Without changing finger position, you are ready to type in a neutral position.

Taking Breaks

Take a 5-minute break from your computer activity every half hour or a 10-minute break every hour. Getting out of your chair will help to prevent fatigue and to keep you sane. Microbreaks, every 15 minutes, may include resting your eyes, breathing deeply, and drinking water. Try mixing non-computer-related activities into your digital routine. At your desk, stretching and yoga exercises, which can be found on the Internet, are suggested. Consider "coffee break" shareware. Going to an online social network site, such as Facebook, is not taking a computer break. This is a good moment to "zone-out" and close your eyes and let your mind wander. This freeing of the body and mind can also encourage the creative process, but be sure to catch and later evaluate any Eureka moments.

Neutral Body Positioning

When adding up the number of hours you spend every year working with computer equipment, it becomes apparent that it is to your benefit to properly set up a computer workstation. To accomplish this, it is useful to understand the concept of neutral body positioning, a comfortable working posture in which your joints are naturally aligned. Working with your body in a neutral

position reduces stress and strain on the muscles, tendons, and skeletal system, and decreases your risk of developing a musculoskeletal disorder (MSD). The following are US Department of Labor's Occupational Safety & Health Administration's (OSHA) guidelines for maintaining neutral body postures while working at your computer workstation:

- Hands, wrists, and forearms are straight, in line, and approximately parallel to the floor.
- Head is forward facing, level or bent slightly forward, and center balanced. Normally your head is in line with your torso.
- Shoulders are relaxed, and upper arms hang normally at the side of your body.
- Elbows are kept close to your body and are bent between 90 and 120 degrees.
- Feet are firmly supported by floor or a footrest.
- Back is fully supported with appropriate lumbar support when sitting vertical or leaning back slightly.
- Thighs and hips are supported by a well-padded, ergonomic seat that is usually parallel to the floor.
- Knees are about the same height as the hips, with the feet slightly forward.

Change Your Working Position

Regardless of how good your working posture is, it is not healthy for one to work in the same static posture or to sit still for prolonged periods of time. Change your working position frequently throughout the day by carrying out the following activities:

- Stretch your fingers, hands, arms, and torso regularly.
- Make small adjustments to your chair, backrest, and footrest.
- Roll your shoulders to loosen and relax them.
- Periodically stand up and walk around for a few minutes.

Voice Recognition Software

Consider an evaluation by a voice therapist who has experience working with computer voice recognition. Learn and use voice warm-up exercises. Speak normally, so the software becomes familiar with your speech patterns. Vocal chords are hydrated through the bloodstream, so it is important to be hydrated. Drink plenty of water and avoid sweet or caffeinated drinks. Do not use throat lozenges to keep working, as this coats but does not hydrate throat and vocal chords, and may mask voice problems and/or injury. If hoarseness or soreness is present, it may indicate a problem requiring attention. As with typing, permanent injuries may occur if problems are not diagnosed accurately and treated early.

RESOURCES

National Institute for Occupational Safety and Health (NIOSH) has a searchable bibliographic database of occupational safety and health publications, documents, and journal articles dealing with ergonomics and musculoskeletal disorders at: www.cdc.gov/niosh/topics/ergonomics/.

Occupational Safety & Health Administration (OSHA): www.osha.gov. See Safety/Health Topics eTools > Computer Workstations (08/2003).

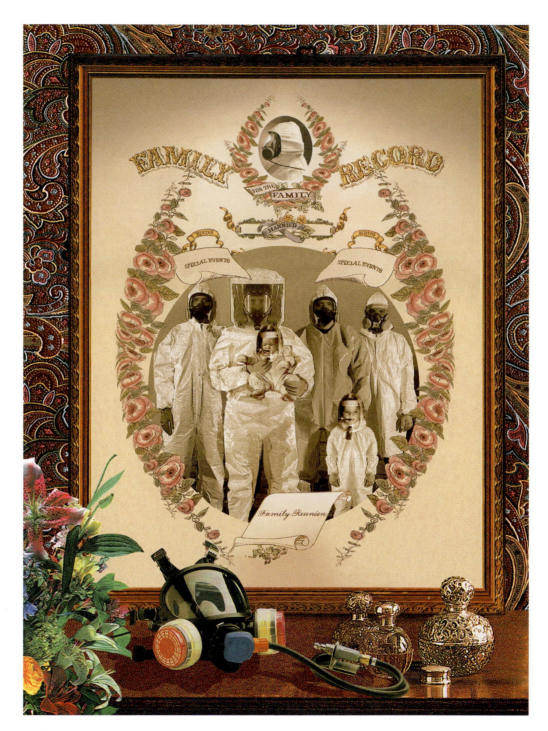

Safety in the color darkroom must be incorporated into a photographer's daily routine. Here Deena des Rioux presents a scenario of "a future view of the past when zero air quality is the norm. In a nostalgic setting, the human subjects are inaccessible: In their place are framed portraits that show 'the family' in protective gear where a breathing apparatus is an everyday accessory."

© Deena des Rioux. *Family Reunion*, from the series *Family Portrait*, 2002. 40 × 31 inches. Inkjet print. Courtesy of the Kinsey Institute for Research in Sex, Gender, and Reproduction, Bloomington, IN.

Safety in the Color Darkroom

It is of vital importance for all photographers to assume responsibility for protecting their health when working with any photo-based process in the color darkroom. Learning all safety precautions and guidelines before beginning to work with any process will help to ensure a long and safe relationship between yourself and the practice of making images.

Guidelines for Chemical Handling and Mixing

Every photographer working in a color darkroom needs to be aware of specific health and environmental hazards to ensure safe working conditions. Before working with any process mentioned in this book, it is necessary for each photographer to become familiar with and observe the basic precautions and guidelines outlined in Box A2.1.

Disposing of Chemistry

Environmental regulations continue to be made stronger, and what may have been acceptable to pour down the drain 10 years ago may not be permissible today. As the beneficiaries of cleaner air and water, photographers are responsible for following local regulations.

Municipal waste treatment plants can handle most photo chemicals solutions up to a certain concentration and volume. Local sewer authorities regulate the concentrations and volume of chemicals released per day into sewer systems. Normally, most individual home photographic processing will not exceed these regulations. However, before setting up a darkroom, contact the local sewer authority for information about the disposal of your photographic solutions. Some sanitation departments have special collection centers for toxic chemicals and other items that should not be placed in with regular garbage, both for the protection of the environment and the safety of the workers.

Box A2.1 Safety Precautions for Chemical Processes

1. Before carrying out any chemical process, including mixing, handling, storage, and disposal, read and follow all instructions and safety recommendations provided by the manufacturer, including Material Safety Data Sheets (MSDS), as well as Appendices 1 and 2 of this book. MSDS are available at the manufacturer's website. Each manufacturer prepares its own MSDS, which typically provide additional ecological, disposal, transport, and regulatory information. For general information about MSDS visit: www.ilpi.com/msds/index.html.

2. Obtain any special safety equipment, such as gloves, goggles, and a facemask that does not leak, before using the materials you have purchased. Note: Facemasks are rated for different levels of filtration, so be sure to use the one that is suited for the task at hand.

3. Become familiar with all the inherent dangers associated with any chemicals used. When acquiring chemicals or when working with a new process, ask about proper handling and safety procedures. Obtain an MSDS for all chemicals used, which can usually be found on the manufacturer's website and/or with the product literature. Keep them available in a notebook for easy reference. Learn how to interpret the MSDS. Right-to-know laws in the United States and Canada require all employers to formally train workers to read an MSDS. Certain color chemicals are more dangerous than others. Para-phenylenediamine and its derivatives, found in some color developers, and formaldehyde and its derivatives, found in stabilizers, are two of the most toxic.

4. Know the first aid and emergency treatment for the chemicals with which you are working. Keep the telephone numbers for poison control and emergency treatment prominently displayed in your working area and near the telephone. Each MSDS has the manufacturer's emergency number on it.

5. Many chemicals may be flammable. Keep them away from any source of heat or open flame, including cigarettes, to avoid possible explosion or fire. Keep an ABC-type fire extinguisher in the darkroom, which can be used for ordinary combustibles (wood and paper), as well as solvent, grease, and electrical fires.

6. Protect chemicals from low temperatures (lower than 40 °F, or 4.4 °C). Otherwise, they may freeze, burst their containers, and contaminate your working environment. Also, chemicals that have been frozen may be damaged, and can deliver unexpected and faulty results.

Box A2.1 Safety Precautions for Chemical Processes—cont'd

7. Work in a well-ventilated space (see Ventilation section below). Hazardous chemicals should be mixed in a vented hood or outdoors. Check the MSDS or the manufacturer's website for recommended ventilation guidelines for any chemicals you are using.

8. Avoid contamination problems by keeping all working surfaces clean, dry, and free of chemicals. Use polystyrene mixing rods, funnels, graduates, and pails. Use separate mixing containers for each chemical, and do not interchange them. Label them with a permanent marker. Thoroughly wash all equipment used in chemical mixing. Keep floors dry to prevent slips and falls.

9. Protect yourself by wearing disposable, chemical-resistant gloves, safety glasses, and plastic aprons. Keep protective equipment within easy reach so that safety practices become automatic. Find a glove maker who provides information that indicates how long the glove material can be in contact with a chemical before it becomes degraded or permeated. Degradation happens when the glove deteriorates from being in contact with the chemical, while permeation occurs when molecules of the chemical penetrate through the glove material. Permeated gloves often appear unchanged and wearers may be unaware they are being exposed to the chemical. Some chemicals can penetrate chemical gloves in minutes and begin to penetrate the skin. Barrier creams, which can protect the skin from light exposure to specific chemicals, can be applied to your skin. Choose the appropriate cream to block acids, oils, or solvents, and use it exactly as directed. Do not use harsh soaps or solvents to wash your hands. After washing, apply a high-quality hand lotion to replace lost skin oils.

10. Consult the MSDS for the proper type of protection required with each chemical or process. When mixing powdered materials, use a NIOSH (National Institute of Occupational Safety and Health)-approved mask for toxic dusts. When diluting concentrated liquid chemicals containing solvents, acetic acid, and sulfites, use a combination organic vapor/acid gas cartridge with the mask. Ideally, all mixing should be done in a local exhaust system. If you have any type of reaction, immediately suspend work with all photographic processes and consult with a knowledgeable physician. Once an allergic reaction has occurred, you should avoid the darkroom chemicals or working in the darkroom, unless your physician approves the use of a respirator. Employers of workers who wear respirators, including dust masks, are required by OSHA to have a written respirator program, formal fit testing, and worker training. People with certain diseases and some pregnant women should not wear them. Check with an occupational and/or environmental physician.

11. Follow mixing instructions precisely. Mix chemicals in prescribed order and exactly according to directions, including the mixing times. Improper mixing procedures can produce dangerous chemical reactions or give undesirable results.

12. Keep all chemicals off your skin and out of your mouth. If you get any chemicals on your skin, flush immediately with cool, running water to avoid developing contact dermatitis over time.

13. Do not eat, drink, or smoke while handling chemicals. Wash your hands thoroughly after handling any chemicals. Food should not be stored in the refrigerator next to chemicals and paper. OSHA forbids the consumption or storage of food or drink wherever toxic chemicals are used or stored.

14. Always pour acids slowly into water. Never pour water into acids! Do not mix or pour any chemical at eye level, because a splash could prove harmful. Wear unvented chemical splash goggles when mixing acids.

15. Label each solution container to reduce the chance of contamination and/or use of the wrong solution.

16. Avoid touching any electrical equipment with wet hands. Install shockproof outlets (ground fault interrupters) in your own darkroom. Make certain all equipment is grounded. Keep the floor dry. When designing a darkroom, plan to separate wet and dry areas.

17. Follow the manufacturer's instructions for proper disposal of all chemicals. Bleach and fix should be filtered through a small, inexpensive silver recovery unit. While the recovered silver can be sold to recoup the cost of the unit, the concentration can be highly toxic and must be handled with caution. Photographers need to be aware of local regulations. Each local water treatment facility has its own rules and can provide a copy upon request. Since household septic systems use bacteria to breakdown waste, they can be easily damaged by photographic chemistry disposal. Most septic systems can handle a few pints of chemistry at any one time. When using larger quantities of chemicals, locate an appropriate disposal site. Purchase spill control centers, which contain special "pillows" or other devices that can be dropped on acids, solvents, or caustic chemical spills to immediately absorb them. These can be purchased at safety supply companies. Wash any part of your body and all equipment that has come into contact with chemicals. Launder darkroom towels separately after each session. Specific questions about Kodak products can be answered by their Environmental Technical Services at (585) 722-5151. Ilford provides a similar service at (201) 265-6000 as does FujiFilm/Hunt Chemicals at (800) 526-0851.

Box A2.1 Safety Precautions for Chemical Processes—cont'd

18. Keep all chemicals properly stored. Use safety caps and/or lock up chemicals to prevent children, friends, and pets from being exposed to their potential dangers. If needed, lockable and leak-proof chemical cabinets, available from safety companies such as Lab Safety and Supply (www.labsafety.com), can be purchased. Store chemicals in a cool, dry area, away from any direct sunlight.

19. People have varying sensitivities to chemicals. Reduce your risk by keeping exposure to all chemicals to a minimum. Some chemicals cause an effect that is immediate and identifiable, while others, such as a skin allergy, can take years to develop. Consult your physician if you have a reaction while working with any chemicals. Be prepared to tell your doctor precisely what you were working with and what your symptoms are. Follow the physician's advice about reducing chemical exposure, using respiratory protection, and other precautions. Photographers should consult physicians who are board certified in occupational medicine or toxicology for such advice.

20. If you are planning a pregnancy, are pregnant, are breast-feeding, or have any preexisting health problems, consult your physician. Share with the physician any information from the MSDS, from this book, or from other sources about possible adverse reactions before undertaking any photographic process. Children, senior citizens, allergy sufferers, smokers, heavy drinkers, and those with chronic conditions and diseases are considered to be more susceptible to the hazards of photographic chemicals.

21. Questions about photographic chemicals can be answered by telephoning the numbers given in Box A2.2 below. Keep them close to the telephone or in your cellphone in case of an emergency.

Specific safety measures and reminders will be provided throughout this book whenever there is a deviation or exception from these guidelines. These instructions are not designed to induce paranoia but are provided to ensure that you have a long and safe adventure in exploring color photography. Remember your eyes, lungs, and skin are porous membranes and can absorb chemicals as liquid and vapors. Developing the habit of informed and careful handling practices is the best way to protect yourself.

Ventilation

It is advisable to work in a space that has a light-tight exhaust fan and an intake vent for fresh air. Exhaust fans are rated by their ability to remove air in cubic feet per minute (cfm). A 10 × 20-foot darkroom with a 10-foot ceiling would require an exhaust fan rated at 500 cfm (against ¼- to ½-inch static pressure) to do 15 air exchanges per hour. It is important to know that floor- and desk-model fans, even those that run at the recommended cfm, will not provide proper ventilation. Bad air needs to be exchanged for good air. The amount of ventilation needed varies depending on what chemicals are used, room size, and conditions. Read the MSDS or contact the manufacturer for suggested ventilation guidelines for chemicals. This type of ventilation, known as general or dilution, is designed to dilute the contaminated air with large volumes of clean air to lower the amounts of contaminants to acceptable levels and then exhaust the diluted mixture from the work area. Dilution ventilation does not work with highly toxic materials or any particle materials that form dusts, fumes, or mists. These materials require what is referred to as local exhaust ventilation, such as a table slot or fume hood, to capture the contaminants at the source before they escape into the room air. Refer to the resources listed in the reference section at the end of this chapter to carefully research this area before constructing a system.

Water for Photographic Processes

Water makes up almost two-thirds of the human body and three-quarters of our planet's surface, and is the key ingredient in most pre-digital photographic processes. Although water itself does not create a safety issue, it is included here because its purity can affect your processing results. The following information applies whenever water is called for in any process discussed in this book.

Use a source of "pure" water. The chemical and mineral composition and pH of your local water source can affect processing results. Color developers are most sensitive to these factors. You can eliminate this variable beforehand by making certain your water source is pure or by using water processed by reverse osmosis. Distilled water often has had certain compo-

Box A2.2 Emergency Telephone Numbers

Numbers for the local poison control hotline are usually listed in the first few pages of your telephone directory. Keep this number, along with the phone numbers listed below, close to the telephone in case of an emergency.

Questions about photographic chemicals can be answered by telephoning the following health and safety numbers, some of which operate 24 hours a day:

- Ilford Medical Emergency, North America, 24-hour hotline (800) 842-9660

- Kodak, North America, 24-hour hotline (585) 722-5151

- Local Poison Control Center:_____

nents (calcium) removed that are required for proper chemical reactions to take place. Water that has gone through a softening process is not recommended for any photographic chemical mixing. This is because water is generally softened by passing it through a treatment tank that contains high amounts of salts. This process alters the chemical composition of the water and can lead to processing irregularities.

RESOURCES

Arts, Crafts and Theater Safety (ACTS). 181 Thompson Street #23, New York, NY 10012. (212) 777-0062. www.arts-craftstheatersafety.org/. ACTS will answer questions about chemicals, work space design, and doctor referral.

Clark, Nancy, Cutter, Thomas and McGrane, Jean-Ann. *Ventilation: A Practical Guide.* New York: Nick Lyons Books, 1987.

Coalition for the Artists' Preparedness and Emergency Response, *Studio Protector: The Artist's Guide to Emergencies*: www.studioprotector.org.

Eastman Kodak Co. *Photolab Design.* Kodak Publication K-13. Rochester, NY: Eastman Kodak, 1989.

Eastman Kodak Co. *Safe Handling of Photographic Chemicals.* Kodak Publication J-4. Rochester, NY: Eastman Kodak, 1979.

Freeman, Victoria, and Humble, Charles G. *Prevalence of Illness and Chemical Exposure in Professional Photographers.* Durham, NC: National Press Photographers Association, 1989.

McCann, Michael. *Artist Beware*, rev. edn. Guilford, CT: Lyons Press, 2005.

National Press Photographers Association, 3200 Croasdaile Drive, Suite 306, Durham, NC 27705. (919) 383-7246. www.nppa.org.

OSHA Publications Office, Room N-3101, 200 Constitution Ave., NW, Washington, DC, 20210; (202) 693-2121. www.osha.gov/pls/publications/publication.html.

Rempel, Siegfried, and Rempel, Wolfgang. *Health Hazards for Photographers.* New York: Lyons & Burford, 1992.

Rossol, Monona. *The Artist's Complete Health and Safety Guide*, 3rd edn. New York: Allworth Press, 2001.

Shaw, Susan D., and Rossol, Monona. *Overexposure: Health Hazards in Photography*, 2nd edn. New York: Allworth Press, 1991.

Spandorfer, Merle, Curtiss, Deborah and Snyder, Jack. *Making Art Safely: Alternative Methods and Materials in Drawing, Painting, Printmaking, Graphic Design, and Photography.* New York: Van Nostrand Reinhold, 1993.

Tell, Judy, ed. *Making Darkrooms Saferooms.* Durham, NC: National Press Photographers Association, 1988.

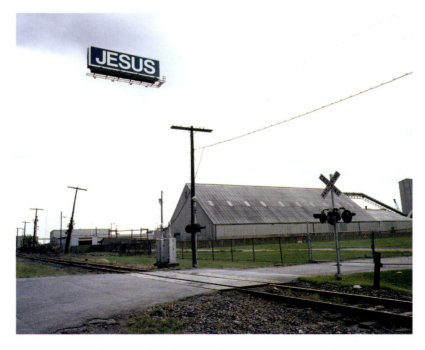

Matt Siber explains that *Floating Logos* was "inspired by the proliferation of very tall signs in the American Mid-West. Perched atop tall poles or stanchions, these corporate beacons emit their message by looming over us in their glowing, plastic perfection." He scans his medium-format film and then eliminates the sign's support structures in Photoshop, allowing them to literally hover above the earth. "Making the signs appear to float not only draws attention to this type of signage but also give them, and the companies that put them there, an otherworldly quality. References can be drawn to religious iconography, the supernatural, popular notions of extraterrestrials, or science fiction films such as *Blade Runner*. Each of these references refer to something that can profoundly affect our lives yet is just beyond our control and comprehension."

© Matt Siber. *Jesus,* from the series *Floating Logos*, 2004. 40 × 50 inches. Inkjet print.

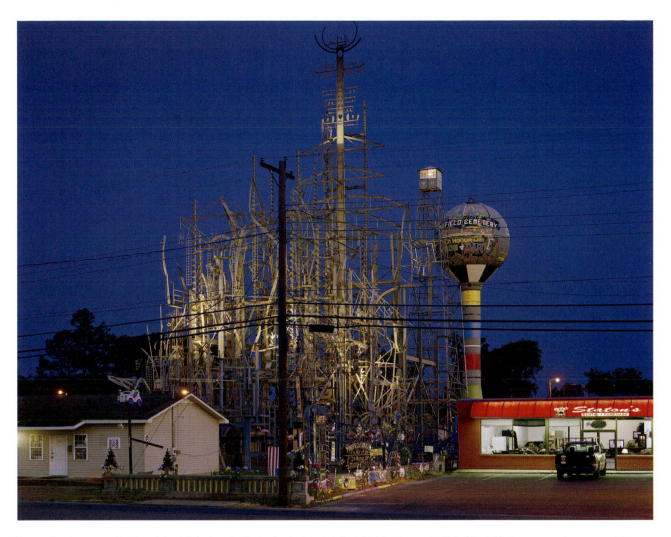

To record an image capable of retaining full shadow details despite the late dusk light, Fred Scruton used a Linhof 8 × 10-inch camera and overexposed the transparency film by changing its official 160 ISO to a rating of 25 ISO. He later compensated for this by scanning the film and adjusting it in Photoshop. To avoid headlight and taillight trails during the 3-minute exposure, the artist covered his lens with a lined film box each time a car passed by. Scruton tells us, "Working in the tradition of the 'heightened document' where a 'straight' photographic or video record can seem to most convincingly reveal the expressive qualities intrinsic to the subject matter itself, this project documents the distinctly individual visions of commercial sign painters, small town eccentrics, and self-taught artists. Full of humor, charm, innocence, and sophistication, and refreshingly distinct from the cultural mainstream, their artworks punctuate the American landscape with a delightful legacy of vernacular expression."

© Fred Scruton. *Billy Tripp's Mindfield; Brownsville, TN, 2008*. 30 × 40 inches. Chromogenic color print.

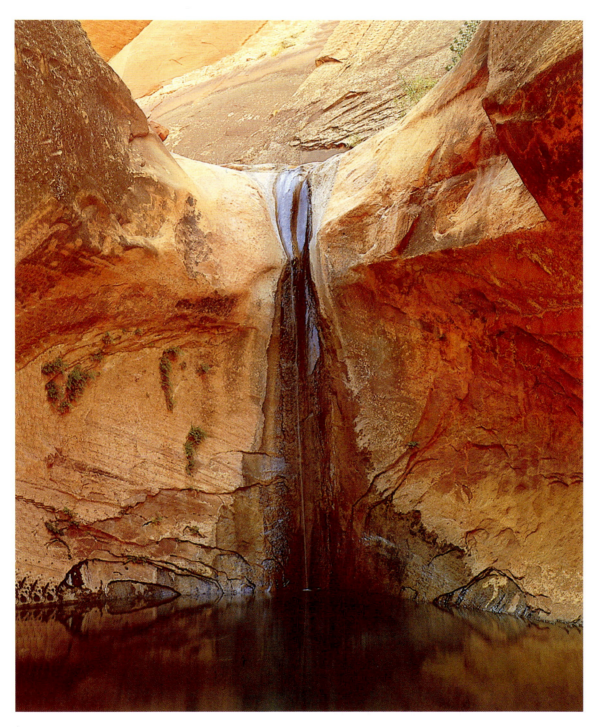

Eliot Porter was a master of the dye-transfer process who became well known through his various publications, such as *The Place No One Knew: Glen Canyon on the Colorado* (1963). The Sierra Club used his "beautiful" color images to help awaken people to ecological issues and the dangers of uncontrolled technology and business while having a side effect of helping color photography become recognized as a legitimate art form.

© Eliot Porter. *Reuss Arch and Amphitheater, Davis Gulch, Escalante Basin, Utah, 1965.* Dye-transfer print. Courtesy of Eliot Porter Archives, Amon Carter Museum, Fort Worth, TX.

 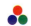

Advanced Exposure Techniques/
The Zone System for Color Photography

What Is the Zone System?

In the late 1930s Ansel Adams and Fred Archer devised the Zone System as a method of explaining exposure and development control to students in black-and-white photography. It is based on the old photo adage: "Expose for the shadows and develop for the highlights." Since then, it has been continually refined and expanded. According to Adams, its purpose was "to provide a bridge between sensitometry and practical creative work by offering step-by-step working methods that do not require extensive training or equipment." Today it offers a conduit between analog and digital processes in color and black-and-white photography.

What Is a Zone?

A "zone" is not a place but a concept. It is the relationship between a subject's brightness and its photographic representation, as density in the negative and a corresponding tone in the final print. Under the Zone System, a full-range print has tones that have been divided into a gray scale of eleven zones (Zone 0 to Zone X), which are identified with roman numerals to avoid confusing them with all the other numerical combinations used in photography. Each zone is equivalent to a one f-stop difference in subject brightness and exposure (see Table A3.1 for a list of the basic zones and their physical equivalents).

Previsualization

The photographer measures the brightness range of the subject and "previsualizes" the print tonal range that is wanted to represent the subject and then picks a combination of exposure and development procedures to make this happen. Previsualization is a mental act in which the photographer imagines how the final print will look, before the camera exposure is even made. It involves combining vision and technique to achieve the photographer's personal response to the subject. The term can be found in the writings and work of Edward Weston, Ansel Adams, and Minor White, and has become the keystone of the modernist, realistic approach to photography. The principles of the Zone System can also be found in the curves and levels (histogram) and high dynamic range (HDR) functions of imaging processing software, providing concrete examples of how present methods have evolved from past ones.

In order to achieve maximum effect and control, a photographer needs to make equipment and material tests to determine the "true" speed of the film being used, and to learn precisely

TABLE A3.1	BASIC ZONES AND THEIR PHYSICAL EQUIVALENTS

Low Values

Zone 0: Maximum black. The blackest black that a film or paper can produce when exposed to white light. Doorways and windows opening into unlit rooms.

Zone I: The first discernible tone above total black. When seen next to a high-key zone it is sensed as total black. Twilight shadows.

Zone II: First discernible evidence of texture; deep tonalities that represent the darkest part of the picture in which a sense of space and volume is needed.

Zone III: Average dark materials and low values showing adequate texture. Black hair, fur, and clothes in which a sense of detail is needed.

Middle Values

Zone IV: Average dark foliage, dark stone, or open shadow in landscape. Normal shadow value for average white (Europe, North Africa, Middle East) skin portraits in daylight. Also brown hair and new blue jeans.

Zone V: 18 percent gray neutral test card. Average black skin, dark skin, or tanned Caucasian skin, average weathered wood, grass in sunlight, gray stone.

Zone VI: Average white skin value in sunlight, diffuse skylight, or artificial light. Light stone, shadows on snow in sunlit landscapes.

High Values

Zone VII: Very light skin, light gray objects, average snow with acute side lighting.

Zone VIII: Whites with texture and delicate values, textured snow, highlights on white skin.

Zone IX: White without texture approaching pure white, similar to Zone I in its slight tonality without a trace of texture.

Zone X: Pure white of the printing paper base, specular glare, or light sources in the picture area.

what alterations in the development process are needed in order to shrink an extremely long tonal range (so it will fit on a piece of paper or film) or to expand a subject's limited brightness range to normal. Once this is done, it is possible, based on the exposure given to the subject, to determine what changes in development are necessary to obtain the desired visual outcome.

The Zone System and Color

Using the Zone System for color photography is similar to the method for black-and-white. The photographer has to learn the zones, be able to previsualize the scene, and place the exposures. The major difference is the greatly reduced flexibility in processing color, since it is necessary to maintain the color balance between all the layers of the emulsion to avoid color shifts and crossovers. Another difference is that contrast is determined not only by light reflectance but by the colors themselves.

Film-Speed Testing

The film-speed test is at the heart of the Zone System. The biggest technical obstacle most photographers encounter when working with color film is making the correct exposure, which is more critical than in black-and-white photography since it determines not only the density but the color saturation. Even with proper exposure techniques, if the film's speed does not agree with your working procedures, the results will not be as expected. If you do not have exposure troubles, leave well enough alone. There is no reason to do a test when you could be making photographs. However, if you have had problems with exposure—especially with underexposed negatives or overexposed slides—run a test and establish your personal film speed. If your exposures are still erratic, it indicates either a mechanical problem or the need to review your basic exposure methods.

The manufacturer's stated film speed is a starting point that is not engraved in stone. It is determined under laboratory conditions and does not take into consideration your personal lens, camera body, and exposure techniques, nor the subject and the quality of light. You can customize your film speed to make it perform to your own style and taste. The film-speed test recommended here is based on the principles of the Zone System, though your results will be determined visually rather than through the use of a densitometer.

The Zone System and Transparency Materials

Exposure is absolutely critical with transparencies, since the film, and not a print, is the final product. If a mistake is made, such as overexposure or underexposure of the film, it cannot be readily corrected in the secondary process of printing, although some correction is possible through scanning and the use of digital software. What is true for negatives is the opposite for positives (transparencies). For both, the areas of greatest critical interest for judging proper exposure are those of minimal density. However, with negatives these are the shadow areas and with transparencies they are the highlight areas. When using the Zone System method of exposure control, meter off the important previsualized highlight and then open up the lens to the required number of stops for proper zone placement. All other tones will then fall relative to the placed zone. The darker values will show up as long as the highlight is metered and placed correctly.

Finding Your Correct Film Speed with Transparencies

You will discover your personal film speed upon a correct rendering of the highlights. The zone used for this test is Zone VII.

The characteristics of Zone VII (the lightest textured highlight) include blonde hair, cloudy bright skies, very light skin, white-painted textured wood, average snow, light gray concrete, and white or very bright clothes.

Zone VIII has even less density and is so close to clear film that it can be difficult to visually distinguish it as a separate tone. It is the last zone with any detail in it. Zone VIII subjects include smooth white-painted wood, a piece of white paper, a white sheet in sunlight, and snow entirely in shade or under overcast skies. It is easy to lose the sense of space and volume in such light objects. Zone VIII contains values so delicate that when seen beside those of Zone II or III they may be sensed as a pure white without texture.

Test Procedures

For this test, use a standard Zone VII value like a white-painted brick wall, a textured white fence, or a textured white sweater. Make the test with your most commonly used camera body and lens, and set the meter to the manufacturer's suggested film speed (ISO). Take the meter reading only from the critical part of the subject and place it in Zone VII. This can be done by either opening up two f-stops or their shutter speed equivalents. Remember the meter is programmed to read at Zone V (18 percent reflectance value, as with the gray card). "Correct" exposure is one that renders Zone V as Zone V (or any single-toned subject as Zone V, if the meter is working correctly). Then make a series of exposures, bracketing in 1/2 f-stops, three stops more and three stops less than the starting film speed. Next, develop the film following normal procedures. Mount and label all 13 exposures, and then carefully examine them with a film loupe or magnifying glass. Look for the slide that shows the best Zone VII value—one that possesses the right amount of texture with correct color and is not too dark. This exposure indicates your correct film speed.

Transparency Film-Speed Observations

Transparency films generally have a more accurate manufacturer's film-speed rating than do negative films. The slower films are usually very close, and you may even want to test them in 1/3 f-stop intervals, two full f-stops in both directions. Medium-speed transparency films tend to run from right on to 1/3 to 1/2 f-stop too slow. High-speed films can be off by 1/2 to one full f-stop. Usually most photographers raise the transparency film speed from the manufacturer's speed. Why? This slight underexposure produces richer and fuller color saturation. With slide film it is imperative that you meter with the utmost accuracy. When in doubt, give it less exposure rather than more. Do not hesitate to bracket and be certain you have what you need and want.

Highlight Previsualization

Once you have determined your personal film speed, correct exposure entails previsualizing the highlights only. Pick out the most important highlight area, meter it, and place it in the previsualized zone in which you want it to appear. You do not have to bother to meter the contrast range between the highlights and shadows. If you are in the same light as the subject being photographed, the correct exposure can be determined by metering

off an 18 percent gray card or, if you are Caucasian, simply metering the palm of your hand in the brightest light in the scene and then placing it in Zone VI by opening up one f-stop. The contrast of the image, just as with color negative film, will be largely a matter of the relationship of the colors that are in the scene being photographed.

Working With Negative Film

All the major color negative films can be developed using Kodak's C-41 process. This is not only convenient but also necessary. Attaining the correct balance of color dyes in the design of negative film has not been an easy task. Standardization within the industry has made this less difficult. Even so, though it is possible to develop many different types of film in a common process, your results will vary widely. This is because each film has its own personality based on its response to different colors. You will need to try a variety of films and even different types of C-41 processes until you come up with a combination that matches your personal color sensibilities.

Exposing for the Shadows: Zone III

Color negatives, as with black-and-white, are exposed for proper detail in the shadow areas. Adequate detail in a Zone III area is generally considered to indicate proper exposure. Zone III indicates "average dark materials." This includes black clothes and leather. In the print, proper exposure shows adequate detail in the creases and folds of these areas. Form and texture are revealed, and the feeling of darkness is retained.

Film-Speed Tests

A Simple Exposure Test

The simplest exposure test is one in which you find a Zone III value (subject) and then meter and place it using a variety of different film speeds (bracketing). The film is developed and carefully examined with a loupe or magnifying glass to determine which exposure gives the proper detail in Zone III. The result provides your proper film speed.

A Controlled Test

Here is an easy and controlled method that provides more accurate results. On a clear day in direct sunlight, photograph a color chart and gray card. Make the test with the camera body and lens you use most often. Set the film speed according to the manufacturer's starting point. Take all meter readings off the gray card only. This way there is no need to change exposure for different zone placements. Make an exposure at this given speed. Then make a series of different exposures by bracketing in 1/2 f-stop increments; go two full f-stops in each direction.

As an example, say you set your film speed at 400 and determined that your exposure is f/8 at 1/250. You would make your initial exposure at this setting and then make four exposures in the minus direction and four in the plus direction. Leave your

TABLE A3.2	FILM SPEED TEST EXPOSURES
f-stop	**Film speed**
f/16	1600
f/11-1/2	1200
f/11	800·
f/8-1/2	600
f/8*	400*
f/5.6-1/2	300
f/5.6	200
f/4-1/2	150
f/4	100

*Starting exposure

shutter speed at 1/250 for all exposures. Table A3.2 gives you the f-stops you would need to expose at and their corresponding film speed.

Visually Determining the Correct Exposure

After making the exposures, process the film following your normal procedures. Next, identify and/or label each frame according to its film speed, and then critically examine them with a loupe in the order they were exposed, beginning with the highest film speed. Pay close attention to the black-and-white density scale on the page photographed. As you look at the negatives, you should notice more of the steps becoming distinct as the speed of the film drops. Your correct exposure will reveal visible separation for all the steps in the scale.

What If You Cannot Decide?

What often happens is that you can narrow your choice to between two frames but then cannot decide which one is correct. If this occurs, choose the one that has more exposure. Color negatives do not suffer as much from overexposure as black-and-white negatives. Because the final print is made up of layers of dyes and not silver particles, slight overexposure does not create additional grain. In fact, overexposing by even as much as two f-stops will not make a negative unprintable. Given the choice of range of exposure for color negatives, overexposure is preferable. It builds contrast, offers protection against loss of detail in the shadow areas, and increases color saturation, which is directly controlled by exposure. Underexposure causes a loss of saturation making the colors look flat and washed out. This cannot be corrected during printing, though some digital correction is possible.

The "No Time" Approach

If you do not have the time to test a new film, the guidelines in Table A3.3 are offered as starting film speeds for negative film. When in doubt, give color negative film more exposure. Table A3.4 recommends starting speeds for transparency film. When in doubt, give color transparency film less exposure.

TABLE A3.3 THE "NO TIME" MODIFIED FILM SPEED FOR NEGATIVE MATERIALS	
Starting speed	**Modified speed**
100	50–80
200	100–125
400	200–300

TABLE A3.4 THE "NO TIME" MODIFIED FILM SPEED FOR SLIDE MATERIALS	
Starting speed	**Modified speed**
50	64–80
100	125–150
400	500–600

Contrast Control

With color negative films there are two important considerations that determine the contrast. The first is that contrast is produced from the colors themselves in the original scene. Complementary colors (opposite each other on the color wheel) produce more contrast than harmonious colors (next to each other on the color wheel). This factor can be controlled only at the time of exposure or by post-exposure software. The addition of fill light when shooting and masking when printing are other methods to control contrast.

Brightness Range

The second factor in contrast control of color negatives is the overall range of light reflectance between the previsualized shadow and highlight areas. This is the same as with black-and-white negatives. To a limited degree, the contrast can be changed by modifying the development time. However, when compared to black-and-white film, the allowable change in development time is much smaller, as any change will affect the color balance, which is finalized during development. With most color negative films, it is possible to adjust the contrast by one zone of contraction or expansion without serious color shifts or crossovers.

Table A3.5 suggests starting development times for Kodak's C-41 process in fresh developer for the first roll of film.

TABLE A3.5 SUGGESTED STARTING DEVELOPMENT TIMES IN KODAK'S C-41 AT 100°F	
Scene contrast	**Development time***
N–1	2 minutes 40 seconds
Normal	3 minutes 15 seconds
N+1	4 minutes

*All times based on first roll in fresh developer.

What Is "N"?

In the Zone System, "N" stands for normal developing time. N minus 1 (N−1) is used when you have a higher-than-normal range of contrast and wish to reduce it. N plus 1 (N+1) is used when you have a scene with lower-than-normal contrast and want to increase it.

Paper and Contrast Control

Compared to black-and-white, contrast control during analog color printing is very limited. It is possible to slightly increase the contrast of the final print by using a higher-contrast paper. By combining the higher-contrast paper with an N+1 development, you can increase the contrast to a true N+1 or to an N+1½ and maybe even an N+2. Corrections beyond these limits require digital assistance.

Index

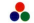

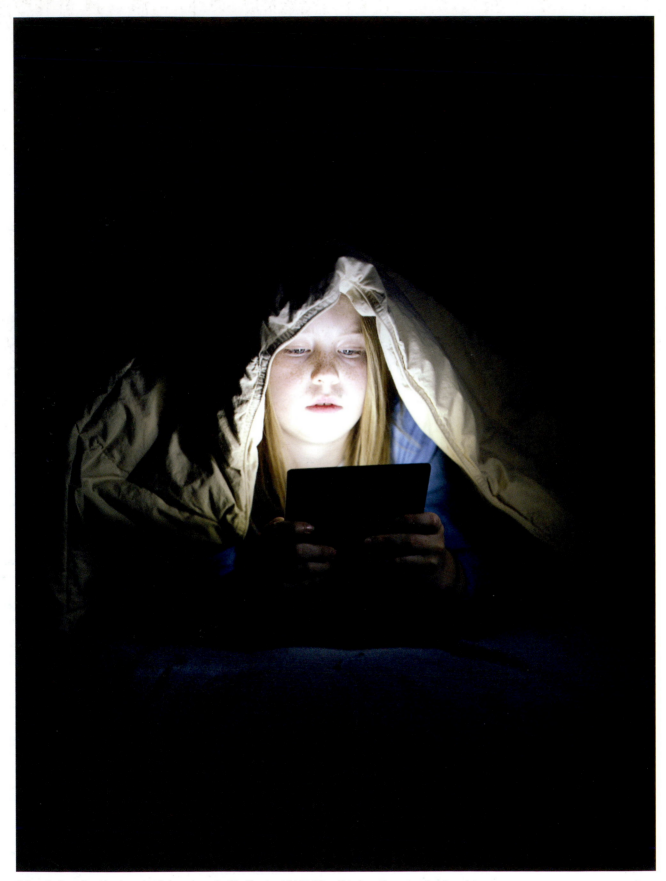

© Evan Baden. *Lila with Nintendo DS,* from the series *The Illuminati,* 2007. 30 × 40 inches. Chromogenic color print.